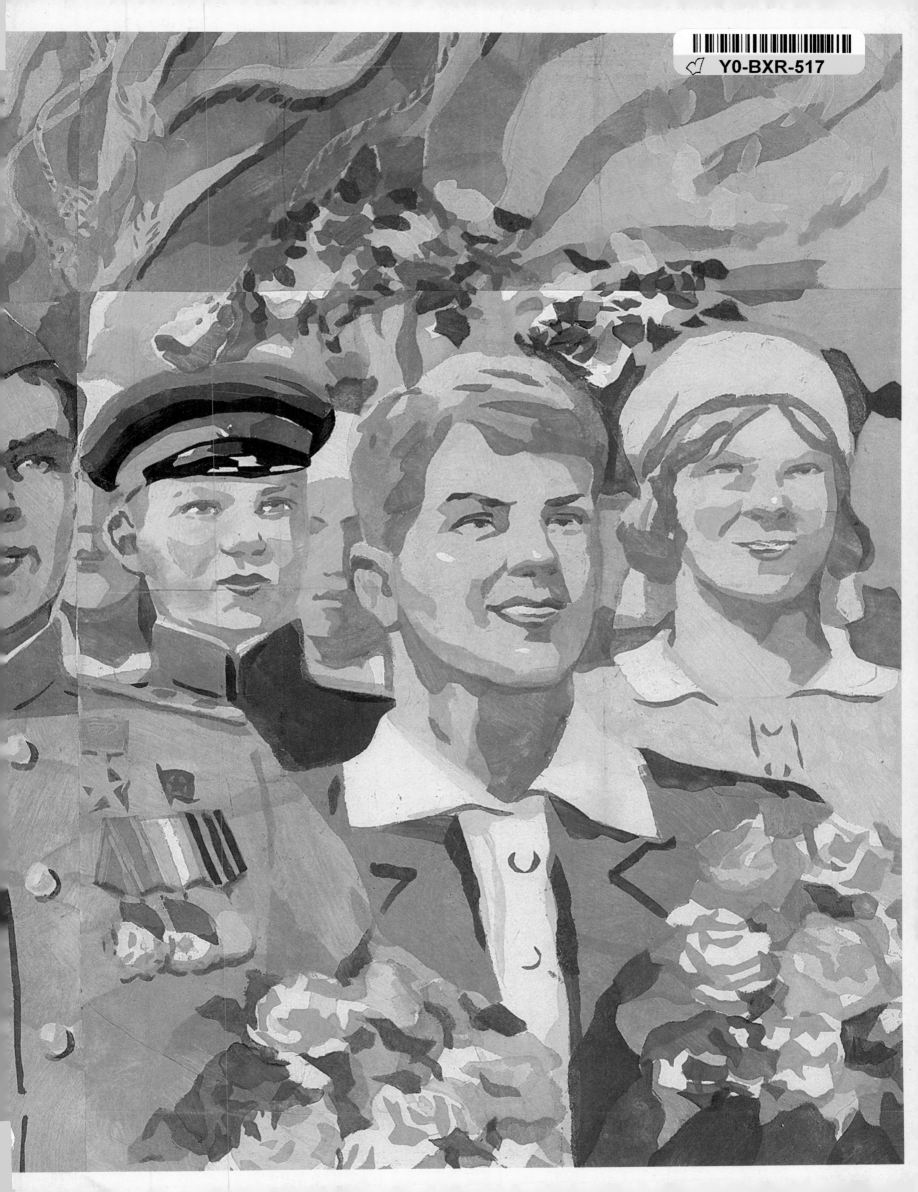

THE ART INSTITUTE
OF CHICAGO

YALE UNIVERSITY PRESS
NEW HAVEN AND LONDON

EDITED BY
PETER KORT ZEGERS
DOUGLAS DRUICK

WITH CONTRIBUTIONS BY
KONSTANTIN AKINSHA
ROBERT BIRD
JILL BUGAJSKI
DOUGLAS DRUICK
ADAM JOLLES

LAUREN MAKHOLM
CHER SCHNEIDER
PETER KORT ZEGERS
MOLLY ZIMMERMAN-FEELEY

SOVIET TASS POSTERS AT HOME
AND ABROAD

1941–1945

WINDOWS
ON THE WAR

Windows on the War: Soviet TASS Posters at Home and Abroad, 1941–1945 was published in conjunction with an exhibition of the same title organized by and presented at the Art Institute of Chicago from July 31 to October 23, 2011.

Generous support is provided by the Ne boltai! Collection.

Research support was provided by Edward McCormick Blair.

Further support is provided by the Exhibitions Trust: Goldman Sachs, Kenneth and Anne Griffin, Thomas and Margot Pritzker, the Earl and Brenda Shapiro Foundation, Donna and Howard Stone, and Mr. and Mrs. Paul Sullivan.

First edition
Second printing
Printed in Canada
ISBN: 978-0-300-17023-8
Library of Congress Control Number: 2011908176

Published by
The Art Institute of Chicago
111 South Michigan Avenue
Chicago, Illinois
60603-6404
www.artic.edu

Distributed by
Yale University Press
302 Temple Street
P.O. Box 209040
New Haven, Connecticut
06520-9040
www.yalebooks.com/art

Produced by the Publications Department of the Art Institute of Chicago, Robert V. Sharp, Executive Director

Edited by
Susan F. Rossen and Susan E. Weidemeyer

Production by
Sarah E. Guernsey and Joseph Mohan

Photography research by Lauren Makholm and Joseph Mohan

Designed and typeset in Akkurat and ITC Conduit by Studio Blue, Chicago, Illinois

Separations by Professional Graphics, Inc., Rockford, Illinois

Printing and binding by Friesens Corporation, Altona, Manitoba, Canada

Details

Front cover
Kukryniksy. *A Thunderous Blow* (TASS 504), June 17, 1942 (p. 214).

Back cover
Margaret Bourke-White. Untitled street scene, 1941 (TASS 60, fig. 2 [p. 171]).

Endsheets (from front to back)
Mikhail Solov'ev, with text by Irina Levidova. *Glory to the Soviet Youth!* (TASS 1290), August 31, 1945 (p. 372); Kukryniksy. Untitled (TASS 1048), early September 1944 (p. 312); Vladimir Ladiagin, with text by Stepan Shchipachev. *Volodia Zuzuev* (TASS 811), mid-September 1943 (p. 252); Viktor Sokolov, with text by Dem'ian Bednyi. *Monsters* (TASS 764), July 31, 1943 (p. 246).

Frontispiece
Pavel Sokolov-Skalia, with text by Samuil Marshak. *The Five Hundredth Window* (TASS 500), June 15, 1942 (p. 213).

Page 12
Ivan Shagin (born 1904; died 1982). Workers of the Hammer and Sickle Factory listening to a public broadcast regarding the invasion of the Soviet Union by Nazi Germany, Moscow, June 23, 1941. German-Russian Museum Berlin-Karlshorst.

Page 26
Pavel Sokolov-Skalia, with text by the Litbrigade. *Defenders of Moscow* (TASS 100), July 28, 1941 (p. 177).

Page 52
Kukryniksy, with theme by Isaak Livshits and text by Samuil Marshak. *Meeting over Berlin* (TASS 143), August 21, 1941 (p. 182).

Page 64
Mikhail Solov'ev, with text by Vasilii Lebedev-Kumach. *Our Troops Continue to Advance* (TASS 603), November 24, 1942 (p. 226).

Page 92
Petr Sarkisian, with text by Aleksei Mashistov. *The End of the Resort Season* (TASS 1050), September 16, 1944 (p. 313).

Page 104
Pavel Sokolov-Skalia, with text by Vasilii Lebedev-Kumach. *The Time for Vengeance Is Approaching* (TASS 506), June 18, 1942 (p. 215).

Page 136
Pavel Sokolov-Skalia, with text by Aleksandr Zharov. *Save Me, Brother!* (TASS 849/849A), November 2, 1943 (p. 257).

Page 160
Photographer unknown. Portrait of a Soviet prisoner of war, July 1941. Granger Collection.

CONTENTS

This volume, *Windows on the War: Soviet TASS Posters at Home and Abroad, 1941–1945*, and the exhibition of the same title that occasioned it focus on a remarkable body of agitational and propaganda posters that were produced almost daily in the Soviet Union over the course of World War II under the auspices of the TASS News Agency. Conceived as visual weapons to combat the invading German forces and mounted in the city streets and public spaces of the Soviet Union, these posters were also sent abroad as ambassadors to gain support for the Soviet cause. This is how the Art Institute came to house a group of over 150 posters that, though they arrived in the early 1940s, were forgotten after the war, only to be "rediscovered" in 1997.

Little published outside of the Russian Federation and thus unfamiliar to Western audiences, the TASS Window posters are unique in the history of poster making by virtue of their scale, chromatic brilliance, and stylistic variety, as well as the collaboration they represent between artists and writers, and their inventive use of the modest yet versatile medium of hand-stenciling. Constituting a remarkable chapter in the history of graphic art and propaganda, the posters afford insight into the Soviet investment in what constituted a war of images waged by all sides of the conflict.

Work on the posters began at the moment of their rediscovery in our vaults, still folded tightly, as they had been received a half-century earlier. Peter Zegers, Rothman Family Research Curator in the Department of Prints and Drawings, with characteristic enthusiasm, focus, and energy, took charge of this project, doing extensive research that would provide invaluable groundwork for a possible exhibition and publication. As he unearthed information that suggested new approaches to the material, the project's conception changed significantly. It was refined when scholars Konstantin Akinsha, Robert Bird, and Adam Jolles joined the Art Institute's TASS team, which was subsequently augmented by Jill Bugajski. They and the many others involved over the years in this challenging and exciting project are thanked in the Acknowledgments that follow. Working with the incisive and wise guidance of Douglas Druick, Prince Trust Curator and Chair, Department of Prints and Drawings, and Searle Curator and Chair, Department of Medieval to Modern Painting and Sculpture, along with the input of an advisory committee of distinguished scholars, the group realized a pioneering publication and exhibition that yield the first fulsome treatment of the subject of TASS posters in the English language and introduce many Soviet artists not previously familiar to Western audiences: Mikhail Cheremnykh, Nikolai Denisovskii, Sergei Kostin, the Kukryniksy, Vladimir Lebedev, Mikhail Solov'ev, and Pavel Sokolov-Skalia, among others.

Coinciding with the seventieth anniversary of the invasion of the Soviet Union by Nazi Germany on June 22, 1941, *Windows on the War* marks the second time in twenty years that the Art Institute has mounted an exhibition that explores the relationship between politics and art, power and propaganda in World War II. In 1991 the Art Institute hosted *"Degenerate Art": The Fate of the Avant-Garde in Nazi Germany*, organized by Stephanie Barron and the Los Angeles County Museum of Art, which brought to light a history that dramatically impacted the accepted narrative of the role of art in Nazi Germany. Now *Windows on the War* presents new works of art and figures of consequence, investigating the Soviet Union's use of images and the place of TASS posters in the complex agenda of a totalitarian nation engaged in what it called the "Great Patriotic War."

Windows on the War signals a broadening of the Art Institute's art-historical horizons to incorporate key moments of the twentieth century in Eastern Europe and the Soviet Union. The exhibition follows the major acquisition of Kazimir Malevich's *Painterly Realism of a Football Player – Color Masses in the 4th Dimension* (1915), and runs concurrently with the exhibition *Avant-Garde Art in Everyday Life*, which addresses significant modernist works – including posters, prints, books, illustrated magazines, and tableware by Soviet, Czech, and other European artists – drawn from the Robert and June Leibowits collection at the Art Institute.

Critical to *Windows on the War* has been the opportunity to represent TASS posters with examples that go beyond the Art Institute's holdings in order to fully display the breadth and complexity of the studio's production and contextualize its unique position in Soviet visual propaganda. This has been made possible by the collaboration of the Ne boltai! Collection, an extraordinary, privately owned repository and archive of political graphics and material culture from the Soviet Union and former Eastern Bloc. The sheer number of TASS posters and other materials reproduced in the present volume attests to the level of access to the collection's holdings that was extended to the project's team. We are deeply grateful to Ne boltai!'s owner, who wishes to remain anonymous, for his extensive and multifaceted support of *Windows on the War*: providing the majority of the loans and underwriting the publication and the related Web site. In each aspect of this collaboration, the generosity and expertise of the collection's curator and manager, Anna Loginova, have been invaluable. To them and other lenders (listed in the Acknowledgments), as well as to the entire TASS team, I extend my gratitude and congratulations.

James Cuno
President and Eloise W. Martin Director
The Art Institute of Chicago

ACKNOWLEDGMENTS

When 157 TASS Window posters were discovered in the Art Institute of Chicago's Department of Prints and Drawings in 1997, the late James N. Wood, then the museum's director and president, was so taken by the works' large dimensions, arresting iconography, and striking palette and surfaces that he suggested we consider an exhibition. This launched us on an exciting odyssey of research and discovery whose scope broadened over the years, involving more individuals and institutions – local, national, and international – than we could ever have imagined at the beginning. We are profoundly grateful to each and every one.

We begin with the Department of Prints and Drawings, where *Windows on the War: Soviet TASS Posters at Home and Abroad, 1941–1945* originated in 2004–05. The story of how the posters were found, and about their condition when we found them, is related in the Introduction. The enormous task of remedial maintenance and restoration of the posters, which had to occur before we could properly examine them and begin documentation and study, was done under the supervision of Harriet Stratis, head of paper conservation, along with David Chandler, Caesar Citraro, and Wrik Repasky. Margo McFarland researched and developed the method used to conserve and encapsulate the posters. Assistant Conservator Kristi Dahm and Novy Family Fellows Melissa Buschey and Rebecca Pollak continued this work. Later on in the project's evolution, Kristi, along with Andrew W. Mellon Fellow in Paper Conservation Cher Schneider and Novy Family Fellow Margaret Bole, addressed the wear and tear of loans from various public and private collections. Our desire to effectively and conscientiously display the posters while remaining true to their nature by not turning them into framed fine-art objects posed significant challenges, given the number of items and large size of many of the posters. This task was deftly executed by Christine Conniff-O'Shea, assistant conservator for matting and framing, and Mardy Sears, conservation technician.

The first phase of research into the posters' origins was undertaken by Anatole Upart, then an intern from the School of the Art Institute, who began cataloguing and photographing the works. A native of Minsk, Belarus, he provided the first translations of the posters' texts. Over the years, students and interns with various academic and studio backgrounds and Slavic-language skills not only provided further translations but also contributed to a vast bank of research materials on which the exhibition's curators and the authors of this book drew. We thank Julia Alekseyeva, Marisa Angell, Yevgenyia Baras, Luba Borun, Natalie Carlsson, Eli Feiman, Jesse Feiman, Elena Mamonova, Maria Marchenkova, Lia Markey, Michelle McCormick, Diana Pilipenko, Claire Roosien, Liza Smirnova, and Miriam Voss. Volunteer Susanna Rudofsky proved to be an indefatigable partner in assisting us with German texts and issues related to World War II. For their translation work, we are also grateful to Olena Chervonik, Conor Klamann, and Elizaveta Speransky.

Department Coordinator Jason Foumberg tracked the budget, coordinated travel, and always remained composed and unflappable. Our project was at times so all-consuming that it impacted the focus and work of others in the department and impinged on their workspaces. For their patience, understanding, and support, we thank, in addition to the aforementioned staff members of Paper Conservation, Jay Clarke, Rachel Freeman, Barbara Hind, Suzanne Karr Schmidt, Elliot Layda, Suzanne Folds McCullagh, Kimberly Nichols, Elvee O'Kelly, Mark Pascale, Karin Patzke, Jennifer Stec, Matt Stolle, Martha Tedeschi, Kate Tierney Powell, and Emily Vokt-Ziemba, as well as volunteers Thomas Baron, Dr. William and Ruth Best, Hugh Stevens, and Mary Young.

The ever-expanding perimeters of *Windows on the War* took us well beyond the Art Institute in our research efforts. At the Hoover Institution Archives, Stanford University, Carol A. Leadenham, assistant archivist for reference, and Rayan Ghazal, head of book and paper preservation, made us feel welcome, greatly facilitated our exploration of the archives' vast holdings, and provided essential information about them. We greatly appreciate the hospitality and research opportunities afforded us at the Wolfsonian Institution, Florida International University, by Marianne Lamonaca, associate director, Curatorial Affairs and Education, and Jonathan Mogul, Andrew Mellon Foundation academic program coordinator.

A number of institutions in the Washington, D.C., area proved critical to our endeavor. We were graciously received at the Library of Congress by Janice Grenci, reference specialist for posters in the Prints and Photographs Division. Janice contributed immensely to our knowledge of the library's vast holdings and assisted us with the foundations of what would become our in-house catalogue raisonné of TASS posters. We are deeply indebted to her for her belief in and support of our mission. At the United States Army Center of Military History, Renee Klish, army art curator, showed us the center's recently discovered TASS posters and guided us through other fascinating aspects of the collection. At the United States Holocaust Memorial Museum, Sarah A. Ogilvie, director, National Institute for Holocaust Education; Susan Goldstein Snyder, associate curator for art and artifacts; and Nancy Hartman, photo archivist, were very helpful.

In New York, we are grateful to Jane Siegel and Tanya Chebotarev, Columbia University Rare Book and Manuscript Library; Samantha Rippner and James Moske, Metropolitan Museum of Art; Paul Galloway, The Museum of Modern Art; Erika Gottfried, Taminent Library and Robert F. Wagner Labor Archives at the Elmer Holmes Bobst Library, New York University; Nicolette Dobrowolski, Special Collections Research Center, Syracuse University Library; and Maire Kennedy.

In the Russian Federation, research was conducted by Andrei Krusanov in the State Archive of the Russian Federation (GARF), Russian State Library (GBL), Russian State Archive of Literature and Art (RGALI), and the Central Moscow Archive-Museum of Private Collections (TsMAMLS), as well as in various other libraries in Moscow and St. Petersburg. Our intrepid research assistants were Liza Smirnova and Irina Tokareva. We are indebted as well to Larisa Kolesnikova for making her personal archive of Nikolai Denisovskii's papers and papers related to the TASS studio available to our research team.

We were eager to involve the local scholarly community in our project because we knew we could benefit from the extensive knowledge of Soviet history, culture, and art in our midst. We therefore formed an advisory committee representing a cross section of disciplines. Our meetings resulted not only in significantly honing our focus but also in involving cultural and academic institutions throughout the Chicago metropolitan area in an exciting roster of related programs and exhibitions, "The Soviet Arts Experience," throughout 2010 and 2011. We thank the committee: Gerard McBurney, artistic programming adviser and creative director, Chicago Symphony Orchestra; Paul B. Jaskot, professor of modern art and architectural history, DePaul University; Christina Kiaer, associate professor of art history, Northwestern University; Benjamin Frommer, Wayne V. Jones Research Professor in History, Northwestern University; Will Schmenner, former motion picture curator and programmer, Mary and Leigh Block Museum of Art; Ryan Yantis, former executive director, and John Zukowsky, former interim director, Pritzker Military Library; Robert Bird, professor, Department of Slavic Languages and Literatures, University of Chicago; Neil Harris, Preston and Sterling Morton Emeritus Professor of History, University of Chicago; Matthew Jesse Jackson, professor of art history, University of Chicago; and Yuri Tsivian, William Colvin Professor of Film, University of Chicago.

Other scholars who provided important information include Tony Hirschel, director, Smart Museum of Art, University of Chicago; Catriona Kelly, professor of Russian, Oxford University; Elena Kolikova, research fellow, Russian State Archive for Documentary Photography and Film (RGAKFD); Katherine Hill Reischl, PhD candidate, Department of Slavic Languages and Literatures, University of Chicago; Monika Spivak, director, Andre Belyi Memorial Apartment in the Aleksandr Pushkin Museum, Moscow; and Helen Sullivan, manager, Slavic Reference Service, University of Illinois at Urbana-Champaign. For their help with research queries big and small, we thank Joe Berton, Dee-Ann Druick, David Gartler (of Posters Plus), Gloria Groom, Nick Hudac, Theo de Klerk, Jim Kort, Suzanne Folds McCullagh, Mary Ellen Meehan (of Meehan Military Posters), Martha Tedeschi, Harm Walma, and Irene Zegers. We also acknowledge the timely interventions of Ben Elwes and Deborah Peña.

We are deeply grateful to the public and private collections that generously lent objects to the exhibition and to their staffs for facilitating the loans. Normally a non-lending institution, the Hoover Institution Archives, Stanford University, agreed to make an exception for this project, thanks to the special efforts and enthusiastic support of Director Richard Sousa. We are deeply grateful to him and the Hoover for their critical participation in our endeavor. We acknowledge the assistance at the Chicago-Kent College of Law, Illinois Institute of Technology, of Keith Ann Stiverson, director, and Emily Barney; at the Chicago Public Library of Mary Dempsey, commissioner, and Elizabeth M. Holland, museum specialist, Special Collections and Preservation Division; and at the George C. Marshall Foundation, Lexington, Virginia, of Jeffrey Kozak, archivist. We express our gratitude to Jack Becker, director, and Matt Clouse, registrar, at the Joslyn Art Museum, Omaha; Helena Zinkham, chief, Prints and Photographs Division, and Tambra Johnson, exhibition registrar, at the Library of Congress; Michael Govan, Wallace Annenberg Director at the Los Angeles County Museum of Art; Barry Bergdoll, Philip Johnson Chief Curator of Architecture and Design, along with Karl Buchberg, Erika Mosier, and Pamela Popeson of the conservation and preparation staff, at The Museum of Modern Art, New York; Geoffrey Swindells, head, Government and Geographic Information and Data Services, Northwestern University Library; and Dr. Gary R. Kremer, director, and Joan Stack, art curator, at the State Historical Society of Missouri. We thank the United States Army Center of Military History and Renee Klish; the United States Holocaust Memorial Museum and Sarah A. Ogilvie; the University of Minnesota Libraries, Cecily Marcus, curator, Givens Collection of African American Literature, Upper Midwest Library Archives and Performing Arts Archives, and Barbara Bezat, assistant archivist, Manuscripts Division; and Wolfsonian Institution, Florida International University, Marianne Lamonaca and Kimberly J. Bergen, senior registrar. William Cellini Jr., Chicago, not only lent to the exhibition but also participated in the project in a number of other meaningful ways. He, along with several other lenders – Hoover Institution, Joslyn Art Museum, Ne boltai! Collection (see below), and University of Minnesota – agreed to part with his holdings long before the opening of Windows on the War so that we could conserve and frame where necessary, and digitally capture every work for inclusion in the exhibition and publication in an accurate and consistent way.

Foremost among the lenders is the Ne boltai! Collection, which became an indispensible partner in many key aspects of our undertaking. In May 2009, we were approached, through an intermediary, by the owner of the collection, who inquired about our plans for exhibiting the Art Institute's TASS Window poster holdings. Discussions led to the collector's invitation to study the materials he has been amassing – Soviet posters and other printed materials and related original artwork dating from 1917 to the late 1980s. With such a significant resource at our disposal, we were able not only to fill in critical lacunae of TASS posters but also to supplement them with a spectacular and meaningful array of conventionally printed materials, providing a context of modes of graphic representation in which the TASS images can be situated. We are profoundly grateful to the owner of this extraordinary collection, who has asked to remain anonymous, for his magnanimity in lending us so many critical works and for his generous support of the exhibition's publication and Web site. We also wish to acknowledge our great debt to Ne boltai!'s curator and manager, Anna Loginova, for facilitating our visits to the collection, assisting in the selection process, and handling all logistical and various other matters with superb professionalism and a spirit of friendship one rarely encounters. The collection's photographer, Kristina Hrabělová, and Alexandr Shklyaruk are also to be thanked.

eventy years ago, in the immediate aftermath of the German invasion of the Soviet Union on June 22, 1941, a group of artists and writers in Moscow joined forces, under the auspices of the TASS News Agency, to produce large-scale posters – Okna TASS or TASS Windows – designed to reassure and rouse the Soviet citizenry while manipulating the information it received in the service of envisioning a new world order.[1] Over the 1,418 days of World War II on the Eastern Front – the "Great Patriotic War" in the parlance of both the Soviet Union and contemporary Russia – the TASS studio produced some 1,240 designs treating subjects that reflected the progress of the war from the Soviet perspective and incorporating an extraordinary range of literary and visual styles that evolved over the course of the war.[2] The resulting body of work is – in its size, scope, and variety – unique in the annals of Soviet visual propaganda, constituting a singular chapter in the broader history of graphic art and poster design, one that is all the more intriguing because it has been hitherto virtually absent from the histories of these subjects in the West.

This silence reigned despite the fact that, as our research revealed, many TASS posters were sent to Great Britain and the United States throughout the war (see fig. 5.46) by the Society for Cultural Relations with Foreign Countries (VOKS). These exports were intended to function as ambassadors: initially raising awareness of and support for the Soviet war effort and then, once the United States had joined Britain and the Soviets in the war against Germany, reporting the progress on the Eastern Front and promoting the three-flag alliance – a staple of the TASS lexicon. These goals were part of the larger strategy to persuade the United States and Britain to establish a Western Front in Europe, which was finally realized with the Normandy landing on June 6, 1944.

DISCOVERING TASS AT THE ART INSTITUTE OF CHICAGO

The TASS propaganda offensive could reasonably have expected only limited success in the United States. Since the October Revolution of 1917, Americans had been highly equivocal about the fundamentally antidemocratic Soviet regime, which had proven its perfidy through its 1939 Molotov-Ribbentrop Pact with Nazi Germany. Nonetheless, championed by the pro-interventionist American Left, reproduced in tabloids like *PM* and wide-circulation publications such as *Look* and *Life*, and exhibited at some of the most prestigious museums in the country, TASS posters garnered visibility and respect – but for a brief moment only. With Allied victory and the Cold War that followed on its heels, the four-year American-Soviet alliance seemed a phantasm, as distant from the present as the four years of newspaper headlines that had reported events on the Eastern Front. In this postwar climate, TASS posters – as well as the American-Russian friendship associations that had promoted their exposure in the United States and the three-flag alliance they had celebrated – were so completely eclipsed that the memory of their achievements, along with their presence in wartime America, was largely erased.

How true this was became dramatically clear to us in the late 1990s. In preparation for a major renovation of the Art Institute of Chicago's Department of Prints and Drawings, all contents of the departmental spaces had to be inventoried and temporarily relocated. As part of this process, a little-used storage closet containing two tiers of slotted storage bins for large framed works was targeted for clearance. Once these contents had been removed and the space scrutinized, we discovered that above the stacked storage bins was a small, troughlike space not readily visible without a ladder. Further investigation revealed unexpected contents: two thick rolls, each approximately seventy-five centimeters in diameter, and twenty-six kraft-paper parcels measuring thirty by forty centimeters. The rolls contained dozens of posters by European and American artists spanning the late 1880s to the 1940s – including World War I and II subjects – only some of which had been accessioned. The cause of this disregard was most likely the old prejudice that viewed posters as a "lesser," popular art form, more the province of design collections than those of prints and drawings.

The parcels turned out to contain an even bigger surprise. The first, when unwrapped, exuded a strong odor of solvents and decaying paper and revealed six tightly folded sheets of newsprint. What these were could not be readily ascertained, since they were in such an embrittled state that attempts to unfold them produced breaks along the fold lines; however, placing one of the folded sheets in a humidity chamber for twenty-four hours – allowing the paper to absorb moisture that would cause the fibers to swell and relax – yielded results.[3] When we unfolded it the next day, we were stunned to see an unusually large and striking image of remarkable chromatic richness, realized by means of stencil and accompanied by texts in Cyrillic. We had no idea what it was we were looking at.

As the humidification and unfolding procedure continued, it took little time to identify the packages' contents: the 157 colorful, stenciled images on very large sheets of assembled paper, each bearing a different number at the upper right and representing a variety of styles and artists, were TASS Window posters. Initial research yielded many more questions than answers, however.

The most significant literature on the TASS studio to date is in Russian. These publications have largely dealt with TASS Windows in monographic form or as part of Soviet poster overviews. While some accounts are serious and illuminating, their shared tendency toward a mythic construction of the studio's role during the Great Patriotic War occludes historical understanding of the form and function of the TASS posters.[4] Indeed, the challenges and problems in this field date back to the Khrushchev era. The initial inventory project, spearheaded by the former Lenin Library in 1965, was selectively incomplete, and this has never been rectified.[5]

In English, information on the TASS posters appears much less frequently. In 1976 Elizabeth Valkenier of the Russian Institute at Columbia University published a brochure of the TASS poster holdings from the Louis G. Cowan Collection.[6] Sixteen years later, the University of Nottingham published a booklet accompanied by microfilm images of its TASS holdings.[7] These two inventories, comprising posters distributed by VOKS, helped to orient our initial investigations. In secondary English material, TASS posters are mentioned only fleetingly, often compared dismissively to artistic accomplishments in avant-garde poster design of the 1920s.[8]

There were other notable obstacles to making sense of TASS production. Only a small fraction of the TASS posters has been reproduced, making claims about the studio's ambitions, the contributions of individual artists, and the changing patterns of production from 1941 to 1945 impossible to assess. Compounding this is the reality that those works in public collections are more often than not unavailable for study, given their large size and fragility.[9] Moreover, an appreciation of their message – focused on the war on the Eastern Front – is often challenging for a Western audience that has historically understood World War II almost exclusively from the perspective of the Western Front and Pacific theater.[10] Finally, nowhere has the story of TASS posters abroad, and particularly

their employment as ambassadors to Great Britain and the United States, been told. What were TASS posters doing in the Art Institute? That question launched our project.

We set out to fill in the many blanks in our knowledge, pursuing the intersecting histories of TASS in the Soviet Union and the posters' reception in wartime America by combing primary sources, working in archives in the United States and Russia, and tracking down posters in other public collections that either knew little if anything about their provenance or, like us, had been unaware they owned them. The more material we discovered, the more convinced we became of the need for a better understanding of the historical and material forces that shaped the conception, production, and content of TASS posters, as well as their public reception in the United States and Great Britain. And the more we unearthed, the more we were both struck by their pictorial singularity, material complexity, and stylistic range and intrigued by the often remarkable talents of the painters and graphic artists who designed them, the collective of studio workers who realized them, and the writers who provided their varied texts. As a result, we assembled a team of scholars and began plans for an exhibition and publication.

The shape of our project evolved through years of research and new findings. It was a process of serial "discoveries" about TASS Windows, nesting within each other like Russian Matryoshka dolls and recalling Churchill's famous description of Russia as "a riddle wrapped in a mystery inside an enigma."[11] He identified the key to unraveling the enigma to be understanding the perspective of Russian national interest. Certainly, this is one point of entry to understanding TASS posters, but there are others.

The dramatic narrative occasioned by the arrival of the 157 posters at the Art Institute between 1942 and 1945 has provided the foundation for our exhibition. Preselected for international distribution to non-Communist countries, these images form only a small part of the studio's total production. We have chosen eighty TASS posters from our collection, augmented by seventy-five from other collections in order to offer a broader historical view of the TASS production than the VOKS gift alone could provide.

Focusing on the relationship between TASS, the Eastern Front, and international distribution, we were able to address the unique, individual

biographies of the artists and poets employed by the studio only in a limited way. We seek neither to pass judgment on the Soviet politics under which they worked nor to examine how these individuals submitted to, or rebelled against, the exigencies of war and daily life in a totalitarian state. The crimes of Stalin were immense, and we do not celebrate the Soviet social system nor exonerate the TASS studio's complicity in supporting such a regime. Nonetheless, further examination of the production of those individuals who contributed most substantially to TASS will illuminate how each developed a unique approach to the challenges of envisioning a victorious Soviet Union.

This publication and exhibition, as well as the related Web site, will make available to the public for the first time more than half of the TASS Windows production. Although we offer significant corrections to existing narratives, our contribution should not be taken as a comprehensive history of the studio. The future disclosure of more archival material or undocumented collections will certainly allow for new narratives.

TASS WINDOWS IN POSTER HISTORY

As this project reveals, TASS poster production constitutes an extraordinary and anomalous chapter in the history of posters and their makers, political functions and uses, and shifting fortunes vis-à-vis the so-called "high" arts. While virtually unknown outside the former Soviet Union, TASS posters are exceptional even within its borders and in the context of its history of agitational propaganda. As posters they are unorthodox, and as this publication explores, their unorthodoxy is multifaceted.

TASS Windows stand outside mainstream modern poster history – from which they have been largely excluded – by virtue of both their medium and its application. Stencil has a history in the West that long antedates printmaking, the proliferation of which was intimately tied to the invention of the printing press in the mid-fifteenth century. Following the advent of printmaking, stencils were often used to embellish black-and-white prints with color, an arguably more consistent technique than the freehand application of color. Despite advances in color printing in woodcut, engraving, etching, and lithography, stencil coloring remained, until the late nineteenth century, an economically attractive, if often cruder, alternative, especially for inexpensive publications at the lower end of the

image market, such as fashion plates, sheet music, religious imagery, and political broadsides like the anti-Bonapartist images produced in France during and following the Franco-Prussian War of 1870–71 (see fig. 1). Stenciling also found widespread application in the decorative arts – especially within the wallpaper, textile, and ceramic industries – and was employed in rudimentary two- and three-color posters.

When, in the 1890s, new photomechanical printing technologies became incontestably the most economical means of realizing color images in large editions – even for popular prints like Russian *lubki* – stencil underwent a transformation in perception and practice along with traditional print media. Relieved of their time-honored role in the publishing industry, etching and lithography on stone were utilized by painters to produce handcrafted prints (so-called "original" prints) in exclusive limited editions. Similarly, stencil – its processes refined, complicated, and practiced by craftsmen of consummate skill – assumed the identity today conveyed by its French name, *pochoir*: a vehicle, especially in early-twentieth-century France, for the production of luxurious, upscale commodities, including limited-edition illustrated books and publications devoted to fashion and industrial design.[12]

French artists in the late 1880s inaugurated the modern illustrated poster (*affiche illustrée*) with color lithography, launching a poster craze that immediately spread to the major urban centers of Europe, England, and North America and persisted with unabated energy into the twentieth century. The large scale permitted by new printing technology enabled posters to become an essential advertising tool in increasingly competitive markets for consumer goods and entertainment. With such opportunities, commercial poster design fostered creative competition among artists eager to try their hands at the latest stylistic trends. From the outset, such experimentation was encouraged by those French theorists who regarded posters as a tool critical to promoting a much-needed revival of the decorative arts, perceived to be in decline since they were driven by an expanding middle class allegedly lacking in refined taste. At issue, the thinking went, were the future prospects and the preeminent reputation of French design in a competitive world economy. At the Paris Exposition Universelle of 1889, critics of various stripes had seen Jules Chéret's large color lithographic posters (see fig. 2) – exhibited on the Champ de Mars while

Fig. 1 Faustin Betbeder
(French, 1847–?)
*A Nest of Caterpillars
– A Tree Nibbled on by
Corsicans Will Grow Green
Again*, 1871

Lithograph with stenciled
color
45 × 34.5 cm
Private collection

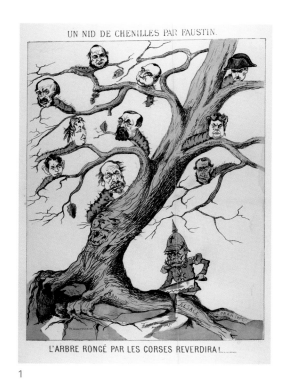

UN NID DE CHENILLES PAR FAUSTIN.

L'ARBRE RONGÉ PAR LES CORSES REVERDIRA!.........

1

simultaneously posted on the streets of Paris – as beacons: "democratic" insofar as they had been designed for a mass audience, and "artistic" in that the work of the "Delacroix of the poster" promoted good taste by providing "le beau dans l'utile," or beauty in a useful object. Awarded a gold medal at the exposition and the focus of a one-man show later in the year, Chéret was invoked in debates about the artificiality of artistic hierarchies and the stifling conventions of officially sponsored art. Indeed, by 1892 influential leftist apologists included writer Anatole France, who referred to posters as "frescoes of the poor," and sculptor Auguste Rodin, who stated that the posters of Chéret and younger followers were "causing art to be brought back into [mass] circulation."[13]

In Russia, whose longstanding cultural links to France were strengthened by the military alliance of 1892, poster design attracted the talents of prominent artists such as Léon Bakst even while the country lagged behind in the international competition for preeminence in the production of artistic posters (*affiches artistiques*).[14] Such images served commercial culture, the arts, and, with the outbreak of World War I, the recruiting and propaganda needs of the czarist government. The 1917 October Revolution brought an abrupt end to the Russian poster revival's ideology of pleasure and consumption and to the competitive market-place that provided an arena for such work. Indeed,

the Soviet state would adopt and ideologically transform the production of posters, becoming the sole sponsor of strategies for the dissemination of political agitation and propaganda.

The ensuing Civil War period (1917–23) witnessed the production of what for some scholars represents the high point in the history of Soviet political-poster design.[15] Many of the resulting posters were color lithographs that were relatively modest in scale (see fig. 5.3), but a remarkable new chapter in the history of poster making was ushered in with the production of large-format stenciled posters – up to three meters in height – issued by the recently founded ROSTA studio. These posters circulated within the cities that produced them and hung in spaces that included the storefront windows that the Revolution had left empty. The creative leaders of the so-called ROSTA Windows produced in Moscow included Mikhail Cheremnykh, a driving force in their inception, and the highly influential poet and occasional artist Vladimir Maiakovskii (see figs. 3.3, 6.7).[16]

Understanding ROSTA Windows and other similar posters (see fig. 3) is a prerequisite for the critical appreciation of the early TASS Windows of two decades later, since both hybridize the traditions that poster designer and ROSTA contributor Dmitrii Moor identified in an unpublished lecture.[17] Posters, he argued, had acquired their modern form in Chéret's work but were anticipated much earlier in Russian icons (see fig. 4) and popular broadsides, both of which occasionally shared similar narrative and illustrative strategies designed to inform, entertain, and persuade.[18] Universal to print cultures, small-scale broadsides – their regional designations including *flugblatt* or *bilderbogen* in German, *canard* or *image d'Épinal* in French, and *lubok* in Russian – traditionally treated sensational news, natural disasters, military exploits, and religious, folk, and fairy tales intended for the broadest possible audience. Their compositional makeup involved either a single image or multiple panels arranged in narrative sequence, in both cases framed by headlines, excerpts from newspapers, and versified captions or rhymes (see figs. 5–6). Related, but often privileging text over images, were wall newspapers, which combined the traditions of newspapers and broadsides and were intended to be displayed on walls or in public showcases (see fig. 1.4).[19]

In harnessing the scale of the modern poster with popular visual practices, ROSTA looked to recent wartime incarnations of *lubki*, commercially produced color lithographs (see fig. 7), including those issued in 1914 by the publishing house Today's Lubok (Segodniashnii lubok), which employed such avant-garde artists as Kazimir Malevich and

Maiakovskii. They had updated the genre, incorporating a Russian Futurist idiom to realize bold, decorative, and simple visual structures and texts (see fig. 6.5).[20] By incorporating the *lubok* form, ROSTA posters necessarily broke with the modern poster protocol of one large image field with text stylistically integrated within it. Rather than being conceived as one overall design, ROSTA posters comprised a series of constituent images and texts, one above the other, on individual sheets of paper glued, at the moment of their public installation, to a common support in a grid order that established a visual and textual sequential narrative.[21]

The ROSTA studio tackled subjects that reflected a wide range of public interests, including news from the various fronts and decrees issued by the Soviet leadership that Maiakovskii transformed into what he called "popular rhymes." Its imagery was cast in a new visual language, adumbrated by recent *lubki* publications and, like them, drawing upon the political caricatures of the satirical journals that had proliferated when censorship had relaxed between 1905 and 1907.[22] Despite individual differences, the ROSTA artists worked in what Cheremnykh later described as the "style of our collective."[23] Its hallmark was its standardized lexicon of types – relatively unchanging pictographs representing a host of stock figures, ideas, and situations – treated in a telegraphically abbreviated style and a reduced but vivid palette in which red and black often defined oppositional elements in the story line: the Soviet peasant, worker, and Red Army soldier appearing in red, and top-hatted capitalists, anti-Bolshevik forces, and other enemies of the state in black. As a result of such largely stable and vivid visual coding, which worked with pungently succinct and inventive texts, ROSTA posters are said to have become legible to a large audience and, despite their revolutionary modernist features, enormously popular.[24]

The ROSTA posters' break with the modern poster tradition also involved their basic material structure. The studio's decision to employ stencils rather than lithography was a practical one.[25] In addition to the fact that printing facilities had, like other manufacturing, suffered during the Revolution and its aftermath, color lithography demanded a host of resources: separate stones or plates for each color printed; time to create, calibrate, print, and then remove the designs from the printing matrices; and power to run the presses through the sequential printings required to produce a single image. By contrast, stencil, a manual system from beginning

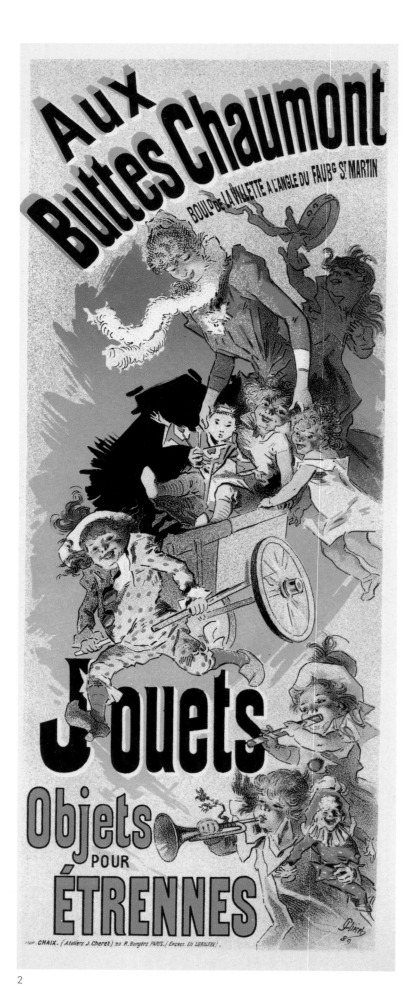

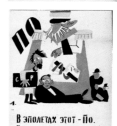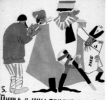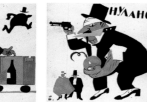

Fig. 2 Jules Chéret
(French, 1836–1932)
*Aux buttes chaumont:
Toys and Gift Ideas for the
Holidays*, 1889
Color lithograph
263 × 108 cm
Musée de la Publicité

Fig. 3 Mikhail
Cheremnykh, with text by
Vladimir Maiakovskii
*A Song That Suggests
What We Think of
Some French Guests*,
September 1921
Publisher: Regional
Committee of the Union of
Art Workers (GUBRABIS)
Edition: unknown
Stencil
Each panel: 53 × 39 cm
Israel Museum

Fig. 4 Artist unknown
(Russian)
*Saint George and the
Dragon with Fourteen
Scenes from His Life*,
1300/50
Tempera on wood
89.5 × 63 × 2.5 cm
Russian Museum

Fig. 5 Artist unknown
(French)
A Horrible Assassination,
August 31, 1833
Publisher: Chez Garson,
Fabricant d'Image
Woodcut and wood
engraving
44.5 × 31 cm
Bibliothèque Nationale

2

3

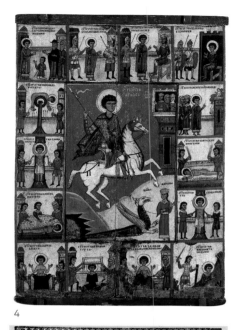

4

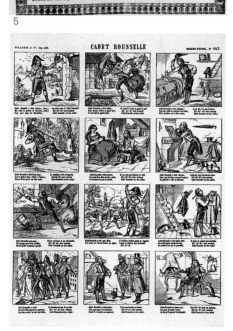

5

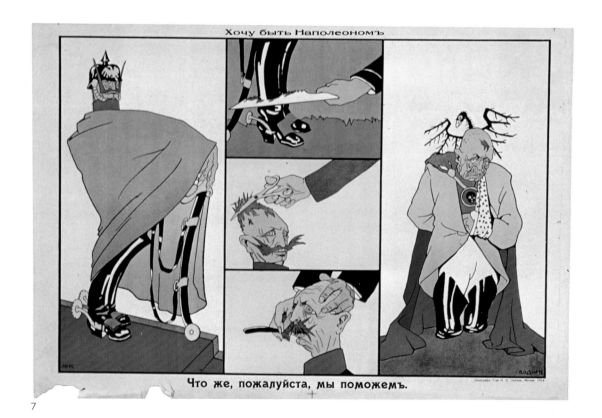

7

to end, could draw upon more readily available resources – notably human labor – while bypassing the economic and maintenance demands and limitations of machine technology in order to realize mural-scale posters. Moreover, it could respond to changing events and produce realizable designs more quickly than printing technology, thereby ensuring the currency of poster messages even if its edition sizes could not rival those of automated printing presses. As Maiakovskii observed of stencil production, "No printing technology could keep pace."[26]

Stencil permitted designers to include more colors in each poster. In lithography the more color a design involves, the longer the printing process takes. Given the poster's need for expediency and immediate responsiveness to events, the five-color palette often found in ROSTA posters could not have been readily matched in contemporary lithographic productions, which, for reasons of both time and cost, were often restricted to two or three colors. Moreover, color applied by hand, even somewhat crudely, has a more vividly material quality than can be achieved in standard, commercial color

lithography. The sensuous immediacy of the zones of primary and secondary color that, along with black, were used in realizing the designs for ROSTA, and later TASS, posters was a critical component of their strikingly successful communication.

Between 1919 and 1922, 944 numbered ROSTA posters were issued, each reproduced 150 times on average.[27] Maiakovskii articulated the ideology that informed them: "We don't need a dead temple of art where dead works languish, but a living factory of the human spirit." Art must be "everywhere – on the streets, in trams, in factories, in workshops and in workers' apartments."[28] An echo of the earlier modern poster creed of art in the streets and the homes articulated by leftist critics in France and absorbed into Soviet cultural ideology, Maiakovskii's statement appeared in a book on his posters published in Leningrad and Moscow in 1940 on the occasion of the tenth anniversary of his death. It would resonate in the ambitions, strategies, and production of the TASS studio, founded in Moscow the following year.

6

But there were also surprising and significant discontinuities. The second TASS creation was not a stencil but a painting, commissioned like others that followed, to be framed and displayed with accompanying agitational texts (see fig. 1.25). Conceiving these works as "window-paintings," the TASS studio had plans to reproduce them in up to fifteen freehand copies. These paintings' singularity, along with the plans for copies made by hand, recall the earliest days of ROSTA production: at first designs appeared in a single copy only, then for a time they were copied by hand, and only later were they multiplied by means of stencil.[33]

This comparison is misleading, however. The reasons underlying TASS's issuing of unique posters were ideologically rather than materially determined. While Cheremnykh might have been content to resurrect ROSTA, there were evidently competing views about what TASS products should look like, and from its outset, the TASS studio quite consciously set out to produce posters that would be like no others, including their ROSTA antecedents. TASS aimed, as studio editor Osip Brik would later articulate, to realize a product that transcended the modest status of ordinary posters and aspired to that of "high" art. In the most current terms, this meant the status of painting. The dozens of window-paintings TASS produced during its first six months attest to this ambition as well as surprising implications for what would seem to be a basic tenet of propaganda: dissemination. The studio's plans to produce up to fifteen handmade replicas of each painting would have permitted a circulation that was spectacularly limited at best. Moreover, they would have diverted resources from the production of stenciled posters, which had yet to achieve the pace that had allowed ROSTA to realize an edition of three hundred posters in a two-to-three-day period at its peak.[34] As it was, these plans for painted multiplication were never fulfilled, though the studio kept commissioning paintings. This indicates a willingness to channel resources from the goals of greater numbers, wider placements, and increased visibility, to that of realizing a product that, though singular or at best severely restricted in its edition size, was deemed to have a more potent aura. At issue, it would seem, was the underlying belief in the authority and power of painting.

The parallel production of painted and stenciled posters meant that at the outset TASS creations came in two forms: TASS "high" and TASS "low."

8

THE DEVELOPMENT OF THE TASS STUDIO

The nineteen-year period separating the activities of the TASS and ROSTA studios witnessed significant changes in Soviet poster design, which, in the aftermath of the Civil War, veered away from the ROSTA model in both visual language and medium, keeping pace with changing political and cultural priorities. The growing perception in the 1920s that the Revolution had to create a popular culture and that avant-garde art was neither intelligible nor acceptable to the masses culminated in Stalin's Cultural Revolution (1928–31). The doctrine of Socialist Realism – art grounded in "real life" – was adopted by the Communist Party leadership in 1934 as the only "creative method." Within four years, the party had realized total control over all the arts.[29] In this changing climate, the pictographs of ROSTA lost their viability. New stylistic modalities, notably photomontage, flourished and then lost official favor as attacks on formalism increased and the emphasis on realism grew.[30] Throughout the period, offset lithography, intrinsic to the development of photomontage, was the medium of choice for

posters, its potential for enormous print runs well adapted to the message dissemination required by the long-range ideological goals of peacetime.

But with the outbreak of war and the formation of the TASS studio, the stencil technique of ROSTA was once again revived. TASS's practical reasons for the use of this medium were similar to those of ROSTA: reliant on manpower rather than machine presses, stencil manufacture reduced supply needs to labor, paper, and paints and enabled the rapid production and circulation of large-scale, topical designs. Common as well to both was the state's aspiration to use posters to carefully and consistently shape its audience – in its projection of an enemy, its didactic ambitions, and its forging of a heroic self-image. TASS's connection to ROSTA was embodied in the person of Cheremnykh, who, as he had been with ROSTA, was instrumental in the formation of the TASS project. Cheremnykh designed the studio's first stenciled poster (see TASS 1 [p. 165]), a work that recalls ROSTA production in its simplified design, limited palette, lexicon of stock figures, narrative sequencing, separation of image and text, and large scale.[31] It inaugurated a production that over the first six months of the war would yield on average one and a half designs a day. There would be other continuities between the studios, including the ambition to disseminate posters and amplify the viewing audience by means of projecting color slides.[32]

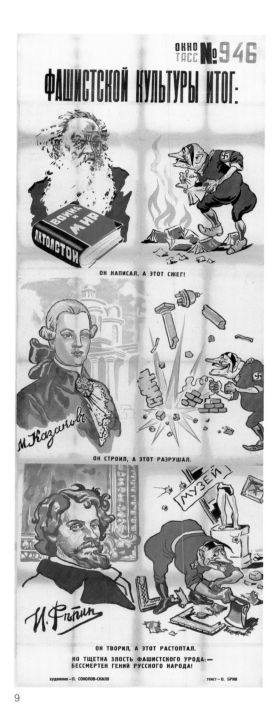

9

The distinctions were reflected by the two dominant visual vocabularies that, broadly speaking, informed studio practice: on the one hand, realism (including Socialist Realism, battle scenes, and didactic or agitational narratives); and on the other, graphic satire. Realism, officially ensconced as a vehicle for the production of images of potentially long-term significance, informed both TASS paintings and stenciled posters. By contrast, caricature was largely confined to stenciled posters, a reflection of its relatively inferior status despite the illustrious forebears whom TASS caricaturists occasionally referenced (see TASS 633 [p. 232]).[35] Perceived as a child of the satirical periodicals, newspapers, and image industry rather than the fine-arts academy, caricature was widely stigmatized as "depictive journalism" rather than "fine art."[36] Similarly confined to stencil, whatever their stylistic vocabulary, were the serial narrative panels that had provided structural logic to ROSTA but were alien to contemporary painting. The pairing of different stylistic means and material forms of delivering an agitational message helped ensure that from the beginning TASS did not aspire to a house style, as had ROSTA.[37]

The distinctions within the TASS studio between high and low art forms were unstable. The Kukryniksy, who were famous in the Soviet press and among TASS's most prolific and trenchant political satirists, also worked as highly successful painters of large-scale realist canvases, including one of the war's most celebrated (fig. 8).[38] Conversely, Pavel Sokolov-Skalia, a dominant force within the studio, began his association with it as a history painter but evolved his signature TASS approach by bridging realism and caricature. This stylistic cross-pollination was paralleled within TASS production as a whole by a bridging of media, the hybridization of the conventions of painting and stencil that yielded the unorthodox technique that became a hallmark of mature TASS production: the single-composition painterly stencil.

As this publication traces, the shift occurred gradually, beginning in October 1941, when, with Sokolov-Skalia as artistic director, the studio concentrated exclusively on stenciled posters. In ceasing to produce window-paintings, however, the studio's leadership did not abandon the aspirations that production had carried; rather, TASS pursued them in an unorthodox way. The artists' experience of working with stencil cutters to realize progressively more complex designs led to the realization that the stencil medium could absorb the full brunt

of painterly ambition on a mural scale if it was pushed beyond its traditional limits.

Key to this strategy was the stencil medium's inherent potential to realize posters with surfaces as chromatically complex, layered, gesturally active, and physically arresting as paintings in oil or gouache. This ability resides in the fact that the means and processes of painting and stencil are similar: oil- or water-based paint is applied to a surface by hand with a loaded brush. In stencils as in paintings, the medium literally sits on the surface, its density and dimensionality recognized by the eye as the sensuous, immediate hallmarks of the handmade "original." By contrast, these properties are essentially foreign to color lithography, especially in the commercial form practiced at the time of the TASS production. Lithographic ink is a very different medium than the paint used in stenciling, lighter in both volume and density; moreover, since it is transferred to paper by the intense pressure of the press, it is absorbed into the paper and so resides in it rather than on it.

To achieve through lithography the "look" of surface density and color saturation that is a TASS signature, individual colors would have had to be run through a press more than once. Employing the number of colors used, on average, in TASS posters from 1942 on would have been prohibitively expensive and time-consuming. Nor, as TASS 946 suggests (fig. 9), would it have been worth the effort.[39] Apparently the only instance in which the studio used offset lithography for a full-scale poster, TASS 946 pales in comparison with the normal TASS product.[40] Although this difference cannot be fully appreciated in publications printed using offset lithography (such as this one), in person TASS 946 appears thinner than stenciled TASS posters, the eye sensing the material discrepancies.

PAINTERLY STENCIL: MEDIUM AND MESSAGE

The differences realizable through the painterly stencil came, as the essays in this publication attest, with notable deficits and benefits. The costs were obvious and inescapable: achieving painterly effects in stenciled posters required more stencils per poster. While the total production of each poster

was guaranteed to exceed the former ambition of producing fifteen copies of window-paintings, each stenciled poster nonetheless proved to be labor intensive. As edition sizes increased, the number of designs realized declined. Furthermore, edition sizes could have been exponentially higher had studio resources been invested in creating simpler designs with many fewer stencils – like earlier productions. But in no case could the number of stenciled TASS posters produced have possibly rivaled the runs of smaller lithographic posters printed by Iskusstvo during the war years. While the publisher realized only 800 designs compared to TASS's 1,240, the total number of copies it produced is said to have exceeded 30 million.[41] Not surprisingly, a concern with high investment and low numerical yield did surface at TASS studio meetings, but the course had been set: to pursue painterly effects through stenciling methods that often had more in common with the sumptuous craftsmanship of French *pochoir* than with the more modest traditions of ROSTA.

Mature TASS posters – those made between the spring of 1942 and the war's end – hybridize two competing ambitions: on the one hand, the telegraphic communication of a memorable message, as brilliantly realized by the ROSTA posters; and on the other, rewarding the closer looking associated with paintings in a museum or art gallery. The nuanced details of TASS posters include both the written texts – often much lengthier than ROSTA's – and their visual counterparts, which, unlike ROSTA's, were complicated by subtleties of surface details, modeling, and, occasionally, surprisingly delicate vignettes such as the ships at sunset incorporated into TASS 470 (p. 212). These would seem to assume that viewers would spend time examining the posters whether – as the differing poster sizes suggest – they were hung indoors or outside. This investment in the beauty of craftsmanship at times even extended to the lithographic production of small-scale, reduced translations of stenciled posters issued in large editions, like TASS 1091 (fig. 10). Better printed than the average interior poster of its size, each poster in the edition of twenty thousand copies had a unit price of 1.75 rubles, seven to eight times more than the twenty or twenty-five kopeks charged for a run-of-the-mill poster of similar size.

With propaganda tightly controlled by the state, the near fetishizing of visual effects at the expense of large production runs could not have occurred without official sanction. TASS Windows, like all Soviet political posters, were expressions of official ideology. From a propaganda perspective, their perceived benefits must have been measured in terms other than numbers. Nor could these have been calculated solely by the potential for a quick response to events, since the complexity of the painterly stencil curtailed turn-around time. Instead, it appears that these posters' benefits were seen to lie in the pictorial potency achievable through the stencil technique and its efficacy as an artistic weapon.

The address given by Aleksandr Gerasimov – the single most powerful figure in the Soviet artistic establishment – to the Federation of Soviet Artists in Moscow within days of the war's end on May 9, 1945, provides a lens through which to consider the TASS posters' efficacy and the continued official commitment to the studio and its underlying rationale. His speech, "The Soviet Fine Arts during the War," began with a consideration of the "art of agitation and propaganda" and a paean to TASS posters. While conceding the "enormous part played by lithographic war posters," Gerasimov stated the primacy of TASS posters, which he lauded for their wide circulation – in the army,

OKHO TACC № 1091

ТЩЕТНЫЕ ПОТУГИ

across the country, and abroad – and the officially recognized talents of the studio's graphic artists and painters, who "[rallied] to their country's defense armed with their own weapons."[42]

Although Gerasimov did not specify his criteria for measuring the effectiveness of TASS's visual weaponry, they can to some degree be inferred from those articulated in his evaluation of wartime painting. These included conservative pictorial values – a preoccupation with "finish," technical resourcefulness and "mastery," and the "investment" of serious labor – as well as more experiential measures: Had the works effectively "touch[ed] the spectator" or left him "cold"? Had any of them "stamped themselves upon our memory"?[43]

To be sure, Gerasimov's expectations for history painting were of a different order than those for posters of current events, given his clear belief in the hierarchical superiority of its genre and medium. But he was also painfully aware that despite his ambitions for painting, it had not, in his estimation, fully realized its potential, despite there being aspects of certain works – including the Kukryniksy's *Zoia* – that he found praiseworthy.[44] Rather, he had to conclude that "our graphic art has won the place of honor among all forms of pictorial expression," its "brilliant masters" including such "gifted craftsmen" of the younger generation as the Kukryniksy.[45] This tension – deriving from the hierarchical distinction between painting and graphic art (and painters and craftsmen) and the awareness that graphic art effectively topped painting for "first place" – speaks to TASS's disjunctive early production, in which Gerasimov himself participated (see TASS 67 [fig. 1.30]). The conflicting aspirations it manifested seemed overall to seek a balance of the kind officially expressed in the resolution passed in March 1942 by the Organizing Committee of the Union of Soviet Artists. Recognizing that the first wave of war posters, albeit effective, had been viciously satirical, it "[called] for the heroic to be given greater emphasis in poster design."[46]

The contemporary shift within the TASS studio – already involved in realist and heroic modes as well as satire – to the painterly stencil can be seen as a strategy to find a creative common ground, opening up a space between high and low that could be effectively inhabited by both painters and graphic artists while lessening the difference between genres and media (and, in the case of the Kukryniksy, their different practices) by making painting models more posterlike and graphic

Fig. 1 Margaret
Bourke-White (American,
1904–1971)
*TASS Editorial Office
Street-Front Display,*

Moscow, July 1941
Syracuse University
Library Special Collections
Research Center

In late July 1941, roughly one month after the German military launched Operation Barbarossa and penetrated deep into Soviet territory, the American photographer Margaret Bourke-White, reporting on the Soviet Union for American publications, came across a propaganda display in the center of Moscow. In one of her photographs of the scene (fig. 1), anxious crowds gather on the street to examine a large-scale installation mounted in the ground-floor window wells of an exhibition hall belonging to the Organizing Committee of the Union of Soviet Artists (SKh SSSR). Offering news of the front and seeking to instill a sense of patriotism in its viewers, the display presented acerbic caricatures of the German invaders and heroic renditions of the Soviet Union's defenders through a series of stenciled posters and at least one framed easel painting, all featuring captions in verse.[1] These window-posters (*okno-plakat*) and window-paintings (*okno-kartina*), as they were termed, had been issued by a studio operated by the central Soviet office for the distribution of news bulletins, the

Telegraph Agency of the Soviet Union (TASS). The studio was housed in the very building on whose windows the works were prominently displayed.[2]

Initially proposed as a means of employing Soviet painters, poets, and caricaturists during the war, the TASS studio created boldly colored, large-scale, hand-painted propaganda. Its stenciled posters in particular enabled the rapid dissemination of information to the urban population.[3] The photographs Bourke-White took of the TASS display date to the early stages of the war, when the studio — having no sense of the arduous, four-year conflict that lay ahead and the severe limitations it would impose on labor and materials — had not yet formulated the program for international distribution that would characterize much of its later work.

The TASS studio was modeled in large part on its legendary predecessor, the Moscow studio operated by the Russian Telegraph Agency (ROSTA) during the Civil War era (1917–23), which issued stenciled posters bearing the agency's acronym.

From the outset, TASS departed significantly from its antecedent by exploring a wider range of paint media. In addition to the casein (poster paint) on paper that served as the medium for its stenciled multiples, the studio used both oil- and water-based media for a series of unique works, including the maquettes it prepared for its stenciled posters and the window-paintings it displayed on its facade during its first four months of operation. Early plans to replicate these paintings by hand in small editions never materialized, and the studio abandoned its investment in window-painting in October 1941. In the months that followed, TASS radically transformed the propagandistic applications and pictorial appearance of the stenciled poster, achieving a higher level of painterly complexity by using a greater number of stencils to achieve more intricate effects. With an expanded chromatic range, more nuanced modeling, developed figural compositions, and rich surface textures, the stenciled posters subsequently issued by TASS assumed an unrivaled position within the operation, vastly surpassing window-painting in

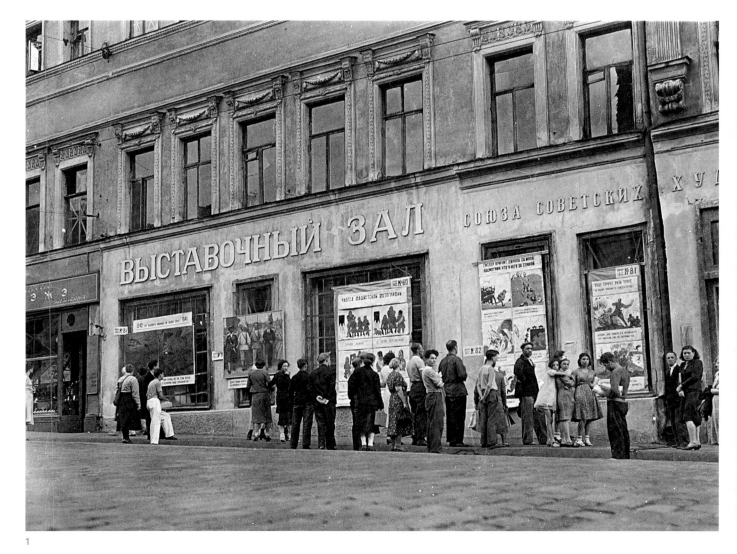

1

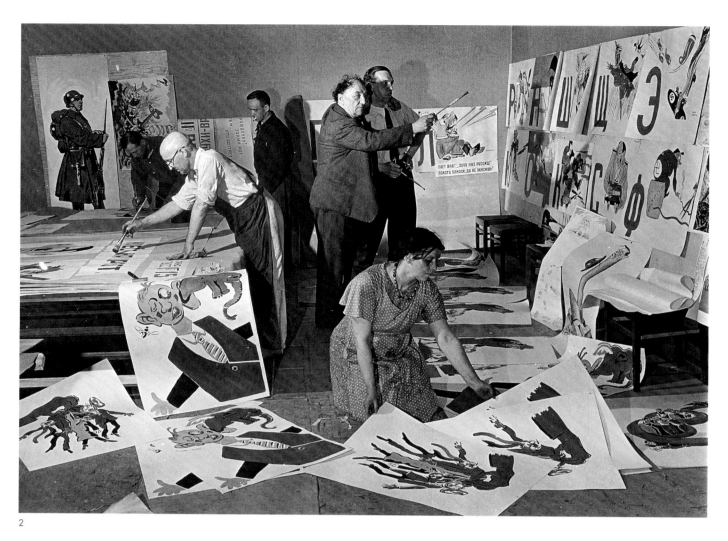

2

Fig. 2 Margaret Bourke-White (American, 1904–1971) *TASS Editorial Office and Studio, Moscow,* July 1941 Syracuse University Library Special Collections Research Center

the range and number of designs issued and the quantity and rapidity of editions circulated, while conveying painterly effects that had not previously been widely associated with the stencil medium.

During their visit to Moscow, which lasted the entire summer, Bourke-White and her husband, the author Erskine Caldwell, were accompanied by Evgenii Petrov, an acclaimed Soviet satirist. After the war, Aleksandr Raskin, a satirist and scriptwriter who worked for TASS, recalled the day Petrov brought the Americans to the studio:

[Bourke-White] developed an interest in TASS. Petrov brought her to us and gave her an unusually grand introduction to the writers and artists who made the window-posters.

I made my bows as best I could. Petrov and I exchanged humorous glances. He looked his best and obligingly led the guests around the office as if all the while meaning to say: "You can think whatever you want over there, but here we have people who work."

Margaret Caldwell [Bourke-White] took a lot of pictures and, with a charming smile, took leave of us.[4]

Situated in the heart of Moscow, between the Bolshoi Theater and Lubianka Square, the TASS studio appeared to be a "poster factory" – in the

words of *Life* magazine – for the mass production of stenciled propaganda.[5] In Bourke-White's staged photographs, posters occupy every available surface in the studio, including the walls, drafting tables, and floor (see fig. 2).[6] It was there that the posters and the captions appended to the window-paintings were produced (the paintings themselves were likely completed in the artists' studios and then taken to the TASS office to be framed, captioned, and displayed). Although the TASS studio adapted its initial technique and compositional approach to stenciling from the ROSTA studio, the iconography of the newer posters was deeply rooted in Bolshevik propaganda, shaped in part by the Soviet anti-Fascist campaign of the 1930s, which had been primarily concerned with the threat posed by the emerging National Socialist Party in Germany.

THE FOUNDING OF THE TASS STUDIO

The poster factory Bourke-White photographed – the spontaneous creation of a particularly committed group of Moscow artists – was no more than one month old when she visited. It had been formed on June 22, 1941, the day Germany invaded the Soviet Union, when the Organizing Committee

of the Union of Soviet Artists hastily convened in its exhibition hall on Kuznetskii Most, its interior walls still bearing a week-old exhibition of contemporary paintings and graphics from the Uzbek, Kirgiz, and Kazakh Soviet republics.[7] The committee debated how the union might contribute to the developing war effort and resolved to model itself in part on the ROSTA studio. The collaborative, hand-painted TASS posters also recall the legacy of hand-crafted wall newspapers (*stengazeta*). Both the ROSTA stenciled posters and wall newspapers had been adopted as temporary replacements for Bolshevik party newspapers, the publication of which had been nearly brought to a halt by the collapse of Russia's printing facilities during the Civil War.

Grassroots endeavors that incorporated both notes and caricatures penned by readers, wall newspapers typically contained exhortatory articles relating to work culture and class struggle. Handwritten in pen and pencil or typed on paper, they were unique editions either installed in public propaganda stands or mounted directly on a wall (see fig. 4).[8] They emulated the format and design of traditional printed newspapers, arranging articles in columns and providing them with concise titles.[9] The conventionally printed poster

Fig. 3 Mikhail
Cheremnykh, with text by
Vladimir Maiakovskii
*The Entente Calculates Its
Annual Balance* (ROSTA
704), December 1920

Edition: unknown
Stencil
141 × 92 cm
Ne boltai! Collection
In exhibition

Fig. 4 Photographer
unknown (Soviet)
A household
cooperative
(Admiralteiskaia
Embankment)

making a wall
newspaper,
Leningrad, 1927/28
Central State Archives
of Film-Foto-Fono
Documents

newspapers (*plakat gazeta*) that proliferated in
the 1930s offered a means of distributing similar
information more widely, combining cartoons and
photographs with sharp political rhetoric (see figs.
5, 18). The painter Pavel Sokolov-Skalia, one of
the founding members of the TASS studio, noted
the graphic appeal of such newspapers when he
wrote in 1943, "A contemporary poster resembles
a newspaper. This newspaper, however, has its
own distinct characteristics: its visual material
and its literary texts, which are mostly poetic, are
unified. [This feature] makes this newspaper more
interesting and gives it a particular direction: it is
designed for the street."[10]

The ROSTA stenciled posters, by contrast, cor-
responded to Vladimir Lenin's appeal in 1918 for
a condensed, "telegraphic" bulletin on newswor-
thy topics.[11] Shaped in large part by the Russian
avant-garde, especially the Cubo-Futurism that
had flourished in Moscow in the second decade of
the twentieth century, the visual style of ROSTA's
imagery was abrupt and schematic, limited to a
reductive palette of two or three unmodulated
colors. The first ROSTA posters were designed in
October 1919 by Mikhail Cheremnykh, a young art-
ist who began publishing cartoons in 1911.[12] Within
the year, he was joined in the studio by the poet
and artist Vladimir Maiakovskii.

The success of the ROSTA posters may be attrib-
uted in part to their intimate link to the *lubok*,
a popular Russian folk print with a narrative
character. Like the printed and hand-colored *lubki*
that had proliferated throughout Russia during
the nineteenth century, ROSTA stenciled post-
ers illustrate a story, albeit often politicized, their
multiple picture panels corresponding to indi-
vidualized, versified captions. One such series of
panels designed by Cheremnykh in December 1920
demonstrates how pictograms, often allegori-
cal in nature, were typically repeated from panel
to panel within the same poster to convey party
policy concerning complex, international topics
(fig. 3).[13] In the first panel, a corpulent, ruddy-nosed
businessman dressed in a top hat and greatcoat
uses an abacus to calculate his annual balance.
Identified as the Entente, the alliance of Western
democracies assembled against both the Central
Powers in World War I and the Bolshevik govern-
ment following the Russian Revolution (1917), the
businessman realizes to his chagrin in the subse-
quent panels that his funds are rapidly dwindling
as they are distributed among the leaders of the
White Russian opposition. Steeped in popular

3

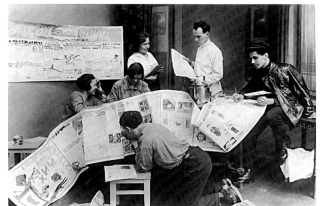

4

Fig. 5 Boris Efimov
To New Victories! (Okno izogiza plakat gazeta 26), December 1, 1931
Publisher: Ogiz-Izogiz

Edition: 5,000
Offset lithograph
141.3 × 103.5 cm
Ne boltai! Collection
In exhibition

Fig. 6 Mikhail Cheremnykh, with text by the Litbrigade
The Fascist Took the Route through Prut (TASS 1), June 27, 1941

Edition: 60
Stencil
200 × 86 cm
Archival photograph, ROT Album, courtesy Ne boltai! Collection

imagery that predated the Revolution and emphasizing image rather than text to relate meaning, the ROSTA posters served as a *Biblia pauperum* (pauper's Bible) for the Bolsheviks.[14]

Among the artists proposing that the ROSTA model be resurrected in 1941 were Cheremnykh and Nikolai Denisovskii, who had also contributed to the original ROSTA studio in Moscow. Since the end of the Civil War, both artists had further refined their skills at crafting political imagery: the former cofounded the satirical magazine *Krokodil* and the latter the Association of Workers of the Revolutionary Poster. They were joined by Sokolov-Skalia, a member of the conservative Association of Artists of Revolutionary Russia (AKhRR).

According to Viktor Maslennikov, who later cut font stencils for the TASS studio, the three visited Aleksandr Gerasimov, the enormously influential head of the Organizing Committee of the Union of Soviet Artists and Joseph Stalin's favorite painter, on June 23, 1941. Gerasimov approved

their proposal to create a new studio based on the ROSTA model and called Kliment Voroshilov, the Peoples' Commissar of Defense of the Soviet Union, to obtain official support for it.[15] Gerasimov then contacted the director of the Artistic Fund (Khudozhestvennyi fond RSFSR) and ordered him to requisition for the future studio the exhibition halls on 11 and 20 Kuznetskii Most and the furniture and equipment necessary for operation. Gerasimov's involvement was not limited to political and technical support, however; he also helped establish the initial parameters of the operation by ordaining that in addition to stenciling posters on paper, the future studio would issue propaganda paintings. For this cause, he helped enlist such established artists as Aleksandr Deineka, Sergei Gerasimov, Boris Ioganson, Vasilii Khvostenko, Iurii Pimenov, and Georgii Savitskii.[16]

On the morning of June 24, Gerasimov received a call from Lieutenant-General Rafail Khmel'nitskii, who informed him on behalf of Voroshilov that

the plan had been approved. Iakov Khavinson, the executive director of the TASS News Agency, was instructed to incorporate the fledgling operation into his organization.[17] Later that day, at a meeting with Denisovskii and Sokolov-Skalia, Khavinson decided to give the new workshop the official title "Editorial Office – Studio for the production of 'TASS Window' military-defense posters" (*Redaktsiia-masterskaia voenno-oboronnogo plakata "Okna TASS"*).[18]

The final decision to establish the new organization was made not by the Council of Peoples' Commissars, but rather by the Department of Agitation and Propaganda of the All-Union Central Committee of the Communist Party. Khavinson explained the nature of the new imagery issued by the TASS studio in a letter to Rozalia Zemliachka, deputy chairwoman of the council:

According to the order of the Department of Agitation and Propaganda of the Central Committee of the All-Union Communist Party

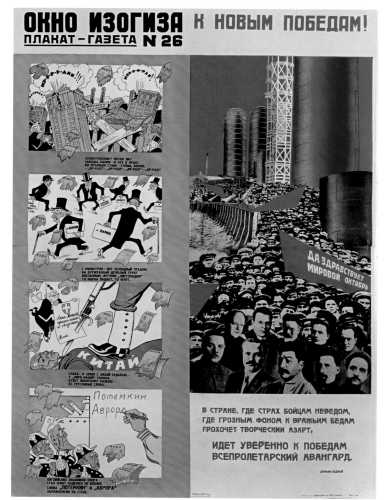

5

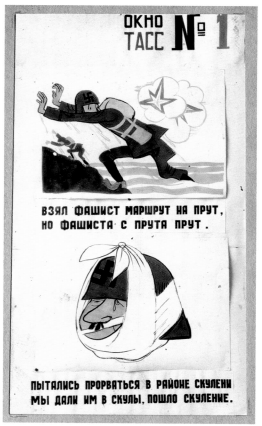

6

*(Bolsheviks), the TASS Agency is starting to release
TASS window-posters, which shall be produced by
a team of highly qualified artists and writers.*

*The daily production of TASS window-posters shall
consist of two posters featuring political carica-
tures with a circulation of 150 copies each and one
large painting (panel) of popular-heroic content
copied in an edition of ten.*[19]

The studio was thus initially mandated to produce
two complementary forms of hand-painted propa-
ganda, both of which would be editioned: stenciled
posters, which would be issued in substantial
releases and revive the tradition of the militant
ROSTA posters of the Civil War era; and easel
paintings – painstakingly duplicated in much
smaller numbers because of the considerable
resources involved – whose heroic figurative style
and large format would be adapted from contem-
porary Soviet painting. Despite this directive, no
evidence remains that copies of window-paintings
were ever produced.

The newly minted TASS editorial office asked
Cheremnykh to design its first release, *The Fascist
Took the Route through Prut* (fig. 6 and p. 165).
Issued on June 27, the poster contained only two
images and four lines of verse and was clearly
modeled on the sequential, schematic ROSTA
prototype. Based on information provided by the
Soviet Information Bureau (Sovinformbiuro),
the agency responsible for providing information
to such distribution outlets as TASS, the poster
addresses the Soviet defense of land that it
had annexed from Romania only one year earlier
through the Molotov-Ribbentrop Pact, a nonag-
gression treaty between the Soviet Union
and Germany.[20]

THE POSTER FACTORY IN PRODUCTION

From its inception in June 1941, the TASS edito-
rial office maintained a permanent staff that
included a director, artistic director, literary editor,
and variety of technical and production manag-
ers. Throughout the studio's brief history, three
figures were most essential to its administration:
Denisovskii served as director; Sokolov-Skalia
was appointed artistic director; and Osip Brik, the
former theorist of Left Front of the Arts (LEF) and
a colleague of Maiakovskii, served intermittently

as literary editor until his death in February 1945
(he was preceded by A. Kulagin, who served briefly
in this capacity from June 1941 through the end of
1942).[21] Each received a permanent salary from the
state and was granted authority to make decisions
concerning the visual and textual dimensions of
posters, their mass production, and their dissemi-
nation. By contrast, almost all of the artists and
writers who worked for TASS were employed on a
contractual basis. In addition to the honoraria they
received for each poster design, they were entitled
to such critical benefits as food coupons.

Initially, subjects were drawn from party directives,
orders issued by the Soviet High Command, or offi-
cial reports distributed by the Sovinformbiuro or
published in newspapers. By July 1941, the studio
began to design posters based on Stalin's speech-
es. Subsequently, topics were developed inside the
editorial office and proposed by artists and writers.
As Sokolov-Skalia recounted in 1942:

*Very often topics are given to an artist or a poet,
but more often they are given to both at the same
time…. Adhering to a strict plan of production, the
editorial office tries to distribute [assignments]
evenly among the authors, so that they have a
consistent amount of work and some time for more
urgent tasks. Keeping in mind the style of each
author, the editorial office is planning potential
work in such a way that all authors will be equally
busy. According to this distribution of labor, each
artist is expected to produce a minimum of 3 to 4
posters per month.*[22]

Topics proposed internally, either by a writer who
had drafted a caption or by an artist who had
prepared a preliminary sketch, were first submit-
ted to the editorial board for approval.[23] Those
endorsed by the board had to be authorized by
the agency's upper administration.[24] Approved
sketches and captions were then returned to the
artists to complete. The final designs – essentially
freely painted maquettes – were forwarded to the
stenciling department, where stencil templates
were cut for the captions and the various colors
that would comprise the accompanying pictures
(see fig. 7). When the TASS studio opened, stencil
cutting posed a considerable technical challenge,
since it had not been practiced widely since the
closure of the ROSTA studio following the Civil
War. Konstantin Likhachev, who had previously
cut stencils for ROSTA, reestablished the largely
forgotten process in the TASS studio by assem-
bling a team of stencil cutters (*rezchiki trafaretov*),
some of whom had previously worked for ROSTA.
Problems arose at the outset when artists with
no experience painting for stenciled replication

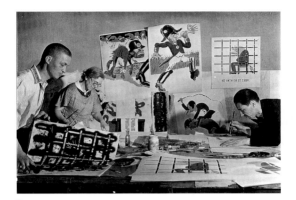

7

8

proposed complex sketches to the TASS editorial
board. Mai Miturich, one of the stencil cutters in
the studio, recalled:

*The original design of the poster was sent to the
workshop, where it was "divided" into stencils.
Poster artists who understood the specifications
of stenciling painted simple originals that required
three to five stencils, but such artists as Savitskii
and Sokolov-Skalia needed thirty or more stencils
for their work. At the studio, the stencil cutters
themselves would do a test copy that would be
approved and then serve as an example for us.*[25]

The test copy of each poster was then forwarded to
a team of stencil painters (*trafaretchiki*) together
with the matching stencils.[26] Individual panels in
each poster were stenciled separately and then
passed on to a team of gluers (*skleishchiki*) that
readied them for immediate distribution by assem-
bling the panels and mounting them on backing
paper (see fig. 8).[27] The studio maintained three
shifts for its complex production line.[28]

Once the TASS editorial office was established,
numerous Moscow artists sought to obtain a posi-

Fig. 9 Archival photographs, ROT Album (page 6), courtesy Ne boltai! Collection

Fig. 10 Archival photographs, ROT Album (page 7), courtesy Ne boltai! Collection

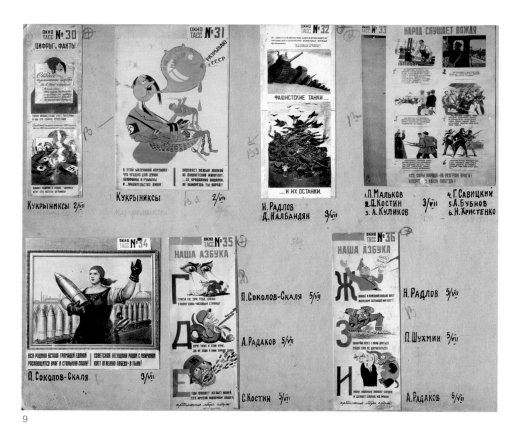

9

10

tion in the production facility. During the war, such an occupation guaranteed food, a modest income, and in some cases release from the draft. By June 25, 1941, some ninety-two artists had already enlisted to work as stencil cutters, stencil painters, and gluers, the vast majority of whom were women, including the wives of several artists who were designing posters for TASS.[29] Honoraria were provided to all those participating in the production process, from proposing topics and creating original art to drafting captions and contributing to the material construction of the final poster.[30] Employment in the stenciling facilities, however, proved to be detrimental to the health of workers, who completed twelve-hour shifts in rooms with noxious materials and poor ventilation. By early fall 1941, the studio was plagued by a chronic shortage of materials and artistic labor, a problem about which the editorial office complained continually throughout the war.[31]

A single copy of each poster designed for circulation was delivered for final approval to the Central Committee and Main Directorate for Literary and Publishing Affairs (Glavlit), the nation's censorship office.[32] If either the design or the caption was rejected by the state censors, or if the topic on which the poster was based "fell out of interest after production," the poster was destroyed.[33] At an organizational summit in early 1942, the editorial office complained noisily about the lengthy review process, which was slowing production and delaying distribution.[34] Among the greatest concerns was that posters would no longer be relevant or would have missed an opportunity to capitalize on a recent development by the time they were distributed. As Aleksandr Rokhovich stated:

We have a lot of drawbacks here actually. First of all, the process of text approval is very slow. What causes it? Besides some degree of disorganization within TASS Windows, there is a complex process of approval.... The Main Directorate for Literary and Publishing Affairs and the Main Repertory Committee have already been mentioned, but we also have delays within our own production. For example, I write a caption. If its theme is acceptable, it should be put into production immediately. But what do we have in reality? I can give you examples when a theme is not approved for production for 5–6–7 days. Here are the examples. We have created a theme about liberated cities. What can be more topical than this theme? We created it 10–12 days ago and it has still not

Fig. 11 Nikolai Sadchikov
(head of Glavlit)
Order No. 502 authorizing
I. Fedorov to maintain
censorship control over
the TASS editorial office,

Moscow, August 11, 1942
Courtesy Ne boltai!
Collection

*been produced. This hampers our work. Why would
I start creating a different theme if that one has not
been produced yet?*

*Let's move on. First they approve a theme separate-
ly from its image. I think this is a mistake. What kind
of situation does it create? After Kulagin approves
a caption it should be approved by the TASS Agency.
At TASS they discuss a caption over the telephone.
This is already not good. They might lose punctua-
tion marks.... My suggestion is that we should treat
artists and poets equally. We should submit images
together with texts for approval.*[35]

To address this problem, the editorial office began
to distinguish between posters on topics that
remained consistent throughout the war (such as
the heroic nature of the Soviet soldier) and those
connected to particular current events (such as
the liberation of Budapest), which needed to be
distributed more rapidly.[36] In August 1942, Nikolai
Sadchikov, the head of Glavlit, introduced a more
streamlined process by appointing a single person
to serve as the official state censor for the TASS
editorial office (see fig. 11).

By the end of 1941, the studio had scaled back its
production ambitions considerably, calling for forty
satirical posters (rather than sixty) and ten heroic
paintings (rather than thirty) to be issued each
month, with poster editions of two hundred and
fifty copies and painting editions of five copies.[37]
The original designs were to be retained by the
studio. Throughout the duration of the war, the edi-
torial office kept meticulous records of its output,
including a registration book and six photograph
albums chronicling its releases by year.[38] The
registration book contains detailed entries on each
poster, including the name of the artist, author of
the text, TASS number, size, medium, number of
panels, release date, and number of copies issued.
It also contains information concerning those
posters the studio decided not to publish. Each
album (referred to here as ROT Albums)typically
contains from two to six closely cropped photo-
graphs per page, arranged by TASS number and
annotated in pen with the name of the artist and
the poster's release date (see figs. 9–10). Many of
the photographs in the albums are of the original
designs for the stenciled posters, which upon com-
parison exhibit slight differences from the posters.
The albums are also the only existing visual record

of the window-paintings issued by the studio, none
of which has been located.

THE FASCIST MENACE AND THE BOLSHEVIK THREAT

Because of their large size, TASS posters were des-
tined for display in a variety of locations, including
store windows and the facades of municipal build-
ings. This manner of distribution adhered closely to
the way in which ROSTA posters had been installed
publicly two decades earlier. As Viktor Shklovskii
recalled in 1940, "[General Anton] Denikin's
offensive was under way. It was imperative that
the streets [of Moscow] should not be silent. The
shop windows were blank and empty. They should
bulge with ideas."[39] Indeed, storefronts had blos-
somed into an important venue for propaganda
display during the Cultural Revolution (1928–31),
when windows along the central boulevards of the
capital were decorated with paintings for political
anniversaries and Moscow city-council elections.[40]

Although the Cubo-Futurist style of the ROSTA
posters had fallen out of favor between the wars,
their militant formal syntax had not. Soviet citizens
were constantly warned of the impending dual
threats of Western capitalism and imperialism
in propaganda posters and displays during the
Cultural Revolution (see figs. 12–13). The figure
of the rapacious capitalist, often depicted with
grasping claws and a fearsome expression, was
an omnipresent feature of such installations.[41] He
was typically set opposite a towering worker or a
steadfast soldier of the Red Army dutifully protect-
ing the national border. Frequently, the Western
bourgeois was tied to the emerging National
Socialist Party in Germany through the symbol of
the swastika. Occasionally, he was given a stereo-
typical ethnic identity, rendered with the hooked
nose associated with Jews.

German citizens were accosted with a similarly
fearsome array of imagery alerting them to the
insidious nature of Communism. A critical compo-
nent of Nazi propaganda from the party's incep-
tion, anti-Soviet rhetoric reached a feverish pitch
in Germany in September 1935, when Joseph
Goebbels, the German minister of public enlighten-
ment and propaganda, accused the Soviet Union at
a major party rally in Nuremburg of carrying out a
systematic campaign of terror against all opposi-
tion. In particular, he identified the Communist
International (Comintern) – the organization
devoted to supervising Communist Party activities
– as a Jewish conspiracy and promised to expose

11

its roots in Germany. His speech, which bore the
title "Communism Unmasked," was subsequently
published and formed the template for a series of
exhibitions held around Germany denouncing the
Soviet Union.[42]

In November 1936, the Coalition of German Anti-
Communist Associations opened *The Great Anti-
Bolshevik Exhibition* in the Deutsches Museum,
Munich. Max Eschle's poster for the show depicts
the destruction of church property, one of the
more fearsome practices Goebbels had previ-
ously associated with the Soviet regime (fig. 14).
A massive, skeletal hand descends from the night
sky to ignite a Gothic cathedral, suggesting that
both Christianity and the German cultural trea-
sures associated with it were being targeted by
Communist atheists. Herbert Agricola's poster for
the anti-Bolshevik exhibition that opened in Berlin
the following year similarly alludes to Goebbels's
speech, promising to reveal "Bolshevism
unmasked." The Expressionistic poster features a
soldier of the Red Army standing before a burning
metropolis, ruthlessly whipping a group of hapless,
submissive prisoners at his feet (fig. 15).[43]

Nazi propaganda often drew treacherous con-
nections between Judaic culture and Soviet
Bolshevism. The German exhibition *The Eternal
Jew (Der Ewige Jude)*, which opened at the
Deutsches Museum in November 1937, featured
numerous dossiers on Jewish Communists active
in Germany and Russia.[44] Horst Schlüter's poster
advertising the show offers a caricature of a Jewish
moneylender, holding gold coins in one hand and
a whip in the other, and carrying under his arm an
extruded map of the Soviet Union (fig. 16).

Despite profound political differences with the
Soviet Union, the National Socialists in Germany
often represented their avowed Communist

Fig. 12 Viktor Deni
*Join the Ranks of
OSOAVIAKHIM to Secure
Soviet Defense*, 1929
Publisher: OSOAVIAKHIM
Edition: 20,000

Offset lithograph
64.7 × 90.8 cm
Ne boltai! Collection
In exhibition

Fig. 13 Moisei Brodskii
(born Poltava, Ukraine,
1896; died Leningrad [?],
1944) and Leonid Karataev
(IZORAM)
*Tribune on Uritskii Square,
Leningrad, May Day*, 1931

Central State Archive
of Documentary Films,
Photographs, and
Sound Recordings of St.
Petersburg

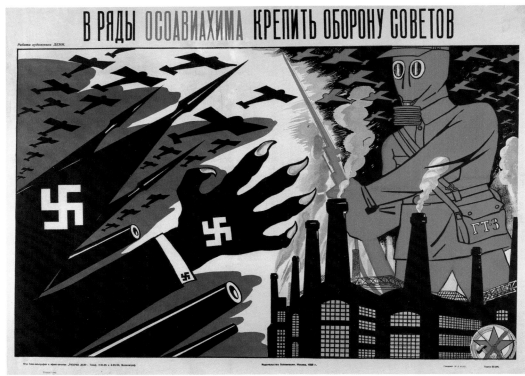

12

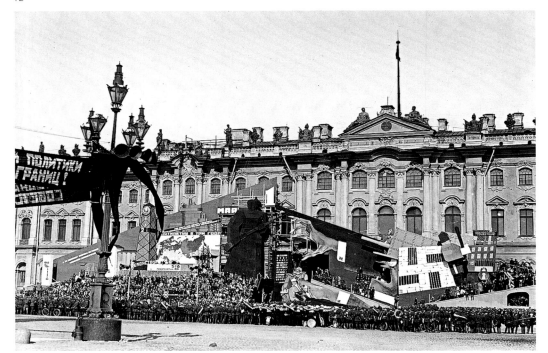

13

enemies with an iconography that strongly resembled how they in turn had been depicted.[45] Indeed, throughout the decade leading up to the war, the two rivals routinely exchanged spiteful caricatures of each other with a remarkable circuity. A Nazi poster designed to promote the traveling version of *The Great Anti-Bolshevik Exhibition* features an image of Earth surmounted by an enormous Bolshevik spider with a human skull for a head, perched atop the Soviet Union and extending its legs across the globe (fig. 19). Initially popularized in the nineteenth century, the satirical image of the spider with a human head had most recently appeared four years earlier in a Soviet poster-newspaper designed by Cheremnykh and published by the Soviet State Fine Arts Publishing House (Ogiz-Izogiz) under the title *Comrade, Keep Careful Watch over the Ranks of the Collective Farms* (fig. 18).[46] Issued to encourage citizens to report collective farmers who failed to share their dividends with the government, the poster features a spider with a scowling human face, bearing the farmer's signature hat and surrounded by a web of vignettes detailing deceitful practices. In 1937, the year of *The Great Anti-Bolshevik Exhibition*, Ogiz-Izogiz published Boris Klinch's poster *Fascism Is the Enemy of Nations* (fig. 17), which envisions yet another monstrous chimera, in this case a giant Fascist octopus-like creature, with guns in place of tentacles, bearing the distinctive helmet of the Wehrmacht.[47]

Following the Anti-Comintern Pact of November 1936, in which Germany and Japan identified the Comintern as a menace to world order, the Soviet Union circulated propaganda denouncing the two powers as jointly committed to subjugating Communist nations. Nikolai Dolgorukov and Viktor Deni depicted the emerging Axis as a two-headed monster in their 1938 poster *Greetings to Armed Border Guards, Sharp-Sighted Guardians of Socialist Countries!* (fig. 21). The Fascist creature extends a threatening claw toward the border, each digit bearing a different inscription (from left to right, terror, espionage, sabotage, provocations, and raids). A Red Army guard stands firmly behind his rifle and bayonet, glaring at the approaching beast. Behind him, an extract from Maiakovskii's 1927 poem "Careful March" reads, "Comrade, follow the angry barking. / Comrade, keep your gunpowder dry."[48]

In addition to employing a consistent iconography, anti-Fascist Soviet propaganda of the 1930s also occasionally illustrated aspects of Stalin's

Fig. 14 Max Eschle
(German, 1890–1979)
Poster for *The Great Anti-Bolshevik Exhibition,
Deutsches Museum,
Munich*, November 1936

Offset lithograph
120 × 84 cm
Deutsches Museum

Fig. 15 Herbert Agricola
(German, 1912–1998)
Poster for *The Great Anti-Bolshevik Exhibition,
Reichstagsgebäude,
Berlin*, November 1937

Offset lithograph
86 × 59 cm
Library of Congress

Fig. 16 Horst Schlüter
(German)
Poster for *The Eternal
Jew, Exhibition in the
Deutsches Museum,
Munich*, November 1937

Offset lithograph
83 × 60 cm
Wolfsonian Institution
In exhibition

speeches, especially those that drew upon colorful proverbs and literary metaphors. A. Rachevskii, for example, designed one such poster in March 1939: *If the Enemy Shoves His Snout into Us, We Will Beat Him from the Front and from the Rear!* (fig. 20). In this poster, pro-Soviet forces violently converge on a member of the Sturmabteilung (SA) paramilitary organization (colloquially known as brownshirts), which helped Adolf Hitler consolidate power over Germany. Bearing the signature claws of the Fascist and a pig's snout, the brownshirt in the center of the poster is crushed between the butt of a rifle borne by a Soviet soldier and the clenched fist of a prisoner who has broken his chains. The image derives from Stalin's speech of January 26, 1934, to the Seventeenth Congress of the Communist Party, in which he warned, "Those who try to attack our country will receive a shattering response, so in the future they will not make a habit of sticking their porcine snouts into our Soviet vegetable garden!"[49] In the same speech, Stalin aligned himself with the oppressed Western proletariat, boasting that "in Europe and in Asia, numerous friends of the working class of the USSR will try to hit the enemy in the rear."[50] The word *tyl* in Russian, which appears at the end of the poster text, refers both to the back of someone's head and to the home front of a nation. So, while the rifle

butt on the right side of the poster bears a red star, identifying it as belonging to the Soviet Red Army, the fist attacking the Fascist brownshirt from the left likely belongs to a German proletarian, who has just liberated himself from bondage.

The iconography of fear and the rabid hatred for Fascism that had proliferated in the Soviet Union during the Cultural Revolution persisted until the Molotov-Ribbentrop Pact was signed into effect in August 1939, at which point the perpetual propaganda war with Germany, which had lasted for over a decade, came to an abrupt halt. The sudden outbreak of hostilities on June 22, 1941, less than two years later, left the Soviet artistic community dazed and unprepared. Two days after the invasion, Iskusstvo released two of the first Soviet posters to address the topic of the war with Germany, both of which present in novel configurations much of the same anti-Fascist iconography that had dominated Soviet satire during the previous decade. Designed by three artists – Porfirii Krylov, Mikhail Kupriianov, and Nikolai Sokolov – who had been publishing satirical drawings collectively under the name the Kukryniksy for nearly two decades, the posters convey a strong sense of national betrayal, while concurrently envisioning what had yet to actually materialize – a powerful Soviet defense that could bring the German advance to a halt.

In *Napoleon Suffered Defeat and So Too Will the Conceited Hitler!* (fig. 23), the Kukryniksy depicted Hitler as an enraged, diminutive tyrant dressed as Napoleon Bonaparte, the French emperor who had disastrously invaded Russia nearly a century and a half earlier. Wielding a pistol and the remnants of the nonaggression pact he has just treacherously shredded, Hitler reels from the blows of a rifle butt thrust in his direction by a Soviet soldier. To suggest that history will repeat itself, Napoleon's tall shadow is cast behind Hitler's retreating form. The silhouette of a pitchfork plunged toward the French leader, bearing the date 1812, the year of his unsuccessful campaign, echoes the motif of the rifle.

In *We Shall Mercilessly Crush and Destroy the Enemy!* (fig. 22), the bestial figure of Hitler tears through the "non-aggression pact between the USSR and Germany," wielding a pistol and dangling a theatrical mask that he has just removed. Like the caricature of Hitler as Napoleon, this poster is rich with allusions to the anti-Fascist propaganda so ubiquitous in the Soviet Union during the interwar era, especially in the features of Hitler's grotesque face and the clawed hand he extends toward the Red Army soldier who has been mobilized to stop him.[51]

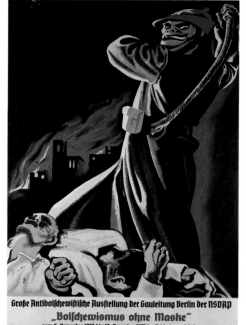

15

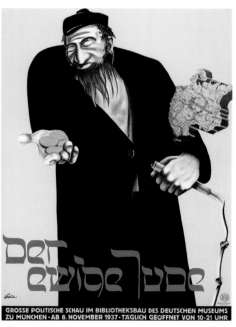

16

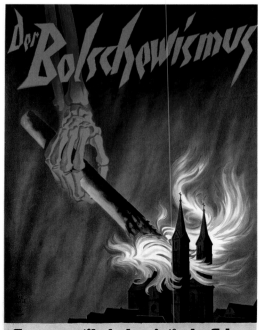

14

Fig. 17 Boris Klinch (born 1892; died 1946), with text by Dem'ian Bednyi *Fascism Is the Enemy of Nations*, January 7, 1937 Publisher: Ogiz-Izogiz Edition: 100,000 Offset lithograph 68.7 × 99.5 cm Ne boltai! Collection In exhibition

Fig. 18 Mikhail Cheremnykh *Comrade, Keep Careful Watch over the Ranks of the Collective Farms (Plakat gazeta izogiza 45)*, August 11, 1933 Publisher: Ogiz-Izogiz Edition: 60,000 Offset lithograph 106.2 × 79.3 cm Ne boltai! Collection In exhibition

Fig. 19 Artist unknown (German) Poster for *The Great Anti-Bolshevik Exhibition*, *Städt Ausstellungshalle*, *Karlsruhe*, April 1937 Offset lithograph 84 × 60 cm Prints and Photographs Division, Library of Congress

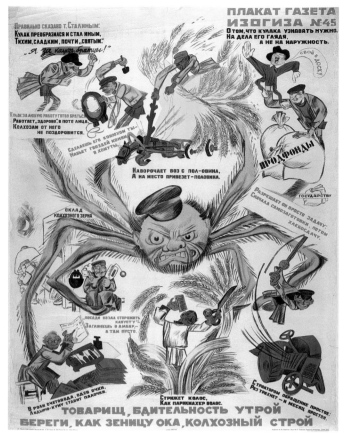

18

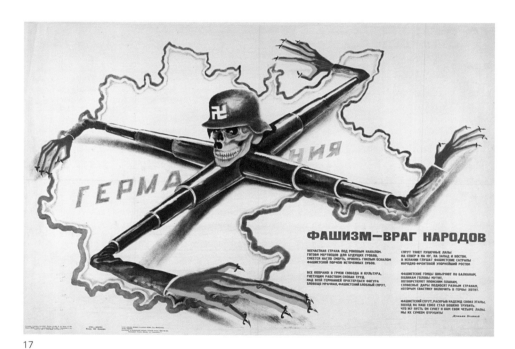

17

19

20

22

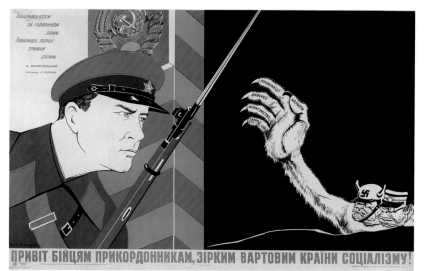

21

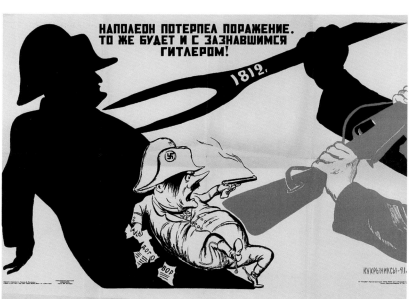

23

Fig. 24 Georgii Savitskii,
with text by the Litbrigade
*Wherever the Red Saber Is
Raised* (TASS 16),
June 29, 1941

Oil on canvas
120 × 135 cm
Archival photograph, ROT
Album, courtesy Ne boltai!
Collection

Fig. 25 Sergei Kostin, with
text by the Litbrigade
*Remember! During
Blackouts Your
Carelessness Is a Crime*
(TASS 2), June 27, 1941

Oil on canvas
150 × 90 cm
Archival photograph, ROT
Album, courtesy Ne boltai!
Collection

THE WINDOW-PAINTING

From the TASS studio's inception, those artists designing satirical posters declared their allegiance to the revolutionary tradition of ROSTA and its legacy of satirical magazines and political caricature. Such magazines had served as a public forum through which graphic artists could exchange designs and establish professional credentials, and it was in their pages that those who later designed posters and wrote poetry for the TASS studio developed their signature satirical styles. Between 1922 and 1924, dozens of these magazines were established; they were concentrated primarily in Moscow and Leningrad and often associated with major newspapers. Boasting circulations in the tens of thousands, the magazines offered the public caricatures of alcoholics, incompetent workers, and corrupt bureaucrats, elements of the labor force that undermined production. As semiofficial satire, they also proved to be highly effective instruments through which Stalin could consolidate his control of the Communist Party by publicly humiliating his rivals.

Krokodil and *Prozhektor* numbered among the most important of these magazines.[52] By 1935, when *Prozhektor* folded, *Krokodil* was the last such magazine remaining, thus acquiring something of a monopoly on state-sanctioned criticism.[53] Following the German invasion, however, *Krokodil*'s resources dwindled substantially, as numerous editorial personnel were drafted into the armed forces and severe material shortages crippled production.[54] Several of the artists and writers associated with *Krokodil* contributed to the TASS studio (including Cheremnykh, Boris Efimov, and the Kukryniksy).[55] So, too, did they publish in *Krokodil*'s chief rival, *Frontovoi iumor*, a satirical magazine published by the Political Department of the Western Front and distributed among Red Army personnel.[56] The graphic artists working for TASS thus found themselves at the epicenter of Soviet visual political satire during the war, their work constantly migrating between the TASS studio and contemporary satirical periodicals.

To complement the graphic artists they were drawing from the ranks of the satirical magazines, the founders of the TASS studio also aimed to involve

the coterie of artists who had dominated Soviet painting since the late 1930s. Despite often working toward the same ideological goals, graphic cartoonists and academic painters were not typically given the opportunity to collaborate. Within the hierarchy of Soviet visual culture, traditional media (easel painting, sculpture, and architecture) were accorded a more vaunted status than illustration, poster design, and political cartoons, which were understood to belong more to the sphere of functional imagery than to high art. Not initially concerned with this distinction, TASS officials sought the participation of a range of accomplished contemporary painters, several of whom had no prior experience designing posters or making graphic art. Initially, these artists contributed window-paintings on predominantly heroic themes to the displays mounted on the facade of the TASS editorial office.[57] As the studio turned away from displaying easel paintings, many of these artists sought to simplify their designs so that their work might be more readily translated into stenciled posters.[58]

In the first months of the war, the studio exhibited paintings in frames with stenciled captions written by the Litbrigade, a group of established poets and authors that produced texts collectively and anonymously to accompany TASS images.[59] Beginning in September 1941, artists began forgoing frames and instead mounted their work (painted on either canvas or paper) directly onto plywood, adjacent to these captions.[60] Some offered little more than cautionary prose, such as Sergei Kostin's *Remember! During Blackouts Your Carelessness Is a Crime* (TASS 2) (fig. 25), which paired the text with a matching image of vigilance.[61] Others provided slightly more lyrical and evocative captions, such as that accompanying Savitskii's *Wherever the Red Saber Is Raised* (TASS 16) (fig. 24), which reads, "Wherever the red saber is raised, wherever our horse places its hoof, there a Fascist will always be killed, there the monster will be stamped into the mud."

The pairing of framed paintings with stenciled captions directing the viewer to a proper reading of the image had been a common feature of the Museum Reform Movement of the Cultural Revolution, when highly politicized didactic labels were added to exhibition displays to explain correlations between art and class.[62] Although many of these labels denounced as bourgeois the avant-garde, formalist works next to which they were mounted, texts extolling the positive qualities of contemporary

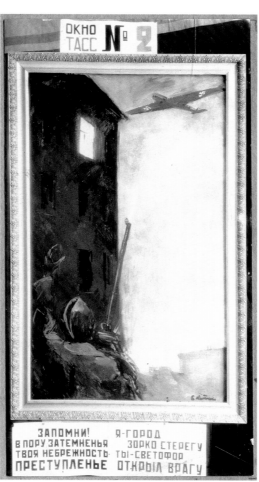

24

25

Fig. 26 Georgii Nisskii,
with text by the Litbrigade
*German Submarines Were
Secretly Creeping into
Soviet Waters* (TASS 26),
July 1, 1941

Oil on canvas
100 × 140 cm
Archival photograph, ROT
Album, courtesy Ne boltai!
Collection

Fig. 27 Photographer
unknown
"Exhibition of
Revolutionary and Soviet
Art Thematics, Tretyakov
Gallery, Moscow,"
VOKS 6–7 (April 1930)

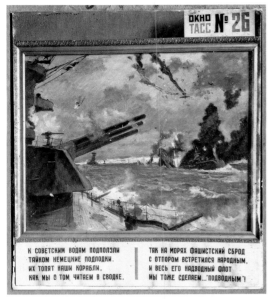

26

27

art had begun to appear by 1930. Aleksei Fedorov-Davydov's *Exhibition of Revolutionary and Soviet Art Thematics*, for example, which opened at the Tretyakov Gallery, Moscow, in May 1930, featured recent work by members of AKhRR and the Society of Easel Painters (OST), among others, supplemented with the enthusiastic slogan, "The Struggle along the Innumerable Fronts of the Civil War" (see fig. 27).[63] The passion for definitive interpretation and the general mistrust of the iconic that it fostered persisted in the TASS studio.

The painters associated with TASS were versed primarily in two foundational traditions: monumental, multifigural, Socialist Realist compositions of the kind that had been developed in the 1920s by AKhRR, featuring robust, young men and women eager to work and defend the motherland; and nineteenth-century battle paintings, which had been revived and given contemporary relevance by Nikolai Samokish and Mitrofan Grekov.[64] A very small number of the paintings displayed by TASS were satirical in tone (see, for example, the caricature of Hitler by Ioganson [fig. 6.8]). Collectively, the paintings demonstrate a wide range of stylistic approaches, from the dense modeling preferred by Savitskii and the fluid brushwork characteristic of Georgii Nisskii, to Sokolov-Skalia's emblematic, flat figures and Kostin's starkly expressive use of line.

The painters most responsible for developing and modernizing the genre of battle paintings were Savitskii and Aleksandr Przhetslavskii. Cavalry warfare, prized by the leadership of the Red Army, proved to be a surprisingly durable topic for TASS painters. Nisskii, who had painted primarily sea-

scapes and industrial landscapes prior to the war, took a leading role in creating a template for depicting modern naval warfare. The first painting he submitted to TASS was *German Submarines Were Secretly Creeping into Soviet Waters* (TASS 26) (fig. 26), which depicts the sinking of a German U-boat in the Baltic with an eye to atmospheric detail and reflective surface effects.[65] After Nisskii contributed one additional painting (TASS 58), his work for the studio was exclusively translated into stenciled posters. The thickly textured surfaces of his paintings gave way in these later works to richly colored patterning and pronounced contours reminiscent of French Fauvist painting (see fig. 3.23).

Sokolov-Skalia, who later contributed some of the most expressive satirical TASS posters and oversaw the studio's turn toward a more painterly form of stenciled image in 1942, began his career at TASS by constructing flatly modeled arrangements often limited to a few isolated figures. Women play a central role in these early window-paintings, some of which seem to have been rendered in the less-blendable, water-based medium of gouache. In *Soviet Soldier, Strike the Enemy* (TASS 28) (fig. 28), a fully equipped Red Army soldier ushers unseen compatriots before a female worker dutifully preparing artillery shells. "Soviet soldier, strike the enemy," the poster's caption exhorts. "Smash the Fascist to dust and smoke. Be calm in your persistent fight. We will provide everything you need for battle." A window-painting released the following

day, *The Whole Country Stood United as One* (TASS 34) (see fig. 9, lower left), which may have been executed in gouache and charcoal, features a muscular woman working in a munitions factory, and one from the following month (TASS 106) depicts a nurse hiding two wounded Soviet soldiers who are being pursued by a German search party.

Sokolov-Skalia's motif of the female worker enjoining her compatriots appeared only the day before Iraklii Toidze released his symbolic depiction of the Soviet Union in *The Motherland Calls!* (fig. 29), among the earliest conventionally printed posters released after the German invasion specifically to recruit conscripts. Here the motherland (*rodina-mat'*) appears as a new Soviet woman, marking the first time the Soviet Union had been allegorized in such a manner since the end of the Civil War era.[66] Possessing a stout physique capable of withstanding the rigors of both maternity and physical labor, she extends a soldier's oath in one hand, while summoning forth soldiers behind her.[67]

Even the all-powerful Gerasimov, whose imprimatur had proved essential to the founding of the TASS studio, contributed materially to the TASS project by offering bust-length portraits of the three Soviet marshals in *Commanders in Chief Voroshilov, Timoshenko, and Budennyi* (TASS 67) (fig. 30). The paintings were displayed in frames on July 14, 1941, as a triptych.[68]

All of the TASS window-paintings were intended to be meticulously duplicated by hand for distribution to various institutions and propaganda outlets

Fig. 28 Pavel Sokolov-
Skalia, with text by the
Litbrigade
*Soviet Soldier, Strike the
Enemy* (TASS 28), July 2,
1941

Gouache (?) on paper
155 × 130 cm
Archival photograph,
ROT Album, courtesy Ne
boltai! Collection

Fig. 29 Iraklii Toidze
(born Tbilisi, 1902; died
Moscow, 1985)
The Motherland Calls!,
1941
Publisher: unknown
Edition: unknown

Gouache and colored
pencil on gelatin silver
print
58.4 ×40.6 cm
The Museum of Modern
Art, New York
In exhibition

at a later date.[69] This practice had, in fact, been common in the Soviet Union since the late 1920s, when the Soviet art industry began manufacturing large quantities of indistinguishable, anodyne pictures. In 1932 the state restructured the four-year-old industrial credit association Khudozhnik as the All-Union Cooperative-Partnership of Artists (Vsekohudozhnik), which permitted much stricter control of artistic commissions and remuneration. On February 4, 1940, the Artistic Fund of the Union of Artists was established by order of the Council of Peoples' Commissars and given jurisdiction over numerous industrial facilities, workshops, and vendors, or what essentially amounted to a conveyer belt for the mass production of anodyne paintings and sculptures. Arguably, the very model the TASS studio embraced – editioning both paintings and stenciled posters – adhered closely to the preexisting Soviet artistic-industrial complex. The plan to copy paintings in the same media in which they were produced was apparently never pursued, however, and the production and display of window-paintings came to a halt in the fall of 1941, as the Germans were poised to invade Moscow. The severe shortage and prohibitive cost of artistic supplies and the labor-intensive, time-consuming nature of easel painting likely made it more of a burden than an asset for TASS. Concurrently, artists within the studio had begun to propose painterly designs for posters that were both more complex than conventional stenciled posters and more simplified than academic easel paintings. With the release of its final painting, Samuil Adlivankin's *Farewell* (TASS 235), on October 25, 1941, TASS brought its total number of paintings to roughly one quarter of its designs to date.[70]

A TALE OF TWO STUDIOS

On October 2, 1941, German forces launched Operation Typhoon, a major offensive to eliminate Soviet defenses around Moscow and capture the capital before the onset of winter.[71] Government employees soon began departing for Kuibyshev (Samara), nearly six hundred miles southeast in the Volga area, which would serve as the provisional capital until the summer of 1943. Two weeks later, on October 15, the State Committee of Defense adopted a formal resolution to evacuate vital government personnel from Moscow. In accordance, the Organizing Committee of the Union of Soviet Artists issued a selective order for the relocation of thirty-five important artists, which included

many of the painters associated with TASS and some members of the administrative staff.[72] On the evening of October 16, the TASS administration ordered that the Moscow studio be abandoned.

Shortly after arriving in Kuibyshev, Cheremnykh, Denisovskii, and Kulagin reconstituted the studio under the direction of the artist Anton Komashko, inviting TASS colleagues who had been similarly uprooted to join them.[73] The output of the Kuibyshev studio was modest; during the last months of 1941, it issued only fourteen posters (twelve of which were produced in December).[74] Operations continued into 1942, even after staff members returned to Moscow in January and February, although following their departure, the Kuibyshev studio produced stenciled posters designed in Moscow.

Following the evacuation, officials closed the TASS studio in Moscow. Those who were not relocated – stencil cutters, stencil painters, and other technical staff – and those who simply refused to depart were left to their own devices. Miturich recalled:

Our studio was closed, and we were invited to TASS to collect our pay. There, within the sacred walls of the telegraph agency, the panic was particularly evident. Papers stamped with the phrase "top secret" were scattered around the floor. The people still hanging around there all took something – one person a typewriter, another something else. I put on a gas mask.[75]

With three German armies at its outskirts, Moscow was consumed by fear. This was no less true for the studio's adherents, whose work remained on view in the street for all to see. Poet Mikhail Vershinin, who had begun contributing to the studio toward the end of 1941, remembered that "posters were being torn down by some panicking hand."[76] When he explained to Sokolov-Skalia that he had noticed that many posters had survived with their signatures torn off, the latter bemusedly explained that "overcautious [artists and poets] . . . are afraid that Hitler will come to Moscow and cut off their ears."[77]

Sokolov-Skalia, somewhat surprisingly, never left Moscow, later explaining that he had wished to stay in the capital and share its fate.[78] On his own initiative, he recommended studio operations almost immediately after the evacuation.[79] The Moscow TASS editorial office reopened on October 17, 1941, under Sokolov-Skalia's supervision. Poet Aleksei Mashistov was provisionally appointed

literary editor, and artist Iosif Feoklistov became production manager.[80] Following the evacuation, the TASS editorial office was essentially the only official visual propaganda outlet remaining in the capital. It immediately assumed responsibility for activities that had previously fallen to other organizations, including providing municipal decorations for the anniversary of the October Revolution, on November 7, and the New Year.[81] For each event, the studio managed to issue a record number of posters.[82]

In the apparent absence of any official review process, the studio executed posters at a prodigious rate, issuing over sixty new designs between the evacuation order of October 15 and the reintegration of the studios in February 1942. Instead of a TASS number, which the studio added to the upper-right corner of each image it released, posters produced in Moscow after the evacuation typically bore only their release dates, stenciled in roman numerals above the name of the capital.[83]

G. Balashov's *Time Works for Us* (TASS 16-XII-41) (fig. 31) was one such poster made by the Moscow studio during this period. Emphasizing the role that winter was playing in decimating the ill-prepared German military, it depicts Soviet troops mobilizing to defend Moscow at left (easily identified by the Kremlin towers) as the colossal, skeletal figure of Death approaches from the right, wielding a prodigious scythe in one hand and an hourglass in the other. Above him (and near the date of the poster),

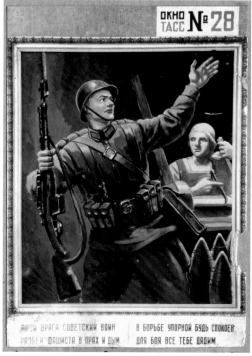

28

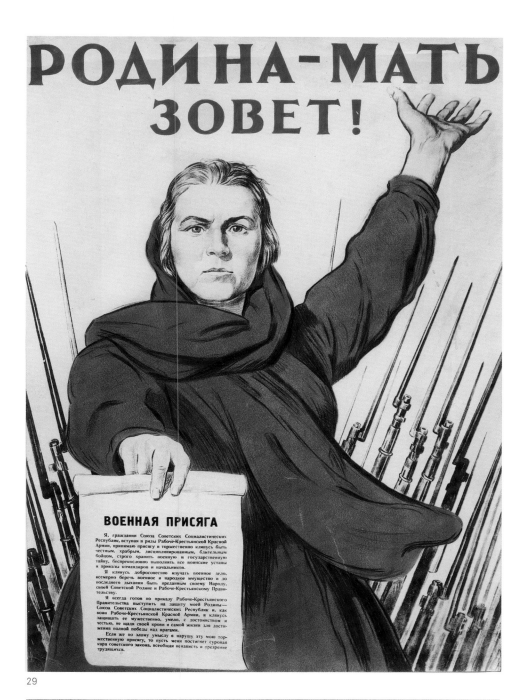

29

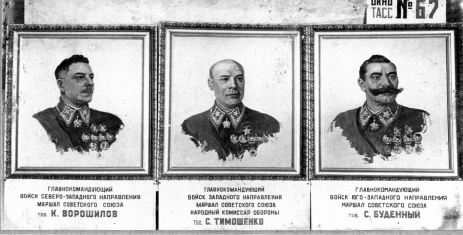

30

Fig. 30 Aleksandr
Gerasimov
*Commanders in Chief
Voroshilov, Timoshenko,
and Budennyi* (TASS 67),
July 14, 1941

Oil on canvas
77 × 240 cm
(overall)
Archival photograph, ROT
Album, courtesy Ne boltai!
Collection

a clock face set against a dark cloud indicates that
midnight approaches. Brought to a halt by freez-
ing weather and fresh Soviet reserves, the German
army suffered terrible losses and failed to capture
the capital.[84]

FRANCHISING THE TASS STUDIO

Although the Union of Soviet Artists initially
subsidized the TASS studio, the operation almost
immediately found itself in a precarious financial
situation. When it first opened in June 1941, the
editorial office was ordered to become not merely
self-sufficient, but actually profitable.[85] Virtually
all materials TASS published were available for
purchase, and only a few items were distrib-
uted free of charge to the military, the Central
Committee, and other high offices.[86] The studio
distributed posters and then later more techno-
logically advanced vehicles for propaganda, such
as slide films and light newspapers, primarily
through paid subscription. Initially, the post-
ers were designed to be displayed in a variety of
locales that, as Khavinson noted in his letter to
Zemliachka, included "railway stations, squares,
metro stations, factories and plants, theaters,
cinemas, shop windows and parks."[87] In 1942
Denisovskii described in a report on TASS activi-
ties, "The main subscribers to our 'Windows' are
major factories, the NKPS [People's Commissariat
of Transportation], Glavvoenstroi [Main
Military Construction Company], NKO [People's
Commissariat of Defense], Rechmorflot [River
and Sea Fleet] clubs, movie theaters, agitational
centers, enlistment offices, home-front military
units, people's commissariats, and other institu-
tions."[88] It is not clear if these venues displayed the
posters on their exteriors, the way they were shown
at the TASS editorial office on Kuznetskii Most, or
if they installed them indoors, in capacious rooms
with high ceilings that could facilitate a different
type of viewing, one that underscored the brilliant
chromatic effects of the painterly poster.

Subscribers included various Communist Party
organs and other enterprises, ranging from the
Central Committee (which received free copies of
the posters) to regional and district committees,
restaurants, plants, and factories. TASS posters
were also sent to educational, social, and cultural
institutions, such as Red Army clubs, universities,
and libraries.[89] One of the first permanent sub-
scribers was the Society for Cultural Relations with
Foreign Countries (VOKS), which began solicit-
ing materials for export in the summer of 1941.[90]

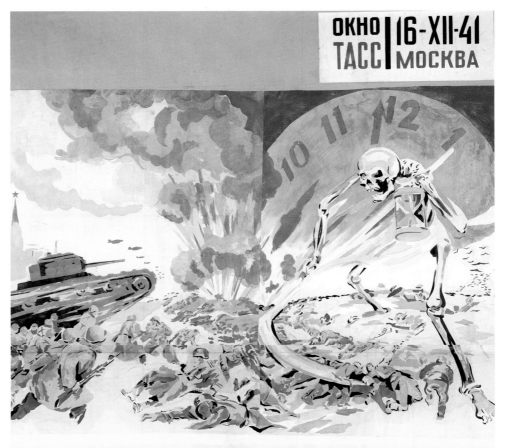

ОКНО ТАСС 16-XII-41 МОСКВА

ВРЕМЯ РАБОТАЕТ НА НАС

ЗИМНЯЯ НОЧЬ ДЛИННА И МОРОЗНА,
КОРОТОК ДЕНЬ И СУРОВ.
ВРЕМЯ СОЮЗНИКОМ НАШИМ ГРОЗНЫМ
ВОЙНОЙ ПОДНЯЛОСЬ НА ВРАГОВ.
И С КАЖДЫМ ЧАСОМ – ЧАЩЕ И ЧАЩЕ
ВЗМАХИ КРОВАВОЙ КОСЫ.
БЛУЖДАЮТ БАНДИТЫ ПО МЕРЗЛЫМ ЧАЩАМ,
СОСЧИТАНЫ ИХ ЧАСЫ.
И СМЕРТЬ ЗА НИМИ КРАДЕТСЯ СЛЕДОМ,
ИЗ НИХ НИКТО НЕ УЙДЕТ.
НАМ КАЖДЫЙ ДЕНЬ ПРИБЛИЖАЕТ ПОБЕДУ,
ГИБЕЛЬ – ВРАГУ НЕСЕТ.

31

Virtually absent from the distribution lists were the political departments for the fronts and military units involved in combat operations. Red Army soldiers encountered TASS imagery largely through reduced commercial editions and postcards.[91]

Unable to meet circulation demands, the editorial office considered franchising the operation by creating autonomous satellite studios in the Soviet republics from which stenciled posters could be generated. Khavinson's order to "place work on the TASS Windows on a broad footing, on an all-union scale" prompted the founding of the first such satellite studio in Tashkent, the capital of Uzbekistan, in January 1942.[92] The so-called UzTAG branch, run by the affiliated Uzbek Telegraph Agency, was tasked with producing posters for and distributing them to the republics of Central Asia.[93] UzTAG editions of TASS posters bear both the original TASS number given by the central office and a separate UzTAG number. The Kukryniksy's *Death for Death* (TASS 428), for example, was published by the Moscow studio on February 24, 1942 (p. 206), and then later reeditioned as a stenciled poster by the UzTAG studio, which gave it the number 177 (p. 207). As in virtually all such cases (which appear to be a result of reverse engineering a stencil template from a stenciled poster), the regional reproduction is cruder than the original TASS version.

In addition to copying images forwarded from Moscow and translating their captions into local languages, the UzTAG branch issued a limited number of its own apparently unique posters, some of which addressed regional topics in a style little influenced by the TASS studio in Moscow. Unlike their Russian counterparts, Uzbek artists did not produce satirical posters, choosing instead to publish images celebrating regional contributions to the war effort for local consumption. UzTAG posters frequently depict Central Asian peasants in provincial costumes, occasionally harvesting cotton, the national crop of Uzbekistan. Viktor Ufimtsev's *Glory to the Heroes of the Labor Front* (UzTAG 357) (fig. 33), for example, depicts a young Uzbek soldier leaving for the front, waving farewell to his parents, who are flanked on either side by emblems of wartime production.[94] The flowering branch of cotton that lies along the bottom edge of the poster serves to extol the region's agricultural products, which were used for both clothing and gunpowder.

The success of the satellite studio in Tashkent led officials in Moscow to consider establishing a Transcaucasian branch of TASS that could reproduce and distribute posters in Azerbaijan, Georgia, and Armenia.[95] Although proposals to do so were rejected, unauthorized TASS studios issuing posters that only vaguely resemble those being produced concurrently in Moscow nevertheless opened across the Soviet Union under such names as TASS Agit-Windows[96] and Windows of KarelFin TAG.[97] The Department of Arts and Bashkir Artists (Bashkhudozhnika) began issuing TASS posters in Ufa, the capital of the Bashkir Autonomous Soviet Socialist Republic, as early as December 18, 1941.[98] These completely original posters also seem to have been executed via stenciling. Some are modernized versions of Russian classics that would have been familiar to literate audiences. Veniamin Briskin and Sergei Rozanov's *Ivanov-*

Susanin (fig. 32), possibly an original maquette for a stenciled edition, takes as its subject a collective farmer who has deliberately misdirected a German convoy away from a shelter that would have protected it from the harsh Russian winter. The narrative is based on the heroic tale of Ivan Susanin, a seventeenth-century logger who led a Polish detachment seeking to kill Czar Mikhail Romanov so far into the woods near Kostroma that it was never heard from again.[99]

The TASS agency name was even appropriated for undertakings not connected to it in any way. In Tomsk, for example, Mikhail Shcheglov established a local TASS poster studio,[100] while at a port in Novorossiisk, local TASS posters were exhibited by members of Communist Youth Organization

Fig. 32 Veniamin Briskin (born Romny, Ukraine, 1906; died Moscow, 1982) and Sergei Rozanov (born Moscow, 1894; died Moscow, 1951) *Ivanov-Susanin* (Bashkhudozhnika TASS

16), c. 1942 Gouache, watercolor, and pen and black ink, over graphite 26.8 × 35.9 cm Ne boltai! Collection In exhibition

Fig. 33 Viktor Ufimtsev (born Barnevka, 1899; died Tashkent, 1964) *Glory to the Heroes of the Labor Front!* (UzTAG 357), c. 1943 Edition: unknown

Gouache and stencil 60 × 83 cm Ne boltai! Collection In exhibition

Fig. 34 Petr Magnushevskii (born 1899; died 1971) *Budapest Has Been Taken! Glory to the Heroic Red Army!* (Okna TASS

Leningrad), February 2, 1945 Edition: 3,000 Offset lithograph 58.2 × 71 cm Ne boltai! Collection

(Komsomol) working under the supervision of Mariia Savchenko, none of whom had any artistic training.[101] Prisoners in the concentration camps of the gulag reportedly designed posters inspired by the TASS examples issued from Moscow.[102]

By the second half of 1942, certain administrators were voicing concern over the amount of manpower TASS required to produce its posters as well as their enormous size, which precluded them from being displayed easily anywhere other than in the street.[103] Between 1943 and 1945, the editorial office continually provoked the anger of the TASS administration by failing to remain within its allocated budget. The editorial board attributed its overspending to cost overruns pertaining to poster production.[104] As the administration approved more complicated designs, the studio was forced to develop ever-larger numbers of stencils, which led to excessive costs in the stenciling department.[105] As a result of these cost overruns, the administration mandated fifteen-percent salary reductions for all studio personnel in April 1944.[106]

The TASS studio's decision to invest so heavily in the medium of stenciling was atypical among Soviet wartime propaganda studios. From June 1941, the city of Leningrad also boasted its own TASS operation (Okna TASS Leningrad), which initially adopted the Moscow studio's stenciling method. Isolated from the rest of the country by the German military from September 1941 through January 1944, Leningrad suffered horribly. For reasons most likely related to the siege, the Leningrad TASS studio was placed under the administrative jurisdiction of the Political Department of the Front (Politupravlenie) from 1942 until 1946, when it was disbanded (along with all other related TASS wartime studios). During the course of the siege, TASS Leningrad gradually shifted its production to lithography, issuing smaller-scale posters with a more limited chromatic range.[107]

What the TASS Leningrad studio sacrificed in color and size, however, it gained in sheer quantity. By 1943, at the height of the studio's operation, as many as six thousand copies of each of its litho-

graphic posters were being printed, far more than the largest edition of stenciled posters issued by the Moscow studio during that period (which never exceeded one thousand).[108] Despite its capacity for producing immense editions, offset lithography required extensive preparations and possessed certain limitations and material requirements. TASS Leningrad thus issued far fewer different posters over the course of the war. Instead, it combined its editions in large, urban displays with photographs and stenciled text panels that could be routinely changed to reflect current developments, recalling wall newspapers.

Artists working for TASS Leningrad designed posters that largely mirrored the genres in which their compatriots in Moscow were working, central among which were graphic satire and heroic realism. A poster dating to February 1945, *Budapest Has Been Taken! Glory to the Heroic Red Army!* (fig. 34), combines elements of both genres to celebrate the Soviet victory over German and Hungarian forces at the Siege of Budapest, which lasted from

32

33

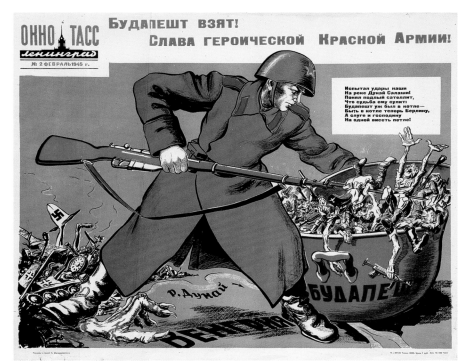

34

Fig. 35 Nikolai Muratov,
with text by Boris
Timofeev
"Rumors Are the Enemy's
Weapon," *Boevoi
karandash* 20, August 1941

Ne boltai! Collection
In exhibition

December 29, 1944, until February 13, 1945. The
image features a steadfast Red Army soldier who
towers over his opponents, straddling the Danube
River in his winter coat and stirring a red cauldron
marked Budapest with the bayonet on his rifle.[109]
He pins beneath his right foot a clawed and bloody
hand reaching out from under a pile of destroyed
German armaments toward Hungary, a motif that
remobilizes Soviet depictions of Western aggres-
sors from the previous decade (see figs. 12 and
13).[110] Contact between the Leningrad and Moscow
TASS studios was likely impossible during the
siege, but posters clearly circulated between
the two cities after it was lifted. The Leningrad
poster, for example, draws heavily on TASS 1027
(pp. 305–06), a stenciled poster designed by the
Kukryniksy in late July 1944, which depicts a Red
Army soldier stirring with the butt of his rifle a
seething black cauldron meant to represent the
city of Minsk, Belarus, and filled with hapless
German soldiers.[111]

Another prominent propaganda organ that used
lithography was *Boevoi karandash*, published by
the Leningrad organization of the Union of Soviet
Artists (LOSKh). During the siege of the city, three
thousand copies of each poster were typically
printed. Following the liberation, as many as fifteen

thousand copies were produced. The demands of
conventional printing technology precluded the
studio from producing many different designs.
Thus, a mere 103 issues of *Boevoi karandash*
appeared during the war, fewer than one tenth of
the number of TASS stenciled designs.[112]

The twentieth issue, printed in August 1941,
warned of the dangers of heeding Nazi propaganda
(see fig. 35). "Rumors are the enemy's weapon . . .
the hidden speech of Hitler," the text reads, above
a crowd of gossiping figures with exaggerated ears.
Below, an oversized sword descends on the gullible
rumormongers, admonishing readers to "Find all
whisperers! Hurry, stop the rumors."

The studio referred to its products, which are more
intimate in scale than the TASS posters, as sheets
(*listl'*). They were designed not for display on the
street, but rather for interior spaces, such as
bomb shelters, army barracks, and administrative
offices. Although most of the artists associated
with *Boevoi karandash* understood themselves to
be working within the tradition of "satirical post-
ers," others used the term "visual fables" (*rasskazy
v kartinkakh*) when discussing their images, asso-
ciating them more with the folklore tradition of the
lubok than with explicit political propaganda.[113]

The practice of returning to earlier Soviet pro-
paganda models found widespread approval in
Moscow during the first months of the war. Just as
those artists producing stenciled posters for the
TASS studio positioned themselves as the heirs
to the ROSTA tradition, a group of students at the
Moscow State Art Institute (MGKhI), working with
Dmitrii Moor and Gleb Goroshchenko, resurrected
the fashion for crafting carnivalesque papier-
mâché effigies of Western imperialists, which
had been popularized in Soviet street festivals of
the 1920s and early 1930s (see fig. 13).[114] In late
1941, the MGKhI studio issued a series of nine
stenciled posters caricaturing the German enemy,
each of which featured figures whose faces were
constructed out of hand-painted papier-mâché.[115]
With the exception of the bas-relief elements,
the MGKhI posters are flatter and much smaller
in scale than their TASS counterparts, containing
large passages of unmodulated, monochromatic
color. *Don't Believe Everything You Hear!* (fig. 36),
which features a bespectacled agent dressed in
black motioning to a bewildered woman with a
grossly inflated ear, exhorts citizens to remain
skeptical of malicious rumors. While certain post-
ers issued by the studio specifically advised Soviet
citizens on issues of national security, others were
designed to denounce Fascism broadly. In *The
Goebbels "School"* (fig. 37), for example, hap-
less German conscripts line up below the politi-
cian, who harangues them from a tribune above.
Bearing a basket filled with Fascist propaganda, he
stuffs copies of Hitler's *Mein Kampf* (*My Struggle*)
(1925–26) into their heads.

THE PAINTERLY POSTER

Abandoned a mere four months into the war, the
window-painting proved to be too costly, labori-
ous, and time-consuming to be an effective vehicle
for the TASS studio. Instead, TASS fully endorsed
the stenciled poster – derived from hand-painted
maquettes – as its signature visual medium.
Between October 1941, the month TASS released
its final window-painting, and February 1942,
after the reintegration of the studios in Moscow,
certain TASS members experimented with more
visually and thematically complex posters. These
bore little resemblance to the schematic designs,
abbreviated phrasing, and limited palettes of the
earlier stenciled editions, whose composition and
technique had been modeled on the celebrated
stenciled ROSTA posters. They demonstrate

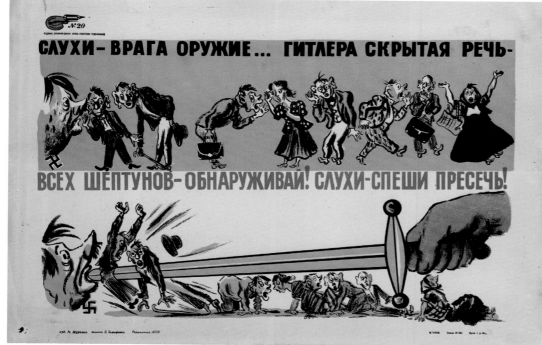

35

instead a more painterly approach to the window-poster, seeking to translate via stenciling the pictorial effects traditionally associated with easel painting. Such posters exhibit a measurably richer level of detail, surface texture, and chromatic nuancing than previous efforts. Advocates for the more painterly stenciled poster clearly strove for intricately layered, multifigural compositions in their original designs, adopting ambitions and conventions associated more with the tradition of figurative painting than that of stenciling.

At the same time that certain members of the studio began exploring the painterly capacities of the stenciled poster, others experimented with a new, multipaneled layout, based on the compositional format of the ROSTA posters. By replacing the signature schematic vignettes with replete and comparatively autonomous panels, these painters essentially combined the narrative-agitational format associated with the ROSTA posters with the visual density associated with window-paintings. In the absence of the recurrent ciphers typical of ROSTA, this novel approach required greater explication in the accompanying captions. The multipanel, painterly format was subsequently widely adopted in the studio and characterized the following year as the window-panel (*okno panno*).

By February 1942, the tide had shifted decidedly in favor of the painterly poster. At an organizational summit in Moscow, Kulagin identified three posters designed by Sokolov-Skalia the previous October as having achieved a new level of synthesis and artistic expertise. He praised how they "skillfully present the unity of texts and images" and went on to explain that he perceived them as "classics in the sense that their visual level is so masterful that they will be a model of how to make posters for years to come."[116] What had been at the time little more than experimental departures from the pictorial conventions associated with stenciling were now understood as significant achievements that were highly influential for subsequent studio endeavors.

The earliest of the three posters Kulagin called out, known as *A Poet's Prophecy* (TASS 210) (p. 230, fig. 2), addresses the German desecration of Russian culture, a theme explored repeatedly by the studio (see, for example, TASS 612 [pp. 229–31]), while also recalling the patriotism of a previous generation. Based on an idea proposed by the writer Anisim Krongauz, the poster features a solitary, bust-length portrait of Aleksandr Pushkin, the bullet-riddled appearance of which is explained by the epigraph at top, provided by

the Sovinformbiuro: "Drunken Fascists opened fire with rifles and pistols on the portrait of the great Russian poet A. S. Pushkin." Stenciled below the portrait is Pushkin's 1831 political poem "The Anniversary of Borodino," which celebrates the 1812 battle in which the Imperial Russian army, despite having to retreat, inflicted heavy losses on Napoleon's Grande Armée. Although written over a century before the present conflict, the text's rancorous tone resonated broadly with contemporary political rhetoric:

Well, well! Having forgotten / Their disastrous retreat they puff themselves up; / Forgetting the Russian bayonet and snow / That buried their glory in the wasteland. / A familiar feast beckons to them anew – / Slavic blood is intoxicating for them; / But their hangover will be fierce; / But long will be the guests' slumber / At the crowded, cold housewarming, / Under the grain of the northern fields!

Composed of some twenty-five different stencils, the poster was one of the most visually complex the studio had issued to date, containing accented highlighting and shadow in the poet's hair, eyes, and face; sumptuous modeling in his scarf; and meticulously rendered, trompe-l'oeil bullet holes in the canvas, frame, and wall.[117]

37

36

38

The second poster, *When You Go to War, Soldier* (TASS 222), also known as *Mother* (fig. 38), was issued ten days later. Designed by Sokolov-Skalia and Aleksandr Danilichev, with text by Margarita Aliger, and based in part on Toidze's *The Motherland Calls!* (fig. 29), the poster contains a similar Soviet matron exhorting young soldiers, sailors, and pilots to remember what they are fighting for. Yet, whereas Toidze's poster alludes to the military conscripts it addresses only through the symbolic array of rifles fixed with bayonets mustered behind the allegorical motherland, Sokolov-Skalia and Danilichev designed a densely layered, multifigural composition that visualizes concretely each of the service branches described in the accompanying poem.[118] While they provided most of the figures in the poster with only schematic features, they modeled the mother by contrast in comparatively rich detail, from the penetrating irises of her eyes and the folds of weather-beaten flesh under her chin to the voluminous scarf wrapped around her neck.

The third and final poster Kulagin named is Sokolov-Skalia's *For the Protection of Odessa* (TASS 242) (fig. 39), with text by Rokhovich, which was derived from a report issued in *Pravda* on September 23 concerning the preparation of municipal defenses to protect the Ukrainian port.[119] Modeled on earlier posters addressing civic defense, this example is composed of five richly developed panels, each with its own caption, light source, and vantage point. The autonomous panels are only loosely connected to one another visually, but they are bound by the theme of the protection of Odessa. The following year, Sokolov-Skalia credited his colleague Savitskii with having invented this novel compositional format – the window-panel – which merges the expansive pictorial capacities of a painting with the sequential, narrative structure offered by a ROSTA poster.[120] Kulagin singled out TASS 242 as a model for how to prepare an effective, complex poster:

We often hear: "Hurry, post your windows quickly, whatever their stage of completion is." This is not right. I have been watching viewers, trying to determine what makes them stop in front of a poster, what grabs their attention. Let's revive our heroic windows along the lines of such works as Odessa. It was outside for a month and there were crowds of people in front of it every day.[121]

On March 22, 1942, one month after the organizational meeting at which Kulagin praised recent achievements in the poster, the State Historical

Museum in Moscow opened the first museum exhibition devoted exclusively to TASS. As Sokolov-Skalia observed in a review of the retrospective, the first gallery of the show was dedicated to the "Defense of Moscow," when posters had been issued to inspire public confidence in the ring of fortifications designed to protect the capital.[122] He distinguished between these "poster-monuments" (*plakaty-monumenty*) and those created after the German assault was rebuffed, whose style he described as having more the character of a "telegraph report" (*telegrafnoe soobshchenie*). As Sokolov-Skalia argued, posters dating to the earlier period occasionally suffered from "many hasty brush strokes" and "poor texts." Nevertheless, he suggested, because they had been made under the constant threat of air raids and artillery bombardment, they should not be judged on the basis of their academic qualities.[123]

According to the initial exhibition plan, the "Defense of Moscow" was part of a much larger section of the exhibition devoted to the "Heroic Spirit" (*geroika*), which included posters addressing both the "heroic spirit of the Great Patriotic war" and the "heroic spirit on the socialist labor front."[124] Significantly, only one of the six planned exhibition sections was reserved for satirical posters, suggesting that the curators considered heroic posters to be more akin to the kind of imagery the museum typically exhibited. Despite this apparent connection, however, none of the window-paintings displayed at the TASS office in Moscow during its first months of operation was included.[125]

The fact that the exhibition affirmed the stenciled poster as the TASS studio's signature medium would hardly have surprised anyone familiar with its recent orientation. The studio had abstained from issuing any new window-paintings since late 1941, and the rich variety of paint media in which it had dabbled since its inception had been strictly curtailed in recent months to the oil pigments with which stenciled posters were routinely prepared. Prior to October 1941, an exhibition on TASS with such narrowly conceived parameters would have been largely unimaginable. By spring 1942, however, the TASS studio had come to be associated first and foremost with the stenciled posters into which it had been channeling its resources in recent months.

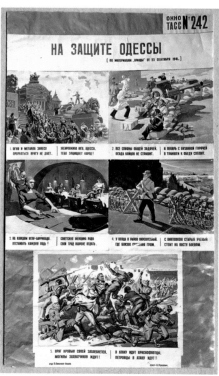

39

1

The images in Bourke-White's photograph include, from left to right (each with text by the Litbrigade), K. Gol'shtein and Nikolai Popov, *From the Battle of the Ice to the Present Day, 1242–1941* (TASS 84), of July 18, 1941; Sergei Gerasimov, *An Armed People Rises* (TASS 85), of July 18, 1941; Nikolai Radlov, *The Wonders of Fascist Photography* (TASS 60 [pp. 170–74]), of July 12, 1941; Leonid Soifertis and Radlov, *Hitler Shouts: "Europe with Me!"* (TASS 82), of July 18, 1941; and Petr Shukhmin, *Our Fuel, Highly Flammable* (TASS 81), of July 18, 1941.

2

The main offices of TASS were located at Nikolskaia Street 7–9.

3

The TASS studio released roughly 1,415 sequentially numbered posters between June 1941 and Dec. 1946. Although their numbers range from 1 to 1,485, approximately seventy were either never released or were published collectively with others (see, for example, TASS 880–883 [p. 263]). Stenciled posters designed after Oct. 1, 1946 (TASS 1445 through 1485), were issued by the Editorial Office of Political Posters of Iskusstvo, following the dissolution of the TASS editorial board (see the Act of Oct. 1, 1946, signed by the editorial boards of both TASS and Iskusstvo, f. 4459, op. 27, d. 346, ll. 1–2, GARF). By the time the studio closed in 1946, the operation had issued roughly seven hundred thousand stenciled posters. The most complete source for these is *Letopis' izobrazitel'nogo iskusstva Velikoi Otechestvennoi voiny*, published during the war by the All-Union Chamber of Books. See, in particular, the special volumes devoted to TASS, "Okna TASS, 1941–42" (1942) and "Okna TASS, 1942–43" (1943). TASS posters issued after 1943 are scattered throughout the later volumes, which are arranged thematically. In 1965, at the height of Nikita Khrushchev's abortive de-Stalinization campaign, the Russian State Library published an abridged catalogue raisonné from which all TASS posters containing pictorial or textual references to Stalin were excluded (Urvilova 1965). Despite its obvious shortcomings, the catalogue raisonné provides precise dates and dimensions for each poster cited, as well as information concerning print runs and later reproductions.

4

Raskin 1963, p. 269. Petrov died in 1942, when the plane in which he was being evacuated from Sevastapol to Moscow was shot down by the Luftwaffe.

5

"Muscovites Take up Their Guns as Nazi Hordes Approach Russian Capital," *Life* 11 (Oct. 27, 1941), pp. 27–32. The term *poster factory* had particular resonance within Soviet culture, as the topic of productivity was continually emphasized throughout the decade preceding the war. Bourke-White published a lengthy account of her several visits to the TASS

studio in her 1942 memoir, *Shooting the Russian War*. She noted of the street displays, "Crowds gathered around each new poster, memorizing the verses to tell their friends. Red Army soldiers passing by jotted down the rhymes and copied the sketches in their notebooks to be reproduced by soldier artists in their own regiments at the front" (Bourke-White 1942, p. 171).

6

Panels from the following posters are visible in Bourke-White's photograph of the TASS studio: on the floor in the foreground is *A Blabbermouth Is a Spy's Delight* (TASS 13 [p. 168]); on the table at left is *Criss Cross* (TASS 15 [fig. 4.5]); pinned to the board at the far left is *On Soviet Soil and in Soviet Air* (TASS 39); along the wall at right *Our ABC (Letters K, L, M)* (TASS 41), *Our ABC (Letters N, O, P)* (TASS 42), *Our ABC (Letters R, S, T)* (TASS 44), *Our ABC (Letters U, F, H)* (TASS 47), *Our ABC (Letters Ts, Ch, Sh)* (TASS 48), and *Our ABC (Letters Sh, U, E, Ia)* (TASS 49). Additionally, two panels that have not been linked to any TASS posters can be seen leaning against the wall at right.

7

See *Khudozhniki* 1941 and Kolesnikova 2005, p. 12. According to TASS stencil cutter Viktor Maslennikov, the June 22 meeting was an unofficial initiative that included him, Mikhail Cheremnykh, Nikolai Denisovskii, and Pavel Sokolov-Skalia, among others. They reported their idea to the organizational committee the following day. See Maslennikov 2007, p. 5.

8

See Kelly 2002.

9

Ibid., pp. 579–80. Catriona Kelly further noted that the Thirteenth Congress (of 1924) recognized the wall newspaper as a potent vehicle for propaganda, describing it as a "weapon for action upon the masses [*orudie vozdeistviia na massy*]" and recommending that it be placed under the administrative oversight of party cells and the Communist Youth Organization (Komsomol). This policy was implemented on Dec. 1, 1924, by the Central Committee of the Communist Party of the Soviet Union.

10

Sokolov-Skalia, "Okna TASS," *Trud*, June 10, 1943, p. 135.

11

As Lenin observed in *Pravda* on Sept. 20, 1918 (Lenin 1965, pp. 171–78):

Why, instead of turning out 200–400 lines, don't we write twenty or even ten lines on such simple, generally known, clear topics with which the people are already fairly well acquainted, like the foul treachery of the Mensheviks, the lackeys of the bourgeoisie; the Anglo-Japanese invasion to restore the sacred rights of capital; the American multimillionaires baring their fangs against Germany, etc., etc.? We must write about these things and note every new fact in this sphere, but we need not write long articles and repeat old arguments; what is needed is to condemn

in just a few lines, "in telegraphic style," the latest manifestation of the old, known and already evaluated politics.

12

According to Cheremnykh, ROSTA posters were initially copied by hand. The idea of reproducing them via stenciling came from the artist A. Pet, creator of the popular poster *The Czar, the Priest, and the Kulak* (1918), who introduced the technique in the spring of 1920 and cut the studio's first stencil. See Cheremnykh, "Maiakovskii v ROSTA," *Iskusstvo* 3 (May–June 1940), p. 39. ROSTA studios in other cities used different media to produce their work. In Iaroslavl posters were printed as lithographs; in Kostroma they were made as linocuts; and in Odessa the images were transferred directly onto walls and fences. See Waschik and Baburina 2003, p. 201.

13

The text of the poster reads, from left to right, top to bottom: "1. The Entente calculates its annual balance / 2. Oh, ho! / 3. Losses are torture for the bourgeoisie / 4. They were giving millions to Denikin / 5. They were giving millions to Vrangel / 6. As a result, losses are in the millions."

14

Despite ROSTA's affiliation with the Russian avant-garde, which by the mid-1930s had been largely discredited in the Soviet Union, Maiakovskii's extensive contributions to the studio guaranteed it an honorary place in the Soviet pantheon. Five years after his death, the poet, whom Stalin publically recognized as "the greatest and most important poet of the Soviet epoch" (Stalin 2006, p. 115), was "introduced [to the people] forcibly, like potatoes under Catherine the Great" (Pasternak 1990, p. 73). The Soviet glorification of Maiakovskii reached its zenith in 1940, the year before war broke out, on the tenth anniversary of his suicide, when his native city, Bagdadi, was renamed after him and encomia, memoirs, and commemorative posters were published (see, for example, the May–June 1940 issue of *Iskusstvo* dedicated to him). On June 22, 1941, the day Germany invaded the Soviet Union, a permanent memorial exhibition on the poet opened in Moscow. See "Usad'ba Khrushchevykh-Seleznevykh," *Gosudarstvennyi muzei A. S. Pushkina*, Pushkin Museum, Moscow, http://www.pushkinmuseum.ru/istor_usad.htm.

15

See Maslennikov 2007, p. 5. Gerasimov was close to Voroshilov, whose portrait he had painted several times since 1927. See Plamper 2010, pp. 231–37.

16

See Maslennikov 2007, pp. 5–6.

17

See ibid., p. 6. Throughout the war, the editorial office of the TASS studio reported directly to the general directors of its parent organization, Khavinson (1939–43) and then Nikolai Pal'gunov (1943–46).

18

Ibid.

19

"Zamestitelu predsedatelia" June/ July 1941.

20

The poster would be one of the few based on Sovinformbiuro bulletins during the first six months of TASS production. Of the more than three hundred posters printed in 1941, only eleven were based on Sovinformbiuro information. Larisa Kolesnikova (Kolesnikova 2005, p. 15) wrote:

Already during the night of June 24–25, the newly formed collective started its work creating the military-defense posters. By the morning of June 25, the first colorful, two-frame poster by artist Cheremnykh appeared in the window of 20 Kuznetskii Most with the verses, "The Fascist took the route through Prut, but he has been pushed back from Prut."

Evidence indicates that posters based on news from the front typically took from thirty-six hours to eight days to design and stencil.

21

See Iastrebov 1959, Kolesnikova 2004, and Valiuzhenich 1993. Evacuated to Molotov (Perm') on July 25, 1941, Brik only returned to Moscow in Jan. 1943, after which he served as the TASS literary editor until his death on Feb. 22, 1945. See Valiuzhenich 1993, pp. 39–40.

22

Sokolov-Skalia c. 1942, pp. 4–5.

23

During the studio's first few months of operation, poster texts were produced not by individual writers but by the Litbrigade, which was composed of established poets and authors. By the end of 1941, however, individual writers were more commonly writing texts.

24

Often the texts were read over the phone, while the designs for the posters were sent to the TASS offices for review. See "Soveshchaniia u t. Khavinsona" Feb. 6, 1942, l. 11.

25

Chegodaeva 2004, p. 271. Miturich said, "Work would begin with the selection and cultivation of colors for each stencil and for the entire run of prints." He went on to note that "toward the end of the twelve-hour shift, things would become slip-shod, paint would leak underneath the stencils, and defects would appear. The [stencil] paper could not withstand the increases in output, which sometimes reached 500 copies. The stencils tore, and we had to make new ones quickly."

26

The studio's efficiency increased constantly throughout the war, as did the number of posters it issued. Around 1942 Denisovskii reported (Denisovskii c. 1942, l. 4):

If no standards had been established for the stencil workers and certain workers were not producing more than 100 copies per shift, in September of 1942 certain comrades set records, [including]

comrade Lebedeva, who painted 1,210 stencils per shift; comrade Novikov, [who painted] 1,183 stencils per shift; comrade Solodovnikova, [who painted] 1,063; comrade Arutcheva, [who painted] 1,464; and, finally, Lebedeva again, who broke her previous record, [with] 1,500 stencils per shift.

27
See Kolesnikova 2005, p. 24. Moris Bekker was in charge of the glue department.

28
Lilia Bespalova, "Vospominaniia o rabote v Oknakh TASS-rezchik-trafaretchik," unpub. ms., l. 1, Kolesnikova Archive.

29
Seventy-five of the artists in the production workshop were women (Maslennikov 2007, p. 6). Among them apparently were the wives of Sergei Kostin, Georgii Nisskii, and others (ibid., pp. 10–11). Miturich recalled that Vitalii Goriaev's wife also worked at the studio. When she started there, she "was enlisted in the 'women's team' ... in the company of some very nice women – artists and artists' wives" (Chegodaeva 2004, p. 276).

30
In 1941 TASS employees were paid the following honoraria for services rendered: forty rubles for proposing a topic and having it adopted; three hundred to three hundred and fifty for a satirical poster design, and four hundred and fifty for a heroic poster design; one hundred and fifty for penning a caption; one hundred for cutting stencils for a poster; and fifty for preparing fonts. The following stipends were paid for posters with a print run of two hundred and fifty: eight rubles for stencil printing; two for font printing; and fifty kopeks for gluing panels. Three rubles were allocated for material costs related to each poster. See Shiriaev 1941. For a precise enumeration of the labor costs associated with poster design and production, see the undated expense estimates in f. 4459, op. 9–2, d. 62, ll. 28–29, 31–31ob, GARF.

31
The studio sought to maintain its output by experimenting with various chemicals until it exhausted the available supply. Paint thinner, for example, was first replaced by cheap turpentine, then by acetone, and finally by bedbug pesticide. See "Soveshchaniia u t. Khavinsona" Feb. 6, 1942, l. 17. During each shift, three to six personnel lost consciousness and were taken to the hospital; see Maslennikov 2007, p. 13.

32
A subdivision of the People's Commissariat for Enlightenment (Narkompros), Glavlit was established on June 6, 1922, and charged with censoring all printed materials in the Soviet Union. The light bulletins and slide films circulated by the TASS editorial office after 1942 required the approval of the Committee for the Control of Spectacles and Repertory (Glavrepertkom).

33
See Shiriaev 1941. TASS 129, 440, and 551 were apparently never published; see the special volumes devoted to TASS – "Okna TASS, 1941–42" (1942) and "Okna TASS, 1942–43" (1943) – in Letopis' izobrazitel'nogo iskusstva Velikoi Otechestvennoi voiny.

34
See Daniil Cherkes's [erroneously transcribed as Cherkesov] remark in the "Soveshchaniia u t. Khavinsona" Feb. 6, 1942, l. 9: "Today we have to visit thousands of institutions to have each poster approved. This is an intolerable situation. This is where we need help. Perhaps we need to have our own political editor or to get approval straight from the Central Committee. Our work would improve greatly then."

35
Ibid., l. 11.

36
In "Doklad o rabote 'Okon TASS' vo vremia Velikoi Otechestvennoi Voiny," Denisovskii sought to counter the official complaint filed in 1943 by Aleksandr Goncharov, a representative of the Central Committee of the Communist Party for the TASS Agency, that TASS posters were taking up to seven days to produce. Denisovskii listed a series of posters he claimed had been executed in twenty-four hours: "Comrade Goncharov can confirm that the posters The Orlov Salient, two posters dedicated to the storm of Kharkov (Kharkiv), posters about Taganrog, and posters based on the orders of comrade Stalin and others were published in 24 hours." Denisovskii was mistaken, however. The poster on the Kursk Salient (which Denisovskii erroneously referred to as the Orlov Salient) was released on Aug. 9, 1943 (TASS 778 [pp. 248–49]), two days after the Sovinformbiuro issued a bulletin on the operation. The posters dedicated to the liberation of Kharkov (TASS 796 and 797) were both released on Aug. 25, 1943, two days after an official notice had been circulated. Finally, the poster dedicated to the liberation of Taganrog (TASS 812) was released on Sept. 14, 1943, nearly two weeks after a report of it was published. See Denisovskii, "Doklad o rabote 'Okon TASS' vo vremia Velikoi Otechestvennoi Voiny," n.d. [c. 1946], f. 922, d. 3, ed. khr. 5, l. 8, Nikolai Denisovskii Papers, Department of Manuscripts, Russian State Library, Moscow. The dating of the document by the Department of Manuscripts may be incorrect, as its content indicates that it was written toward the end of 1943 or the beginning of 1944.

37
See Shiriaev 1941.

38
These materials are currently in the collection of the Department of Visual Arts, Russian State Library, Moscow. On the TASS registration book, which we were not able to consult, see Maslennikov 2007, pp. 40–41.

39
Shklovskii 1972, p. 142.

40
As Maurice Hindus observed (Hindus 1933, pp. 264–65):

On November 7, 1932, one of the features of the celebration of the fifteenth anniversary of the Revolution was a display of flowers in the eating places of Moscow, and exhibits of paintings in the windows of the leading shops on the main streets of the city. For the time being, every important shop had been converted into an art gallery. The subjects concerned themselves preeminently with the factory and the kolhoz [collective farm]. There were paintings of blast furnaces and workers tending them; of machine shops with men bent over their tools; of forges with men stalking round molten metal; of new construction projects with men singly, in groups, in multitudes, heaving brick, lumber, and other materials. There were paintings of cattle and horses grazing in rich pastures, and of fields, forests, brooks, and buildings on collective farms; of men doing the work in the fields. Crowds of pedestrians stopped and looked and discussed these exhibits. Whatever their shortcomings as works of art, the subjects were decidedly arresting.

41
OSOAVIAKHIM, an acronym for the Union of Societies Providing Assistance to the Defense, Aviation, and Chemical Industry, was established as a Soviet civil-defense league in Jan. 1927 by merging three existing organizations: the Societies of Defense Assistance, Friends of the Aviation Fleet, and Friends of the Chemical Defense Industry. The league's seal transposes attributes of each of the three military disciplines associated with it – a rifle, a propeller blade, and a gas mask – onto a hammer and sickle, a cog, a sheaf of wheat, and a red star. "GT-3," inscribed on the satchel carried by the Soviet soldier at right, is the name of the civil gas-mask filter OSOAVIOKHIM produced in 1929.

42
Goebbels 1935. See Behrends 2009, p. 534.

43
The exhibition originated in Nuremberg in Sept. 1937 and then traveled to several venues. See Zuschlag 1995, pp. 300–09; and Zuschlag 1997.

44
See Geyer and Fitzpatrick 2009, pp. 410–12; Zuschlag 1995, pp. 309–14; and Zuschlag 1997.

45
See Geyer and Fitzpatrick 2009, p. 422:

To a marked degree both Soviet Russia and Nazi Germany viewed each other and composed their image of each other in terms of their putative roles in an epic struggle for "Europe." However, Soviet analyses of Nazi Germany generally avoided ethnic essentialism, largely preferring to attribute contemporary Germany's ills to Nazism, although in other key respects, its image of Nazi Germany was comparable to the Nazi image of the Soviet Union.... In effect, each country developed a model for the other which was virtually a mirror image of that of its rival; that which was represented as positive in one side's account of the contrast between themselves and the other was presented in hyperbolically negative terms in the other's country as primitive and backward, even "barbaric," thereby claiming superiority for themselves as more rational and organized.

46
The poster text translates as: "Poster Newspaper, Izogiz no. 45. / That it's better to recognize a kulak / By looking at his deeds, / Not at his appearance." The caption for the image at top left reads, "Comrade Stalin rightly says: / The kulak has transformed and become different, / Quiet, sweet, almost, 'holy.'" Below that text is the caption, "The kulak is ready to take on any task: / He works 'heartily' in the sweat of his brow, / Striking a blow at the heart of the collective farms." Under the hammering worker, the text reads, "You make him into a groom, / And he sticks the horse's collar full of nails." Under the farmer being towed by a horse is the text "Piling up a cart with half the barn, / In its stead he brings back half." Under the man smoking, the caption reads, "'Put an ass in charge of guarding the cabbage' – / You look in the storehouse and find it empty." Under the man with the abacus, the text says, "In the role of accountant, putting on his glasses, / He inflates the achievements of his lazy relative." Under the man with scissors is the text "He trims ears of grain, / Like a barber does hair." At the bottom right is the caption "The way to deal with tractors is simple: / A single blow, and a month of idling." Below that caption, the text reads, "He simply resolves the task: / First he takes his own share, then submits his state contribution." At the base, the caption says: "Comrade, triple your vigilance! / Guard the communal farm as the apple of your eye!"

47
Initially proposed in Oct. 1936, the poster was only published in Jan. of the following year. Bednyi's complete text reads:

Fascism is the enemy of nations / This unfortunate country, under the pressure of destiny, / Is readying caskets for its future dead. / Death laughs impudently, glowing with the crooked grin / Of teeth spoiled by the disease of Fascism. // Everything has been desecrated. / Freedom and culture have been sullied. / Labor has been chained into oppressive bondage. / A dark and ominous figure has spread over all of Germany: / The malicious Fascist octopus. // The octopus extends his tentacles of guns / To the north and south, east and west. / Fascist henchmen in Spain are destroying / The hardy sprout of the Popular Front. // Fascist messengers scramble all over the Balkans. / They confound the Polish nation, / And kowtow to Japanese plans. / They are making verbal commitments to various countries / That want to add the

When the TASS studio began its poster-making initiative in June 1941, its artists could not have anticipated the technical and material challenges that four years of war would bring. Despite the perils, shortages, and physical strain of the conflict, TASS artists managed to produce 1,415 designs of varying visual and aesthetic complexity and thematic diversity through the medium of stencil. By the time the studio closed in 1946, it had produced between 690,000 and 700,000 stenciled posters.[1] The final products serve as a record of the artists' vision and technical proficiency, the workshop collaboration, and the physical exigencies of war.

WHAT IS A STENCIL?

A stencil is made by cutting shapes (openings) into a sheet of paper, cardboard, or thin metal, which then becomes a template for applying color to a receiving support (most often a sheet of paper or fabric). Keeping the stencil firmly in contact with the support in order to prevent color seepage under the edges, the stenciler applies paint with a brush through the stencil openings (see fig. 1).[2] This process, which can be repeated on multiple surfaces for the life of the stencil, results in a consistency of painted forms each time the template is employed.

The use of stencils enables the translation of an artwork into a series of multiples, each of which is unique because it is painted by hand. In reproducing an original design, the stencil cutter must interpret the source image by evaluating the forms, tones, and structure of the initial design and dividing these elements into isolated shapes, which define the types of openings that will be cut into several stencil templates (depending on the level of complexity of the image). The process of tracing color fields from an original design onto a sheet of tracing paper likely facilitated image transfer for TASS stencil cutters; such thin, transparent paper could serve as an intermediary template and would have allowed them to easily cut one or, more likely, a stack of several sheets of rigid, heavyweight stencil paper. Applying color sequentially through multiple stencils creates a reproducible interpretation of the original design.

The TASS studio modeled its use of stencil on the precedent of the ROSTA studio, which operated mainly in Moscow and Leningrad during the Russian Civil War (1917–23) (see figs. 1.3, 3.3, 5.6). The classic stencil technique employed for ROSTA posters involved a limited range of colors and stencils. Color was brushed on evenly to produce more or less homogeneous, flat tonal passages. A quintessential example of an early TASS poster that follows the ROSTA model is TASS 143, *Meeting over Berlin* (fig. 2; see also pp. 182–83), which reveals how the basic elements of a stenciled image come together. The design consists of a limited palette of four colors – gray, blue, red, and black – with minimal overlap of pigments, and it makes substantial use of negative space (namely the unpainted paper) in the background and select areas of the figures, flags, planes, bombs, and lettering.

Meeting over Berlin is composed of two sheets of paper that make up the image and three additional ones on which the poster text (TASS number, title, and poetic caption) is stenciled. TASS posters were never realized on a single sheet of paper, but were instead composed of between five (like this example) and eighteen sheets (for a particularly large example, see TASS 100 [pp. 177–78]). Multiple paper sections allowed stencil templates to remain a manageable size; if they were too large, templates would become unwieldy, flimsy, and difficult to handle. Furthermore, the arm's-length dimensions of the smaller sheets corresponded well with the studio's assembly-line practice of allocating one set of stencils per person per workstation to maximize time and efficiency. For the earliest TASS posters, the component paper pieces were adhered to secondary backing papers, which allowed them to be assembled into holistic compositions while providing extra support (see TASS 60, fig. 1 [p. 171] and back cover). This two-part mounting process is unique to posters produced in 1941 and the first half of 1942.

Even simple designs like *Meeting over Berlin* required more stencils than one might imagine. Though it may seem that a single stencil could be used for each color in a design, visual evidence reveals a more complex practice. In the upper panel of TASS 143, two different stencils were used for the identical red, and two more were utilized for the black. In both cases, this was necessary to segment areas of negative space within a form – the highlight on the bombs and the white contour around the red star – which could not be done with a single stencil. Producing such shapes involves the same challenges as cutting a letter *O* out of a piece of paper.

The falling bombs at the bottom right of the lower panel demonstrate how certain design decisions impact stencil complexity (see detail on p. 52). If the Kukryniksy had intended the bombs to be completely black, with no white highlight, the stencil cutter could have cut the bomb shape out of one stencil template and simply painted it in. Instead, the artists designed the falling bombs with a white highlight in the center to create the illusion of light reflection, as well as a sense of volume and movement, thereby enhancing the dynamism of the composition. To achieve this effect, the stencil had to be cut in two or more parts that connect – in this case, a left and right side – in order to maintain the passage of unpainted space within the form. Such misleadingly simple details constitute design decisions that augment the visual impact of the image and the complexity of its production.

Other passages in TASS 143 reveal this multistep stenciling process. In the second panel, two stencils were used for the black and another two for the gray. In addition to creating the highlights in the bombs, the black stencils were used to differentiate between the silhouette of the city and the text inserted within it; the sheen of slightly different black paint and various application textures are discernable in the panel. The overlapping gray arcs representing clouds also display evidence of a two-part stenciling process: each arc came from an individually cut stencil opening, and two sets of arc stencils were overlapped to form the design. Where the arcs overlap, the paint has more weight, and each set of arcs was intuitively painted in a different direction, animating the visual field with distinct surface textures that intensify the feeling of mass and movement in the plumes emanating from the exploding city. The alternating brushstrokes yield a dynamic surface materiality.

In all, eleven stencils were used to create this two-panel image: six in the upper panel (two red, two black, one blue, and one gray) and five in the lower panel (two gray, two black, and one red). To ensure that the various color fields aligned properly on each sheet, TASS stencil painters utilized a system of registration, evidenced by tiny pinholes at the right and left sides of each panel. Pins were used to fasten each stencil template to the paper support, guaranteeing consistent placement and securing the stencils firmly as color fields were painted in. Painting with multiple stencil templates and no registration system would have resulted in

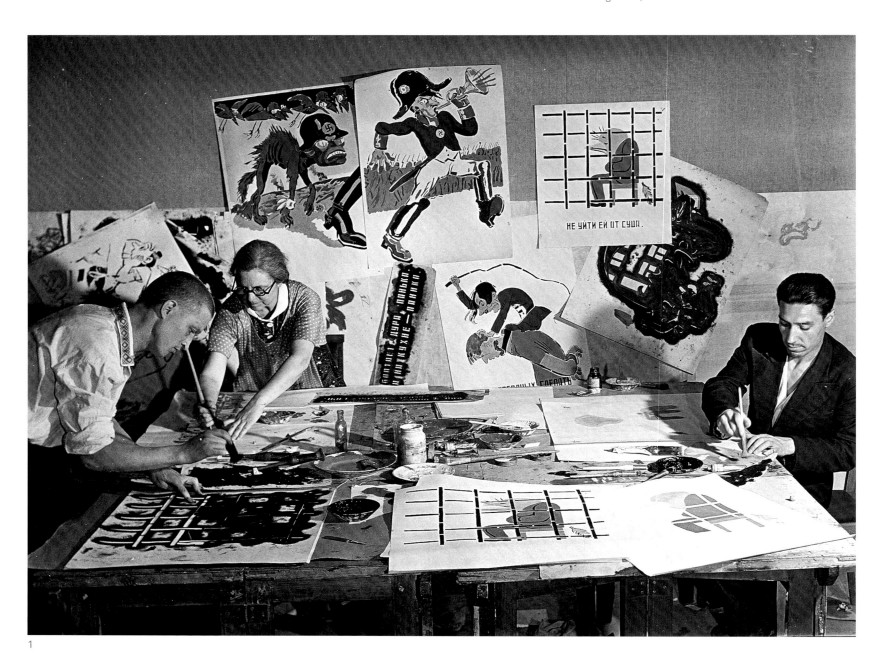

1

Fig. 6 Pavel Sokolov-
Skalia, with text by
Dem'ian Bednyi
*The Moralistic Wolf (A
Fable)* (TASS 757) (details),
July 19, 1943
Edition: 800
Stencil

2010.171: 237.5 × 83 cm;
2010.172: 240.5 × 83.5 cm
The Art Institute of
Chicago, gift of the U.S.S.R.
Society for Cultural
Relations with Foreign
Countries, 2010.171–72
In exhibition

6

In contrast to the kaleidoscopic and bold color
patches in *The Moralistic Wolf*, a wide variety of
painterly brush and sponge use, rag wiping, and
subtle transparent washes appear in the works
of Lebedev. Examining the stylistic differences
between Sokolov-Skalia's Hitlerite wolf and
Lebedev's *Captured!* (TASS 912) (p. 268) reveals
how the artists' decisions yielded strikingly diver-
gent final products. Lebedev's naturalistic wolf (fig.
7) eschews the black outline and tightly knit planes
of uniform vivid colors of Sokolov-Skalia's carica-
ture. Instead, in Lebedev's design, the color palette
is more delicate and naturalistic. The cream paper
and unpainted passages create a tone upon which
to build color using transparent washes or leave
untouched as a color field in its own right.

Lebedev's wolf reveals a purposeful layering of
multiple translucent stencil passages, necessitat-
ing a very different stencil-cutting and pigment
application strategy than Sokolov-Skalia's design.
Dry-brushed and stippled passages of diaphanous
gray, beige, brown, and black overlay planned areas
of negative space to produce a soft, velutinous fur
pelt. The first stencil layer comprising the wolf's
body is a pale pinkish beige, upon which zones of a
transparent warm beige and golden brown provide
the structure of the wolf's coat. Over this, masses
of darker, more opaque gray and black build an
additional paint layer that develops density in
sections of the pelt, adding definition and vol-
ume to the wolf's body. In yet another layer, lively
emphatic dark strokes, which were subsequently
overlaid with transparent light gray wash, indicate
the direction of hair growth. On top of this layer,
large stencils were cut for sections of stippling
charcoal gray paint that was interpretively dabbed
with a dry brush to create a lifelike texture for the
wolf's coat. This gauzy texture feels spontaneous,
and indeed this type of painting demanded a high
degree of subjectivity on the part of the stencil
painter. Even so, each line and plane of the design
remains bracketed by the edges of a stencil.

With the predominance of single-image com-
positions and the direct joining of paper panels
from 1942 on, more pronounced color shifts and
inconsistencies between paper panels in the same
poster became evident, attesting to the piecemeal
assembly-line nature of the TASS operation. Slight
differences in color and degrees of pigment den-
sity from one sheet to another reveal that multiple
batches of paint were separately mixed at different
workstations. At times, varying weights of pigment
application, brushwork, or painting style betray

Fig.1 Pavel Sokolov-
Skalia and Nikolai
Denisovskii, with text by
Vasilii Lebedev-Kumach
Our One Thousandth Blow
(TASS 1000), June 5, 1944
Edition: 600
Stencil

160 × 123 cm
The Art Institute of
Chicago, gift of the
U.S.S.R. Society for
Cultural Relations with
Foreign Countries,
2010.82
In exhibition

On June 5, 1944, to celebrate the third anniversary of its wartime production, the TASS studio issued its one thousandth poster since the German invasion of the Soviet Union three years earlier (fig. 1). Typical of the studio's later work, the hand-stenciled poster contains a colorful, tightly focused, figural image at center, complemented by a diffuse array of texts placed above and below it. At the top right, the studio's moniker, OKNO TASS (TASS Windows), identifies the publisher and indicates that the poster was specifically designed to be placed in street-level windows along metropolitan boulevards, where it might compete for the limited attention of war-weary Muscovites. The scarlet number 1000 in the poster's top-right corner indicates its chronological placement within the studio's production.[1] The title, *Our One Thousandth Blow*, appears in bold capital letters at the top of the poster; just beneath it, a short, italicized epigraph attributed to Vladimir Maiakovskii, a Futurist Soviet poet, declares, "I want the pen to be on a par with the bayonet." Drawn from the poem "Homeward," published in 1925, four years before Maiakovskii's suicide, the epigraph and the image to which it is appended announce the TASS studio's understanding of its wartime mission.[2]

The scene at the poster's center — credited to Nikolai Denisovskii, the studio's director, and Pavel Sokolov-Skalia, its artistic director — reiterates Maiakovskii's graphic analogy. The figure of Adolf Hitler recoils in a desperate effort to avoid the objects that are thrust threateningly toward him by the Soviet archetypes at right. A fanged creature with claws, hardly distinguishable as human, Hitler bears the signature large nose and forward-swept hair with which Sokolov-Skalia often depicted him during the war. Blood stains his uniform, starkly illustrating the animism underlying this type of wartime propaganda. Like many posters from the war era, *Our One Thousandth Blow* is a study in carefully calibrated contrasts: Soviet hands are arrayed against subhuman Nazi claws; the red star brandished by the Soviet Red Army soldier at top right opposes the Nazi swastika on Hitler's armband; and the figures inhabit a bifurcated space of solid colors that clearly distinguishes one side from the other, with the abyss of darkness at left countered by a bright wash of daylight at right.

The caricature of Hitler as a subhuman cornered by an array of Allied forces was common to Soviet wartime propaganda. A conventionally printed poster entitled *Death to Fascism* (fig. 2), released on June 29, 1941, only one week after the German

1

invasion of the Soviet Union, depicts Hitler as an enraged, ax-wielding, gun-toting gorilla, gesturing menacingly to the East. Printed by the State Publishing House for Children's Literature (Detgiz) in Leningrad, the poster defies conventional perspective by situating the apelike Hitler atop a flattened map of Europe, much of which he has already sullied with dirty footprints. A tight phalanx of bayonets confronts the dictator from the East, the frottaged wood grain of the rifles to which they are attached contrasting sharply with the solid block

of red that denotes the boundaries of the Soviet Union. A similar array has been mustered against Hitler in *Our One Thousandth Blow*, but in the TASS poster, the German leader's grasping claws are challenged by human arms, each clothed in a different fabric and wielding a different implement. The soldier at top grasps a rifle fixed with a bayonet; beneath him, civilian arms thrust a pencil and

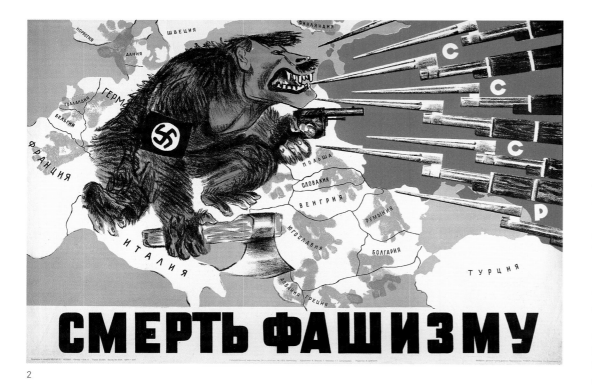

СМЕРТЬ ФАШИЗМУ

2

pen, equal in size and stature to the rifle, toward Hitler. The poster's meaning is resoundingly clear: soldier, writer, and artist are working collectively to repel the enemy.

Although similar to innumerable other posters celebrating vocational contributions to the Soviet war effort, *Our One Thousandth Blow* is atypically self-referential. It asks the viewer to make sense of it not literally, but metaphorically, as the pen and pencil will be used only indirectly to bring bodily harm to Hitler. Yet unlike the bayonets that flank them, the artistic implements exhibit a relationship to the caricature of Hitler that is left deliberately ambiguous. Although they seem to threaten the German leader, they might just as well have been used to fashion his grotesque image, thus suggesting an unusual second order of representation within the poster.[3] The bald confrontation between the artists' tools and their target foregrounds a series of larger questions concerning the TASS studio's operations that are too often lost amid discussions of its accomplishments. Through what pictorial means did the studio aspire to contribute to the war effort? To what extent do its posters meaningfully engage with or decisively depart from earlier Soviet models of printed graphic satire and heroic figurative painting? Finally, how, if at all, did the studio modify its approach to designing propaganda as the war progressed from a largely defensive campaign to one concerned with expanding the Soviet sphere of influence?

"WE WORK FOR THE SOVIET STREET": THE 1942 TASS ORGANIZATIONAL MEETING

Questions concerning the nature and scope of wartime visual propaganda were the focus of a major TASS organizational meeting held in February 1942, once the German assault on Moscow had been successfully repelled and some order, at least provisionally, restored to the capital. Presided over by Iakov Khavinson, executive director of the TASS News Agency, the meeting marks one of the earliest occasions on which high-level studio personnel met to discuss production and design issues, and certainly the first since their dispersal from the besieged capital some four months earlier. Administrators took advantage of the reunion to solicit opinions from artists and poets concerning production and design issues, and the group bluntly debated why certain posters had succeeded while others had failed. Of paramount importance to the participants was the establishment of fundamental criteria that would govern the studio's subsequent production.

The allusions to Maiakovskii in *Our One Thousandth Blow* evoke the TASS studio's historical precedent, the celebrated ROSTA studio of the Russian Telegraph Agency, at which the poet had played a pivotal role some two decades earlier, during the Russian Civil War (1917–23), when the Soviet Red Army struggled against a coalition of anti-Bolshevik groups, including the White armies, Ukrainian nationalists and anarchists, and an abortive Western intervention. Despite their apparent indebtedness to ROSTA, however, posters issued by the TASS studio departed significantly from their predecessors at a fairly early point in the war. In his opening comments at the organi-

zational meeting, Sokolov-Skalia singled out the overwhelmingly pictorial nature of TASS posters as their defining characteristic and the feature that distinguished them most clearly from the ROSTA posters. "From the outset, the TASS windows contained much more 'visual language' [*izo-iazyk*] than the ROSTA windows," he claimed. "If the ROSTA windows were dominated by textual material, then in our work the visual material is more important and up to the present it remains so in the windows."[4]

As an artist, Sokolov-Skalia was clearly invested in poster production and design, but his claim signals more than simply his professional allegiance to artists. The ROSTA poster studio had been formed initially to disseminate information and propaganda rapidly while the Bolshevik Party consolidated national power.[5] Like many of the earliest TASS posters, ROSTA posters were stenciled, multipaneled, and composed of flat, schematic images accompanied by short captions in verse (see fig. 3).[6] For Sokolov-Skalia, these posters derived their meaning from the way in which their poetic narrative directed the accompanying imagery, an idea that had been proposed by the literary historian Viktor Shklovskii two years earlier, when he noted: "Each [ROSTA] drawing had a textual significance. The text connected the drawings. If those window-posters had been printed without drawings, the text would have had to be changed; otherwise it wouldn't have been understood."[7] The captions in these posters occasionally took the form of a *chastushka*, a poem resembling a limerick (technically, a quatrain in trochaic tetrameter). Underscoring the observations made by Shklovskii and Sokolov-Skalia, Maiakovskii, who joined the ROSTA studio shortly after it opened and became its greatest champion, later referred to the posters themselves as "decrees instantaneously publicized as a *chastushka*."[8]

Sokolov-Skalia and his colleagues perceived the dangers inherent in developing more pictorial approaches to propaganda, specifically the risk that artistic form might distract from or even overwhelm the very political rhetoric it was meant to embody, a concern that had haunted Soviet visual culture for the better part of two decades.[9] A forceful debate ensued at the TASS organizational meeting concerning the compositional modes and pictorial genres best suited to the studio's products, how the posters were designed, and the manner in which they were

Fig. 2 Vasilii Vlasov (born
St. Petersburg, 1905; died
Leningrad, 1979), Teodor
Pevzner (born 1904;
died 1941), and Tatiana
Shishmareva (born
St. Petersburg, 1905; died
St. Petersburg, 1995)
Death to Fascism,
June 29, 1941
Publisher: Iskusstvo
Edition: 20,000
Offset lithograph
60.4 × 90.4 cm
Ne boltai! Collection
In exhibition

Fig. 3 Vladimir
Maiakovskii
*Forward, Comrades, to
New Positions!!*
(GPP 289), August 1921
Edition: unknown
Stenciled watercolor
230 × 130 cm
Ne boltai! Collection
In exhibition

3

Fig. 4 Aleksandr Ustinov
(born Moscow, 1909; died
Moscow, 1995)

*Crowd Viewing Mikhail
Cheremnykh's "What
Hitler Wants – And What
He Will Get" (TASS 5),
Moscow,* June 1941

presented to the public. Sokolov-Skalia drew attention to the principal formats in which the studio had been working since the start of the war. "From the outset," he proposed, "three directions of windows were pursued [at TASS]: the window in the form as it was in ROSTA, [or] the narrative-agitational [*povestvovatel'no-agitatsionnoe*], then the window-poster [*okno-plakat*], and the window-painting [*okno-kartina*]." Although he went on to indicate that there is "no contradiction among these three types of windows," by the time of the meeting, the editorial office was producing more than two new window-posters for every narrative-agitational window it issued and as many as five for every window-painting.[10]

A substantial number of the earliest TASS stenciled posters, especially those designed by Mikhail Cheremnykh, who had previously served as the artistic director of the ROSTA studio, belong to the narrative-agitational genre. Such posters as *What Hitler Wants – And What He Will Get* (TASS 5) (see fig. 4 and p. 166) convey narrative through a series of schematic, sequential cartoons accompanied by versified, qualifying captions. Adhering to ROSTA's approach to the stenciled poster, the narrative-agitational genre is characterized by its reduced color palette and flat, monochromatic passages. Although it dominated studio production during the first six months of the war, it suffered a noticeable decline beginning in February 1942 and appeared only infrequently thereafter, virtually vanishing by the end of the hostilities. The window-painting – typically either a framed painting on canvas or pigment on paper attached to board appended with hand-stenciled discursive labels – had flourished briefly during the first four months of the war and was not revived after the reunification of the studios. The concise, painterly stenciled window-poster would account for the overwhelming majority of subsequent TASS editions, which by this point encompassed a growing range of genres and formats. A comparatively new phenomenon, in contrast to these other two formats, the window-poster marked a decisive departure from earlier Soviet forms of visual propaganda.

Sokolov-Skalia concluded that window-posters should henceforth be designed along three distinct "parallel lines": the satirical window (*satiricheskoe okno*), the heroic window (*geroicheskoe okno*), and the window-panel (*okno panno*).[11] While the first two categories referred to genres essential

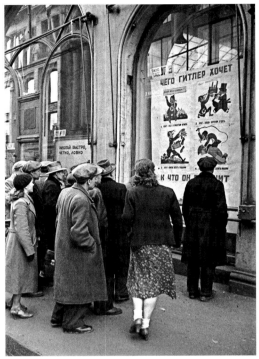

4

to Soviet visual culture prior to the war, the third indicated a unique design format exclusive to the window-poster. Sokolov-Skalia credited the format's development to Georgii Savitskii, who had by this point contributed at least five paintings and designed a dozen such posters for the studio.[12] Nevertheless, at his report later that spring to the Organizing Committee of the Union of Soviet Artists (SKh SSSR), Sokolov-Skalia clarified the painter's profound influence, stating that "[Savitskii's] window-panels have been copied and reproduced by all possible means."[13]

Window-panels comprise up to five autonomous, illustrated scenes, which collectively depict a sequence of connected events, invariably culminating in Soviet victory and German defeat. Unlike a comic strip, however, wherein the narrative is embedded in the images, or the ROSTA posters, which combine text and image almost seamlessly, window-panels typically contain an accompanying narrative stenciled below each panel that clarifies an otherwise opaque visual sequence. The narrative in such posters moves from top to bottom. Although it resembles the narrative-agitational poster in its compositional structure, the window-panel features richly developed, pictorial components rather than unmodeled, schematic pictographs. In an early example, *So the Saying Goes* (TASS 237) (fig. 5), Savitskii illustrated the aphorism "once bitten, twice shy" through two autonomous, vertically stacked panels replete

with visual information, whose relationship to each other is not readily apparent. At the top, a German soldier cowers in fear before a shrub, while in the lower panel, Soviet partisans ambush a German convoy. The text beneath the panels clarifies the pictorial narrative considerably: "A frightened crow is afraid of a bush // Because partisans often hide behind bushes."

When the window-panel contains three or more panels, as those made after August 1942 frequently do, the narrative reads from left to right, top to bottom. In keeping with the studio's trend toward increasingly elaborate stenciled posters, Savitskii conceived his later window-panels with a heightened amount of pictorial detail and narrative complexity. In *Successful Attack* (TASS 820) (fig. 6), for example, he designed four panels in a rich assortment of bright colors to convey an event unfolding in two separate settings. At top left, Soviet partisans attempting to enter an occupied village stealthily make their way around a group of German guards on a grassy knoll. The next panel depicts the partisans having successfully entered the village, vanquished the occupying army, and liberated prisoners from a camp. At lower left, still in the village, the partisans meet with the liberated villagers and decide to return with them to the safety of the forest. The final scene shows the Soviets capturing the German sentries on the same grassy knoll depicted in the first panel.[14]

To Sokolov-Skalia's three categories of window-poster – satirical, heroic, and panel – Denisovskii added the grotesque window (*grotesknoe okno*), a term that had particular resonance within recent Soviet visual culture and literary theory. Not all of the meeting's participants agreed with Sokolov-Skalia's classifications, however. In response to his complaint that certain posters are "hard to perceive visually," for example, artist Daniil Cherkes proposed that TASS design its posters expressly according to their intended venues rather than by subject:

In my opinion we do not take into consideration the sites where our "windows" might be exhibited. "Windows" ought to be created in relation to where they will be mounted. We should agitate the people in various ways. We should not eliminate or stifle any of our directions. Let all of them develop. There are "chamber windows" [kamerny okna] and then there are more resonant "windows" [okna bol'shogo

Fig. 5 Georgii Savitskii, with text by I. Bukmen *So the Saying Goes* (TASS 237), October 28, 1941

Edition: 120
Stencil
150 × 87 cm
Archival photograph, ROT Album, courtesy Ne boltai! Collection

Fig. 6 Georgii Savitskii, with text by Aleksandr Zharov *Successful Attack* (TASS 820), October 3, 1943

Edition: 600
Stencil
126 × 117 cm
Ne boltai! Collection

zvuchaniia]. I believe, however, that certain "windows" should only be placed inside. We should not hang all of them outside. Some of the "windows" are lost outside, but they might be appropriate for the interiors of theaters, cinemas, or the metro, where we could display our "windows" with greater success. Posters that are designed to be shown outdoors should arrest the attention of passersby even from the other side of the street.[15]

Perhaps recognizing the value of encouraging development in a variety of different directions concurrently, Khavinson resisted "canonizing" established approaches and welcomed experimentation, provided any new efforts offered sharpness, clarity, and broad comprehensibility. "Who is our audience?," he asked his colleagues. He answered the question:

5

6

We do not work for a narrow circle of intelligentsia who are able to judge artistic merits of our work. We do not work for a refined audience of specialists. We work for the masses. To use the term that's been used here already, we work for the Soviet street. Everything that can help us achieve our agitational-propagandistic goals in the Soviet street, whether it is a poster or a heroic painting – everything should be used.[16]

Although earlier commentators had previously associated a wide range of genres with TASS, by February 1942 the studio's disparate products seem to have been consolidated under the complementary rubrics of heroic realism and graphic satire.[17] With their deep roots in Soviet visual culture, these two genres proved sufficient for encapsu-

lating a variety of associated subcategories of visual propaganda. One particularly useful way to distinguish the function of graphic satire from that of heroic-realist imagery is to consider the former as an example of what Jacques Ellul described as the "propaganda of agitation" and the latter as the "propaganda of integration." According to Ellul, the propaganda of agitation is subversive and oppositional, obtaining an explosive momentum for a short duration. Although typically generated by revolutionary movements, such propaganda may also be used to galvanize a nation for war.[18] The exclusive application of graphic satire to the enemies of the Soviet Union indicates its agitational status. Both the parameters and targets of Soviet graphic satire varied wildly in the decade leading up to the war, developments that help account in large part for the genre's volatility in the 1930s, when new stylistic and iconographic models swiftly replaced those that preceded them.

Fig. 7 Pavel Sokolov-
Skalia, with text by
Samuil Marshak
*The Five Hundredth
Window* (TASS 500), June
15, 1942

Edition: 300
Stencil
189 × 87 cm
Courtesy Ne boltai!
Collection

Fig. 8 Petr Sarkisian, with
text by Samuil Marshak
Our ABC (Letter T) (TASS
713), April 28, 1943
Edition: 600

Stencil
145 × 75 cm
Ne boltai! Collection

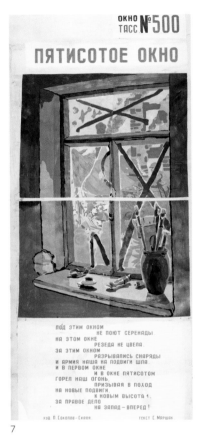

7

8

The propaganda of integration, by contrast, encourages permanent conformity and "aims at making the individual participate in his society in every way. It is a long-term propaganda, a self-reproducing propaganda that seeks to obtain stable behavior in terms of the permanent social setting."[19] Although subject to a certain degree of individual interpretation and stylistic variation, the heroic-realist mode in which Soviet citizens were depicted during the war did not deviate substantially from the way in which they had been rendered prior to it. This iconographic consistency was balanced against the consideration that heroic realism in the 1940s did not necessarily signify the same code of conduct as it had during the previous decade, a point made emphatically clear by the sudden appearance of "national Bolshevism" during the war.

How exactly these genres might be mobilized most persuasively in specific contexts, however, continued to be a topic of debate, and at critical moments throughout the war, various TASS administrators, poets, and painters returned to this fundamental question so as to determine the efficacy of their work.[20] Nevertheless, by establishing the basic conventions for its posters at the 1942 meeting, the TASS studio also introduced a considerable amount of pictorial uniformity. Despite some internal protests, it abandoned its earlier experiments with unique window-paintings and increasingly turned away from the narrative-agitational model adapted by Cheremnykh from ROSTA, signaling Sokolov-Skalia's ascendency in the editorial office. Following the organizational meeting, the TASS studio strove to create more elaborate visual arrangements, employing a wider array of stenciled colors in ever-larger editions.[21] For Sokolov-Skalia, the window-poster promised to expose a vast segment of the urban population to the rich texture, chromatic range, and dynamic compositions of Soviet figurative painting in only a fraction of the time that traditional painting required.

ARTIST-AGITATORS

In *Our One Thousandth Blow*, stenciled beneath the image of Hitler threatened by pen, pencil, and bayonets is a poem written for the poster by Vasilii

Lebedev-Kumach, a member of the Litbrigade working in the TASS studio. It reads:

I'm proud that the pen has been equated to the bayonet. / And among other weaponry in the battle / The Bolshevik's burning word / Helps to inflict a blow against the enemy. / Maiakovskii! Realizing your dream, / Both poet and artist are at their posts. / Verse and prose, drawings and vibrant posters / Tirelessly and menacingly massacre the enemy!

Lebedev-Kumach understood that his captions provided something of a discursive analogue to Maiakovskii's pen, which in turn served as a weapon as much as the bayonets wielded by Red Army soldiers fighting on the front line.

Maiakovskii's belief that art and poetry contributed in some material fashion to national defense enjoyed renewed appreciation during the war. In the spring of 1942, an anonymous editorial entitled "Khudozhnik-agitator" extended the analogy of the writer's arsenal to the visual arts:

"A living Bolshevik word," Pravda recently wrote, "is a part of the Red Army's military equipment alongside tanks and airplanes. We should take care of it and love it no less than our rifles or guns." We can easily use these words when we talk about art agitation.

Like a living word, a visual image provides a powerful form of ideological ammunition for teaching the masses. An image created by a masterful hand has the power to embody people's feelings and thoughts. It reverberates in the heart of every honest man, strengthens his faith in himself [and] in his people, and inspires him to fight the enemy heroically.[22]

Such rousing rhetoric proved to be popular among artists and writers contributing to the Soviet wartime propaganda effort. The following year, for example, Sokolov-Skalia declared, "My weapon is the three hundred posters I created during the war."[23] The cover of the February 1943 issue of the Russian satirical magazine *Krokodil* makes the argument even more inclusive by illustrating all of the arts coming to the nation's defense. Poets, musicians, and painters, among others, mobilize on either side of the two steadfast infantrymen at center.

Self-referential images of artists and writers wielding the tools of their trade as weapons were relatively rare, however, as they undermined the effectiveness of propaganda by pointing to the tendentious means by which it was constructed.

Fig. 9 Mikhail
Cheremnykh, with text by
Nina Cheremnykh
*Four Years of TASS
Windows* (TASS 1255),
June 16, 1945
Edition: 750

Stencil
143 × 79 cm
Library of Congress

Fig. 10 El Lissitzky
(Lazar Lissitzky) (born
Pochinok, 1890; died
Moscow, 1941)
*Beat the Whites with the
Red Wedge*, summer 1920
Publisher: Litizdat

Edition: unknown
Offset lithograph
48.3 × 69 cm
Ne boltai! Collection
In exhibition

More typically, such images aimed to expose the fabricated nature of enemy propaganda. The figure of Joseph Goebbels, the German minister of public enlightenment and propaganda, is consistently depicted in TASS posters as the source of dangerous misinformation about the Soviet Union. TASS 536 (p. 222), for example, decries vicious rumors circulated by German propagandists claiming victory over the Soviet fleet. In the top frame, Goebbels appears as a U-boat, his pen a torpedo stealthily cruising toward a hapless Soviet vessel. The lower frame dismisses the first image as mere fantasy, offering instead a view of a Soviet submarine sinking several German ships. Petr Sarkisian's *Our ABC (Letter T)* (TASS 713) (fig. 8) transforms Goebbels's pen into a sniper rifle. The poster depicts the German minister seated in an enormous inkwell, taking aim at a "List of Soviet Divisions" mounted on the wall, while "he shoots lies made from ink."

To the extent that it draws attention to its own artistry, *Our One Thousandth Blow* was surely an answer of sorts to the TASS studio's detractors, especially those who had summarily dis-

missed its artists as "mechanical decorators" (*mekhanicheskie oformiteli*) and its poets as "versificators" (*stikhotvorets*).[24] These charges had been put forth after the studio issued its first anniversary poster, in June 1942, *The Five Hundredth Window* (TASS 500) (fig. 7), by Sokolov-Skalia, which offers a distant view onto war-torn streets from the artist's studio. Tape that has been placed over the windows to prevent the glass from shattering peels off one pane to reveal Red Army soldiers waving banners while planes dodge antiaircraft fire overhead. The battle scene visible through the window appears as an inverted TASS poster within a poster, its dynamic composition and heroic theme directed toward the studio interior instead of the street. The poster is strikingly different than subsequent anniversary editions, in large part because of the way it positions the studio's contribution to the war effort as a concealed and sheltered activity. Artistic implements that were later rendered as weapons (as well as paintbrushes and tubes of pigment) are here dutifully arranged on the tranquil windowsill, safely removed from the conflict taking place outside.

The studio revisited the question of its efficacy on one last, dramatic occasion, its fourth and final anniversary. In *Four Years of TASS Windows* (TASS 1255) (fig. 9), Cheremnykh's axonometric drawing of a scarlet pencil bearing the studio's name traverses the picture plane diagonally, skewering the Soviet Union's enemies.[25] "Our pencil is always sharpened," proclaims the text at the bottom of the poster. "Its blow has been and will be sharp." With an arsenal of more traditional armaments notably absent from this poster, the pencil assumes sole responsibility for capturing and subduing the Axis leadership. If in *Our One Thousandth Blow* TASS identified itself as a member of the Soviet armed forces, venturing out of the protected confines of the studio and onto the proverbial field of battle, here it declared its goal achieved, the opposition gruesomely impaled on the sharpened tip of its pencil.

Cheremnykh's dynamic composition deliberately recalls the formal tension of its predecessor. So too, however, does it engage with one of the most iconic Soviet formal investigations into the visual syntax of opposition, El Lissitzky's *Beat the Whites*

9

10

Fig. 11 Artist unknown (Soviet)
Proletarians around the World Unite!, 1921
Publisher: All-Ukrainian State Publishing House, Odessa

Edition: unknown
Offset lithograph
62.9 × 71 cm
Ne boltai! Collection
In exhibition

Fig. 12 Artist unknown (Soviet)
Peasant, Don't Forget Your Brothers, the Prisoners of Capital, 1925/30
Publisher: MOPR

Edition: 40,000
Offset lithograph
71.4 × 106.8 cm
Ne boltai! Collection
In exhibition

with the Red Wedge (fig. 10). Lissitzky designed this starkly reductive print for the political administration of the Western Front during the summer of 1920, when the front lines of the Polish-Soviet War were approaching Vitebsk.[26] The large red triangle at left, meant to embody the Bolshevik state, aggressively penetrates the white circle at right, which accordingly signifies the counterrevolutionary forces.

Issued by the Literary Publishing House of the Front (Litizdat), whose stated goal was to circulate materials of a "military-agitational character" among Bolshevik troops and supporters, *Beat the Whites with the Red Wedge* marks an early attempt to politicize Suprematist geometric abstraction, a goal to which Lissitzky and his compatriots working in the Affirmers of the New Art (UNOVIS) studio in Vitebsk firmly adhered.[27] Lissitzky intermittently combined text and image, allowing the individual words that comprise the title to reiterate and amplify the pure forms and colors with which they are interwoven. By deliberately avoiding any particulars, the poster extends its political rhetoric to every imaginable sphere of Soviet activity, not simply the war. As Jean-François Lyotard proposed, "To beat the whites with the red wedge is not only to win the civil war, rebuild the economy, and construct collectivism; it is to drive this wedge into all the white zones of experience and ideology, of the established.... The closed, enveloping sphericity of white investment must everywhere be opened and shattered by red acuteness."[28]

Both *Four Years of TASS Windows* and *Beat the Whites with the Red Wedge* were designed around an emphatic X-shaped composition: in the former, the pencil runs perpendicular to the bodies of the Axis leadership, the two intersecting in the rotund corpse of Benito Mussolini. At the center of Lissitzky's print, the top edge of the triangle crosses the left edge of the black trapezoid over which the white circle is transposed. Like Lissitzky's monochromatic forms, which reject the rules of spatial recession, Cheremnykh's pencil draws attention to both the poster's surface and its constructed nature. The pencil, however, surges from lower right to upper left, inverting the disorienting, downward motion of Lissitzky's red wedge, and instead presenting itself to the viewer.

Roman Jakobson perhaps best articulated Lissitzky's fervently modernist vision of agitational propaganda in "The Tasks of Artistic Propaganda" (1919), in which he proposed that the goal of any propaganda poster is as much the inculcation of a single aesthetic system and the unequivocal elimination of all of its predecessors as it is the promulgation of any political rhetoric printed upon it.[29] According to such a view, the triumph of Suprematist abstraction is synonymous with the demise of more traditional means of figural depiction (what Lyotard referred to as the "writing of images" in order to distinguish them from Lissitzky's "pure creation of figures"). Jakobson's observation, however, can equally be brought to bear on Cheremnykh's poster, since his point relates to all examples of visual propaganda. *Four Years of TASS Windows* may implicitly acknowledge the persuasiveness of Lissitzky's visual syntax, but it openly endorses graphic satire as the most effective means of championing its cause.

THE SYNTHETIC TRAJECTORY OF SOVIET GRAPHIC SATIRE

The practice of graphic political satire flourished in the early years of the Revolution, after having been carefully regulated under the watchful eye of the czar's censors for several centuries. Its development in Soviet Russia is associated in particular with the Civil War period, when the ROSTA studios were operational, and the Cultural Revolution (1928–31), when class enemies were subjected to public ridicule and stereotyping.[30] Among the most imposing challenges facing Russian graphic designers during the Civil War was the creation of a consistent visual vocabulary through which to convey the ideological substance of Bolshevism to as wide an audience as possible. This audience, composed of both urban and rural, literate and illiterate constituents, was largely unfamiliar with either the fundamental tenets of Bolshevism or the goals of the Communist Party. As a result, Bolshevik propaganda posters were suffused with

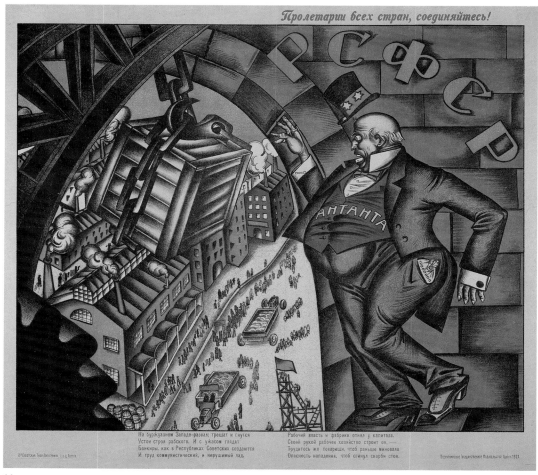

11

12

a wide range of representations – often in allegorical form – during the Civil War period, especially of those concepts the party sought to challenge (see figs. 3 and 1.3, for example).

In the 1920s, Soviet artists developed a more consistent, class-based typology with which to represent the key abstract notions associated with Marxist theory, particularly the concept of capital. Previously envisioned as a serpentine monster, following the Civil War, capital came to be almost invariably identified with an obese, well-dressed businessman wearing a top hat and occasionally smoking a cigar. As Victoria E. Bonnell persuasively argued, this iconographic shift paralleled a critical turn against allegorical imagery. [31] In 1925, for example, critic Viacheslav Polonskii decried representations that "obscure [class] interests and substitute for them bittersweet words, lofty allegories, and symbols," and in 1931 Vladimir Vert took issue with images whose "exaggeration, model deformation, [and] superficial symbolism conceal the political essence of class conflict."[32]

An anonymous poster published in 1921 by the All-Ukrainian State Publishing House, Odessa,

draws vivid attention to the impending confrontation between Soviet workers and Western bankers (fig. 11). Entitled *Proletarians around the World Unite!*, the print depicts a corpulent profiteer at right, his pockets overflowing with money and the word *entente* printed across his vest, signaling his membership in the alliance of Western democracies opposing the Bolshevik government following the Russian Revolution. (He bears a discernable resemblance to concurrent Soviet caricatures of Western capitalists.) He stumbles with shock as he comes across the "workers' economy" of the Russian Socialist Federative Soviet Republic (RSFSR), his girth symbolically counterbalanced by the finished products of industry at left, presumably waiting to be distributed equitably.[33]

Capitalists were also often depicted conspiring with the clergy against the interests of peasants and workers. An anonymous poster of 1925/30, circulated by the Central Committee of the International Society for the Relief of Revolutionary Fighters (MOPR), strongly contrasts the deleterious effects of capitalism with the benefits conferred by Communism, in part by associating religion with oppression. Entitled *Peasant, Don't Forget Your Brothers, the Prisoners of Capital*, it juxtaposes a Soviet paradise at left, in

which workers enjoy literacy, ample harvests, and communal housing, with Western capitalism at right, in which impoverished workers are shackled, bayoneted, and lynched by gun-toting capitalists and cross-wielding priests (fig. 12). Two figures seated in the foreground of the Soviet paradise read the newspaper *Put' MOPR*, published by the organization responsible for printing the poster.[34]

Vert specifically praised Dmitri Moor for designing posters whose iconography "reveals the true face of our enemy . . . without resorting to cheap invention."[35] Moor's highly confrontational 1931 poster *Workers of the World, Unite against the Class of Exploiters!* (fig. 13) provides the hostile opposition with concrete figural forms and features. Printed by the Art Department of the State Publishing House (Ogiz-Izogiz), the organization that assumed central control for printing propaganda posters in Moscow and Leningrad after 1930, the two-paneled poster promotes the cause of the Red Front Fighters' League, a Communist organization in Weimar Germany. [36] A proletarian wearing a red badge with the emblem of the clenched, upright fist on his lapel leans into the composition, glower-

Fig. 13 Dmitri Moor
*Workers of the World,
Unite against the Class of
Exploiters!*, 1931
Publisher: Ogiz-Izogiz
Edition: 40,000

Offset lithograph
104.1 × 143.2 cm
Ne boltai! Collection
In exhibition

Fig. 14 Vitalii Goriaev,
with text by
Dem'ian Bednyi
Banker's Dogs (TASS 493),
June 14, 1942
Edition: 300

Stencil
220 × 88 cm
Courtesy Ne boltai!
Collection

13

14

ing at a cluster of opponents. The largest of them, an overweight, grimacing capitalist with a hooked nose, towers above a pope and cardinal, a Social Democrat at a lectern, and a police officer brandishing a pistol.[37]

By the early 1930s, some believed that Russian satire had already reached its zenith in the pre-Soviet period of proletarian disenfranchisement.[38] To a great extent, the German invasion of 1941 can be credited with reinvigorating satire and removing the restrictions that had been placed on it during the previous decade, especially following the Molotov-Ribbentrop Pact of 1939. In the TASS studio, the genre blossomed from biting cartoons published in newspapers to monumental artistic propaganda displayed prominently on public streets. The studio recognized satire as essential to its mission – a survey taken in June 1945 concluded that one third of all of its posters were satirical in nature (the actual number may have been closer to one quarter) – and its treatment of the genre reactivated approaches that had largely laid dormant since the Civil War period.[39]

Vitalii Goriaev's *Banker's Dogs* (TASS 493) (fig. 14) illustrates the TASS studio's heterogeneous approach to satire, offering elements of allegory, caricature, and class-based satirical imagery. In the poster, a pack of ravenous, flesh-colored dogs with the faces of Nazi leaders and iron crosses attached to their collars converges on a hapless German town, its snow-covered rooftops illuminated by the winter moon.[40] Over the horizon lurks the towering figure of a banker, identifiable by his attire and through Dem'ian Bednyi's text, which reads: "The Fascist dogs snarled, / And rushed to commit daring robberies / Securing profits for bankers. / A banker shouted at them from behind: / 'Go! Go! Go! Go!'"[41] The banker has just released the hounds from the leashes that dangle from his hand, suggesting that he finances and enables the Nazis.

The studio's use of satirical models that had long since fallen out of favor occasionally confused its audience. This is evident, for example, in a notable series that elaborated on a comment made by Joseph Stalin at the Celebration Meeting of the Moscow Soviet of Working People's Deputies and Moscow Party and Public Organizations, on November 6, 1941. Stalin distinguished Hitler from an earlier aggressor, Napoleon Bonaparte: "Some refer to Napoleon, asserting that Hitler is acting like Napoleon and bears every resemblance to him. First, however, Napoleon's fate must not be forgotten. Second, Hitler no more resembles Napoleon than a kitten resembles a lion."[42] In late November and early December, TASS issued no fewer than

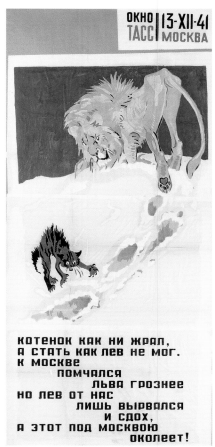

15

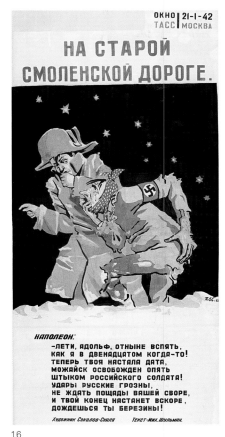

16

Fig. 15 Vladimir Trofimov, with text by Mstislav Levashov (born Moscow, 1912; died 1974) *The Lion and the Kitten* (TASS 13-XII-41), December 13, 1941

Edition: 150
Stencil
120 × 80 cm
Courtesy Ne boltai! Collection

Fig. 16 Pavel Sokolov-Skalia, with text by Mikhail Vershinin *Along the Old Smolensk Road* (TASS 21-I-42), January 21, 1942

Edition: 150
Stencil
100 × 85 cm
Courtesy Ne boltai! Collection

three posters illustrating Stalin's feline analogy, each experimenting with satire in a different way. Vladimir Trofimov's *The Lion and the Kitten* (TASS 13-XII-41) depicts a scrawny kitten desperately trying to follow in the footprints of a lion as the two retreat across a barren, snow-covered landscape (fig. 15). "However much the kitten ate, it was unable to become a lion," the caption reads. "The threatening lion charged toward Moscow, / But we struck and killed the lion, / And this one too will perish near Moscow!"

At the February 1942 organizational summit, TASS literary editor A. Kulagin criticized the caption's author, Mstislav Levashov, for only further obfuscating Stalin's original metaphor.[43] In contrast, he praised an earlier poster on the same theme issued by the studio in Kuibyshev – Boris Efimov and Nikolai Dolgorukov's *The Lion and the Kitten* (TASS 309) – for clarifying the metaphor and providing concrete references to the allegorical figures.[44] By late January 1942, the Moscow studio seems to have amended its use of satire to avoid the kind of confusion to which its earlier allegorical posters had given rise. In *Along the Old Smolensk Road* (TASS 21-I-42) (fig. 16), Sokolov-Skalia revisited the theme of Hitler's relationship to Napoleon without evoking either of the animals to which Stalin had previously likened them. A bruised and battered Hitler, clutching his jaw and his backside, wades through the snow in tattered clothes, beneath a clear, wintry night sky. Pointing toward the west, Napoleon counsels him, "Run back now, Adolf, / As I did long ago in 1812! / Now it is your turn!"[45]

The studio explored several different avenues for caricaturing the German high command, directing most of its efforts at Hitler and Goebbels. The genre had attracted renewed interest in academic circles prior to the war, likely in response to the avalanche of satirical material circulating throughout Europe. Writing in 1940, art historians Ernst Gombrich and Ernst Kris credited Italian Baroque painter Annibale Carracci "not only for the invention of the art but of the very word caricature."[46] Carracci had likened classical art to caricature on the grounds that each pressed beneath the "surface of mere outward appearance" in favor of a truth not contingent upon superficial qualities; if the former aspired to "perfect form," then the latter's goal was "perfect deformity." Gombrich and Kris reasoned that in caricature

Similarity is not essential to likeness. The deliberate distortion of single features is not incompatible with a striking likeness in the whole.... The real aim of the true caricaturist is to transform the whole man into a completely new and ridiculous figure which never-

theless resembles the original in a striking and surprising way.

Soviet art historian and critic Vladimir Kemenov, writing in 1943, underscored this point when he qualified "artistically convincing" caricatures as satirical images that are "realistic in their very foundation" no matter how fantastic and exaggerated they are in execution.[47]

The TASS studio turned to classical models in preparing several satirical posters during the summer of 1941. In *Apollo-Goebbels* (TASS 69) (fig. 17), the Kukryniksy (an acronym for three graphic artists – Porfirii Krylov, Mikhail Kupriianov, and Nikolai Sokolov – who had been publishing collectively since training together in the 1920s) depicted the German minister of propaganda as the famed *Apollo Belvedere* (fig. 18). Cast as a grossly inferior copy of the Greek deity, the unsightly and attenuated Goebbels comes across as preposterous. With mouth agape, he is surrounded by sycophantic newspaper reporters kissing his feet and sucking on his fingers and toes. A fig leaf placed over his groin is marked with a swastika, and the robe thrown over his left arm bears the name of the official National Socialist German newspaper, *Völkischer Beobachter*, through which most of his statements were circulated. "Here he is, the master of false reports," the caption declares. "The god of lying tongues, / The patron of all fakes, / And the 'supreme commander' of all slanderers!" In place of the broken bow held by the original figure, the artists added the main weapon with which Goebbels was associated, his fountain pen, which leaks ink onto the back of an adoring writer below.[48]

Unlike allegorical satire, caricature proved particularly adaptable in the absence of any substantive qualifying text. In his review of the first retrospective of TASS posters at the Historical Museum in Moscow in March 1942, Sokolov-Skalia singled out Petr Shukhmin's *Near Rostov* (TASS 11-XII-41) (fig. 19) as an example of "eye-catching" and "telegraphic" design.[49] The poster synthesizes satirical elements in a formally dynamic composition with the graphic isotypes associated with the Institute of Visual Statistics (Izostat), the Soviet office responsible for developing statistical propaganda addressing national productivity during the 1930s. As bullets pierce the ground around him, a frostbitten, bedraggled officer of the Wehrmacht desperately flees the city of Rostov, just to the northeast of Moscow, where the Red Army had recently enjoyed one of its first major victories. His swift tra-

Fig. 17 Kukryniksy, with
text by the Litbrigade
Apollo-Goebbels
(TASS 69), July 14, 1941
Edition: 60

Stencil
200 × 123 cm
Courtesy Ne boltai!
Collection

Fig. 18 *Apollo Belvedere*
(Roman copy after a
lost Greek original by
Leochares), A.D. 130/40
Marble

H. 224 cm
Vatican Museums

jectory is indicated by a scarlet arrow emanating from the city and traversing the wintry landscape, which is strewn with articles of clothing that the officer has abandoned in his haste to escape.[50]

THE HYPERBOLIC BODY

Sokolov-Skalia and Denisovskii disagreed over the extent to which the concept of the grotesque ought to be considered a separate genre. Sokolov-Skalia, for his part, remained distinctly ambivalent about distinguishing the grotesque from the satirical. In his spring 1942 report on the TASS exhibition in Moscow, he acknowledged that Sergei Kostin had "gained impressive popularity through his heroic and grotesque windows" and credited the Kukryniksy with having "created and perfected the type of window that could be defined as satirical-grotesque [*satiricheско-grotesknoe*]."[51] At the 1942 organizational meeting one month earlier, however, he had pointedly neglected to include

the grotesque among the various genres in which he considered TASS artists to be working and had associated the Kukryniksy specifically with the satirical window.

Denisovskii, in contrast, singled out the grotesque poster in 1942 as a separate genre altogether, although neither he nor any of his contemporaries seems to have defined the term or identified which posters might be characterized as such.[52] During World War II, Russian literary historian Mikhail Bakhtin developed an expansive definition of the grotesque image of the body that seems particularly useful in qualifying the TASS artists' graphic and conceptual approach to caricature, if not its social function.[53] For Bakhtin the concept of "grotesque realism" stood in stark opposition to the artistic canon of antiquity, according to which the body is "first of all a strictly completed, finished product."[54] Derived from the comic-festive forms of folk culture, the grotesque body, by contrast, is "a body in the act of becoming. It is never finished, never completed; it is continually built created, and builds and creates another body."[55]

The grotesque body transgresses the normal confines of the body in favor of a corporeal topography steeped in exaggeration, hyperbole, and excess.

Such a vision of the body featured prominently in early Soviet propaganda concerning enemies of the state. As the Soviet antireligious movement gained traction in the 1920s, the figure of the capitalist was often associated with religious functionaries and deities. Moor's poster *United, but Two-Faced* (1923/28), designed for the antireligious journal *Bezbozhnik u stanka*, for which he served as artistic director, explicitly conflates capitalism and Christianity by merging the body of Christ with that of a Western capitalist (fig. 20). The print parodies the Russian Orthodox tradition of depicting Christ Pantokrator seated on a lyre-shaped throne, transforming the throne into the body of the Western capitalist and Christ's halo into his hat. The word *L[o]rd* appears to the left of his top hat, the word *capital* to the right. "The world of the bourgeoisie has two faces," the text below explains.

17

18

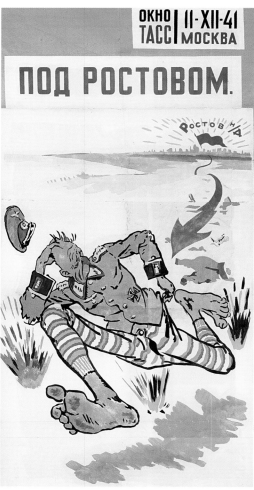

19

20

77

Fig. 21 Pavel Sokolov-
Skalia
The Molting Raven (TASS
417), February 4, 1942
Edition: 300

Stencil
115 × 90 cm
Courtesy Ne boltai!
Collection

Its earthly face is capital, its heavenly face is christian morality. Capital keeps the proletarian's body and life enslaved; hypocritical, saccharine christian morality stupefies the consciousness of the proletarian, bringing it to submission. In contemporary society, capital and christ coexist in the same organism — brothers working for the same master, the bourgeoisie.[56]

(In the text, all references to Christianity and Christ were deliberately lowercased.) The "two-bodied image" that results from the merging of Christ with the Western capitalist exemplifies Bakhtin's description of the grotesque body.[57]

For Bakhtin the grotesque body was typically characterized by exaggerated, distended parts, such as monstrous bellies, protruding noses, abnormally attenuated appendages, gigantic ears, and, above all, a gaping mouth that consumes everything in its path.[58] A central feature of the rich tradition of Soviet caricature, the hyperbolic body was also widely explored by artists associated with the TASS studio, especially for caricatures of the Nazi leadership.[59] The theme of the marionette, which Bakhtin identified as an extension of the doubled body and a major motif of the grotesque during the Romantic era, offered a ready vehicle for the TASS studio to caricature the various puppet regimes that sought to appease Germany.[60] The Axis powers were alternately depicted as dolls, hand puppets, and jokers, all animated by Hitler.

Bakhtin also identified "wild anatomical fantasy" occasioned by the merging of animal and human body parts as emblematic of the grotesque.[61] The TASS studio deployed an expansive bestiary to signify the Axis leadership, rendering Hitler in particular in a spectacular array of chimerical forms.[62] Among the most popular of these imaginary hybrids was the raven posing as a peacock, a motif that appeared repeatedly following Stalin's November 6, 1941, speech deriding the marauding Germans as "ravens decked in peacock feathers." He noted, "No matter how much ravens may try to disguise themselves in peacock feathers, they will not cease to be ravens."[63] Sokolov-Skalia's vivid poster *The Molting Raven* (TASS 417) (fig. 21) caricatures Hitler as one of the masquerading birds. Casting a long shadow beneath a full moon that gleefully mocks him, the German leader lies in a barren, snow-filled landscape, surrounded by peacock feathers that will not adhere to him. His bent beak is echoed by the twisted cannon on the abandoned German tank behind him, whose derailed track calls attention to his immobilized body. While the title above the image mocks Hitler

by recalling Stalin's poetic analogy, the text below disparages him further by quoting his own speech of January 30, 1942, in which he announced, "I do not long for military fame."[64]

Images of dismemberment, as Bakhtin noted, served as critical sources for the medieval concept of grotesque parody, drawn from narratives concerning either diabolical torture or the miraculous relics of saintly martyrs.[65] TASS posters are rich with parodic allusions to corporeal anatomizations, where their meaning is far less ambiguous. Boris Zemenkov's poster *Visual Aids* (TASS 447) (fig. 22) provides a graphic compendium of torture devices, before which Goebbels instructs a young Fascist

neophyte on how to inflict excruciating pain. Associating German methods of interrogation with barbarism, the poster darkly proposes that "Fascist offspring should be trained in these examples."[66]

VISUALIZING WARTIME COMMUNISM

Although bound to a different set of rules than graphic satire, heroic realism was very much its tactical complement: artists turned to graphic satire when depicting the enemies of the Soviet

Fig. 22 Boris Zemenkov,
with text by
Aleksandr Rokhovich
Visual Aids (TASS 447),
April 20, 1942
Edition: 300

Stencil
157 × 82 cm
Archival photograph, ROT
Album, courtesy Ne boltai!
Collection

Union, and they employed heroic realism when portraying its compatriots. Just as the TASS studio's application of caricature and satire proved to be both rooted in Soviet visual tradition and highly adaptable to the circumstances of the ongoing war with Germany, so too did its approaches to heroic realism prove diverse. Whereas the conception of graphic satire fluctuated wildly among allegory, caricature, and concrete class representation in the decades preceding the war, heroic realism was accorded flexibility primarily in its stylistic treatment. Some TASS artists actively promoted an archly conservative approach to figurative painting, especially those – Shukhmin, Nikolai Sokolov, and Mikhail Solov'ev, among others – who had been connected with the Association of Artists of Revolutionary Russia (AKhRR), the most influential arts organization in Soviet Russia between 1922 and 1932. Others maintained an uneasy truce with Socialist Realism, the idealized, aggrandizing figurative style in which all Soviet painters were officially instructed to practice after 1934.[67] This latter group included Kostin and Georgii Nisskii, who had previously identified with such modernist groups as the Society of Easel Painters (OST). Its members had absorbed the painterly vocabulary of German Expressionism and the compositional methods of photomontage.

Produced for mass consumption, Socialist Realist art offered broad accessibility and promoted an unwavering sense of joyful optimism. As Boris Groys argued, it is characterized by the utopic projection of the future onto the present, establishing both the exemplary and the normative for emulation through a highly ritualized set of figural conventions involving healthy, patriotic Soviet citizens who exude enthusiasm no matter what task they are engaged in.[68] To the extent that it visualized Communism, as opposed to simply falsifying reality, Socialist Realism is perhaps best perceived as an epic gesture at aesthetic transformation, an effort to "produce reality by aestheticizing it" through fantasy, simulation, and substitution, as Evgenii Dobrenko described it.[69]

For the painters working for the TASS studio, the concept of Socialist Realism was implicitly related to heroic realism, a term that derived from AKhRR's 1922 "Declaration of the Association of Artists of Revolutionary Russia," drafted immediately following the Civil War in an effort to promote reconstruction. The declaration famously announced its

commitment to "depict the present day: the life of the Red Army, the workers, the peasants, the revolutionaries, and the heroes of labor."[70] The group cultivated idealized images of the Soviet people, believing that such images would contribute to the formation of a classless society. To achieve this goal, AKhRR concluded that "the day of revolution, the moment of revolution, is the day of heroism, the moment of heroism – and we must reveal our artistic experiences in the monumental forms of the style of heroic realism."[71]

For the TASS studio, the genre of the heroic poster covered a vast expanse of subject matter that seems irreconcilable in retrospect. It encompassed both topical concerns that addressed specific events (see, for example, TASS 579 [p. 224], 1173 [pp. 341–42], and 1238 [p. 361]) and idealized views of Soviet society that offered patriotic imagery only vaguely bound to the moment (see, for example, TASS 470 [p. 212], 828/828A [p. 254], 880–883 [p. 263], and 1290 [p. 372]). Because of its subject matter, the heroic poster was, by necessity, subjected to greater critical scrutiny than any other poster genre. An anonymous editorial published in March 1942 noted that a lack of rigorous artistic observation was plaguing poster design:

A poster image should communicate its message in a short, clear, and expressive form. It should concern itself with the primary, the most important and current issues.

Unfortunately, not all posters adhere to these requirements. Only an artist who observes the faces of soldiers with love and care can properly depict a hero of the Patriotic War. Only an artist who is attentive to every detail of the soldiers' ammunition, who strives to capture the most typical [aspects] of the soldiers' image can show the most typical and the most essential [aspects] of our epoch. Only a patriotic artist who has mastered a laconic, vivid poster form can perform this task.[72]

The putative idealism of Socialist Realism – its isolation and detachment from individuals entrenched in particular historical circumstances – made it especially vulnerable to cliché and repetition, especially in those TASS posters that referred to particular events.

The earliest heroic-realist TASS posters served less as a celebration of military accomplishments than as a call to action, a vehicle for summoning citizens to the defense of the nation and its capital and envisioning (if not achieving) Soviet success on the battlefield. Such a utopic model is evident in *Dig Our Trenches around Moscow* (13-XI-41) (fig.

22

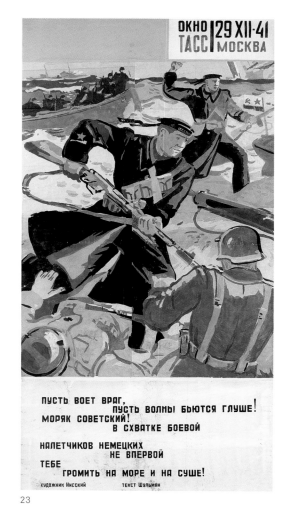

Fig. 23 Georgii Nisskii,
with text by Mikhail
Vershinin
Untitled (TASS 29-XII-41),
December 29, 1941
Edition: 120

Stencil
125 × 100 cm
Courtesy Ne boltai!
Collection

25) by the DITS Brigade (a team of artists composed of Vitalii Demidov, Konstantin Ipatov, Aleksei Sapozhnikov, and Iaroslav Titov). In this poster, a stolid, matronly figure stands firm with a shovel hoisted onto her left shoulder and her right hand held up in the air. Her gesture recalls the beckoning figure popularized during the second week of the war by both Sokolov-Skalia (see TASS 34 [fig. 1.9, lower left] and 28 [1.28]) and Iraklii Toidze in *The Motherland Calls!* (fig. 1.29). The verse beneath the woman urges her compatriots to "Dig our trenches around Moscow / With your fast and sharp spade, / All these trenches you are digging / Will become Fascists' graves." Behind her, an amorphous mass of laborers (many of whom were likely women) work frantically to prepare a line of antitank trenches to ring the western edge of the city.[73]

The style of early heroic posters ranged from images of the fully modeled bodies generated by AKhRR to the flattened, schematic figures associated with OST, whose graphic tendencies remained evident in the work of several artists employed by the TASS studio, although the group had disbanded by 1930. Throughout the mid- to late 1920s, OST strove to revitalize modern easel painting by reconciling sanctioned realist themes concerning proletarian life with the painterly style of Central European modernism. Acknowledging OST's indebtedness to recent German painting, Aleksei Fedorov-Davydov, the former deputy director of the State Tretyakov Gallery in Moscow who ran the TASS studio in Tashkent after 1942, categorized the group's style as "expressionist realism."[74] In keeping with the group's preference for linear forms and flatness, Nisskii paid little attention to detail or modeling in TASS 29-XII-41 (fig. 23). The figures struggling along the shoreline – even those that seemingly tumble out of the picture plane in the foreground – give little sense of spatial recession.[75]

The rich surface patterning that such a uniformly flat pictorial space can occasion is evident in Aleksandr Deineka's *China on the Way to Liberation from Imperialism*, a print that exemplifies OST's interest in militant realism at a time when the Soviet Union was attempting to extend its sphere of influence into China (fig. 24).[76] Russia, which had been supporting the Communist Party of China since the latter's founding in 1921, here encouraged its neighbor to rid itself of Western and Japanese influences.[77] A slim Chinese soldier, wearing a bandoleer and carrying a red banner, delivers a knockout blow to a more heavyset officer of the Japanese Imperial Navy, sending him reeling back toward the Chinese coastline, which is dotted

Fig. 24 Aleksandr Deineka
*China on the Way
to Liberation from
Imperialism*, 1930
Publisher: Ogiz-Izogiz
Edition: 30,000
Offset lithograph

77.5 x 109 cm
Ne boltai! Collection
In exhibition

Fig. 25 DITS Brigade,
with text by Mikhail
Kul'chitskii (born Kharkov,
Ukraine, 1919; died near
Trembachero, 1943)
*Dig Our Trenches around
Moscow* (TASS 13-XI-41),

November 10, 1941
Edition: 120
Stencil
150 × 125 cm
Courtesy Ne boltai!
Collection

with modern factories, traditional regional architecture, and the Great Wall. Beyond the immense figures, the rigidly uniform and colorless Yellow Sea is denoted by a series of slender, wavy lines interrupted only by four silhouetted battleships bearing the flags of the competing imperial powers: Japan, the United States, and Great Britain.

The Soviet Cultural Revolution gave rise to bellicose anti-imperialist propaganda, through which a more varied, multiethnic vision of heroic masculinity emerged. This is evident in the photomontage poster made by Gustav Klutsis on the occasion of the 1931 *Anti-Imperialist Exhibition* mounted at the Culture and Recreation Park in Moscow (fig. 28). A vivid example of the developing Soviet interest in complex graphic design, the poster presents a Russian soldier poised behind field glasses, keenly observing British Prime Minister James Ramsey MacDonald and Raymond Poincaré, former prime minister of France, striding toward him through a field of hand-painted crosses. Joining the soldier and gazing anxiously in the same direction are a Soviet worker, two African men, and an Asian man. The latter three figures foreground the anti-imperialist theme of the exhibition by suggesting that peoples colonized by Western European nations might turn to the Soviet Union for assistance in their quests for national independence. The multiracial bulwark thus provides a visual model to illustrate the quote from Vladimir Lenin mounted above it: "Let's transform the imperialist war into civil war."[78]

By the mid-1930s, Soviet artists had begun to consider their own ethnic minorities in relation to the idealized Russian heroism they had grown accustomed to depicting. Dolgorukov's militant appeal for national defense, *Long Live Our Indigenous, Invincible Red Army – Powerful Fortress for the Peaceful Labor of the People of the USSR, Faithful Guardian of the Achievements of the October Socialist Revolution* (fig. 26), includes a Central Asian cavalryman among the various members of the Soviet armed forces it presents, demonstrating the equality of ethnicities in the union.[79] "We stand for peace and uphold the cause of peace," the poster proclaims, quoting Stalin, "but we are not afraid of threats and are prepared to answer the instigators of war blow for blow."[80]

Like these earlier, conventionally printed posters, TASS posters endorsed a broad, multicultural view of heroic realism.[81] The ethnic groups of the autonomous Socialist republics featured prominently after the summer of 1942, when the Red Army began to campaign for their liberation. Vargi Aivazian's *Oath of the People of the Caucasus* (TASS 571) (fig. 27) calls for every Caucasian to "be as a mountain, / To block the road of Nazi aspirations!" The poster depicts an ethnic Caucasian confidently rising up with machine gun in hand, a sheathed *kinzhal* (dagger) and grenades on his belt. The spectacular Caucasian mountain range, bathed in morning light, rises behind him. Although he is attired in the *cherkeska* (jacket) and *papakha* (fur hat) specific to the region, his precise national identity is left deliberately vague. Significantly, he also appears beside a Soviet soldier of the Red Army, ensuring that there is no confusion about which side he serves. The poem clarifies this relationship: "So that the enemy cannot boldly tread on the beauty of your valleys, / So that you can live in front of us harmoniously, like brothers, / Forward, Georgians, Azerbaijani, Armenians! / You must fight till the last breath!"[82]

Matthew Cullerne Bown noted that the Organizing Committee of the Union of Soviet Artists passed

25

a resolution in March 1942 requiring that heroic realism be emphasized with greater frequency in poster design.[83] By late 1944, the genre of the heroic window had become thoroughly conventionalized. Emblematic, universalizing compositions featured the people of the autonomous and Soviet republics, typically one male and one female, each adorned in indigenous costume and bearing the respective arms of the republic. As the Red Army pushed across Eastern Europe into Germany, the studio also began to issue posters celebrating the liberation of various cities, which often contain such framing elements as curtains, flower garlands, and banners unfurling in the wind.[84] This pseudo-Baroque pictorial convention, which was concurrently applied with great relish to posters celebrating the wartime contributions of particular vocations or regions (see TASS 1099), had the additional effects of aggrandizing the figures inhabiting the poster and lauding their role in the Soviet war effort.[85]

NARRATING A HEROIC PAST

While it experimented with various approaches to envisioning Soviet victory, the TASS studio struggled to develop a viable template for depicting the Wehrmacht in defeat. An early effort, Vladimir Vasil'ev and Iurii Pimenov's *On the Southern Front* (TASS 414) (fig. 29), was criticized shortly after its release in late January 1942 as exaggerated, unrealistic, and redundant.[86] The painter Shukhmin, who had helped found the conservative AKhRR, went so far as to advocate returning to popular pictorial conventions associated with early-nineteenth-century history paintings, especially those that depicted Napoleon's beleaguered army in full retreat during the punishing Russian winter of 1812. "Consider Prianishnikov's *The French* and other paintings," he beseeched his colleagues at the February 1942 meeting. "We should create solid window-posters that viewers understand."[87] Shukhmin may have been referring to any one of

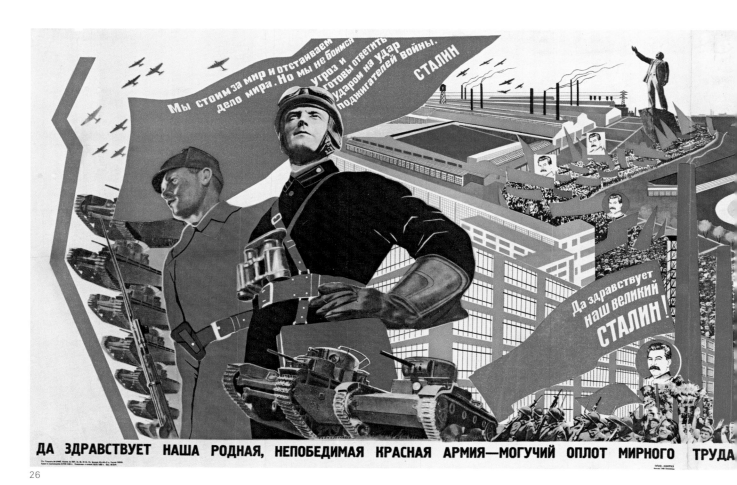

26

27

28

ОВ СССР, ВЕРНЫЙ СТРАЖ ЗАВОЕВАНИЙ ОКТЯБРЬСКОЙ СОЦИАЛИСТИЧЕСКОЙ РЕВОЛЮЦИИ.

Н. ДОЛГОРУКОВ

Fig. 26 Nikolai Dolgorukov
Long Live Our Indigenous, Invincible Red Army – Powerful Fortress for the Peaceful Labor of the People of the USSR, Faithful Guardian of the Achievements of the October Socialist Revolution,
November 20, 1935
Publisher: Ogiz-Izogiz
Edition: 125,000
Offset lithograph
60.5 x 178.5 cm
Ne boltai! Collection
In exhibition

Fig. 27 Vargi Aivazian (born 1908; died 1950), with text by Makar Pasynok (Isaak Kogan-Laskin) (born 1893; died 1946)
The Oath of the People of the Caucasus (TASS 571), October 24, 1942
Edition: 400
Stencil
240 × 105 cm
Ne boltai! Collection

Fig. 28 Gustav Klutsis (born Koni parish, Latvia, 1895; died Moscow, 1938)
The Anti-Imperialist Exhibition, 1931
Publisher: Ogiz-Izogiz
Edition: 5,000
Offset lithograph
140.1 x 104 cm
Ne boltai! Collection
In exhibition

Fig. 29 Vladimir Vasil'ev and Iurii Pimenov, with text by Arkadii Kogan
On the Southern Front (TASS 414), January 30, 1942
Edition: 300
Stencil
132 × 95 cm
Archival photograph, ROT Album, courtesy Ne boltai! Collection

Fig. 30 Illarion Prianishnikov (Russian, 1840–1894)
In the Year 1812, 1874
Oil on canvas
83 × 141 cm
State Tretyakov Gallery

29

30

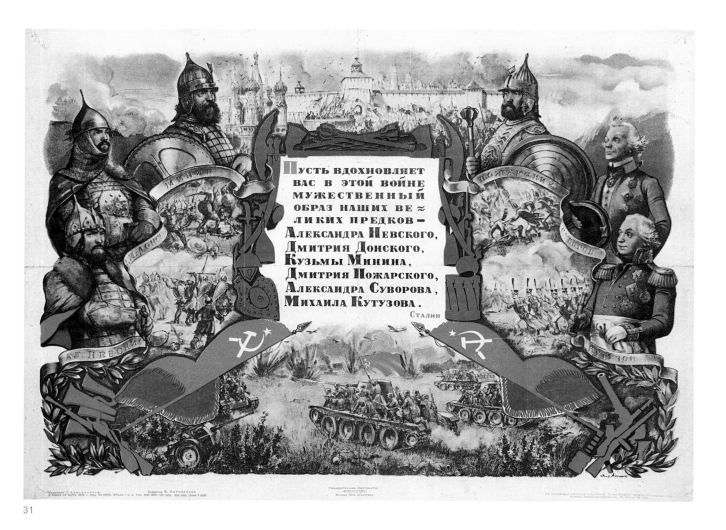

Fig. 31 Petr Aliakrinskii
*Let the Valiant Image
of Our Great Ancestors
Inspire Us in This War*,
July 15, 1942
Publisher: Iskusstvo
Edition: 600,000
Offset lithograph
42.1 × 57.6 cm
Ne boltai! Collection
In exhibition

31

several paintings by Prianishnikov on the subject of the French retreat from Russia, the best known of which at the time was *In the Year 1812* (fig. 30).

Although not identified at the 1942 organizational meeting, a small but significant number of TASS posters were devoted to episodes drawn from earlier periods in Russian history. By the time Germany surrendered to the Allies in May 1945, the studio had issued approximately fifty such posters.[88] In a report on TASS dating to roughly March 1942, Sokolov-Skalia counted the "posters dedicated to the history of our motherland" (*okna na temuy iz istorii nashei rodiny*) as belonging to one of the emerging genres.[89] Such posters were categorized in *Letopis' izobrazitel'nogo iskusstva Velikoi Otechestvennoi voiny*, the catalogue of visual materials authorized by the Central Committee and Main Directorate for Literary and Publishing Affairs (Glavlit), as "the heroic past of the Russian people," thus explicitly connecting them to the genre of heroic realism.[90] These images contributed to a notable trend in the direction of historical self-construction, a relatively novel concept in Soviet visual culture. As far back as 1923, the People's Commissariat for Enlightenment (Narkompros) had forbidden the teaching of nationalist history. During the years following the Great Purge (1936–38), when many of the Bolshevik heroes of the Civil War had been executed, however,

Russocentric propaganda escalated to a fever pitch. In an effort to cultivate a pragmatic, usable past, the Soviet leadership developed a statist policy of "national Bolshevism," according to which key figures and events from Russian history were rhetorically linked to contemporary advances in the Soviet Union.[91]

From the outbreak of hostilities with Germany, Soviet leaders firmly committed to comparing current events to historical Russian precedents. Nonetheless, it was not until November 7, 1941, that Stalin identified specific heroes from the Russian pantheon during an address in Red Square on the occasion of the anniversary celebration of the October Revolution. He exhorted members of the military: "Let the valiant image of our great ancestors – Aleksandr Nevskii, Dmitrii Donskoi, Kuz'ma Minin, Dmitrii Pozharskii, Aleksandr Suvorov, Mikhail Kutuzov – inspire us in this war!"[92] Although the Soviet administration may have agreed by this time on certain key figures from Russian history, there was no consensus about how best to incorporate them into contemporary propaganda. As a result, artists contrived all sorts of approaches to illustrate Stalin's speech and to convey the relevance of Russian history to the present.

Petr Aliakrinskii, for example, placed Stalin's text at the center of a 1942 print devoted to the speech, issued by Iskusstvo (fig. 31). He framed the text with arms and armor, on either side of

which he added portraits of the historical generals mentioned in the text attired in battle regalia and officer's dress. The heroes' names are repeated on the banners that separate them from the historical vignettes to which they correspond; these progress clockwise chronologically, with the current conflict depicted at the bottom of the poster.

Other artists chose to foreground the present war and to place its historical precedents in the background as a ghostly shadow. Viktor Ivanov and Olga Burova, for example, issued a series of six posters in 1942 through Iskusstvo to illustrate Stalin's Red Sqaure speech. Each poster juxtaposes the speech with a quote from one of the six Russian heroes Stalin evoked and compares contemporary Russian soldiers defending their homeland to historical figures engaged in similar activities. In the design devoted to Dmitrii Donskoi, *Better an Honorable Death than a Shameful Life* (fig. 32), Russian soldiers leap across a gulley with bayonets fixed, while fires rage in the distance. A flattened, decorative frieze of fourteenth-century cavalrymen carrying scarlet shields hovers above and behind them, bearing a banner that reads, "Be afraid not of death, but of defeat, as it will bring both death and humiliation."[93]

Fig. 32 Viktor Ivanov and Olga Burova
Better an Honorable Death Than a Shameful Life, January 20, 1942
Publisher: Iskusstvo

Edition: 60,000
Offset lithograph
87.3 × 57.6 cm
Ne boltai! Collection
In exhibition

Fig. 33 Petr Shukhmin
A Nation's Avengers (TASS 511), July 8, 1942
Edition: 300
Stencil
215 × 80 cm
Ne boltai! Collection

Fig. 34 Pavel Sokolov-Skalia, with text by Aleksei Mashistov
The Heroic Nation (TASS 407), January 1942 (?)
Edition: unknown (150–300)

Stencil
201 × 150 cm
Archival photograph, ROT Album, courtesy Ne boltai! Collection

Artists working for TASS clearly struggled to some extent to develop effective visual models for presenting history in relation to contemporary events, presumably because earlier models were not readily available to them. TASS 407 (fig. 33), for example, was singled out at the 1942 organizational meeting as a noteworthy failure. Designed by Sokolov-Skalia and entitled *The Heroic Nation*, the poster juxtaposes two vignettes depicting Russians repelling German invaders: at left Aleksandr Nevskii clubs a German knight, and at right a contemporary Russian infantryman bayonets a soldier of the Wehrmacht. The poster fails to identify the figures, however, and provides no explanation of their relationship beyond the visual analogy. Later efforts offer more adventurous visual solutions for correlating historical events and the current conflict.[94] Shukhmin's pseudo-cinematic poster *A Nation's Avengers* (TASS 511) (fig. 34) depicts Russian partisans preparing to ambush occupying forces from three separate historical periods

– 1812, 1918, and 1942. Building on the model provided by Ivanov and Burova, Shukhmin carefully segregated the historical epochs from one another by relegating them to separate planes within the composition, rendering them in three distinct hues, and stamping them with precise historical dates to anchor the references.[95]

"IT IS SAID THAT HORSESHOES BRING HAPPINESS"

A significant number of TASS posters addressed the home front, especially production and conservation efforts. In his March 1942 report, Sokolov-Skalia identified "instructional" or "didactic" windows (*instruktivnye okna*) as a useful domain into which the TASS studio was expanding. Eclipsed only by the narrative-agitational model during the first year of the war, instructional

posters comprised nearly one fifth of the studio's total output and the overwhelming majority during its final eighteen months of production following the surrender of Germany.[96] Such posters served to guide broad sections of the population in quotidian activities, often by presenting a series of interrelated scenes depicting cause and effect. Denisovskii's *Collect Scrap* (TASS 454) (fig. 35) offers a narrow view of a Soviet T-34 tank speeding across a wintry, forested landscape, kicking up clouds of snow. Various pieces of scrap metal occupy the ambiguous blue space around the vignette, including empty tubes of paint and two horseshoes. At the bottom of the poster, Samuil Marshak's poem reads:

It is said that horseshoes / Bring happiness. / This view is partly / fair and sensible. / A nail, a horseshoe, a frying pan, / An old faucet – / All very valuable discoveries / In these days of war. / A bicycle wheel, / Old rails at the station, / These are useful items during war, / Melted and made into tanks!

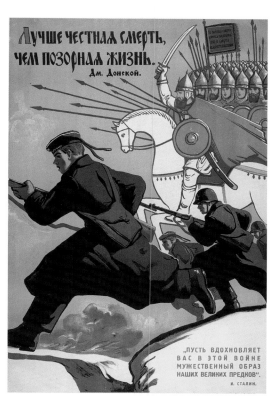

32

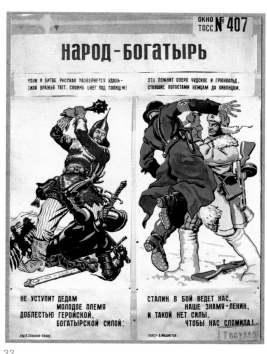

33

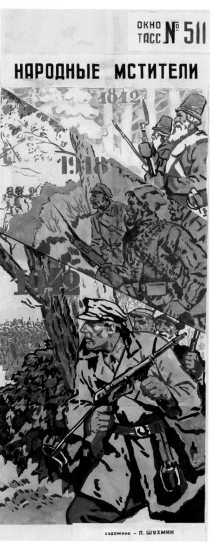

34

ОКНО № 454
ТАСС

СОБИРАЙТЕ ЛОМ.

ГОВОРЯТ, ПРИНОСИТ СЧАСТЬЕ
ЛОШАДИНАЯ ПОДКОВА.
ЭТО МНЕНИЕ ОТЧАСТИ
СПРАВЕДЛИВО И ТОЛКОВО.

ГВОЗДЬ, ПОДКОВА, СКОВОРОДКА,
СТАРЫЙ КРАН ВОДОПРОВОДНЫЙ—
ОЧЕНЬ ЦЕННАЯ НАХОДКА
В ЭТИ ДНИ ВОЙНЫ НАРОДНОЙ.

КОЛЕСО ВЕЛОСИПЕДА,
СТАРЫЙ РЕЛЬС НА ПОЛУСТАНКЕ
ПРИГОДЯТСЯ ДЛЯ ПОБЕДЫ,
ПЕРЕПЛАВЛЕННЫЕ В ТАНКИ!

ХУД. Н.ДЕНИСОВСКИЙ ТЕКСТ – С.МАРШАК

35

Fig. 35 Nikolai
Denisovskii, with text by
Samuil Marshak
Collect Scrap (TASS 454),
April 25, 1942

Edition: 300
Stencil
198 × 80 cm
Courtesy Ne boltai!
Collection

The text thus reiterates the accompanying imagery, emphasizing that new tanks are born from recycled metal refuse.[97]

Occasionally, artists devised clever, complex compositions that conveyed directions to the public. *Save Electricity!* (TASS 565) (fig. 36) by Solov'ev and Nikolai Sokolov, for example, addresses the need for wartime energy conservation. It depicts an operator standing beside large stockpiles of wood and switching on a generator, sending power surging through the adjacent wires. The wires encircle, and the operator points to, a series of related vignettes below that illustrate precisely how the valuable commodity should and should not be expended.[98]

A PIVOTAL MOMENT

Early 1942 proved to be a pivotal moment for the TASS editorial office – not simply because its constituents were reunited in Moscow after a long and uncertain separation. More importantly, the office's conception of its practice was crystallizing firmly around the stenciled window-poster and those genres and formats associated with it. By endorsing the window-poster, TASS turned decisively away from two significant pictorial models it had previously embraced – the narrative-agitational model practiced by Cheremnykh and associated with ROSTA posters, and the window-paintings fostered by Aleksandr Gerasimov, the head of the Organizing Committee of the Union of Soviet Artists. Sokolov-Skalia's articulation of the "visual language" of TASS not only provided the kind of authoritative direction necessary to make the studio more effective as a propaganda outlet, but it also offered to the studio's adherents a more precise sense of how their propaganda differed from that which had preceded it and how it was particularly well suited to the challenges of its epoch. With its broad spectrum of color and the speed with which multiples could be generated, the stenciled poster offered a highly effective means of transmitting the telegraphic political message of the moment to a broad international audience.

Sokolov-Skalia clearly assumed that the studio's work had this kind of import. At his meeting with the Organizing Committee of the Union of Soviet Artists later that spring, he felt comfortable enough to describe the transformation that had taken place at TASS – the emergence of richly pictorial stenciled posters – as a "giant

Fig. 1 Kukryniksy, with
text by the Litbrigade
Rid Your Attics of Rubbish
(TASS 53), July 10, 1941
Edition: 60

Stencil
200 × 63 cm
Courtesy Ne boltai!
Collection

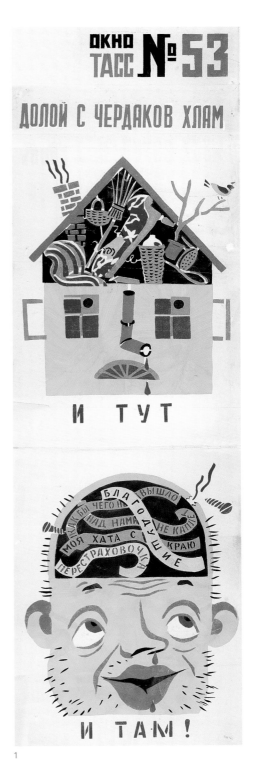

1

V iewing TASS posters in the fall of 1945, Louis Aragon declared: "Yes, here is the immortal spirit of [the poet Vladimir] Maiakovskii."[1] Aragon was well placed to judge, since, in addition to being a prominent French poet and Communist, he was married to Elsa Triolet, the sister of Maiakovskii's long-time lover, Lily Brik. Aragon no doubt had in mind the debt the works owed to the ROSTA posters, stenciled satirical images created for display in store windows by artists and poets under the sponsorship of the state news agency, on which Maiakovskii worked during the Russian Civil War (1917–23). Indeed, some of Maiakovskii's for-mer collaborators on the ROSTA posters were instrumental in the TASS initiative, including writer Osip Brik (Lily's husband) and artist Mikhail Cheremnykh. Along with the overall concept of the window-poster and its mode of production, one of the clearest formal links between the TASS and ROSTA posters was the inclusion of poetic texts.[2]

The TASS artists periodically returned to the basic structure of their ROSTA predecessors: multiple panels with simple schematic drawings and punchy rhymes printed in stenciled block letters (see fig. 1).[3] The TASS team even reprised some of Maiakovskii's specific themes, for instance in two series of ABC posters: while for Maiakovskii *B* had stood for "Bolsheviks" and "Bourgeois," for the TASS writers it stood for "Bandit Romanians" (TASS 29) and "Bulldog-Bandito Mussolini / Who serves as a lap-dog in Berlin" (TASS 644). Just as Maiakovskii had refrained from signing his poster texts (and other works as well), so did the TASS literary team, or the Litbrigade, maintain a semblance of collective (and therefore anonymous) authorship, at least at the beginning of World War II.

TASS writers eagerly encouraged the associa-tion with Maiakovskii, who in the course of the 1930s had been recognized as a Soviet classic. In addition to dedicating TASS 1000 (pp. 294–96) to Maiakovskii's "dream," they hung over the entrance to their winter 1942 exhibition at the Historical Museum in Moscow a Maiakovskii poster featur-ing the ending of his 1927 poem "A Visual Aid": "In all the corners of the globe / The workers' slogan should be such: / Speak to Fascists in the language of fire, / In bullet words and in bayonet barbs."[4]

The Maiakovskii pedigree was widely acknowl-edged by contemporaries. In Boris Polevoi's novel *The Story of a Real Man* (1947), the narrator describes his protagonist's return to Moscow in

the middle of the war: "He was surprised … by the TASS Windows, which peered out at passersby from walls and shop windows as if they had leapt into the street out of Maiakovskii's books."[5]

It was not uncommon, however, for the comparison to Maiakovskii to be turned against the TASS poets, as in a critical assessment from April 2, 1942, by dramatist Georgii Munblit:

The essential fact is that the drawing plays the main role in the majority of [TASS] "Windows." It is much more complex, painterly and self-sufficient than the drawings on Maiakovskii's posters. As far as the poems are concerned, in TASS Windows they more or less accompany the drawing, sometimes on equal footing, but more often than not fail-ing to keep up. In many cases the drawings are so eloquent that the text they are supplied with simply seems superfluous. Very seldom does the text exist independently, as it could with Maiakovskii.[6]

A similar note was struck by poet Aleksei Surkov: "One feels insulted on behalf of the genre [of poetry] that Maiakovskii nurtured when … you read [Aleksei] Mashistov's bland verses 'The Partisan Woman' glued to a huge colorful poster."[7] Poet Nikolai Glazkov, a friend of Lily and Osip Brik, wrote a biting epigram: "I'm told the TASS Windows / Are more useful than my poems. / A toilet-bowl is also useful, / But it is not poetry."[8]

One notes a profound contradiction in these responses between an acceptance of Maiakovskii's model of a militant, functional poetry and the expectation that TASS poets create texts that "exist independently" of their original contexts and meet the standards of "poetry." The contradictory desire for both functionality and aesthetic autonomy can be explained in part by reference to the changes in the Soviet cultural landscape after Maiakovskii's suicide in 1930. With the rise of Socialist Realism in 1932–34, Soviet culture turned away from the formal experimen-tation of the 1920s and embraced an essentially neoclassicist rhetorical program based on a strict hierarchy of genres (with the novel at the top and verse satire at the bottom), elaborate rules for the correct performance of each genre, and the can-onization of exemplary artists and masterpieces from the past. In fact, few if any of Maiakovskii's poster texts stand on their own without their graphic accompaniment. Nonetheless, the TASS poets were caught in a bind: insofar as they were expected to imitate the consummate rebel, their willingness to flaunt the dominant aesthetic criteria of mainstream Soviet culture could be both their strongest asset and greatest vulnerability.

Fig. 2 Daniil Mel'nikov,
with text by the Litbrigade
At the Leader's Call (TASS
78), July 18, 1941
Edition: unknown

Stencil
Dimensions unknown
Archival photograph, ROT
Album, courtesy Ne boltai!
Collection

Fig. 3 Kukryniksy, with
text by Samuil Marshak
*Brave against Sheep,
a Sheep against the Brave*,
1942

Ink and gouache
31.1 × 26.7 cm
State Tretyakov Gallery

CALLING THINGS NAMES

One of the striking qualities of many texts on the TASS posters is their direct, at times self-consciously crude satire. Satire of this kind was deeply rooted in Soviet literature, sanctioned by authoritative statements such as the following from Maksim Gor'kii:

Class hatred must be inculcated through organic disgust with the enemy as a being of a lower type, not through arousing fear at the strength of his cynicism or his cruelty…. I am completely convinced that the enemy is in fact a being of a lower type, that he is a degenerate both physically and "morally."[9]

In its grotesquerie and blunderbuss bombast, Soviet satire of the 1930s often descended into mean-spirited ridicule, so predictable and devoid of irony that it was easily ignored. Nonetheless, the establishment of an experienced cadre of writers and an extensive archive of poetic and rhetorical means for belittling enemies of the state and extolling Soviet virtues meant that the authorities were able to mobilize teams of experienced satirists for work on TASS posters in Moscow and Leningrad within hours of the declaration of war on June 22, 1941. Similar poetic texts were produced for dissemination via other media, from postcards to radio. The question was whether anyone would notice, or whether these efforts would simply blend into the background noise of war.

The power and limitations of poetic satire are evident in the work of the genre's best-known Soviet practitioner throughout the 1920s and 1930s, Dem'ian Bednyi (fig. 4). Bednyi specialized in couching nasty ideological attacks in folksy poetic forms such as the fable, using animals to capture political figures' typical characteristics (see TASS 757 [pp. 244–45] and 1114 [p. 326]). His extensive texts for TASS flouted some of the standard rules for poster poetry, especially that posters should be visible and legible "from the other side of the street."[10] His wordy posters often required such attentive perusal that they had to be exhibited in well-lit interiors "like the theater, the cinema and the metro."[11] Munblit complained that TASS authors such as Bednyi seemed to imagine the viewer "reclining comfortably in an armchair with the intention of devoting two or three hours to

reading."[12] Bednyi's work demonstrates the tendency in satirical poetry toward an automatism of form, in which familiar poetic measures absorbed new names and topics in a continuous stream of verbiage.

Still, Bednyi's fables point to some of the posters' important functions: using proper names, identifying essential attributes, and asserting connections between isolated phenomena. One of the clearest examples of this naming function is TASS 22 (p. 169), attributable to Semyon Kirsanov.[13] Here the contrast between text and image does not just identify a disjuncture between Nazi ideology and the Nazi leaders themselves, but also asserts it as a fundamental characteristic of Nazism. Merely pointing out this disjuncture is sufficient to disarm the Nazis, at least ideologically. Moreover, the image and verse complement each other so neatly that the poster would be unintelligible without one or the other.

Frequently, however, a poster text seems simply to enunciate what is already amply clear from the image, as in Bednyi's poem for TASS 640 (p. 235), *Metamorphosis of the "Fritzes,"* a brilliant visual gag by the Kukryniksy showing a formation of marching German soldiers turning first into swastikas and then into crosses in a cemetery. Inevitably, powerful images such as this led to criticism that texts did not add anything substantive to the posters' visual effect. In TASS 40, the artist Sergei Kostin contributed his own captions to three helmets left on the field of battle by defeated German forces in 1242 ("The distant past"), 1914 ("The not-so-distant past"), and 1941 ("The present"). Poet Nikolai Aduev added a brief rhyming couplet to underscore the point: "Three epochs / All three just as bad for the Germans."[14] One early response to the TASS posters praised the text by Aduev, Kirsanov, and Aleksandr Raskin in TASS 78, *At the Leader's Call* (fig. 2). Here four men – a veteran of the Civil War, a student, an athlete, and a teacher – respond to Joseph Stalin's call for volunteers. Each provides his reason for enlisting in the military:

*Back in nineteen-eighteen
I beat up Germans in Ukraine,
My hand is still quite strong today:
I'm enlisting in the call-up.*

*I want to be in the steel ranks,
I want to defend my fatherland.
My brothers bravely fight at the front:
I'm enlisting in the call-up.*

*I'm ready for defense and labor;
I'm tempered by sport,
And with an entire column of athletes
I'm enlisting in the call-up.*

*For many years untiringly
I've led youth to knowledge.
They will continue their beloved work:
I'm enlisting in the call-up.*[15]

The redundancy of the text underscores the close correspondence between ideology (text) and reality (image) in Soviet discourse, in which *a* always equals *a* and only *a*, no matter how many times and in how many variations it is repeated.

A fair number of definitions and slogans were derived from official pronouncements, particularly Stalin's speeches, in which the Soviet leader struck an increasingly populist tone. Three different posters from December 1941 were inspired by Stalin's comment in a speech of November 7: "Hitler no more resembles Napoleon than a kitten resembles a lion." TASS 471 and 472 (see fig. 3) were based on Stalin's version of a popular saying: "Brave against sheep, a sheep against the brave."[16] In such posters, the viewer witnesses, as it were, the birth of a metaphor, the truth value of which is not diminished by the fact that it advertises itself as a figure of speech. An analogous function is performed by captions drawn from canonical Russian and Soviet literature. One of the artist Pavel Sokolov-Skalia's most resonant early posters (now lost) rallied the Soviet forces defending Moscow by citing a line – "Isn't Moscow behind us?"[17] – from Mikhail Lermontov's poem about the Battle of Borodino, the major confrontation between Russia and Napoleon's forces in the defense of Moscow in 1812. While these revered texts draw upon tradition to legitimate contemporary ideology, they also assert the continuing legitimacy of tradition as a source of truth about the present. Soviet media culture was a structure of repetition.

TASS verses also attributed truth-telling power to traditional sayings, folksy (sometimes ribald) humor, and even the Russian language itself. The caption to TASS 1 (p. 165) is based on untranslatable puns on toponyms of war, which makes the Russian language seem to be ridiculing the enemy. A similar function was sometimes performed by tautological or other easy rhymes that were

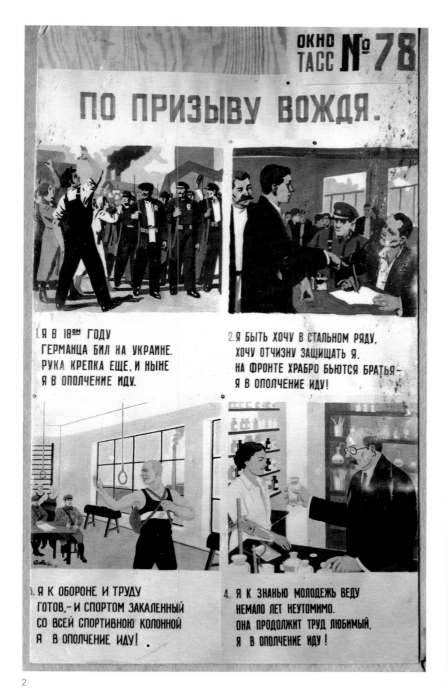

2

3

Fig. 4 Kukryniksy
Dem'ian Bednyi, 1932
From Kukryniksy and
Aleksandr Arkhangel'skii
(born Yeysk, 1889; died

Moscow,1938), *Pochti
portrety: Druzheskie
sharzhi i epigrammy*
(Federatsiia, 1932)

4

Fig. 5 Vitalii Goriaev and
Leonid Soifertis (born
Il'intsy, Ukraine, 1911;
died Moscow, 1996), with
text by the Litbrigade
Criss Cross (TASS 15),
June 21, 1941

Edition: 60
Stencil
105 × 130 cm
Archival photograph,
ROT Album, courtesy Ne
boltai! Collection

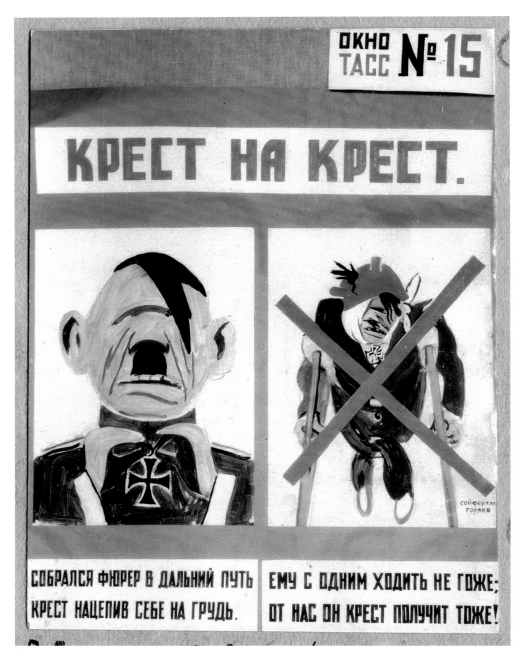

5

frowned upon in canonical Soviet poetry. Nina
Cheremnykh, who composed texts for images by
her husband, Mikhail Cheremnykh, commented on
the origin of the caption to TASS 952 (p. 277):

*I had one pet peeve: I avoided verbal rhymes. I
thought that if I'm writing such a brief text I should
be ashamed to resort to easy verbal rhymes. And
yet one of the TASS Windows "It happened on the
Dnieper, / The same was on the Dniester," where
the sorry-looking wet Fascists crawl out of the
water, ended thus: "It's impossible to cry or sigh –
/ There's no time even to dry." This ending proved
popular and was frequently recited by the TASS
Windows workers.*[18]

By foregrounding their own ham-fisted cheesiness,
such posters celebrated the ability of language to
cut through the fog of war and ascertain the
true state of affairs. Normal standards of rhetoric
and poetry were trumped by the need for
plain speaking.

Though the TASS posters' poems frequently seem
unsophisticated, this does not mean they were
easy to produce. Nina Cheremnykh recalled:

*As soon as I had to make an urgent caption, even
one that wasn't so urgent, I immediately felt the
urge to sleep.... My head went thick and dull. Not
a single thought, not even a glimmer of one! ... What
an unpleasant state! ... And suddenly the moment
came when my head cleared and I began to write.
I wrote a lot, even if only two lines were needed,
and took it all to Cheremnykh. He looked at it and
said: "Don't force it; don't push it; that won't work.
Just press on!" And I pressed on. He was a magnifi-
cent editor. Out of the mass of verbiage he could
choose just what was needed.*[19]

Nina Cheremnykh's story illustrates why the TASS
poets originally felt it so important to work collec-
tively (with one another and/or with a visual artist)
and with the close guidance of editors and critics,
as if the erasure of individual authorship would
allow the truth to emerge more fully, more purely,
and with greater insistence.

Responding in a 1944 essay to constant criticism
of the TASS poets' aesthetic achievement, Brik
located the strength of the ROSTA and TASS post-
ers "not in the special characteristics of form, not
in the special qualities of the text, but in the pro-
found agitational persuasiveness of the text and
the image – in the precise and clear knowledge in
the name of what idea these posters were creat-
ed."[20] As Brik argued, such posters were less effec-

tive at developing ideas than giving things their proper names and inciting appropriate action.

PROVIDING THE SLOGAN

Throughout its history, the Soviet poster was less commonly conceived as a medium of propaganda, as a rhetorical elaboration of official policy, than as one of agitation, as capable of provoking an active response from viewers. Accordingly, posters frequently focus on the mediation between concept and action, which in Soviet discourse meant providing a slogan (*lozung*). One early example of this procedure is TASS 5 (p. 166), *What Hitler Wants – And What He Will Get*, attributed to Mikhail Cheremnykh and the Litbrigade, in which Hitler's aims are identified and contrasted with the Soviet response. As the war drew on, such demonstrations of the gap between Nazi propaganda and reality turned into a constant call for retribution and revenge.

The TASS team endeavored to make this mediation as open and broad-based as possible, going so far as to accept some of the many poems submitted by amateur writers (see, for instance, TASS 634 [p. 233]). An accountant named Romanov suggested the topic of TASS 15, one of the best-received early posters (fig. 5).[21] The openness of Soviet poetic culture was another testimony to the legacy of Maiakovskii, whose revolution in verse had been a profoundly democratizing one. Over time, however, the preference for sharp counterpoint between image and text and for pithy slogans led TASS editors to adopt increasingly professional working methods. The first clear enunciation of this policy came in a letter of February 20, 1942, from the director of TASS, Iakov Khavinson, to Aleksandr Fadeev, head of the Union of Soviet Writers:

Comrade Fadeev!

At the most recent, expanded meeting of the presidium of the Writers' Union you stated that "remarkable cadres of writers are participating alongside artists in the creation of 'TASS Windows.'" This is no longer the case. It is true that, at the beginning of the Fatherland War, some of the best poets took part in creating literary texts for "TASS Windows," and active work was performed

by: [Samuil] Marshak, [Semyon] Kirsanov, Dem'ian Bednyi, Lebedev-Kumach, Aduev and others. But for more than two months now . . . no member of the Writers' Union [has been] taking active part in this interesting work, so needed by the country.

Naturally, this has markedly lowered the quality of the literary texts. You know yourself that the literary text determines to a large degree the quality of the window-posters as a whole. Now it is completely clear that "TASS Windows" have become one of the sharpest forms of mass visual political agitation in the war for the fatherland; they are received well by the army, at factories, train stations, on city squares; their distribution is increasingly broad. We have the ability to issue more posters and to make them more interesting and better.

I request that you pose at a meeting of the presidium . . . the question of assigning the following poets for systematic work on "TASS Windows": 1. Marshak – as leader of the brigade. / 2. [Aleksei] Surkov. / 3. Dem'ian Bednyi. / 4. [Stepan] Shchipachev. / 5. Kirsanov. / 6. Anatolii Gusev / 7. [Aleksandr] Tvardovskii / 8. [Konstantin] Simonov.[22]

Khavinson's letter had an immediate effect. Some younger writers were released from their duties. At a meeting on February 26, 1942, the presidium of the Writers' Union resolved to recall Marshak and Bednyi to Moscow from points east, where they had been evacuated for safety, and to charge Marshak with selecting "the composition of a brigade that will ensure the success of this extremely important vector of the defense-propaganda activity of the Writers' Union."[23]

Among the TASS poets, only Marshak was widely considered to be, like Maiakovskii, "the inventor of slogans, not [just] their interpreter in verse."[24] At a 1943 discussion on "Satire and Humor," Marshak declared, "We often stamp our feet in place and speak about the very same traits [of the enemy], forgetting that he constantly changes, turns, and camouflages himself in ever new colors. We need to be able to grab him by the hand with every movement and catch him red-handed." "A satirist," Marshak concluded, "must have the eye of a spy."[25] He also had to be, it seems, as accurate as a sniper: Kornei Chukovskii described Marshak's poems as "laconic like gunshots."[26] Boris Begak contrasted Marshak's sly humor, "dripping with derision and destructive irony," with Bednyi's preference "for furious head-on attack."[27]

Marshak followed Maiakovskii's example by contributing poetry for all manner of uses, including epigrams, captions for newspaper caricatures,

and leaflets dropped over enemy lines. Marshak and the Kukryniksy also created labels for goods intended for army consumption. The following text for *makhorka* (a rough kind of tobacco favored by many soldiers) accompanied a Kukryniksy drawing of a soldier smiling and pointing to falling enemy aircraft: "Sharp-eyed antiaircraft gunner, / Guard our skies both day and night. / Smoke out the attacking enemies / By giving them a taste of 'makhorka.'" Marshak called such texts "a piquant spice for the pea soup or wheat porridge."[28] Chukovskii found the same virtues in Marshak's captions for TASS posters: "These verse posters possess such accessible, undeniable form, that, whether you read them at the factory, in the metro, in the barracks or on the go, in a hurry, their entire thought immediately reaches you, even if you're slow on the uptake, tired, or sleepy."[29]

Marshak's sloganeering satisfied both Maiakovskii's ideal of functionality and the critics' preference for texts that could stand by themselves on the strength of their inventive and fluent use of language. One critic effused:

However distinct the satirist is from the children's writer in Marshak, still we see before us the same wondrous artist. We recognize in Marshak's satirical verse the poet's old intonations; we are once again delighted by the dynamic and lithe rhythm, the clarity and definition of words and phrases, and the precision of his couplets and stanzas.[30]

Marshak's inimitable formulations also gave lie to the semblance of collective authorship. Raskin told a revealing story about TASS 124 (pp. 180–81):

Marshak usually stuck around in our room, read our poems and helped to "pin down" a difficult line. Once he got so carried away that he "inadvertently" wrote an entire satirical poem, "Superbeasts," along with Moris Slobodskoi and me. I recall that he was very surprised and kept repeating: "I never thought it was so interesting to write poems collectively."[31]

Raskin went on to relate that the poem appeared in a newspaper as Marshak's alone. Though this was evidently an oversight, Marshak later included the poem in his own books of poetry. This story signals a marked prejudice against the principles of collectivity and anonymity and a preference for smaller pairings of renowned artists and poets, especially Marshak and the Kukryniksy, who were neighbors and maintained constant contact.

Fig. 6 Photographer
unknown
Samuil Marshak and the
Kukryniksy (left to right),
n.d.

Fig. 7 Kukryniksy, with
text by Samuil Marshak
"The Cannibal Vegetarian,
or Two Sides of the Same
Medal," *Pravda*, August
11, 1941

Sometimes a poem by Marshak served as the inspiration for an image. One such example is a cartoon by the Kukryniksy that seems to have closely followed a poem by Marshak (see fig. 7): "This kind / little man / commissioned a medal for himself: / I feel so sorry / For slaughtered little sheep / And lambs! // As we know, every medal / Has another side / And on it we read / The fatal words: / 'I don't need sheep's blood / I need human blood!'" In this regard, an account by Nikolai Sokolovas of the "Marshkukryniksy" foursome (see fig. 6) at work is revealing:

The three of us and Marshak sit at different sides of the table.... One draws a caricature of Hitler. Two struggle with the sketches of a caricature for Pravda. *The drawing and poem must be submitted to the editor today.... [Marshak] looks at the drawing. He likes it but is afraid that the fine and sharp lines will be blunted when penned in. We are mutually concerned: he for the drawing and we for the poem. In caricatures Marshak likes when we satirize everyday trifles. We remark: the shorter the poems the stronger, the angrier they turn out.*[32]

Viktor Shklovskii complained that, "working for every day, [Marshak] was unable to ensure that his poems would survive that day."[33] Whereas in Maiakovskii's day the function of the slogan was always to dissolve itself in action, by 1941 one was expected to write both for the moment and for history. Our interest in these verses seventy years later shows that these aims were not necessarily incompatible; indeed, it is precisely the texts' ephemeral functionality that has endowed them with lasting importance.

EPIC CHARACTERS

In early 1942, Il'ia Erenburg published a sober assessment of the role of literature during all-out war, calling writers "the conscience of the nation." "On the march," he wrote, "there is no place for psychological novels. In bivouac there is no time for historical canvasses. The time for *War and Peace* will come. Now we have only war, without quotation marks; not a novel but an epoch."[34] Nonetheless, as names and slogans accumulated during the war, poets found themselves creating longer works, often united less by an overarching theme than by recurring fictional characters.

One of the earliest sequences developed around the character of Young Fritz, created by Marshak and the Kukryniksy and first seen in TASS 177 (September 11, 1941) (pp. 186–88) . Based on a poem that Marshak originally published in the newspaper *Komsomol'skaia pravda* on September 2, the poster tells, in eight distinct panels, the story of the ill-fated upbringing of Fritz, a German soldier. Fritz resurfaced in TASS 307, *Young Fritz* (pp. 199–200), from December 10; it was intended as the first in a series, although no further installments appeared. Young Fritz was taken up by various writers for TASS posters and other stories and

6

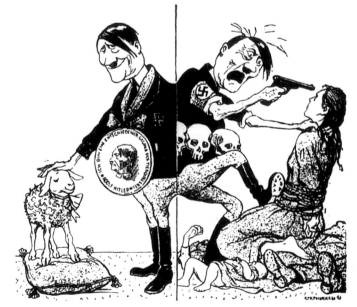

7

Fig. 1 Artist unknown (American) *Russian: This Man Is Your Friend, He Fights for Freedom*, 1942 Publisher: Graphics Division, OFF, US Government Printing Office

Offset lithograph 26 × 19 cm Northwestern University Library In exhibition

Fig. 2 Roy Hudson (American) Front cover of *Who Are the Reds?* (Workers Library Publishers, 1937)

Radical Pamphlets Collection, Ball State University Archives

After the Japanese bombed the American naval base at Pearl Harbor, Hawaii, on December 7, 1941, the United States formally entered World War II on the side of the Allies. As a result, the federal government began to produce war posters such as *Russian: This Man Is Your Friend, He Fights for Freedom* (fig. 1), one of a series identifying the country's new military alliances, printed by the Graphics Division of the Office of Facts and Figures (OFF) in 1942.[1] In this poster, a fresh-faced Russian soldier elevates his gaze to a distant illuminated horizon, symbolizing a future of Allied cooperation and victory. The medals pinned to his chest signify his bravery, and the gun slung over his shoulder demonstrates his competence. These martial hallmarks contrast with his callow, nonthreatening grin. He is wholesome and clean, a young recruit not yet mauled by the savagery and trauma of the Eastern Front. His helmet is emblazoned with a hammer-and-sickle insignia within a star, and he is labeled "Russian."[2]

This 1942 poster of the United States' new Russian "friend" – the Soviet soldier – was widely distributed within the country, and it was chosen as a diplomatic representative of American war-poster design to be sent to the Soviet Union to manifest Allied camaraderie.[3] This international poster exchange was initiated by the Moscow-based Society for Cultural Relations with Foreign Countries (VOKS). It was under the rubric of wartime cultural reciprocity, brokered by VOKS, that the Art Institute of Chicago received its collection of TASS posters.

Who was the Russian friend featured in American war posters, and what interests did he stand for? Following decades of tense and vacillating diplomacy between the United States and the Soviet Union, by 1941 the American public remained unconvinced of the answer (see fig. 2).

In the century preceding the Soviet rise to power, the two countries had maintained relatively good relations. Though they fought as allies at the beginning of World War I, during the twilight years of the Russian monarchy, the American public had grown increasingly critical of the anti-Semitism, Siberian labor camps, and deteriorating social control under the Romanov dynasty (1613–1917). The United States accepted the attempted Russian Revolution of 1905 (1904–07) and that of 1917, believing the insurrectionists and provisional government might replace the czar with a democratic

republic modeled on those of Western nations.[4] Increasing turmoil in Russia, as well as internal disputes over the country's continued role in World War I, empowered a coup d'état by Vladimir Lenin's Bolshevik Party in October 1917. The promise of an American-style revolution was jettisoned with the establishment of the Russian Socialist Federative Soviet Republic (RSFSR).[5] Diplomatic strife grew with ongoing military conflicts, exacerbated by the United States' occupation of the Russian Far East in 1918–20, the endangering of supply routes, and the disruption of business interests. Fear of the spread of revolution furthered mistrust and disenchantment between the Soviets and Americans, prompting the first Red Scare in the United States (1918–20). In 1920 the United States decided to withhold diplomatic recognition of the Bolsheviks, a policy it maintained until 1933.[6] Though relations stabilized in the 1930s, the unforeseen nonaggression pact between Joseph Stalin and Adolf Hitler in 1939 reignited American wariness of the Soviet Union.

This chapter tells the story of the uneasy alliance and wartime cultural exchange between the United States and the Soviet Union during the years 1939–43, a contentious period when neither alliance nor victory was assured. Though it is often taken for granted that the exigency of war stopped all meaningful cultural production, exhibitions, and exchanges, the conflict in fact incited important moments of interchange and influence that prevailed despite political fluctuations and military peril. This chapter examines how graphic art and TASS posters produced a public image of the alliance between the United States and the Soviet Union in the years preceding and at the onset of American military involvement in World War II. Considering the role of VOKS in disseminating Soviet art in the United States, and the American friendship agencies that promoted the Soviet cause, this essay culminates in 1943, with the turn of the war in favor of the Allies and the Soviet exhibitions held at the Museum of Modern Art (MoMA) and the Metropolitan Museum of Art, both in New York, and at the Art Institute.

Before the era of mass digital communications, public graphics played a critical role in conveying information and orienting public behavior. Fervent disagreements over how to produce a unified, effective American design polarized debates on how cultural production should stylistically and ideologically express the values of freedom and democracy. This would have far-ranging consequences for the subsequent postwar period.

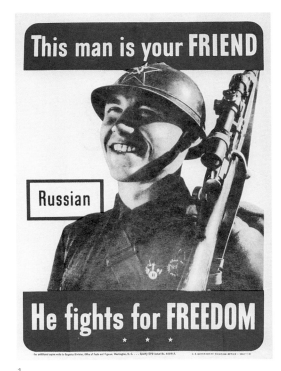

1

2

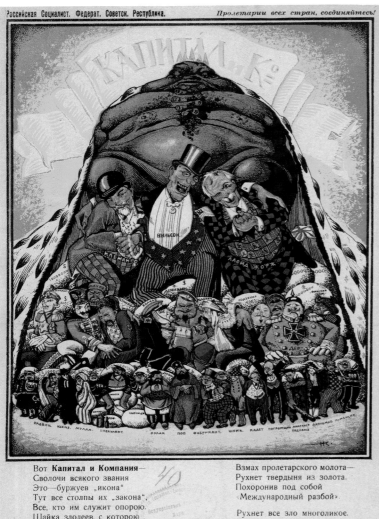

3

4

Fig. 3 Nikolai Kochergin
(born Moscow, 1897; died
Leningrad, 1974)
Capital and Co., 1920
Publisher: MGSNKh
Edition: unknown

Offset lithograph
45 × 26.3 cm
Ne boltai! Collection
In exhibition

The wartime images presented in this chapter, produced in both the Soviet Union and the United States, and exemplified by the exchange of TASS posters, affirm an important dialogue between the Soviet and American art worlds that was obscured by the political rhetoric and oppositional historiographies of the Cold War.

AMERICAN-SOVIET RELATIONS AND VISUAL CULTURE, 1917–39

THE UNITED STATES THROUGH SOVIET EYES

The revolutions of 1917 and the establishment of a Bolshevik-led Soviet state led to diplomatic and economic asymmetries that – flamed by war, fanaticism, and fear – would underlie American and Soviet relations for the remainder of the century (see fig. 4). These regimes were not merely opposing forces, however; mutual dependencies – economic, military, and social – often shaped identity and culture on both sides. Though Bolshevism and capitalism were construed as ideological opposites, the Soviets were neither willing nor able to cut off international trade and diplomatic ties in order to become materially and politically self-contained. The imaging of the capitalist world in the Soviet Union was thus imbued with oppositional rhetoric that masked the ambivalence inherent in the new regime's self-constitution.

Nikolai Kochergin's *Capital and Co.* (fig. 3) displays in hierarchical fashion the enemies of the Bolshevik state.[7] Atop the human pyramid sits the ermine-clad incarnation of capital: a grotesque mountain of green flesh. His shape and stature resemble those of Moloch, an ancient Semitic god whose evocation implied costly sacrifice of life. The scaly reptilian form also recalls images of Saint George slaying the dragon, a religious tale deeply imbedded in Russian culture. This story was modified by early Bolshevik artists to depict a heroic male proletarian slaying the beast of capitalism. Atop a nest of moneybags at the creature's feet, French Prime Minister Georges Clemenceau, American President Woodrow Wilson, and British Prime Minister David Lloyd George cavort and scheme; they each have beastlike paws. Below them are strata of Soviet class enemies, including defeated counterrevolutionaries,

Fig. 4 Artist unknown
(American)
Over There, Over Here,
c. 1919
Publisher: Stanley
Service Co.

Edition: unknown
Offset lithograph
Dimensions unknown
Library of Congress

Fig. 5 Artist unknown
(Soviet)
*Gift of the American
Nation, ARA*, 1920
Publisher: Mospoligraf
Edition: 10,000

Offset lithograph
71 × 53 cm
Hoover Institution
Archives, Stanford
University
In exhibition

Fig. 6 Ivan A. Maliutin
(born Balkovo, 1889; died
Moscow, 1932)
*Here Is Our Report on the
Fight against Famine*
(GPP 324), 1921–22

Edition: unknown
Stencil
225 × 128.5 cm
Ne boltai! Collection
In exhibition

priests, speculators, kulaks, landlords, and under-ground anarchists.[8]

Though capitalism was often exhorted as an enemy of the Soviet Union, the United States as a nation was not always viewed as such. Immediately following the production of Kochergin's image, the world became aware of a dire famine in Russia. The American Relief Administration (ARA) – a program initiated by Herbert Hoover to assist war-torn Europe during World War I – was extended to Soviet Russia in 1921.[9] The American distribution of aid is depicted in the poster *Gift of the American Nation, ARA* (fig. 5), in which a benevolent American Lady Liberty or Columbia doles out soup to hungry children in a pastoral setting. The flat, bright planes of color outlined in black recall traditional folk reverse painting on glass and the mass-produced prints known as *lubki*. This poster likely drew on Russian folk design in order to appeal to the rural populations that were the target of aid programs.

The Soviet acknowledgement of ARA aid is also reflected in a poster produced by the Glavpolit-prosvet (GPP) studio, an operation that briefly superceded the ROSTA studio (fig. 6).[10] This work illustrates how starving peasants attempted to overcome both White anti-Bolshevik forces and food shortages during the Civil War (1917–23) through agricultural planning and donations of seeds from Sweden and the United States. The multipanel narrative, simplified graphic vocabulary, and stencil technique of ROSTA posters would be remobilized in the 1940s by the TASS studio.

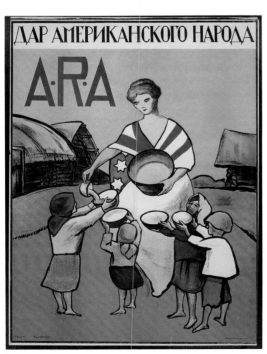

5

6

Fig. 7 Boris Efimov, with
text by Dem'ian Bednyi
*1931 Was a Black Year for
Capitalism (Plakat Gazeta
Izogiza Mezhdunarodnii
Politobzor)*, 1932

Publisher: Ogiz-Izogiz
Edition: 20,000
Offset lithograph
102.8 × 35.2 cm
Ne boltai! Collection
In exhibition

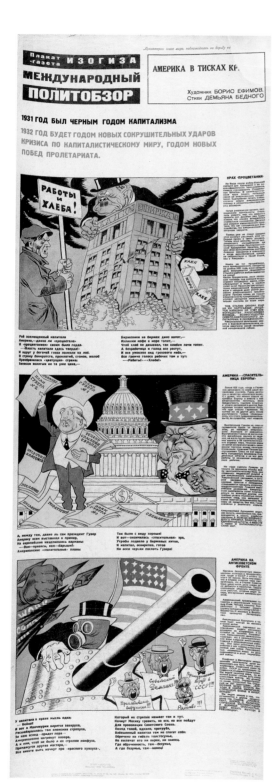

7

As the Soviet regime became entrenched in the 1930s, social and financial disparities between the United States and the Soviet Union solidified to ideology. A wall newspaper illustrated by Boris Efimov, with poetry by Dem'ian Bednyi, spins the financial deterioration surrounding the Great Depression as a symptom of capitalism's degeneracy (fig. 7).[11] Employing a grotesque, wasteful bureaucrat to signify capitalist hypocrisy, this work attacks Hoover's policies on American farm aid, industrial labor, and economic assistance to the failing German economy.

The political and economic chasms between Bolshevism and democracy, Communism and capitalism, were not the only ideological disagreements between the Soviet Union and the United States in the period leading up to World War II. Social equality, fundamental to both democratic and Communist rhetoric, galvanized controversy, which the Soviets addressed by lambasting the hypocrisy of American race relations. A forceful graphic work by designer Dmitrii Moor, *Freedom to the Prisoners of Scottsboro* (fig. 8) dramatically proclaims capitalism – a monstrous, corpulent businessman in the guise of the Statue of Liberty – as the sinister catalyst behind American racism. Capital, holding aloft a human skull atop an electric chair, roars with wild-eyed aggression. His left hand, adorned with a diamond pinky ring and swastika cuff links (signaling the association between Fascism and capitalism) rests on a

guillotine. The chained African Americans, flanked by church officials on the left and police on the right, express both defiance and acquiescence. Falsely accused and unjustly convicted in 1931 by an all-white jury of gang-raping two white women, the Scottsboro boys eventually escaped execution through repeated retrials and protracted controversy. The case was heavily publicized and financially supported by the Communist Party of the United States of America (CPUSA) and became a popular subject for activist American artists; as Moor's design indicates, it also drew significant attention in Moscow.

THE MARCH TOWARD WAR: THE 1930S

A former revolutionary Bolshevik, Stalin had led the Soviet Union since 1924, following the death of Lenin. In 1933 two other leaders destined to impact the future of the world came to power: American President Franklin D. Roosevelt and German Chancellor Adolf Hitler. The rise of international Fascism in the 1930s, especially in Germany, was perceived as a threat to the Soviet Union because of its overt anti-Communist rhetoric, eastward-looking territorial aims, and harsh suppression of German Communists. Despite the tensions mounting in Europe, however, American-Soviet relations were fairly stable in the early 1930s. By this time, the Bolsheviks had proven to the world that they were not a transitory governing power, and business between the Soviet Union and United States had dramatically increased. Stalin's "economic miracle" awed many Americans who had been humbled by the financial disaster of the Great Depression. Nonetheless, the road toward diplomatic recognition was rocky, with disagreements about trade and credit terms, old debts, rumors of Soviet oppression and the failure of Soviet agricultural collectivization, and fear of the Communist International (Comintern) insidiously infiltrating American culture through CPUSA.[12] Even with these reservations, when Germany withdrew from the League of Nations in the summer of 1933, France asked the Soviet Union to join in its place.[13] A few months later, in November, Roosevelt met with Soviet Commissar for Foreign Affairs Maksim

8

Fig. 8 Dmitrii Moor
*Freedom to the Prisoners
of Scottsboro*, 1932
Publisher: Ogiz-Izogiz
Edition: 30,000

Offset lithograph
103 × 73.1 cm
Ne boltai! Collection
In exhibition

Fig. 9 Nikolai Dolgorukov
*Only Capitalists Need
Imperialist War*, August
16, 1939
Publisher: Izostat

Edition: 50,000
Offset lithograph
61.9 × 85.2 cm
Ne boltai! Collection
In exhibition

Litvinov and settled on terms for official diplomatic recognition, which was granted in November 1933. Despite ongoing disputes, primarily with regard to trade and debts, relations prospered until 1935. The late 1930s saw the unraveling of much of the good will that had been built up throughout the decade: conflicts over trade grew between the United States and the Soviet Union, and the assassination of Sergei Kirov, an official in Stalin's immediate circle, foreshadowed the tyrannical purges, show trials, and executions to come in the Soviet Union.

Onslaughts against capitalism continued to shape visual culture in the second decade of Bolshevik rule in Russia, assailing not only the United States but also other capitalism-driven nations, including the budding Axis powers of Germany and Japan. Nikolai Dolgorukov's 1939 poster *Only Capitalists Need Imperialist War* (fig. 9) draws an analogy between the moneybags of capitalism and piles of skulls – casualties of greed – and sounds a warning for the onset of war. The poster quotes Viacheslav Molotov: "The imperialist war, which involves many countries in Europe and Asia, has already started to reach a gigantic scale. The danger of a new world-historical battle is growing, especially from the side of the Fascists and their protectors." The poster, dated August 16, 1939, was issued only days before the Soviet Union signed a nonaggression pact with Germany on August 23.

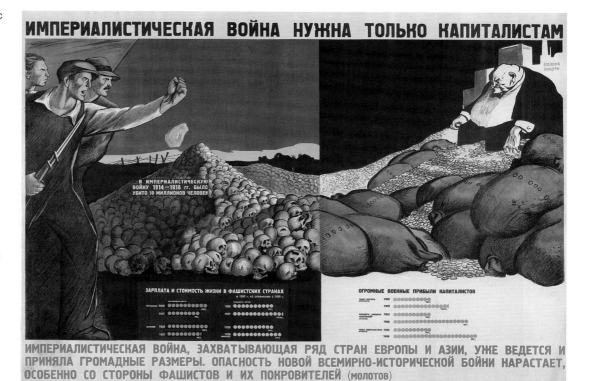

9

INTERVENTIONISM VERSUS ISOLATIONISM: 1939–41

THE WAR OF IMAGES AND THE PRESS IN THE UNITED STATES

As the conflict in Europe escalated, Americans found themselves divided over the issue of the United States' involvement in the war. Many noncommercial advocacy agencies, the press, and private companies across the political spectrum fought to communicate their message during these years, leading to a multivocal and entrepreneurial approach to poster making that exposed the American public to a confusing barrage of graphics. This inundation of images reached a fever pitch in 1941, before the Japanese attack on Pearl Harbor.

The interventionist movement, which favored American participation, used poster design to elicit emotional responses, persuade audiences, and incite political action. Building off of Americans' sense of urgency and fear, as well as a store of

American symbolism, allegories, and values, these posters sought to convince the populace that staying out of the war was the country's greatest danger. In *Stop 'em over There Now* (fig. 10), Cecil Calvert Beall depicted a menacing enemy soldier looming on the horizon just beyond a cowering mother and her children. His uneven shoulders give the impression of motion, as though he is advancing on his victims; his snarling countenance is dehumanized by his large white pupils. The poster's alarming orange background and the placement of the O like a target on the enemy's forehead emphasize the need for American action.

A second interventionist poster, *Speed up America* (fig. 11), by James Montgomery Flagg, exploits the same sense of urgency. Renowned for the World War I Uncle Sam recruiting poster *I Want You*, Flagg again mobilized the American icon in this design. No longer static, Uncle Sam is in the process of mounting his horse to gallop to the country's defense, with a squadron of planes to reinforce him. His flying hair and determined brow, as well as the loose brushwork of the design, increase the drama of the scene. With his signature top hat in

hand, he strikes a pose that evokes, in a cinematic fashion, the cowboylike heroism of his gesture at the same time that it draws the viewer's eye to the fiery swastika rising over a burning city.

In opposition to the interventionist perspective, the America First Committee (AFC) became the country's leading antiwar organization by the spring of 1941. The isolationist AFC actively embraced visual propaganda to convey its message. The poster *The People Say No War* (fig. 15) draws on Dadaist techniques of textual collage to bombard the viewer with newspaper headlines. The frenetic layering of blocks of text provides a sense of exigency, and the multitude of headlines implies a strong coalition behind the antiwar movement. To summarize the central message, red lettering overlays the collage, but the title competes with the cacophony of black typography in the background. The use of textual collage as a design element in American war posters was quite unusual. It is likely that the artist quoted this style in order to evoke the antiwar sentiments of the European Dadaists (see fig. 13). The overlapping elements give the poster a sense of temporality, of spinning headlines rolling off the presses day after day – a technique drawn from cinema rather than from commercial advertising.

Fig. 10 Cecil Calvert Beall
(American, 1892–1967)
*Stop'em over There
Now*, 1941

Offset lithograph
83 × 59 cm
George Marshall Research
Foundation Collection
In exhibition

Fig. 11 James
Montgomery Flagg
(American, 1877–1960)
Speed up America,
1940/41

Publisher: Plampin Litho
Co., Inc.
Offset lithograph
114.8 × 75.5 cm
Ne boltai! Collection
In exhibition

Fig. 12 William Gropper
(American, 1897–1977)
"Let 'em Have It!,"
Sunday Worker,
December 14, 1941

10

11

AFC was a diverse coalition of isolationist factions founded in September 1940, following the June fall of France to the Nazis, in response to what many saw as Roosevelt's inevitable march toward war. This trajectory was interpreted through the president's establishment of the first peacetime selective-service act in American history, the approval of the Lend-Lease Act to supply war materials to Great Britain (and later the Soviet Union, as immortalized in posters such as TASS 992 [pp. 290–92]), the gradual installation of American troops in Greenland and Iceland, and the signing of the Atlantic Charter.[14] Isolationist factions had many reasons for opposing American intervention in the budding European conflict; foremost was the acrid memory of World War I, with its long-term devastations and socioeconomic consequences. In the words of the aviator Charles Lindbergh, the most vocal celebrity voice for AFC, war seemed to be the surefire road to "race riots, revolution, destruction," and the catalyst that enabled Fascism and Communism to develop.[15]

The Chicago branch of AFC was the group's heart and organizing center, contributing, with the *Chicago Tribune*, to the conservative tone of public culture in the city.[16] The Chicago AFC poster *War's First Casualty* (fig. 16) relies on very different graphics and symbolism than the group's previous text-based design. Produced in a straightforward, illustrative style, the poster depicts a missile shooting across the American skyline and violently striking the upraised arm of the Statue of Liberty, severing the torch at her forearm. The statue serves as an embodied, personified symbol of American democracy, and the title of the poster reinforces the threat depicted in the image.

A similar dichotomy between interventionist and isolationist perspectives developed in the press during this period (see fig. 14). A few key publications and artists shaped the culture of the American Left, where sympathy toward the Soviet Union was most vocal – and most visually expressed. The mouthpiece of CPUSA was the *Daily Worker*, illustrated by the lively cartoons of Fred Ellis, William Gropper, and Robert Minor. Totally dedicated to the party line, the *Daily* Worker was a key source of information for American Communists.

New Masses, a magazine founded in 1926, featured equally pungent cartoons by such artists as Hugo Gellert, Gropper, Louis Lozowick, and John Sloan. In the 1930s, the Federal Art Project Graphics Division fostered a strong movement of left-wing printmaking that enabled publications like *New Masses* to showcase a wide variety of prints and drawings beyond typical political cartoons. Regardless, images of social criticism maintained a strong appeal, and artists such as Gropper cultivated a caricatural bite in dialogue with political graphics produced in the Soviet Union (see fig. 12).[17]

A new liberal publication in New York, spearheaded by the journalist Ralph Ingersoll, a former editor of *Time*, also found its footing at this moment. *PM*, launched on June 18, 1940, was designed as a different kind of daily magazine, infused with luminary writing and strongly image-driven – a tabloid-format "picture paper" that did not accept advertising. *PM* published award-winning maps by Harold Detje (see fig. 18) and launched the political cartooning career of Theodor Geisel, better known as Dr. Seuss (see fig. 17 and TASS 606, fig. 1 [p. 228]). Strongly advocating an anti-Fascist, interventionist position, the publication was supported by the Chicago billionaire investor Marshall Field III, founder of the *Chicago Sun* (which later became the *Chicago Sun-Times*), revealing a significant divide between Field and the ultra-conservative *Chicago Tribune*, run by Republican Colonel Robert R. McCormick and illustrated with the entertaining but definitively isolationist, anti-European cartoons of Frank Orr and Joseph Lee Parrish (see TASS October 1, 1941, fig. 3 [p. 196]). Ingersoll's former associates at the popular mass magazines *Life, Time*, and *Fortune* were equally invested in covering the burgeoning war effort.

TOTALITARIANISM

On August 23, 1939, a shocking alliance between Nazi Germany and the Soviet Union, formalized by the Molotov-Ribbentrop Pact, led to not only suspicion and isolation of American Communists, but also a virtual Red Scare that would last for twenty-two months, until June 22, 1941.[18] Maintaining a "tenacious and myopic" loyalty to Moscow, CPUSA was forced to abandon its explicit anti-Fascist stance, a position constitutive of the party throughout the 1930s. The treaty threw CPUSA into ideological confusion, drawing American Communists sharply into conflict with those in the United States who opposed Hitler's expansionism – the interventionist factions in which CPUSA had previously played a key role. Instead, the party reoriented itself to an isolationist political posi-

12

13

The Enemy Within

14

15

16

Fig. 17 Dr. Seuss
(Theodor Geisel)
(American, 1904–1991)
*And the Wolf Chewed up
the Children...*, PM,
October 1, 1941

Fig. 18 Harold Detje
(American)
"Nazi War Machine
Feeds on Wealth of Nine
Nations," *PM*, August 6,
1940

tion buttressed by a paltry rhetoric of pacifism to protect Soviet interests.

Interpretive parallels between Hitler's Nazi party and Stalin's Bolsheviks from the 1930s on, and especially during the Long Red Scare of 1940, transcended military alignments (see fig. 19). The strict regulation of cultural production and the forceful exclusion of avant-garde artistic styles led to an exodus of cultural workers from both Germany and the Soviet Union in the late 1930s. Though one party was far right politically and the other far left, Americans grouped them together under the moniker *totalitarian*, a word that first gained currency in the 1920s. Adapted from the Italian *totalitario*, meaning "complete or absolute," it originally referenced Benito Mussolini and the Italian Fascist state but was later adapted to describe any government that operated in a top-down comprehensive mode, under one political party intolerant of dissent.

As a term, therefore, totalitarianism linked the operating styles of dictatorships on both the Right and Left.[19] This conflation is demonstrated by a silkscreen poster produced by the New York State Works Progress Administration (WPA) Art Project after the signing of the Molotov-Ribbentrop Pact (fig. 20). In this work by an unknown designer, an arm cuffed in a civilian suit reaches in from the right to contribute a vote to a ballot box. The word on the vote, *ja*, means "yes" in German. From the left, a larger fist with a military-style sleeve descends upon the voting hand, forcing it to insert the vote into the box. The eye is drawn from the monochromatic gray of the central design to the three flags underlining the interaction, the red Nazi flag at left, the Soviet hammer-and-sickle flag at right, and the blue flag of Fascist Italy at center. The title, *Your Lot in a Totalitarian State*, wraps the visual message and the national standards together: no matter which enemy country is represented, totalitarianism signifies coercion in a manner diametrically opposed to the freedoms of the United States.

This color-saturated poster indicates a shift in printmaking techniques at the end of the 1930s in the United States. The media of lithography and woodcut, forged by political illustrators and printmakers such as Honoré Daumier and Käthe Köllwitz, had long been symbolic of social purpose and often radical politics. In 1940, however, silkscreen was proclaimed by the art critic Elizabeth McCausland to be "the most popular graphic art of the twentieth century"; it soon began to overtake lithography as a symbol for the democratization of the arts.[20] Silkscreen was interpreted as democratic because of its ability to reproduce images manually (without a press) in vibrant multiples while maintaining the saturation and texture of the original in each version. A silkscreen (also called a screenprint or serigraph) is produced through a stencil-based process, so when stenciled TASS posters began arriving in the United States, the medium – along with the biting quality of the images – resonated with artists and audiences. After the attack on Pearl Harbor shifted American wartime allegiances, the poster *Your Lot in a Totalitarian State* was reissued, demonstrating the adaptability and flexibility of the silkscreen medium. The Soviet flag was replaced by the ensign of the Imperial Japanese Navy.

"...and the Wolf chewed up the children and spit out their bones ... But those were <u>Foreign Children</u> and it really didn't matter."

17

18

MOMA'S CALL TO ARMS

Amid the struggle between isolationist and interventionist perspectives in the United States, museums also took a political stand. In 1940 planning began at MoMA for a phantasmagoric, monumental display to be housed in an enormous temporary addition to the museum. Originally referred to by its organizers as "Exhibition X," the title chosen for the public was *For Us the Living*.[21] MoMA's plans for this spectacular artistic intervention in the war debate would have resulted in – had they been executed – the largest anti-Fascism exhibition held in the United States.

The installation was intended to promote American strength and unity and convey the threat of Nazism through a multisensory extravaganza covering thousands of square feet of exhibition space.[22] Critical of the complacency of American democracy, the organizers sought to convey a warning to the home front: "Americans must be better Americans in their own home town. The incitement of democ-

racy by and for Americans is quite as much part of National Defense as a larger army and navy."[23] With its goal of indoctrination and persuasion through spectacle, this exhibition would have rivaled the most sensational propagandistic displays of power and ideology in any of the totalitarian nations it criticized.

Although MoMA never realized *For Us the Living*, citing scale and cost as the obstructive factors, it did not give up its wartime political engagement. Starting with exhibitions in 1940 – including *Paris at War*; *"PM" Competition: The Artist as Reporter*; and *War Comes to the People: A Story Written with the Lens* – the museum rallied the cultural world to awareness of war efforts in Europe.

In April 1941, MoMA launched its first art-poster competition, the *National Defense Poster Competition*. The museum's inspiration grew out of an assessment of the disparity between Britain's commercial-design industry and the images being used for national defense.[24] Observing that "the very finest modern posters were used commercially, but the posters used in the British defense effort have been decidedly inferior," the organizers

may have had in mind posters such as McClelland Barclay's *Britain Must Win, Help Bundles for Britain* (fig. 21), whose awkward mélange of allegory, pathos, and metaphor make it difficult to discern the action depicted or its relationship to the text.[25] Seeing this same discrepancy developing in American poster design, the organizers believed the competition would be an opportunity to bridge art and propaganda, not only "further[ing] the cause of modern art" but also making available to the government the "best work that modern artists can do in this field."[26]

Artists submitted more than six hundred poster designs that were shown anonymously to a jury of museum curators.[27] The exhibition that opened to the public in mid-July featured the thirty most-lauded works, including fourteen prizewinners. John Atherton and Joseph Binder, the overall winners, created posters in a modernist idiom with a reduced graphic vocabulary, revealing the judges' predilection for "simplicity, directness, novelty."[28] Atherton's defense poster (see fig. 22) features

JERRY DOYLE ON STALIN
"Forward Marx!"

19

20

BRITAIN MUST WIN
HELP BUNDLES FOR BRITAIN
NATIONAL HEADQUARTERS 745–5TH AVE. NEW YORK CITY

21

two disembodied hands representing the union of labor and government. The planar color fields of the background are a nod to modernist collage, as is the black cut-out silhouette of the factory, given dimensionality only by the stylized puffs of smoke escaping from its towers. Contrasting with these color fields, the hands are a finely executed photomontage that draws the eye to the center of the composition.

MoMA organizers were criticized for the competition's approach by the Joint Committee of National Defense for the Society of Illustrators and the Artists Guild, organizations of professional commercial designers who saw fine-art poster competitions as wrongheaded. The guild asserted that crafting a persuasive image with the goal of "awakening the great masses of Americans to dangers and problems of which most of them are but dimly aware" was a cultivated trade that required "a high degree of professional competence, knowledge of advertising and of the psychology of the public."[29] Commercial designers feared such competitions might promote the "wrong type" of poster, causing

the government to "lose valuable time and do a less effective job." Worse, curators might be prejudiced toward designs that were not American enough, trapped in a "fixed belief in the superiority of almost any foreign artistic idiom over the American," a spokesman wrote. "We are concerned lest our national defense posters speak with an axis accent."[30] In the tense months preceding the United States' entry into the war, the battle between American art and advertising was far from over.

Between the United States' formal declaration of war and the defeat of Japan, MoMA mounted nearly forty more politically engaged exhibitions. Following the National Defense Poster Competition, the museum organized several design competitions and exhibitions, including Art in War: OEM [Office of Emergency Management] Purchases from a National Competition, Salvage Posters, New Posters from England, and United Hemisphere Poster Competition. The frightening image This Is the Enemy (fig. 23) by Karl Koehler and Victor Ancona won a prize at the National War Poster Competition hosted by the museum from November 1942 to January 1943. The style of this poster, exemplifying a trend toward grim, confrontational illustrations, would be embraced by one faction in the design debates to come.

AMBASSADORS FOR INTERVENTION: THE FIRST TASS POSTERS, JUNE 22–DECEMBER 1941

IMAGING THE NEW ALLIANCE: GREAT BRITAIN AND THE SOVIET UNION

On June 22, 1941, Germany invaded the Soviet Union, shattering the Molotov-Ribbentrop agreement. Perhaps attesting to the tensely anticipatory nature of that pact, the Soviets had not produced any pro-German images during the time of nonaggression. In contrast, the signing of the Anglo-Soviet Agreement on July 12, 1941, by Great Britain and the Soviet Union prompted many iconic visual examples of Allied unity. Immediately following this pact, the TASS studio issued Nikolai

Fig. 22 Photographer
unknown (American)
John Atherton's
(American, 1900–1952)
prizewinning defense
poster *Buy* on a public

billboard at the corner of
42nd Street and
Fifth Avenue in
Manhattan, c. 1941
MoMA Archives

Fig. 23 Karl Koehler
(American, 1913–2000)
and Victor Ancona
(American, 1912–1998)
This Is the Enemy, 1942
Publisher: Grinnell
Lithographic Co.

Offset lithograph
112.6 × 60.7 cm
The Art Institute of
Chicago, John H. Wrenn
Memorial Collection;
Stanley Field Endowment,
2005.406
In exhibition

Fig. 24 After the
Kukryniksy
Meeting over Berlin (TASS
143) (English version),
c. 1941
Publisher: Stafford &
Co., Ltd.

Offset lithograph
76 × 50.7 cm
Ne boltai! Collection
In exhibition

Radlov's *Agreement of the Greatest Historical and Political Significance* (TASS 68) (p. 176), showing the strangling of a caricatured Hitler in the grasping handshake of Britain and the Soviet Union. Another poster on this same topic, *Anglo-Soviet Agreement* (pp. 193–96), was made with stencils, using the same method as the TASS posters. The English-language lithographic poster *Meeting over Berlin* (fig. 24) adapted a design by the Kukryniksy for TASS 143 (pp. 182–83) for a British audience.

These critical posters, produced in the early months of Soviet fighting, found their way to Britain through an important agent. In late September 1941, Minister of Supply Lord Beaverbrook traveled with American special envoy William Averell Harriman to meet with Stalin to discuss material aid for the Soviet war with Germany (see fig. 25).[31] The works Lord Beaverbrook transported from the Soviet Union were later published in the book *The Spirit of the Soviet Union*, featuring a woeful depiction of Soviet revenge by Vachaga Tevanian (fig. 26) on the cover. In the foreword, Beaverbrook

asserted, "Rarely has the architectural fraudulence of [Hitler's] 'New Order,' the brutality of its racial discrimination and the blindness of its Neanderthal mentality been more strikingly revealed than in these cartoons."[32] Many of the images were republished for English audiences by Beaverbrook's Ministry of Supply, including Efimov's chilling *Maneater* (fig. 27 and p. 197) and Radlov's *Agreement of the Greatest Historical and Political Significance*. Adapting the design of the latter, the poster advocated, "Rush British arms to Russian hands" (fig. 28). The Ministry of Supply also translated and reproduced the Kukryniksy's *We Smashed the Enemy with Lances* (fig. 31) and one of their earliest and most celebrated war posters (fig. 29; see fig. 1.23). In it a Red Army soldier forces a rotund, pint-size Hitler back toward the west with the butt of his rifle. Holding a smoking gun and the shreds of the Molotov-Ribbentrop Pact, Hitler casts a shadow that assumes the shape of Napoleon. In contrast, the Soviet soldier's shadow becomes that of a nineteenth-century Russian soldier impaling the French leader, suggesting that history is fated to repeat itself. The British publisher Stafford & Co., Ltd., also reproduced early Soviet posters, including Efimov's iconic caricatures from TASS 22, exposing the hypocrisy of Nazi ideology (fig. 30; see p. 169).

The British firm Sanders Phillips & Co., Ltd., reciprocated the exchange of imagery with a series of bilingual photomontage posters intended for display in Russian factories: *We Sink the Fascist Pirates*, *My Message Comes in Fighter Planes*, *We Too Are Fighting – For Our Future*, and *We Shoot the Fascists out of the Sky* (fig. 32). Four of a series of ten professing brotherhood between the Soviet Union and Britain, the posters utilize flat color planes in the backgrounds to push forward and isolate the cut-out photographic images, a stylistic approach akin to the designs of Viktor Koretskii (see figs. 50, 52) or Gustav Klutsis (see fig. 3.28). The floating text panels and modish color contrast with the affable but determined faces of the young workers. The slick British design eschews the pernicious humor and vitriolic belittlement that produce a sense of immediacy and guileless hatred in the Soviet posters.

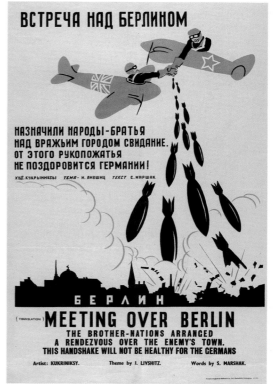

24

23

25

26

27

28

Fig. 28 After Nikolai Radlov
*Rush British Arms to
Russian Hands [Agreement
of the Greatest Historical
and Political Significance]*
(TASS 68) (English version),
July 14, 1941
Publisher: Ministry of
Supply, Great Britain
Offset lithograph
71 × 48 cm
Ne boltai! Collection
In exhibition

Fig. 29 After the
Kukryniksy
*But Russia Needs the
Tools Now! [Napoleon
Failed and So Will the
Conceited Hitler!]*
(English version), 1941
Publisher: Ministry of
Supply, Great Britain
Offset lithograph
47 × 72 cm
Ne boltai! Collection
In exhibition

Fig. 30 After Boris Efimov
*Pictorial Presentation
of the True Aryan [Visual
Presentation of "Aryan"
Descent]* (TASS 22)
(English version), 1941
Publisher: Stafford & Co.,
Ltd.
Offset lithograph
76 × 102 cm
University of
Minnesota Libraries
In exhibition

Fig. 31 After the
Kukryniksy
*We Smashed the
Enemy with Lances*
(English version), 1941
Offset lithograph
72.5 × 50 cm
Ne boltai! Collection
In exhibition

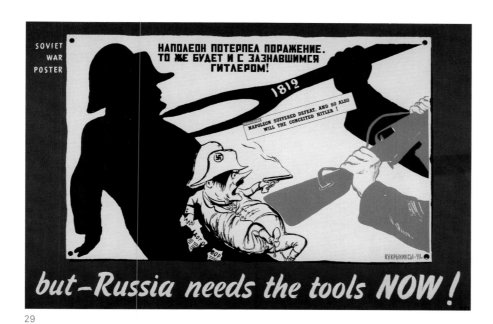

29

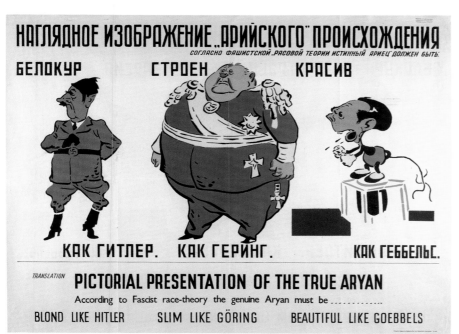

30

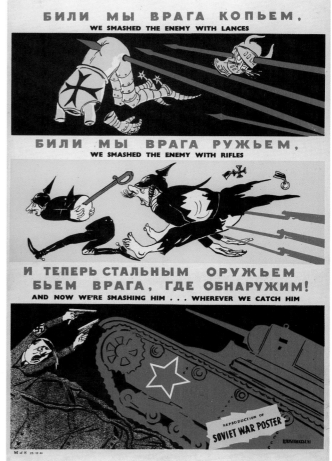

31

Fig. 32 Artist unknown
(English)
*We Sink the Fascist
Pirates*, *My Message
Comes in Fighter Planes*,
*We Too Are Fighting –
For Our Future*,

*We Shoot the Fascists out
of the Sky*, 1941
Publisher: Sanders Phillips
& Co., Ltd.
Offset lithographs
Each: 75 × 49.5 cm

The Art Institute of
Chicago, John H. Wrenn
Memorial Endowment
and Stanley Field funds,
2008.93–96
In exhibition

Fig. 33 Photographer
unknown (American)
Ralph Ingersoll, April 19,
1946
Bettmann Archive

Fig. 34 "Report on Russia:
Russian War Posters Mix
Humor and Bitterness,"
PM, November 12, 1941

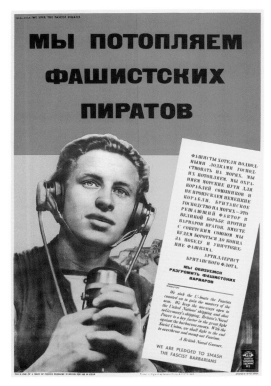

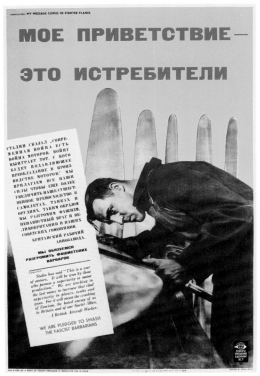

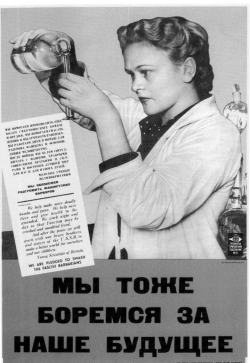

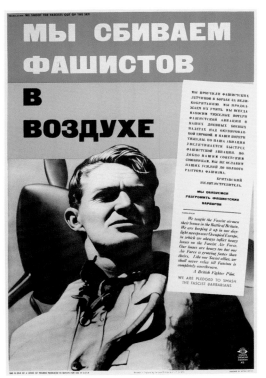

FATALISTIC MOSCOW: THROUGH AMERICAN EYES, 1941

The British would not stand alone for long in their alliance with the Soviets. Hitler's breach of the Molotov-Ribbentrop peace treaty and advance upon Soviet territory in June 1941 inflamed an American journalistic push to report on the Soviet war effort and prompted most major American newspapers to establish war correspondents in Moscow and along the Eastern Front. In particular, three intrepid Americans sought to document the perils of the summer and fall of 1941 for *PM* and *Life*. Ingersoll, photographer Margaret Bourke-White, and her husband, writer Erskine Caldwell, devoted themselves to the quotidian, humane, and artistic dimensions of the Soviet war effort – as well as its military story – and served as the eye witnesses to this experience for the American public. They facilitated the text and images that gave a human face to Soviet life and cultural production, and brought the story of the TASS studio to the United States.

Committed to the power of images, Ingersoll (fig. 33) was a staunch idealist who had made a name for himself both for his brilliance and for his strong personality. His significance in publishing stories and images of this moment cannot be underestimated. After the German invasion of the Soviet Union, he sought special clearance to travel there to cover the war. Departing from San Francisco on July 17, 1941, Ingersoll claimed that he was in

33

Russian War Posters Mix Humor and Bitterness

IT'S probably not co-incidence that the fiery love of freedom that produces good fighters against Fascism also produces good poster artists. Spanish Loyalist posters, you may remember, were some of the best anywhere in the 1930s. Here are samples, all hand-painted, brought from Moscow by Ralph Ingersoll, of the current Russian product — characteristically unrestrained.

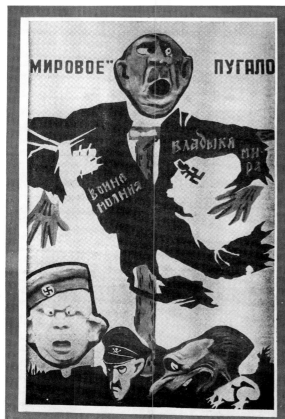

МИРОВОЕ" ПУГАЛО

Hitler, as the "World Scarecrow," impresses only Goering, Himmler and Goebbels. His coat is labeled "Blitzkrieg" and "Lord of the World." Faces on the original poster are paper masks in bas-relief.

British and Russian air forces join hands to give Germany the two-front war that many Germans feared.

A German soldier is depicted chained to prevent desertion—a favorite atrocity story in arsenals.

This one jibes at German efforts to create Aryans. The sign in the background says: "Breeding Point."

Busts of Einstein and the poet Heine, symbols of old German culture, are swept aside by Nazi worship of bestiality.

Nazis, again caricatured as beasts, are entertained by the spectacle of a child impaled on a sword.

34

a "race with the Germans" to Moscow; when he arrived, they were less than one hundred and fifty miles from the capital.[33] One of the few foreign journalists to interview Stalin, Ingersoll returned to New York on October 27 and wrote an extensive series of articles about the Eastern Front for *PM*. He also brought with him a cache of early TASS posters, some of which he published in lavish spreads (see fig. 34).[34] These include 109 (p. 179); 124 (pp. 180–81); 143 (pp. 182–83); 173 (p. 185); 177 (pp. 186–88); and 178 (pp. 189–90).[35]

If Bourke-White and Caldwell had not trekked to Moscow in the spring of 1941, American audiences would have had no access to photographs or English-language accounts of the inner workings of the TASS studio (see fig. 35). On a hunch that the role of the Soviet Union in the brewing global conflict would imminently shift, they began their cultural reconnaissance in March 1941, three months before the German invasion. At the end of June, Bourke-White was the only foreign photographer in Moscow. Confronted with the Soviet order that anyone

caught with a camera would be shot on sight, she leveraged her diplomatic, consular, and personal ties to be granted the privilege to photograph.[36]

Bourke-White not only visited and photographed the TASS studio, but she also arranged for TASS posters to be shipped back to the United States on behalf of *Life*.[37] The first image of the studio at work appeared in *Life* on October 27, 1941. Bourke-White also arranged to have TASS posters sent to her in the United States; some of these works appeared in the magazine on August 24, 1942 (see fig. 37).[38] Her memoirs of the sojourn – and the story of her visit to the TASS studio – were published as *Shooting the Russian War* in 1942.

VOKS AND TASS POSTERS IN THE UNITED STATES

The responsibility for guiding cultural travelers from abroad, like Bourke-White, and fostering a positive image of the Soviet Union in the rest of the world belonged to VOKS (see fig. 36), which was founded in the 1920s to improve the Soviet Union's image internationally, after the Revolution

and subsequent Civil War isolated the new regime and negatively impacted the way it was perceived beyond its borders. Because its mission was international communication and collaboration, primarily with non-Communist intellectuals (as well as the cultivation of agents of influence and surveillance of foreigners visiting the country), VOKS faced challenges during Stalin's purges in the second half of the 1930s.[39] In an environment of extreme paranoia, the mission of intellectual exchange with foreigners became a liability. The agency suffered "paralyzing waves of suspicion"; indeed, two VOKS leaders were executed, as were an indeterminate number of lower-level staff members.[40] The severe destabilization of VOKS by the end of the 1930s may suggest that the decimated agency played no wartime role.[41] However, VOKS was resuscitated to work with TASS and take on an international public-relations position with the Soviet friendship agencies abroad when the nation entered World War II.

The American audience was at the forefront of VOKS's international distribution program after the TASS initiative began in June 1941. Following

35

36

the August 1941 announcement that the tripartite Moscow Conference – a meeting between Beaverbrook, Harriman, and Stalin – would occur in September, the TASS studio produced the first poster reflecting American participation in the war effort, *Dangerously Ill* (TASS 159 [p. 184]). After entering the war in December, the United States was regularly entreated, acknowledged, and lauded in Soviet poster design. The images of Allied cooperation – often represented by the combined flags of the Soviet Union, the United States, and Great Britain – resulted in many iconic posters, including *A Thunderous Blow* (TASS 504 [p. 214]) and *We Will Sever All the Wicked Enemy's Paths, and from This Noose He Will Not Escape* (TASS October 1, 1941, fig. 1 [p. 194]).

The first shipment of TASS material was sent to the United States in July 1941.[42] These posters were produced in small edition sizes (between sixty and one hundred and fifty). The posters shipped to the United States were prepped for exhibition and packaged in sections, with separate image, text, title, and TASS number panels meant to be trimmed and assembled on-site. Due to the slowness of wartime mail, the first installation of TASS posters did not arrive in New York until the end of October 1941; they were sent to the American artist-activist Rockwell Kent and to MoMA.[43]

A lifetime Socialist and supporter of radical causes, Kent advocated on behalf of Soviet art in the United States and served as the point of first contact for VOKS and communication with Soviet poster designers and artists (see fig. 38).[44] He encouraged and facilitated the exchange of visual art between the Office of War Information (OWI) and VOKS, using the American-Russian Institute for Cultural Relations with the Soviet Union (ARI) as an intermediary to securely expedite mailings during the war years. He utilized his knowledge of Russian design and his position as the head of the politically active anti-Fascist artist collective United American Artists (UAA) to attempt to transform the visual language of American propaganda and its role in supporting the war.[45] Kent had been exchanging letters with the staff at VOKS since before the Nazi invasion in June 1941; in turn, VOKS sought to benefit from Kent's political views, connections, and dedication to social-realist art.

Kent and MoMA were not the only VOKS-facilitated American destinations for TASS posters. Similar

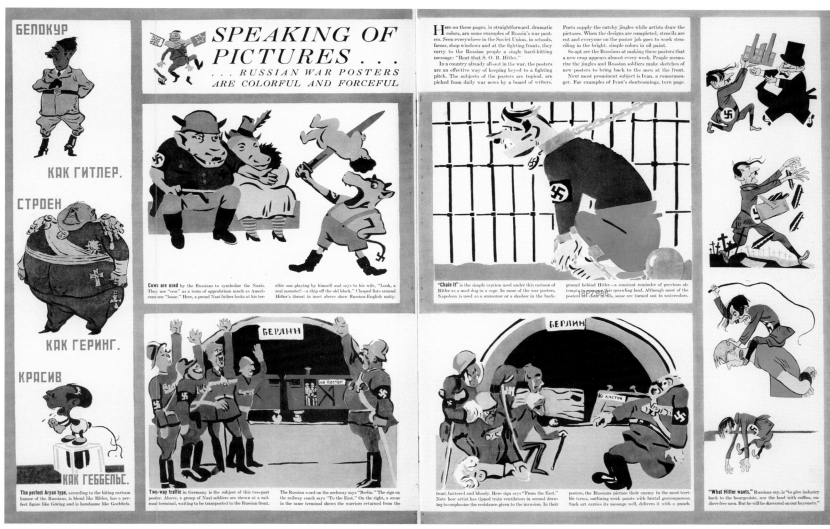

packages were sent to Russian War Relief, Inc. (RWR), a dynamic fundraising agency with offices in several American cities; the National Council for American-Soviet Friendship (see fig. 39),[46] ARI, and other Soviet-American friendship agencies that VOKS supported from abroad.[47] Kent forwarded his increasing collection for display to UAA, which circulated it to several small venues.[48] It eventually went to Los Angeles, where it was auctioned by RWR (see fig. 42).[49] RWR reproduced Soviet posters for the purpose of raising awareness and funds and also produced its own set of graphics, including Elliott Anderson Means's *Help Put Him Back in Our Fight* (fig. 41) and the photo-based *Aid to Russia Helps Us!* (fig. 43), which relied on American idioms of realistic illustration and multivignette photomontage to garner support for the Soviet cause. In 1942 RWR also produced the film *Our Russian Front* (see fig. 44). Though a moving ode to the Russian war effort, *Our Russian Front* did not have the popular appeal of former United States Ambassador to the Soviet Union Joseph E. Davies's book *Mission to Moscow*, first published in 1941 and made into a film in 1943 (see fig. 40), starring Walter Huston, the same actor who did the voice-over narration for the previous film. RWR's support of the Soviet war effort augmented the images produced by private agencies, such as the series *Produce for Victory* (see fig. 45), published by the Seldon-Claire Co. in Chicago.

VOKS special-ordered nearly one thousand TASS posters for international distribution in 1942, targeting its publicity efforts at the United States and Great Britain, as well as other allied and neutral countries.[50] Most TASS posters sent abroad were likely delivered to the various branches of Soviet friendship societies with preexisting relationships to VOKS. Some orders were bundled together into exhibition sets that in 1942 were sent to China, England, Iran, South Africa, and the United States (see fig. 46).[51] Some of these were specially produced with stenciled text panels in the language of their destination countries, such as *Brutality Graduates* (also known as *Matriculation*) (TASS 177) (pp. 186–88), deposited at MoMA by the Soviet embassy in Washington, D.C.[52] MoMA's first posters were picked up from customs in December 1941; they included at least seven TASS posters and one rare bas-relief papier-mâché work by Moor and and his students at the Moscow State Art Institute (later called the Moscow State Academic Art Institute named after V. I. Surikov) (see figs. 48 and 1.36–37).[53] Other posters shown in the United States have English labels taken from the publication of the works in *Moscow News*, the English-language newspaper printed in the Soviet Union.[54]

One TASS poster from this period that was often reproduced by the leftist American press is Sergei

Fig. 39 William Gropper
(American, 1897–1977)
"Congress of American-
Soviet Friendship,"
New Masses, November
17, 1942

Fig. 40 Artist unknown
(American)
Poster for *Mission to
Moscow*, 1943
Chisholm Larsson Gallery

Fig. 41 Elliott Anderson
Means (American, 1905–
1962)
*Help Put Him Back in Our
Fight,* 1941
Offset lithograph
110 × 71.5 cm
Private collection
In exhibition

Fig. 42 Photographer
unknown (American)
Hollywood celebrities
reviewing Russian
posters (including the
bottom panel of TASS 301
by the Kukryniksy and
Vitalii Goriaev, December
9, 1941, Kuibyshev) for an
RWR competition (left to
right: Thomas Mitchell,
Charles Boyer, Edward
G. Robinson, and Norma
Shearer), *Life*, August 24,
1942

Fig. 43 Artist unknown
(American)
*Aid to Russia Helps Us!
Give to Russian War
Relief*, 1942
Publisher: Allied Printing
Offset lithograph
54 × 33.5 cm
Private collection
In exhibition

39

40

41

Fig. 54 Nikolai Dolgorukov
*Wipe Fascist Barbarians
off the Face of the Earth*,
1941
Publisher: Detgiz
Edition: 200,000

Offset lithograph
88.7 × 60 cm
Ne boltai! Collection
In exhibition

Fig. 55 Maclean
(American)
Oh, Yeah?, 1941
Publisher: US Government
Printing Office
Offset lithograph

51.5 × 40.5 cm
Private collection
In exhibition

1942: MOBILIZATION AND BACKLASH ON THE AESTHETIC FRONT

IMAGES ON THE OFFENSIVE: THE UNITED STATES ENTERS THE WAR

The bombing of Pearl Harbor exponentially increased the stakes for American poster design in the service of national defense. Soon thereafter, the first official American war poster was issued by the Government Printing Office (fig. 55). The mostly monochromatic and illustrative design features five German soldiers singing the Horst Wessel song "Today, Germany is Ours / Tomorrow, the Whole World." The soldiers, holding sheet music, appear slightly bestial, with deadened eyes and tiny fangs. Below the image is the American retort, "Oh, yeah?" The confusing duality of voices, poor design, and lack of visual or textual power to assert American strength or compel action prompted vitriolic criticism:

Is this the plane on which the division of psychological warfare proposes to wage the struggle for the defense of Christian civilization and the principle of human dignity?...If this wretchedly drawn and worse conceived poster can serve any purpose, it is the purpose of arousing in us, as [a] substitute for courage, those blind and malignant fears and hatreds which have already wrought so much disaster and desolation in the world.... In our own moral interest, therefore, let us not in these matters imitate the most disgusting devices of our adversaries.[61]

The warning not to imitate the visual tools of Axis propaganda grew out of structural and organizational, as well as stylistic and thematic, challenges in American poster production. Two key questions confronted American designers: First, who should take control of American image production so as to provide a cohesive, unified message for the public? Second, what should an authentic and efficacious American design look like and how should it

characterize the enemy and play on people's ideals and emotions? These questions were reflected in the increasingly confusing, disjointed images produced for American propaganda posters during the early war years.

Unlike Nazi Germany and the Soviet Union, the United States and Great Britain did not have a strong, centralized, government-based avenue for production, approval, and dissemination of poster designs. Instead, political special-interest groups and corporations were at liberty to produce as many images, of whatever kind, as they wished. This freedom, so fundamental to American democracy, produced an oversaturation of images and contradictory messages, making the posters largely ineffectual for inducing political action. As early as October 1941, Kent wrote directly to Roosevelt, criticizing the government for not organizing artists in a Soviet-style governmental studio for "production for defense."[62] The lack of arts centralization and strong leadership proved to be a key admonition of art critics, who believed that American and British posters were "too many, too soft and too full of technical errors."[63]

The public entreaties of Kent and others to the Office of Emergency Management (OEM), the president, and the military may have touched a nerve. In June 1942, Roosevelt consolidated three prewar agencies to form OWI under Elmer Davis, making Francis E. Brennan, formerly of *Fortune* magazine, the chief of the Graphics Division.[64] OWI promulgated a big-picture ideology in an attempt to mobilize artists for the war effort. Its Propaganda Division – at least before 1943 – aimed to explain the significance of the war and spin American involvement not just as a matter of self-defense, but also as an international effort to destroy Fascism. The government was careful not to create parallels between OWI and Goebbels's overblown propaganda apparatus in Germany, and also sought to distance the United States' current embroilment in international conflict from the mistakes of World War I and President Wilson's divisive choices. Therefore, tracts on the differencesbetween Fascism and democracy had to be more subtle and transparent and less persuasive, forcefully didactic, and deceptive than those produced by the Nazi propaganda machine, guiding people to make up their own minds. OWI sought to accomplish this by making the conflict personally meaningful for Americans.[65] Generally skirting ideological language, its goal was to show the fate of the average American under possible Nazi domination.

55

Despite OWI's desire not to dramatize the war through ideological rhetoric, it repeatedly asserted that the conflict was a battle of ideologies. In the 1942 introduction to a special issue of *ARTnews* devoted to war posters, Brennan emphasized:

The essence of art is freedom. Without it the world of art could not exist. We know that the enemy is trying to destroy freedom – that he has long since chained together his men of talent.... And we saw more than impending war in the light of his fires – we saw ... the inevitable end of truth as decent men had known it ... an unprincipled plan to degenerate and possess men's minds. What this means to art has been said by greater pens than this – but if it needs saying again it means, quite simply, that if this war is lost, no artist worthy of the name will ever again put brush to canvas in free pursuit of his own imagination.[66]

Such potent and ideologically loaded rhetoric had its roots in the prelude to global war in the 1930s. Hitler's oppression of modernist intellectual life and art – demonstrated most forcibly by the Degenerate Art exhibition of 1937 – was echoed by the philosophically dissimilar but equally rigid Stalinist mandate of Socialist Realism in the Soviet Union beginning in 1934. By 1937 it had become clear to an international public that no cultural dis-

Fig. 56 Artist unknown
(American)
*Bowl Them Over,
More Production*, 1942
Publisher: War Production
Board

Offset lithograph
102 × 71 cm
Private collection

56

sent would be allowed by either the Nazi or Soviet regimes.

In 1938 Leon Trotsky, Diego Rivera, and André Breton published the manifesto "Towards a Free Revolutionary Art" in *Partisan Review*.[67] In their view, truly free art had to spring from the inherent political beliefs of the artist and could not be proscribed from above. Free art was not apolitical or necessarily abstract in content or style, but "true art … insists on expressing the inner needs of man and of mankind in its time – true art is unable not to be revolutionary, not to aspire to a complete and radical reconstruction of society." How a political artistic practice should look and what it should mean became urgent questions that would linger for the remainder of the 1940s, particularly for American artists who sought to passionately mobilize the public and clearly communicate their ideals without replicating the stylistic constraints, dogmatism, or centralized propaganda machines of totalitarian states.

POSTERS THAT KILL GERMANS

Once the Soviet Union allied with Britain, the unique style, medium, and passionate expression of Soviet posters seemed to offer an alternative approach for a convincing and cohesive visual language that would not speak with an "Axis accent." Soviet designs were seen as more immediate, inciting, and caustic in their demonization of the Fascist threat than American posters. Their humor was a vehicle to mobilize a vicious antipathy, a technique unfamiliar to American audiences, as noted by MoMA curators at the time: "The insistence on humor and ridicule in these posters is a strange phenomenon. Humor is generally not considered the medium through which to inspire hate and arouse people to action…. Yet the Russians have proved the opposite."[68] American posters that attempted to demean the enemy with humor, such as *Bowl Them Over, More Production* (fig. 56) by the War Production Board, came off as quirky and slapstick. As Metropolitan Museum curator Alice Newlin observed, Soviet posters "are very interesting and original, mostly satirical and extremely savage – caricatures of Nazis, etc. The British and American ones I saw are pretty dull."[69] Unlike many American posters, Soviet designs had no comic hero. American humor could not capture the antagonism and disgust, the enmity and scorn, conveyed by Soviet posters.

The evocative and unusual nature of Soviet posters trickling into the United States was observed in many articles in 1941–42. These laud the pointed visual compositions of Soviet posters – their ability to communicate forcefully, incite action, and foment hatred of the enemy. As allies of the Soviets, Americans were able to praise these posters' effective designs and adopt persuasive image strategies from Soviet artists, even when those approaches grew from a still-suspect social system. Critics admired Soviet posters for their organizational structure and ideological impact as well as for their designs:

In the creation of the sort of posters we need, the Soviets have a twenty-year lead on us. While we were selling breakfast foods, they were selling a new way of life.… Artistic standards have rarely been neglected in their design – the high aesthetic content helps the effectiveness.… Russian posters by their directness can provoke, inspire, amuse, impel, awe and instruct without so much as a word of text. And they kill Germans.[70]

The assertion that posters should have the capacity to kill Germans, which raised the bar for designers and audiences on both sides of the Atlantic,

was made by J. B. Nicholas, chairman of London's Advertising Service Guild, in the May 1942 issue of *Art & Industry*. He said that a war poster "is not a picture to sell pills, but to save civilization…. Posters, however clever, are a waste of paper unless they kill Germans." By the spring of 1942, the Soviet Union possessed the only beseiged capital on the European continent that had not fallen. With the severe weakening of Hitler's armies in Russia, the powerful Soviet designs of the Moscow studios were seen as instrumental in literally defeating the enemy.

It was not just the TASS posters' unusual approach to satire that struck American audiences; their medium also made an impact. The extraordinary potential for color and palpable surface texture in stencil-based media, as well as the technical and economic ease of foregoing lithographic presses, dramatically increased their appeal and the appeal of related practices, such as silkscreen, at the end of the Depression.[71] By the time of the United States' entry into the war, the popularity of silkscreen as a medium was at its height.[72] Published in 1942, *Silk Screen Stenciling as a Fine Art* lauded the technique of the TASS studio. Proclaiming modern silkscreen stenciling "the American development of this process that is of revolutionary importance" in the introduction to the book, Kent drew a direct line from Russian to American production. Silkscreen combined the "spirit and freshness of the original" with the urgency and wide exposure of mass reproduction at street level.[73] The perceived connection between the "distinctly American and democratic" silkscreen medium and the similar design approach employed in TASS posters to some degree effaced the sense of national and political difference that had separated American and Soviet art in the past.[74]

CONFLICTS BETWEEN ART AND ADVERTISING SPLIT OWI

Despite the seemingly cogent and purposeful expression of some of OWI's goals for graphic design, the office was rife with disagreement between 1942 and 1943. At the root of the discord was a power struggle between staff contingents endorsing a fine-art approach, on one hand, and

Fig. 57 Ben Shahn
(American, 1898–1969)
This Is Nazi Brutality,
1942
Publisher: OWI, US
Government Printing
Office

Offset lithograph
96.8 × 71.4 cm
The Art Institute of
Chicago, Mr. and Mrs.
T. Stanton Armour Fund,
2008.213
In exhibition

those favoring a commercial one on the other. Posters by academically trained artists like Ben Shahn were criticized as "unattractive" by Price Gilbert, former vice president of Coca-Cola, who was brought in to head the Bureau of Graphics and Printing. The changing of the guard at OWI ushered in a new "Madison Avenue" approach to the war – mobilizing the principles of business and advertising for defense images.[75] After the mass resignation of OWI staff writers in April 1943,

"so completely, in fact, did advertising take over OWI, and so increasingly did the latter's operations come to resemble the work of the Advertising Council, that the concept of government war information lost all coherence."[76] This had, in fact, long been a conflict between the worlds of fine art and advertising design, and in the corporations, institutions, and government branches that sought their images in the service of defense.

Despite these conflicts, fine artists continued to create powerful poster designs. Ben Shahn's *This Is Nazi Brutality* (fig. 57) was one of only two works by Shahn printed for OWI. In this image, inspired by the destruction of Lidice, Czechoslovakia, an industrial village razed by the Nazis in retaliation for the 1942 shooting of Nazi official Reinhard Heydrich, Shahn portrayed a cornered man cloaked in a hood, fists clenched and enchained, standing against a high brick wall. The very low angle evokes a feeling of claustrophobia and renders the looming captive monumental. To reinforce the documentary sentiment of the poster design, a text in telegram format runs across the torso of the figure.

The design's challengers thought the grittiness, confrontation of atrocity, understated sentiment, vertiginous perspective, angularity, and modernist articulation of form would make it inaccessible to a lay audience. OWI's Gilbert preferred Norman Rockwell's familiar realism – the agency published millions of copies of his *Four Freedoms* (fig. 58). Realism, in this sense, signified a design vocabulary more than it did a factual approach to the fears and losses of the war. A poster's language, Gilbert insisted, must be simple and direct, because "high-sounding" words would lose the prospective audience. Shahn and Brennan objected to reducing theme, design, and content to a digestible level for the American populace, and they composed a poster protesting the selling out of OWI graphics. Mocking Gilbert's former role at Coca-Cola, Shahn and Brennan's poster design (now lost) allegedly depicted the Statue of Liberty, arm upraised, carrying not a torch but four frosty bottles of Coca-Cola, with the motto "The War That Refreshes: The Four Delicious Freedoms!"[77]

Following the attack on Pearl Harbor, Thomas Hart Benton, a stalwart figure in the WPA-driven social realism and Regionalism of the 1930s, began to doubt the ability of the New Deal to effect any real social change. In 1942 the disillusioned artist sequestered himself in his studio and produced eight grim paintings, the series *The Year of Peril* (see fig. 59). Benton's intervention sits at the crossroads of American social-realist practice and the stylistic debates over images in the service

Fig. 58 Norman Rockwell
(American, 1894–1978)
*Four Freedoms: Save
Freedom of Speech, Save
Freedom of Worship,
Freedom from Want,
Freedom from Fear*, 1943

Offset lithographs
Each: 71 × 51 cm
Northwestern University
Library
In exhibition

Fig. 59 Thomas Hart ·
Benton (American, 1889–
1975)
Exterminate!, 1942

Oil on canvas
248 × 183 cm
State Historical Society
of Missouri
In exhibition

of warfare. His images and words, published in a magazine describing the series, leave no doubt as to his own opinion:

There are no bathing beauties dressed up in soldier outfits in these pictures. There are no silk-stockinged legs. There are no pretty boys out of collar advertisements to suggest that this war is a gigolo party. There is no glossing over of the kind of hard ferocity that men must have to beat down the evil that is now upon us. There is no hiding of the fact that War is killing the grim will to kill. In these designs there is none of the pollyanna fat that the American people are in the habit of being fed.[78]

Eschewing social realism, *The Year of Peril* paintings display drama and grotesquery heightened through exaggerated features, symbolism, vibrant color, and monumentality. The works' dramatic scale and expression of fierce hatred correlate with the TASS posters. However, Benton's depiction of a massive, terrifying enemy and diminutive but plucky American soldiers is the opposite of the typical Soviet approach, which sought to aggrandize the Red Army through Socialist Realism and belittle the enemy through demeaning and dehumanizing caricature. Though some of the TASS posters are horrifying, they leave no doubt as to the ability of Soviet good to conquer Fascist evil.

VOKS 1942 CAMPAIGN

In 1942, as the stylistic debates over American war posters intensified, the TASS studio boosted operations, increasing production from one hundred and fifty stenciled copies per poster to three hundred in the beginning of February 1942 and four hundred by the end of March, with some editions of five hundred produced by late April. VOKS, in turn, also broadened its efforts, increasing and adjusting its international distribution of TASS posters. It began to ship abroad fully assembled TASS posters stenciled on cheaper and less sturdy newsprint than the exhibition-prepped panels that had been mailed to the United States in 1941. These were folded into packages instead of being sent as sectioned exhibition panels as they had been previously. Inaugural shipments of the new poster type, containing three posters apiece, were sent to the Smithsonian Institution, MoMA, the Art Institute, and presumably elsewhere in mid-summer 1942. The first TASS posters that the Art Institute received were 470 (p. 212), 507 (p. 216), and 519.[79] At the turn of 1943, posters arrived in bulk at the Metropolitan Museum and the Art Institute.[80]

Both MoMA and the Metropolitan Museum mounted large-scale Soviet exhibitions in 1943 featuring TASS posters. The Metropolitan Museum was unsuccessfully solicited on a few occasions to mount a Soviet poster exhibition by RWR and ARI before formulating *The Soviet Artist in Wartime* with the National Council of American-Soviet Friendship and the Library of Congress.[81] This exhibition appeared at the Metropolitan Museum even before the institution received sixty TASS posters from VOKS, which were accessioned in March 1944.[82] One of the few American publications on the TASS posters came out of these collaborations. In 1945 the Metropolitan Museum, in conjunction with RWR, published a reduced-size portfolio of TASS images printed with English translations, with a foreword written by Director Francis Henry Taylor, no doubt as a component of RWR's fundraising campaign.[83]

In 1943 MoMA assembled *War Posters and Cartoons of the USSR*, which was composed of forty-three works on loan from the Soviet embassy in Washington, D.C., some TASS posters sent directly to MoMA by VOKS, and others from the collection of Joseph D. Stamm. Though MoMA had been receiving works from VOKS since December 1941, only two TASS posters belonging to the museum were displayed in the exhibition. The full-size TASS posters exhibited include 86 and 177 (pp. 186–88) (courtesy of the embassy) and 507 and 514 (from MOMA's summer 1942 VOKS shipment); the remainder, a selection of reduced lithographic posters (what MoMA records call "handbills"), came from Stamm.[84] A member of the United States Navy Reserves, Stamm had accompanied Joseph B. Davies – of *Mission to Moscow* fame – as a naval aide on his second trip to Russia and acquired a group of posters.

The Art Institute also mounted an early exhibition of Soviet war posters in 1942. The works shown were lent by the Chicago Forum for Russian Affairs, as the exhibition preceded the museum's receipt of the first TASS shipment by about six months. Though 157 TASS posters entered the Art Institute's collection after this inaugural show, they were not displayed at the museum until the 2011 exhibition that occasioned the present publication.

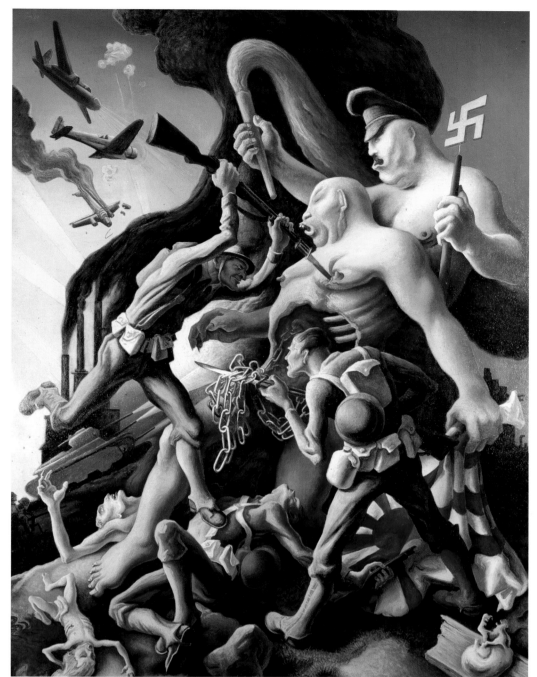

59

Fig. 60 Artist unknown
(American)
*Peace – We Won It
Together, Let's Keep It
Together*, 1945
Publisher: Orientation
Branch, Information
and Education Division,

Theater Service Forces,
European Theater
Offset lithograph
48.5 × 61 cm
William Cellini Jr.
Collection
In exhibition

Fig. 61 Nikolai Dolgorukov
Every Dollar Is Sullied . . .,
1946
Publisher: Iskusstvo
Edition: 100,000

Offset lithograph
89.5 × 60 cm
Ne boltai! Collection
In exhibition

60

CONCLUSION

The onset of the Cold War meant that much of
the evidence of the optimism (see fig. 60), visual
dialogue, and political sympathy fostered between
the United States and the Soviet Union in 1941–45
would be buried for decades. With the hysteria and
fearmongering of the Cold War amplifying actual
espionage and violence, the alliance between the
Soviets and Americans was quickly forgotten on
both sides (see fig. 61).[85] Both historical distance
and the breakdown of oppositional rhetoric fol-
lowing the 1991 collapse of the Soviet Union have
enabled new information to surface and evalua-
tions to take place. The perception that the war
years, a brief moment of alliance in a century of
contestation, were devoid of cultural dialogue can
now be reassessed. Virtually unknown, or unre-
membered, in the United States until now, the
story of the impressive and evocative TASS poster
series fills what was previously a historical omis-
sion. The massive distribution and exposure effort
in the United States sheds light on international
exchange, leftist cultural activity during the war,
institutional participation, and controversies over
American poster design.

The TASS series represents one of the last initia-
tives of visual-arts exchange between the United
States and the Soviet Union before the Cold War, at
least until the slow onset of the thaw in relations
after 1956. As such it is an exemplary case study
of the imaging and outreach of a partnership long
neglected. It helps to expose the fact that the blur-
ring of the realms of fine art and propaganda, the
question of creative ingenuity, and the "democra-
tizing" of media and style were issues that affected
artistic practice on both sides of the divide. The
opportunity to examine these foundations anew
illuminates hidden corners of our collective history
and perhaps helps to dislodge the recalcitrant
cultural polarity that plagued much of the rest of
the twentieth century.

61

We are dazzled by the carrion-crows,
By the black letter-ravens
The sky became hoarse with the lies
Of the belligerents.

To destroy the bloom of youth
The war is producing militant lies
like a louse,
Packed in the underwear of dirty newspapers.

Vermin is breeding
It crawls from brain to brain
Infecting people with crazy ravings,
As if by typhus today.
Bitten by bloodsuckers
A nation is attacking another nation
And calling its own killers – heroes
(And cursing the foreign killer).

Mikhail Zinkevich, "The Lies of War" (1941–42)

In 1944 Osip Brik, literary editor of the TASS studio and former leading theorist of the avant-garde group Left Front of the Arts (LEF) – which had included such figures as the poet Vladimir Maiakovskii, artists Aleksandr Rodchenko and Varvara Stepanova, and writer and theorist Sergei Tret'iakov – published the essay "Painting Went out into the Street." The text, which appeared on the pages of the literary magazine *Znamia*, represented not just the meditations of a former champion of radical art now serving as an official in a propaganda outlet. In effect, it sought to protect the TASS studio and thus Brik's own post in the operation, which by the second half of 1944 were in a shaky position. Brik decided that the easiest way to save the "poster factory" was to stress the uniqueness of both the operation and its products.

Seeking to justify the production of TASS posters as a singular artistic experiment with specific application to the political exigencies of the time, Brik rejected what he called "the popular view concerning the specific nature of poster art."[1] He believed that discussions of "specificity," or the qualities that were seen to distinguish the poster from other art forms, were instigated by trained poster artists trying to protect what they saw as their domain from dangerous newcomers such as painters, who during the war became active in the production of propaganda posters. Brik wrote, "As a rule, the specificity of the poster is sought in certain generalizations about [this art form]: schematic style, heightened emotionality."[2] Yet such qualities were, Brik believed, typical of both posters and easel paintings; the only genuinely distinctive feature of the poster was the relative rapidity of its production.

Brik asserted that the creators of TASS posters, many of whom had no experience in graphic arts prior to World War II, did not mimic the conventions of poster style, according to which, in his opinion, forms were reduced to generalization and schematization. Rather, they tried to enrich posters with painterly devices, thereby elevating them above mere design to the level of paintings. The democratization of painting through replication and the adoption of its principal devices by so-called lower art forms became main characteristics of TASS posters, distinguishing them from typical "specific posters," a term Brik used to describe the mass-produced, conventionally printed examples issued by major publishing houses.[3]

The widespread dissemination of painting was made possible not only by the TASS posters, which often brilliantly replicated the painterly manner of their creators, but also by the efforts of the TASS workshop, which tried "to capture individual pictorial style in its completeness, accomplishing in the handmade stenciled translation of the exact copy of the painting-poster not a printed reproduction, but a kind of 'multiplied original.'"[4] The studio's use of stencils distinguished its posters from the products of most Soviet printing houses. The hand-painting involved in stenciling afforded artists the opportunity to develop a rich palette of bright colors that could not have been realized through lithography. Utilizing an extremely complicated production technique employing numerous stencils, the TASS studio created sophisticated posters intended to reproduce painterly effects rather than simply achieve technical and aesthetic economy, as the ROSTA studio had employed stencils to do in its Civil War posters.

Such a transformation of painting to poster, in Brik's opinion, continued the tradition of the first period of the TASS operation – from June 1941 to the fall of that year – when framed easel paintings were exhibited in the windows of the TASS studio on Kuznetskii Most. He argued provocatively that these individual paintings were "true posters" because "their ideological clarity and the precise correlation of the image and the slogan-captions attached to their frames guaranteed the necessary intensity of agitational impact" required by the circumstances of war.[5]

In the functional hierarchy of visual-propaganda genres, Brik situated TASS posters somewhere between newspaper cartoons, which could be published immediately, and conventionally printed posters, whose long production cycle prevented them from rapidly addressing the burning issues of the day.[6] In general, he saw traditional poster art's constant manipulation of the same repertory of images as a major limitation. The inventiveness of true poster artists resided in their ability to discover new variations, rejecting "minor, topical details" and creating a "generalized poster" in order to locate "universal images" in topicality.[7]

The aim of Brik's article was to demonstrate the continuing need for TASS posters. In his view, the labor-intensive method of stencil reproduction utilized by the TASS studio ensured the posters' high artistic value. The hybrid of painting and poster produced in the TASS studio was effective because it went against the grain of mechanical reproduction; instead of faceless copies printed in enormous editions by large publishing houses, each TASS poster was a "multiplied original." Juggling

Fig. 1 KGK Brigade (Viktor Koretskii, Vera Gitsevich [born Moscow, 1897; died Moscow, 1976], Boris Knoblok [born 1903; died 1984])

Woman Delegate, Stand to the Fore!, 1931
Publisher: Izogiz
Edition: 20,000
Offset lithograph
100.5 × 70 cm
Ne boltai! Collection

Fig. 2 Vladimir Khvostenko (born 1899; died 1979)
Arrival of Lenin in Petrograd, 1930
Publisher: Gosudarstvennoe Izdatel'stvo

Edition: 30,000
Offset lithograph
71 × 88.9 cm
Hoover Institution Archives, Stanford University

the Socialist Realist construction of high and low art forms, Brik tried not only to coin the term *poster-painting* but also to position TASS posters on the hierarchical ladder of Soviet arts, placing them above conventional posters and below paintings.

But in fact Brik's argument was weak. By 1944 the topicality of TASS posters was visibly waning, giving way to typical Socialist Realist compositions not altogether different from the imagery of "specific posters." Like conventionally printed examples, TASS posters increasingly addressed "timeless" topics, such as heroic labor on the home front, and employed clichés not connected to actual events but instead belonging to the corpus of visual mantras of Soviet agitprop.

THE PRE-TASS HISTORY OF THE SOVIET POSTER

AGITATIONAL PAINTING

During the mid-1920s, realist artists tried to transform their easel creations into monumental posters, hoping that their ideological subjects would

give painting a new role in the Soviet state. Heroic realism, a term coined by the Association of Artists of Revolutionary Russia (AKhRR) theorists in the first half of the 1920s to describe the new painting style promoted by the association, had to be transformed into a propaganda device. As AKhRR explained, "In the hands of proletarians, easel art is becoming a powerful agitational weapon of emotional influence on the masses."[8]

Critics on the Left dismissed the effort to turn traditional painting into an agitational (activist) tool, however. In 1924 Brik himself had written:

All attempts to transform easel painting into agitational painting [agitkartina] are fruitless. Not because it is impossible to find a gifted artist, but because it is impossible by definition. The easel painting is designed for long-term existence, for years and even centuries. But what agitational topic can survive such a period? What agitational painting will not become outdated in a month's time? And if a topic of agitational painting were to become outdated, what would remain of it? It's impossible to treat short-term topics through devices designed for long-term existence. It's likewise impossible to construct a day-long topic to last for centuries. For this reason, agitational painting can't compete with

the agitational poster [agitplakat]; for this reason, there are no good agitational paintings.[9]

This opinion contrasts significantly with that expressed in Brik's essay "Painting Went out into the Street," written twenty years later, after he had become a member of the TASS studio. Indeed, a shift in attitudes toward agitational paintings, even among those associated with the artistic Left, had taken place throughout the Soviet Union by the early 1930s. In 1931 Pavel Novitskii, the former rector of the Higher Art and Technical Institute (VKhUTEIN),[10] stated, "From a delicate tool of expression of the inner world of the individual, painting was transformed into a tool for mass political agitation, a medium for the artistic design of mass agitational campaigns."[11]

While agitational paintings played an important role in this change, "timeless" propaganda images continued to dominate posters dedicated to the events of the day. By the late 1920s and early 1930s, these images were being used not only in the works of AKhRR realists but also in those of such photomontage artists as Gustav Klutsis, who often attempted to transform his large-scale posters into monumental paintings.[12]

1

2

Fig. 3 Gustav Klutsis (born Koni parish, Latvia, 1895; died Moscow, 1938) *Stalin*, 1930s

Photomontage with gouache
34 × 54 cm
Ne boltai! Collection

Fig. 4 Artist unknown (Russian) *The Storm of Trapezund*, c. 1915 Publisher: I. A. Morozov Edition: unknown

Chromolithograph
66 × 83.8 cm
Hoover Institution Archives, Stanford University

During the Cultural Revolution and the First Five-Year Plan (1928–32), as the New Economic Policy was curtailed and supplanted by rapid industrialization and forced collectivization, the poster had played a leading role in Soviet art. Although poster production of the late 1920s and early 1930s was dominated by photomontage, artists practicing other techniques were mobilized to take part in the propaganda campaign. Indeed, posters were so important for the Soviet ideological apparatus that in March 1931 the Central Committee of the Communist Party issued a special resolution, placing the production of visual propaganda under the strict control of the Central Committee and Main Directorate for Literary and Publishing Affairs (Glavlit).[13]

PAINTING INTO POSTER: THE SOVIET LUBOK

Since the mid-1920s, the struggle in the Soviet Union between Constructivists and the traditional realist painters connected with AKhRR had been mainly expressed in the debate about the efficiency of different forms of image production.[14] The Constructivists – who not only introduced

photomontage as a medium, but also swiftly transformed it into an efficient propaganda tool – glorified the economy of the photograph and the ease of making photomontage (see fig. 3).[15] Realist painters faced serious difficulties in justifying their painterly exercises in the same way. The dissemination of painting through exhibitions could not compete with the striking circulation of rapidly printed photomontages (see fig. 1).[16] Thus, AKhRR developed innovative means of distributing the canvases created by its members, transforming these paintings into posters through reproduction and the addition of captions.[17]

From the mid-1920s to the early 1930s, AKhRR disseminated hundreds of easel paintings as offset color reproductions, usually supplemented with prose or versified captions explaining their ideological content (see fig. 2).[18] Such reproductions were called Soviet *lubki*, although they were only distantly related to the traditional Russian folk pictures of this name. Indeed, any resemblance to that artistic tradition was to the late-nineteenth-century comercially printed *lubok* (see fig. 4),[19] which was quite distinct from the seventeenth- and eighteenth-century Russian folk prints that had strongly influenced the propaganda *lubki* produced by Maiakovskii and Kazimir Malevich (see

figs. 5, 7) during World War I, as well as the ROSTA posters of the Civil War period. In Russian tradition, the word *lubok* had multiple meanings: originally, it was used to define traditional folk pictures; in the second half of the nineteenth century, when *lubki* began to be produced commercially, however, the word became synonymous with low taste, vulgarity, and kitsch. In its AKhRR incarnation, the Soviet *lubok*, which drew on the term's original meaning, gave the works of the association's members a peculiar double life. Their paintings existed as paintings, adorning exhibition halls, and as small-scale prints that bore captions, were widely distributed, and achieved broad popularity. In this way, the same medium united both high and low art forms.[20] This approach was quite innovative; before the Revolution, reproductions of paintings, which appeared in popular magazines and as postcards, had not had such extensive circulation. The AKhRR involvement with Soviet *lubki*, however, transformed easel painting into the propaganda poster through the addition of a discursive caption. In a sense, the Soviet *lubok* was the direct predecessor of the heroic TASS easel paintings.

Colorful reproductions of genre paintings depicting happy harvesting on collective farms and heroic cavalry battles (see fig. 6),[21] Soviet *lubki* were used

3

4

Fig. 5 Kazimir Malevich
(born Kiev, Ukraine, 1879;
died Leningrad, 1935)
*Into Wagons of the
French, German Corpses
Were Tightly Wrenched;
Their English Brothers
Carried Kegs Stuffed with
Germans Who Lost Their
Legs*, c. 1914
Publisher:
Segodniashnii lubok
Edition: unknown
Color lithograph
40.1 × 58.5 cm
The Art Institute of
Chicago, Edward E. Ayer
Fund in Memory of
Charles L. Hutchinson,
2009.281
In exhibition

Fig. 6 Mikhail Avilov (born
St. Petersburg, 1882; died
Leningrad, 1954)
*Battle with Vrangel
Troops*, late 1920s/
early 1930s
Publisher:
Gosudarstvennoe
Izdatel'stvo
Edition: 50,000
Offset lithograph
45.7 × 58 cm
Hoover Institution
Archives, Stanford
University

Fig. 7 Vladimir
Maiakovskii
*For an Entire Month the
Turks Did Float, beneath
a Crescent Moon; but Like
the Turks in the City Sinop
They Didn't Forsee the
Flood*, c. 1914
Publisher: Segodniashnii
lubok
Edition: unknown
Color lithograph
55.7 × 37.6 cm
The Art Institute of
Chicago, Wirt D. Walker
Trust, 2009.279
In exhibition

by peasants and workers as affordable decoration for both village huts and proletarian living quarters, not only for their ideological content, but also for their attractive and understandable imagery. Their lower-middle-class appeal made them more popular than the ideological and more formally experimental Constructivist photomontage posters. The use of color printing also made Soviet *lubki* more engaging than the black, red, and gray Constructivist prints.[22] The only unresolved issue of the AKhRR reproduction efforts was size. Soviet *lubki* were modest in scale, as the printing technology of the time only permitted color printing in small formats, thereby making it impossible to infuse reproductions with the monumental quality of the large-scale originals.

5

6

THE RESURGENCE OF EASEL PAINTING

In the late 1930s, after Socialist Realism was declared the only valid artistic method in the Soviet Union, the traditional nineteenth-century hierarchy of artistic genres was revived – with easel painting again regarded as the highest form of visual art.[23] Posters, still important for political propaganda, were now treated as a secondary genre. Although this period was marked by an attempt to create Soviet mass culture, partly based on the American model, this could not compete with the high arts, which in the second half of the 1930s became an integral element of the new Soviet ideological program. The construction of the Palace of Soviets[24] and the All-Union Agricultural Exhibition of 1939,[25] the opening of the first line of the Moscow subway on May 15, 1935,[26] and the other colossal architectural projects of the period were collectively treated as the highest state priority and conceived as the material manifestation of the triumph of Socialism, placing the goal of synthesizing the arts on the nation's agenda.[27] The desired union of architecture, painting, and sculpture was a more important concern than such "applied-art" disciplines as poster art. The poster could only poorly reflect the grand aspirations of the frescoes of the marble palaces of Socialism.

A NATION AT WAR: THE POSTER MAKES A COMEBACK

One of the traditional poster's notable strengths was its ability to portray enemies in a way that easel paintings could not. Tret'iakov believed that

Fig. 13 Viktor Koretskii
*Partisans Beat the Enemy
without Mercy!*, n.d.
Photomontage
17.4 × 12.5 cm
Ne boltai! Collection

Fig. 14 Viktor Ivanov and
Ashot Mirzoian
*Get the Kulak off the
Collective Farm!*, c. 1930
Publisher:
Khudozhestvennoe
izdatel'skoe AKTs. O-VO
AkhR
Edition: 20,000
Offset lithograph
50 × 69.8 cm
Swarthmore College
Peace Collection

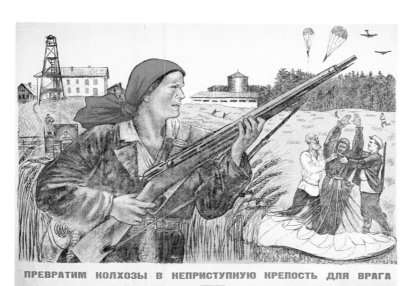

11

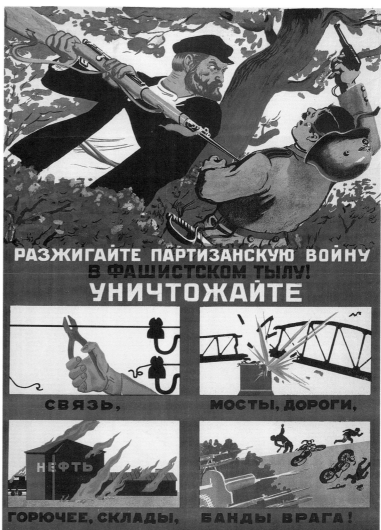

12

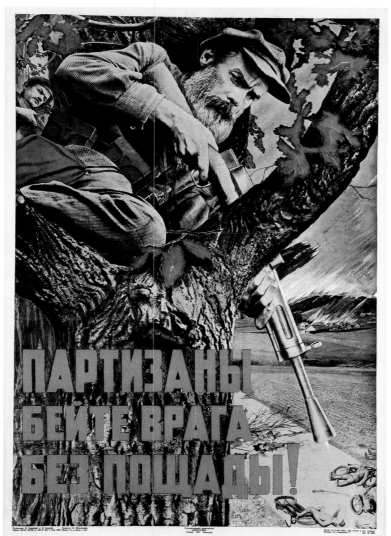

13

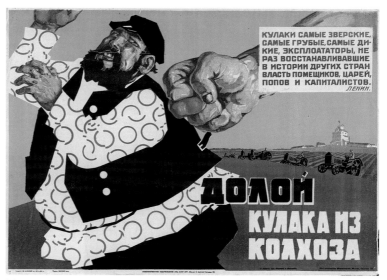

14

Fig. 15 Nikolai Zhukov
(born Moscow, 1908; died
Moscow, 1973)
Beat Them to the Death,
November 30, 1942
Publisher: Iskusstvo
Edition: 50,000
Offset lithograph
34.8 × 27.5 cm
Ne boltai! Collection
In exhibition

Fig. 16 Photographer
unknown (Soviet)
Viktor Koretskii's poster
Save Us! posted on a tree
beside a Soviet artillery
battery, 1940s
Viktor Koretskii Archive,
Ne boltai! Collection

Fig. 17 Viktor Koretskii
Save Us!, 1942
Pencil, gouache, and
collage
28.8 × 19.1 cm
Ne boltai! Collection
In exhibition

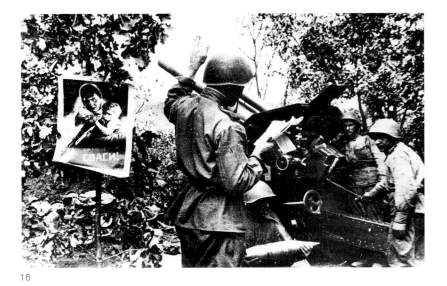

16

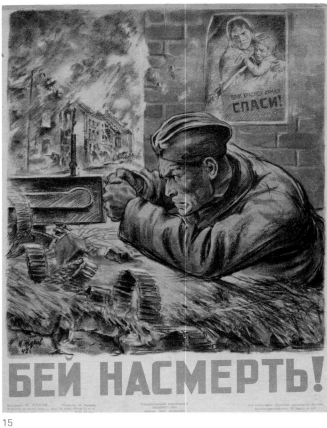

15

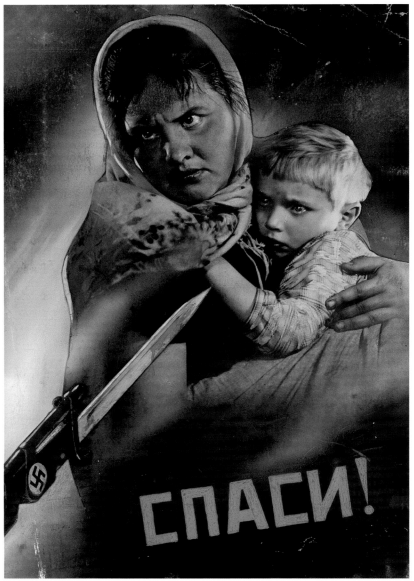

17

Soviet visual propaganda developed two leading types of partisan iconography: the poster dominated by the image of the people's avenger and the story poster, depicting heroic partisan exploits. Aleksei Kokorekin's poster *Incite Partisan War behind Fascist Lines, and Destroy the Enemy's Communications, Bridges and Roads, Fuel and Storehouses, and Bands*, published in 1941, unites both of these themes (fig. 12). The upper portion of the poster features a stereotypical bearded partisan bayoneting a Nazi officer, identifiable by his toothbrush mustache. The lower portion is divided into four panels illustrating what the partisan must destroy. These scenes recall the genre of didactic posters issued during the war by both the main publishing houses and TASS, although in Kokorekin's poster they are used not so much to instruct as to depict common partisan operations.

Narrative posters on partisan themes varied from such successful compositions as *Repayment with Interest* (TASS 191) (pp. 191–92) – created by the artistic group the Kukryniksy, with a biting poem by Samuil Marshak – to the detailed, graphic narrative *Alyosha the Scout* (TASS 191, fig. 2 [p. 192]), by Viktor Ivanov and published in 1943. In Ivanov's poster, the main hero is not the bearded partisan, but his heroic grandson, who discovers the location of enemy troops. *Alyosha the Scout* not only recalls the traditional folk-picture genre of the *lubok*, but also reflects Socialist Realism's transformation of the genre.[82]

IMAGES OF HATRED

Along with Socialist Realist imagery of partisans and various Soviet heroes, TASS posters and other forms of propaganda utilized pitiless cartoons – archetypal illustrations of hate, satirical images that were not only anti-Nazi but also openly anti-German. Writing about Soviet wartime propaganda as a whole, Argyrios Pisiotis explained:

Soviet propaganda called on soldiers and people to exterminate the Germans mercilessly, and to avenge their nation.... Furthermore, the iconography of posters reveals not only the total identifica-tion of the Nazi and the German, but also an unusually frequent depiction of Germans as low forms of life, especially rodents and insects.[83]

These images were effective at provoking Soviet hatred of the German people. In the early stages of the war, the remnants of internationalist sentiment toward the German proletariat were quickly forgotten, and the word *Nazi* soon became synonymous with *German*. In his 1942 article "Kill!," Il'ia Erenburg wrote, "We have realized that Germans are not human. From now on, the word 'German' is the most horrible curse for us.... Don't talk. Don't become indignant. Kill. If you don't kill at least one German per day, your day is lost." The writer urged, "Kill a German! – an old mother is begging you. Kill a German – a child is beseeching you. Kill a German – the native land cries."[84] Erenburg's war cry, building on that of Konstantin Simonov's May 1942 poem "Kill Him!" (p. 220), provoked a flood of images calling on Soviet soldiers to seek revenge against and exterminate Germans (see TASS 527 [pp. 217–20]). Such images were designed to have an emotional impact. They depicted tortured girlfriends and wives, tied and presumably raped by the occupiers; mothers with infants facing German guns; and dead and mutilated children. The erotic and sadistic connotations of such imagery were striking.

One of the most popular posters of this type was Koretskii's photomontage composition *Save Us!*, which depicts a terrified woman with a child in her arms facing a blood-stained bayonet marked with a swastika (fig. 17). The photomontage was featured in Nikolai Zhukov's poster *Strike to the Death*, which shows both the propaganda image itself and the action inspired by it (fig. 15). *Beat Them to the Death* depicts a Soviet machine gunner shooting fiercely; Koretskii's poster appears on the ruined wall behind him. Zhukov's poster is not so much a propaganda fantasy as a reflection of the reality of the war. Indeed, Koretskii's archive contains an anonymous photograph of a Soviet artillery battery in readiness; posted on the tree next to the cannon is his image of the frightened mother and child (fig. 16). Other depictions of Nazi brutality include Viktor Deni's *Kill the Fascist Monster* (fig. 19), which contrasts the hanged Soviet martyr Zoia (see TASS 849/849A, fig. 5 [pp. 260]) with the ugly, lustful face of a Nazi officer; Koretskii's *Death to Infanticides!* (fig. 20), featuring a little girl killed by Nazis; and Ivanov's *Private, We're Waiting for You, Days and Nights!* (fig. 18), in which weeping women in torn prison robes (the sign identifying them as "Soviet prisoners of war") call out to soldiers from behind the bars of Nazi dungeons. TASS artists made an impressive contribution to this type of propaganda, repeatedly deploying strikingly similar images of abused women and mutilated infants (see figs. 21, 23).[85] Such posters often openly appropriated Christian iconography, as in Fedor Antonov's *Mother* (TASS 564) (fig. 22).[86]

Soviet poster art had no earlier tradition of such voyeuristic depictions of human suffering. Graphic images of the victims of the Revolution and Civil War (including scenes of rape and torture) generally appeared exclusively in anti-Bolshevik visual propaganda. In the Soviet tradition, the most striking depiction of peasant torment was Dmitrii Moor's *Help!* (fig. 24), issued during the Lower Volga famine of 1921. The poster is starkly printed in black, with only the cream of the paper defining the elderly, skeletal peasant, who pleads with upraised arms. His clothes are tattered, and he is barefoot, his misshapen body accentuated by Moor's sparse, graphic drawing. Moor had originally planned to surround this hapless figure with evidence of the famine's merciless devastation but ultimately chose to emphasize the direness of the situation simply by isolating the desperate peasant and a single, desiccated stalk of wheat behind him against an empty, unbroken sea of black ink. He used a minimalist graphic language to create a powerful symbol of the famine.

The wartime avalanche of hatred continued unabated until April 14, 1945, when it was interrupted by a call to retreat issued by Georgii Aleksandrov, head of the Central Committee's Department of Agitation and Propaganda. His article in that day's issue of *Pravda* signaled a shift in political direction.[87] Aleksandrov informed the newspaper's readers that Stalin never identified "Hitler's clique with the German people" and that "our ideas don't include the annihilation of the German people." It was a bit late for such backpedaling – the burning of Königsberg (see TASS 1173 [pp. 341–42])[88] and the looting of Budapest[89] had already occurred, and the eastern part of Germany was now behind Soviet lines. Indeed, the ravaging of Berlin, which would start in May, was already a foregone conclusion at this point.[90]

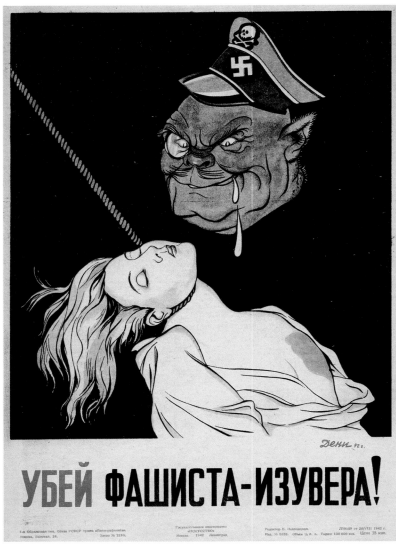

18

19

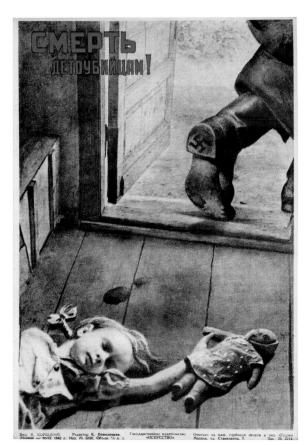

20

Fig. 18 Viktor Ivanov
Private, We're Waiting for You, Days and Nights!,
1945
Publisher: Iskusstvo
Edition: 75,000
Offset lithograph
53.5 × 79 cm
William Cellini Jr.
Collection

Fig. 19 Viktor Deni
Kill the Fascist Monster!,
August 20, 1942
Publisher: Iskusstvo
Edition: 150,000
Offset lithograph
40 × 28.6 cm
Ne boltai! Collection
In exhibition

Fig. 20 Viktor Koretskii
Death to Infanticides!,
1942
Photomontage, chalk,
gouache, white photo
paper, and wooden board
102 × 75 cm
Ne boltai! Collection

Fig. 21 Pavel Sokolov-
Skalia, with text by
Dem'ian Bednyi
Sister, Be Brave!
(TASS 752), 1943
Edition: 800
Stencil
165 × 85 cm
Ne boltai! Collection

Fig. 22 Fedor Antonov,
with text by Samuil
Marshak
Mother (TASS 564), 1943
Edition: 400
Stencil
185 × 87 cm
Ne boltai! Collection

Fig. 23 Nikolai
Denisovskii, with text by
Stepan Shchipachev
Killers (TASS 715), 1943
Edition: 600
Stencil
178 × 83 cm
Ne boltai! Collection

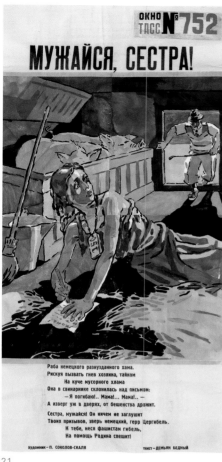

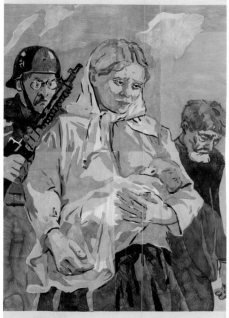

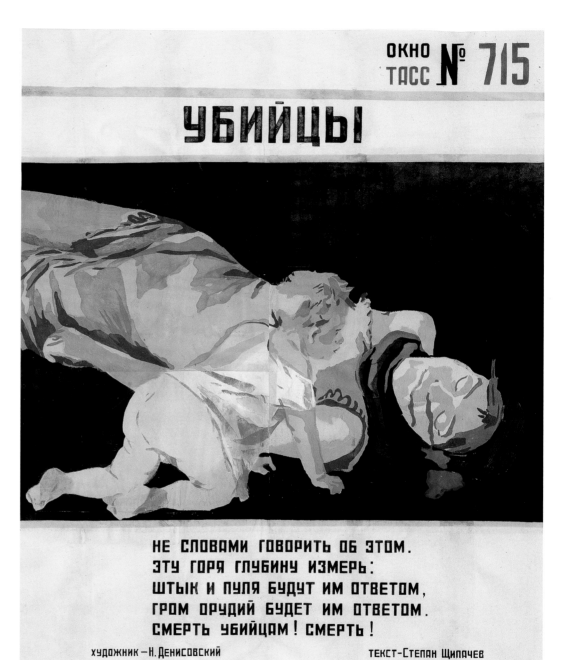

21

22

Fig. 24 Dmitrii Moor
Help!, 1921
Publisher: unknown
Edition: unknown

Offset lithograph
106 × 72 cm
Ne boltai! Collection
In exhibition

Fig. 25 Artist unknown
(German)
*Vinnitsa: Don't Forget
What Happened*, 1940s
Offset lithograph
86.5 × 59.5 cm
William Cellini Jr.
Collection

24

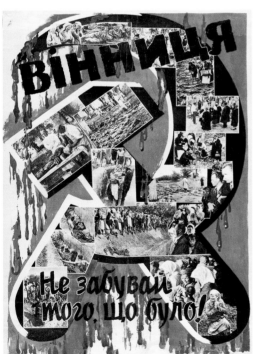

25

PERSUADING THE ENEMY

Both TASS posters and conventionally printed Soviet posters served as visual propaganda aimed at the Soviet population, not the enemy. Thus, a special propaganda organ was created for the latter audience – the flyer *Front Illustrierte Zeitung (FIZ)*, published by the Main Political Directorate of the Red Army. *FIZ* served as the primary propaganda vehicle directed at German and other Axis troops. The very name of the publication deliberately recalled the title of the magazine *Arbeiter Illustrierte Zeitung (AIZ)*. (Published by the German Communist Party with the support of the Soviet Union, *AIZ* became famous worldwide for its publication of John Heartfield's photomontages in the 1920s.) *FIZ*, a broadsheet printed on an irregular basis from 1941 to 1944, mainly contained photographs with minimal text encouraging enemy forces to surrender. Issues of *FIZ* were packed into bomb casings specially made by the Soviet air force, and dropped over enemy lines.[91]

The wartime broadsheet continued the photomontage tradition through its inclusion of grotesque images by Aleksandr Zhitomirskii, whom Heartfield described in 1961 as his best pupil and follower.[92] In addition to photomontage, the leaflet used photographs produced by such figures as Arkadii Shaikhet and Semen Fridliand, who had previously been associated with avant-garde photography. *FIZ*'s layout recalled that of Soviet Constructivist publications.[93] In sharp contrast to the equation of Nazis to other Germans in TASS posters, *FIZ* illustrated macabre, Heartfield-like photomontages of the Nazi leadership (see fig. 28) alongside images of simple German soldiers being used as cannon fodder (see fig. 29).[94]

To demonstrate to enemy troops the senselessness of this bloodshed, *FIZ* published letters and photographs of loved ones allegedly found in the pockets of dead Germans. Special issues of *FIZ* were dedicated to the happy lives of the German prisoners of war in Russian camps. In *FIZ*, Soviet propaganda was translated into the language of international modernism with a strong, albeit rather old-fashioned, German flavor. Anti-Hitler cartoons published in *FIZ* are reminiscent of the imagery of TASS posters, and some of them may even have been inspired by the works of TASS artists. Even as he depicted Hitler as a spider or vulture sitting on human skulls, however, Zhitomirskii transformed these images into illusionary photomontages that added to the grotesque a touch of dreamlike surreality foreign to TASS caricatures.

NAZI PROPAGANDA – JEWS, BOLSHEVIKS, AND STALIN

From the beginning of the German occupation of the Soviet Union, the Nazi regime produced propaganda materials directed toward local populations. This operation was not centralized – such materials were published by different bodies in Germany and parts of the occupied territories. In places such as Latvia and Ukraine, the Nazis employed local artists and printed the texts in the countries' national languages. Nazi posters can be divided into the following categories: vicious anti-Semitic posters employing both caricature and macabre, grotesque imagery; satirical posters of Stalin (see fig. 26); posters depicting the Soviet secret police's acts of brutality, including the 1938 execution of over nine thousand political prisoners in Vinnitsa (Ukraine) (see fig. 25)[95] and the Katyn Massacre (Smolensk province, Russia) of 1940 (see fig. 27);[96] heroic posters featuring monumental figures of German soldiers protecting workers in the occupied territories (see fig. 30); images of volunteers serving in the Waffen-SS; symbols of German military might; posters calling on the population of the occupied territories to detain saboteurs (see fig. 31);[97] and iconic images of Hitler. A special group of posters was dedicated to the happy lives of Soviet citizens drafted to work in Germany. In addition to graphic posters, the Germans disseminated posters and leaflets containing series of photographic images, which served as the Nazi counterpart to the TASS photographic posters produced by Fotokhronika TASS.[98]

In many ways, the posters produced for the occupied territories adopted the tactics employed in the visual propaganda intended for Germany. In them illustrative realism highlights both the grim determination of the German effort (see fig. 32) and the plight of the non-enemy victims of the war (see fig. 33).[99] In striking contrast to the Third Reich's actual policies regarding the occupied territories, Nazi propaganda lacked any demonstrable anti-Russian or anti-Slavic sentiment; it was instead obsessively focused on Jews. Whereas German anti-Bolshevik posters from 1918 into the 1920s were dominated by the image of the brutal, unkempt, bearded Bolshevik, armed with a dagger or bomb, in the mid-1930s, this beastly creature was supplanted by the evil Jewish commissar. This

Fig. 26 Artist unknown (German) *Murderer and Arsonist Stalin Lost the Game*, 1940s

Offset lithograph Dimensions unknown

Fig. 27 Artist unknown (German) *Katyn*, 1940s Offset lithograph 42 × 29.5 cm William Cellini Jr. Collection

trend dominated Nazi propaganda throughout the war. Its later iterations are emblemized by Mjölnir's *Victory or Bolshevism!* (fig. 37). The left-hand portion of this poster features a happy German mother and an animated child bathed in sunlight. The right depicts a group of suffering civilians submerged in darkness and dominated by the gigantic head of a Jewish commissar wearing the Budenovka military hat, which had not been used by the Red Army since the 1930s. The image of the commissar is based on a photograph of a Soviet prisoner of war taken by a Nazi photographer in 1941 (see TASS 60, fig. 7 [p. 173]).

Portraits of Soviet prisoners of war – predominantly Jews and Asians – were constantly recycled in posters, pamphlets, and street displays (see fig. 35).[100] The anti-Semitic posters produced for the occupied territories often employed archaic iconography. For example, *Constitution of the USSR* (fig. 34) parodies the Soviet coat of arms – the globe adorned with a hammer and sickle in the original is transformed here into a caricature of a Jew wearing a yarmulke. Under this iconoclas-

tic version of the Soviet emblem, a train of three coaches in which corpulent Jews are seated is pulled by a pauperized Russian peasant with a hammer and sickle in his hand.[101]

Another poster produced for the Soviet occupied territories employs the motif of the troika, but instead of horses, three Russians – a peasant, a worker, and an intellectual – are harnessed side by side. In a chariot adorned with the Star of David and the letters *USSR*, Stalin mercilessly whips his "horses"; attached to the whip is the acronym for the Stalinist secret police (fig. 36). Ironically, the poster's compositional structure is mirrored in TASS 621, *The Slaveholder* (fig. 38).[102] Designed by Vladimir Milashevskii, it depicts slave laborers exerting visible effort to push heavy wheelbarrows loaded with stones. Behind them looms the menacing figure of an enormous Nazi officer with a huge belly.

Nazi visual propaganda aimed at the occupied territories was unable to compete with its Soviet counterpart in volume or quality. Nazi cartoons

of Stalin never reached the negative depths of the Soviet depictions of Nazi leaders; indeed, only Jews, a group that had been demonized in German posters since the 1930s, were portrayed as roaches and rats by Nazi artists.

THE END OF THE HYBRID GENRES

In 1943 Viktor Deni created the poster *The Red Army Broom Will Completely Sweep away the Scum* (fig. 39). The artist depicted a heroic Red Army soldier standing against the night sky, amid explosions of colorful fireworks and the red silhouette of the Kremlin. The soldier holds a rifle with a "bayonet broom" attached to its muzzle. Each bayonet contains the name of a Soviet city liberated by the Red Army – Orel, Smolensk, Briansk, Kharkov, and Stalino, among others. Using this unique instrument, the blond hero sweeps away the dwarfish Nazis, who scatter with an order signed by Hitler,

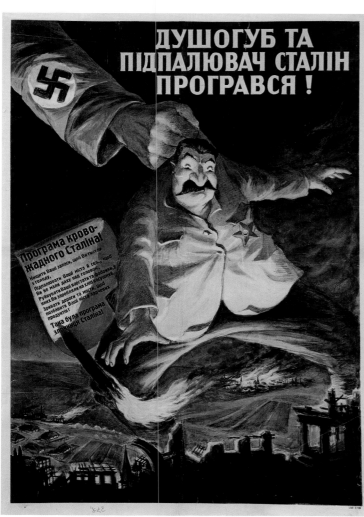

26

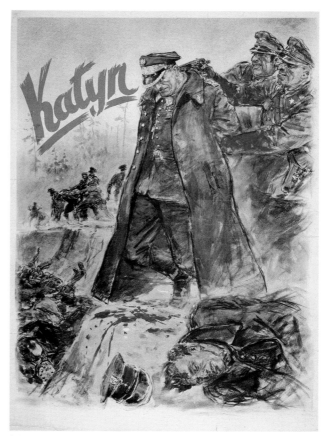

27

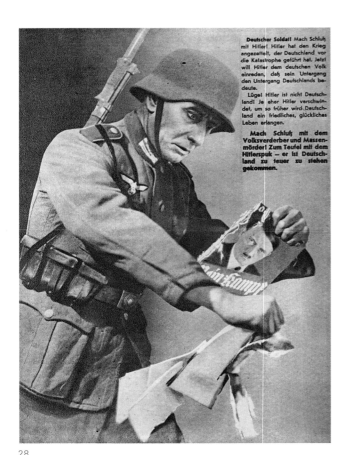

28

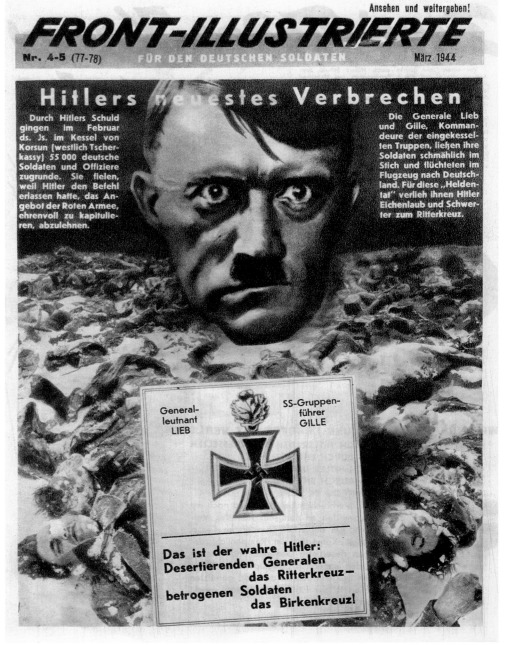

29

30

31

32

33

153

Fig. 34 Artist unknown (German)
Constitution of the USSR, 1940s
Offset lithograph
42.5 × 59.5 cm
William Cellini Jr. Collection

Fig. 35 Artist unknown (German)
Serbs, Are Those Your Brother Slavs?, 1940s
Publisher: Offsetdruck Beranek Belgrade
Edition: 15,000
Offset lithograph
83.5 × 58.5 cm
Ne boltai! Collection

Fig. 36 Artist unknown (German)
Troika Runs through Russia . . ., 1942
Offset lithograph
78.9 × 62.2 cm
William Cellini Jr. Collection
In exhibition

Fig. 37 Mjölnir (Hans Schweitzer) (German, 1901–1980)
Victory or Bolshevism!, 1943
Offset lithograph
118.4 × 80.5 cm
Los Angeles County Museum of Art
In exhibition

Fig. 38 Vladimir Milashevskii, with text by Aleksandr Zharov
The Slaveholder (TASS 621), December 14, 1942
Edition: 500
Stencil
165 × 82 cm
Ne boltai! Collection
In exhibition

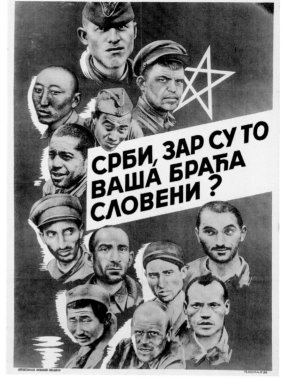

35

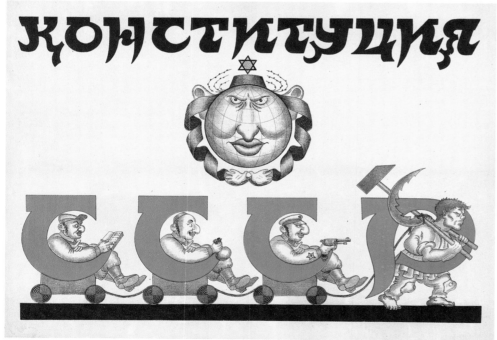

34

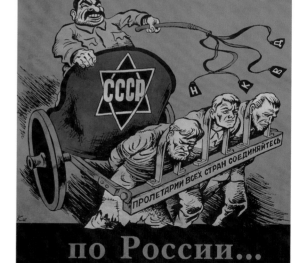

36

"Terror and Slavery for the People." The poster's geometric composition was well calculated; the gigantic figure of the Soviet soldier is balanced by two vertical elements – the Kremlin tower on the right and the Nazis on the left. The red rifle bisects the composition, forming a diagonal that runs from lower left to upper right. Deni's poster was so popular that in 1945 he again depicted the same heroic soldier now standing on a black Nazi banner and eradicating the same tiny Nazis with a gigantic ax. The 1945 version differs from the original poster in that the Red Army hero is dressed in a summer uniform, the composition is slightly modified, and

the title was changed to the past tense (*The Red Army Broom Completely Swept away the Scum*).

The year before Deni issued his remake, the TASS office released *You Reap What You Sow* (TASS 958 [p. 280]), a poster designed by Sokolov-Skalia. Irina Petrova's versified caption contrasts a peaceful, rye-sowing collective farmer with Hitler, who harvested wars and ultimately his own death. The rustic farmer appears in the left-hand portion of the Sokolov-Skalia poster. He is protected by a towering Red Army soldier, who uses the butt of his rifle to hit the grotesque figure of Hitler, seated on a heap of tanks and cannons and holding a bent dagger in his blood-spotted hand. The soldier's

rifle divides the composition in half, forming a diagonal running from the lower left to the upper right. This composition exhibits striking similarities to the Deni poster; the main difference between the two is size (Sokolov-Skalia's is larger). Despite their similarities, the conventional poster created by Deni was available to a much broader public and thus able to assert a stronger influence. Indeed, the flaw in Brik's thesis about the uniqueness of the painterly poster was his failure to acknowledge the importance of the efficiency of propaganda, which was defined not by the aesthetics of the method of reproduction but by the volume of circulation.

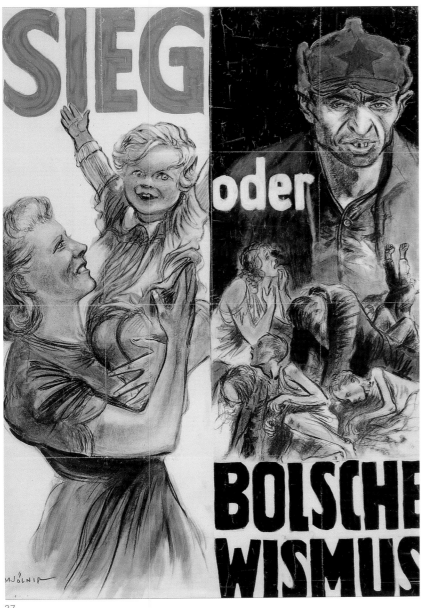

37

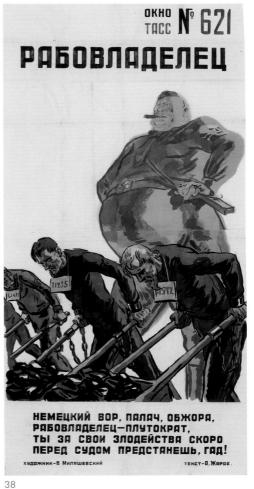

38

Fig. 39 Viktor Deni
*The Red Army Broom Will
Completely Sweep away
the Scum*, October 12,
1943

Publisher: Iskusstvo
Edition: 25,000
Offset lithograph
59.6 × 75.4 cm
Ne boltai! Collection
In exhibition

With the end of the war, the traditional themes reflected in the TASS posters were no longer relevant. Efforts to save the agency using arguments about the uniqueness of stencil reproduction, a technique that had become extremely complicated and achieved a previously unheard-of exactitude, were doomed to failure. Peacetime did not require hybrid genres; paintings left the streets and returned to the exhibition halls, including that now vacated by the TASS officials, artists, and stencil cutters. In the postwar epoch, artists returned to the time-honored medium of easel painting, which better suited the demands of idealized heroic imagery, and to propaganda posters reproduced in runs of hundreds of thousands of copies.

After the closing of the TASS studio, the operation was all but forgotten. It was not until 1965 that the Lenin Library, Moscow (now the Russian State Library), published an index of the TASS posters, giving birth to a mythic history that was later enhanced by memoirs and recollections of the participants of the studio. By the 1970s, when World War II became a part of the Soviet political religion, TASS posters were treated as canonical images, proving that when canons were speaking Soviet muses were not silent. Numerous posters created by the Kukryniksy and other TASS artists were constantly reproduced and became representations of the most merciless and destructive war of the twentieth century for generations of Soviet people. In their visual memory, Hitler remains "the raging Führer" ridiculed by the gifted TASS artists and writers.

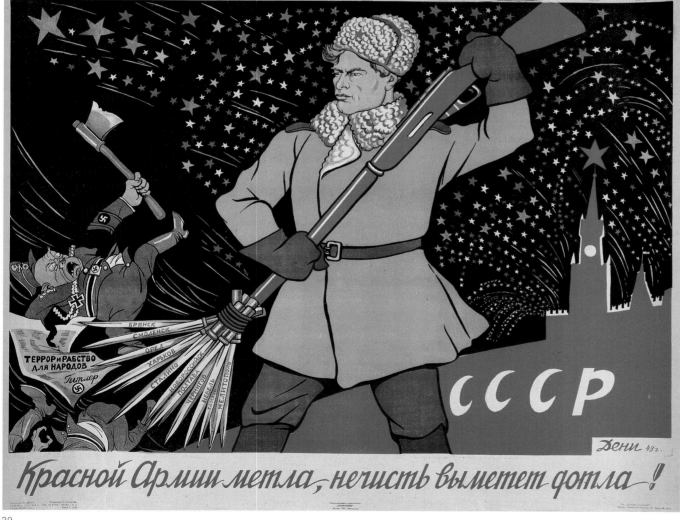

THE SUMMER SOLSTICE BONFIRE IGNITED BY
NAZI GERMANY'S INVASION OF THE SOVIET UNION
ON THE WEEKEND OF JUNE 21–22, 1941,
RAGED FOR FOUR YEARS, CAUSING APOCALYPTIC
DEVASTATION AND TAKING THE LIVES OF TENS
OF MILLIONS.

OF THE ONE THOUSAND FOUR HUNDRED AND
ELEVEN DAYS OF WAR ON THE EASTERN
FRONT, THE FOLLOWING PAGES ILLUSTRATE
ONE HUNDRED AND FIFTY-SEVEN THROUGH
A SELECTION OF TASS WINDOW POSTERS, EACH
REPRESENTING A DAY OF THE WAR.

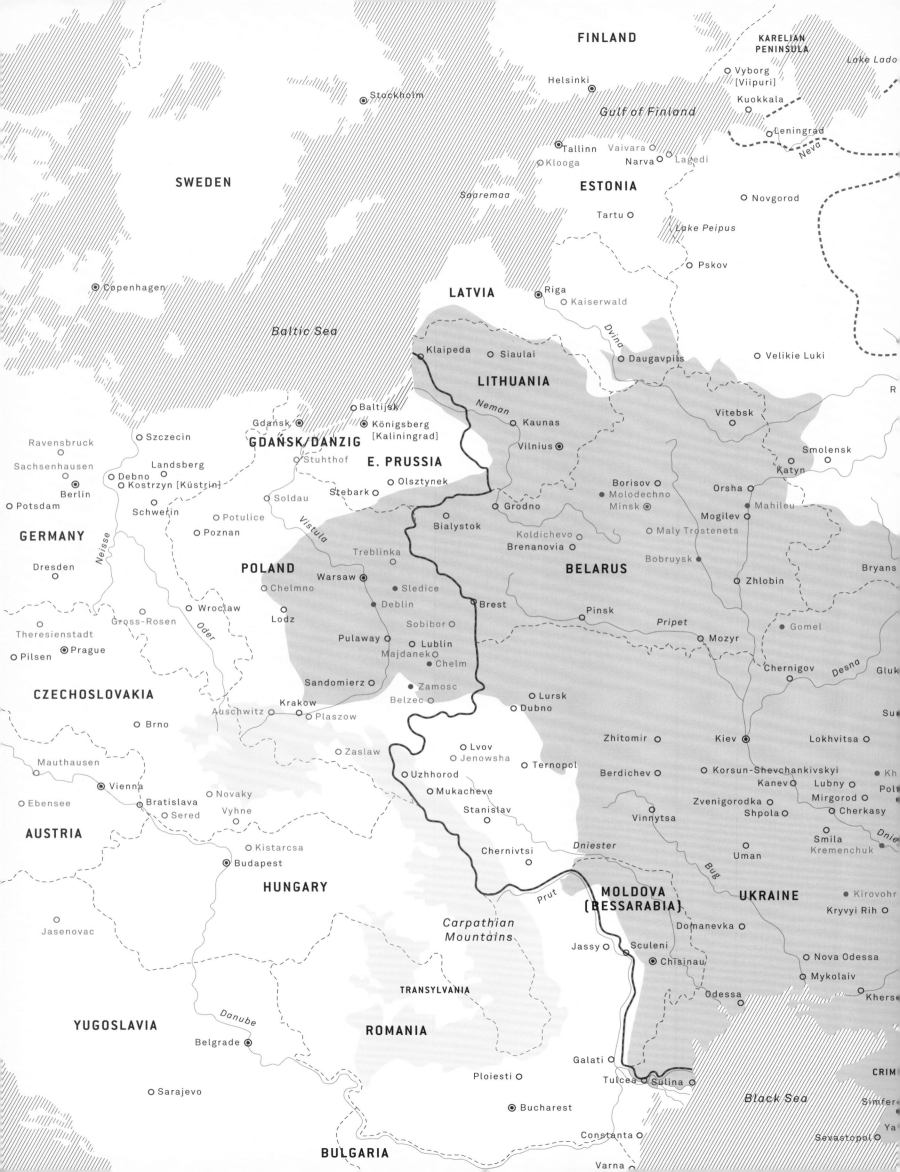

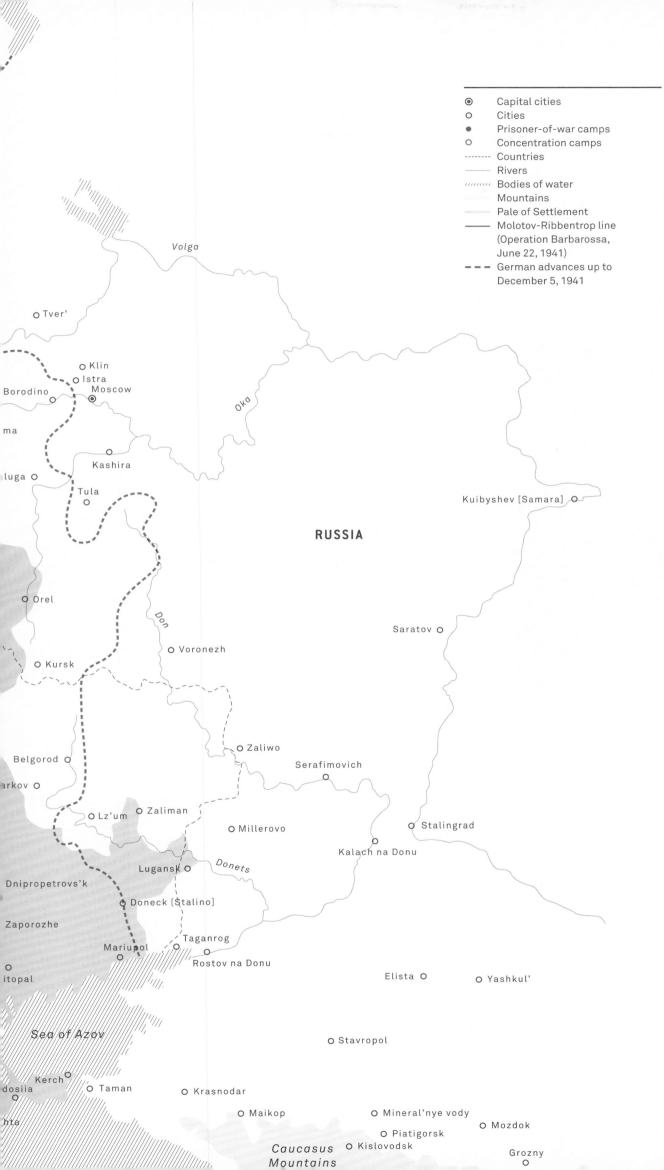

Capital cities
Cities
Prisoner-of-war camps
Concentration camps
Countries
Rivers
Bodies of water
Mountains
Pale of Settlement
Molotov-Ribbentrop line
(Operation Barbarossa,
June 22, 1941)
German advances up to
December 5, 1941

The Pale of Settlement

From 1791 until the February 1917
Revolution, Jewish residency in the
multinational Russian empire was
legally restricted to the geographical
area in European Russia designated
as the Pale of Settlement (*cherta
osedlosti*). Forbidden to reside in
Russia proper without special permits,
Jews were confined to provinces and
districts within the Pale, along with the
ethnically and nationally diverse popu-
lations of the regions that Russia
had absorbed into its empire through-
out history – Belarus, Bessarabia,
Latvia, Lithuania, Moldavia, Poland,
and Ukraine.

With parts of western Europe reconfig-
ured after the 1919 Treaty of Versailles
and the founding of the Soviet Union in
1922, the geographical area formerly
known as the Pale of Settlement – now
home to several sovereign nations –
nevertheless remained the ancestral,
religious, and cultural home of Jewish
communities, despite the freedom of
movement and social mobility that
Soviet authorities permitted and their
attempts to force cultural assimila-
tion. Because of their geographical
location and constituent populations,
the lands included in the former Pale
of Settlement were destined to suf-
fer heavily during World War II on the
Eastern Front.

Volga

Tver'

Klin
Istra
Borodino Moscow

Oka

ma

luga Kashira

Tula

Kuibyshev [Samara]

RUSSIA

Orel

Don

Kursk Voronezh

Saratov

Belgorod

arkov

Zaliwo

Serafimovich

Lz'um Zaliman

Millerovo

Stalingrad

Lugansk

Donets

Kalach na Donu

Dnipropetrovs'k

Doneck [Stalino]

Zaporozhe

Mariupol Taganrog

Rostov na Donu

Elista Yashkul'

itopal

Sea of Azov

Stavropol

Kerch

dosiia Taman Krasnodar

Maikop Mineral'nye vody

Mozdok

Piatigorsk

Caucasus Kislovodsk
Mountains Grozny

Superimposed on the United States (one-to-one scale)

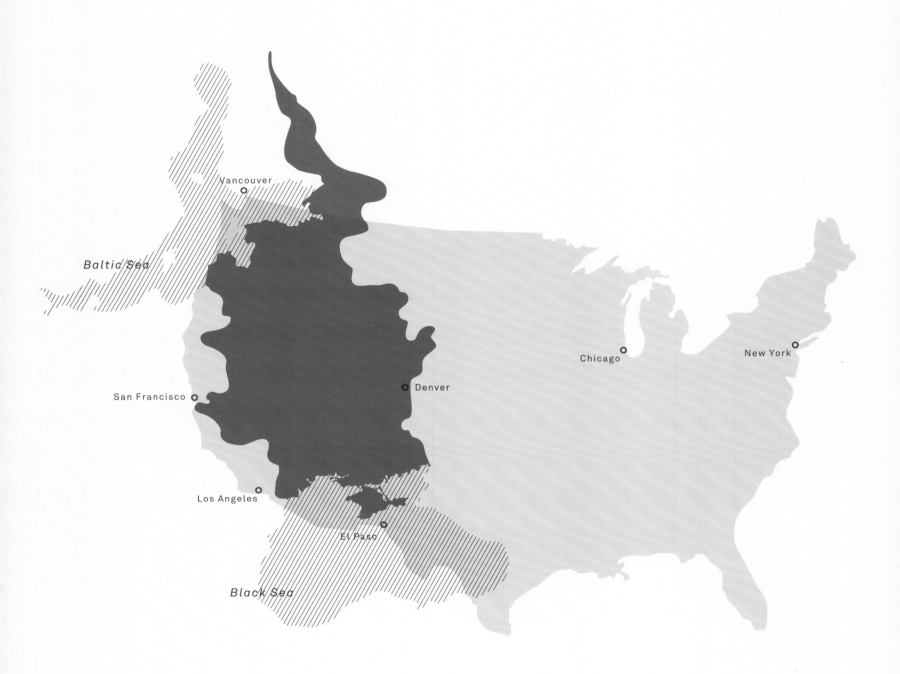

Image: Mikhail Cheremnykh
Text: Litbrigade (Nikolai Aduev[1])
Edition: 60

Stencil
200 × 86 cm
Not in exhibition

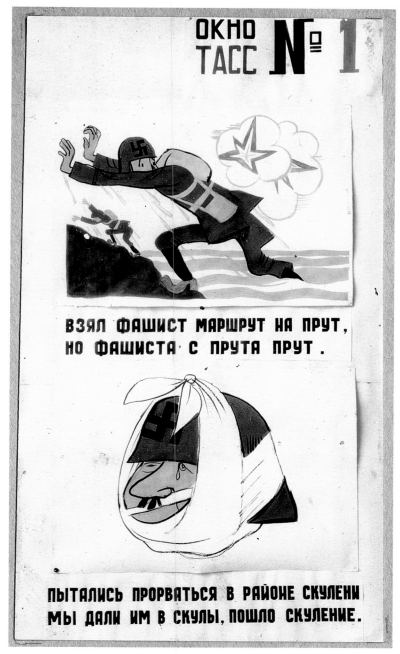

TASS 1, archival photograph, ROT Album, courtesy Ne boltai! Collection

*The Fascist took the route through Prut,
But he has been pushed back from Prut.
They tried to break through the region of
 Sculeni
We struck them in the face and they
 started whining.*

The first TASS poster, issued five days after the German invasion of the Soviet Union, depicts at top an image of two German soldiers under fire, fleeing toward the left (or west) up a river embankment. The bottom panel shows a helmeted German soldier with a Hitler-like moustache swathed in bandages. The caption refers to the Prut River, the natural demarcation line between Romania (an Axis ally) and the recently annexed territory of Bessarabia (1940), renamed the Moldavian Soviet Socialist Republic (Moldova), on the Southern Front. The Moldavian town Sculeni is situated on the Prut, north of the Romanian town of Jassy. The strategic bridgehead at Sculeni was the site of fighting between the Red Army and German-Romanian forces.

The text accompanying this poster is signed collectively by the pool of writers and poets referred to as the *Litbrigada* (literary brigade, or Litbrigade), who worked alongside the visual artists in the TASS poster studio. The notion of collective authorship was seen as an appropriate mode of cultural production in a Socialist society.[2] It also connotes folk culture, which can be considered the anonymous voice of an entire nation. This at least had been the poet Vladimir Maiakovskii's conceit in his ROSTA posters and some of his poems, such as "The Soviet ABC" (1919) and, most notably, "150,000,000" (1921), which was published without attribution.

The verse in this poster is based on untranslatable puns, a hallmark of ROSTA posters from the Civil War era (1917–23), for which Maiakovskii served as the main author and editor. The first couplet takes advantage of the coincidence between the name of the Prut and the third-person-plural, present-tense form of the Russian verb "to push" or "to shove." Employing short words and a blunt, masculine rhyme, it calls to mind the verbal experiments of Russian avant-garde poets. The second couplet, a more melodic measure, plays on the name of the town Sculeni. The Russian word *skuly* means "cheek-

bones," and the related word *skulenie* indicates the whimpering sounds dogs make when threatened.

At the start of the war, only days before this poster was issued, the Red Army Air Force bombed the bridge over the Prut, thwarting the enemy's attempts to cross the river and allowing the Soviet forces to remain in position on the river's eastern bank. By June 27, however, the bridgehead was taken by the Germans, who then secured the Sculeni region and ordered its civilian population to evacuate. In effect, the situation recorded in this poster had reversed, with the Red Army forced to withdraw.[3]

Cheremnykh founded the ROSTA studio in 1919. His simplified drawing style and the limited palette of this poster, as well as its multipanel format, relate to his early work with Maiakovskii on the ROSTA posters. As in those, the design here is informed by Russia's rich broadsheet (*lubok*) tradition, which included depictions of battles during World War I and the Civil War. A hallmark of the artist's poster oeuvre is the graphic shorthand – including pronounced contours in red, yellow, and black – that he used to create stylized images of explosions and fires. Another similarity to the ROSTA posters is that, like them, early TASS posters such as this were mounted onto a secondary support, which was not the case with later TASS posters. The elongated, vertical format seen here and in many TASS posters was determined by the actual dimensions of the variously sized windows of the ground-floor TASS studio at 11 and 20 Kuznetskii Most.

Image: Mikhail Cheremnykh
Text: Litbrigade
Edition: 100

Stencil
Panel 1: 71.6 × 97 cm; panel 2:
70 × 98 cm; panel 3: reconstruction
Ne boltai! Collection

What Hitler Wants

1. *He wants – to confiscate bread from peasantry*
2. *He wants – to give factories to the bourgeoisie*
3. *He wants – to sow the earth with graves*
4. *He wants – to turn free people into slaves*

And What He Will Get

*For every blow he will get three in return
For every fire he will get ten in return*

*He will get the bayonet, bullets and lead
He will get Fascism's inglorious end.*

In four panels, an antic Adolf Hitler is seen pursuing the aims outlined in the text. The sign Hitler holds in the first reads: "Land to the gentry." In the fifth, Hitler has been skewered by a bayonet. The rhyming couplets comprising the text serve mostly to interpret for viewers the ideological content of the images. The couplets' formal structure and blunt dogma are derived from the poetic legacy of Maiakovskii.

The narrative layout, cartoonlike figures, and poetic form are all elements of ROSTA posters. Shorthand images such as the miniature factory Hitler hands over to the corpulent bourgeois industrialist in the second panel and the top hat and tuxedo of the capitalist are a continuation of ROSTA's iconographic lexicon (see figs. 1.3, 3.3). While the red, green, ocher, and black were applied with a loaded brush, resulting in solid areas of color, the shaded black texture of the burning buildings and crosses was probably achieved with dabs made using a relatively dry, hard-bristled brush.

Stenciled versions of this poster exist in the Uzbek language. At least three distinct versions of TASS 5 are known. This poster reached a wide audience when it was made into an animated cartoon, with the same title, that was part of a series of films categorized as "animated political posters." The poster was reproduced in *Life* magazine on August 24, 1942.

Image: Petr Shukhmin
Text: Litbrigade
(Nikolai Aduev[1])
Publisher: Ogiz-Gospolitizdat
Edition: 50,000

Offset lithograph
72 × 27.4 cm
Signed in monogram, bottom right: *P.Sh*
[in Cyrillic]
Ne boltai! Collection

You thought you'd find a place to land
Upon our Soviet borders!
Keep coming! When you arrive
We have a landing place ready!

The fear of sabotage by German agents infiltrating the Soviet Union during the tumultuous and uncertain first months of the war prompted the motif of a German parachutist being welcomed by a Soviet soldier armed with a bayonet or pitchfork. The enemy parachutist was a popular theme in posters and cartoons in the conflict's initial phase. It was treated twice by TASS artists in the six days prior to a broadcast Joseph Stalin made to the nation on July 3, 1941, his first as head of state since the outbreak of the war. He declared, "We must wage a ruthless fight against all the disorganizers of the rear, deserters, panic-mongers, rumormongers; we must exterminate spies, diversionists, and enemy parachutists."[2] Just days before TASS 9 appeared, the motif was the subject of a cartoon published in *Krokodil*, the satirical weekly that was the Russian equivalent of Germany's *Simplicissimus* and England's *Punch*. Lampooning aside, the threat of infiltrators was a real one, and some posters alerted Soviet civilians to the dangers, urging them to vigilance in the defense of

their villages and collective farms (see fig. 6.18).

TASS artist Shukhmin worked in two representational vocabularies – caricature for the enemy and realism for the sons and daughters of the motherland. This practice was established in the 1920s and 1930s (see fig. 1.21). The poem complements the image less sonically than graphically: its three exclamation marks echo the form of the raised bayonet. Nonetheless, this might be an example of the "inexpressive" verse for which the TASS posters were frequently criticized during the war.

TASS issued the original stenciled version of this poster, measuring 230 × 90 cm, on June 28, 1941, in an edition of fifty. The design for TASS 9 was displayed, framed, in the TASS studio windows. The poster was reproduced in the Moscow-based, English-language newspaper *Moscow News* on July 3, 1941. Founded by American Socialist Anna Louise Strong in 1930, the newspaper was intended for an international readership and was distributed worldwide. The newspaper *Komsomol'skaia pravda*, the official organ of the Central Committee of the Communist Youth Organization (Komsomol), regularly featured black-and-white reproductions of TASS posters, including this one, which appeared in its June 29, 1941, edition. With a daily circulation of 850,000 to 3.1 million readers, the newspaper significantly increased the recognition and popularity of TASS posters. From the outset, TASS poster designs were selectively reissued in reduced formats and large editions by means of offset lithography by state-run publishing houses such as Ogiz-Gospolitizdat.

In the United States, TASS 9 featured in an article, "Soviet War Posters," in the December 1941 issue of *Soviet Russia Today*, the New York–based pictorial monthly published by Friends of the Soviet Union.[3]

ОКНО ТАСС
№ 9

Ты на советском рубеже
Искал посадочной площадки!
Лети, лети! Тебе уже
Готово место для посадки!

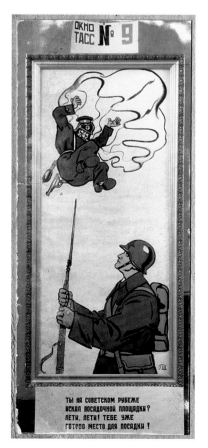

Fig. 1 TASS 9 (original design), archival photograph, ROT Album, courtesy Ne boltai! Collection.

Image: Aleksei Radakov
Text: Litbrigade (Nikolai Aduev, Osip Brik, Semyon Kirsanov[1])
Publisher: Ogiz-Gospolitizdat

Edition: 20,000
Offset lithograph
71 × 54.5 cm
Ne boltai! Collection

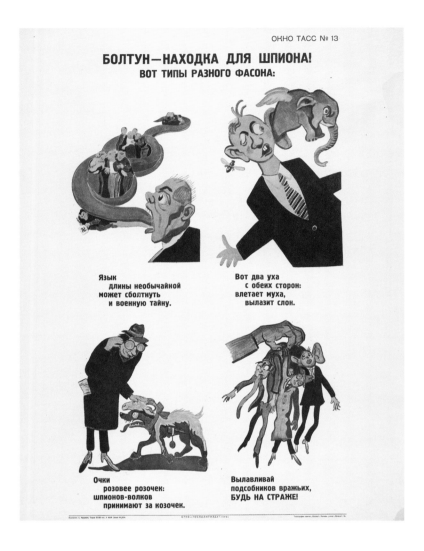

A Blabbermouth Is a Spy's Delight!
Here are his various faces:

His tongue / is of incredible length,
it can even blab / a military secret.

Here are two ears, / and from both sides
A fly enters / and an elephant emerges.

His spectacles / are rosier than roses:
They mistake / spying wolves for sheep.

Help to catch / the enemy's accomplices,
Be vigilant!

In the first panel of this poster, a rumormonger's snakelike tongue clutches a group of citizens. What he cannot see, hiding under the tongue, is a note-taking Nazi spy. In the following panel, a rumor the size of a fly enters a man's right ear, only to exit the other as an elephant. The third panel depicts a citizen petting the pelt of a sheep; the rose-colored glasses he wears prevent him from observing the armed wolf beneath. Rumormongers – indicated by their inordinately long tongues and over-sized ears – are rounded up in the final panel.

Radakov was a member of the Petrograd ROSTA studio. As in other early TASS posters, the couplets here relate clearly to Maiakovskii's poetics, most notably in the use of inventive

rhymes and a staggered arrangement of lines called a "ladder." The subject – urging civilians not to believe everything they hear and to refrain from gossip – was treated in posters on both the Allied and Axis sides of the war. The topic was particularly important in the Soviet Union in the early months of the conflict, given the devastating string of defeats by the enemy that the official press did not report. Indeed, rumor-mongering was the focus of a number of cartoons and posters. The title of this poster became a popular saying, especially among Russian children who used it to shame schoolmates who informed or simply talked too much.

The reduced, conventionally printed version of TASS 13 featured here was widely disseminated. The original stenciled poster, issued on June 29, 1941, features in a Margaret Bourke-White photograph (fig. 1), under the heading "Speaking of Pictures. Russian War Posters are Colorful and Forceful," which appeared in *Life* magazine on August 24, 1942.

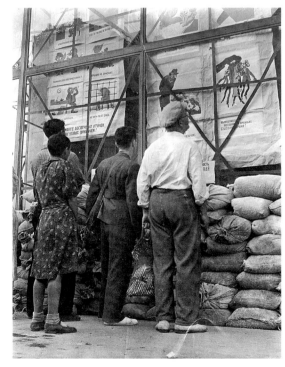

Fig. 1 Margaret Bourke-White (American, 1904–1971). *Street Scene*, 1941. Syracuse University Library Special Collections Research Center. This photograph shows people examining TASS 13 (right) and 37 (left) on the windows of a dietary shop on Gorkii Street, Moscow.

Image: Boris Efimov
Text: Litbrigade (Semyon Kirsanov[1])
Edition: 100

Stencil
270 × 61 cm
Not in exhibition

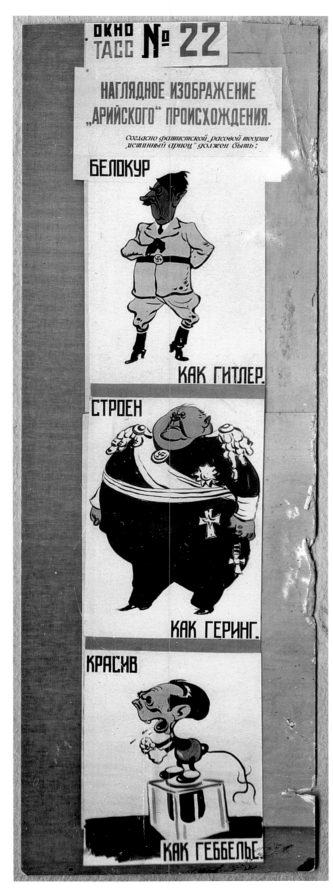

TASS 22 (original design), archival photograph, ROT Album, courtesy Ne boltai! Collection

A Visual Presentation of "Aryan" Descent.

According to Fascist race theory, the "genuine Aryan" must be:
Fair like Hitler.
Slender like Göring.
Handsome like Goebbels.

Hitler and his close associates Hermann Göring (Reichsmarschall and commander of the Luftwaffe) and Joseph Goebbels (minister of public enlightenment and propaganda) are lampooned here for possessing none of the physical attributes that the Nazis assigned to the ideal Aryan (see TASS 307.1 [p. 200]). The contrast between text and image pointedly and wittily demonstrates the disjuncture between Nazi ideology and reality. This poster's imagery is interesting in its possible connection to the description of the "ideal Aryan" from the left-wing British writer Julian Huxley in his international bestseller *We Europeans* (1936): "Our German neighbors have ascribed to themselves a Teutonic type that is fair, long-headed, tall and virile. Let us make a composite picture of a typical Teuton from the most prominent exponents of this view. Let him be as blond as Hitler, as dolichocephalic as Rosenberg, as tall as Goebbels, as slender as Goering, and as manly as Streicher."[2]

Efimov was a member of the Odessa ROSTA studio. Particularly striking here is the degree to which Efimov's caricature of Goebbels resembles Walt Disney's Mickey Mouse (fig. 1). In 1935 Disney had won a special prize in animation at the first Moscow film festival (the jury's president was the movie director Sergei Eisenstein). Efimov transformed the ubiquitous, much-loved character into the sinister Joe Rat, which immediately became one of the artist's signature images.[3] He expanded the triumvirate of characters seen in this poster to include Heinrich Himmler (commander of the SS), Robert Ley (head of the German Labor Front), and Alfred Rosenberg (Nazi racial ideologue), and depicted the motley crew in various combinations.

TASS 22 appeared in a variety of Soviet publications throughout the war, including a leaflet in German that was dropped behind enemy lines to demoralize German troops.[4] This work was one of a group of TASS posters that Stalin presented to Lord Beaverbrook, Britain's minister of supply, in early October 1941, during the Anglo-Soviet Lend-Lease negotiations.[5] The British Ministry of Information reissued it, oriented horizontally, in English and Russian (fig. 5.30). In the United States, Russian War Relief, Inc. (RWR), published a suite of four prints based on a selection of TASS posters, among them the Goebbels and Göring panels of TASS 22. The entire poster was reproduced in *Life* on August 24, 1942 (fig. 5.37).

Fig. 1 Left: Boris Efimov. This image of Joe Rat is a detail of a cartoon entitled "The Berlin Gang of Bandits," which appeared in *Pravda* on July 18, 1941. Right: Walt Disney (American, 1901–1966). Mickey Mouse, created in 1928, is seen here in a character model sheet.

Image: Nikolai Radlov
Text: Litbrigade (Nikolai Aduev,
Aleksandr Rokhovich[1])
Edition: 60

Gouache over carbon-transfer drawing
and incising with evidence of secondary
layer of graphite in some areas and
stenciled letters (panel 4)
Each panel: 64 x 88 cm
The Museum of Modern Art, New York

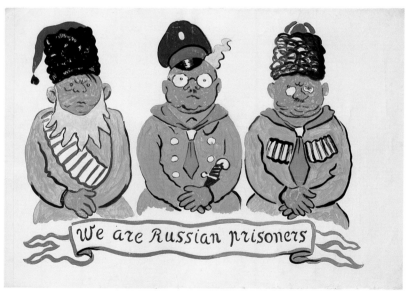

A photographer sporting a Hitler-like hairstyle and moustache transforms three balding, middle-aged German storm troopers (known as "brown-shirts") into make-believe Soviet prisoners of war by dressing them in assorted uniforms, including a conical headdress (*papakha*). The message seems to be that fraudulent propaganda is consistent with other examples of German criminality, such as Hitler's treacherous rupture of the Molotov-Ribbentrop Pact and the severe mistreatment of civilians in occupied territories.

One-line captions in the original TASS 60 (see fig. 2) that accompany its four images are supplemented by two rhyming couplets that comment on the rudimentary narrative. In the Museum of Modern Art's example, the banner below the figures in the finished "photograph" at the lower right reads, "We are Russian prison-ers," in English. This, and the unusual process of the poster's creation (see TASS 63 [p. 175]), indicate that the Society for Cultural Relations with Foreign Countries (VOKS) intended the poster for distribution in English-speaking countries.

Radlov – a member of the Petrograd ROSTA studio – fashioned here a droll parody that makes light of a very grave situation and nefarious practice, in which the Nazis used photographs of Soviet prisoners of war to engen-der contempt for the enemy from the East: Poles, Belarusians, Russians, Ukrainians, Jews, Sintis, and Roma. By July 12, 1941, when this poster was issued, the Soviets had suffered major setbacks. In a pincer movement near Bialystok, Poland, and Minsk, Belarus, the advancing German army

had encircled Soviet forces, taking 324,000 prisoners of war. That VOKS chose TASS 60 to serve as an ambas-sador for the Soviet cause suggests a strategy to counter the aggressive propaganda campaign issuing from the Reich Ministry of Propaganda. Indeed, the unheroic trio of Germans, with their lumpen features and dopey expressions, is intended to give the Nazis some of their own medicine, aiming as it does at the central Nazi concept of a superior race.

From the outset of the war, PK units (Propaganda Kompanie Einheiten), comprising various media-related personnel and photographers assigned to the front, supplied the German propaganda machine with photographs of prisoners of war. Soviet soldiers of various cultural and racial backgrounds (the Soviet Union comprised fifteen republics and multiple ethnicities) were con-trasted with the Nazi ideal: the sup-posed physically and intellectually superior Aryan. The prisoners were shown in ways designed to empha-size their "subhuman" status. Such photographs – often featuring three figures, as in TASS 60 – appeared in the daily and weekly German press (see fig. 7), accompanied by cap-tions that further underscored the inferiority of people with Asiatic, Semitic, and Slavic features. The countenances of Soviet prisoners of war were included in newspapers intended for posting on walls, posters, and broadsheets with ironic head-ings (see figs. 4–5). Himmler's SS headquarters (Hauptamt) produced a

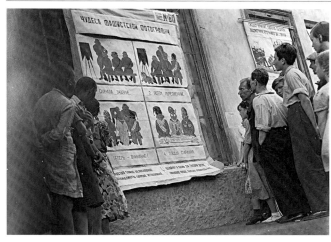

Fig. 2 Margaret Bourke-White (American, 1904–1971). Untitled street scene, 1941. Syracuse University Library Special Collections Research Center. This photograph shows TASS 60 on display outside the TASS studio on Kuznetskii Most, Moscow. Partly obscured behind the crowd at right is TASS 82, issued on August 18, 1941.

VORWÄRTS CHRISTLICHE SOLDATEN!

Fig. 3 Arthur Johnson (American, born Germany, 1878–1954). "Vorwärts Christliche Soldaten!" ("Onward Christian Soldiers!"), *Kladderadatsch*, March 21, 1943. The specter of the "subhuman" rises over a vast army of Allied soldiers. They are being waved off to war by the archbishop of Canterbury, whose open cloak reveals him wear-ing a Roman battle outfit below his cleric's collar. Whispering to him conspiratorially is a caricatured Jewish businessman holding up a menorah.

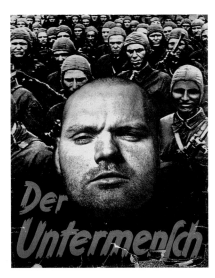

Fig. 1 Photocollage cover of *Der Untermensch* (*The Subhuman*) (Der Reichsführer-SS, SS Hauptamt, 1942). Deutsches Historisches Museum, Berlin.

Ein amerikanisches Zeugnis:

Die amerikanische Zeitschrift „Time"
schrieb in ihrer Ausgabe vom 7. Juli 1941:

BERICHT AUS DER UdSSR.

Einer der letzten und zuverlässigsten
Berichte über die kürzlichen Vor-
gänge hinter der Stahlmauer der
Zensur in der UdSSR. kam in der
letzten Woche über das Kabel aus
Tokio von einem „Time"-Korrespon-
denten, welcher mehrere Jahre in der
Sowjetunion zugebracht hatte und
kurz vor dem deutschen Einmarsch
das Land verlassen hatte.

ROTE ARMEE

Die Rote Armee war beim Ausbruch
der sowjet-deutschen Feindseligkeiten
etwa 7 000 000 Mann stark. Die Hälfte
waren Proletarier, ein Viertel Bauern,
ein Viertel „Stehkragen"-Arbeiter.
Unter den etwa sechs bis sieben Mil-
lionen ausgebildeter Reservisten, die
jetzt alle mobilisiert werden, bilden
die Bauern eine absolute Mehrheit.
Rußlands enorme landwirtschaftliche
Bevölkerung ist im wesentlichen mit
der Sowjetherrschaft unzufrieden ...
Aus diesem Grunde, wenn der Krieg
weiter fortschreitet und die Armee
mehr und mehr aus Bauern bestehen
wird, wird die Moral eine Neigung
zur Zersetzung annehmen.
Vor sechs Wochen sagte ein bärtiger
Bauer, Kolkoznik, in einem Dorf in
der Nähe Moskaus zu mir: „Wann
werden die Deutschen nach
Rußland kommen, um die
Ordnung wiederherzustel-
len?" Die Unterhaltung fand statt
in einem kleinen staatlichen Dorf-
Kaufladen, wo der Bauer einige Eier,
das Stück zu einem Rubel, gekauft
hatte. Diese Eier waren von seinen
eigenen Hühnern gelegt worden, aber
er war gezwungen, sie dem Staat
für 20 Kopeken das Stück zu ver-
kaufen und sie zu einem Rubel zu-
rückzukaufen. Dies ist ein ausgezeich-
netes Beispiel der neuen Taktik, etwa
vier Fünftel der landwirtschaftlichen
Erzeugnisse in indirekten Steuern
einzunehmen und so dem Bauern
kaum genug zum Leben zu lassen.
Ein Bekannter, ein Maschinist in einer
Moskauer Fabrik, in den hohen Drei-
ßigern, der drei Kinder hat, lebt in
einem Zimmer mit nur einem kleinen
Fenster und verdient 600 Rubel im
Monat, den Preis eines wollenen An-
zuges schlechter Qualität. Um dieses
Gehalt aufrechtzuerhalten, muß er
regelmäßig Ueberzeit arbeiten.
Ganz allgemein gesagt, die Land-
bevölkerung ist sehr unzuverlässig,
aber die Stadtbevölkerung wird gut
kämpfen.

MORAL

Wenn die Deutschen Hemden, Ta-
schenlampen, Fahrräder, Schuhe, Ra-
dios usw. in großen Quantitäten nach
Rußland senden könnten, dann wür-
den die meisten Bauern und wahr-
scheinlich auch die Arbeiter damit zu-
frieden sein, unter deutscher Ober-
herrschaft zu leben ... Im Jahre 1932,
als ich zuerst nach Rußland kam, ar-
beiteten viele Leute noch unter Selbst-
aufopferung, weil sie ernstlich und fa-
natisch an die sozialistische Idee
glaubten. Jetzt sind die meisten dieser
Leute unter den Aexten der verschie-
denen Ausmerzungen gefallen, und
die meisten Russen arbeiten, weil sie
mit kriminellen Anklagen bedroht
sind, wenn sie die Arbeit verweigern.
Dies alles hat eine Situation hervor-
gerufen, worunter irgendein auslän-
discher Eroberer, der es verstehen
würde, die Bevölkerung wenigstens
so gut wie die Bolschewiken — und
das ist kein hoher Standard — zu
füttern und ihr einige einfache Ver-
brauchsgüter zu geben, das Land
ohne wesentliche politische Schwie-
rigkeiten regieren könnte.

BEREITSCHAFT

Als ich Moskau am 10. Juni verließ,
sah ich über 200 Militär-Transport-
züge zwischen Chita und Krasnoyarsk
westwärts rollen auf der Transsibi-
rischen Eisenbahn. Die Züge bestan-
den durchschnittlich aus 25 Waggons,
davon zehn mit Truppen besetzt, der
Rest beladen mit Tanks, Ambulanzen,
Munition, Munitionswagen, Panzer-
wagen, Lastkraftwagen, Flak-Ge-
schützen, ja sogar mit einigen ver-
packten Flugzeugen ... Diese Züge
beförderten wahrscheinlich die me-
chanisierte Zwölfte Armee, die im
Sommer 1939 bei Khalka Grol unter
dem Befehl des Generals Stern gegen
die Japaner kämpfte. Die Soldaten
sagten, daß sie ihre Bestimmung
nicht wüßten, aber sie hielten es für
sehr wohl möglich, daß sie gegen
Deutschland eingesetzt würden. Ihre
Ausrüstung sah benutzt aus, war je-
doch noch in gebrauchsfähigem Zu-
stand.

So sieht der Bolschewismus aus

den diese Soldaten Stalins über Europa bringen sollten

Die „Befreiung der Arbeiter und Bauern", in Wirklichkeit: Elende Holzschuppen und Erdlöcher als Behausung

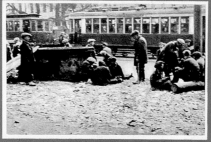 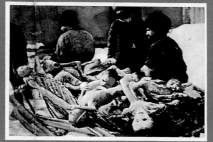 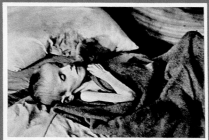

So sieht das „Paradies der Kinder" aus: Verwaist, verwahrlost und verhungert ist die Jugend in den Städten und Dörfern

 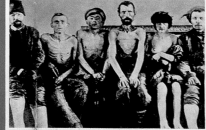 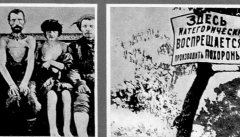

Statt „Arbeit und Brot": Verkommene Felder und vereilendete Tiere, verhungernde Menschen. Charakteristisch das Plakat: Es ist verboten, Leichen in den Parks zu beerdigen"

„Glaubens- und Gewissensfreiheit" in der Praxis: zerstörte Kirchen, geschändete Heiligtümer, in Fässern eingesperrte Priester . . .

Fig. 4 The man at the center of the collage of faces at the
top of this double-sided German broadsheet is also seen
at the far left of fig. 7. The banner headline reads, "This is
the face of Bolshevism that Stalin's soldiers will bring to
Europe." Ne boltai! Collection.

fifty-two-page brochure entitled *Der Untermensch* (*The Subhuman*), which features PK photographs of Soviet prisoners of war (fig. 1). These photographs were also used as the basis for derogatory cartoons by German graphic satirists (see fig. 3).[2]

The Soviet photographic counteroffensive began with radiophotos that the TASS press agency distributed worldwide in early July. Photographs featuring wholesome and smiling Soviet gunners appeared in the *New York Times*, *Chicago Daily News*, *PM*, and other newspapers and magazines (see fig. 6) just a few days before TASS 60 was issued. TASS 60, with its comic mood, was at odds with the grim realities in more ways than one. A month after its posting, Soviet prisoners of war found themselves on death marches and in open boxcars (see fig. 8) without food and water, on their way to prisoner-of-war camps (stalags) located deep inside Nazi-occupied territory. On August 16, 1941, Stalin issued Order 270, which declared, "Soldiers who allow themselves to fall into captivity are traitors to the motherland." This order would remain in effect long after the war ended. Those captured soldiers who survived the horrors inflicted upon them in Nazi prison, labor, and concentration camps would return home only to be punished by sentences in another form of death camp, the Soviet gulag.[3]

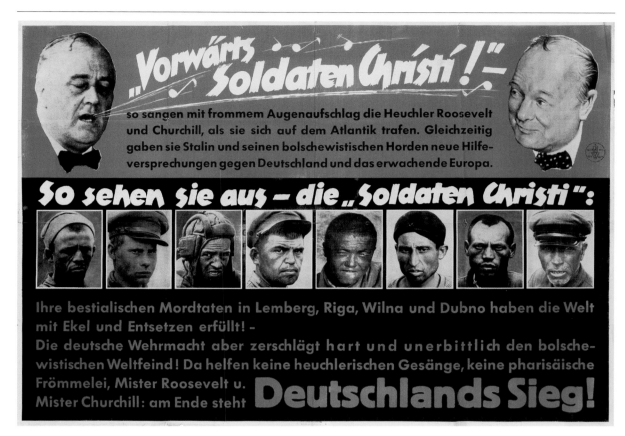

Fig. 5 The German wall newspaper *Parole der Woche* of September 17–23, 1941, features the heads of the American and British leaders declaring "Onward Christian Soldiers." Below runs the legend: "Thus sang, with pious upward glances, the hypocrites Roosevelt and Churchill when they met on the Atlantic. At the same time they gave Stalin and his Bolshevik hordes new promises of assistance against Germany and the awakening Europe." Over the heads of eight Soviet prisoners of war of various ethnicities, their expressions hardened or distrustful from their brutal combat experiences, a banner reads: "That's what they look like – the Christian soldiers." The text below continues: "Their beastly murderous deeds in Lemberg [Lviv], Riga, Wilna [Vilna], and Dubno have filled the world with disgust and horror. But the German Wehrmacht hits the Bolshevik world enemy hard and relentlessly! No hypocritical hymns, no pharisaical bigotry will help here, Mr. Roosevelt and Mr. Churchill: at the end stands Germany's victory." Ne boltai! Collection. In exhibition.

Fig. 6 Photographer unknown (Soviet). "Russ Gunners Show Teeth – Two Ways," *Chicago Daily News*, July 9, 1941. The caption reads, "Russian machine-gun troops flash smiles as they face the enemy somewhere on the long front. This picture is one of the first radiophotos ever sent from Moscow. Soviet troops also have 'shown their teeth' to the Nazis in another way, wiping out two motorized regiments today in Northern White Russia, according to a report." Published only eighteen days after the German invasion, this photograph put a positive face on the suffering and devastation on the Eastern Front.

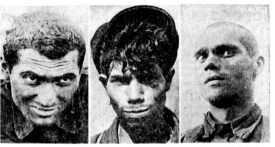

Fig. 7 Photographer unknown (German). "The Führer's Word," *12-Uhr-Blatt*, October 9, 1941. The caption below these images of Soviet prisoners of war reads, "We are fighting against an enemy that – and I have to say it here – consists not of human beings, but of animals and beasts!"

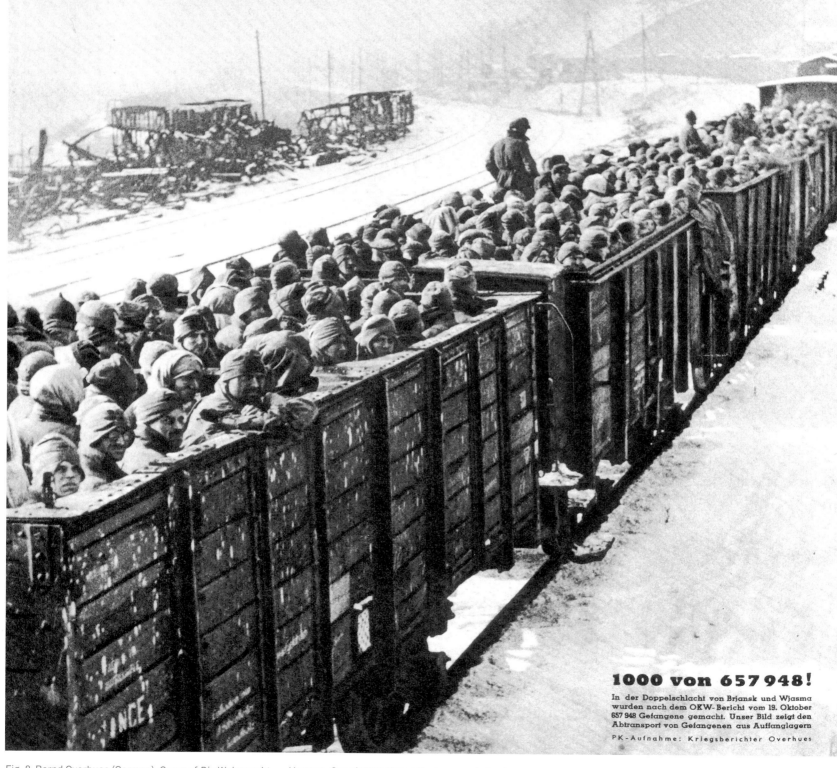

1000 von 657948!

In der Doppelschlacht von Brjansk und Wjasma wurden nach dem OKW-Bericht vom 19. Oktober 657948 Gefangene gemacht. Unser Bild zeigt den Abtransport von Gefangenen aus Auffanglagern

PK-Aufnahme: Kriegsberichter Overhues

Fig. 8 Bernd Overhues (German). Cover of *Die Wehrmacht* 23 (November 5, 1941). This photograph signals a major German victory over the Soviets. The headline "1000 of 657,948!" is followed by a caption that reads, "According to the OKW-report of October 19, 657,948 [Soviet soldiers] were taken prisoner in the double battle of Bryansk and Vyazma. Our picture shows the transport of prisoners from transit camps." The twenty-seven million Russians who died in World War II included three million prisoners of war such as the men seen here.

Image: Pavel Sokolov-Skalia
Text: Litbrigade
Edition: 1

Gouache, tempera, or poster paint over
freehand graphite with minimal traces
of carbon-transfer drawing
128 × 88 cm
The Museum of Modern Art, New York

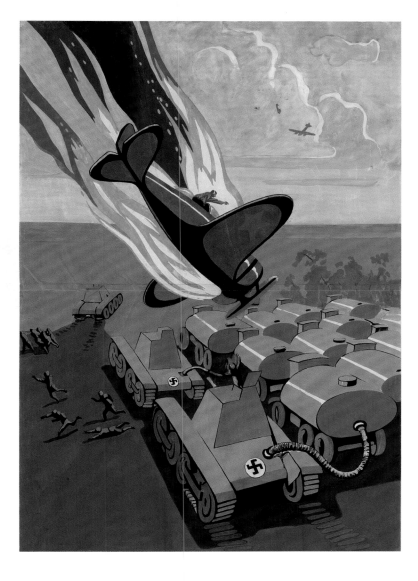

The Feat of Captain Gastello
When his fuel tank's aflame, when there
* is no salvation,*
When the seconds of his life are
* numbered,*
His last second is for victory,
His last breath is for his country!
His obedient machine will not let him
* down,*
Like a bomb on its target, like a torch it
* will fall.*
And into the midst of tanks, gunpowder,
* and fuel*
He throws himself and his airplane.
A hit, an explosion! The Fascists flee
* crying,*
The fire catches them on the run.
. . . Thus dies the citizen-warrior,
His very death bringing death to the
* enemy.*

Five days into the war, the plane
flown by Soviet pilot Nikolai Gastello
received a direct hit from antiair-
craft guns during an air attack on
German transport columns. Gastello
directed his burning aircraft toward
the Germans' fuel-tank trucks and
crashed among them, setting them
ablaze. Gastello, his navigator, and his
two gunners lost their lives.

This act of self-sacrifice immediately
propelled Gastello into the pan-
theon of Soviet heroes, and he was
commemorated in word and image.
Gastello's photograph, featured in
Pravda on July 27, was distributed
worldwide, including in the liberal
New York tabloid *PM* on July 24. The
topicality of this poster may be one
of the reasons it found its way to the
United States for use in exhibitions in
support of the Russian war effort.

This is among the earliest TASS poster
designs by Sokolov-Skalia, head of
the studio's visual team. Its realist
style differs from his later work, which
is a unique and powerful blend of real-
ism and caricature (see, for example,
TASS 887 [p. 264] and 958 [p. 280]).

The poem, in iambic pentameter, uses
a coarse vocabulary and very rough
rhymes; clearly, like many of the
texts for TASS posters, it was writ-
ten quickly. The last line, adapted
from an Orthodox Church Easter
hymn – "Christ is risen from the dead
/ trampling down death by death" –
illustrates how, despite the Soviet
government's hostility toward religion,
religious imagery could be used in
defending the motherland.

Recently, researchers have ques-
tioned the accuracy of the official
account of Gastello's death, suggest-
ing that it was romanticized in the
service of home-front propaganda.

The Museum of Modern Art's (MoMA)
example belongs to a unique group
of twenty-three TASS posters
received by the Russian embassy in
Washington, D.C., in January 1943.
Sometime in the following February
or March, the embassy, hoping for an
exhibition, sent the group to the New
York museum. TASS 63, along with
TASS 60 (pp. 170–74) and others in the
shipment, is notable because, unlike
other studio posters, it is not sten-
ciled. Instead, it reveals a combina-
tion of drawing, carbon transfer, and
incising under hand-brushed painting.
While the posters sent to Washington
carry dates that would indicate that
they were made before the closing
of the TASS studio for safety during
the battle of Moscow (about half the
staff either went to work in Kuibyshev
[Samara] or otherwise dispersed in
the fall of 1941), they were most likely
made after the studio was reunified
in February 1942. By this time, the
stencils used for the early posters
could have been destroyed or lost. If
the studio received requests from
various Soviet embassies for diplo-
matic "exhibitions sets," it would have
had to institute a different method
to replicate stenciled images. The
options would have included tracing
forms from existing stenciled post-
ers and using the tracings to create
outlines, drawing them, or cutting new
stencils. However they were made,
the outlines could then have been
hand-colored. This process is evident
in several works that MoMA received
from the Russian embassy, including
TASS 60. TASS 63 was executed almost
entirely by hand.[1]

A reduced, conventionally printed ver-
sion of this poster was issued in 1943
in an edition of ten thousand copies.

Fig. 1 TASS 63, archival photograph, ROT
Album, courtesy Ne boltai! Collection.

Image: Nikolai Radlov
Text: Litbrigade
(Nikolai Aduev, Osip Brik[1])
Publisher: Sotrudnik
Edition: 5,000

Offset lithograph
46.5 × 31 cm
Ne boltai! Collection

Agreement of the Greatest Historical and Political Significance

Two hands in friendship strong as steel
Are extended one to the other;

The Fascist throat their grip will feel,
Throttling till life is ended.

Caught in a handshake between the recently partnered Great Britain (left) and the Soviet Union (right), a throttled Hitler drops a bloodstained ax and a revolver.

When informed on June 22, 1941, of Germany's invasion of the Soviet Union, Prime Minister Winston Churchill went on the radio. He offered "the government of Soviet Russia any technical or economic assistance which is in our power, and which is likely to be of service to them." Britain sought to ensure Soviet strength in the conflict on the Eastern Front, thereby diverting resources Hitler could put to use on the Western Front. On July 12, Sir Stafford Cripps, British ambassador to the Soviet Union, and Viacheslav Molotov, people's commissar for foreign affairs, signed a mutual-aid pact "to render each other assistance and support of all kinds and in all times in the present war against Hitlerite Germany." In addition

the agreement specified that the two partners would "neither negotiate nor conclude an armistice or peace treaty except by mutual agreement."[2]

TASS 68, issued on July 14, celebrates this critical Anglo-Soviet alliance; it was quickly reproduced in a reduced format (seen here) in a conventionally printed mass edition so that it could be widely distributed. TASS 68, either in its stenciled or conventionally printed form, was among a group of posters that Stalin presented to Lord Beaverbrook in late September (see TASS 22 [p. 169]). It appeared in a reissue, intended for distribution in factories, printed in Britain with English and Russian texts (see fig. 5.28). The British Ministry of Information included it, with English text, in *Comrades in Arms! Britain and the U.S.S.R.*, a November 1941 pamphlet.

The throttling of Hitler became a leitmotif not only in Soviet poster production but also in the United States, which would soon join the Allies.

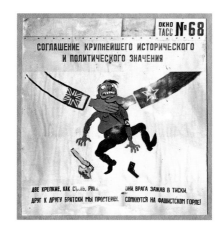

Fig. 1 TASS 68 (original design), archival photograph, ROT Album, courtesy Ne boltai! Collection.

Image: Pavel Sokolov-Skalia
Text: Litbrigade
(Nikolai Aduev, Osip Brik[1])
Edition: 100

Stencil
317.5 × 165 cm
Joslyn Art Museum

Defenders of Moscow

Panel 1: Our fearless steel birds
Chase the enemy from the red capital
Panel 2: The antiaircraft gunner,
* guarding the great city*
Covers the sky with a curtain of fire.
Panel 3: Searchlight operators during
* air-raid alarms*
Prevent the ignoble thieves from hiding.
Panel 4: Balloons patrol the heights,
Balloon operators to your posts!
Panel 5: If a wily bandit breaks through,
A firefighter will protect the house from
* fire.*
Panel 6: Our police are not renowned for
* nothing;*
They achieve exemplary order.
Panel 7: With valor and courage the
* entire nation*
Greets each hostile air raid.

The Soviet people possess immutable
* qualities:*
Discipline, endurance, and heroism.

This poster's seven images deal with the Luftwaffe's nightly attacks on Moscow (the Kremlin's towers can be seen in the distance in the sixth panel), which began on July 21–22, 1941. The American photographer Margaret Bourke-White was in the capital at the time and photographed the air raids. She wrote of "an extraordinary night when the German parachute flares, like a string of pearls, were dropped in parallel rows over the Kremlin. Drifting with the wind, they descended slowly to earth in snake-like lines. . . . It was as though the German pilots and the Russian anti-aircraft had been handed enormous brushes in radium paint and were executing designs with the sky as their vast canvas."[2]

The scenes depicted, from top to bottom and left to right, are Stalin's "falcons" in aerial combat with the Luftwaffe, antiaircraft batteries, noise detectors and searchlights, antiaircraft barrage balloons, the

ОКНО ТАСС № 100

ЗАЩИТНИКИ МОСКВЫ

1. БЕССТРАШНЫЕ НАШИ СТАЛЬНЫЕ ПТИЦЫ
ВРАГА ОТГОНЯЮТ ОТ КРАСНОЙ СТОЛИЦЫ

2. ЗЕНИТЧИК, ВЕЛИКИЙ ГОРОД ХРАНЯ
СТАВИТ СПЛОШНУЮ ЗАВЕСУ ОГНЯ.

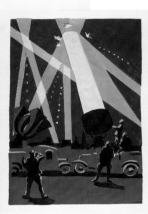

3. ПРОЖЕКТОРИСТЫ В ТРЕВОЖНУЮ ПОРУ
НЕ ДАЮТ УКРЫТЬСЯ ПОДЛОМУ ВОРУ.

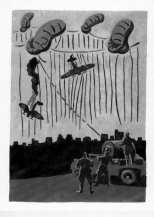

4. АЭРОСТАТЫ БЕРУТ ВЫСОТУ.
АЭРОСТАТЧИКИ НА ПОСТУ!

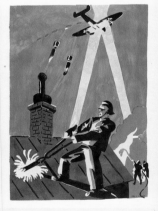

5. ЕСЛИ ПРОРВЕТСЯ БАНДИТ КОВАРНЫЙ
ДОМ ОТ ОГНЯ ОТСТОИТ ПОЖАРНЫЙ.

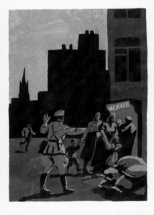

6. МИЛИЦИЯ НАША НЕДАРОМ ОТМЕЧЕНА
ОБРАЗЦОВЫЙ ПОРЯДОК ОНА ОБЕСПЕЧИЛА.

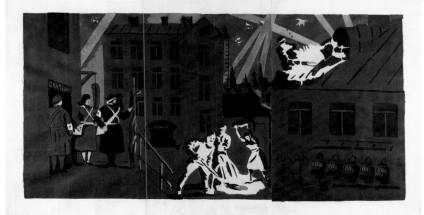

7 ОТВАГОЙ И МУЖЕСТВОМ ВЕСЬ НАРОД
ВСТРЕЧАЕТ КАЖДЫЙ ВРАЖИЙ НАЛЕТ.

СОВЕТСКИХ ЛЮДЕЙ НЕИЗМЕННЫЕ СВОЙСТВА-
ДИСЦИПЛИНА, ВЫДЕРЖКА И ГЕРОИСТВО.

neutralizing of live bombs, and bomb shelters. The seventh panel shows an air-raid warden and nurses observing members of a firefighting brigade extinguish fires caused by the attacks. In addition to celebrating the Soviets' "discipline, endurance, and heroism," the poster had didactic value, showing how to disarm an incendiary bomb. This is one of a plethora of posters that dealt with many of these topics (see fig. 1).

In this early, didactic poster, Sokolov-Skalia created a design that allowed for ready translation into stencils. Following the principles of ROSTA posters, he employed areas of flat color and a limited palette with bold chromatic contrasts, but to very different effect because of the realism of his style. The nocturnal setting enabled the artist to exercise inventiveness with color and highlights. In the third panel, for example, the brown hue of the automobiles melts into the shadowed background; the cars are defined only by the blue reflections that indicate the contours of their wheels.

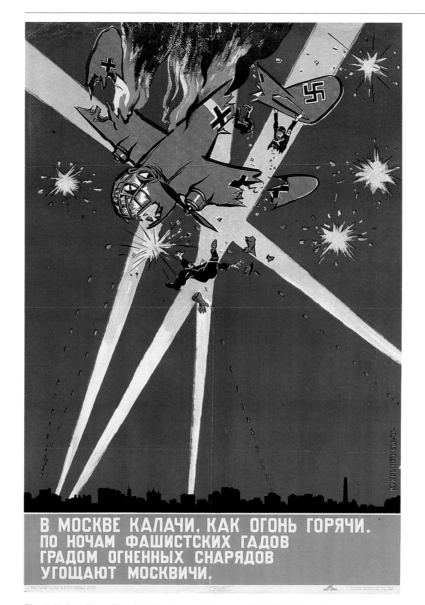

Fig. 1 Kukryniksy. *Flaming Blasts over Moscow*, 1941. Publisher: Iskusstvo. Edition: 25,000. Offset lithograph; 89.5 × 57 cm. Ne boltai! Collection. The text reads, "In Moscow the buns are hot like fire. / Nightly the Fascist scumbags / With a rain of fiery shells / Are served by Moskovites." In exhibition.

More important, perhaps, is the symbolism of the handshake over the enemy's capital. It refers to the military alliance that had been signed between the Soviet Union and Great Britain (see TASS 68 [p. 176]). When TASS 143 was posted for public viewing, it attracted the attention of at least two western correspondents working in Moscow. Cyrus L. Sulzberger observed, "Posters display rejoicing Russian and British pilots halting momentarily in the air over Berlin to shake hands."[1] Alexander Werth reported on August 27 that "Moscow is taking an increasing interest in England and the RAF [Royal Air Force]. There is a new poster showing an RAF man and a Soviet airman shaking hands over Berlin."[2]

The journalist Ralph Ingersoll obtained an example of this poster while on assignment in the Soviet Union and reproduced it in the November 12 issue of *PM*, which had featured the Soviet bombing of Berlin on the front page of its August 8 issue. The Nazis took issue with this poster (see fig. 1). A conventionally printed variant designed by the Kukryniksy was published with each of the bombs clearly marked with the Red Star and Union Jack (fig. 2). The British promoted the poster by producing a bilingual version to be displayed in offices and factories (fig. 5.24). TASS 143 was also reproduced in *Comrades in Arms! Britain and the U.S.S.R.*, published by the British Ministry of Information in November 1941.

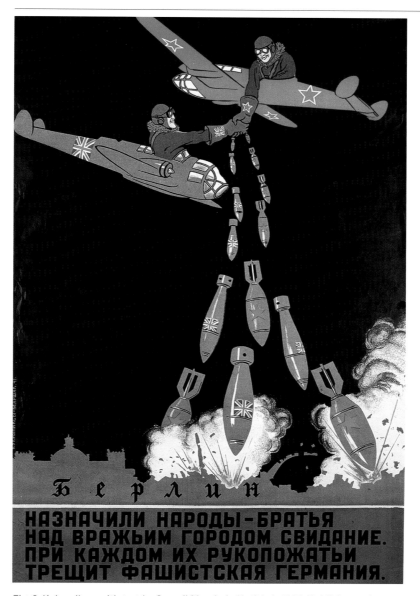

Fig. 2 Kukryniksy, with text by Samuil Marshak. *Untitled*, 1941. Publisher: unknown. Edition: unknown. Offset lithograph; dimensions unknown. The text on the poster reads: "The fraternal nations made an appointment / Over the enemy city. / With their every handshake / Fascist Germany splinters."

Image: Vitalii Goriaev
Text: Nikolai Aduev, Aleksandr Raskin,
Aleksandr Rokhovich
Edition: 120

Stencil
140 × 83 cm
Not in exhibition

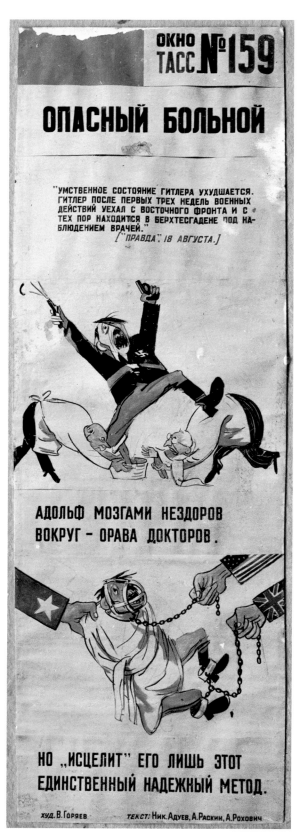

TASS 159 (original design), archival photograph, ROT
Album, courtesy Ne boltai! Collection

Dangerously Ill

*Hitler's mental state is worsening.
Following the first three weeks of
fighting, Hitler left the Eastern Front
and from that moment on has been
in Berchtesgaden under doctors'
observation. (Pravda, August 18.)*

*Adolf is sick in the head.
Doctors teem around his bed.*

*But the only way to "heal" him
Is this single, safe treatment.*

In the top panel, two asylum atten-
dants are unable to administer a
rudimentary hydrotheraphy treatment
(popular among psychiatrists in the
1940s) to Hitler, who flails about wildly,
holding a gun and a hand grenade.
In the bottom panel, the muzzled,
straight-jacketed, and manacled
Führer is held in check by the Soviet
Union, the United States, and
Great Britain.

TASS 159 exemplifies the dominant
TASS studio style in the early months
of the war: simplified images, multiple
panels, a relatively restricted use of
stencils, and a close pairing of image
and text. It is notable that, although
three poets contributed to these four
lines, the poem is crude, probably
intentionally so. The first two lines
make a blunt joke about the enemy's
plight, while the last two comment
wryly on the future course of events.

This poster is significant because it is
the first time that TASS artists includ-
ed the American flag along with those
of the Soviet Union and Great Britain.
The Soviets and the British had agreed
by mid-August to exchange war sup-
plies. TASS 159 speaks directly to the
joint message issued by Franklin D.
Roosevelt and Churchill to Stalin on
August 14, 1941. They wrote:

*We realize fully how vitally important
to the defeat of Hitlerism is the brave
and steadfast resistance of the Soviet
Union and we feel therefore that we
must not in any circumstances fail
to act quickly and immediately in
this matter of planning the program
for the future allocation of our joint
resources.*[1]

The missive called for a meeting in
the Soviet Union between the three
nations, a proposal that Stalin accept-
ed.[2] A number of liberal newspapers
celebrated this action.[3] But American
opinion was divided. On August 18,
an editorial in the strongly isolation-
ist *Chicago Daily Tribune* declared:
"Without the advice and consent of
the senate, Mr. Roosevelt has formed
what, for all practical purposes, is an
alliance with the bloodiest tyranny
this world has ever seen." In response
to this stance, the more liberal
Chicago Daily News published a car-
toon depicting Hitler using its rival's
headquarters – the landmark Tribune
Tower – as an organ to play music lull-
ing Americans to sleep (fig. 1).

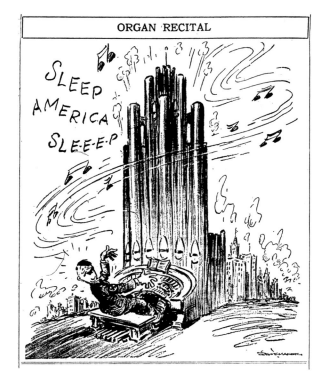

Fig. 1 Vaughn Shoemaker (American, 1902–1991). "Organ
Recital," *Chicago Daily News*, August 20, 1941.

Image: Nikolai Radlov
Text: Nikolai Aduev
Edition: 120

Stencil
268 × 125 cm
Joslyn Art Museum

*Here You Will Find Exact Information
Concerning Hitlerite Education*

A special command announced:
"A young Fascist is not required to think."
*The command should be understood to
 mean:*
"A young Fascist is required not to think."

*"Toward this end young brains
 Are enclosed in special vices.
 In their heads there should remain
 Only what this picture advises."*

*" . . . Every Copernicus and even Galileo
 Is declared a Jew and his memory
 dissolved.
 It is enough for our young people to
 know
 That the sun revolves around Germany."*

*"In order for Aryan youths to act soundly,
 Let them study international law.
 But this course of study will succeed
 only
 If it is the law of violence."*

*"In order that Fascist youth
 Thoroughly learns to pillage,
 A relevant sport must be introduced:
 Who can grab the biggest sack of loot?"*

*The Führer has raised a bandit breed,
 A disgrace to the German people.
 One thing the Fascist scoundrel did not
 say:
 That bandits always come to a bad end!*

Lampooning the brainwashing and brutalization of German youth was a favorite subject for TASS artists and writers. The first of TASS 173's five panels shows the head of a uniformed youth being compressed by a Nazi Party member between the covers of Hitler's autobiographical manifesto *Mein Kampf* (*My Struggle*) (1925–26). As a result of the pressure, his brain's gray matter, marked "Sieg Heil" (hail victory), oozes from his head into a bowl. The second panel features portraits of the astronomers Nicolaus Copernicus and Galileo Galilei, both defaced with the word *Jew*. Defying these astronomers' long-accepted discoveries about the solar system, the wall map depicts a swastika-sun orbiting Germany. The third panel shows hooligans hitting a student in the head. In the fourth, two pillagers run with their haul toward the "finish line." Among the thugs in the last panel — one holds an ax, others carry bottles (perhaps Molotov cocktails) — are three characters wearing helmets inspired by the headgear of Teutonic knights of yore. Radlov's characteristic facial types are similar to those in the first poster issued by the American government after the declaration of war with Germany on December 11, 1941 (fig. 5.55).

Whereas many of the early TASS designs employ color areas independent of contour lines to represent form (see, for example, TASS 100 [pp. 177–78] and 109 [p. 179]), Radlov's use here of insistent and bold black contours for most of the forms is wittily descriptive and graphically emphatic.

TASS posters such as this one were disseminated to a large audience through their reproduction in newspapers and weeklies; TASS 173, for example, appeared in *Komsomol'skaia pravda* on September 3, 1941.

ОКНО ТАСС № 173

ЗДЕСЬ ТОЧНЫЕ СВЕДЕНИЯ НАЙДЕШЬ,
КАК ГИТЛЕР ВОСПИТЫВАЕТ МОЛОДЕЖЬ.

ОБ'ЯВЛЕНО БЫЛО ОСОБЫМ ПРИКАЗОМ:
"МЫСЛИТЬ ФАШИСТ МОЛОДОЙ НЕ ОБЯЗАН.
ПРИКАЗ НАДЛЕЖИТ ПОНИМАТЬ В ТОМ СМЫСЛЕ,
ЧТО ФАШИСТ МОЛОДОЙ ОБЯЗАН НЕ МЫСЛИТЬ".

"ДЛЯ ЭТОГО ЮНОШЕСКИЕ МОЗГИ
БЕРУТ В СПЕЦИАЛЬНЫЕ ТИСКИ.
В ГОЛОВЕ ЛИШЬ ТО ОСТАТЬСЯ ОБЯЗАНО,
ЧТО НА РИСУНКЕ ЭТОМ ПОКАЗАНО".

"ВСЯКИХ КОПЕРНИКОВ С ГАЛИЛЕЯМИ
АННУЛИРОВАТЬ И ОБ "ЯВИТЬ ЕВРЕЯМИ.
С МОЛОДЕЖИ ВПОЛНЕ ДОСТАТОЧНО ЗНАНИЯ,
ЧТО СОЛНЦЕ ВРАЩАЕТСЯ ВОКРУГ ГЕРМАНИИ"

"ЧТО-Б АРИЙСКИЙ ЮНОША ДЕЙСТВОВАЛ ЗДРАВО
-ПУСТЬ ИЗУЧИТ МЕЖДУНАРОДНОЕ ПРАВО,
НО УЧЕНЬЕ ТОГДА ЛИШЬ СЧИТАТЬ УДАЧНЫМ
ЕСЛИ ЭТО ПРАВО БУДЕТ КУЛАЧНЫМ"

"ДЛЯ ТОГО ЧТО-Б ФАШИСТСКАЯ МОЛОДЕЖЬ
ИЗУЧИЛА ДОСКОНАЛЬНО ГРАБЕЖ,
ВВОДИТСЯ АКТУАЛЬНЫЙ СПОРТ:
КЕМ БУДЕТ БОЛЬШИЙ УЗЕЛ СПЕРТ"

БАНДИТСКУЮ ВЫРАСТИЛ ФЮРЕР ПОРОДУ
НА ПОЗОР ГЕРМАНСКОМУ НАРОДУ.
ОДНОГО НЕ СКАЗАЛ ИМ ФАШИСТСКИЙ ПРОЙДОХА-
ЧТО БАНДИТЫ-ВСЕГДА КОНЧАЮТ ПЛОХО!

ХУД. Н. РАДЛОВ. ТЕКСТ НИК. АДУЕВА.

Image: Kukryniksy
Text: Samuil Marshak
Edition: 120
Stencil

Panel 1: 67.4 × 73.1 cm; panel 2: 67.2 × 73 cm; panel 3: 67.3 × 72.9 cm; panel 4: 68 × 73 cm; panel 5: 67.3 × 73.2 cm; panel 6: 68.2 × 73.2 cm
Stamp on verso, in red ink: *AMERICAN RUSSIAN INSTITUTE / 101 Post Street / San Francisco, California*

Glued onto the six panels at left is a printed page with English translations of the captions, originally published in *Moscow News*, September 5, 1941. Hoover Institution Archives, Stanford University

Brutality Graduates

*1 Fritz, his mother's darling lamb,
Once came to school for an exam
The first question the teacher posed:
Why did a Fascist need a nose?*

*2 Fritz gave reply without delay,
"To sniff out treason every day
And denounce colleagues by the score.
That's what a Fascist's nose is for."*

*3 Next the lords of science did ask:
Are Fascists' hands good for any task?
"To swing an ax and wave a sword!
To burn and hack and loot and hoard!"*

*4 "What is the use of Fascist feet?"
"To goose step up and down the street,
Left, right, left, right!" bold Fritz said.
"And what use is a Fascist head?"*

*5 "To wear a helmet of iron cast,
Or don a beautiful gas mask.
Not for thinking anyhow."
(He leaves that to the Führer now.)*

*6 Everyone was pleased with Fritz.
They said, "This boy will be a hit.
Such a bold and courageous lad,
He'll make a first-class Nazi cad!"*

*Ma and Pa are glad to know
Their little Fritz is Gestapo.*[1]

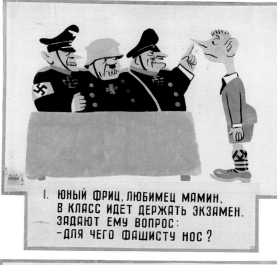

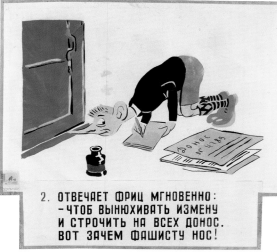

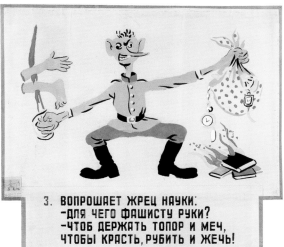

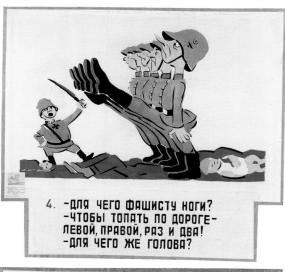

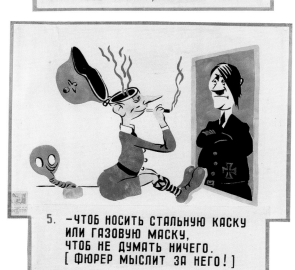

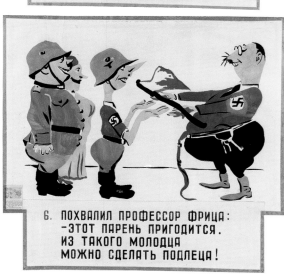

The Russians adopted Fritz, a diminutive of Frederick and Friedrich, as a pejorative archetype of the German soldier. While the character appeared soon after the outbreak of the war, the symbolic use of his moniker goes back to "der Alte Fritz" (Old Fritz) in reference to Frederick the Great, the eighteenth-century Prussian ruler who was a formidable military adversary of czarist Russia. Even before his ascent to power in 1933, Hitler was widely viewed – even by Germans – as Old Fritz's descendent. Over the course of the war, TASS artists and others working for the satirical press lampooned Fritz in a variety of ways as the historical enemy of Russia (see TASS 307 [pp. 199–200] and 460 [p. 208]).

Showing Fritz's head as an empty vessel, with a helmet hinged to the back of his skull, as seen in panel five of TASS 177, was a favorite device of the Kukryniksy. The trio was indebted to graphic satirists of the past, as well as George Grosz and his contemporaries, including artists associated with the German satirical periodical *Simplicissimus*, who also used metaphorical devices to define their characters (see fig. 2).

Image: Kukryniksy
Text: Samuil Marshak
Publisher: unknown
Edition: unknown
Stencil

Panels 1–4: 59 × 63 cm (each); panels
5–6: 73 × 63.5 cm (each)
The Museum of Modern Art, New York

With its question-and-answer format and jocular repetitions, Marshak's narrative recalls the children's verses for which he was most renowned. In Young Fritz, he created a character of enduring interest who reappears not only in TASS posters by other artist-writer teams but also in other media, including poems and film.

Significant differences can be observed when comparing the stenciled version of TASS 177 with reduced, conventionally printed versions most likely intended for publication in magazines. In at least one instance (fig. 3), the Kukryniksy altered the latter, replicating the original in pen and ink heightened with color. In this example, they embellished Fritz's face with acne in the form of swastikas (panels 1, 4–6). Other changes include Fritz's hand in panel 2 and the officer's stance in panel 4. TASS 177 was featured, in black and white, in the September 15, 1941, issue of Moscow News. A conventionally printed, reduced version that is more closely related to its stenciled prototype was published by Iskusstvo in 1943 in an edition of ten thousand. The existence of several reduced versions attests to the popularity of the subject. Such comic treatment of serious subjects typifies the way the Kukryniksy, and TASS artists in general, relied on humor as an effective means to diminish the enemy. The stenciled version with English text included here, from MoMA, was made specifically for exhibition.

TASS 177 was first reproduced in the United States in the December 24, 1941, issue of PM. Having returned by this time to New York from his Soviet assignment, Ralph Ingersoll was receiving TASS posters sent from Moscow through the mail, as did others on VOKS's international mailing list. In Great Britain, the poster was reproduced in the February 7, 1942, issue of the popular illustrated weekly Picture Post. The same year, it appeared in Lord Beaverbrook's 1942 book Spirit of the Soviet Union. The present example was part of an exhibition of TASS posters that circulated in the United States under the auspices of the American Russian Institute, San Francisco.

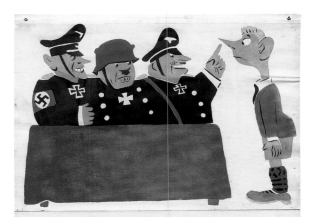

1. FRITZ – HIS MAMMA'S FOND CREATION – PASSED A FINE EXAMINATION; THUS THE MASTER'S QUESTION GOES: "WHY'S THE • FASCIST • GOT A NOSE?"

2. FRITZ'S ANSWER IS QUITE BRIGHT: "TIS TO SNIFF TO LEFT AND RIGHT, SIGNS OF TREASON TO DISCLOSE, – THAT'S THE DUTY OF HIS NOSE!"

3. QUESTION NUMBER TWO: "NOW SAY, WHY HAVE FASCISTS FINGERS, PRAY?" "TIS TO GRASP A SWORD OR AXE, THAT DESTROYS AND KILLS AND HACKS."

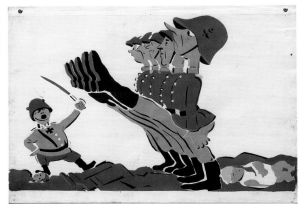

4. HERE COMES QUESTION NUMBER THREE: "HE HAS LEGS AND FEET, I SEE. WHAT DO ALL THESE LIMBS "FOREBODE? "JUST TO STAMP ALONG THE ROAD."

5. ANSWER QUESTION NUMBER FOUR: "HE HAS GOT A HEAD... WHAT FOR?" "TO WEAR HELMETS FOR PROTECTION OR A MASK AGAINST INFECTION" THOUGHTS PRECLUDED FROM THE HEAD... FUHRER THINKS FOR HIM INSTEAD.

ARTISTS KUKRINIKSY TEXT BY S. MARSHAK.

6. THE PROFESSORS ARE ELATED WITH THESE ANSWERS BRIGHTLY STATED, OF THIS SCAMP SO FOUL AND SLY YOU COULD MAKE A SNEAKING SPY. POPPA, MAMMA MAD WITH JOY LOOKING PROUDLY AT THEIR BOY. AND THE SCAMP CROWS WISER, SHARPER AS AN AGENT OF GESTAPO.

Fig. 1 TASS 177 (original design), archival photograph, ROT Album, courtesy Ne boltai! Collection.

Fig. 2 Karl Arnold (German, 1883–1953). "Hail Prussia!," cover of *Simplicissimus* (May 15, 1932). Playing on a saying attributed to Frederick the Great (whose shadowy countenance hovers behind the stylized image of Hitler) – "In my nation, every man must get to Heaven only according to his own way" – the caption of Arnold's image reads, "In my nation, every man must get to Heaven only according to my way." Prior to Hitler's rise to the position of German chancellor, satirists such as Arnold spoofed his admiration for Frederick the Great. In subsequent years, *Simplicissimus*'s artists and writers were persecuted by the Nazis, and the magazine itself was strong-armed into a pro-Nazi stance before it was shut down in 1944.

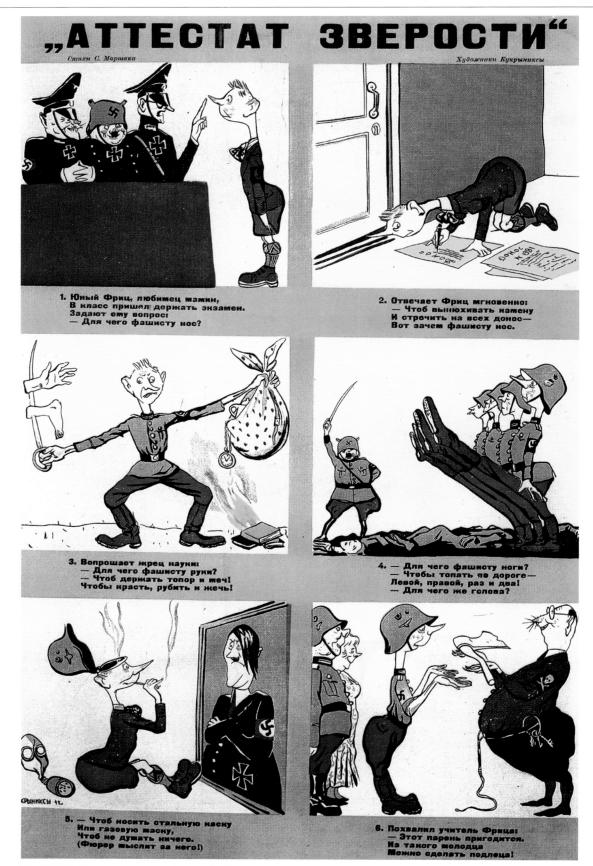

Fig. 3 TASS 177 (reduced version), 1943. Publisher: unknown. Edition: unknown. Offset lithograph; 81 ×52 cm.

Image: Pavel Sokolov-Skalia, Mikhail Solov'ev
Text: Aleksandr Raskin, Georgii Rublev
Edition: 120
Stencil

Panel 1: 63.1 × 69 cm; panel 2: 62.9 × 68.9 cm; panel 3: 63.8 × 68.9 cm; panel 4: 63.8 × 68.6 cm; panel 5: 71.2 × 131.3 cm
Stamp on verso, in red ink: *AMERICAN RUSSIAN INSTITUTE / 101 Post Street / San Francisco, California*

Glued onto the five panels at left are typewritten translations in English of the captions to each panel.
Hoover Institution Archives, Stanford University

A Scheduled Appearance.

Panel 1: *The Fascists occupied the village*
And in fear of the partisans
They posted this sign
(They had a dimwitted plan).

Panel 2: *The day of the fifth came and went*
And the Fascist captain growled
That despite the threat of violence
No one bothered to show.

Panel 3: *So the captain changed the sign,*
Cursing the villagers' stubbornness
And so he extended the deadline
By three more days, until the eighth.

Panel 4: *But vainly awaiting the meeting,*
The Fascists sat alone,
And the final deadline was changed
To the thirteenth of the month.

Panel 5: *The partisans finally appeared*
Right on schedule on the thirteenth.
And seeing their expected guests
The "Nazis" took to their heels.

Panel 6: *On foot, on horse, by car*
They fled however they could,
But their guests still made sure
That they no longer felt at home.

In a Nazi-occupied village, doltish German soldiers ordering partisans to surrender become the laughingstock of the locals, who know what the partisans are planning. The twenty-four-line poem, written in the most common measure – iambic tetrameter – is unremarkable. What is more interesting is the notice posted by the Germans on the wall in four of the panels. It is the same from panel to panel, except for different dates, and it reads: "To the Russians, as they say / We wish no harm. / All men / Must appear on the [date] of this month. / Capt. Von Skett." The text contains multiple spelling and grammatical errors that Germans can make in Russian, thus providing a verbal

ФАШИСТЫ ЗАНЯЛИ СЕЛЕНЬЕ
И ОПАСАЯСЬ ПАРТИЗАН
ТАКОЕ ДАЛИ ОБЪЯВЛЕНЬЕ
(У НИХ БЫЛ СВОЙ НЕ ХИТРЫЙ ПЛАН).

ВОТ ПЯТОЕ ЧИСЛО МИНУЛО
И КАПИТАН ФАШИСТСКИЙ ЗОЛ.
ЧТО ПОД РЕВОЛЬВЕРНОЕ ДУЛО
НИКТО С ПОВИННОЙ НЕ ПРИШЕЛ.

ВНЕС КАПИТАН ТОГДА ПОПРАВКУ,
УПРЯМСТВО РУССКОЕ КЛЯНЯ,
И ПАРТИЗАНАМ СРОКИ ЯВКИ
ПРОДЛИЛ ОН РОВНО НА ТРИ ДНЯ.

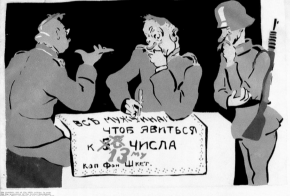

ФАШИСТЫ НЕ ДОЖДАВШИСЬ ВСТРЕЧИ
СИДЕЛИ ДОЛГО ЗА СТОЛОМ,
И СРОК ПОСЛЕДНИЙ БЫЛ ПОМЕЧЕН
ТОГДА ТРИНАДЦАТЫМ ЧИСЛОМ.

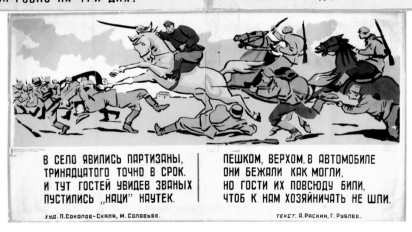

В СЕЛО ЯВИЛИСЬ ПАРТИЗАНЫ,
ТРИНАДЦАТОГО ТОЧНО В СРОК.
И ТУТ ГОСТЕЙ УВИДЕВ ЗВАНЫХ
ПУСТИЛИСЬ „НАЦИ" НАУТЕК.

ПЕШКОМ, ВЕРХОМ, В АВТОМОБИЛЕ
ОНИ БЕЖАЛИ КАК МОГЛИ,
НО ГОСТИ ИХ ПОВСЮДУ БИЛИ,
ЧТОБ К НАМ ХОЗЯЙНИЧАТЬ НЕ ШЛИ.

ХУД. П.СОКОЛОВ-СКАЛЯ, М. СОЛОВЬЕВ. ТЕКСТ: А. РАСКИН, Г. РУБЛЕВ.

caricature of the enemy by giving him a distinctive voice. It is noteworthy that in TASS posters neither Hitler nor other German leaders "speak" with a stereotypical German accent; in fact, they mostly remain mute (or, in the case of Goebbels, simply unintelligible).

The striking stylistic disjuncture in this poster between the first four panels, with their pronounced caricatural character, and the lower one, which is in a much more naturalistic style, indicates that Sokolov-Skalia and Solov'ev did not work on each scene together. Panels 1 through 4, by Sokolov-Skalia, exhibit what would become his hallmark facial exaggerations, as seen in the bulbous nose (which borders on the obscene) and patchwork modeling of the face of the officer in panel 1. Solov'ev's panoramic battle scene at the bottom introduces an abrupt change of tone. The broad landscape and the action – with the partisans rushing in on horseback from the right to trounce faceless German troops – serve as the heroic culmination of the satirical narrative vignettes above. In his mature work for TASS, Sokolov-Skalia would harmonize both satirical and realist elements in a single composition.

This poster was intended to give hope to the civilian population. While, in the initial stages of the war, partisan action was spontaneous and mostly uncoordinated, villagers in German-occupied territories who were aware of partisan activities found themselves in precarious situations. Orders and decrees issued by the occupying powers and relating to the topic of partisans and collaborators did not mince words. Here is a passage from one such order, from October 1941: "Collective punitive measures will be carried out immediately for non-compliance with these orders (in serious cases the shooting of the responsible inhabitants, in less serious cases their arrest and the confiscation of foodstuff, etc.)."[1]

On June 29, 1941, the Soviet government ordered the complete evacuation or destruction of "all valuable property" and the immediate organization of guerilla warfare in any region that had to be left in the enemy's hands.[2] Stalin's broadcast to the nation on July 3, 1941, incorporated aspects of the order:

The enemy is cruel and implacable. He is out to seize our lands, watered by our sweat, to seize our grain and oil secured by our labor. . . . In case of forced retreats of the Red Army units, all rolling stock must be evacuated, the enemy must not be left with a single engine, a single railway car, not a single pound of grain or gallon of fuel. . . . All valuable property, including nonferrous metals, grain and fuel which cannot be withdrawn, must without fail be destroyed. In areas occupied by the enemy, guerilla units, mounted and on foot, must be formed, diversionist groups must be organized to combat the enemy troops, to foment guerilla warfare everywhere, to blow up bridges and roads, damage telephone and telegraph lines, to set fire to forests, stores and transports. . . . Conditions must be made unbearable for the enemy and all he accomplishes. [He] must be hounded and annihilated at every step, and all [his] measures frustrated.

Stalin's call to arms resulted in a substantial number of posters issued in 1941 dealing with partisan warfare (see figs. 3.5, 6.12).

An example of this poster was part of a batch of TASS posters that Ralph Ingersoll received from the Soviet Union. He reproduced it in the December 24, 1941, issue of *PM*. The poster was also published in the British periodical *Picture Post*, on February 7, 1942, as well as in the 1942 book *Spirit of the Soviet Union*. This particular example was shown in an exhibition of TASS posters that traveled around the United States under the auspices of the American Russian Institute, San Francisco.

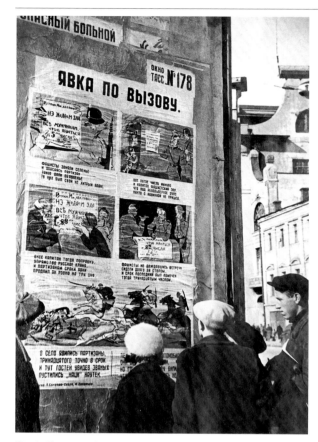

Fig. 1 Photographer unknown. Moscow street with onlookers taking in TASS 178, which has been pasted over TASS 159 (p. 184). Hoover Institution Archives, Stanford University.

First British Tank-for-Russia Gets a Whopping Big Send-Off

Britain has just celebrated Tanks-for-Russia Week. The first tank off the assembly line (above) was christened *Stalin*, plastered with Victory Vs and presented to Ivan Maisky, Soviet Ambassador to Britain. British workingmen cheered. Tank Week was more than a propagandist's symbol of the sincerity of Britain's support of Russia. During the week, symbol production jumped 20 per cent, breaking all British records.

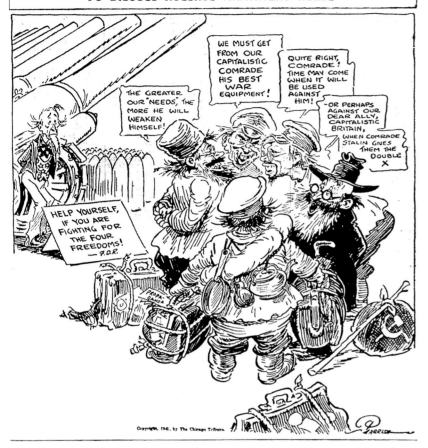

Fig. 3 Joseph Lee Parrish (American, 1905–1989). "Our Red Comrades Are in This Country to Discuss Russia's Armament Needs," *Chicago Daily Tribune*, August 10, 1941. Reflecting the biases of Americans of Parrish's generation relating to the "Old World," here a bunch of uncouth, awkward Bolsheviks, straight out of an Eastern European village, conspire to take advantage of Uncle Sam's largesse. This cartoon would not have been out of place in *Der Stürmer*, *Völkischer Beobachter*, or any other example of the Nazi popular press.

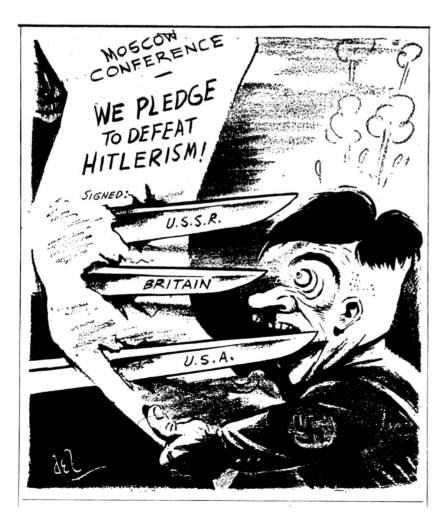

Fig. 4 Del (American). "Moscow Conference – We Pledge to Defeat Hitlerism!" *Daily Worker*, October 3, 1941. This cartoon was influenced by the Kukryniksy poster *We Shall Mercilessly Crush and Destroy the Enemy!* (fig. 1.22).

Image: Boris Efimov
Publisher: unknown
Edition: unknown
Stencil with heightening by hand
87.5 × 64 cm

Printed label at bottom left: *Loaned by / AMERICAN RUSSIAN INSTITUTE / 101 Post Street / San Francisco*
Hoover Institution Archives, Stanford University

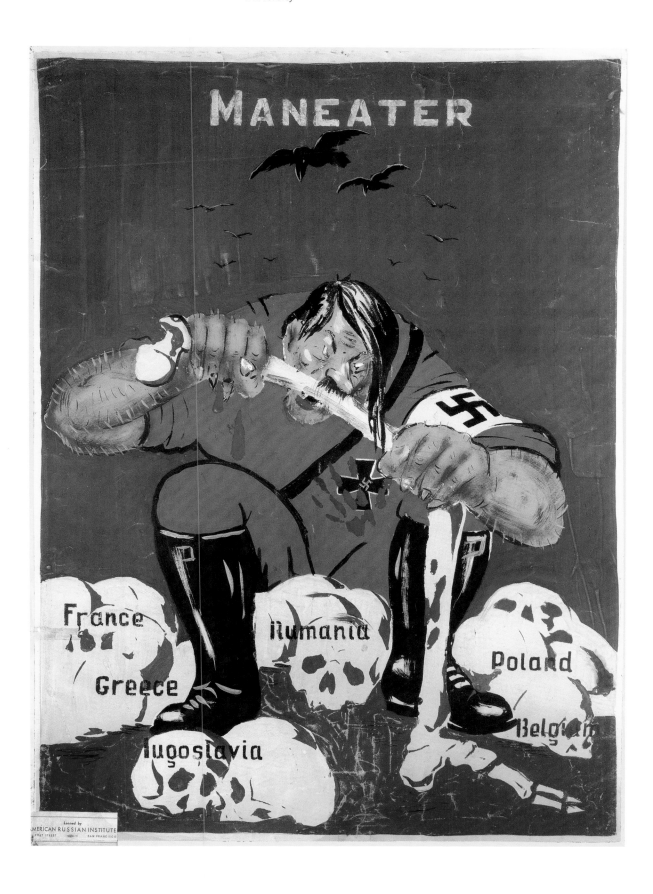

A frenzied Hitler, blood dripping from his mouth and hands, gnaws on a human femur. His hairy arms and hands and long fingernails intensify this image of Nazi bestiality. Flying toward him in the dark sky is a menacing flock of crows. The Führer is surrounded by skulls carrying the names of the European nations Germany had conquered to date (left to right: France, Greece, Yugoslavia, Romania, Poland, and Belgium). The skulls sit, like outcroppings of land, in a sea of blood. Efimov's emphatic brushwork, bold palette, and strong contrasts contribute to the horrific scene.

While it cannot be determined with certainty that this poster was made at the TASS studio, Efimov was a TASS artist. Furthermore, an example of this poster, along with a number of TASS posters and other materials, was presented to Lord Beaverbrook, Britain's Minister of Supply, by Stalin or his representative upon the successful conclusion of the Moscow Lend-Lease conference. In Britain a lithographic reproduction of the design was made carrying the legend "Reproduced from the original design presented to Lord Beaverbrook on the instruction of M. Stalin" (see fig. 5.27). This particular example was part of an exhibition of TASS posters that circulated in the United States during the war under the auspices of the American Russian Institute, San Francisco.

Image: Kukryniksy
Text: V. Goriaev, Aleksandr Rokhovich
Edition: 150

Stencil
190 × 87 cm
Not in exhibition

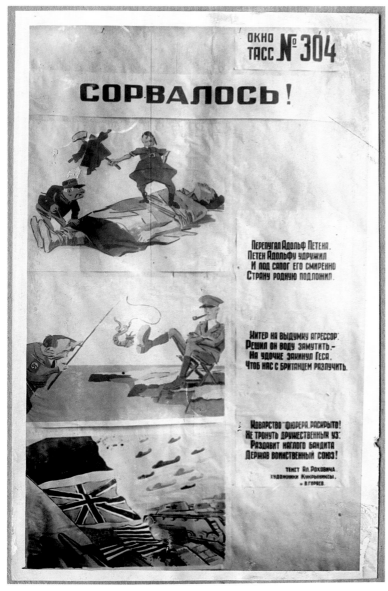

TASS 304 (original design), archival photograph, ROT Album, courtesy
Ne boltai! Collection

Foiled!

Adolf frightened Petain.
Petain did Adolf a favor
And meekly placed his country
Under Adolf's boot.

The aggressor is a cunning inventor:
He decided to muddy the waters. –
He cast a line with Hess as bait
In order to divide us from the Brit.

The Führer's treachery was revealed!
He cannot touch our friendly ties:
Our military alliance
Will crush the arrogant bandit.

While he was Moscow correspondent
for the *New York Herald-Tribune*,
Walter B. Kerr wrote one of the
more fulsome descriptions found in
the American press about a newly
issued TASS poster. Filing his story
from Kuibyshev (Samara), the Soviet
Union's temporary seat of govern-
ment, Kerr wrote under the heading
"War Posters Bring U.S. Flag to Russia
Again." The article appeared in the
Washington Post on December 8, 1941,
which is four days before TASS 304 is
recorded as having been issued. This
underscores the problem of dating
and sequencing the TASS posters:
their "official" date of publication is
not always correct. The column ran
as follows:

Huge posters on which the American
flag is shown closely linked with the
British and Soviet flags are being
prepared for display throughout the
Soviet Union.

A similar theme was used about a
month ago in posters displayed in
Moscow and also in a documentary
motion picture "Victory Will Be Ours"
which has been shown in the last
few months.

Until recently the American flag
seldom has been seen in this country,
except over the American Embassy
at Moscow and the consulate
at Vladivostok.

The newest poster has been produced
by TASS Window, a division of the
official TASS news agency. It measures
7 by 3 feet and includes three pictures
beneath each of which is a text. The
drawings are by Kuprianov, Krylov and
Niksokolov [sic], three well-known art-
ists who work together under the name
of Kukreniksi [sic]. The texts are by a
well-known writer, Rokhovich.

One picture shows Adolf Hitler stand-
ing over Marianne, a woman's figure
symbolizing France, with a pygmy
Petain near by. The text says:

"Adolf is scared. Petain has helped
Adolf and humbly has laid his country
beneath Adolf's boots."

The center picture shows Hitler hold-
ing a fishing rod across the English
Channel toward England, with Rudolf
Hess dangling at the end of the line
of bait. English officers are pictured
sitting in England and kicking disdain-
fully at Hess. The text for this is:

"The transgressor is a cunning inventor.
He decides to muddy the waters and
cast Hess on a fish line to separate us
from the British."

The bottom picture shows Soviet,
British and American flags, in that
order, with masses of planes and tanks.
Its accompanying text says:

"Der Fuehrer's cunning is unveiled.
Friendly ties will not be affected. Our
bandit will be crushed by the militant
union of powers."

On May 10, 1941, Hess, Hitler's
deputy in the Nazi Party, had flown
to Scotland to negotiate a separate
peace between Great Britain and
Germany. This included a proposal
that Britain would support a war
against the Soviet Union. The suspi-
cion that the Western powers might
pursue a separate peace was a recur-
rent theme in TASS posters (see, for
example, TASS 931 [p. 273] and 938 [p.
274]). Marshal Philippe Petain was a
World War I hero who, after the fall of
France in June 1940, headed the Vichy
government, which presided over
unoccupied France but collaborated
with the Germans in occupied France.

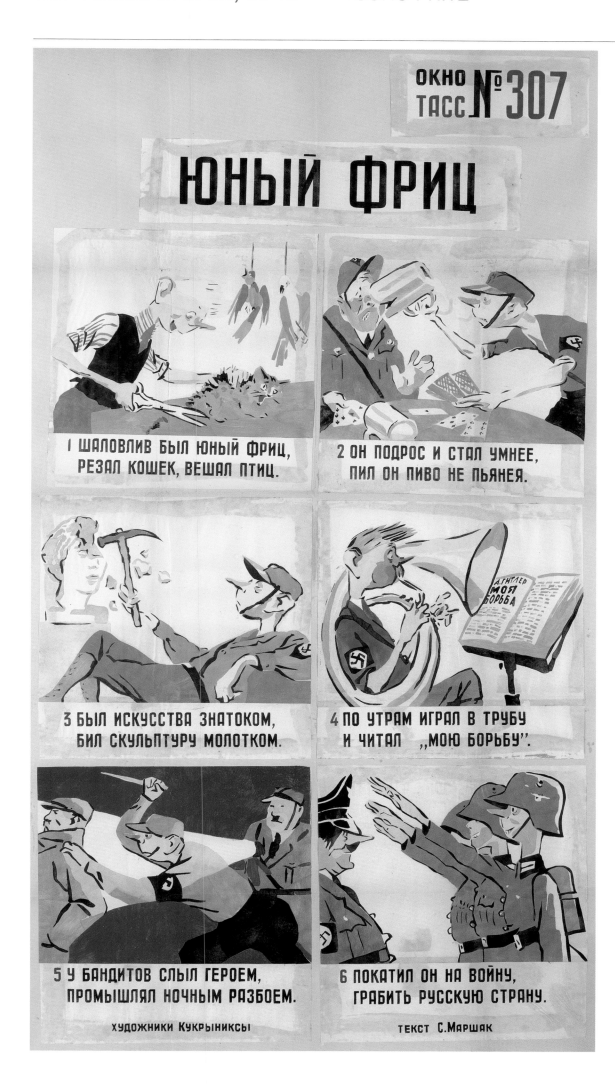

ОКНО ТАСС №307

ЮНЫЙ ФРИЦ

1 ШАЛОВЛИВ БЫЛ ЮНЫЙ ФРИЦ, РЕЗАЛ КОШЕК, ВЕШАЛ ПТИЦ.

2 ОН ПОДРОС И СТАЛ УМНЕЕ, ПИЛ ОН ПИВО НЕ ПЬЯНЕЯ.

3 БЫЛ ИСКУССТВА ЗНАТОКОМ, БИЛ СКУЛЬПТУРУ МОЛОТКОМ.

4 ПО УТРАМ ИГРАЛ В ТРУБУ И ЧИТАЛ „МОЮ БОРЬБУ".

5 У БАНДИТОВ СЛЫЛ ГЕРОЕМ, ПРОМЫШЛЯЛ НОЧНЫМ РАЗБОЕМ.

6 ПОКАТИЛ ОН НА ВОЙНУ, ГРАБИТЬ РУССКУЮ СТРАНУ.

художники Кукрыниксы текст С.Маршак

Image: Kukryniksy
Text: Samuil Marshak
Edition: 6
Stencil
168 × 97 cm
Ne boltai! Collection

Young Fritz

*1 Young Fritz was full of mischief,
Cutting cats and hanging birds.*

*2 He grew up and got still smarter,
Drinking beer without getting drunk.*

*3 He was a connoisseur of art,
Striking sculptures with a hammer.*

*4 In the morning he would blow a horn
And read "Mein Kampf."*

*5 Among bandits he was quite a hero,
Plotting their nocturnal raids.*

*6 He set off merrily to war
To pillage the Russian land.*

Young Fritz's proclivities for sadism, degeneracy, and gratuitous violence, as well as his brutish disregard for civilized life, make him an excellent candidate for the Nazi Party's paramilitary storm troopers (SA), or brownshirts, who facilitated Hitler's rise to power. While these men were regarded as model Germans by the Nazis (see fig. 1), more often than not they came from unsavory elements of German society. They became legendary for their intimidation of political opponents, instigating street violence and enforcing boycotts against Jewish-owned businesses. Young Fritz's experiences with the SA prepare him well for service in Hitler's army.

Fritz's venal character provided much material for satirists working for TASS, foremost among them the Kukryniksy.[1] The Nazi youth's nefarious propensities, as depicted in the present poster's multipanel narrative, were later summarized in a cartoon featured in *Komsomol'skaia pravda*, a newspaper intended for teenagers and young adults (fig. 2). In the cartoon, Fritz, planted in a German helmet-cum-flowerpot, resembles a cactus with six branchlike arms. Each arm engages in an activity for

which Young Fritz was known and despised: he is a slayer of babies, robber, destroyer of cultural properties, arsonist, murderer, and executioner. Cartoons and posters such as these were intended to instill hatred of the enemy in an age group already at the front or soon to be called up.

Like the text he wrote for TASS 177 (pp. 186–88), Marshak's couplets here are based on simple declarative sentences and mostly tight, masculine rhymes. This creates a repetitive, drumbeat rhythm that underscores the robotic nature of Nazi education.[2]

This poster – allegedly one of only six stenciled – is in remarkably good condition. It shows how, in the early TASS posters, individual sheets, each carrying a single image, were glued to a secondary support, thus physically uniting the narrative. TASS 307 is one of fourteen posters indicated in the studio's records as having been produced in Kuibyshev (Samara), where a number of TASS artists and writers were evacuated in mid-October 1941, during the battle of Moscow. The Kuibyshev posters each bear a TASS series number.

Whereas TASS 177, an earlier Kukryniksy poster, relies on flat tonal areas and drawing to render form, TASS 307 reveals a new interest in interior modeling and defining volume through multiple and at times overlapping colors, requiring a broader palette and more complex stencils. Moreover, sections of TASS 307 demonstrate a new strategy of paint application, such as in Fritz's facial features in panel 3, where transparent layers were purposefully placed over previously applied pigment, generating more painterly effects and a dynamic sense of volume.

Fig. 1 W. E. M. Engelhard (German). *S.A. Mann Brand* (*Storm Trooper Brand*), 1933. Offset lithograph; dimensions unknown. Deutsches Historisches Museum, Berlin. The early Nazi propaganda film that this poster advertises details the adventures of a young storm trooper, Fritz Brand, as he fights German Communists and their Soviet "handlers." As an American critic wrote when the film arrived in the United States, Fritz "is supposed to epitomize in his likable person the hopeful, fighting spirit of the millions of young Germans rallied to the standard of Adolf Hitler" (*New York Times*, May 28, 1934).

Fig. 2 Kukryniksy. "Fritz's Plumage," *Komsomol'skaia pravda*, May 1, 1943. Below the cartoon's title is the following legend: "Recently, the German-Fascist newspaper *Frankfurter Zeitung* published a photograph: German soldiers, armed to the teeth, break down the door of a civilian dwelling. The caption reads, 'Every German can become like this.' Thus, the newspaper attracts 'volunteers' to the Hitlerite army from among the youth, promising them a career as thugs and bandits."

Image: Sergei Kostin
Text: Mikhail Vershinin
Edition: 150
Stencil

Panel 1: 20.3 × 39.4 cm; panel 2: 16.3 × 47.8 cm; panel 3: 62.1 × 51.2 cm; panel 4: 62 × 51 cm; panel 5: 53.1 × 51.9 cm; panel 6: 28.8 × 48 cm
Hoover Institution Archives, Stanford University

A Telephone Conversation

Panel 1: *Berlin*
Straight off Hitler scatters curses
And screams at the top of his lungs!
"Mussolini, how is Egypt?"
"Mussolini, is Cairo yours?"

Panel 2: *Rome*
From fear Il Duce's head turns numb,
His body breaks into a cold sweat:
"Repeat your words, but clearer now –
Where are you now? Are you in Moscow yet?"

Panel 3:
The Führer utters even stronger curses,
And falls into ever-darker despair:
– Can it be that even Il Duce
Is hinting at Moscow?

The subject of a telephone conversation between the various heads of state was popular in propaganda produced by all sides during World War II (see fig. 3). Mutual military setbacks inform the conversation depicted here between the Axis partners Hitler and Benito Mussolini. At the time that this poster was issued, Hitler's army was retreating through snow-covered territory outside Moscow, having been repelled by the Soviets. At the same time, German and Italian forces that, under Field Marshal Erwin Rommel, had tried to establish a foothold in Egypt in order to seize control of the Suez Canal, were being repelled from the Egyptian border by combined British and Polish troops. Thus, in this poster, neither Axis leader wishes to hear about defeat, let alone admit to it. While bullied by the German leader about his lack of success in Egypt, we are to assume that Mussolini – his face the colors of the Italian Fascist flag – takes delight in inquiring whether Hitler is calling him from Moscow.

As German forces marched toward Moscow in October 1941, most of the members of the TASS studio were evacuated to Kuibyshev (Samara), roughly five hundred miles to the southeast, which became the nominal capital of the Soviet Union until the summer of 1943. Although limited in supplies and staff, the TASS studio in Moscow executed posters intermittently during the battle of Moscow. These bear only their release date, stenciled in roman numerals above the name of the city where they were issued. This practice seems to have ended in late January 1942 (after the successful defense of Moscow), when the artists in Kuibyshev were able to return.[1]

A version of this poster was made in Uzbek and Russian (fig. 2). The translator of the Russian text retained the sense of the original while creating inventive rhymes in Uzbek. This poster illustrates how by 1941 the dominant literary and visual idioms of Soviet culture had found effective equivalents in the culturally and linguistically diverse republics of the Soviet Union.

At a meeting held in February 1942 by studio artists and writers to evaluate the TASS posters issued to date, TASS director Iakov Khavinson singled out TASS 22-XII-41, which he described as "Hitler … swearing like a sailor" and as a fine example of the right balance between image and text:

[They]'ve done a good job with both an image and a caption.... I think that a caption, which has such great significance when combined with an image, must be perfected to the full. In my opinion, we should shorten some of the captions.[2]

In its assured, shorthand rendering of form and dramatic, restricted palette, this poster embodies the spirit of ROSTA precedents. Most remarkable about Kostin's method in *A Telephone Conversation* is that, despite being boldly applied in large areas, the colors are not entirely flat, revealing dynamic manipulation of thinly applied paint that activates the composition, as does the tension between the poster's simplicity and economy of form and the energetic brushwork. The thinning of the color may have been due to the need to extend paint supplies. However, the end result is one of expressive power, anticipating the delicacy of application seen in Kostin's later work.

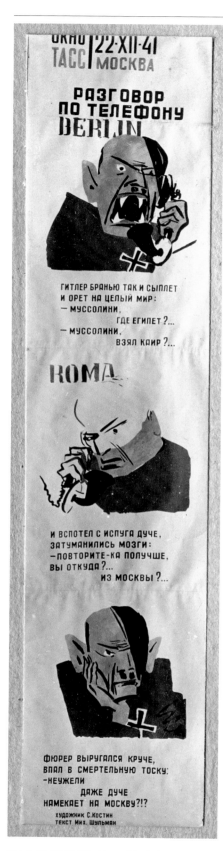

Fig. 1 TASS 22-XII-41, archival photograph, ROT Album, courtesy Ne boltai! Collection.

Fig. 2 TASS 22-XII-41 (Uzbek/Russian version), n.d. Publisher: UzTAG. Edition: unknown. Stencil; panel 1: 69 × 59.5 cm; panel 2: 70.5 × 59 cm; panel 3: 84.5 × 59.5 cm. Ne boltai! Collection. In exhibition.

Fig. 3 Joseph Lee Parrish (American, 1905–1989). "I'm Glad You Dug up Your Constitution, Joe: I Can't Find Ours," *Chicago Daily Tribune*, October 8, 1941. Roosevelt dangles his cigarette holder in an effete manner, while Stalin assembles pieces of a torn-up Soviet constitution. Unbeknownst to the former, the latter has not put the fragment with the word *freedom* (evoking the American president's "four freedoms") into place.

Image: Pavel Sokolov-Skalia
Edition: 150
Stencil

Panel 1: 62.2 × 88.2 cm; panel 2: 62.2 × 88.3 cm; panel 3: 62.2 × 88.3 cm
Signed in stencil, panel 3, lower right: *PSS* [in Cyrillic]
The Museum of Modern Art, New York

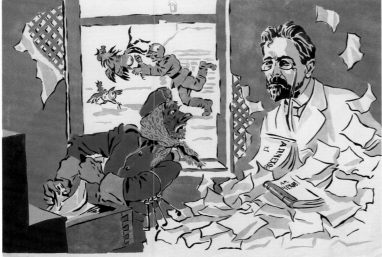

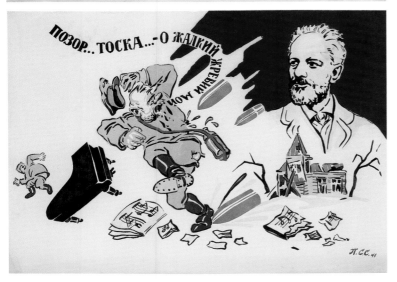

Iasnaia Poliana
"It was a mob of looters, each of whom carried a pile of things that he thought valuable and necessary." Leo Tolstoy, War and Peace.

Istra
"You can earn your food by hunt or by theft." Anton Chekhov, "The Boys."

Klin
"Shame...Heartache...Oh, my pitiful lot." Petr Tchaikovsky, Eugene Onegin (aria of General Fürst).

This is one of the first posters in which Sokolov-Skalia combined two stylistic strategies: grotesque caricature for the enemy and monumental realism for revered Russian historical figures. The top panel shows a burning building in a snowy landscape. Set against the billowing black smoke is the giant specter of Leo Tolstoy, holding his novel *War and Peace* (1869). Hitler runs to the left, or westward, carrying loot on his back and a portrait of the author under his left arm. Through the window depicted in the middle panel, a German soldier is seen trying to catch a chicken. Inside, another soldier, a scarf protecting his head from the cold, rummages through a desk drawer. He is startled by the appearance of playwright Anton Chekov, identified by books that carry his name. The bottom panel shows a damaged homestead below the image of the composer Petr Tchaikovsky. Fleeing bombs, a German soldier cries, "Shame ... Heartache ... Oh, my pitiful lot!"

Being looted and/or destroyed here are Tolstoy's Iasnaia Poliana estate, where he was born and lived; Chekhov's modest house in Istra; and Tchaikovsky's house-museum in Klin. The Germans took over Iasnaia Poliana, located near the town of Tula, 120 miles south of Moscow, between October 24 and December 14, 1941;

they used it as a military hospital. The house in Istra – about seventeen miles northwest of Moscow – in which Chekov resided in 1883–84, was occupied briefly and destroyed by the Nazis during their retreat from the capital. Klin – situated fifty-three miles north of Moscow – was captured by the Germans on November 24–25, 1941, but was retaken by the Soviets three weeks later. During their occupation of Klin, German soldiers were billeted in Tchaikovsky's house-museum, turning it into a storage and repair facility and causing considerable damage.

On January 7, 1942, the Soviet government issued a report on German atrocities – including the destruction of cultural property – in Nazi-occupied Soviet territory that had been recaptured by Soviet troops. It describes the wreckage as an "unheard-of picture of pillage, general devastation, abominable violence, outrage and massacre, perpetrated by the German Fascist occupiers upon the noncombatant population during the German offensive, occupation and retreat."

Although the poster featured here was created before the release of the report, the order and selection of the cultural sites it depicts seem to have been based on the report, to which the editors of the TASS studio must have had access. For example, it declares:

In their malicious persecution of Russian culture, the German invaders revealed the utter vileness and vandalism of German Fascism. For a month and a half the Germans occupied world-famous Iasnaia Poliana, where one of the greatest geniuses of humanity, Leo Tolstoy, lived and engaged in creative work. This glorious memorial of Russian culture, cleared of invaders on December 14 [1941] by Red Army troops, was devastated, soiled, and finally set on fire by the Nazi vandals. The great writer's grave was defiled by the occupants.[1]

The poet and journalist Aleksei Surkov wrote about the desecration of Tchaikovsky's residence as follows:

On December 15 [1941], when Soviet troops liberated the town of Klin, it was revealed that the house in which the great Russian composer Tchaikovsky lived . . . had been devastated and pillaged by Nazi officers and soldiers. In a building of the museum, the brazen occupants had set up a garage and had used for heating this garage manuscripts, books, furniture and other museum exhibits – some of which, by the way, were stolen by the German invaders. In doing so, the Nazi officers knew that they were deriding the most remarkable memorial of Russian culture.[2]

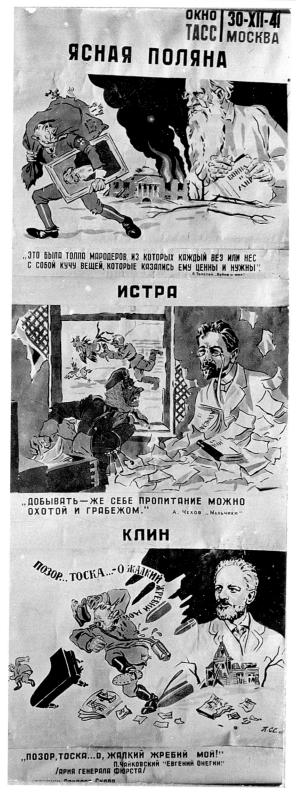

Fig. 1 TASS 30-XII-41, archival photograph, ROT Album, courtesy Ne boltai! Collection.

Image: Kukryniksy
Text: Samuil Marshak
Publisher: Iskusstvo
Edition: 50,000

Offset lithograph
42.3 × 29 cm
Ne boltai! Collection

Parasite upon Parasite

With eyes flashing, the colonel-baron
Commanded: "Stand to attention!"
But upon seeing how itchy his battalion
 was,
He commanded them to order their
 "Lice to attention!"

Against a darkened sky over a snow-covered plain, German soldiers – some wrapped in layers to protect themselves from the cold, others insufficiently dressed – remove lice from their own and fellow soldiers' heads, bodies, and clothing. Birds are happy to assist them in this activity.

The text of the poster is based on an untranslatable pun between the Russian command "stand to attention" (literally, "Hands on trouser seams [*shvy*]!") and lice (*vshi*). The pun was apparently not original to Marshak, but he used it to reveal the discrepancy between the vaunted orderliness of the German forces and their actual pathetic state. The contrast is made more emphatic by the fact that the colonel is a baron. The original TASS poster (fig. 1) is titled *Lousy Company*. The reduced version shown here bears the title the poem carried when Marshak republished it.

This comical rendering by the Kukryniksy of lice-infested soldiers ankle-deep in snow makes light of a scourge that afflicted Russians as well as Germans. Spending day and night in their uniforms in dugouts or trenches for weeks on end and without adequate facilities for bathing and laundering, soldiers on both sides had to endure swarms of lice. They engaged in frantic scratching and scraping to relieve intense itching, which interfered with sleep, focus, and combat. Laying eggs on body hair, clothing, and bedding, lice can carry and transmit other diseases, such as recurring fever, trench fever, and typhus. The latter caused the deaths of tens of thousands of Soviet prisoners of war and ravaged captives in German labor and concentration camps. Parcels of looted garments that German soldiers sent home from the battlefields carried lice to vulnerable civilian populations as well.

This reduced, commercially printed version was priced at thirty-five kopeks.

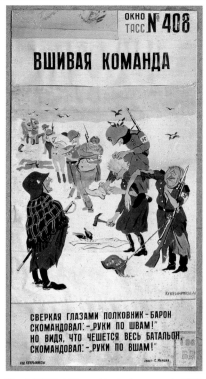

Fig. 1 TASS 408, archival photograph, ROT Album, courtesy Ne boltai! Collection.

Image: Kukryniksy
Text: Samuil Marshak
Edition: 300

Stencil
261 × 128.5 cm
Stenciled, lower left: *Kukryniksy—42*
[in Cyrillic]
Ne boltai! Collection

Death for Death

The warrior carried out the sentence
Of the people's sacred vengeance:
The butcher, strangler, and marauder
Was executed in short order.

Death for Death takes up a subject – Nazis murdering Soviets for their clothing with the intention of warming themselves or sending it back home to family – that TASS posters, as well as conventionally printed posters and cartoons, frequently treated throughout the war.

On a snow-covered knoll, a Red Army soldier, dressed in winter camouflage, shoots and decapitates a German soldier – his head and bare feet wrapped in rags – who was about to take the clothing and footwear of a young girl he had just killed. The German soldier's improvised knapsack, a repurposed Nazi banner or flag, is presumably filled with more loot.

TASS 428 measures over two and a half meters in height; the image proper comprises eight separate stenciled sheets glued onto a secondary support. It speaks to a new direction in the studio beginning in 1942: the interest in creating a single-image composition on a monumental scale seems to have been inspired by the return of evacuated TASS team members following the battle of Moscow (see also TASS 468/468A [pp. 210–11] and 527 [pp. 217–20]).

A reduced, conventionally printed version of TASS 428 was made by the studio in an edition of ten thousand copies in 1943.

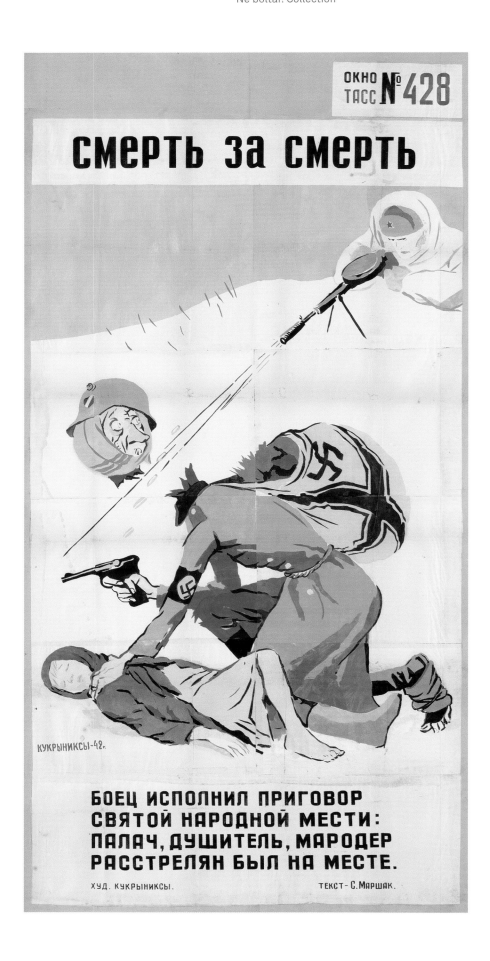

Image: Kukryniksy
Text: Samuil Marshak
Edition: unknown

Stencil
136 × 81 cm
Ne boltai! Collection

This stenciled poster, with text in Uzbek and Russian, is a reduced version of TASS 428. The Uzbek translation of the verse offers a slight variation on the Russian-language version, reproduced at the right:

The warrior carried out the people's
* sentence.*
Took for its holy vengeance
Shooting right there on the spot
One of the merciless thieves.

That this is a satellite studio production is evident in the relatively crude craftsmanship it exhibits. While TASS 428 served as a model for the Uzbek version, the stencils for the latter had to be recut. The registration marks for the green stencil are clearly visible below the German's foot and severed head. The green tone of the soldier's foot, hands, and face is more prominent than in TASS 428, suggesting that he was suffering from frostbite and adding an inadvertent ghoulish element to the image.

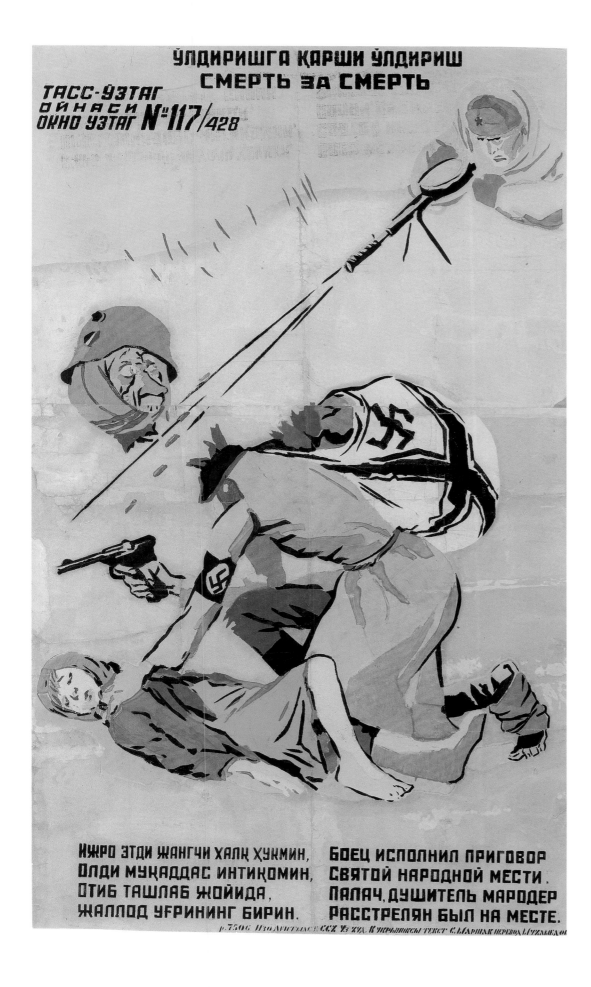

Image: Nikolai Radlov
Text: Sergei Mikhalkov
Edition: 500

Stencil
Each panel: 64 × 88 cm
The Museum of Modern Art, New York

A Meeting with an Ancestor

He is five minutes away from death.
The melting ice cracks beneath Fritz.
For the last time to his bride Bertha
The soldier sends a farewell.

And meeting Fritz on the melting ice,
Rattling the iron of his rusty mail
From the bottom rises a Teutonic knight
Who says, "Halt, soldier!"

"Tell me, descendant, really,
Haven't the Germans, my kith and kin,
Learned after seven centuries,
Not to fight with the Russians?

"The Slavs clobbered me out on the ice,
And now the Slavs are clobbering you.
What, have you forgotten history?
Do you no longer heed it?"

Fritz's muffled voice could be heard
Already from beneath the ice:
"Our mad Führer won't let us
learn our lessons from history!"

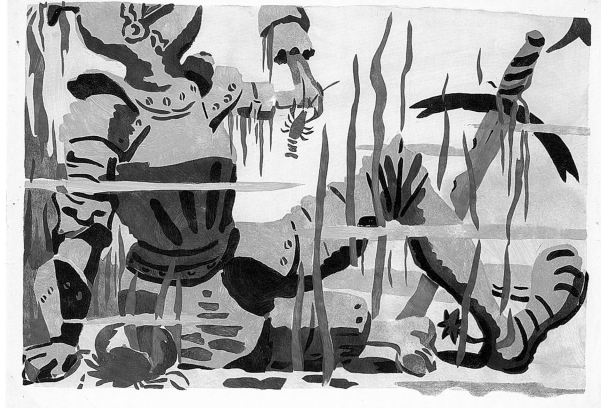

This poster evokes the legendary Battle of the Ice, of April 5, 1242, on frozen Lake Peipus (also known as Lake Chudskoe), on the border of present-day Estonia and the Russian Federation. It pitted crusading Teutonic Roman Catholic knights against Russian Eastern Orthodox Christians. Led by Aleksandr Nevskii, the Russians defeated the Teutons.

This image depicts an encounter between a drowned Teutonic knight and a contemporary German "Fritz," who will share his underwater grave. Before 1917 valiant imperial warriors featured in commercial posters advertising such products as galoshes, beer, soap, and farm implements.[1] During World War II, Nevskii, like so many heroes of Russia's czarist past, was invoked to instill patriotic pride in the motherland's fight with the Nazis. Sergei Eisenstein's acclaimed cinematic dramatization of Nevskii's battle (1938) prepared the groundwork for this glorification. The film, withdrawn from circulation after the Molotov-Ribbentrop Pact of 1939, was rereleased immediately after the German invasion, along with other anti-German films.

Mikhalkov, who contributed texts for five TASS posters, was best known as the author of the Soviet national anthem (1944; revised by the author in 1977 and again in 2000, it is now the anthem of the Russian Federation) and as a prolific children's writer. His *Moia ulitsa* (*My Street*) (1943) instructed youngsters how to view wartime propaganda posters (see fig. 1).

Image: Nikolai Radlov
Text: Sergei Mikhalkov
Publisher: UzTAG
Edition: unknown

Stencil
105 × 114 cm
Ne boltai! Collection

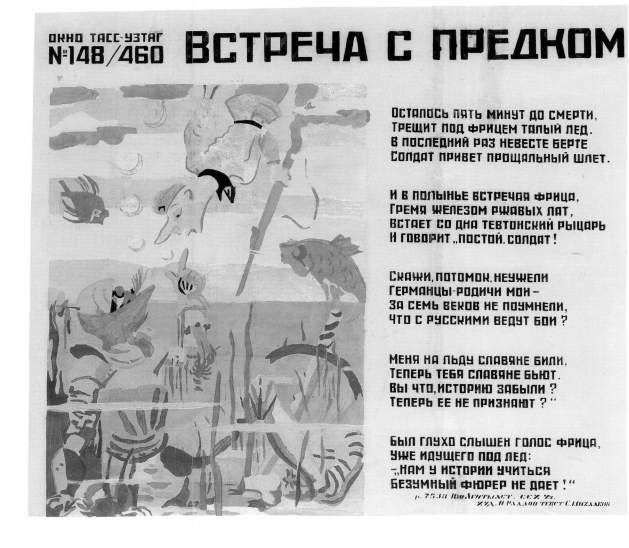

Fig. 1 Vladimir Vasil'ev and Iurii Pimenov, with text by Sergei Mikhalkov. *Maia ulitsa* (*My Street*) (Detgiz, 1943). The poem reads, "Here they display TASS Windows / For the entire city to see. / The people rush along the streets / But everyone still stops to read / The funny window-poster. // I see Hitler's portrait / And I know that he is a cannibal. / But I do not shake from fear; / I simply laugh it off. / I hold Daddy by the hand / And I do not fear the Germans!" In addition to illustrating the poem, this image depicts contrasts of daily life in wartime Moscow. At the right, a mother wheels a baby carriage along a sidewalk beyond which sit two antiaircraft batteries.

In both versions of this poster, the light application of pale hues effectively suggests an underwater setting. New stencils were cut for the UzTAG version of TASS 460, as comparison with that in MoMA reveals. Lacking the text, the MoMA poster was stenciled on two separate sheets, which still have their margins. These would have been cut before assembling the poster, as in the Uzbek version. The paper is more durable than the cheaper newsprint used for most TASS posters. Like the Hoover Institution's holdings of TASS posters (see TASS 109 [p. 179], 124 [p. 180], and 178 [pp. 189–90], for example), those in MoMA's collection were intended to travel in order to garner public support in the United States for the Soviet cause. Apparently, the Soviet embassy in Washington, D.C., received a set that included this poster with a plan in mind for the museum to organize a circulating exhibition of them; it was not realized.

Image: Kukryniksy
Text: Samuil Marshak
Edition: 500

Stencil
247 × 142 cm
Ne boltai! Collection

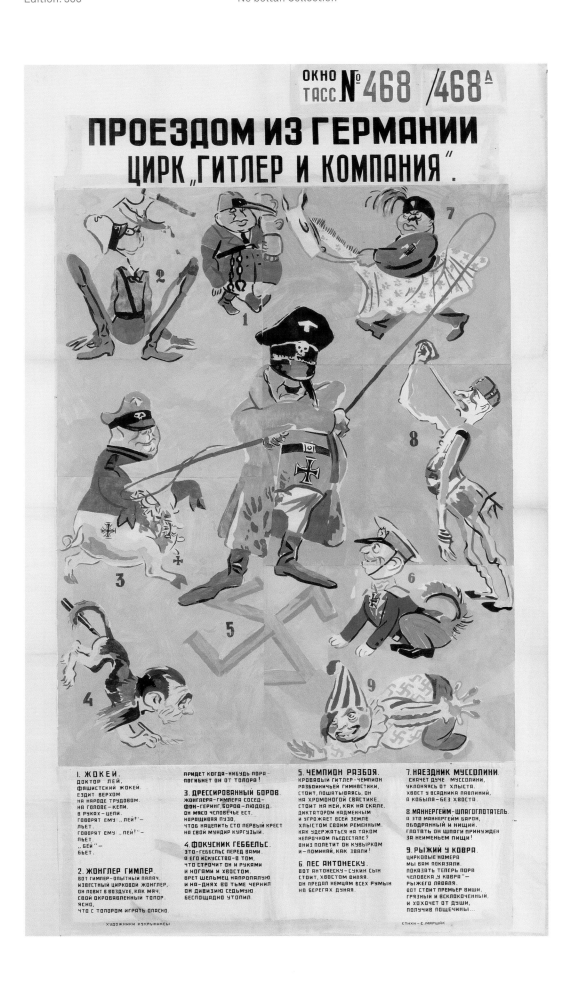

On Tour from Germany "Hitler and Company" Circus

1 The Jockey
Fascist minion, Dr. Ley
Takes his order, draws his pay,
Jockey-like, he seems to be
Riding hard on Germany.

2 Juggler Himmler
Himmler the killer
Axe in air
Juggles with skill
But not with care.

There's danger in treating
An axe like a toy
One day it will slip
And the butcher destroy.

3 The Trained Boar
Von Goering, the greedy, man-eating boar,
Eats his fill and asks for more,
Increasing his girth with piggish grunt
To display the medals on his front.

4 Magician Goebbels
Goebbels the writer, a side-show treat
Scribbles with hands, and tail and feet
Lifts his voice in a desperate cry
Shouting that all Goebbels lie.
The ink that flows from his merciless pen
Is enough to drown a division of men.

5 Champion Robber
To teeter on a swastika
Is very, very dumb
Especially since Hitler has
No equilibrium.

6 Dog Antonescue,
Antonescue, with cunning knavery
Sold his countrymen into slavery.
He cares not a fig for Roumania's loss
As he wags his tail at his German boss.

7 Horseman Mussolini
With nothing to gain
And with no tail to wag,
Mussolini just gallops
A terrified nag.

8 Mannerheim – Sword Swallower
Just a hungry beggar,
Ponder your sins on
Gobble up this nice long sword
It's full of vitamins.

9 The Clown
In history
Laval goes down
As just a foolish
Dirty clown.

TASS 468/468A is notable for its aim to be physically overwhelming. Its festive colors initially draw the viewer in before he or she becomes aware of such disquieting elements as the bloodstained handprints on Hitler's greatcoat. Against a bold expanse of pink, the Führer's Nazi cohorts and Axis partners revolve around him as if in orbit. The arms of the swastika on which he stands, like a sinister ringmaster, are bent at an exaggerated angle in order to suggest the centrifugal motion of the performers. They epitomize the grotesque, merging the uncomfortably ribald and ludicrous with such distortions as the scatological stiletto of Goebbels's poisonous fountain pen, Göring's porcine prancing, and the menacing balancing act that Himmler attempts with a bloody ax.

This vertical poster is based on a horizontal Kukryniksy cartoon that appeared in *Komsomol'skaia pravda* on May 8, 1942. With the exception of Himmler, who squats in the poster, and Pierre Laval, who bows, the poses of the performers are more or less the same in both images.

On the day TASS 468/468A appeared, *Pravda* published a cartoon – "The Fascist Jazz Band" – by the Kukryniksy, with a caption by Marshak.[1] The cartoon reflected a report that the German authorities in the occupied Netherlands had banned the performance of any music by Tchaikovsky. It is possible that both cartoons were submitted to the TASS editorial board for realization as a poster, and the editorial board selected the circus theme.

A reduced, conventionally printed version of this poster was issued in 1943 by the TASS studio in an edition of ten thousand copies. The above translation from the Russian of Marshak's poem accompanied a reduced version included in the portfolio *Soviet War Posters*, issued by RWR in 1943.[2]

Image: Konstantin Vialov
Text: Vasilii Lebedev-Kumach
Edition: 200

Stencil
176.5 × 75 cm
The Art Institute of Chicago, gift of The
U.S.S.R. Society for Cultural Relations
with Foreign Countries, 2010.218

Naval Guardsman

Fascist pirates, you have no hope
Of escaping alive from the guardsmen,
When the guardsmen meet their enemy
They leave only wreckage in their wake.

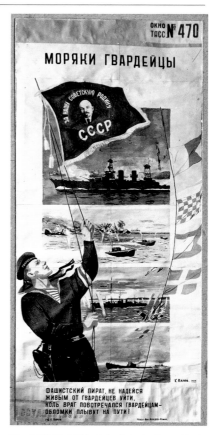

Fig. 1 TASS 470 (original design), archival
photograph, ROT Album, courtesy Ne
boltai! Collection.

This poster celebrates the establishment of naval-guard units on June 19, 1942. In the Soviet Union, the status of "guardsmen" was awarded to military units that demonstrated heroism in combat. They received special standards, such as the fringed banner with a portrait of Lenin inscribed "For Our Soviet Motherland the USSR" that the young sailor hoists in the present poster. He wears a flat-topped, visorless cap (*bezkozirka*) with a tally that displays the word *gvardeiskie* (guards). The two other flags at the right are that of the Soviet land force (above) and the naval ensign (below). Their positions relative to one another indicate that the navy was now following the valiant example of the land forces and therefore could be similarly honored. The poster's original design showed Soviet naval numeric and signal flags (fig. 1). In the background is a sequence of combat encounters between Soviet and German ships and aviation bombers.

TASS 470 embodies the new pictorialism of the studio following the reunion of studio members after the return of evacuees to Moscow. Previously, evocative, gradual color washes such as those in the backgrounds of the four naval battle scenes here were unusual for TASS. They could have been produced by dabbing or brushing pigment through a stencil and then extending and softening the color with a damp, clean brush. The many mottled and overlaid transparent tones and shading employed in both the water and vivid skies create multiple effects derived from several traditions. Among these is the highly controlled craftsmanship of ROSTA-inspired TASS posters from 1941. Another is a shading technique in Japanese printmaking known as *bokashi*. Finally,

achieving such graded color shifts in stenciled areas, particularly evident in the bottom seascape, requires manipulations typical of painting.

Vialov specialized in naval scenes, which he rendered in a realistic style (see also TASS 992 [pp. 290–92]). Lebedev-Kumach was best known for his popular song lyrics, including "The Song about the Motherland," which he wrote for a 1935 film, *Circus*, and which became an unofficial anthem for the Soviet Union; and "Holy War," which appeared in the nation's major newspapers two days after the German invasion and was performed frequently throughout the war. The present poster's quatrain, in a lyrical amphibrachic meter, could easily have been set to music as a kind of rousing anthem for naval guards.

A reduced, conventionally printed version of TASS 470 was issued by the TASS studio in 1943 in an edition of ten thousand. This poster was in the first shipment of TASS posters dispatched to the Art Institute of Chicago in July 1942 by VOKS.

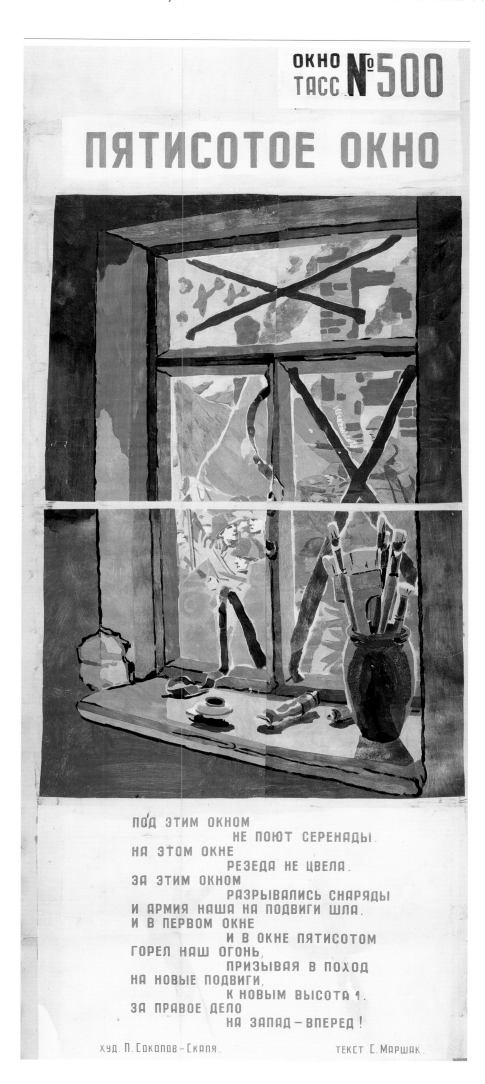

Image: Pavel Sokolov-Skalia
Text: Samuil Marshak
Edition: 300
Stencil
189 × 87 cm
Courtesy Ne boltai! Collection
Not in exhibition

The Five Hundredth Window

*Under this window, no one sings
 serenades.*
*On this windowsill, no mignonette
 blooms.*
Outside this window, shells exploded,
*And our army marched to perform heroic
 deeds.*
*From the first window to the five
 hundredth*
Our fire has burned as a battle cry:
To new heroic deeds, to new heights
*For the good cause, to the West
 – onward!!*

In this very painterly interior scene, light shines through a taped-up window onto a windowsill that holds an inkpot, tube of paint, and jar of assorted implements, including paint, paste, and stencil brushes. Observed through the window are the faint contours of ruined buildings and Red Army soldiers advancing to the left, or westward. One holds a fringed banner. Above fighter planes are involved in combat. While the window, ledge, and artists' tools are meant to evoke the TASS studio in Moscow, what we see outside is allegorical, representing the theater of war on the Eastern Front. For this melancholy poster, Marshak created a text with a sing-song quality, which was unusual for him. He might well have intended the poem to be set to music, as was the text in TASS 124 (pp. 180–81).

TASS 500 commemorates the first anniversary of the war, as well as of the studio's poster project. The juxtaposition of the atelier's interior and the modest implements used by the artists and writers with the fighting outside underscores the oft-repeated assertion that the TASS team members were as much soldiers as their uniformed compatriots. TASS's "poster-bayonets" functioned as critical weapons in the war effort.[1]

Image: Kukryniksy
Edition: 300
Stencil
214 × 116.5 cm

The Art Institute of Chicago, gift of The U.S.S.R. Society for Cultural Relations with Foreign Countries, 2010.94

Chicago Daily Tribune

2 CENTS PAY NO MORE! THE WORLD'S GREATEST NEWSPAPER **FINAL**

VOLUME CI—NO. 140 C FRIDAY, JUNE 12, 1942—33 PAGES PRICE TWO CENTS

U.S. JOINS REDS IN WAR PACT

Agree on Opening Second Front Against Germany This Year

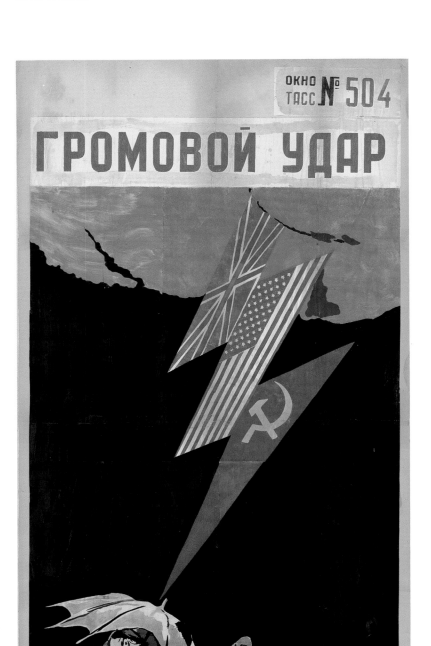

A Thunderous Blow

Cowering under a tattered umbrella near a wrecked German tank and plane, Hitler and Mussolini – their bloody hands clutching the umbrella handle – are struck by a lightning bolt made up of the flags of Great Britain, the United States, and the Soviet Union. One of the Kukryniksy's boldest designs, TASS 504 celebrates the signing of a defensive alliance between the three nations. This important pact received headline coverage throughout the world. The *Baltimore Evening Sun* reported on June 11:

President Roosevelt and Soviet Commissar V. M. Molotov, the White House announced today, have reached a "full understanding ... with regard to the urgent tasks of creating a second front in Europe in 1942.... Another momentous development announced today, in London, was that Russia and Britain had signed a twenty-year mutual assistance treaty.

On the Soviet side, the agreements initiated a propaganda offensive directed at those countries not occupied by the Axis powers and sympathetic to the Allied cause. Through VOKS, TASS posters – the Soviet Union's paper ambassadors – were dispatched around the world to encourage support of the Russian war effort and a second front, in western Europe, that would divert the Germans away from the Eastern Front. This effort coincided with a campaign to help acquaint Russians with their Allied partners. As the *Washington Post* correspondent Henry C. Cassidy reported from Kuibyshev (Samara) on August 3:

In view of the fact Russia has been virtually isolated from the outside world since the Bolshevik revolution, some observers believe books, pamphlets and motion pictures portraying the United States and England are almost as urgent to the Soviets as planes, tanks and guns.... The Russians are cooperating in this campaign with pamphlets, newspaper articles, and posters emphasizing unity with the

United States and Great Britain. The latest window poster shows British, American, and Soviet flags striking like lightning at Hitler and Mussolini bundled under an umbrella.[1]

This poster, like all the others, was the result of a number of hands. It comprises four sheets, each separately stenciled by various individuals and then combined into a unified composition. The differing treatment of the gray cloud – brushed in on the right-hand sheet and dappled in the left-hand one – reveals the individual expression involved in translating the overall design into stencil. The concern for painterly effects, even in this satirical image, is especially evident in the modeling of Mussolini's face, where the flesh tone, violet, gray, and black were applied in contingent as well as overlapping strokes to create a sense of volume.

The visual theme of the lightning bolt striking enemies of the state in Soviet iconography goes back to 1921, when Viktor Deni created a poster showing a capitalist struck by lightning in the form of words "III internats" (Third International).[2]

On June 20, 1942, *Komsomol'skaia pravda* reproduced TASS 504 with the following poem, entitled "Thunderstruck," by Dem'ian Bednyi:

Feeling in their guts / Their certain defeat, / The thieving band / Of Fascist cardsharps / Have set on edge / Their fine pfennig. / But now, / threatening them with harm, / Above them fly // Three victorious flags. / Thunder has struck! / It will be followed – / The enemy won't escape punishment – By lightning-quick / Fatal blows.

A reduced, conventionally printed version of this poster was issued in 1943 by the TASS studio in an edition of ten thousand copies. TASS 504 was featured on the cover of the May 1943 issue of *Soviet Russia Today*, the mouthpiece of the New York–based Friends of the Soviet Union. It was reproduced in *VOKS Bulletin* 5–6 (1942).

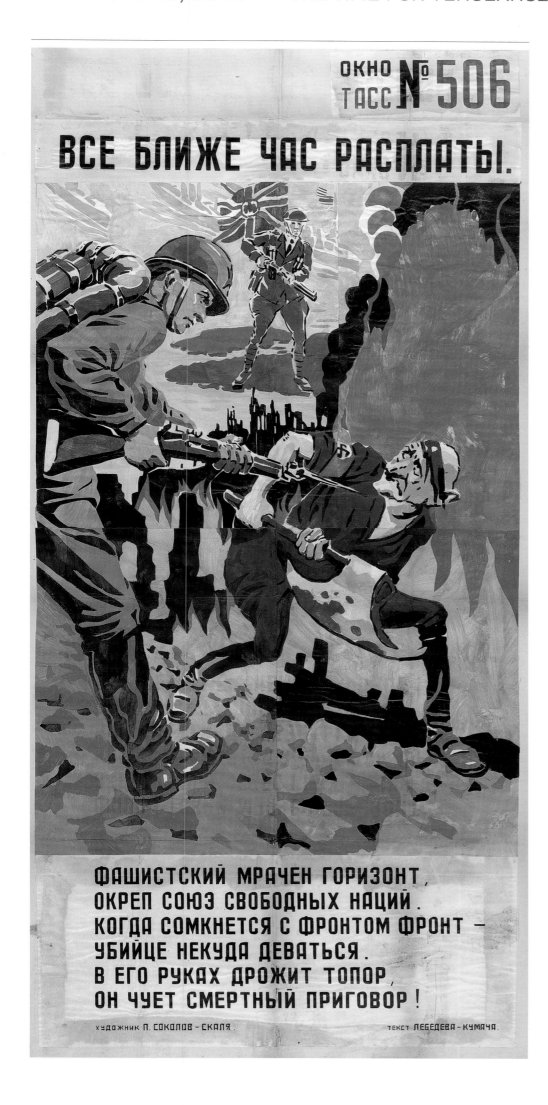

Image: Pavel Sokolov-Skalia
Text: Vasilii Lebedev-Kumach
Edition: 300
Stencil
189 × 93.5 cm
The Art Institute of Chicago, gift of The
U.S.S.R. Society for Cultural Relations
with Foreign Countries, 2010.170

The Time for Vengeance Is Approaching.

The Fascist's outlook is somber,
For the union of free nations has
* strengthened.*
When one front joins the other front –
The murderer will have nowhere to go.
The ax trembles in his hand,
He senses his death sentence!

A Red Army soldier, his Mosin-Nagant
rifle fitted with a bayonet, attacks
Hitler, who holds a large, blood-
stained, half-moon ax that resembles
medieval prototypes. Behind Hitler,
Europe burns. On the topographical
contours of Ireland and England, and
in front of the Union Jack, stands the
archetypal British soldier (dubbed
"Tommy"), rifle at the ready. At the top,
three ships, one flying the American
flag, move toward the British Isles.

Stalin continued to press for a second
front in western Europe. The idea res-
onated with the American and British
public, as attested to by numerous
favorable editorials, cartoons, and
rallies. The present poster, with its
blend of representational strategies
– caricature to ridicule Hitler (note his
absurd comb-over hairdo) and realism
to glorify the Soviet soldier and his
British comrade – exemplifies the
mature TASS-poster style of Sokolov-
Skalia. The increase in the poster's
chromatic range signals the studio's
growing mastery over cutting and
printing multiple stencils.

The image's striking composition
blends three perspectives: one from
the figures of the Red Army soldier
and Hitler to the English channel; a
second from Hitler to the figure of
Tommy, who stands higher up, on the
purple landmass of England; and a
third from Tommy to the boats below
and behind him.

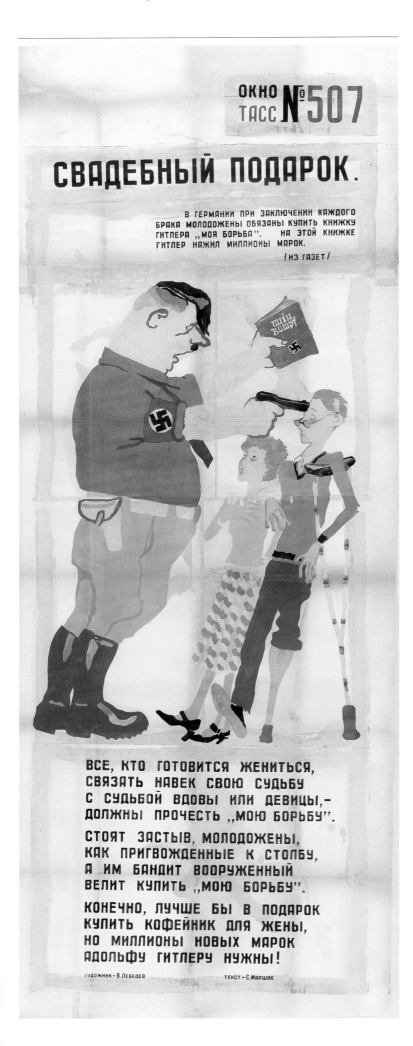

Image: Vladimir Lebedev
Text: Samuil Marshak
Edition: 300
Stencil
236 × 93.5 cm
The Art Institute of Chicago, gift of The
U.S.S.R. Society for Cultural Relations
with Foreign Countries, 2010.214

The Wedding Present.

*In Germany for every marriage
Newlyweds are obliged to purchase
Hitler's "Mein Kampf." This book has
Earned millions of marks for Hitler.
(From newspaper reports)*

*Everyone who wants to marry,
To bind his fate for evermore,
With the fate of a widow or maiden:
Everyone must read "Mein Kampf."*

*The newlyweds are frozen in place
As if they are nailed to a pillar,
And an armed bandit orders them
To purchase "Mein Kampf."*

*Certainly, it would be better
To buy a coffee pot for one's wife,
But Adolf Hitler needs
Millions more marks.*

The topic of Hitler's profits from his
book *Mein Kampf* – its sales made
him a very rich man – was a favorite
among graphic satirists. Here the
German leader towers over a young
couple, coercing them at gunpoint into
buying the book. The emphatic use
of opaque pink to render the exposed
flesh of the corpulent Führer rein-
forces the association of the Nazis
with pigs (see also TASS 768 [p. 247]
and 837 [p. 255]). Interestingly, in this
poster the Führer resembles Ernst
Röhm, the infamous cofounder and
leader (until his execution on Hitler's
orders in 1934) of one of the most
vindictive and murderous forces in
Germany, the Nazi Party militia, or
Sturmabteilung (SA).

The rendering of the lanky groom as a
serious, bespeckled type with a peg
leg and crutch suggests that he could
be a maimed war veteran. The poem
indicates that his bride could be a
war widow. By the time this poster
appeared, Germany had been at war
for almost three years.

Image: Kukryniksy
Text: Konstantin Simonov
Edition: 600

Stencil
286.5 × 114 cm
Ne boltai! Collection

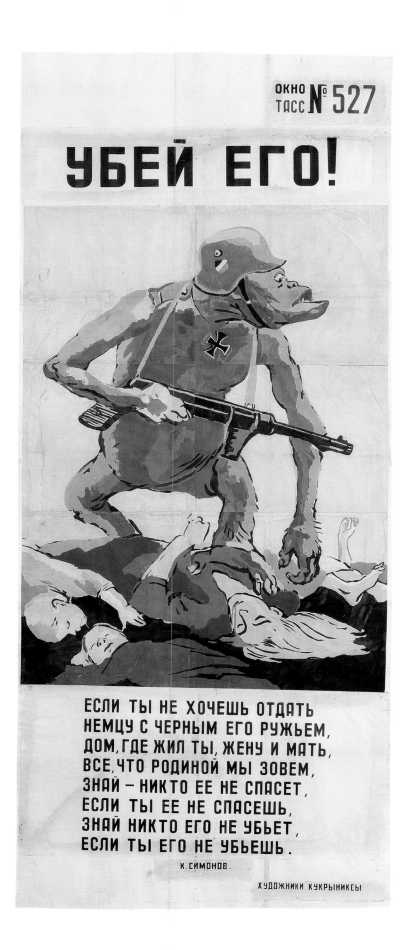

Kill Him!

If you don't want to give away
To a German, with his black gun,
Your house, your wife, your mother
And everything we call our native land.
Then know your homeland won't be saved
If you yourself do not save it.
And know the enemy won't be killed,
If you yourself do not kill him.

Simonov, along with Vasilii Grossman and Il'ia Erenberg, was one of the most prominent Soviet authors writing about the war. All three spent much time reporting from the front for *Krasnaia zvezda* (see fig. 8). There were 1,357 military newspapers such as *Krasnaia zvezda*; they had a daily circulation of 6,256,000.[1] The July 18, 1942, issue of the newspaper published Simonov's long poem "Kill Him!" It reappeared the next day in *Komsomol'skaia pravda*, was adapted for TASS 527, and was often reprinted and anthologized thereafter. The poet Nikolai Tikhonov reported that in besieged Leningrad the poem's title was painted onto walls in "meter-high letters."[2] Stalin reputedly called "Kill Him!" a poem that brought victory closer.

Simonov described "Kill Him!" as a "bitter" poem, inspired by the "grave events of that summer." The complete poem (p. 220) provides a virtual catalogue of the injustices being wrought against the addressee's family, including the beating of his mother, the defiling of his father's grave, and the rape of his wife. The poem urges the addressee not to let others act for him but to "kill at least one" German. It has an unusual, syncopated meter that creates a sense of exceptional urgency. "Kill Him!" was widely emulated by other poets. On July 22, 24, and 28, Semyon Kirsanov published in *Komsomol'skaia pravda* three poems with similarly imperative titles: "Punish," "Stop," and "Destroy." Agniia Barto followed up with her own "Kill Him," which appeared in the same newspaper on September 23.

In TASS 527, a gorilla-like creature wearing Nazi insignia and carrying a submachine gun (MP40) tramples a slain woman and two children. The incongruity between the poster's subject and its pale pink palette sharpens the brutal impact of the image. This visual dissonance renders the figure more monumental, monstrous, and shocking.

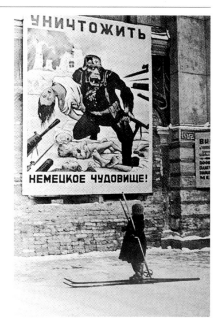

Fig. 1 Photographer unknown. Wintry scene in Leningrad, where a giant poster, based on a Kukryniksy cartoon published in *Pravda* on August 6, 1942, hung in a window of the department store Gostinydvor on Nevskii Prospekt. During the Leningrad Blockade (September 8, 1941–January 27, 1944) – one of the longest and most destructive sieges in history – every two to three days "new TASS Windows appeared on the streets. They were like balm for the Leningrad dwellers who awaited them like their daily bread" (Kolesnikova 2005, p. 137).

The image of the enemy as a gorilla had appeared in World War I posters (see fig. 2). The animal, interpreted as a rampaging brute, became a trope for all that is evil and menacing, the personification of the enemy regardless of ideology, whether Bolshevism (see fig. 4) or Fascism (see fig. 6). Among American isolationists, the metaphor was extended to academics, who were blamed for the New Deal and supporting entrance into the war (see fig. 3). At TASS the subject appeared numerous times until the war's end (see for example fig. 5 and TASS 606 [pp. 227–28] and 1243–1244 [pp. 363–65]).[3]

This poster was issued in the largest edition size produced by the TASS studio to date. Moreover, records indicate that it was reproduced in reduced-format editions at least three times: twice as offset lithographs (in 1942 in Kuibyshev in an edition of twenty thousand and in the same year by the TASS studio in an edition of eight thousand [fig. 9]) and once by the TASS studio as a small silkscreen.

Fig. 2 H. R. Hopps (American, 1869–1937). *Destroy This Mad Brute – Enlist U.S. Army*, 1917. Offset lithograph; 96 × 72 cm. Private collection. The image of the abduction of a woman (usually Caucasian) by an ape can be found in a variety of media, from mid-nineteenth-century sculpture to the 1933 American film *King Kong*.

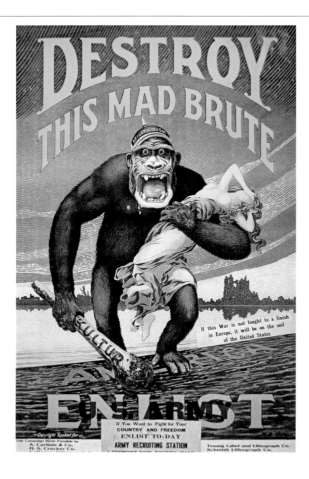

Fig. 3 Carey Orr (American, 1890–1967). "What's in a Name?," *Chicago Daily Tribune*, September 17, 1941.

Fig. 4 Julius Engelhard (German, 1883–1964). *Bolshevism Brings War, Unemployment, and Famine*, 1918. Offset lithograph; 124.5 × 94 cm. The Art Institute of Chicago, William McCallin McKee Memorial Fund, 2010.348. With an ignited bomb in one hand and a knife in the other, the Bolshevik beast is ready, in the opinion of the organization that commissioned the poster (Society to Fight Bolshevism [Vereinigung zur Bekämpfung des Bolschewismus]), to destroy all that is good and right.

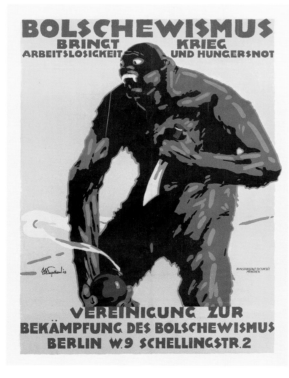

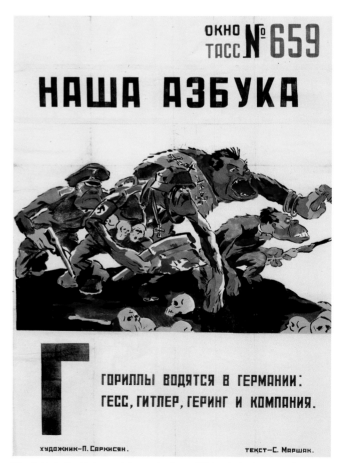

Fig. 5 Petr Sarkisian, with text by Samuil Marshak. *Our ABC (Letter G)* (TASS 659), March 15, 1943. Edition: 600. Stencil; 128 × 86 cm. Ne boltai! Collection. The text reads, "They're raising gorillas in Germany / Hess, Hitler, Göring, and Company."

Fig. 6 Boris Prorokov (born Ivanovo-Voznesensk, 1911; died Moscow, 1972). *Fascism Is the Enemy of Culture*, 1939. Publisher: unknown. Edition: unknown. Offset lithograph; dimensions unknown. Courtesy Ne boltai! Collection. Here a Soviet artist responded to the threat of totalitarian regimes to freedom of thought. The gorilla has chopped down monuments to Darwin (left) and Heine (right) and tramples on books by Rolland, Voltaire, Marx, Einstein, and Gor'kii.

Fig. 7 Vasilii Vlasov (born St. Petersburg, 1905; died Leningrad, 1979), Teodor Pevzner (born 1904; died 1994), and Tatiana Shishmareva (born St. Petersburg, 1905; died St. Petersburg, 1995). *Death to Fascism*, June 29, 1941. Publisher: Iskusstvo. Edition: 20,000. Offset lithograph; 60.4 × 90.4 cm. Ne boltai! Collection. This poster, issued just over a week after the Germans invaded the Soviet Union, shows the Nazi gorilla, armed with pistol and ax, leaving his dirty footprints across Europe. He is stopped at the border of the Soviet Union by a phalange of bayonets. In exhibition.

Kill Him![4]
Konstantin Simonov

If your home means anything to you
Where you first dreamed your Russian
 dreams
In your swinging cradle, afloat
Beneath the log ceiling beams.
If your house means anything to you
With its stove, corners, walls and floors
Worn smooth by the footsteps of three
Generations of ancestors.

If your small garden means anything to
 you
With its many blooms and bees aglow,
With its table your grandfather built
Beneath the linden – a century ago.
If you don't want a German to tread
The floor in your house and chance
To sit in your ancestors' place
And destroy your yard's trees and plants.

If your mother is dear to you
And the breast that gave you suck
Which hasn't had milk for years
But is now where you put your cheek;
If you cannot stand the thought
Of a German doing her harm.
Beating her furrowed face
With her braids wound round his arm.
And those hands which carried you
To your cradle washing instead
A German's dirty clothes or making him
 his bed.

If you haven't forgotten your father
Who rocked you to sleep in his arms,
Who was a good soldier, who vanished
In the high Carpathian snows
Who died for your motherland's fate,
For each Don and each Volga wave,
If you don't want him in his sleeping
To turn over in his grave,
When a German tears his soldier picture
With crosses from its place
And before your own mother's eyes
Stamps hobnailed boots on his face.

If you don't want to give away
The woman you walked with and didn't
 touch,
When you didn't dare even to kiss
For a long time – you loved her so much,
And the Germans cornering her
and taking her alive by force,

Crucifying her – three of them
Naked on the floor, with coarse
Moans, hate and blood, –
Those dogs taking advantage of
All you sacredly preserved
With your strong, male love.

If you don't want to give away
To a German with his black gun
Your house, your mother, your wife
All that's yours as a native son
No: No one will save your land
If you don't save it from the worst.
No: No one will kill this foe,
If you don't kill him first.

And until you have killed him, don't
Talk about your love – and
Call the house where you lived your home
Or the land where you grew up your land.

If your brother killed a German,
If your neighbor killed one too,
It's your brother's and neighbor's
 vengeance,
And it's no revenge for you.
You can't hide behind another
Letting him fire your shot.
If your brother kills a German,
He's a soldier; you are not.

So kill that German so he
Will lie on the ground's backbone,
So the funeral wailing will be
In his house, not your own.
He wanted it, so it's his guilt
Let his house burn up, and his life.
Let his wife become a widow;
Don't let it be your wife.
Don't let your mother tire from tears;
Let the one who bore him bear the pain.
Don't let it be yours, but his
Family who will wait in vain.

So kill at least one of them
As soon as you can. Still
Each one you chance to see!
Kill him! Kill him! Kill!

Fig. 8 Konstantin Simonov writing from the trenches. From "Poet with a Gun," in *The Russian Glory* (RWR, c. 1942).

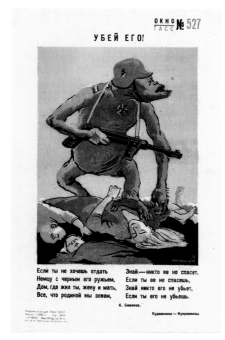

Fig. 9 TASS 527 (reduced version), 1942.
Edition: 8,000. Offset lithograph; 31 x 19.5 cm.
Ne boltai! Collection.

Image: Vladimir Lebedev
Text: Samuil Marshak
Edition: 600

Stencil
231.5 x 91.5 cm
The Art Institute of Chicago, gift of The
U.S.S.R. Society for Cultural Relations
with Foreign Countries, 2010.116

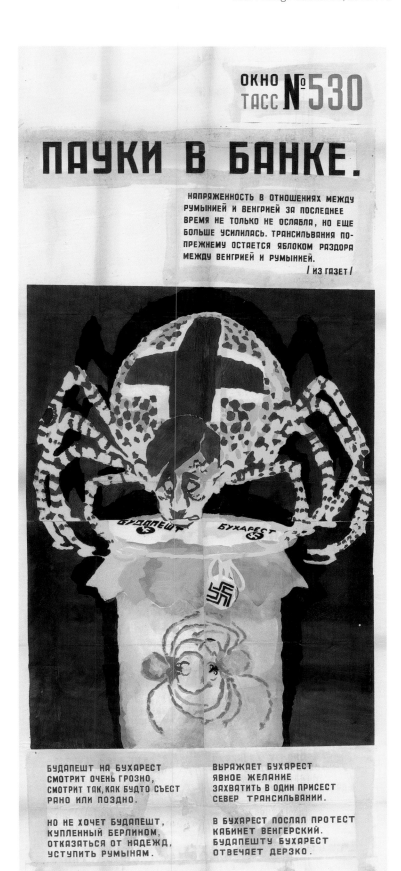

Spiders in a Jar.

*Tensions between Romania and Hungary
have not eased as of late, but rather
have escalated. Transylvania remains a
bone of contention between Hungary and
Romania. (From newspaper reports)*

*Budapest stares at Bucharest
In a very menacing way.
It looks as if it's hatching plans
To gobble it up one day.*

*But Budapest has been bought out
By the German treasury,
And it resists losing hope
And caving in to the Romanians.*

*Bucharest clearly wants
To add to its territory
By grabbing up in one fell swoop,
The North of Transylvania.*

*The Hungarian cabinet to Bucharest
Sent a diplomatic protest,
But very brazenly Budapest
Was answered by Bucharest.*

*Thus on the sly
Two hungry spiders
Argue and quarrel
In Hitler's jar.*

Two small spiders fight in a glass jar
whose paper lid is labeled "Bucharest"
and "Budapest." Over the lid hov-
ers a huge spider with Hitler's face
anxiously observing the struggle he
seeks to contain. In this inventive
poem, Marshak made full use of the
similarity between the names of the
Romanian and Hungarian capitals
to show how the aggression of Axis
nations ultimately became directed at
one another.

Issues of national and ethnic iden-
tity were at the root of the conflict
between Hungary and Romania.
Transylvania, which had been part of
Hungary, was transferred to Romania
in the Trianon Treaty of 1920. Twenty
years later, the second Vienna Award,
signed August 30, 1940, ceded
Northern Transylvania to Hungary,

while Southern Transylvania remained
within Romania. This resulted in mas-
sacres by Hungarians of Romanians
living in Northern Transylvania. To
quell this conflict, a combined Italian-
German arbitration commission was
dispatched in the summer of 1942
to investigate interethnic condi-
tions in both parts of Transylvania,
which is what TASS 530 refers to. In
September 1944, an armistice agree-
ment between the Allies and Romania
would return Northern Transylvania
to Romania.

The spider has long been a favorite
subject for graphic satirists. Able
to weave nearly invisible webs to
ensnare victims, the insect was seen
as particularly sinister. A German
poster (fig. 1.19) employs the spider
metaphor to suggest the menace
Bolshevism represents to the entire
world. In a cautionary poster by
Cheremnykh (fig. 1.18), a spider rep-
resents a kulak, a destructive force in
the guise of a collective farm worker.
At the end of each of the spider's eight
legs are vignettes related to various
communal agrarian activities that the
kulak tries to sabotage.

This ingenious composition is a far
cry from those that Lebedev, over
twenty years earlier, had created for
the Petrograd ROSTA studio, where
he was a principal artist. The remark-
able simplicity and experimental
character of his designs made them
controversial; even some of his ROSTA
colleagues wondered whether their
level of abstraction made them
incomprehensible to broad audi-
ences.[1] Subsequently, abstraction
was denounced as an expression
of bourgeois elitism. In TASS 530,
Lebedev revealed his pre-ROSTA roots
in political caricature.

Image: Pavel Sokolov-Skalia, Nikolai
Radlov
Text: Samuil Marshak
Edition: 300

Stencil
177 × 87 cm
The Art Institute of Chicago, gift of The
U.S.S.R. Society for Cultural Relations
with Foreign Countries, 2010.169

Fascist reports, false reports
Have long ago sunk our valiant fleet,
But our destroyers and our submarines
Still sink German sharks.

The Soviet navy comprised four major
fleets: the Northern, Baltic, Black
Sea, and Pacific. The Northern fleet,
which plied the Arctic Ocean and the
White and Barents seas, safeguarded
convoys with Lend-Lease cargo
en route from North America and
England to Murmansk and Archangel
(Arkhangelsk). At the time TASS 536
was issued, the Baltic fleet — the
Soviets' largest — was confined to the
Gulf of Finland because the Axis part-
ners controlled the Baltic. Nazi media
delighted in suggesting the severity of
Soviet naval losses.

This poster tackles Nazi propa-
ganda head-on. In the top panel,
Nazi Propaganda Minister Goebbels,
mimicking a submarine, torpedoes
an enemy warship with his fountain
pen. The bottom panel shows a Soviet
submarine successfully destroying
a German vessel. Another ship sinks
in the background. Thus, the artists'
image infers that German reportage
of Axis superiority at sea was mis-
leading. It suggests a greater "truth":
that the Soviet navy had actually
been victorious against the Germans.
While Goebbels's pen is not sufficient
to make a hit, the potency of visual
propaganda cannot be denied.

A reduced, conventionally printed
version of TASS 536 was issued by the
TASS studio in 1942 in an edition of
ten thousand.

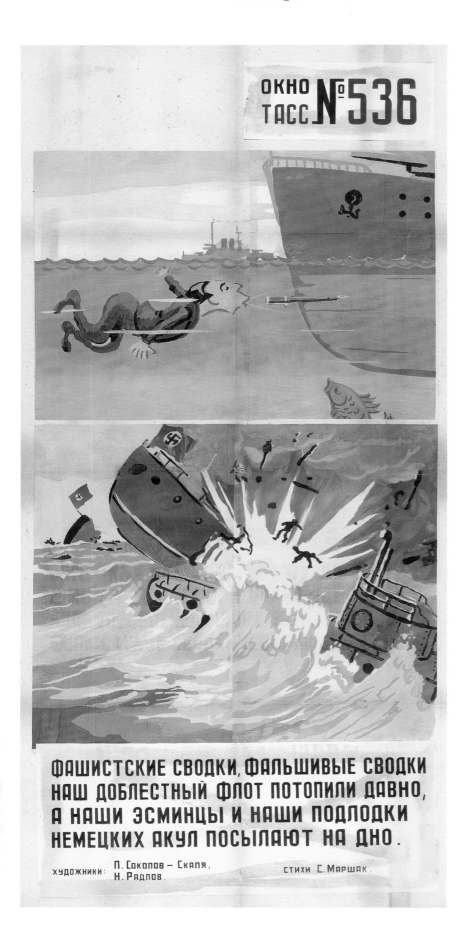

Image: Petr Shukhmin
Edition: 500

Stencil
230 × 112.5 cm
Ne boltai! Collection

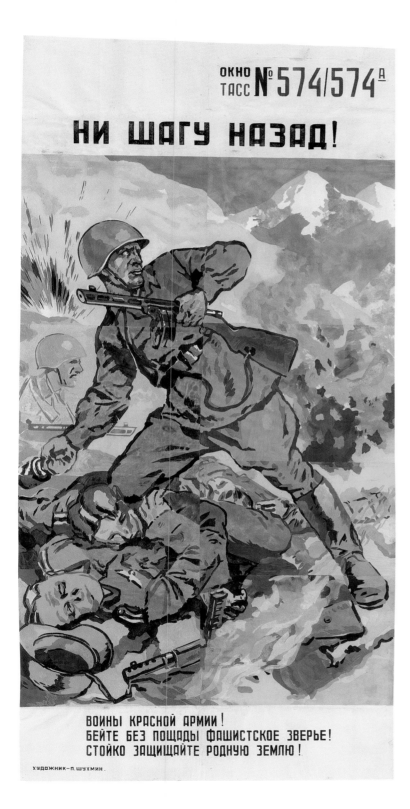

Not a Step Back!

Soldiers of the Red Army!
Strike the Fascist beast without mercy!
Staunchly defend your homeland!

Against an explosive, rugged terrain, a member of the Red Army moves over the putrifying corpses of German soldiers. In his left hand, he holds a machine gun (PPSh-41), and in his right a grenade, which he is poised to throw. Shukhmin's contributions to the TASS poster project were mainly in the "heroic" mode, although he occasionally rendered caricatures of the enemy, albeit in a realistic manner. Though the drawing in TASS 574/574A is unremarkable, one loses oneself in areas of great chromatic complexity that function abstractly to translate the painterly effects and brushwork of the original design. The text comprises three imperatives devoid of any poetic aspiration.

The poster's subject is the Red Army's North Caucasian Strategic Defensive Operation (July 25–December 31, 1942). It aimed to prevent the Germans from taking control of the Caucasus region and thus thwart German access to the Soviet Union's Caucasian oil facilities. This resource was critical to both the Soviet and German armies in successfully concluding the war. In this effort, the Soviets were helped by the fact that the Germans had to reduce their troops in the Caucasus theater of war in order to beef up their forces in the increasingly fanatical siege of Stalingrad (see TASS 579 [p. 224]).

The poster's title derives from a line in the preamble to Stalin's Order 227, issued on July 28, 1942:

The enemy delivers more and more resources to the front, . . . penetrates deeper into the Soviet Union, captures new areas, devastates and plunders our cities and villages, rapes, kills and robs the Soviet people. . . . Some units have abandoned [their posts] without resisting and without orders from Moscow, thus covering their banners with shame. . . . It is time to stop the retreat. Not a step back! This should be our slogan from now on.

The proclamation ordered the execution of any Soviet soldier, no matter his rank, who retreated without permission, calling such men traitors to the motherland. It acknowledged indebtedness to the "halt order" Hitler had issued the previous December 26 when trying to prevent a full-scale

Fig. 1 Konstantin Eliseev (born St. Petersburg, 1890; died 1968), with text by Sergei Vasilev (born Kurgan, 1911; died Moscow, 1975). "Not a Step Back!," cover of *Krokodil* 30 (August 17, 1942). Ne boltai! Collection. The text reads: "Fascists are trying to burn and crush us. / Red fighter! / Russian soldier! / Your motherland calls you! / Not a step back! Not a step back! / Fight like a lion! Stand till the end! / Don't spare your bullets on a pack of killers. / For the Russian sun! For Honor! For life! / Your house, / Your field. / Your garden, / Your children call out: Hold on! / Not a step back! Not a step back!"

retreat after the Germans were rebuffed by the Soviets in the battle of Moscow.

The order stipulated that soldiers accused of disciplinary offenses would be assigned to penal battalions, units dispatched to the most dangerous sectors of the front. Blocking detachments, which were also deployed during the Russian Civil War, had to shoot fleeing and deserting troops. Between the issuing of Order 227 and TASS 574/574A, over one thousand Soviet troops were killed by blocking units and 130,000 sent to penal battalions. The threat of death destroyed the morale of those fighting on the front lines, and the blocking detachments were quietly withdrawn but not officially disbanded until November 1944. TASS 574/574A was one of several images that took up the message of Order 227 (see fig. 1).[1]

Not a Step Back! is a stark reminder of the dire consequences for not holding ground. Issued in late October, as ferocious fighting took place in and around Stalingrad, the poster unquestionably aimed to motivate the tenacious defenders of the city, as well as those involved in defending the Caucasus region.[2]

ОКНО ТАСС № 579

ВОИНЫ КРАСНОЙ АРМИИ! ПУСТЬ КАЖДЫЙ РУБЕЖ ПОД СТАЛИНГРАДОМ, КАЖДАЯ УЛИЦА И ДОМ, ГДЕ ЗАСЕЛИ ГИТЛЕРОВЦЫ, СТАНЕТ ДЛЯ НИХ МОГИЛОЙ! ОПРОКИНУТЬ И ОТБРОСИТЬ ВРАЖЕСКИЕ ПОЛЧИЩА—ТАКОВ БОЕВОЙ ПРИКАЗ РОДИНЫ!

ХУДОЖНИК – П. Шухмин.

Пролетарии всех стран, соединяйтесь!

Всесоюзная Коммунистическая Партия (больш.).

ПРАВДА

Орган Центрального Комитета и МК ВКП(б).

№ 276 (9047) | Суббота, 3 октября 1942 г. | ЦЕНА 15 КОП.

Ожесточенная битва за Сталинград продолжается. Фашистские банды напрягают все силы, чтобы овладеть волжской твердыней.

Воины Красной Армии! Пусть каждый рубеж под Сталинградом, каждая улица и дом, где засели гитлеровцы, станет для них могилой! Опрокинуть и отбросить вражеские полчища—таков боевой приказ Родины!

Image: Petr Shukhmin
Edition: 400
Stencil
167 × 79 cm
Ne boltai! Collection

Red Army soldiers! Let every border near Stalingrad, every street and house where Hitler's men have taken up positions, become their grave! Overthrow and expel the enemy hordes. This is the motherland's battle command!

Against a background of ruined buildings and an exploding tank, Red Army soldiers take aim, the one to the left using a Mosin-Nagant rifle and the other a machine gun (PPSh-41). As in Shukhmin's other posters from this period, the text here has no poetic features. It is a direct quote from the second paragraph of a masthead story published in *Pravda* on October 3, 1942. The first paragraph reads: "The bitter battle for Stalingrad continues. The Fascist hordes are fighting tooth and nail to seize the Volga stronghold."

TASS 579 was issued on the fifty-third day of the battle for Stalingrad (Volgograd). The siege, which lasted from July 17, 1942, to February 2, 1943, resulted in over two million deaths before the Red Army defeated the Axis troops, which proved to be a turning point in the balance of power along the Eastern Front in favor of the Soviets. When the Germans moved into the outskirts of the city, they encountered Red Army forces and had to engage in fierce street battles. Streets, blocks, houses, and rooms became the settings for hand-to-hand combat. This image, and others like it (see fig. 6.15), was probably inspired by one of the many photographs and newsreel images of the moment.

This design epitomizes a painter's approach to a poster. The viewer is asked to read the image as a painting: it takes time to pull together the variegated passages in the lower portion and register them as rubble. That these areas resist easy legibility counters the TASS studio's dictum that all of its poster designs communicate meaning in a telegraphic manner.

Image: Petr Aliakrinskii
Edition: 400

Stencil
139.5 × 113 cm
Ne boltai! Collection

Glory to Our Partisan Men and Women!

On a hill behind birch trees, partisans watch the derailment of an enemy supply train and take aim at escaping military personnel.

In Order 345, issued on November 7, 1942, to mark the occasion of the twenty-fifth anniversary of the October Revolution, Stalin reiterated that the armed forces and the partisans "can and must clear our Soviet soil of the Hitlerite Fifth [Army]! To do this it is essential . . . to fan the flames of the popular guerilla movement at the rear of the enemy, to devastate the enemy rear, to exterminate the German-Fascist blackguards."

The territories Germany occupied in the Soviet Union – notably Belarus and parts of the Ukraine and northern Russia – were densely forested, as well as covered with impregnable marshland. This terrain provided Soviet partisans with the shelter necessary to launch covert operations.

Partisan groups were drawn from local populations, along with a mix of such elements as Red Army stragglers and collaborators with the Germans who, because of repressive Nazi measures, joined the partisans under a promise of amnesty. By May 1942, partisan activities had become coordinated, logistically supported, and linked with the strategic plans of the Soviet command. Disrupting and destroying German supply lines was of paramount importance. Railroad cars carrying troop reinforcements, ammunition, petrol, and food had to be prevented from reaching their destinations. Partisan units disrupted the railroad infrastructure, raiding railway facilities, mining railroad bridges and miles of tracks, blowing up engines and cars, and killing or at least disabling the crew (see also fig. 6.12). The work of Soviet partisans inspired *We Are Guerillas* (fig. 1). Chronicling partisan exploits, the booklet aimed to garner support for the Soviet war effort from English-language readers.

Fig. 1 Cover of *We Are Guerillas* (Soviet War News [England], 1942).

Image: Mikhail Solov'ev
Text: Vasilii Lebedev-Kumach
Edition: 400

Stencil
166.5 × 121 cm
Ne boltai! Collection

Our Troops Continue to Advance

Heroes! Our entire nation rejoices today
To hear of your success in battle!
May the retreat of the Germans from
* Stalingrad*
End with their total defeat!

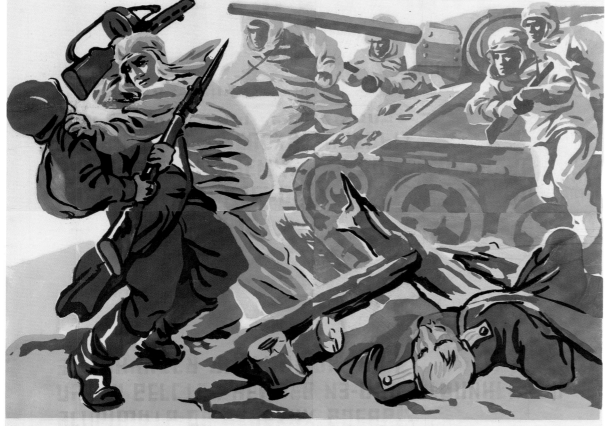

Here Soviet infantry soldiers, in pad-ded snowsuits, wield submachine guns as they stride next to a T34 tank and engage in hand-to-hand combat with the enemy on snowy ground. Known as descent troops (*tankode-santniki*), they rode into battle holding onto the exterior of tanks, jumping off when close enough to engage the enemy. The direction of their forward march, from back right to front left, conveys a sense of efficacy, immediacy, and topicality, rein-forced by the bluntness of Lebedev-Kumach's quatrain.

While at first glance the space in which the action takes place seems shallow, the intensity of the palette, enhanced by black contour lines, pulls the combatants into the foreground, while the softening of hues and absence of black in the background enhances the sense of spatial recession.

TASS 603 depicts Operation Uranus (November 19–30, 1942), a counter-offensive against the Axis forces besieging Stalingrad. The Sixth German Army was augmented by Romanian, Italian, Hungarian, and Croatian troops. Using a pincer movement, Red Army forces sur-rounded the enemy in a pocket near Kalach-on-the-Don on November 23, one day before TASS 603 appeared. On November 24, the *Chicago Daily Tribune* quoted a midnight com-munication from the Soviets: "Our tankmen broke into the flank of the enemy troops and disorganized their defenses. Soviet infantry following the tanks went into attack and defeated the Hitlerites." On the same day, *PM* announced, "The avenging hour has struck at Stalingrad. The Red Army has proved that it is not only able to hold the enemy, but to destroy him completely."

ОКНО
ТАСС № 606

ЧТО ДЕНЬ ГРЯДУЩИЙ МНЕ ГОТОВИТ?

ХУДОЖНИК – В. ЛЕБЕДЕВ.

Image: Vladimir Lebedev
Edition: 400
Stencil
156.5 × 87 cm
Ne boltai! Collection

What Bringeth Forth the Morrow?

Launched by Anglo-American expeditionary forces on November 8, 1942, Operation Torch opened a second front, not, as Stalin urgently requested, in western Europe, but in North Africa, to expel the Axis powers from the region. The operation directly impacted the future of Mussolini, permanently thwarting his imperialist ambitions. The desert armies of Italy and its Axis allies, under the command of Field Marshal Erwin Rommel, were already losing ground to a successful drive westward from Egypt by the British, led by Field Marshal Bernard Montgomery. By the time TASS 606 appeared, Allied Expeditionary Forces (AEF) were advancing on Tunis, forcing the Germans to divert troops and planes from the Eastern Front to Italy, Sicily, and North Africa.

Graphic artists in the Allied nations had a field day ridiculing the Italian dictator and his doomed leadership (see fig. 1). In TASS 606, an apelike Mussolini, fleeing on all fours, moves over the scorched and burning Italian peninsula from south to north. Across the Mediterranean looms the coast of North Africa, above which appear, like locusts, ominous squadrons of fighter planes.

The title of TASS 606 comes from *Eugene Onegin*, Pushkin's verse novel (first published in its entirety in 1833), on which Tchaikovsky based his eponymous opera (1879). "What Bringeth Forth the Morrow?" was known to all Russian school children. Tchaikovsky

used it for a much-loved aria sung by the character Vladimir Lenskii on the night before the duel to which he has challenged Onegin. He wonders about his fate: "Where, oh where, have you flown / The gilded days of my springtime? / What bringeth forth the morrow? My gaze looks to it in vain, / It is concealed in deep gloom" (chapter 6, stanza 21). And indeed he dies at Onegin's hands. Numerous TASS posters incorporate quotations from works – most often those in a rousing patriotic vein – by Pushkin, Mikhail Lermontov, and other classical Russian poets. TASS 606 features such a text in a more tongue-in-cheek manner than usual, by relating the pathetic Lenskii to the Italian dictator.

The layering of colors in a variety of ways – including dappling and dry, textural brushwork – and the creation of forms through juxtaposed tones instead of an armature of outlines demonstrate Lebedev's ability to achieve an overall painterly unity that belies the actual execution with stencils. Here, as in other Lebedev posters for TASS, there is so much flexibility and creativity in the paint application that the shapes defined by stencil boundaries dissolve and are less pronounced than in designs by other TASS team members.

AEF INVADES AFRICA

Try and Pull the Wings Off These Butterflies, Benito!

Fig. 1 Dr. Seuss (Theodor Geisel) (American, 1904–1991). "Try and Pull the Wings Off These Butterflies, Benito!," *PM*, November 11, 1942.

Image: Petr Sarkisian
Text: Dem'ian Bednyi
Edition: 400
Stencil
196.5 × 88 cm
Ne boltai! Collection

Fascist "Art Historians"

Ribbentrop's "trophy-seeking" band
Has burgled Europe,
Its museums and its palaces.
Experienced robbers, the Fascist
 evildoers
Set forth to decimate Soviet museums.
In places where the enemy achieved a
 temporary victory,
The Fascist "art historians,"
Those scoundrels, have stolen
Paintings, statues, columns, tiles –
Examples of the rarest cultural treasures,
Everything our ancestors collected,
All the things our fathers left us.
But the awesome hour is near when they
 must pay
For the ruined ancient palaces,
For every museum, palace of culture,
 church of ours.
They will be forced to wail when they fall
 into our hands –
The organized thieves,
"Professors and Doctors"
Of the Fascist art-historical "thieving
 science" –
And before the court, the first to present
 his robber's defense
Will be Ribbentrop, the "art historian."

Uniformed and civilian Nazi personnel, having ransacked a museum, leave the premises with their booty and, in the process, trash many other valuable objects. The looting and destruction of Russian cultural property preoccupied the TASS editorial board and artists alike throughout the war (see fig. 4). Despite the seriousness of the topic, most early posters used graphic satire to express similar concerns (see fig. 1). In a more realist vein is TASS 210, which features a bullet-riddled, mass-produced portrait of Pushkin that could be found in village schools throughout the Soviet Union (fig. 2). (The 1827 original, by Orest Kiprenskiii, is in the State Tretyakov Gallery, Moscow.) The creators of TASS 210 took advantage of the recognizability of the image and the nation's reverence for Pushkin to express indignation and contempt for the perpetrators of such cultural barbarity. TASS 30-XII-41 (pp. 203–04) and 17-I-42 also treat this subject.

On November 2, 1942, the presidium of the Supreme Soviet decreed

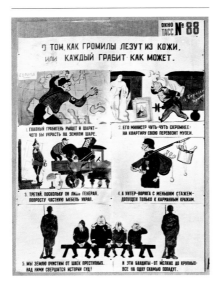

Fig. 1 Nikolai Radlov, with text by the Litbrigade. *On How the Hoodlums Are Outdoing One Another, or Each Ransacks What He Can* (TASS 88), July 21, 1941. Edition: 60. Stencil; 240 × 114 cm. Archival photograph, ROT Album, courtesy Ne boltai! Collection. The text reads: "1. The pillager in chief prowls and rummages about – / What can I steal on the globe?; 2. His minister is just a bit more modest / He moves a museum into his home; 3. The third, since he's merely a general, / Simply pilfers civilians' furniture; 4. A low-ranked thief with less experience – / Is allowed only pocket theft; 5. We will cleanse the world of the criminal bands! / History will issue its judgment on them. // And these bandits, from low to high, / Will all end up on the same court bench."

the formation of the "Extra State Committee for ascertaining and investigating crimes perpetrated by the German-Fascist invaders and their accomplices, and the damage inflicted by them on citizens, collective farms, social organizations, State enterprises and institutions of the U.S.S.R." Among the committee's responsibilities was to assess

the damage caused by the Hitlerite invaders through the ransacking and destruction of the artistic, cultural and historical values of the peoples of the U.S.S.R., the destruction of museums, scientific institutions, hospitals, schools, establishments of higher education, libraries, theaters and other cultural institutions, also buildings, equipment and utensils of religious worship.

Pravda published an article entitled "Hitler's Criminal Clique Steals and Destroys Cultural Treasures of the Soviet Union" on October 17. On the same day, the newspaper published the confession, reproduced in facsimile, of Norman Förster, a member of the SS Sonderkommando Kuensberg. Captured in the region near Mozdok, in the present-day Republic of North Ossetia-Aliana, during the battle of the Caucasus in the summer of 1942, Förster outlined the looting activities of his unit to date. He emphasized the role of the German Ministry of Foreign Affairs, under Joachim von Ribbentrop: "Before departing for Russia, Major Kuensberg gave us an order from Ribbentrop – to thoroughly 'sweep' all scientific institutions, libraries, palaces, to shake up the

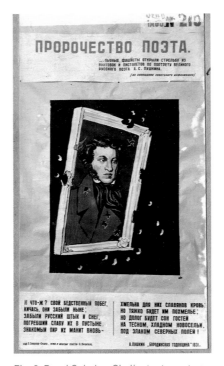

Fig. 2 Pavel Sokolov-Skalia, text montage by Anisim Krongauz (born Kharkov, Ukraine, 1920; died 1988), with text by Aleksandr Pushkin (Russian, 1799–1837). *A Poet's Prophesy* (TASS 210), October 5, 1941. Edition: 150. Stencil; 110 × 83 cm. Archival photograph, ROT Album, courtesy Ne boltai! Collection. The text under the title reads: "'Drunken Fascists opened fire with rifles and pistols on the portrait of the great Russian poet A. S. Pushkin.' From a bulletin of the Soviet Bureau of Information." The text at the bottom is from an 1831 poem that Pushkin wrote to celebrate the occupation of Warsaw on the very day that the great battle between Napoleonic and Russian forces took place at Borodino, near Moscow, in 1812. It reads: "Well, well! Having forgotten / their disastrous retreat they puff themselves up; / Forgetting the Russian bayonet and snow / That buried their glory in the wasteland. // A familiar feast beckons to them anew – / Slavic blood is intoxicating for them; / But their hangover will be fierce; / But long will be the guests' slumber / At the crowded, cold housewarming, / Under the grain of the northern fields!" The text at the bottom right reads, "A. Pushkin, 'Anniversary of Borodino.'"

archives and put our hands on everything that has a certain value." Förster acknowledged the existence of

special teams concerning the seizing of museums and valuable antiques in the occupied countries of Europe and eastern regions. At the head of these commands are qualified civilians. As soon as the troops take any major city, immediately heads of these teams arrive with all kind of specialists. They inspect the museums, art galleries, exhibitions, cultural and artistic settings . . . and confiscate everything of value.

The final portion of the article addresses the ideological aspect of Nazi looting:

The Hitlerites . . . want to destroy and eradicate Russian national culture and the national cultures of other nations of the Soviet Union. They set as their goal not only the material, but also the spiritual disarmament of the nations of the U.S.S.R. . . . to fool the Soviet people and turn them into mute slaves of German barons. . . . The avenging hand of the Soviet people will catch all the burglars and robbers, wherever they might be, and will repay them in full for all their crimes.[1]

The fate of Russian cultural sites prompted a number of authors and artists to organize a demonstration on November 29. The writer Aleksei Tolstoy, architect Viktor Vesnin, composer Dmitri Shostakovich, and filmmakers Aleksandr Dovzhenko and Ivan Pyr'ev, among others, spoke at the Anti-Fascist Demonstration of Soviet Workers of Literature and Art. In addition to publication in the Soviet press, the speeches delivered that day were gathered into a book, which was translated into English in order to inform and incite action beyond the Soviet Union's borders.[2]

The decree, demonstration, and *Pravda* article all seem to have prompted Sarkisian's image in TASS 612. Ribbentrop's order, to which Förster's confession refers, explains the reference to the German minster of foreign affairs in the opening and closing lines of TASS 612's poem. Also mentioned is the looting of the Lvov (L'viv) Museum, which had a famous

Image: Kukryniksy
Text: Dem'ian Bednyi
Edition: 600

Stencil
173.5 × 124 cm
Ne boltai! Collection

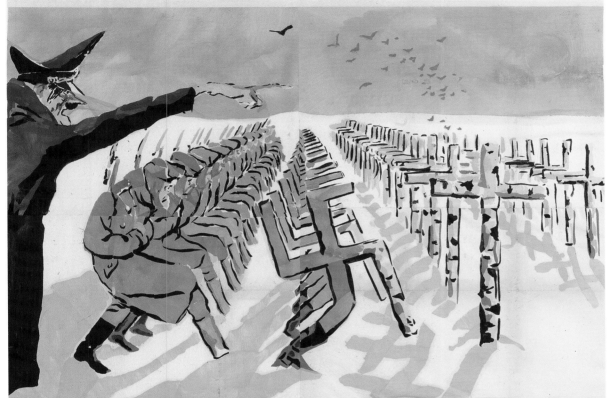

Metamorphosis of the "Fritzes"

Like wild animals, with savage howls
They lunge into a roaring stream.
This is Hitler, row by row,
Chasing the "Fritzes" toward the East.

Here, every window hides a sniper;
Here, the bushes conceal death;
Here, swallowing the stranger's land
The misled "Fritzes"
Metamorphose into crosses.

Death for the German swine
Is not some sorcery;
It is the battle triumph
Of the Soviet Army!

Tens of thousands of Axis soldiers died in and around Stalingrad during the winter of 1942–43. Here, on snow-covered ground under a bleak sky, Hitler orders German soldiers to advance. They morph into walking swastikas (a favorite trope among graphic satirists since the rise of Hitler) and then into crosses made of birch trees (a national symbol of Russia). Over the horizon, a flock of crows, harbingers of death and doom, anticipate the soldiers' fate. The poster combines the notion of a suicidal devotion to evil with the belief that the beloved Russian motherland possesses an almost-magical power to destroy its enemies.

Bednyi's text parodies a romantic ballad such as Pushkin's "Demons" (1827), which, in a similar troachic tetrameter, tells of forces haunting the Russian steppe. Fiodor Dostoevskii drew on this poem for his 1868 novel *Demons*, which refers to the Gospel story of the Gaderene swine (Mark 5:1–14): encountering a man possessed, Jesus rids him of his demons, which emerge as pigs that throw themselves off a precipice.

This poster is one of the most effective that the Kukryniksy designed for TASS. In a single image, they integrated distinct, sequential narrative elements – Hitler, the troops, swastikas, and crosses – with such touches as a dramatic perspective and ice-blue shadows. The tension between delicate coloration and bold humor enriches and complicates the image. Finally, the pattern of forms creates a rhythmic movement across the pictorial space and underscores the inevitability of a bad end.[1]

TASS 640 was included in a portfolio published by RWR.

Image: Vladimir Lebedev
Text: Samuil Marshak
Editon: 600

Stencil
174 × 86.5 cm
Ne boltai! Collection

Hurry, Doctor, please prescribe
Vichy for the ailing Hitler!
Hitler's belly aches
From drinking our mineral water.

Here Lebedev fully deployed his gifts as a colorist and painter-illustrator. The vivid palette, reliance on color to build forms that do not utilize black contour lines, and skillful use of complementaries – saccharine pinks and bilious greens, oranges, and blues – result in an animated surface that suggests the queasiness of Hitler's gastric distress.

Coming to the aid of an ailing Hitler are Pierre Laval, premier of the Vichy government of unoccupied France, offering a bottle of the town's famed mineral water; Goebbels and Göring, who hold an enema syringe at the ready; and the beleaguered Mussolini, whom Göring waves away because he might upset the Führer even more. Göring is often shown with his field-marshal baton, but the shape of the form in his right hand here indicates that it is indeed an enema syringe. For many generations of graphic satirists,

this implement was a favorite narrative device. Thus, in TASS 653 Lebedev may have been paying tribute to satirists who preceded him.

The note at Hitler's feet reads, "Under intense pressure from the Red Army, the German troops have retreated from Georgievsk, Piatigorsk, Kislovodsk, and Mineral'nye vody." All four are spa towns in southern Russia (the last name translates literally as "mineral waters"). Thus, the joke seems to be that Hitler is deriving little relief from his foreign occupations. In fact, the Red Army recaptured the region in early January 1943.

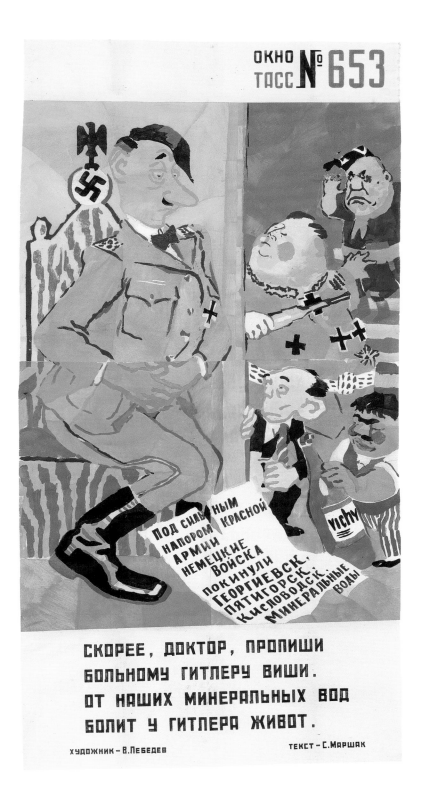

Image: Nikolai Denisovskii
Text: Samuil Marshak
Edition: 600

Stencil
124 × 82.5 cm
Ne boltai! Collection

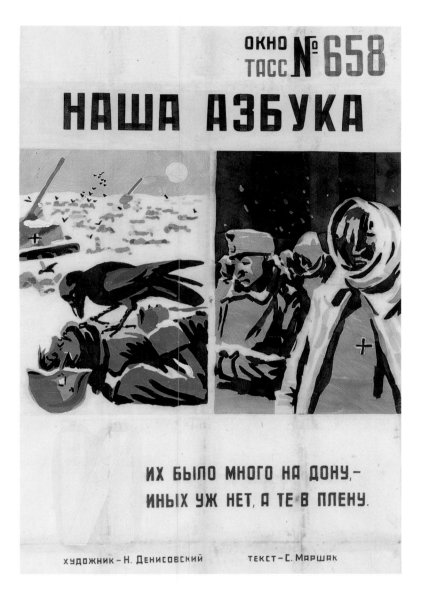

Our ABC [Letter I]

There were so many on the Don –
Some are no more, the rest are captives.

The panel at the left shows a wintry battlefield, illuminated by the setting sun and strewn with abandoned tanks and dead soldiers. In the foreground, a crow preys on the corpse of a soldier. At the right are snow-covered German prisoners of war (one of whom wears an Iron Cross) bundled up against the cold.

Marshak's couplet parodies the beginning of "Arion," an 1827 poem by Pushkin: "There were many of us in the skiff. / Some pulled taut the sails." The second line is modeled on a proverbial saying taken from Pushkin's verse novel *Eugene Onegin* (see TASS 606 [pp. 227–28]): "Some are no more, the rest are far away" (chapter 8, stanza 51). Both lines by Marshak begin with the Cyrillic letter *I*, though both are pronouns and therefore not especially appropriate for an *ABC*, an alphabet series inspired by Maiakovskii's ROSTA posters. TASS artists first explored the idea of an alphabet series in the summer of 1941 (see the right-hand side of fig. 1.2 and, for a later series, fig. 3.8 and TASS 527, fig. 5 [p. 218]).

With its simplified forms, bold lines, and palette of black, gray, blue, and pink, TASS 658 chillingly captures the stark conditions of winter warfare. Its two panels reflect the situation on the battlefields surrounding Stalingrad and Rostov-on-the-Don, which the Soviets recaptured from the Germans on February 14, 1943. At Stalingrad alone, one hundred sixty thousand German soldiers were killed in combat or died of starvation or exposure, and ninety thousand were captured. The source of the right-hand panel is a photograph of German prisoners on the Northwestern Front that appeared in *Pravda* on March 31, 1942 (fig. 1). That Denisovskii turned to the photograph almost one year after it was published indicates that TASS artists kept source material on file for reference and future use.

The theme of the crow and death was treated throughout the war. In images relating to the Eastern Front, the crow is most often paired with birch-tree crosses marking impromptu graves. Others depict a crow eating slain or frozen corpses in the aftermath of battle.

Denisovskii was a member of the Moscow ROSTA studio.

Fig. 1 S. Korshunov (Soviet). Untitled photograph, *Pravda*, March 31, 1942. The caption that appeared with the photograph reads, "Northwestern Front. Captured soldiers and noncommissioned officers from the divisions of the surrounded 16th German army."

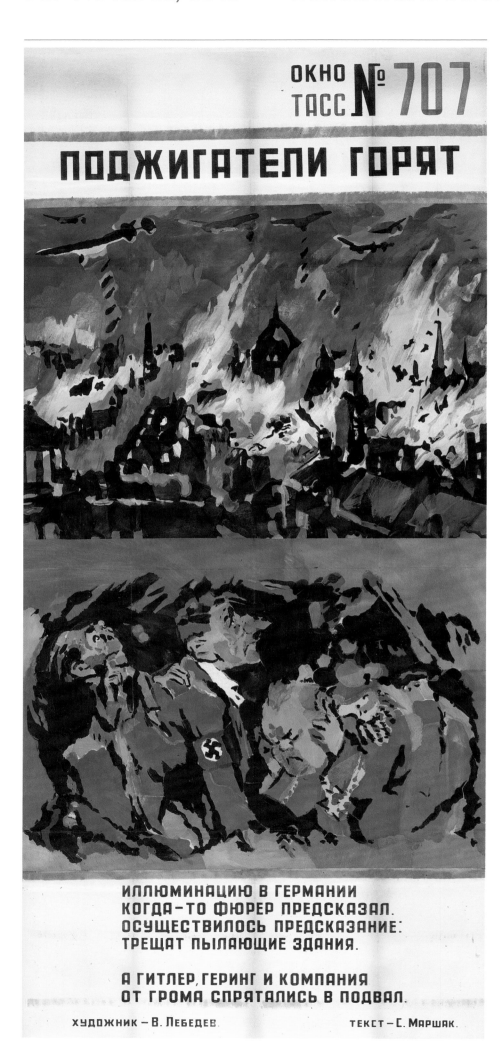

ОКНО ТАСС № 707

ПОДЖИГАТЕЛИ ГОРЯТ

ИЛЛЮМИНАЦИЮ В ГЕРМАНИИ
КОГДА-ТО ФЮРЕР ПРЕДСКАЗАЛ.
ОСУЩЕСТВИЛОСЬ ПРЕДСКАЗАНИЕ:
ТРЕЩАТ ПЫЛАЮЩИЕ ЗДАНИЯ.

А ГИТЛЕР, ГЕРИНГ И КОМПАНИЯ
ОТ ГРОМА СПРЯТАЛИСЬ В ПОДВАЛ.

ХУДОЖНИК — В. ЛЕБЕДЕВ. ТЕКСТ — С. МАРШАК.

Image: Vladimir Lebedev
Text: Samuil Marshak
Edition: 800
Stencil
173 × 79 cm
The Art Institute of Chicago, gift of the
U.S.S.R. Society for Cultural Relations
with Foreign Countries, 2010.117

The Arsonists Burn

The Führer had predicted
Fireworks for Germany.
His prediction has come true:
The burning buildings crackle.

And Hitler, Göring, and company
Hide from the thunder in the cellar.

Hitler, Goebbels (sitting on Hitler's lower back), and Göring (kneeling and covering his ears) all take refuge in a shelter during a night attack. Exploding bombs light up the sky. At the time this poster appeared, the industrialized Ruhr area of Germany was subject to daily and nightly bombing by British and American forces. However, such actions were not restricted to Germany; they included other strategic locations in Nazi-occupied Europe, such as the French ports of St. Nazaire and Lorient and the Italian port of La Spezia.

Here, as he had done in his paintings in the 1930s, Lebedev built his composition by blocking in areas of color using a minimum of contours. In the upper scene, the stark contrast of dark buildings against red-hot flames and the open, painterly rendition of forms, without a linear scaffolding, combine to produce an image of dislocation and collapse. As such it conveys the degree of strength that the Soviet Union's powerful allies were able to deploy in inflicting such conflagrations upon Nazi-controlled areas.

Image: Petr Aliakrinskii
Text: Aleksandr Zharov
Edition: 600

Stencil
206 × 74 cm
Ne boltai! Collection

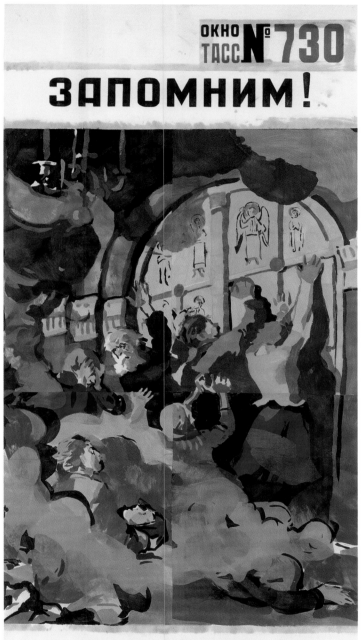

We Shall Remember!

The Fascists abandoned the village:
They burned its buildings to the ground.
With their rifle butts they herded
The peaceable villagers into the church.

They closed the iron gates
And set the church on fire . . .
Then these wild German beasts
Left the area right away . . .

Comrade! For this take vengeance
On the brown reptiles.
The enemy cannot escape judgment.
Destroy them, oh soldier, without mercy.

Smoke fills the interior of a Russian Orthodox church in which villagers have been locked. Some lie on the floor gasping for air; others try to force open the door. The meter of the poem is a melodic amphibrachic trimeter, which helps to transform this hideous war crime into an inspiring battle cry. In this image, one does not find an internal variety of color or nuanced blending of tones. Instead of creating a foggy atmosphere to indicate smoke, Aliakrinskii chose to employ passages of solid color, a schematic approach that flattened the hues. This abbreviated handling may have derived from the artist's experience as a stage designer.

Before the war, the Soviet government had been hostile to religion and had even destroyed churches. During the war, however, it relaxed its stance in response to pressure from the Allies and in recognition of the strength much of the population drew from religion. The choice of a church rather than another kind of building as the setting for TASS 730 reveals the studio's awareness of this new reality and of the patriotic and propagandistic value of the Russian Orthodox Church. Here a symbol of the assault on the Russian soul, the burning church would have incited the fury of religious soldiers against the enemy.

TASS 730 refers to broader cruelties as well. The Nazis pursued a systematic policy of inflicting collective penalties on entire populations for acts committed by individuals. A case in point is a massacre that took place on March 22, 1943, at Khatyn, north-east of Minsk, Belarus. After partisans attacked and killed a German police officer and three Ukrainian collaborators, German troops retaliated by surrounding the village, driving its inhabitants into a shed, and setting it on fire.[1]

An event related directly to the image in TASS 730 took place at a Soviet military hospital in Kharkov (Kharkiv), Ukraine, on March 13, 1943. The city, which had been captured by the Germans on October 24, 1941, was retaken by the Red Army on February 16, 1943, only to fall again into Nazi hands exactly one month later. In the battle for the city, German Special Forces killed eight hundred convalescing Soviet soldiers by nailing shut the entrance to a hospital and throwing explosives into the building, setting fire to the wards. Those who could save themselves jumped out of windows, only to be shot down. The next day, the Germans went through other hospital buildings, setting fires and shooting survivors. One woman later testified, "When I got to the ... hospital, I could not recognize it as the same in which my husband was being treated. A ghastly sight confronted me. Everywhere there were piles of ruins and all over the place were strewn bodies of charred and brutally tortured Soviet citizens."[2] Her husband suffered the same fate. This and other crimes were the focus of military tribunals held in the liberated cities of Krasnodar and Kharkov on July 14–17 and December 15–18, 1943. These war-crime trials concerning Nazi atrocities were the first to be held. The proceedings were published in English in 1944.[3]

Image: Vladimir Lebedev
Text: Samuil Marshak
Edition: 600

Stencil
135 × 151 cm
Ne boltai! Collection

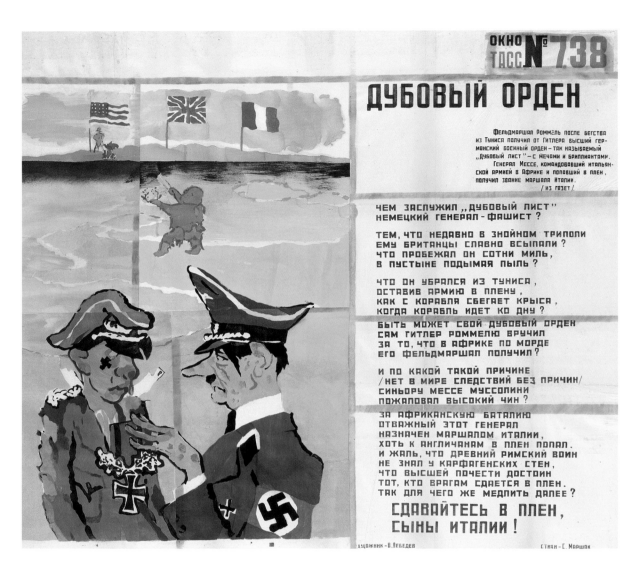

The Order of the Oak

After his flight from Tunisia, Field Marshal Rommel received from Hitler Germany's highest military decoration – the so-called "Oak Leaves" – with swords and diamonds. General Messe, who commanded the Italian army in Africa and was taken prisoner, was promoted to Marshal of Italy. (From newspaper reports)

*What did he do to deserve the "Oak Leaves,"
The German Fascist-General?*

*Was it by being roundly thrashed by the British
Recently in Tripoli?
Was it by running hundreds of miles
In the desert raising dust behind him?*

*Was it by escaping from Tunisia,
Leaving the army in captivity,
Just as rats run from a ship
Sinking to the bottom of the sea?*

*Could it be that Hitler
Presented Rommel with his Order of the Oak Leaves
In recognition of the way that Africa
Slapped his field marshal in the face?*

*And for what reason
Because no end is without cause,
Did Mussolini bestow upon Signor Messe
His high rank?*

*For the African battle
This brave general
Was appointed marshal of Italy
Though he was taken prisoner by the English*

*And it's a pity that the ancient Roman warrior
Did not know at the walls of Carthage
That the highest honors
Go to the man who surrenders to his enemies.
So why delay any further?*

*Deliver yourselves into captivity,
Sons of Italy!*

Against the backdrop of the Adriatic, the Italian peninsula, the Mediterranean, Sardinia, Corsica, and the North African coast, over which fly the flags of the Americans, British, and free French, Hitler pins a medal on a battered Rommel. Mussolini, his clothes in tatters, holds a laurel wreath and marshal's baton. He stands on the Italian peninsula and gestures toward a figure on the North African coast, a pipe-smoking officer of the victorious AEF. In front of the officer is a form that could represent a kneeling General Giovanni Messe, whom the text mentions.

Marshak's poem is unusually verbose and convoluted in its syntax. One would expect him to have made a sharper point of the paradox of defeated generals being decorated

with an "order of oak" (the Russian word for *oak* can denote a dimwit, so the title of the poster could be read as "a dimwitted medal").

The subject of Hitler and Mussolini bestowing their nations' most coveted military awards on defeated marshals would have seemed incredible to TASS studio members. They were acutely aware that Stalin dealt with defeated generals very differently. For example, General Dimitri Pavlov, Soviet commander in the early days of the German invasion, was held responsible for losing the battle of Bialystok-Minsk. He was relieved of his command, arrested, charged with military incompetence and treason, and executed on Stalin's orders.

 On March 9, Rommel, concerned about the worsening position of the Axis forces in North Africa, had

flown to Berlin for meetings. In poor physical health and demoralized, he was ordered to take sick leave. His requests to return to North Africa were denied. But on March 11, Hitler awarded him the Knight's Cross with Oak Leaves, Swords, and Diamonds.

Messe, a veteran of Operation Barbarossa, in which he commanded the Italian and Expeditionary Corps in the Soviet Union, was sent to North Africa to lead the Italo-German Tank Army (formerly Rommel's Panzer Army Africa) in January 1943 against the AEF in Tunisia. On May 12, when Tunis fell to the Allies, Messe was named Marshal of Italy. The following day, he, along with the Italian and German troops under his command, formally surrendered.

Image: Kukryniksy
Text: Samuil Marshak
Edition: 600

Stencil
153.5 × 143.5 cm
Ne boltai! Collection

Fritz's Caftan

Storm troops are going to the front,
So the German gets down to fix the rail.
Into the iron he pounds a nail.
But suddenly – a blast, fire and dust!
A fountain of shrapnel and fire:
Partisans have blown up the line!

Without taking time to draw a breath,
The German again repairs the rails.
Into the iron he pounds more nails.
But suddenly – a column of earth flies!
His ears ring,
His eyes sting.
Partisans have blown up the line!

What can you do! Despite the pain
The work must begin again.
With the hammer the German strikes iron,
But then there is a final blast.
Rubble flies like a flock of birds.
And upward, with them, flies Fritz.

The troop of Soviet partisans
Has fulfilled the plan to perfection.

An industrious German soldier, part of a railroad track-repair unit, is surrounded by explosions and subsequently blown to bits. The poem's title refers to a classic Russian tale, "Trishka's Caftan," by the nineteenth-century fabulist Ivan Krylov. A peasant, Trishka, attempts to mend his torn coat by cannibalizing it for patches, which ends up making the coat's condition worse rather than better. The fable became emblematic of any Sisyphean labor.

The Kukryniksy's comic-strip rendering is at odds with the poster's deathly serious subject, the lethal consequences of the partisans' mining of German rail communications. Throughout Nazi-occupied territory, trains constituted the chief and most vital carrier of supplies. In occupied and unoccupied areas alike, partisans targeted important railroad lines, stations, junctions, and bridges, using ground tactics supported by Soviet military air strikes. Demolition of the railway infrastructure by employing powerful explosives intensified in the spring of 1943, when the Germans were preparing for Operation Citadel, the assault on the Kursk salient (see TASS 778 [pp. 248–49]). Partisan actions over that spring and summer have become known as the "War of the Rails."

In October 1942, Hitler issued the "Bandenbekampfung" (bandit-hunting) directive, aimed at eradicating partisan activities. Henceforth, SS-affiliated forces protected the railways, ferreted out Soviet operatives, and made sure that the partisans did not have access to farm crops.

Image: Petr Shukhmin
Text: Dem'ian Bednyi
Edition: 600

Stencil
214.5 × 80.5 cm
Ne boltai! Collection

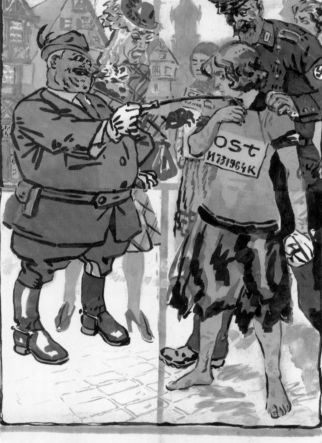

The German Gets out of Hand . . .

*A female slave . . . captured, shame and
 torment
Such clear evidence of this are
Her slashed arms,
Her tattered clothing.*

*Like two dogs before a bone,
A German woman looks at the slave with
 greedy anger,*

*And the German. . . . A pair of disgusting
 mutts!
Herr Müller pokes her with a rod
And says, "Gut! Gut!"*

*Like cattle – bearing a mark of hygiene –
At any German locale!
The marketplace square sees
A trade in Russian people.*

*The criminals drag to the immoral
 auction
Soviet girls and children,
German trade has got out of hand
Before their own ruin!*

In the picturesque market square of a German town, bruised and bandaged Russian civilians are offered as slave laborers by a Nazi officer. They are examined and prodded by Germans, rendered as grotesque stereotypes: a corpulent, cigar-chopping land-owner wearing a Bavarian Miesbacher hat and his fashionably outfitted, cruel-looking female companion. The accompanying poem indicates that the man, Herr Müller, approves of the bare-footed female offered to him, while she recoils from the touch of his riding crop.

The captive is colorless, in compari-son with the German pair's exagger-ated skin tones, which underscore their immorality. The officer's face is defined by motley blue-and-red passages, with shorthand indications of his eye patch and sinister, toothy smile. His facial features are suggest-ed so minimally that they fragment upon close examination. The venal German woman seems inspired by the Neue Sachlichkeit distortions of Otto Dix and George Grosz, an association that underscores her "Germanness" and heightens the crude character of her countenance. The violet-vermilion of her lips matches the red of her handbag, hat, and shoes, accesso-ries that signal the excess that her profiteering has allowed. Her hands, covered by blood-red gloves, curl in a grasping, clawlike gesture.

The sign around the captive's neck reads "OST" (East), a reference to the workers forcibly conscripted from occupied territories of the Soviet Union to work in Germany. They were forced to wear the blue-and-white OST badge. Germany faced a short-age of laborers, which threatened adequate support of the war industry. Thus, Soviet prisoners of war – men and women, as well as teenagers and young adults – were selected to work in armament and automobile plants, on large-scale engineering projects, in German-owned factories and shops, on railroads, in mining and agricul-ture, and as domestics. Only the latter could avoid living in the fenced and guarded camps provided for the labor-ers, many of whom died as the result of appalling living conditions and mistreatment.

ALWAYS, IN ALL TIMES AND AGES, RUSSIAN SOLDIERS HAVE CLOBBERED THE PRUSSIANS

Image: Vladimir Milashevskii
Text: Aleksei Mashistov
Edition: 600

Stencil
200 × 86.5 cm
Ne boltai! Collection

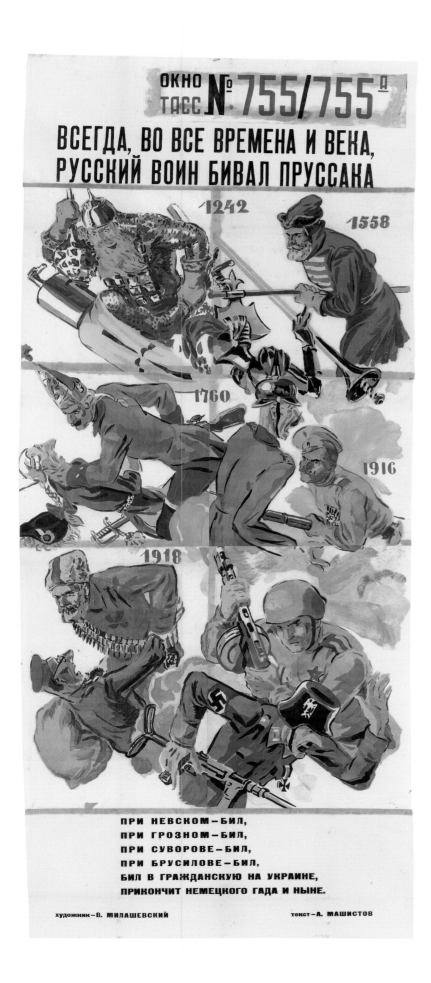

Always, in All Times and Ages,
Russian Soldiers Have Clobbered the
 Prussians

At the Neva – clobbered,
Under Ivan the Terrible – clobbered.

Under Suvorov – clobbered,
Under Brusilov – clobbered,
They were beaten in Ukraine in the Civil
 War,
Russian soldiers will finish off the
 German vermin now as well.

Six interconnected, emblematic images depict belligerent encounters over the centuries between Russian and German forces. They include the conflict between Teutonic knights and the troops led by Aleksandr Nevskii in the 1242 Battle of the Ice (see also TASS 460 [p. 208]) and an episode at the beginning of the Livonian War (1558–83), when the army of Czar Ivan IV (the Terrible) occupied German-dominated Dorpat (Tartu, Estonia). Early in his military career, Aleksandr Suvorov was part of the Russian army when, along with Austrian troops, it occupied Berlin for a few days in October 1760 during the Seven Years' War (1756–63). The Russians retreated upon learning that the Prussian leader Frederick the Great was approaching with a relief army. The Brusilov Offensive took place in June–August 1916 on the Eastern Front in Ukraine; it resulted in the greatest single victory of the Triple Entente (France, Great Britain, and Russia) against the Central Powers (Germany, Austria-Hungary, and Turkey).

Following the February and October 1917 revolutions, Ukraine became the site of struggle for control of the area between the Central Powers (still engaged in World War I) and the Bolsheviks, as well as several attempts to establish it as an independent entity. Fighting between opposing camps (each claiming Ukraine) lasted until March 1921; the Ukrainian Soviet Socialist Republic was incorporated into the Soviet Union in 1922. The 1918 conflict depicted on TASS 755/755A suggests that after the Compiègne armistice the Germans did not depart willingly from areas they had occupied in Ukraine, Belarus, and southern Russia. In fact they actually left in an orderly fashion. Thus, the TASS studio was not above reshaping history for nationalistic purposes.

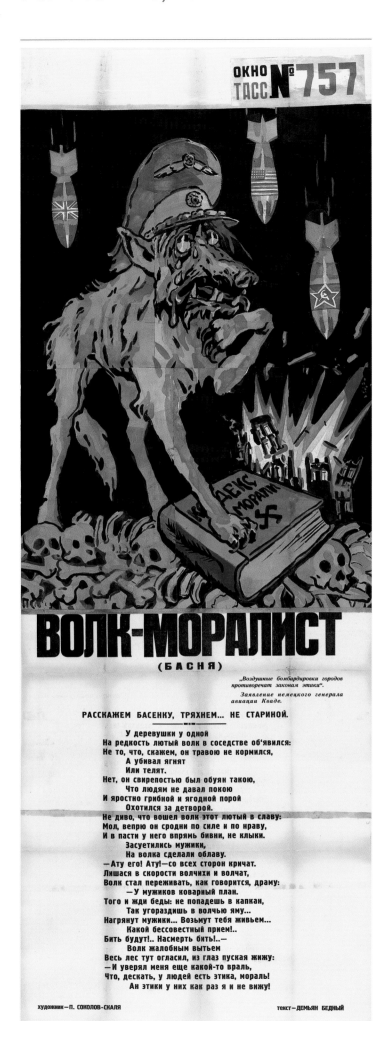

Image: Pavel Sokolov-Skalia
Text: Dem'ian Bednyi
Edition: 800
Stencil
240.5 × 83.5 cm
The Art Institute of Chicago, gift of the
U.S.S.R. Society for Cultural Relations
with Foreign Countries, 2010.172

The Moralistic Wolf (A Fable)

"Air bombardments of cities are contrary
 to ethical laws"
Speech by the German Airforce General
 Quade.

Let us tell a little fable, let us recall . . .
 not ancient times.

In a certain village
An unusually fierce wolf turned up as a
 neighbor.
Not that he killed the lambs and calves
Instead of feeding on grass.
Oh, no, he was so fierce
He did not allow the people any peace.
And savagely at berry time and
 mushroom time
He hunted for their children.
It's no surprise that this fierce wolf
 became renowned.
They said, "In strength and in character,
 he's like a wild boar.
And in his mouth there are not fangs but
 tusks!"
The peasants murmured among
 themselves
And staged a raid on that wolf.
"Get him!" they cried from all sides, "Get
 him!"
Quickly losing his mate and cubs,
The wolf began to suffer, as they say, the
 drama.
"The peasants have a treacherous plan!
One thing worse than the next: If you
 don't get caught in a trap,
You'll fall into a wolf pit!
The peasants will appear and take you
 alive!
What a shameless approach."
And with this pitiful wailing,
The wolf declared, emitting slime from
 his eyes,
"Some liar tried to tell me
That humans have ethics and morals!
I don't see any ethics in them at all!"

A wolf, its tail between its legs, stands over human skeletons. Its right paw rests on a volume entitled *Code of Morality*. The crying beast, wearing a general's hat, watches the Allies bomb a German city.

TASS 757 was inspired by the poem it includes, which was first published in *Pravda* on June 18, 1943. Bednyi often used fables in which animals serve to lampoon political figures. His work tended to be verbose, contradicting those who believed that posters needed to be legible from a distance and should therefore eschew complex images and lengthy texts. Here Bednyi reversed the reader's expectations, depicting the wolf (symbolizing Hitler) not as a merciless predator but rather as a pathetic hypocrite. The poem's reference to the wolf's not "eating grass" but hunting children was a jab at Hitler's vegetarianism, so ironic in view of his bloodthirsty aims and actions.

The moral issue to which this poster refers relates to tactical versus strategic bombing. Beginning in January 1943, the British and Americans cooperated in the tactical bombing of military targets and the strategic bombing of nonmilitary targets, such as production, transportation, and communication hubs often located in or near highly populated areas. In a radio address on April 2, 1943, German General Erich Quade questioned the morality of the Allied air attacks over the industrial Ruhr area, branding them as unethical because the victims were innocent civilians. The Allies ridiculed Quade's feeble attempt to justify the heavy German bombing of Guernica (1937), Warsaw (1939), Rotterdam (1940), and London (1940) for military reasons. The British and American press reminded readers that Hitler's regime had initiated indiscriminate bombing (see fig. 1). Between Quade's speech and the date TASS 757 appeared, Germany suffered nonstop Allied air raids. As might be expected, the Nazis blamed these "immoral" attacks on Jews (see fig. 2).

Bednyi's poem may concern partisan warfare, given its several references to peasants, which was very different from the Allied air raids. If so, the poem and image could have existed entirely independently from each other before they were partnered in TASS 757.

This is the first poster in which Sokolov-Skalia gave Hitler a crocodile-like physiognomy. A crocodile figures in traditional Russian children's tales, and the character inspired the title of the satirical magazine *Krokodil* (founded in 1922). Thus, by the 1940s the crocodile had become a personification of satire.

Fig. 1 Carl Somdal (American, 1902–1980). "It's His Own Weapon," *Chicago Daily Tribune*, May 31, 1943.

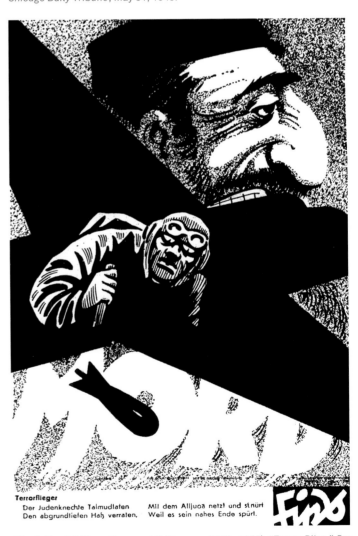

Fig. 2 Fips (Philippe Rupprecht) (German, 1900–1975). "Terror Pilot," *Der Sturmer*, July 22, 1943. Blaming Allied air attacks on Jews, the text of this cartoon reads, "The Jewish-lackey Talmudists / Reveal their abysmal hatred, / Which old Judas incites and fuels / Because he senses his immanent end." Behind the falling bombs is the word *murder*.

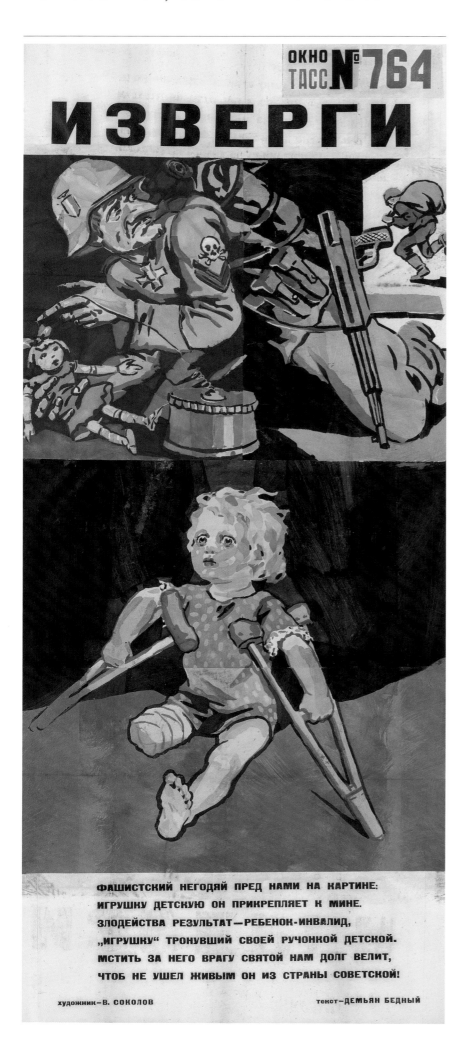

Image: Viktor Sokolov
Text: Dem'ian Bednyi
Edition: 600
Stencil
204 × 89 cm
Ne boltai! Collection

Monsters

*The Fascist scoundrel before us in the
 picture*
Attached a mine to the child's toy.
*The result of this villany is a child
 invalid,*
Who touched the "toy" with its little hand.
Revenge on this enemy is our sacred duty
So he doesn't leave the Soviet land alive.

In a darkened interior kneels a German soldier, his uniform displaying a skull and crossbones, which identifies him as a member of the Waffen-SS, and a type of neck order. He attaches the wire of an explosive device to a doll. Through an opening at the right, we see a soldier running with a bag filled with loot. Below is the victim, a child with the stump of one leg bandaged. Among the symbols of wartime cruelty – actual or alleged – none is as affecting as the innocent victim, especially a child. Given the ferocity and carnage perpetrated by the German forces occupying Soviet territory, it is not hard to understand why the TASS studio employed this kind of sentimental propaganda.

Using crutches, the one-legged toddler attempts to maneuver himself or herself out of a bed in a dark, windowless space. The infant's very painterly head was achieved with economic brushwork transformed by the stencil cutters into a striking image of fourteen colors. The palpability of the pigment sitting on the paper's surface lends the child a strong, compelling presence.

Image: Vladimir Lebedev
Text: Samuil Marshak
Edition: 800

Stencil
216 × 84 cm
Ne boltai! Collection

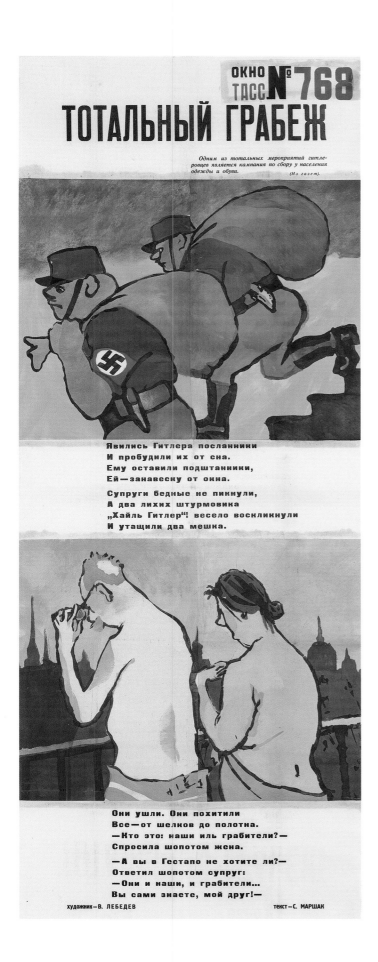

Total Plunder

One of the extreme methods employed by Hitler's army are campaigns to collect clothing and shoes from the general population. (From newspapers)

*Hitler's emissaries appeared
And woke them from their sleep.
They left him only his underwear,
They left her only a window curtain.*

*The poor couple let out not a squeak
And the two dashing young storm
 troopers
Merrily cried out, "Heil Hitler!"
And ran off with two sacks.*

*They left. They stole everything
From silks to linens.
"Who was it: our own troops, or
 marauders?"
Asked the wife in a whisper.*

*"Do you want to end up before the
Gestapo?"
Answered the husband in a whisper.
"They are both our own and marauders …
As you well know, my friend!"*

Soviet satirists clearly enjoyed lampooning Nazi clothing drives (see fig. 1), creating endless variations on the theme from the droll (see, for example, TASS 19-I-42) to the depressing, as is the case of TASS 768. In the winter of 1941–42, temperatures on the Eastern Front dropped to forty degrees below zero. When the German army invaded the Soviet Union, it had not been issued adequate winter clothing because Hitler had mistakenly calculated that the campaign would be successful before winter set in. As the conflict wore on, the problem worsened. Here two Nazi storm troopers descend a staircase of a German dwelling, each laden with a sack containing, as the poem reveals, clothing and other items they have just confiscated. From a balcony, beyond which we see a city skyline, the victims – a seminude, middle-aged couple – helplessly observe the soldiers' departure.

Lebedev seems to have modeled the storm trooper at left after the SA's former leader, Erich Röhm, especially his piglike snout and the roll of fat at the nape of his neck. The artist also did this in TASS 507 (p. 216). In the present work, the large, simplified forms, restrained palette, strong contrasts of light and dark, and unmodulated application of pigment all produce a bold effect that underscores the Nazis' villainous behavior. Nonetheless, the poster succeeds in highlighting the contrast between the abbreviated, yet delicately colored flesh tones of the two victims and the coarser hues, rendered with equal subtlety, used to define the victimizers. In this way, the artist heightened the vulnerability of the pathetic couple.

Fig. 1 René Ahrlé (German, 1893–1976). *Give away Old Woven Fabrics and Shoes! Woven Fabrics and Shoe Drive, May 23 to June 12, 1943.* Offset lithograph; dimensions unknown. This poster's generous donor of used clothing belies the nefarious means by which much of this kind of material was actually procured.

Image: Kukryniksy
Edition: 600

Stencil
155.5 × 102 cm
Ne boltai! Collection

There Was a Shout near Orel and It Echoed in Rome

Here, as in TASS 640 (p. 235), the Kukryniksy combined two events that actually happened at different times and places. Hitler, rendered as a tiger complete with stripes and a nearly severed tail, stands on land, his arm caught in a trap labeled "Kursk salient." Mussolini sinks to the bottom of the sea, weighed down by a boulder inscribed "Hitler's Aid." A powerful tension is created in the composition, with Hitler and Mussolini being pulled in opposite directions, an aspect that is at once dynamic and, perhaps, symbolic.

TASS 778's title is based on a Russian saying, "As the shout went, so did the echo," meaning one gets the response one deserves. The association between Hitler and a tiger refers to the Tiger-1, a heavy German tank designed to counter the Soviet tanks T-34 and KV-1 (see fig. 1).

Essentially, this poster is an enlargement of a cartoon of the same subject by the Kukryniksy that appeared in *Pravda* on July 28, 1943. The poster and cartoon both acknowledge recent critical military setbacks for Hitler and Mussolini. Hitler's forces were defeated in the battle for the Kursk salient. A *salient* is a military term for a battlefield that projects into enemy territory, forcing its defenders to confront the enemy on three sides. The Kursk salient was 160 miles long, stretching from Orel on the northern shoulder to Belgorod on the southern shoulder (both had been occupied by the Germans since October 1941). Kursk is located between these two cities. In what they called Operation Citadel, the Germans aimed to encircle and eliminate the Soviet forces centered around Kursk, which the Red Army had reclaimed in February 1943. This encounter involved 3,155 German and 3,275 Soviet tanks (in addition to troops, guns, and mortar). The Soviets managed to hold out against

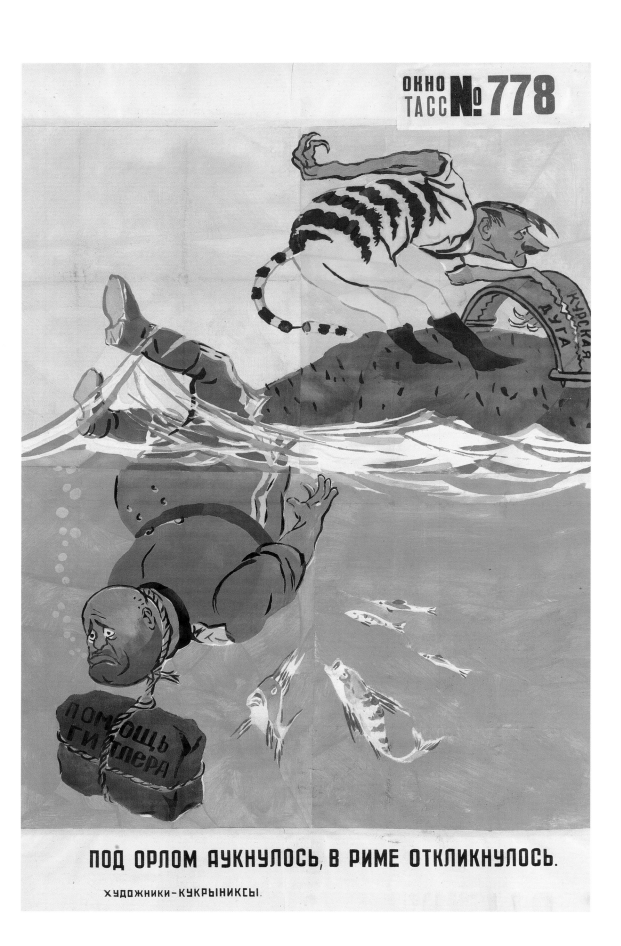

ПОД ОРЛОМ АУКНУЛОСЬ, В РИМЕ ОТКЛИКНУЛОСЬ.

ХУДОЖНИКИ-КУКРЫНИКСЫ.

the Germans, exhausting them in the process, and on July 12 launched a counter offensive, Operation Kutuzov. The most critical fight of the campaign, which took place at the railway junction of Prokhorovka, involved over 1,200 tanks (the largest such battle in history) and resulted in a graveyard of men and matériel. On August 5, three days after TASS 778 appeared, the Soviets would retake Orel and Belgorod.

Mussolini's troops suffered a major setback in Sicily, when beginning on July 9, the AEF – Britain, Canada, the United States, and Free France – under General Dwight D. Eisenhower, invaded Sicily by land and sea. Their strength forced Hitler to cancel Operation Citadel on July 17 in order to divert troops to the island. Sicily would fall to the Allies on August 17. Three weeks before, on July 25, Mussolini was dismissed as the Italian premier by King Victor Emmanuel and eventually arrested; he was replaced by Marshal Pietro Badoglio. That same day, the *Chicago Daily Tribune* reported an announcement from Stalin that "Germany's 19 day old offensive in Russia had collapsed on the graves of 70,000 Nazis." As headlines of newspapers at this moment attest, the enormity of these events was not lost upon the world at large.

Brushy paint application and the use of several stencils in TASS 778 enhance the representation of the blue water. The fish were not painted on the surface but instead were created in the negative, as untouched areas between the openings of the stencils that defined the water. Thus, the fish seem to dart with animation and lightness around the inert, sinking forms of Mussolini and the large rock to which he is tied, both rendered in solid, deeply saturated colors.

Welcome, America's Heroes of the Sea!

Labor's Summer Job
By Adam Lapin
—See Page 8

Daily Worker

★ ★ 2 Star Edition

NATIONAL UNITY FOR VICTORY OVER NAZISM—FASCISM

Vol. XX, No. 160 NEW YORK, TUESDAY JULY 6, 1943 (8 Pages) Price 5 Cents

NAZIS LAUNCH OFFENSIVE AT OREL, LOSE 586 TANKS IN THE FIRST DAY

3 CENTS PAY NO MORE!

Chicago Daily Tribune

THE WORLD'S GREATEST NEWSPAPER

FINAL ★★

VOLUME CII.—NO. 161 C SATURDAY, JULY 10, 1943.—28 PAGES PRICE THREE CENTS

EISENHOWER STRIKES!

Allied Troops Storm Shores of Sicily

И «ТИГР» НЕ ВЫВОЗИТ…

Рис. Бор. Ефимова.

ФЮРЕР:—Скорей тащи другую вывеску, Геббельс; эта уже СОРВАЛАСЬ!..

Fig. 1 Boris Efimov. "And the 'Tiger' Will Not Save Him," *Krasnaia zvezda*, July 9, 1943. The text on the sign that is falling down reads: "Hurry up and bring me another sign, Goebbels. This one has already been torn down." Goebbels rushes forward with another sign, which says, "The Germans aren't advancing, the Soviets are!"

Image: Petr Sarkisian
Text: Dem'ian Bednyi
Edition: 600

Stencil
121 × 115.5 cm
Ne boltai! Collection

A Dying Flower Farm

Despite Goebbels's reassuring speech, the turmoil of the Nazi camps is growing every day.

What is this? A groan? A cry?
Positively scandalous!
All the buds are drooping
And one has already fallen.

Goebbels the florist.
Is an expert on buds,
But what do you know:
The weather has changed,
And the flowers are withering fast!

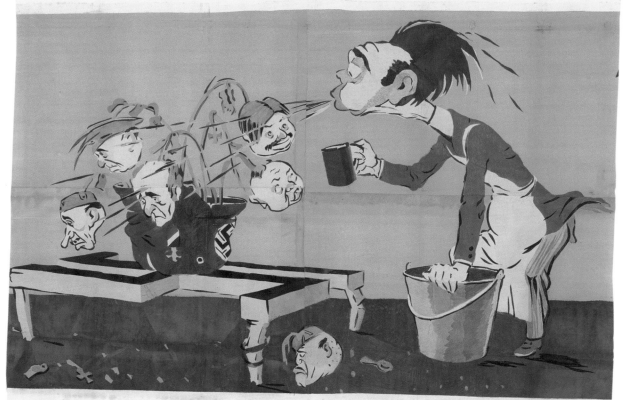

ГИБНУЩЕЕ ЦВЕТОВОДСТВО ОКНО ТАСС №799

Несмотря на успокоительные речи Геббельса, растерянность в лагере гитлеровцев растет с каждым днем.

Что такое? Стон ли? Крик ли?
Положительно скандал!
Все бутончики поникли,
А один уже упал.

Геббельс в роли цветовода.
По бутонам он знаток.
Но дела такого рода:
Изменилася погода,
Вянет явственно цветок!

художник – П. САРКИСЯН

текст – ДЕМЬЯН БЕДНЫЙ

An inverted German helmet, placed on a low, rickety table shaped like a swastika, serves as a planter for a six-stemmed plant with five drooping flowers in the form of human heads. They represent Axis leaders (clockwise): Laval of Vichy France, Norwegian Prime Minister Vidkun Quisling, Romanian Prime Minister Ion Antonescu, Finnish Commander in Chief Carl Mannerheim, and Hungarian Regent Miklos Horthy. The sixth "blossom," representing the now-deposed and jailed Mussolini, lies on the floor amid remains of uniforms and medals. Goebbels, with his right hand clutching a mug and his left resting on a bucket, tries to revive the plant by spraying it with water from his mouth.

This poster forecasts the future of the Axis partnership after the armistice the Allied forces and Italy signed on September 3. In response to the Allies' penetration of southern Italy and the capitulation of the Italian government, Hitler immediately ordered the German troops stationed in the country to seize control over the north and central regions. Goebbels's first public

Celebrate Victory at Garden Tonight!

Pages 2, 3, 4, 5—
For More News on Italy

Daily Worker

★ ★ 2 Star Edition

NATIONAL UNITY FOR VICTORY OVER NAZISM—FASCISM

Vol. XX, No. 216 NEW YORK, THURSDAY, SEPTEMBER 9, 1943 Entered as second-class matter May 4, 1943 at the Post Office at New York, N. Y., under the Act of March 3, 1879 (8 Pages) Price 5 Cents

ITALY SURRENDERS TO U.S., BRITAIN, SOVIETS
Soviets Take Stalino, Liberate Entire Donets

response to Italy's fall appeared in the September 12 issue of *Das Reich*, the weekly Nazi mouthpiece he founded. Anticipating the potential effects on the remaining Axis leaders, he wrote:

Regarding this time and its suffering, there is only one sin and that is cowardice. Anyone who cowardly avoids a decision will have to capitulate one day concerning it. He who gets weak in the knees when in danger would do well to at least hide this from his fellow men in order not to infect them too with his fickleness. One should strive in times of war to perceive every crisis and every burden in the light in which it will appear a year or even a decade later; then one can overcome it easier.

He concluded, "At some time this last battle will be fought. Lucky are the nations that will then stand on the winning side. At no moment are we in doubt that we will occupy first place among them."

Assessing the consequences of Italy's surrender in the September 12 issue of the *New York Times*, George Axelsson wrote:

Regarding fascism, Berlin boasts that it will be revived inside the Italian provinces occupied by the Germans, presumably under the nominal leadership of some fascist quisling. That

fascist dummy state would in German eyes save the Tripartite Pact in that it would deprive Germany's vassals of an excuse to quit the pact on the pretext that it no longer exists, as Hungary is already reported to contemplate doing.

That very day, German paratroopers succeeded in freeing Mussolini from his detention compound in the mountainous Abruzzo. Subsequently, he was proclaimed head of a new puppet state, the Italian Social Republic (RSI; alternatively known as the Salò Republic).

In substituting human heads for blossoms, Sarkisian was working with a device popular with graphic satirists since the eighteenth century. TASS 799 appears flatter than most of the studio's posters. Its muted colors lack a palpable presence on the paper surface; rather, they seem to sink into it.

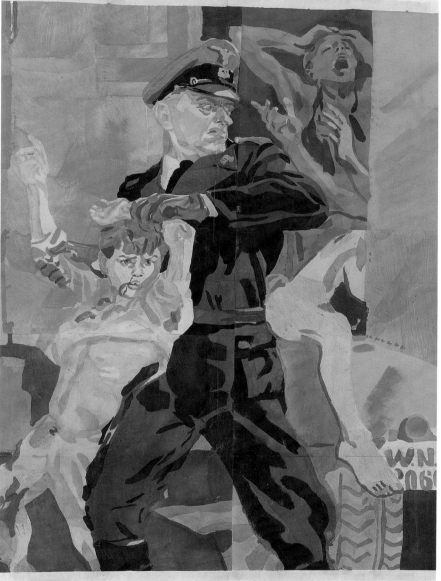

Image: Vladimir Ladiagin
Text: Stepan Shchipachev
Edition: unknown (probably 600)
Stencil
186 × 81.5 cm
Ne boltai! Collection

Volodia Zuzuev

When they began putting sick children in the "murder vans," Volodia Zuzuev cried, "Farewell, Comrade Stalin, farewell, nurses – I shall return no more!" (From the testimony of witness Inozemtseva at the trial of German Fascist occupiers for atrocities committed in Krasnodar)

Children cried in the hospital. At the gates
A truck as big as a train car opened its black mouth.

As they shoved him into the jaws of the death van,
The child cried out like an adult: "Farewell, Comrade Stalin!"

He looked at his loved ones. In his eyes were pain and sorrow.
"Farewell, nurses – I shall return no more."

The enemy mob was merciless and black.
But the nation heard this child's cry.

And the Red Army soldiers heard the cry in battle:
They marched forth vowing to avenge the children's lives.

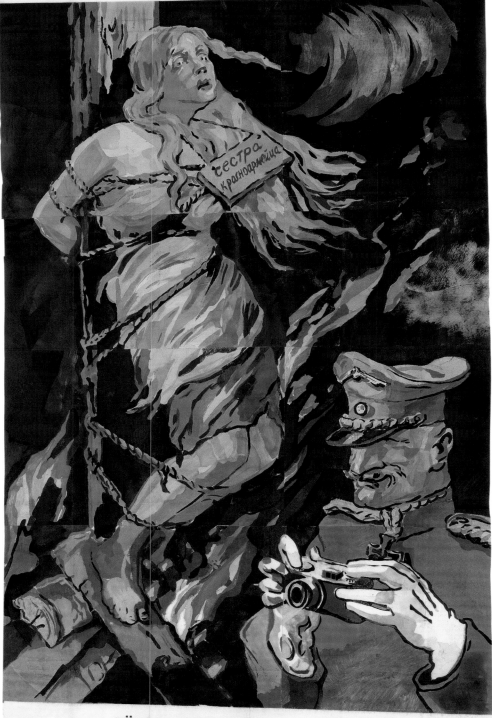

Image: Pavel Sokolov-Skalia
Text: Aleksandr Zharov
Edition: 800
Stencil
235.5 × 114 cm
Ne boltai! Collection

Save Me, Brother!

The villains set her
On a bonfire for cruel torture.
Soldiers, make haste to save
Your suffering sisters!

A smug German officer has just taken a photograph of a woman who is tied to a stake and about to be consumed by leaping flames and smoke. The officer's outsized hands sport white gloves, a subtle touch that suggests his false innocence, cynical sense of superiority, and clinical remove from the heinous act in which he has participated. From the victim's neck hangs a sign that reads "Sister of a Red Army man." Although the female figure is generalized, she does not represent "Mother Russia." Rather, she serves as a symbol of the brutal victimization of Soviet women at the hands of the enemy. The subject – addressing both the martyrdom of an innocent victim and psychopathic sadism – demonstrates the titillation the execution prompted in at least one bystander. We in turn are witness to a double infraction upon this woman's unimaginable suffering. While this is a rare example of an immolation in the TASS repertory, the theme was more frequent in conventionally printed posters (see fig. 2).

This gruesome scene alludes to a phenomenon of modern warfare. No matter how barbarous and disturbing the atrocity, the impulse to document prevails. Photography has been used in this way from racist lynchings in the American South to the torture of prisoners at Abu Ghraib, Iraq, and more recently by the self-designated "Kill Team" of American soldiers in Afghanistan.[1] As we have seen (TASS 60 [pp. 170–74]), the Germans sent special units comprising writers, photographers, and radio and cinema personnel to provide visual and oral records of the war for propaganda purposes.

But photographs were not always the work of professionals in an official

Fig. 1 Photographer unknown (German). *Zoia Hanged*. Published in Petr Lidov, "Five German Photographs," *Pravda*, October 24, 1943. The sign hanging from Zoia's neck reads, "She set fire to houses." The writer of the accompanying text wonders: "Where was [Zoia] in her last moments? In her imagination, was she embracing her mother? Was she reporting to her commander? Or was she saying farewell to Stalin at the Kremlin?" A similar good-bye to Stalin was allegedly said by a child, Valodia Zuzuev, as he was taken to his death (see TASS 811 [pp. 252–53]). For another photograph of the young woman's death, see fig. 5.

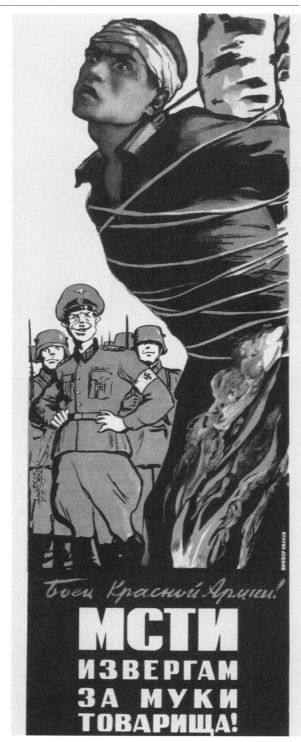

Fig. 2 Viktor Ivanov. *Soldier of the Red Army! Exact Vengeance on the Fiends for Your Comrade's Torments!*, 1943. Publisher: Iskusstvo. Edition: unknown. Offset lithograph; 57 × 22 cm. Central State Scientific-Technical Archive (CSSTA) of Ukraine. The idealized Russian youths that Ivanov depicted in his poster designs are typically handsome and strapping, even when they are suffering, as here. Tied to a birch tree – symbol of the motherland – the flames of a fire licking at his legs, a young soldier resembles depictions of the Christian martyr Saint Sebastian. Following the time-honored Soviet formula of illustrating good and evil, the image is completed by caricatured German soldiers, one of whom grins maliciously at the heroic victim.

capacity. Military personnel of all ranks used their own cameras to capture events that they participated in or saw (see fig. 4). The German camera and film manufacturer Agfa in fact used the line "A Bridge between Front and Home" in advertising its products during the war.[2] The Soviets came upon such photographs when searching prisoners or the bodies of dead German soldiers. They made sure to publish them in the Soviet press (see fig. 3). On October 24, 1943, *Pravda* and *Krasnaia zvezda* reproduced five snapshots of this nature as evidence of Nazi cruelty and to encourage even greater hatred for the enemy. Petr Lidov, the *Pravda* writer, declared, "The imbecilic photographer clicks the switch of his camera; he does not understand at all what is going on. Otherwise he would not immortalize an image that can serve as the symbol of the immeasurable shame of Germany." One image shows "the last minutes of the murder of Zoia Anatol'evna Kosmodem'ianskaia (Tania). The Germans killed her at noon on November 29, 1941.... No one but the Germans could take such pictures" (fig. 1; see also fig. 5).[3] One of the photographs appeared in the *Chicago Daily News* on November 9. *PM* published all five on November 10.

 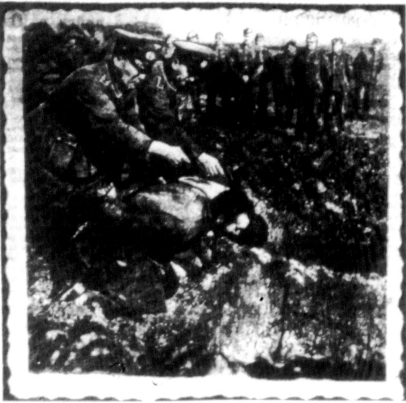

Fig. 3 Photographer unknown (German). Execution by German soldiers of Soviet partisans or civilians, *Krasnaia zvezda*, September 8, 1943. The text that accompanied these photographs reads:

These photographs were published in the newspaper Za rodinu *of the Northwestern Front, after being found on a captured German soldier, Ludwig, a member of a punitive unit of the 16th German army. The photographs were in his wallet, and we must presume that he showed them to his partners in pillaging and plundering. The pictures show how the Gestapo execute Soviet people. You see ordinary rank-and-file Russian peasants; their hands are tied; they have been set on their knees in front of a hole; and the German butchers are preparing to shoot them in the back of the neck. A squat German sergeant-major leads his subordinates in meting out this terrible reprisal. The sergeant-major is preparing to shoot these helpless people. He is calm, this Fascist, this mad German dog! He is accustomed to such reprisals. // Around him stand German soldiers, who watch the execution with obvious pleasure. They stand in nonchalant poses, some folding their arms behind their backs, others smiling. // These images, which were taken by an amateur German photographer, typify the German occupation. This is how the two-legged German beast behaves in our land. Thus the Germans avenge the helpless Russian people for their love for the homeland. // Avenge, soldier, the German fiends: We will find the sordid German butchers in this photograph wherever they might hide. Our avenging hand will reach them and woe will come to the German butchers and their accomplices, who commit infamous crimes and injustices on our Soviet land!*

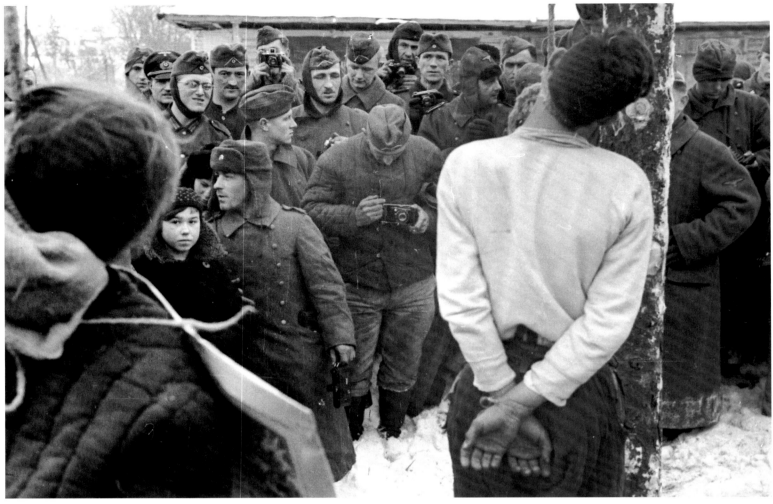

Fig. 4 Photographer unknown (German). German soldiers taking photographs of an execution, n.d.

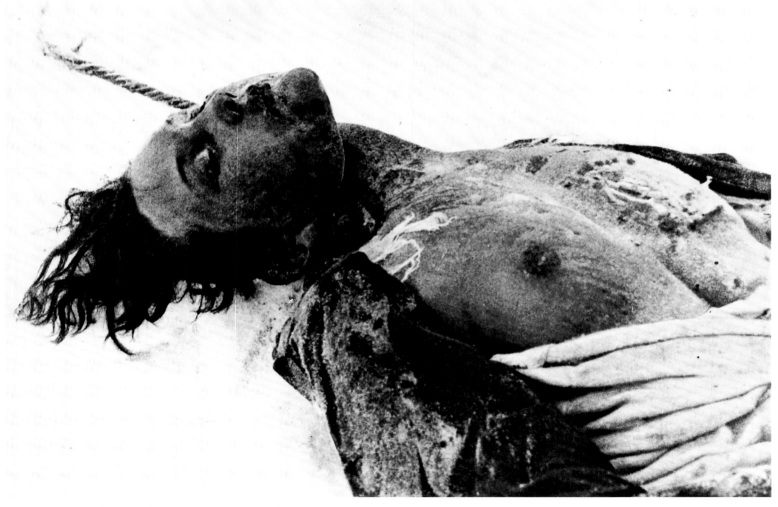

Fig. 5 Sergei Strunnikov (born 1907; died Poltava, 1944). *Zoia*, December 1941. Gelatin silver print; 9.6 × 13.8 cm. Art Gallery of New South Wales, purchased 1997. The eighteen-year-old Zoia was cut down from the gallows, and this photograph shows her mutilated body lying frozen in the snow. This image inspired a number of posters, including ones by the Kukryniksy and Viktor Deni (fig. 6.19).

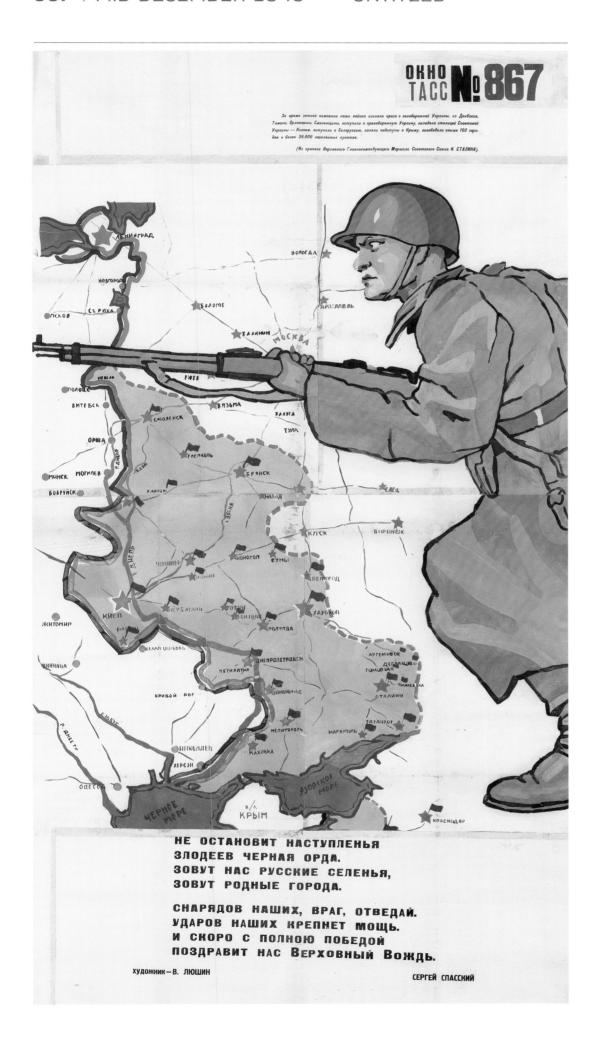

ОКНО ТАСС № 867

За время летней кампании наши войска изгнали врага с левобережной Украины, из Донбасса, Тамани, Орловщины, Смоленщины, вступили в правобережную Украину, овладели столицей Советской Украины — Киевом, вступили в Белоруссию, заняли подступы к Крыму, освободили свыше 160 городов и более 38.000 населенных пунктов.

(Из приказа Верховного Главнокомандующего Маршала Советского Союза И. СТАЛИНА).

НЕ ОСТАНОВИТ НАСТУПЛЕНЬЯ
ЗЛОДЕЕВ ЧЕРНАЯ ОРДА.
ЗОВУТ НАС РУССКИЕ СЕЛЕНЬЯ,
ЗОВУТ РОДНЫЕ ГОРОДА.

СНАРЯДОВ НАШИХ, ВРАГ, ОТВЕДАЙ.
УДАРОВ НАШИХ КРЕПНЕТ МОЩЬ.
И СКОРО С ПОЛНОЮ ПОБЕДОЙ
ПОЗДРАВИТ НАС ВЕРХОВНЫЙ ВОЖДЬ.

ХУДОЖНИК—В. ЛЮШИН СЕРГЕЙ СПАССКИЙ

Image: Vladimir Liushin
Text: Sergei Spasskii
Edition: unknown (probably 600)
Stencil
183.5 × 100.5 cm
Ne boltai! Collection

During the summer campaign, our troops have driven the enemy out of the left bank of Ukraine, out of the Donbass, Taman', the Orel region and the Smolensk region; they have entered the right bank [of] Ukraine and captured the capital of Soviet Ukraine, Kiev; they have entered Belarus and occupied the approach into the Crimea; they have liberated more than 160 cities and 38,000 towns. – From an order of the Superior Commander and Marshal of the USSR, J. Stalin

*The black horde of villains
Will not stop our advance.
The Russian villages call to us
Our native cities call.*

*Taste our bombs, enemy,
The power of our strikes will increase.
And soon the Supreme Leader
Will congratulate us with our complete victory.*

A determined Red Army soldier charges westward against the backdrop of a map featuring the areas – detailed in the order from Stalin quoted above – that the Soviets seized back from the Nazis during the summer–fall campaign of 1943.

The text at the top of the poster refers to Stalin's Order 309, of November 7, 1943, when the twenty-sixth anniversary of the 1917 Bolshevik Revolution was commemorated. The day before this order was issued, Stalin had delivered a three-part address before a joint meeting of the Moscow Soviet of Working People's Deputies and Representatives of the Moscow Party and Public Organizations. The speech summarized the great inroads achieved during the summer–fall campaign. On the eve of the anniversary celebration, *Pravda* and *Krasnaia zvezda* both featured a full-page map illustrating the size of the land the Soviets had recovered. With the reclaiming of Soviet territory came a propaganda offensive that resulted in numerous posters celebrating the Red Army's advances (see figs. 1–4). These advances were eagerly chronicled in the media of Allied nations as well.

Chicago Daily Tribune

THE WORLD'S GREATEST NEWSPAPER

3 CENTS PAY NO MORE!

FINAL ★★

VOLUME CII.—NO. 312 C [ALSO U.S. PAT. OFFICE. COPYRIGHT 1943 BY THE CHICAGO TRIBUNE.] THURSDAY, DECEMBER 30, 1943.—28 PAGES THIS PAPER CONSISTS OF TWO SECTIONS—SECTION ONE PRICE THREE CENTS

REDS 48 MI. FROM POLAND

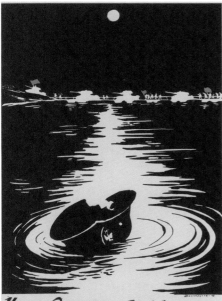

Fig. 1 Nikolai Dolgorukov. *The Dnieper Is Wondrous in Calm Weather...*, 1943. Publisher: unknown. Edition: unknown. Offset lithograph; dimensions unknown. The caption is a quotation from Nikolai Gogol's 1831 story "A Terrible Vengeance." Dolgorukov relied on the viewer's familiarity with classic Russian literature to make the connection.

Fig. 2 Viktor Ivanov. *To the West*, 1943. Publisher: Iskusstvo. Edition: 200,000. Offset lithograph; 50.7 × 33.4 cm. Ne boltai! Collection.

Fig. 3 Viktor Ivanov. *We Drink the Water of Our Native Dnieper, and We Will Drink from the Prut, the Nemen, and the Bug!*, 1943. Publisher: unknown. Edition: unknown. Offset lithograph; 89 × 60 cm.

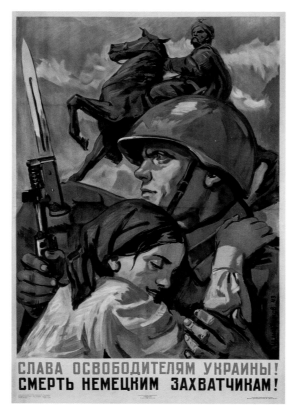

Fig. 4 Dementii Shmarinov (born Kazan, 1907; died Moscow, 1999). *Glory to the Liberators of Ukraine! Death to the German Invaders*, 1943. Publisher: Iskusstvo. Edition: 25,000. Offset lithograph; 93.4 × 62.6 cm. Ne boltai! Collection.

Image: Nikolai Denisovskii
Edition: unknown (probably 600)
Stencil
294.6 × 147.3 cm
Ne boltai! Collection

*Let the triumphant banner of the great
 Lenin protect you!*
*Under the banner of Lenin – Onward to
 victory!*
(J. Stalin)

Against a wintry sky pierced by the
beam of a searchlight stands the
figure of Lenin, an image inspired by
a much-reproduced 1919 photograph
taken on Moscow's Red Square dur-
ing May Day celebrations. However,
the inclusion at the right of TASS
880–883 of the spire of the Cathedral
of the Saints Peter and Paul fortress
confirms this site as Leningrad. Here
Lenin – the leader of the Bolshevik
movement and founder of the Soviet
Union as the first official Socialist
state – is surrounded by armed sail-
ors and workers, one of whom holds
a red banner. The entire scene harks
back to the October 1917 Revolution,
when the city was still called
Petrograd (it was renamed Leningrad
in 1924).

This, one of the largest of the TASS
posters (it is composed of fourteen
individual sheets), commemorates
the twentieth anniversary of Lenin's
death, on January 24, 1924. The studio
editorial board selected the text for
TASS 880–883 from the last lines of a
speech Stalin delivered in Moscow's
Red Square on November 7, 1941,
during the twenty-fourth-anniversary
celebration of the October Revolution.
The poster also serves as an homage
to Leningrad's beleaguered residents
– civilian and military. On January 22,
Pravda published a story describ-
ing a solemn memorial meeting on
the occasion of the anniversary of
Lenin's death. The headline, "Under
the Banner of Lenin – Stalin's Soviet
People Go to Victory," is very close
to the text in TASS 880–883. For the
population of Leningrad, this head-
line and Stalin's words were about
to come true. On January 27, the
Leningrad blockade, a siege in which
nearly two million people perished,
was lifted after 872 days.

Image: Pavel Sokolov-Skalia
Text: Aleksandr Zharov
Edition: 600
Stencil
164.5 × 86.5 cm
Ne boltai! Collection

Happy New Year!

The New Year!
The day of total reckoning
With the Fascist band draws near.
This is the year when
The enemy's bones will be scattered!

Two German soldiers in a dugout celebrating New Year's Eve are surprised by a member of the Red Army in winter camouflage aiming a submachine gun at them. His towering presence evokes the recent military advances of the Soviets during the 1943 summer–fall campaign. The success of this poster relies on a variety of contrasts. The brilliant palette of complementaries – yellow and purple, orange and blue – and the depth of color result in a vibrant image in which the warm tones suggest a fire-lit interior that contrasts with the cold blues of the Russian winter. The poster also features Sokolov-Skalia's typical use of opposite types: the risible, oafish Germans are diminished by the monumental figure of the heroic Soviet soldier who bursts into their den like a bolt out of the blue. The low vantage point and exaggerated perspective heightens the contrast. The perfunctory rhyme adds little to the sharp differentiation that is immediately established between the awesome image and the traditional New Year's greeting.

TASS 887 also heralds what the Soviets and their partners, Great Britain and the United States, would have in store for the enemy in the coming year. Between November 28 and December 1, Stalin, Churchill, and Roosevelt met in Tehran, Iran, to work out the final strategy for defeating the Nazis. The plan's centerpiece would be, at long last, the opening of a second front in France in the spring of 1944.

Image: Pavel Sokolov-Skalia
Text: Dem'ian Bednyi
Edition: 600

Stencil
173 × 87.5 cm
Ne boltai! Collection

A German Christmas Tree

Fritz greedily plundered Europe,
And he swept it with a broom.
"Well," the robber sneered,
"Let's set up a Christmas tree!"

The scoundrel was so full of cheer!
Wines, roast veal, and chicken
Geese and everything besides,
He hung on his Christmas tree!

Suddenly, the candles all went out!
Fritz howled like a wolf.
From the sky terrifying "presents"
Tumbled down onto his tree!

It was a touching scene;
Everything perished: the house, the
* veranda . . .*
And Fritz's Christmas tree was turned
Into a fir cross for his grave!

In the top-left panel, we see a middle-aged, well-fed Fritz, his hands full of Christmas booty. To the right, he decorates his tree with sausage, bread, bottles of wine, and swastikas. Piled around the tree are more holiday provisions, including a game bird ready for cooking. In the bottom-left panel, bombs rain down on Fritz and his tree, cooking his goose, as it were. And so he dies ignominiously, buried head first in a pile of snow. The Christmas-tree base becomes his cross.

Eschewing his usual discursive narrative style, Bednyi here tightly constructed his poem around vivid contrasts, complementing the four scenes rather than literally explaining them. Each stanza is based around a key word rhyming with "fir tree" (*elka*): broom, veal, wolf, and veranda. Sokolov-Skalia could not suppress his chromatic virtuosity, even in this biting caricatural poster. For example, he used a range of prismatic tones to convey the mottled flesh of poultry skin, modeling through color rather than value.

Image: Kukryniksy
Text: Osip Brik
Edition: 600

Stencil
171.5 × 85.5 cm
Ne boltai! Collection

The Lunatic Reception of the Commander in Chief

General from the Eastern Front: "What shall we do now, Führer?"
Hitler: "Wait a minute! Let me gather my thoughts."

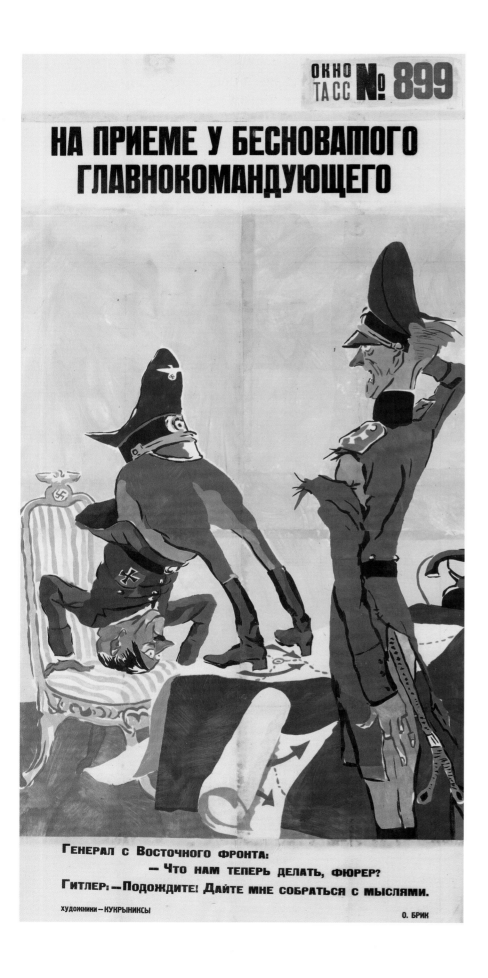

Standing at attention is a German officer – his hand mangled and fingers missing, his hat and shirtsleeve torn, his pants gone, and his suspenders dangling below his ripped coat. He reports to Hitler's posterior, on which perches an officer's hat, about the deteriorating situation on the Eastern Front. On and below the table on which Hitler's boots rest are maps that refer to the encirclement of German troops and their retreats. As is the case with many of the Kukryniksy's TASS posters, color does not play a critical role in constituting the image – which relies on drawing. Rather, color is an embellishment that increases the legibility of the design and its ability to be effective on a large scale.

Along with TASS 912 (p. 268) and 925 (p. 270), this poster relates to military events taking place during the Korsun-Shevchenkovskii Operation, in particular the Battle of the Korsun-Cherkasy pocket (January 24–February 16, 1944), southeast of Kiev. Two Red Army divisions circled a vast German salient along the Dnieper River from Kanev to Cherkasy (Korsun was the center of the German stronghold). One armored inner ring surrounded the Wehrmacht, while an external ring prevented relief forces from going to the aid of their trapped confreres. The Germans suffered great losses of men and equipment, resulting in an outcome that the Red Army could describe as successful, but a significant number of German forces still managed to break through the Red Army rings.

This cheeky image is closely related to a Kukryniksy cartoon that appeared on the back cover of the March 1944 issue of *Krasnoarmeets*, a Red Army magazine. The Kukryniksy delighted in ridiculing Hitler and the Nazi brass by depicting them in demeaning poses. TASS 899 was reproduced at the TASS studio by conventional means in an edition of twenty thousand later in March 1944. A reduced version of the drawing related to the poster was produced as a postcard.

Image: Boris Shirokorad (born Belgorod region of Kursk, 1907; died 1998)
Text: Sergei Spasskii
Edition: 600
Stencil
167 × 87 cm
The Art Institute of Chicago, gift of The U.S.S.R. Society for Cultural Relations with Foreign Countries, 2010.161

A Terrifying Ghost

February 2 is the anniversary of the defeat of German Fascist forces at Stalingrad.

Hitler can't sleep. Through the darkness
A skeleton appears to him.
Goosebumps rise on his skin.
"Remember Stalingrad, Hitler!
We died there a year ago –
Soon the same will happen to you!"

This poster was issued one year after the seven-month siege of Stalingrad ended in favor of the Soviets. Here Hitler is startled in his bed by the saluting corpse of a largely decomposed German soldier, which towers above him. Lifting himself off his pillow, Hitler grabs his collar in fear while clutching a candleholder, the likely source of the scene's spectral shadows. The apparition has risen to an upright position from a snowy common grave that becomes a mantle punctuated with crosses. TASS 901 alludes to the devastating losses suffered by the Axis forces during the siege. Apparitions on a battlefield of the dead appear often in traditional popular Russian prints, or *lubki*.

Spasskii's poem echoes that of a particularly well-received early studio poster, *Criss Cross* (TASS 15 [fig. 4.5]): "The Führer set off on a journey / Pinning his iron cross to his chest. / But he deserves more than a single cross: / He'll receive a cross from us as well." The connection between texts written three years apart may suggest that the studio wished to infer that Hitler's defeat was portended long before Stalingrad, indeed from the very start of the war.

Shirokorad's style here is indebted to the caricatural vocabulary of more prominent TASS artists such as the Kukryniksy and Shukhmin. The fact that the six separate sheets that comprise the poster are not correctly aligned reveals the potential for errors in the studio's assembly-line process.

Image: Vladimir Lebedev
Text: Aleksei Mashistov
Edition: 600
Stencil
175 × 87 cm

The Art Institute of Chicago, gift of The
U.S.S.R. Society for Cultural Relations
with Foreign Countries, 2010.118

Captured!

*To the north of Zvenigorodka and Shpola,
our troops have continued to battle to
destroy the surrounded enemy force.
(From the operational communiqué of
February 15, 1944)*

*The wild beast won't escape death –
All escape routes are cut off.
The bloodthirsty wolf has been ensnared.
It's our duty to – finish him off!*

A wounded wolf half crouches over
a swastika depicted on a map. He
is trapped in a circle of red flags,
each labeled with the name of a
city. Clockwise from top left, they
are Boguslav (Bohuslav), Mironovka
(Myronivka), Kanev (Kaniv), Cherkasy,
Smela (Smila), Shpola, Zvenigorodka
(Zvenyhorodka), and Lysianka. With
the exception of Boguslav and
Mironovka, which are located in Kiev
province (*oblast*), the cities mentioned
here are in Cherkasy province in
central Ukraine. In effect, Lebedev's
design for TASS 912 was inspired by
the circular form this group of cities
assumes on maps of the region.

The composition refers to a technique
used in hunting wolves, wherein
hunters surround an area inhabited
by the animals with brightly colored
flags tied together with string. Fearing
close contact with unfamiliar objects,
wolves will not move beyond the circle
and thus can be hunted down. As in
TASS 757 (pp. 244–45), the depiction
of the wolf succeeds in expressing
both the ferocity and the weakness of
the enemy. In keeping with the savage
character of the image, Mashistov's
verse is purposefully harsh; the
iambic tetrameters that provide the
narrative information alternate with
shorter iambic trimeters that give the
poet's judgment: the enemy has no
way out and must be eliminated.

In his children's-book illustrations of
the 1920s and 1930s, Lebedev often
featured animals. Here he conveyed
the density and texture of the wolf's
coat by juxtaposing and layering areas
of dry scumbling with fluid brushwork.
To achieve such effects in stencil
involved applying the paint through
the stencil apertures in a highly inter-
pretive, freehand manner.

Image: Aleksandr Danilichev
Text: Aleksei Mashistov
Edition: 600
Stencil
179 × 85.5 cm

The Art Institute of Chicago, gift of The
U.S.S.R. Society for Cultural Relations
with Foreign Countries, 2010.73

The Order of Ushakov

In battle Ushakov was undefeated.
He's justly called "Suvorov of the Seas."
He brought glory to Russia on the seas.
His labors are a model for all sailors.

Oh, heroes of our native fleet,
May our evil enemy tremble at the sight
* of you.*
Wear with honor the order of Ushakov –
The symbol of the art of war, victory, and
* glory!*

This image depicts the upper gun deck of an imperial Russian man-of-war engaged in battle. The figure holding a telescope is Admiral Feodor Ushakov (1744–1817), imperial Russia's most illustrious navy commander. He examines the effects of a shot from a cannon fired by the gunnery officer next to him. The Order of Ushakov is integrated into the design.

During the war, the Soviet military established honorary orders named after imperial military luminaries such as Aleksandr Suvorov (1942), who never lost a battle; and Mikhail Kutuzov (1943), whose defeat of Napoleon's forces in 1812 was the turning point of the war. The Order of Ushakov, intended for naval personnel who were victorious against the larger Axis naval forces, would be first awarded on May 16, 1944.[1] That same day, another order would be established, named for Pavel Nakhimov, who commanded Russian naval and land forces during the siege of Sevastopol in the Crimean War (1853–56). He was commemorated in TASS 940, issued on April 11, 1944.

The poem, with its confusing syntax and lines of varying length (the latter is not evident in the literal translation), is an unsatisfying effort by Mashistov. However, the clumsy diction and archaic lexicon could be a nod toward Russian poetry of Ushakov's time, which was dominated by pompous odes addressed to the czar and other noble personages.

A reduced version of TASS 919 was published by the studio in 1944 in an edition of twenty thousand copies.

Image: Nikolai Denisovskii
Edition: 600

Stencil
171 × 86.5 cm
Ne boltai! Collection

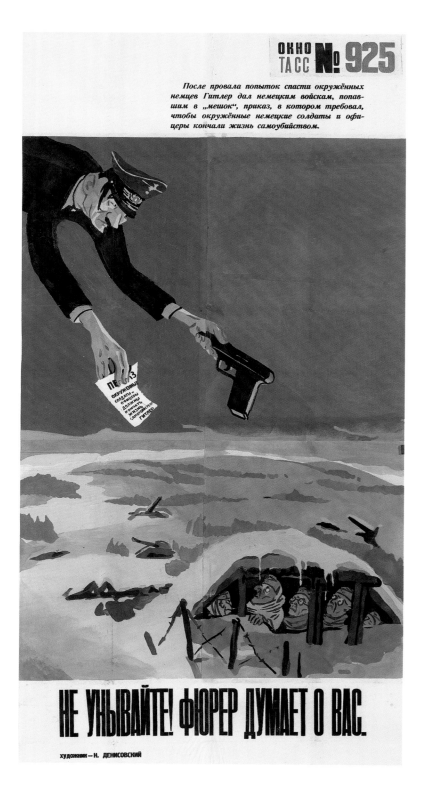

After failed attempts to rescue the surrounded Germans, Hitler issued an order to the German soldiers caught in the "sack," demanding that the surrounded soldiers and officers commit suicide.

Don't lose heart! The Führer is thinking of you.

TASS 925 refers to members of the Wehrmacht who were surrounded by Russians in the Korsun-Cherkasy pocket and could not escape. German soldiers, bundled up against the cold, huddle in a dugout at sunset. Beyond them stretches a snowy field strewn with tanks and bodies. Against the darkening sky, Hitler appears from above, much like the figure of God or Jesus appears before the devout in ex-voto images. However, the Führer is no bringer of salvation. He extends in his right hand a paper that reads: "ORDER. Surrounded soldiers and officers must commit suicide. Hitler." With his left hand, he offers the soldiers a pistol.

Artists received news bulletins from the Soviet Information Bureau (Sovinformbiuro). But they did not always use the information in a similar way (compare TASS 925 to Efimov's February 19 cartoon [fig. 1]).

The difference in the color of the sky at the left and right indicates that the artists working on this poster employed pigments of slightly different hues. This could have been the result of either wartime shortages of the ingredients that went into to the preparation of the colors or simply human error.

Fig. 1 Boris Efimov. "Their Waiting Is Over," *Krasnaia zvezda*, February 19, 1944. The text at the top is identical to that on TASS 925. The caption at the bottom reads, "The arrival of aid from the Führer." The title of the book is *Suicide Handbook*, the label on the bottle says "Poison," and the text on the ribbon declares: "To the soldiers of the Eighth German army from the inconsolable Adolf Hitler. Heil me!"

Image: Moa
Edition: 600

Stencil
159 × 64 cm
Ne boltai! Collection

The Shining Heel

A model of the order for German generals who have "distinguished themselves" in the Korsun-Shevchenkovskii region.

In Russian to "shine by one's heel" means to flee, like a rabbit that raises its tail as it scampers away. All the action in this image takes place under the bottom of a large foot, its heel bearing a swastika, that is mounted onto an Iron Cross. German officers and soldiers who have been trapped in the Korsun-Cherkasy pocket (see TASS 899 [p. 266]), make a run for their lives toward an awaiting Luftwaffe plane under a sky of flames and smoke. TASS 925 (p. 270) also focuses on surrounded Axis troops, but in that image Hitler turns on them.

With the enemy now in retreat, Moa could transform a threatening image of a heel squashing victims (see fig. 6.20) into something pungently funny. The German military decoration being spoofed here is the Star of the Grand Cross of the Iron Cross, established in 1939. It was intended for the most successful German general of the war once Germany achieved victory, but it was never awarded. Here the Axis soldiers flee in defeat. In effect, the artist has awarded them the "Order of the Shining Heel," or the "Order of Cowards."

ОКНО
ТАСС № 928

„СВЕРКАЮЩАЯ ПЯТКА"

Проект ордена для награждения германских генералов, „отличившихся" в районе Корсунь-Шевченковский.

художник—МОА

ПОСЛЕ КРЫМСКОЙ КАМПАНИИ

Берлинское радио сообщило, что маршал Антонеску прибыл на фронт «для награждения отважных румынских воинов»...
Рис. Бор. Ефимова.

Маршал Антонеску отмечает наградами наиболее отличившиеся ЧАСТИ румынской армии.

Fig.1 Boris Efimov. "After the Crimean Campaign," *Krasnaia zvezda*, May 17, 1944. Among the Axis troops trapped in the Korsun-Cherkasy pocket were Romanians. Efimov addressed here the defeat of the Romanian and German troops by the Red Army in the Crimean Offensive (April 8–May 12, 1944; see TASS 971 [p. 283]). The text at the top reads, "The Berlin radio has reported that Marshal Antonescu has arrived at the front 'to award brave Romanian soldiers....'" The text at the bottom reads, "Marshal Antonescu awards the most distinguished PARTS of the Romanian army."

Image: Kukryniksy
Edition: unknown
Stencil
127.5 × 119.5 cm

The Art Institute of Chicago, gift of The
U.S.S.R. Society for Cultural Relations
with Foreign Countries, 2010.99

*The German-Fascist bandits are
now scrambling to find ways of being
delivered from catastrophe. They
have once again resorted to a "total"
mobilization at the rear, even though
the human resources of Germany are
exhausted. (From the order of the
Supreme Commander in Chief, comrade
J. Stalin, of February, 23, 1944).*

*The Search for Human Resources in
Germany*

Goebbels and Hitler run frantically,
pulling a battered helmet by its
leather straps. The helmet bears a
swastika-shaped label that reads
"Total Mobilization." A boy, an old man
with a cane, and an amputee attempt
to flee their leaders' recruiting efforts.
The incorporation into TASS posters
of Stalin's words without any poetic
adornment points to the special
status accorded to the Supreme
Commander's language, especially
as the tide of war turned in his favor.
Earlier TASS posters had adapted
metaphors that Stalin included in his
speeches. For instance, an unnum-
bered poster, TASS 13-XII-41 (fig.
3.15) is based on a comment Stalin
made on November 7: "Hitler no more
resembles Napoleon than a kitten
resembles a lion." TASS 472 illus-
trates Stalin's version of a traditional
Russian expression: "Brave against
sheep, a sheep against the brave"
(see fig. 4.3). TASS 930 is the first of
several posters featuring extended
quotes from Stalin's Order of February
23, 1944, issued on the twenty-sixth
anniversary of the founding of the
Red Army (see also TASS 931 [p. 273],
938 [p. 274], and 941 [p. 276]). Here
the Soviet leader expressed cautious
optimism about the course of the war
and called for continuing efforts to
maintain Soviet superiority.

The technical refinement of this bold
image is evident in the area of the
ground on which the helmet lies and
the figures flee. The stencilers cre-
ated a thin, uneven wash of pale color
over the surface of the paper sup-
port before applying the colors that
define the forms. This painterly touch,
though not required to realize the
basic design, nonetheless enhances
it: the modulated band of ground
interacts dynamically with the con-
trasting black band above it, as well
as intensifying the sense of frenzied
movement across the composition.

Image: Kukryniksy
Edition: unknown (probably 600)
Stencil
157.5 × 85 cm

The Art Institute of Chicago, gift of The
U.S.S.R. Society for Cultural Relations
with Foreign Countries, 2010.100

*The Fascist bosses are making desperate
attempts to introduce discord into the
camp of the anti-Hitler coalition and
thus prolong the war. (From the order of
the Supreme Head Commander in Chief,
comrade J. Stalin, February 23, 1944)*

An Attempt Using Unfit Means

The title of TASS 931 derives from
a Russian law referring to an attempt
to commit a crime with means that
are incapable of achieving the
desired effect, such as employing the
wrong kind of weapon or poison. In
most circumstances, the person
can still be held responsible for the
attempted crime. The expression
became widely used to denote overly
ambitious or misguided intentions.
Thus, in this striking image, Goebbels-
like minions pathetically try to
dismantle a monumental bridge
lined with the Allies' standards
by adhering tiny placards to the
foundations, where in effect no one
will see them, that declare, "Designs
for a separate peace."

The document – an order from Stalin
dated February 23, 1944 – from which
the poster's text was excerpted puts
into perspective the Allies' anxiety
about Nazi attempts to create sepa-
rate peace agreements with neutral or
Allied nations:

*The German-Fascist brigands are
now tossing about in search of ways
to save themselves from disaster....
The Fascist bosses are undertak-
ing desperate attempts to introduce
discord into the camp of the anti-
Hitler coalition and thus extend the
war. Hitler's diplomats are shuttling
from one neutral country to another,
attempting to make alliances with
pro-Hitler elements in those countries,
hinting at the possibility of a separate
peace either with our government
or with our allies. All these ploys of
Hitler are doomed to failure, as the
anti-Hitler coalition is founded on the
vital interests of the Allies who have
set themselves the task of smashing
Hitlerite Germany and her accom-
plices in Europe. It is this very commu-
nity of basic interest that leads to the
consolidation of the fighting alliance of
the U.S.S.R., Britain, and the U.S.A. in
the progress of the war.*

Image: Pavel Sokolov-Skalia
Edition: unknown (probably 600)
Stencil
187 × 84.5 cm

The Art Institute of Chicago, gift of The
U.S.S.R. Society for Cultural Relations
with Foreign Countries, 2010.174

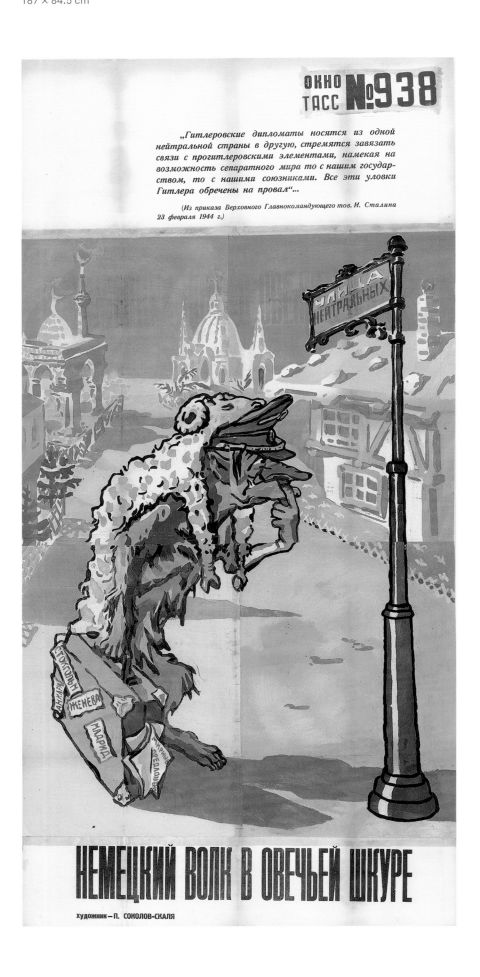

*Hitler's diplomats are shuttling from one
neutral country to another, attempting to
make alliances with pro-Hitler elements in
those countries, hinting at the possibility
of a separate peace either with our
government or with our allies. All these
ploys of Hitler are doomed to failure. (From
the order of the Supreme Head Commander,
comrade J. Stalin, February 23, 1944)*

The German Wolf in Sheep's Clothing

Hitler – a wolf in sheep's clothing –
stops to consult a street sign, which
reads "Neutral Street." Situated in the
background are buildings that evoke
architectural styles native to Sweden,
Switzerland, Turkey, and Spain (all
"neutral" countries). Hitler carries a
suitcase bearing labels of destinations
such as Stockholm, Geneva, Madrid, and
Ankara. Protruding from the suitcase is a
"peace proposal."

Like TASS 931 (p. 273), this poster's text
comes from the address Stalin gave on
February 23, 1944, regarding the Axis
powers' attempts to break down the
combined strength of the Allies by offer-
ing individual peace treaties to Allied or
neutral states. Reaction to these efforts
was immediate and impassioned. In the
March 17, 1944, issue of *PM*, Victor H.
Bernstein declared:

*The answer to all terms is the terms
which the United Nations have already
inexorably laid down: UNCONDITIONAL
SURRENDER. And the answer to all
pleas for a separate peace is the answer
already pledged by FDR, Churchill and
Stalin: PEACE INDIVISIBLE. // It is the tim-
ing, and not the terms, of Hitler's trick-
ery, that is important. It is timed at the
moment when the second front is in prep-
aration. It is aimed, unquestionably to
delay the second front. UNCONDITIONAL
SURRENDER and INDIVIDUAL PEACE.
Hitler already has his answer.*

Image: Pavel Sokolov-Skalia
Text: Dem'ian Bednyi
Edition: 600

Stencil
193.8 × 87 cm
The Art Institute of Chicago, gift of The
U.S.S.R. Society for Cultural Relations
with Foreign Countries, 2010.175

Secret and Counter-Secret

*The Germans can't utter a word without
lying.
Before the inevitable catastrophe
They decided to lie that their regiments
Have been reinforced with "secret
equipment."
They say that with such excellent military
equipment
They can sweep away any front – a piece
of cake!
Boasting of their concealed equipment,
The "equipment" they've used is actually
their tongues.
They're hopeful that they'll find some
fools
Who will believe in their "military secret"
And slacken their zeal for combat!*

*Should we divulge the counter-secret?
The Fascists are counting on fools in
places
Where there have never been any:
All the fools are in Berlin!*

Hitler –an anxious look on his face
– sits at a table on a stage under a ban-
ner that reads: "World Attraction!!!
New! Secret! Weapon!!!" His left hand
makes an obscene gesture (known
as the fig sign) – another reminder
of ROSTA's iconographic lexicon –
which he hides from the onlookers
behind the officer's hat he holds in
his right hand. Goebbels orates from a
makeshift platform, anxiously eyeing
his boss. At least one of the listeners
seems skeptical: the man at the lower
left, immediately below Hitler, lifts his
left index finger circumspectly to his
mouth. A bombed-out building looms
in the background. Bednyi's commen-
tary drives the point home in typically
prolix fashion.

"New Axis Secret Weapons Strictly
Phonies" ran the headline of Willy
Ley's column in the February 8, 1944,
issue of *PM*. Ley wrote:

*The Axis propaganda machinery still
is scattering information about secret
weapons. Here is the latest from the
Berlin end of the Axis, originating, for
a change, from Istanbul [sic], Turkey
(those long range rocket stories came
from Stockholm and Zurich). It is
a "horrifying weapon" which, if used,
would "turn London into a fiery furnace,
consuming most of the population."
The humane Nazis (including Himmler,
no doubt) hesitate to use it, the story
says. Of course they have never tried to
turn London into a fiery furnace before.
The 20,000 fires they set in a single*

*night at the height of the blitz were
purely accidental.*

Ley then discussed the issue of
"negotiated peace" addressed in TASS
931 (p. 273) and 938 (p. 274). "The
weapon will be used if invasion of the
continent shows that all hope of a
negotiated peace is gone. Then, and
only then, the following will happen, or
rather would happen if they did have
such a weapon and if the whole story
were not obviously phony."

In truth, the Nazis did indeed have a
potent new weapon in their arsenal:
the unmanned, pulse-jet-powered
V-1 bomb. Prompted by the Allied
Normandy invasion, they would fire
the first V-1s on June 13, 1944, at
London from launch sites along the
Pas-de-Calais in northern France
and along the Netherlands' North Sea
coast. This would begin a three-month
indiscriminate terror offensive aimed
at the British population.

This boldly outlined and vividly mod-
eled image represents Sokolov-Skalia
at his best. The success of the design
is the result not only of the succinct
visual description of the anecdote, but
also of the virtuosity of color handling
in the portrait of Hitler. He modeled
the face using areas of distinct color
that he knew would merge to suggest
volume when viewed from a distance.

Image: Mikhail Solov'ev
Edition: unknown (probably 600)
Stencil
121 × 122 cm

The Art Institute of Chicago, gift of The
U.S.S.R. Society for Cultural Relations
with Foreign Countries, 2010.193

*In the course of the current winter
campaign, the Red Army has liquidated
powerful German defenses all along
the Dnieper, from Zhlobin to Kherson,
thereby undermining the Germans'
calculations of a protracted defensive
war along the Soviet-German front.
(From the order of the Supreme
Commander in Chief, comrade J. Stalin,
February 23, 1944)*

В ходе нынешней зимней кампании Красная Армия ликвидиро-
вала мощную оборону немцев на всем протяжении Днепра от Жлобина
до Херсона и тем самым опрокинула расчеты немцев на успешное
ведение затяжной оборонительной войны на советско-германском
фронте.

(Из приказа Верховного Главнокомандующего тов. И. Сталина 23 февраля 1944 г.)

художник—М. СОЛОВЬЕВ

This dramatic image is one of many
TASS posters that refer to Stalin's
address on the occasion of the
twenty-sixth anniversary of the
founding of the Red Army (see, for
example, TASS 930 [p. 272], 931 [p.
273], and 953 [p. 278]). The Dnieper
River is seen here, in a bird's-eye
view, cutting through a snow-covered
terrain from Zhlobin, Belarus, in the
north, to Kherson, Ukraine, in the
south. An immense shovel, that of
a Red Army soldier, clears away the
snow and the German armed forces.

The poster's streamlined design and
limited palette, allowing for a very
straightforward and economical use
of stencils, are unusual for Solov'ev,
who typically created more detailed
compositions for his heroic figurative
images. The only colors involved are
the unmodulated red of the shovel,
hands, and city signs; the icy blue that,
together with the untouched paper
surface, suggests ruts and piles of
snow; and the black that defines the
tiny figures and the river. The economy
of means used to realize this poster is
critical to its immediate impact.

Image: Mikhail Cheremnykh
Text: Nina Cheremnykh
Edition: 600

Stencil
184 × 88 cm
The Art Institute of Chicago, gift of The U.S.S.R. Society for Cultural Relations with Foreign Countries, 2010.66

ОКНО ТАСС № 952

ДЕЛО БЫЛО НА ДНЕПРЕ.

ТО ЖЕ БЫЛО НА ДНЕСТРЕ.

НИ ВЗДОХНУТЬ, НИ ОХНУТЬ,— НЕКОГДА ОБСОХНУТЬ!

ХУДОЖНИК – М. ЧЕРЕМНЫХ Н. ЧЕРЕМНЫХ

It Happened on the Dnieper.

The same was on the Dniester.

It's impossible to cry or sigh – There's no time even to dry.

Having reclaimed Ukrainian territory from the occupying German forces between the Dnieper and Dniester rivers, the Soviets crossed the Prut River into Romania on April 1, 1944. Among the reasons behind this push was the desire to deprive the Axis forces access to the Ploesti oil fields and thereby stymie their ability to continue the war.

The Red Army – indicated by the helmet with the red star that appears above the horizon at the upper right like the dawn of a new day – pushes the retreating Germans westward. They frantically climb a river embankment. In TASS 952 – a collaboration between the Cheremnykhs – both image and text underscore the repetitive nature of German defeats. The writer Nina Cheremnykh said about the caption:

I had one pet peeve: I avoided verbal rhymes. I thought that if I'm writing such a brief text I should be ashamed to resort to easy verbal rhymes. And yet one of the TASS Windows: "It happened on the Dnieper. / The same was on the Dniester," where the sorry-looking, wet Fascists crawl out of the water, ended thus: "It's impossible to cry or sigh – / There's no time even to dry." This ending proved popular and was frequently recited by the TASS Window workers.

The thing is: we never told anyone that this ending was thought up by [Mikhail] Cheremnykh, not by me.[1]

It is very likely no coincidence that Mikhail Cheremnykh was assigned to design this poster. The founder of the ROSTA poster studio and cofounder of the TASS studio, he must have been delighted to rework the topic he had taken up in TASS's very first poster, *The Fascist Took the Route through Prut* (p. 165). From the very beginning of the war, he expressed the firm belief that the German invaders were fleeing and would continue to do so. Now, nearly thirty-five hellish months later, he delivered another witty vision of Axis forces retreating ignominiously, with the Red Army in hot pursuit.

This poster exhibits the graphic and chromatic restraint that signals Cheremnykh's roots in the ROSTA tradition, the influence of which had largely disappeared from current TASS production. The differences between TASS 1 and 952 indicate the studio's much-expanded practice by 1944. TASS 952 features a multifigural and deeply receding background, an update on the shallow space of ROSTA and very early TASS works. Both TASS 1 and 952 contain Cheremnykh's trademark explosions.

Image: Petr Shukhmin
Edition: unknown (probably 600)

Stencil
163 × 84 cm
Ne boltai! Collection

The enemy is suffering loss after loss. However, he is not yet defeated. Hitler's bandits, seeing their approaching death and the inevitability of revenge for the monstrous deeds they have committed on our land, are resisting with the fury of doomed men. They are throwing their last forces and their last reserves into battle, clutching onto every last meter of Soviet land and every single advantageous position. (From the order of the Supreme Head Commander, comrade J. V. Stalin, February 23, 1944)

Death to the German Occupiers!

Against a sky of flames and smoke, a gigantic, rapacious figure, the personification of the German armies, crawls forward on a battlefield alongside advancing Lilliputian tanks. A large Red Army rifle butt smashes his bloodied, outstretched right hand. The blood-covered fingers of his left hand clutch a machine gun. A salvo from a large Soviet tank hits him in the face, which bleeds as well.

The phrase "Death to the German Occupiers" and variations on it appeared often in all manner of Soviet discourse, serving as a kind of greeting and mantra. Stalin frequently ended his public appearances in this manner. Nearly two months after he delivered the address commemorating the twenty-sixth anniversary of the founding of the Red Army, the phrases he used continued to resonate for the TASS studio's editorial board.

The composition of TASS 953 combines discrepant perspectives and scales to dramatic effect. The vertiginous bird's-eye view and high horizon line monumentalize the powerful Red Army tank in the right foreground and the implicit presence of the Soviet soldier whose rifle butt is visible at the left. TASS 953 acknowledges the tenacity of the Axis forces in the face of Soviet might.

Image: Kukryniksy
Edition: 600
Stencil

158.5 × 85 cm
The Art Institute of Chicago, gift of The
U.S.S.R. Society for Cultural Relations
with Foreign Countries, 2010.101

Deadly Concern

*Hitler: "The situation on the Eastern
Front requires me to surround your
countries with my attention."*

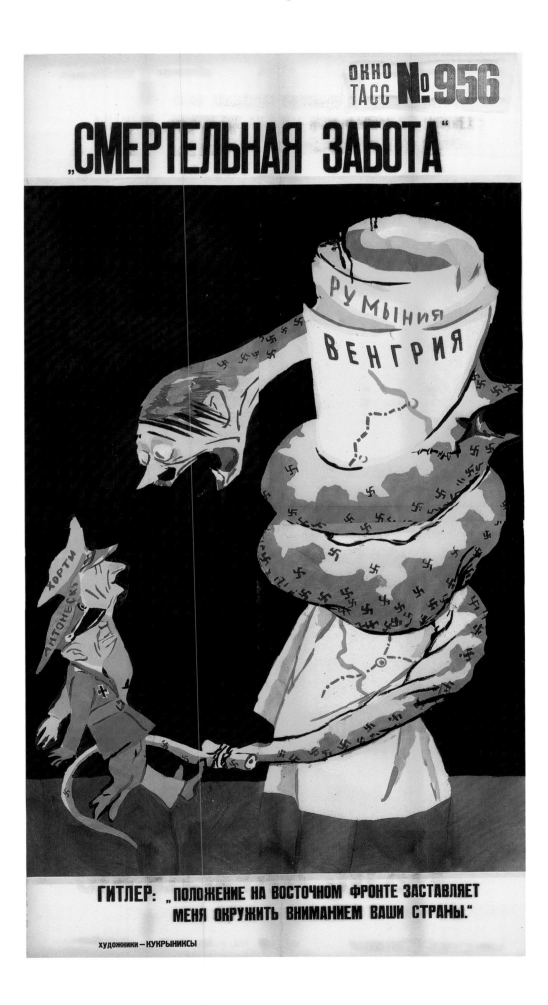

Vipers, hydras, and dragons abound
in Russia's rich *lubok* tradition, which
influenced a number of TASS post-
ers, including this image of Hitler in
the guise of a viper. The Führer's skin,
which has ruptured, exhibits mark-
ings shaped like swastikas. He coils
his body tightly around two rolled-up
maps, one of Romania and the other
of Hungary. Caught in his broken tail –
mended but clearly weakened – are
Hitler's Axis associates Antonescu of
Romania and, behind him, Horthy of
Hungary, both of whom Hitler is poised
to swallow. His broken skin and tail
allude to the deteriorating relation-
ship between the Führer and his
increasingly reluctant partners.

Having learned about Hungary's
overtures to the Allies for a peace
treaty, Hitler ordered his troops to
occupy the nation on March 19, 1944.
In the wake of this bloodless take-
over, called Operation Margarethe
I, Horthy remained head of state,
but a pro-German government was
installed with Döme Sztojay as prime
minister. A second offensive, called
Operation Margarethe II, was planned
for Romania. Hitler not only feared
that this ally would try to desert the
Axis cause but also knew that a Soviet
invasion of Romania was probably
imminent. In addition to weaken-
ing Germany's position, the Soviet
occupation of Romania would deprive
it of access to the Romanian oilfields,
which were critical to its continuation
of the war. Operation Margarethe II
would not happen. Antonescu would
fall the following August, prompting
Romania to switch sides.

Image: Pavel Sokolov-Skalia
Text: Irina Petrova
Edition: 600

Stencil
141 × 121 cm
The Art Institute of Chicago, gift of The
U.S.S.R. Society for Cultural Relations
with Foreign Countries, 2010.177

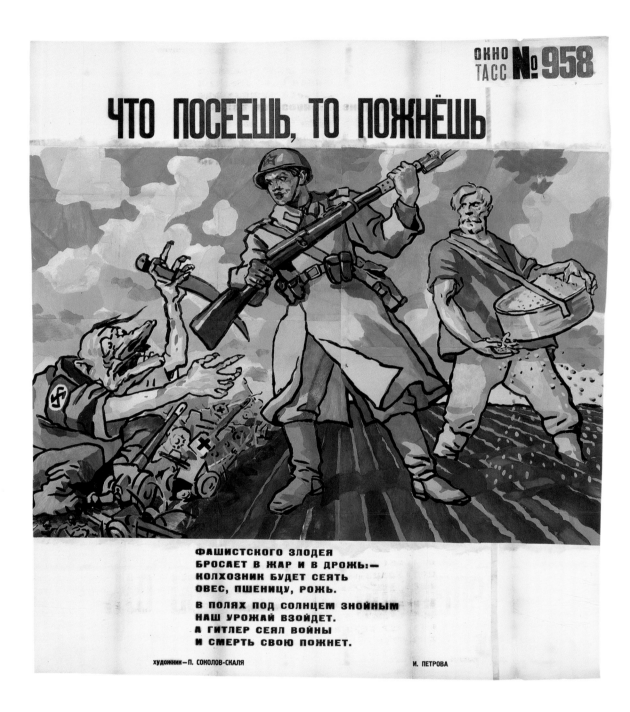

You Reap What You Sow

The Fascist villain
Is feverish and trembling: —
The collective farmer sows
Oats and wheat and rye.

In the fields, under the hot sun
Our harvest will rise up.
But Hitler sowed war,
And he will reap his death.

This image conveys the growing optimism of the Soviets in the spring of 1944. A Red Army soldier strides over a freshly ploughed field and, with the butt of his Mosin-Nagant rifle, holds both a dagger-wielding Hitler and his miniaturized war machines at bay. Behind the soldier, and echoing his stance, is a farmer sowing his crop.

Like Sokolov-Skalia's image, in which heroic realism confronts caricature, Petrova's poem is split between damning satire (lines 1–2, 7–8) and life-affirming realism (lines 3–6). The two mini-narratives – Hitler, who sowed death, will reap death, while the Soviet peasant plants his fields and will harvest grain – are in total opposition, and there is no doubt as to which scenario will result in victory.

Here, as is often the case in Sokolov-Skalia's mature TASS posters, the extraordinary richness of color – in the palpably dense blue of the sky, for example – more than the composition, makes the image memorable. Contemporary color printing, whether lithography or offset lithography, could not achieve such eye-popping chromatic effects. Sokolov-Skalia's recognition of this clearly prompted him to use a striking palette in his designs. Their successful realization relied on the inherent potential of stenciled color and the expertise of the entire TASS team.

TASS 958 was most likely informed by Viktor Deni's poster *The Red Army Broom Will Completely Sweep away the Scum*, issued on October 12, 1943 (fig. 6.39).

Image: Moa
Text: Aleksandr Zharov
Edition: 600

Stencil
203.5 × 89 cm
Ne boltai! Collection

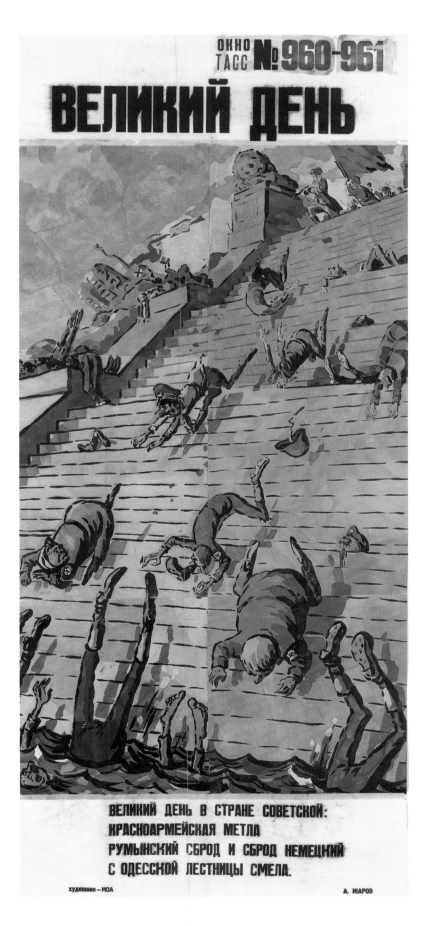

A Great Day

It is a great day in the Soviet land.
The broom of the Red Army
Has brushed Romanian and German
 rabble
Off the Odessa steps.

The flag-waving Red Army drives assorted Axis military personnel into the Black Sea via the Potemkin Steps in Odessa, Ukraine. The staircase, which is considered the symbolic entrance to the city from the sea, is a dramatic 27 meters high and 142 meters long. It was made famous by Sergei Eisenstein in his 1925 silent movie *The Battleship Potemkin*, which relates the 1905 mutiny of the crew against the ship's imperial officers. In this celebrated film's most unforgettable scene, a crowd turns out to welcome the ship and its heroic crew. Czarist troops shoot into the throng, and innocent victims fall down the steps to their deaths. They include a baby in a carriage that its mother could not hold on to after she was shot (see fig. 1).

While this event never actually occurred, Eisenstein made it horrifyingly and indelibly believable. Moa took advantage of one of the most famous passages in Russian cinema to transform a terrifying scenario into an image of victory, with the Soviets chasing a retreating enemy force. Odessa had been occupied by German and Romanian troops since October 17, 1941. TASS 960–961 commemorates the recapture of the city by the Red Army on April 10, 1944, during the Odessa Offensive (March 24–April 14, 1944). The artist used dynamic purple shadows to create a flickering, cinematic effect of motion; they accentuate the volume and sense of suspended animation as the caricatured figures tumble through space.[1]

Fig. 1 Sergei Eisenstein (born Riga, Latvia, 1898; died Moscow, 1948). Still from *The Battleship Potemkin*, 1925.

Image: Mikhail Solov'ev
Editon: 600

Stencil
119.5 × 123 cm
Ne boltai! Collection

Tractor drivers, combiner drivers and mechanics of machine and mechanized tractor stations and state farms! Through shock work let us achieve complete and unerring use of machinery and tractors in agricultural work! Let us guarantee a high quality of field management! (From the Appeals of the Central Committee of the All-Union Communist Party, [for] May 1, 1944)

In the distance, between the two plough blades shown in a dramatic close-up, farmworkers converse. The topic of this poster – reconstituting reconquered land for agriculture – was a central concern for the Communist Party leadership.

Compositionally, this image of the restoration of agriculture is among the most powerful in the TASS repertory. In its bold and unexpected viewpoint, the poster makes conscious reference to the unconventional and vertiginous perspectives employed by the Soviet avant-garde in earlier decades. With 138 TASS posters to his name, Solov'ev was one of the studio's most prolific artists, and the present poster is arguably one of his best.

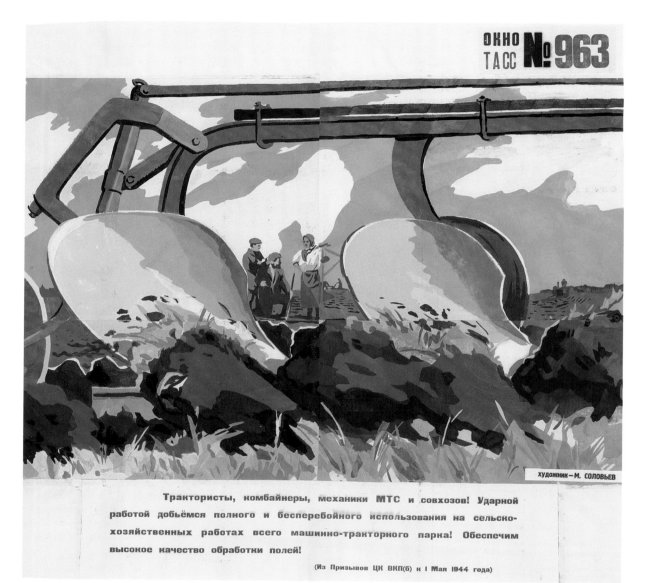

ОКНО ТАСС № 963

художник—М. СОЛОВЬЕВ

Трактористы, комбайнеры, механики МТС и совхозов! Ударной работой добьёмся полного и бесперебойного использования на сельско-хозяйственных работах всего машинно-тракторного парка! Обеспечим высокое качество обработки полей!

(Из Призывов ЦК ВКП(б) к 1 Мая 1944 года)

Image: Mikhail Cheremnykh
Edition: 600
Stencil
140 × 82 cm

The Art Institute of Chicago, gift of The
U.S.S.R. Society for Cultural Relations
with Foreign Countries, 2010.67

Crimea – The All-Union Health Resort

*What is healthy for the Russian is death
for the German!*

The left half of the composition shows
what the Crimean was like before
and what it will be again after the end
of the Axis occupation – a holiday
destination with beach resorts and
health spas. The right half shows the
hands of a Red Army soldier forcing
Hitler with the butt of his submachine
gun into the Black Sea. His drown-
ing follows that of his Axis partner
Antonescu (identified by name in the
ring of water surrounding his bloodied
hand), who symbolizes the Romanian
occupying forces. Washed up on shore
behind them are slain Axis soldiers
and wrecked armaments.

"What is healthy for the Russian
is death for the German" is an old
Russian saying. Since "German"
(*Nemets*) was traditionally under-
stood to indicate all foreigners who
could not speak Russian, the say-
ing was taken to acknowledge the
existence of different standards
and tastes in various cultures. It
is a Russian equivalent of "There's
no arguing with taste." True to his
Maiakovskian heritage, Cheremnykh
revealed a hidden dimension in the
saying that proved especially relevant
in the last year of the war, as Soviet
forces were reclaiming territory and
condemning the Nazis to death.

The Red Army's Crimean Offensive
(April 8–May 12, 1944) resulted in the
complete recapture of the Crimean
peninsula from occupying German
and Romanian forces. This included
the devastated port city of Sevastopol,
which was retaken by the Red Army
on May 9, 1944, just three days before
this poster was issued.

Image: Mikhail Cheremnykh
Edition: 600
Stencil
134.5 × 75 cm

The Art Institute of Chicago, gift of The
U.S.S.R. Society for Cultural Relations
with Foreign Countries, 2010.68

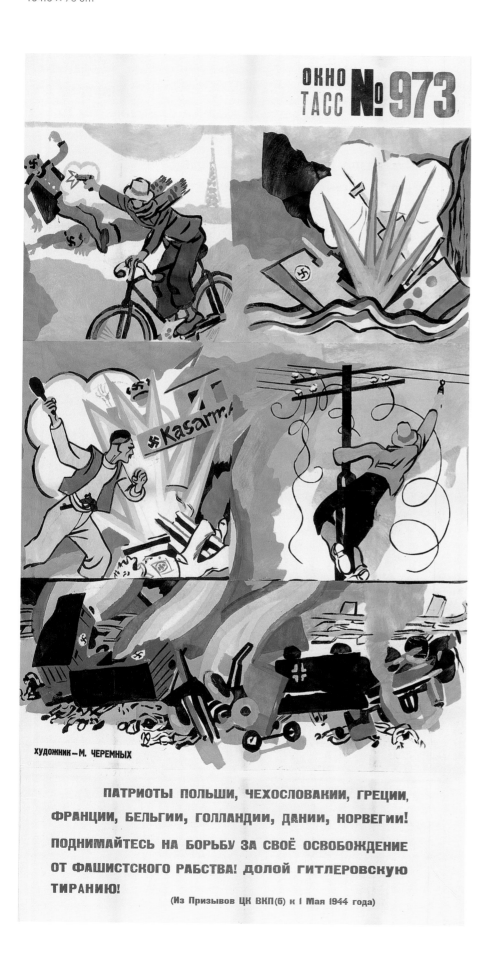

*Patriots of Poland, Czechoslovakia,
Greece, France, Belgium, Holland,
Denmark, and Norway! Rise up to
struggle for your freedom from Fascist
slavery! Down with Hitlerite tyranny!
(From the Appeals of the Central
Committee of the All-Union Communist
Party, [for] May 1, 1944)*

This poster, with its separate narra-
tives dealing with non-Soviet partisan
activity and its bold, simplified design,
again recalls Cheremnykh's work in
the 1920s for ROSTA.

Each of the five scenes that com-
prise this poster depicts acts of
resistance and sabotage throughout
Nazi-occupied Europe. The image at
the top left shows a bicyclist who has
apparently shot two Nazis; one lies
on the ground and the other, wearing
the cape of a Parisian policeman, falls
over him. The Eiffel Tower rises in the
background, identifying the action
as the work of the French Resistance.
The adjacent scene depicts a Nazi
ship being split in two by an explo-
sion. In the middle-left image, a Greek
throws a grenade into an already
blown-up Nazi compound. A corpse
lies at his feet. Opposite, a figure cuts
communication wires. The bottom
scene illustrates the derailment of
Nazi supply lines. In response to such
insurgent activity, Hitler established
"anti-bandit" (Bandenbekampfung)
units that were active throughout
Nazi-occupied Europe, including the
Balkans (see fig. 1).

Fig. 1 Artist unknown (Soviet). "Untitled,"
Krokodil 11–12 (April 12, 1944). The text at
the top reads matter-of-factly: "Hitler has
established a special badge of distinction
in three grades for battle with partisans."
But the text below provides the Soviet
view of the award: "Badge of distinction
of the fourth grade given to the Fritzes by
the partisans. As a rule, it is worn in the
forehead, in the chest, and in the back."

Image: Mikhail Solov'ev
Text: Osip Brik
Edition: 600

Stencil
142.3 × 123.5 cm
Ne boltai! Collection

On the Enemy's Trail

Onward, heroes,
On the enemy's trail!
Our banner of victory
Is leading us west.

ОКНО ТАСС №976

ПО ВРАЖЬЕМУ СЛЕДУ

С.С.С.Р.

ПО ВРАЖЬЕМУ СЛЕДУ,
ГЕРОИ, ВПЕРЁД!
НАС ЗНАМЯ ПОБЕДЫ
НА ЗАПАД ВЕДЁТ.

художник—М. СОЛОВЬЕВ О. БРИК

A group of stalwart Red Army soldiers moves confidently forward. The one at the left carries a fringed standard bearing the partially visible name of a guards division. The central figure holds a submachine gun in his right hand and signals his men with his left hand to follow him. Both he and the soldier at the right are heavily decorated. The signpost indicates the Soviet border. This poster by the classic Socialist Realist painter Solov'ev demonstrates his ability to adapt his style to the medium of stencil, simplifying his modeling in rendering the idealized figure types that populate the composition.

Although not acknowledged in the text or image, Solov'ev's heroic depiction of advancing Red Army soldiers may have been informed by phrases from Stalin's May Day address (Order 70, May 1, 1944). Stalin extolled "the outstanding successes of the Red Army." The "practically incessant offensive" it had been waging was "exterminating the enemy vermin and sweeping it out of the Soviet land." He continued, "Acting in the great cause of the liberation of their native land from the Fascist invaders, the Red Army has emerged on our nation's frontiers with Romania and Czechoslovakia."

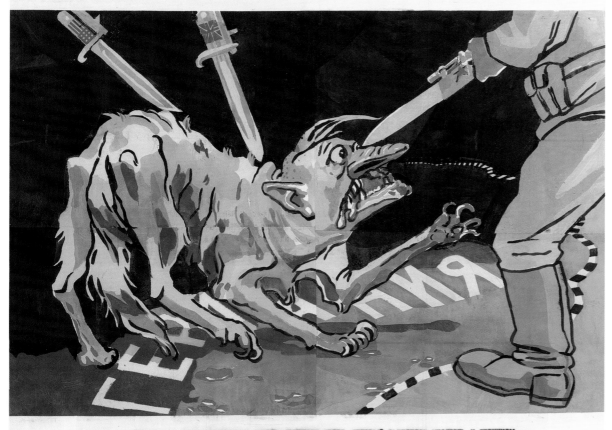

ОКНО ТАСС №981

Немецкие войска напоминают теперь раненого зверя, который вынужден уползать к границам своей берлоги — Германии для того, чтобы залечить раны. Но раненый зверь, ушедший в свою берлогу, не перестает быть опасным зверем. Чтобы избавить нашу страну и союзные с нами страны от опасности порабощения, нужно преследовать раненого немецкого зверя по пятам и добить его в его собственной берлоге.

(Из Приказа Верховного Главнокомандующего
тов. И. В. Сталина 1 Мая 1944 года).

художник — П. СОКОЛОВ-СКАЛЯ

Image: Pavel Sokolov-Skalia
Edition: unknown (probably 600)
Stencil
123.5 × 128 cm
Ne boltai! Collection

The German troops now resemble a wounded beast that is compelled to crawl back to the frontiers of its lair – Germany – in order to heal its wounds. But a wounded beast that has retired to its lair does not cease to be a dangerous beast. To rid our country and our allies' countries from the danger of enslavement, we must stay on the heels of the wounded German beast and finish it off in its own lair. (From the order of the Supreme Commander in Chief, comrade J. V. Stalin, May 1, 1944)

Trapped by three daggers affixed to rifles bearing the Allies' national symbols, a scruffy, blood-covered wolf with Hitler's terrified face crouches on a map of Germany.

Here Sokolov-Skalia provided an inventive visual equivalent to a metaphor from Stalin's latest order. It was not a new metaphor, having already inspired TASS 976 (p. 285). Indeed, Stalin's comparison of Berlin to a lair became one of the most popular concepts used in the political indoctrinations of Red Army soldiers.[1] Various paragraphs of Stalin's speech also influenced a number of other posters, including TASS 982 (p. 287), which indicates the TASS studio's ongoing engagement with Stalin's public statements and orders.[2] The speech also served as a source for posters, magazine covers, and newspaper cartoons in the Soviet Union as well as abroad (see fig. 1).

KILL THE BEAST IN HIS LAIR—STALIN

Fig. 1 Fred Ellis (American, 1885–1965). "Kill the Beast in His Lair – Stalin," *Daily Worker*, May 2, 1944. Wielding his sword, a Nazi colossus meets assailants on all sides, one of which is a gun barrel labeled "2nd Front." Clearly, the *Daily Worker* took Stalin's May 1, 1944, Order of the Day to heart.

ОКНО ТАСС № 982

МАННЕРГЕИМ

АНТОНЕСКУ

ХОРТИ

Под ударами Красной Армии трещит и разваливается
блок фашистских государств. Страх и смятение царят ныне
среди румынских, венгерских, финских и болгарских „союзников"
Гитлера.

(Из Приказа Верховного Главнокомандующего
тов. И. В. Сталина 1 мая 1944 года).

художники — КУКРЫНИКСЫ

Image: Kukryniksy
Edition: unknown (probably 600)
Stencil
119 × 118.5 cm
The Art Institute of Chicago, gift of The
U.S.S.R. Society for Cultural Relations
with Foreign Countries, 2010.102

*Under the blows of the Red Army, the
bloc of Fascist states is cracking and
falling to pieces. Fear and confusion
reign among Hitler's Romanian,
Hungarian, Finnish and Bulgarian
"allies." (From the order of the Supreme
Commander in Chief, comrade J. V. Stalin,
May 1, 1944)*

The symbolic hand of a Red Army
soldier uses a sword to cleave a
brick edifice shaped like a swastika.
Chained to the ruined structure are
(counterclockwise) the Axis leaders
Mannerheim (Finland), Antonescu
(Romania), and Horthy (Hungary).
Also visible are the legs of another
man – perhaps the Bulgarian prime
minister, Dobri Bozhilov – who has
fallen headfirst from his perch. For
the Kukryniksy, the shackled Axis
"partners" have become Hitler's pris-
oners, awaiting their fate on Soviet
terms. This could be said of Hitler as
well. While he is not in chains and
holds a gun, he clings to one of the
swastika's arms and looks with terror
at the mighty hand and sword above
him. The intense red of the hand
and sword suggests that the latter
has come directly, red-hot, from the

anvil and is able to strike through the
Nazi structure without meeting any
resistance.

Here the TASS editors used another
quote from Stalin's 1944 May Day
address. The Soviet leader remarked,
"These underlings of Hitler, whose
countries have been occupied, or are
being occupied, by the Germans, can-
not now fail to see that Germany has
lost the war." He predicted:

*Romania, Hungary, Finland and
Bulgaria have only one chance to
escape disaster: to break with the
Germans and to withdraw from the
war. However, it is difficult to expect
that the present governments of these
countries will prove capable of break-
ing with the Germans.... The peoples
of these countries will have to take
the cause of their liberation from the
German yoke into their own hands.
And the sooner [they] realize to what
impasse the Hitlerites have brought*

*them, the sooner will they withdraw all
support from their German enslavers
and underling quislings in their own
countries, the less will be the sacri-
fice and destruction caused to these
countries by the war, and the more can
they count on understanding from the
democratic countries.*

In fact, acting on the increasing
certainty that Germany was losing the
war, Horthy had made overtures to the
Allies for an armistice. In response,
Hitler invaded and occupied Hungary
on March 20, 1944. In the following
months, other Axis partners (such as
Romania and Bulgaria) would join the
Allies, resulting in the breakup of the
Axis alliance.

Image: Mikhail Cheremnykh
Text: Dem'ian Bednyi
Edition: 600
Stencil
131 × 104 cm

The Art Institute of Chicago, gift of The
U.S.S.R. Society for Cultural Relations
with Foreign Countries, 2010.69

The Hour Approaches

From a ruthless, awesome punishment
He will not escape, the German octopus.
Blows threaten the monster:
Now here, now there.

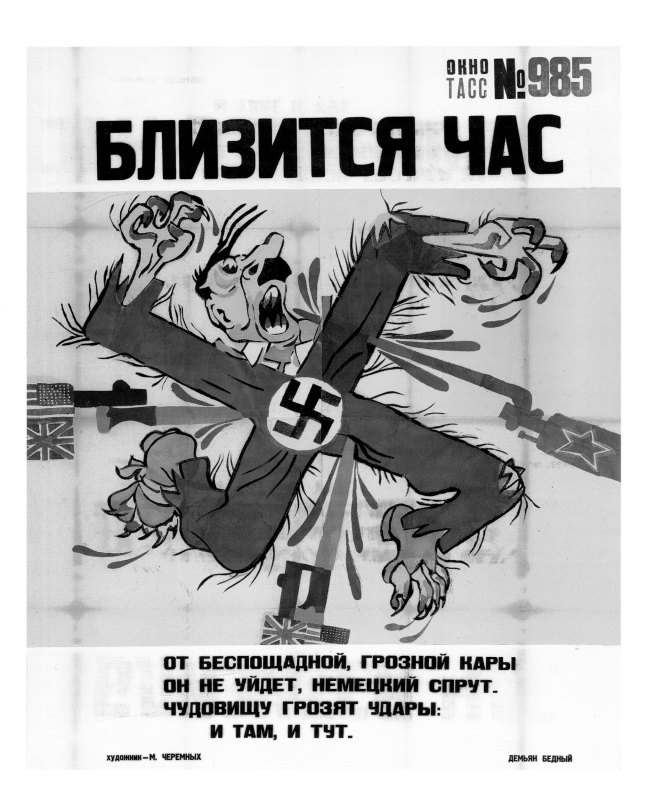

Here Cheremnykh created an image of
Hitler by grafting human and animal
features onto the shape of a swas-
tika. Unable, even with clawed hands
and feet, to find traction, the hirsute
Führer spins like a pinwheel. His
motion is checked by Allied bayonets:
the American and British weapons
puncture his body and that of the
Soviets penetrates clear through. The
quatrain, quite brief for the normally
wordy Bednyi, ends with a short final
line, whose four syllables seem to
beat out the last blows against the
enemy. As is the case with TASS 939
(p. 275), Bednyi's text does not entirely
correspond to the image: he pic-
tured Hitler as an octopus, whereas
Cheremnykh imagined him as an
animal-like dervish. Bednyi may have
been thinking of a poem he wrote that
appeared on a 1937 anti-Nazi poster
(fig. 1.17), in which he compared the
swastika to an octopus.

Issued twelve days before the
launching of Operation Overlord – the
Allied invasion of German-occupied
western Europe on the beaches of
Normandy – Cheremnykh's image
demonstrates the growing realiza-
tion that Hitler would be defeated.
Each bayonet reflects the positions
of the Allied forces: the Western
Front in France, the Southern Front in
Italy, and the Eastern Front. The Red
Army would soon launch Operation
Bagration (June 22–August 19) in
support of the Anglo-American forces
in western Europe. Now faced with a
new battle line, Hitler indeed would
be forced to withdraw troops on the
Eastern Front, which would allow the
Soviets to reconquer their territory
and gain footholds in Romania and
Poland. Underlying these actions was
the issue of which portions of the
European continent each ally would
claim and who would win the race
to Berlin.

Image: Petr Sarkisian
Text: Aleksei Mashistov
Edition: 600
Stencil
168 × 82 cm

The Art Institute of Chicago, gift of The
U.S.S.R. Society for Cultural Relations
with Foreign Countries, 2010.148

ОКНО ТАСС №986

ОСВОБОДИМ БРАТЬЕВ!

ОРДЫ ВРАЖЬИ СМЕТАЯ,
ПАЛАЧЕЙ ИСТРЕБЛЯЯ,
МЫ С ПОБЕДОЙ ПРОЙДЕМ ВСЕ ПУТИ,
ЧТОБ ОТ РАБСКОЙ ЗЛОЙ ДОЛИ,
ИЗ ФАШИСТСКОЙ НЕВОЛИ
НАШИХ БРАТЬЕВ РОДИМЫХ СПАСТИ!

ХУДОЖНИК—П. САРКИСЯН А. МАШИСТОВ

Liberate Our Brothers!

Sweeping away the enemy hordes,
Destroying the butchers,
We shall victoriously walk all paths,
In order to free our blood brothers
From the evil fate of slavery
And Fascist captivity.

A determined Red Army soldier, his rifle affixed with a bayonet, throws open a wooden gate to a barbed-wire enclosure. To the left is the Nazi guard he has just struck: blood streaming from his nose and mouth, he holds a two-strand whip in his right hand but falls on top of the MP40 submachine gun slung over his left shoulder.[1] In the background, a soldier shakes the hand of a man accompanied by a woman and child, their faces rendered in ashen tones.

Unrelated to a specific historical event, this representation of the freeing of Soviet slave laborers as the Red Army moved west was intended to spur the soldiers on. Mashistov here attempted a complex metrical scheme based on two lines of anapestic bimeter (two unstressed syllables followed by a stressed one) followed by one line of anapestic trimeter. The effect is something akin to a song or an anthem.

This image belies a dark truth: in addition to Russian prisoners who had defected to the Germans, collaborators, anti-Communist Soviet citizens, and soldiers recruited by Nazi occupiers, Stalin condemned as traitors to the motherland soldiers, partisans, and civilian refugees who had managed to survive the atrocious conditions of German camps. The penalty for such "treason" was to be killed directly by a firing squad or suffer a slower, but inevitable, death in the labor camps (gulags) in Siberia and other Arctic regions of the Soviet Union.

As early as October 1944, the Soviets and Great Britain would begin to negotiate the fate of the prisoners of war; they would become pawns in the postwar chess game between Russia and the West. At the Yalta Conference in February 1945, political expediency would push Britain and the United States into agreeing to repatriate to the Soviet Union all Russian prisoners whom their forces liberated. This would result in the release of thousands to Stalin's "care."

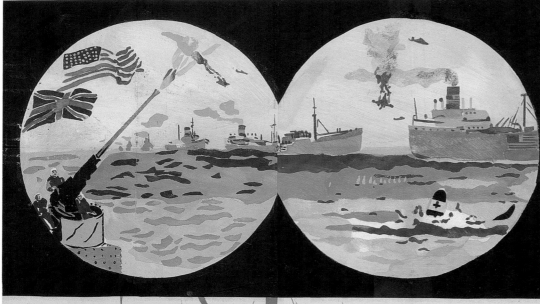

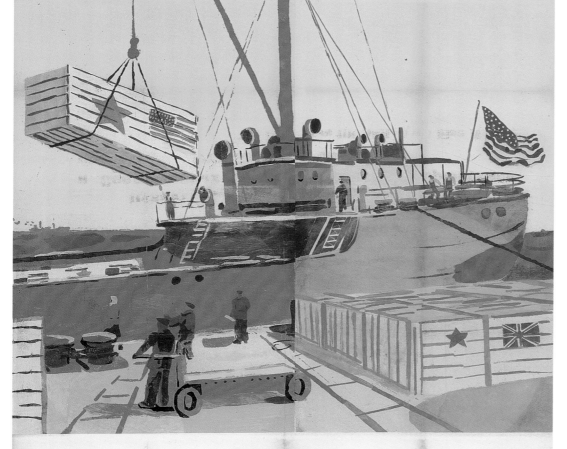

Image: Konstantin Vialov
Edition: 600
Stencil
158 × 85 cm
The Art Institute of Chicago, gift of The
U.S.S.R. Society for Cultural Relations
with Foreign Countries, 2010.221

*Greetings to the brave sailors of Great
Britain and the United States of America,
fighting the Fascist pirates! (From the
Appeals of the Central Committee of
the All-Union Communist Party, [for]
May 1, 1944)*

Observed through binoculars, a
convoy of American and British ships
is attacked by German planes, which
in turn are brought down by Allied
antiaircraft guns mounted on escort
vessels. The scene below depicts
the unloading of the cargo from an
American vessel at a Russian port.
The crates are marked with the flags
of Great Britain and the United States,
as well as with the Red Star of the
Soviet Union.

TASS 992 is a rare acknowledgment on
the part of studio artists of the Lend-
Lease program in which the United
States provided Great Britain and the
Soviet Union with millions of dollars
in war equipment and supplies. While
Soviet artists did not often depict the
Lend-Lease operation per se, they
acknowledged their nation's alliance
with Great Britain and the United
States in a multitude of graphic imag-
es. Between August 1941 and May
1945, seventy-eight convoys of Allied
merchant ships, sailing under flags of
various nationalities and manned by
merchant marines of equally diverse
backgrounds, made perilous journeys
from North America, Great Britain,
and Iceland to and from Russian ports.
In order to avoid being decimated
along the way by German U-boats and
submarines and by aircraft based in
German-occupied Norway, the con-
voys were accompanied by a variety

of American, Canadian, and British escort ships, including destroyers, corvettes, armed trawlers, and anti-aircraft auxiliary vessels. The threat of the German navy and its submarine fleet, combined with the extreme Arctic weather conditions, made the journey to and from northern Russia among the most hazardous assignments of the war, one in which many lost their lives.[1]

The absence of the Soviet flag in TASS 992 suggests that the destination of the convoy pictured here was the port of Murmansk on the Barents Sea or Archangel (Arkhangelsk) on the White Sea, in northern Russia. Convoys plying the Pacific Ocean from the West Coast of the United States to Vladivostok would do so under a Soviet flag, since the Soviet Union was not at war with Japan. In addition to the aforementioned destinations was the Persian Corridor, including the Iranian port of Banda Shapur on the Persian Gulf.

For the Allies, the subject of the convoys was a potent one. Regardless of a poster's purpose – whether to recruit, convey cautionary messages, or encourage the purchase of war bonds – British and American graphic designers were inspired by every aspect of the harrowing journeys through German submarine-infested waters (see figs. 1–4). Arranged in a narrative sequence, these numerous posters read like a suspenseful graphic novel. They represent various aesthetic approaches to graphic design among American and British artists involved in posters supporting the war effort.

Fig. 1 Stevan Dohanos (American, 1907–1994). *Bits of Careless Talk*, 1943. Offset lithograph; 102 × 72.5 cm. The Art institute of Chicago. In exhibition.

Fig. 2 McClelland Barclay (American, 1891–1942). *"Sub Spotted – Let 'Em Have It!,"* 1942. Offset lithograph; 102 × 71 cm. In exhibition.

Fig. 3 Anton Otto Fischer (American, 1882–1962). *A Careless Word . . . A Needless Sinking*, 1942. Offset lithograph; 95 × 72 cm. The Art Institute of Chicago. In exhibition.

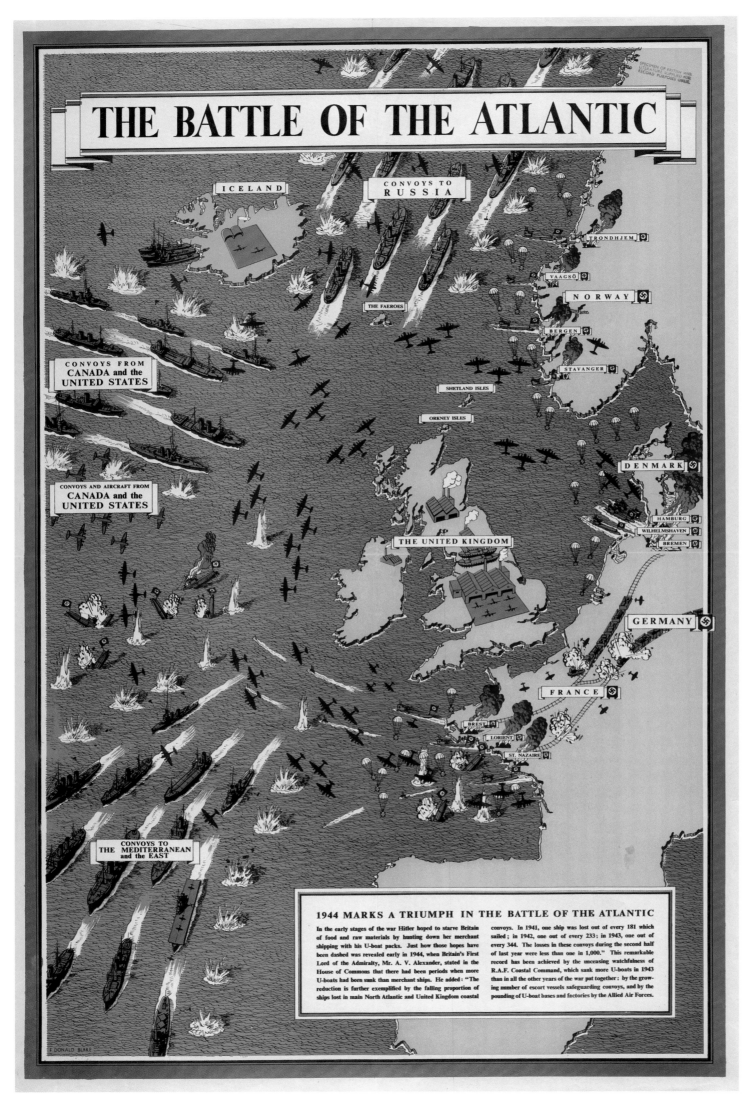

Fig. 4 Donald F. Blake (English, 1908–1997). *The Battle of the Atlantic*, 1944.
Offset lithograph; 76 × 51 cm. University of Minnesota Libraries. In exhibition.

Image: Kukryniksy
Edition: 1,200
Stencil
118.5 × 123 cm

The Art Institute of Chicago, gift of The U.S.S.R. Society for Cultural Relations with Foreign Countries, 2010.103

Three Years of War

A pistol-toting Hitler is caught in Soviet pincers. The gold-colored cuff band has partly detached from his right sleeve and assumes the form of a lightning rod, an allusion to the literal unraveling of the *blitzkrieg*.

Pincers were one of the favorite devices of graphic satirists, including members of the TASS studio. Here the Kukryniksy turned the tool into a figure three, commemorating the end of the third year of the Great Patriotic War.

Image: Pavel Sokolov-Skalia, Nikolai
Denisovskii
Text: Vasilii Lebedev-Kumach
Edition: 600

Stencil
160 × 123 cm
The Art Institute of Chicago, gift of The
U.S.S.R. Society for Cultural Relations
with Foreign Countries, 2010.82

Image: Sergei Kostin
Text: Samuil Marshak
Edition: 1,200

Stencil
202 × 83.5 cm
The Art Institute of Chicago, gift of The
U.S.S.R. Society for Cultural Relations
with Foreign Countries, 2010.86

The Former Ersatz Landowners

Along the Berlin streets
There wanders every day
A Ukrainian landowner
With outstretched hand.

Of his former grandeur
Nothing now remains
But a feather in his hat —
And nothing more at all.

Next to him, despondent,
There wanders his wife.
"Mein Gott! What's happened to us?"
She says with melancholy.

Hitler gave us as a gift
An estate near Poltava,
In the shade of an old oak grove
And with lions at the entrance!

My husband and I, we drove around
In a carriage like noble counts,
And in our possession
We had two hundred peasant souls!

We were very pleased
To have serfs of our own.
But all of them joined the ranks
Of the Soviet partisans.

Everything ended terribly!
One silent night
We had to run away
From the army of the Reds!

We ran through all the puddles
Now trotting, now at a gallop.
And my husband and I,
We lost our last wardrobe.

All that remains from our estate
Is this here bicycle …
Have pity on us!
Give us money for a meal.

On a street corner of a bombed-out city stands a tall, burly man holding a cane and wearing a feather-capped hat. He carries a sign that states, "Help Me, a Former Ukrainian Landowner." His handlebar mous-tache recalls that of Kaiser Wilhelm II, who died in 1942 in Nazi-occupied Netherlands and who was often caricatured by graphic satirists in World War I (see Introduction, fig. 7; and TASS 1126 [p. 329]). Next to the man is his dejected and shamed wife, who clutches an umbrella and a handbag. On the wall behind them leans a bicycle with a "Poltava 901" license plate.

Rather than collaborating on the poster from the outset, Marshak appears to have written the poem and then had it illustrated by Kostin. The image illustrates the poem's every detail, from the feather in the man's hat to the bicycle. Marshak's plain-tive, satirical account of the miseries experienced by so-called German colonists is fanciful. The town of Poltava referred to in the poem is located east of the Dnieper River, in eastern Ukraine. While they occupied all of Ukraine, only in western Ukraine did the Nazis successfully establish their own civil government, begin-ning in September 1941. In that fertile region, Hitler's Garden of Eden, the Nazis aimed to establish agricultural colonies of Germans, in accordance with their race theory. This population would include *Volksdeutsche*: ethnic Germans born outside Germany now residing in the Soviet Union and other Aryan types from occupied countries, such as the Dutch. Gladdened by having wrested the Ukrainian bread-basket from the Soviets, Hitler estab-lished his furthermost Eastern Front strategic headquarters, Werewolf, near Vinnitsa. During 1942–43 the ethnic cleansing of Jews, as well as the enslavement and deportation of other undesirable local residents to Germany or labor camps in the occupied territories, allowed the rul-ing authorities to provide colonists with the victims' homesteads and formerly state-held land. Hegenwald, near Zhitomir, which also housed Himmler's headquarters, was one such colony. While Marshak invented the landowners' privileges, the threat posed by the Soviets was real. The experimental German colonies were only a year old when, by November 1943, they had to be abandoned because of partisan reprisals and the advance of the Red Army.

Although in its specifics Kostin's image follows Marhak's text closely, its formal qualities are relatively painterly, heightened by the pink paper on which it was stenciled. The artist's interest in pattern and the virtuoso laying-in of washes com-pete with the legibility so prized by the TASS studio leaders. This poster attests to the great skill of Kostin and stencil cutters in translating one medium into another without compromising the integrity of the original design.

Image: Pavel Sokolov-Skalia
Text: Dem'ian Bednyi
Edition: 1,500

Stencil
169.5 × 139.5 cm
Ne boltai! Collection

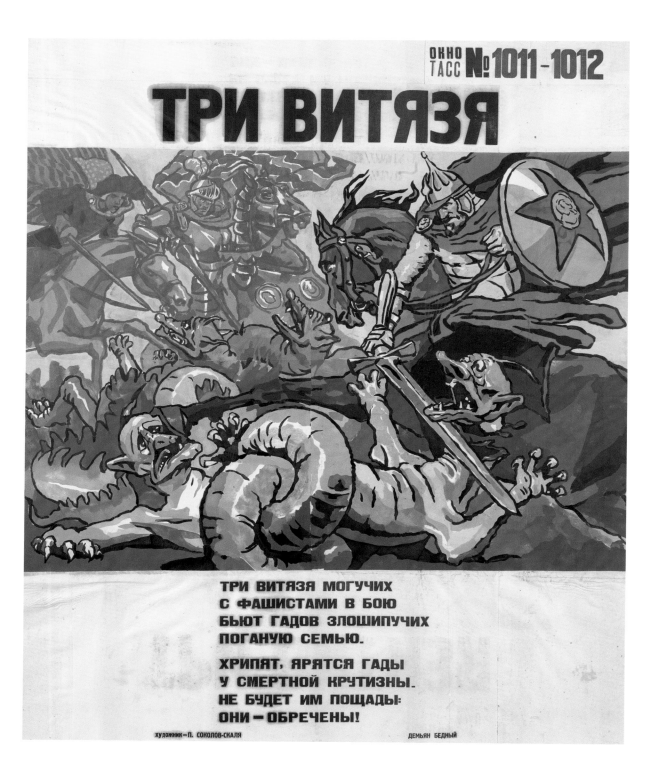

Three Knights

Three powerful knights
In battle with the Fascists
Are beating the accursed family
Of vilely hissing monsters.

The monsters wheeze with rage,
Tottering at the brink of death.
There will be no mercy for them:
For they are doomed!

Like Saint George, knights on horse-back – symbolizing the Allies – attack Nazi dragons. At the left an American Revolutionary soldier, wearing a cloak comprising the Stars and Stripes, charges with a rapier; in the middle, an armored figure whose wrap is made of the Union Jack, attacks with a lance; and at the right, a red-cloaked and armored medieval warrior – reminiscent of Aleksandr Nevskii (see TASS 460 [pp. 208–09]) – wields a sword and holds a shield decorated with a Red Star emblazed with a sickle and hammer. The humanoid faces of the monsters in the foreground recall Sokolov-Skalia's representations of Hitler.

While TASS 1011–1012 refers to the invasion of Normandy by British and American forces on June 6, 1944, Sokolov-Skalia's update on the theme of the apocalyptic battle between good and evil derives from such traditional sources as the Russian *lubok*, which had developed a rich vocabulary of war imagery. *Three Knights* is another example of evoking the mythic national past in order to inspire the current struggles of the Soviet people (see, for example, TASS 755/755A [p. 243]).

Image: Mikhail Solov'ev, Petr Sarkisian
Text: Vasilii Lebedev-Kumach
Edition: 1,000

Stencil
203 × 86 cm
The Art Institute of Chicago, gift of The
U.S.S.R. Society for Cultural Relations
with Foreign Countries, 2010.211

*The Allied Forces Have Crossed the
Channel*

*The "unconquerable" Napoleon
Failed to cross the channel.
But the obsessed Hitler bragged
That he would subdue the British Isles.*

*"I'm greater than Napoleon!
I will capture Albion!"*

*The corporal threatened for two years,
But everything turned out backward:
The Allied fleet has crossed by force
The foamy waters of the Channel.*

*It's the end of the corporal, kaput!
He's caught in pincers everywhere!
He's beaten everywhere, and everywhere
 is hell for him!
Cherbourg is liberated, Vitebsk taken!*

Of the TASS posters dealing with the
Allied invasion of western Europe, this
one includes the most literal depic-
tion. In the top panel, a physically
unprepossessing Hitler, with the mon-
umental ghost of Napoleon seated
behind him, steps toward the English
Channel and gazes toward Great
Britain. In the bottom scene, heroic
Allied forces, bearing the standards
of the United States and Britain and
rifles at the ready, take the beaches
and cliffs of Normandy, forcing Hitler
to stumble backward. Following a
now-familiar protocol, Solov'ev and

Sarkisian depicted the Allies in the
heroic realist manner accorded to
Red Army soldiers, while caricature
signals Hitler's absurdity.

Lebedev-Kumach was in good form
in this set of verses. In boasting of
his superiority to Napoleon, Hitler
uses the word *vyshe*, which means
"greater" but also "taller." Thus, Hitler's
strategic plan is revealed to rest on
a fundamental misunderstanding of
what constitutes military might. Even
more belittling is Lebedev-Kumach's
description of the Führer as a "corpo-
ral" (*efreitor*) – his rank in World War
I – as he was frequently referred to in
Soviet discourse. (Napoleon's troops
referred to him affectionately as
the "little corporal.") While Hitler was
decorated for heroism in World War
I, his rank was the lowest to which an
ordinary soldier could be promoted.

Vitebsk, in present-day Belarus, was
under German occupation from July
10, 1941, and was retaken by the Red
Army on June 26, 1944. Allied forces
freed the French coastal town of
Cherbourg on June 27.

Fig. 1 Kukryniksy. "An Inescapable Situation," *Pravda*,
June 17, 1944. Hitler and his Axis partners – Laval,
Mannerheim, Horthy, and Antonescu – are besieged from
the west by Great Britain and the United States and from
the east by the Soviets.

Image: Vladimir Lebedev
Text: Dem'ian Bednyi
Edition: 1,000

Stencil
171.5 × 84.5 cm
The Art Institute of Chicago, gift of The
U.S.S.R. Society for Cultural Relations
with Foreign Countries, 2010.122

A Belarusian Landscape

Are these birds? No, not birds –
They are exploded Fritzes.
Their detachment is in shreds –
The work of partisans!

From behind a screen of pine trees,
German army personnel, papers,
materiél, railway ties, and a train
wheel explode into the night sky.

The event alluded to in TASS 1017
is the Belarusian partisans' pre-
lude, on June 19, 1944, to Operation
Bagration (June 22–August 19, 1944)
(see TASS 1027 [pp. 305–06]). In this
offensive, partisan detachments were
instructed to wreak havoc with the
Nazi railway communication lines,
supply depots, and Axis-occupied
villages. With explosive charges sup-
plied by the Red Army Air Force, they

launched the largest synchronized
attack across the entire strategic
sector; it came to be known as the
partisans' "greatest single blow of
the war against the German lines of
communication."[1]

Lebedev's wonderful color sense,
coupled with his bold, brushy, and
dappled application of pigment,
resulted here in a riotous explosion of
color and form, a veritable visual fire-
works celebrating impending victory.

Fig. 1 Boris Efimov. *The Hot "Potato,"* before July 2, 1944.
Pen, india ink, and blue wash; 23.5 × 16.8 cm. Ne boltai!
Collection. Very similar in form and spirit to TASS 1017 is
this drawing for a cartoon, inspired by a Belarusian folk
song, that appeared in *Krasnaia zvezda* on July 2, 1944. It
lampoons the fate of the German forces during Operation
Bagration. A dance called *Bulba* (which means "potato" in
Ukrainian and Belarusian) was created in the 1930s by the
celebrated choreographer Igor Moisiev, whose company
pioneered a new form of concert folk dance and became
one of the world's most popular dance troupes.

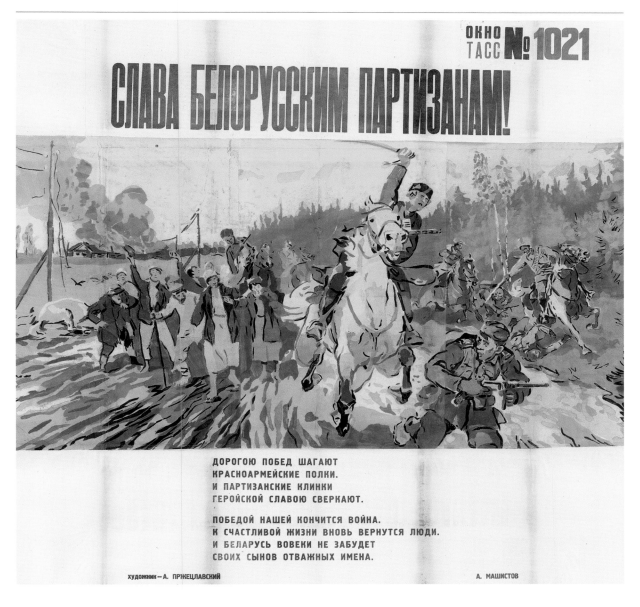

Image: Aleksandr Przhetslavskii
Text: Aleksei Mashistov
Edition: 620
Stencil
125.5 × 130 cm
The Art Institute of Chicago, gift of The
U.S.S.R. Society for Cultural Relations
with Foreign Countries, 2010.133

Glory to the Belarusian Partisans!

*Along the road of victory march
The Red Army regiments.
And the partisan blades
Shine with heroic glory.*

*The war will end with our victory,
And people will return to a happy life.
And Belarus never shall forget
The names of its valorous sons.*

Partisans on horseback charge and slay German soldiers who have been leading a group of civilians. In the background, a farm burns against a yellow sky. At the side of the road at left, crows hover around a dead horse. The cut wires dangling from telegraph poles reveal the partisan action that prompted the Germans to round up and take revenge on the villagers.

This poster demonstrates an interesting interplay between title, text, and image, each of which refers to a separate dimension of the war in Belarus. The poem's first stanza highlights the different roles of the Red Army and the partisan detachments: the former march proudly, while the latter are engaged in hand-to-hand combat. The second stanza provides a confident prediction of peaceful life and the indelible place the heroic fighters have earned in Belarusian collective memory. The poster's title suggests

straightforward praise of the partisans. And finally, the image appears to focus on a heroic rescue. Together, the elements of the poster provide a multifaceted account of this moment of the war.

The poem illustrates why Mashistov was sometimes seen as a weak link among the regular TASS poets. The first stanza is in a wobbly iambic tetrameter, but the second stanza shifts to a more solid pentameter while retaining the A-b-b-A rhyme scheme.

The date of issue, August 21, 1944, and the reference to Belarusian partisans in the title and poem allude to the close collaboration between the partisans and the Red Army in Operation Bagration (see TASS 1027 [p. 305–06]) in the destruction of the German Army Group Center (June 22–August 19, 1944). However, the headgear that the mounted partisans wear is akin to the *papakha* of the Kuban, Terek, and Don

Cossacks. Given the homogeneous makeup of partisan units, the editorial board of the TASS studio might well have had access to information about Cossack stragglers or escaped prisoners of war who had joined the partisans in Belarus.

A specialist in battle subjects (see TASS 1146 [p. 337]), Przhetslavskii conceived the original design for this poster, with its multifigure composition and deep space, as a history painting. But both the artist, who had designed four TASS posters to date, and the stencil team that translated his work had learned to convey complex painterly effects with an economy of means and by incorporating vivid chromatic effects. Here the complementary shades of violet and yellow suffice to effectively represent smoke billowing into a summer sky.

Image: Vladimir Ladiagin
Text: Aleksei Mashistov
Edition: 1,020

Stencil
178 × 85.5 cm
The Art Institute of Chicago, gift of The
U.S.S.R. Society for Cultural Relations
with Foreign Countries, 2010.109

Liberated Ukraine Gathers the Harvest

The villages of Ukraine
Have seen much woe.
But we have wiped out the German
* butchers*
With an avalanche of steel.
Again the fields rustle
With golden wheat,
So that in our native Soviet land
There might be ample bread!

The upper panel shows civilians in a
barbed-wire enclosure guarded by
a German sentry. In the background,
a farmstead or village burns. In the
lower panel, we see the same site –
identifiable by the black tree that
the artist included at the right of
both scenes – entirely transformed.
The smoky red sky in the top panel
is replaced below by a clear blue
expanse with a single white cloud. The
horizontal bands of barbed wire in the
foreground of the top scene become
sheafs of grain, ready for harvest-
ing. Finally, those imprisoned by the
Germans in the top portion, having
been liberated by Soviet troops, can
again take up their work in the fields
in the bottom scene. There a man and
a woman admire grain in the man's
cupped hand, while a little boy holds
a Wehrmacht helmet, referencing a
battlefield now transformed. Thus,
TASS 1025 celebrates both the victo-
ries of the Red Army and the agricul-
tural contributions of Ukraine.

Mashistov's lively text, in alternating
trochaic tetrameters and trimeters,
reads like a folk ditty (*chastushka*), a
quick, improvised rhyme commonly
performed to musical accompani-
ment, say, by an accordian. The
reference to this popular folk genre
helps to excuse the very approximate
rhymes. Each couplet calls to mind
a vivid image: of grief, victory, nature,
and material abundance. This
musical text illustrates why
Mashistov was known mostly for his
work with composers.

Image: Kukryniksy
Edition: 1,200
Stencil
174 × 86.5 cm

The Art Institute of Chicago, gift of The
U.S.S.R. Society for Cultural Relations
with Foreign Countries, 2010.105

Two Cauldrons

An empty cauldron in Berlin . . .
. . . And the Russian cauldron near Minsk.

The crown of Hitler's head yawns open
like a jug; his ears are handles, one of
which is broken. He seems perplexed.
Unlike the Führer's empty "container,"
around which two mice cavort, the
cauldron below is filled to the brim
with trapped German soldiers. A
member of the Red Army uses the butt
of his rifle to stuff them all in.

Like the vice and pincers, the cauldron
was a frequent source of puns and
metaphors for TASS artists and other
graphic satirists present and past
(see figs. 1.34, 6.5, and TASS 1164 [p.
340]). In Russian, as well as German
and English, the word *cauldron* can
denote "encirclement." Here the
Kukryniksy played up the double
meaning of the word in yet another
contrasting dual image of German
failure and Russian success.

The town of Minsk, Belarus, was occu-
pied on June 28, 1941, one week after
the Germans invaded the Soviet Union.
It was recaptured on July 3, 1944, by
the Red Army in the Minsk Offensive
of Operation Bagration (June 22–
August 19).

The aim of Operation Bagration was
to trounce occupying German forces
and retake Belarus. The Red Army's
massive encirclement of German
forces east of Minsk resulted in the
eradication of entire armies and the
taking of tens of thousands of German
prisoners of war.

A very similar cartoon by the
Kukryniksy appeared in *Pravda* on July
8, 1944 (fig. 2), and a closely related
watercolor, very likely intended for
reproduction in a satirical magazine,
exists (fig. 1). There are subtle but
marked differences between the
poster, cartoon, and watercolor. The
most significant is the greater number
of tiny soldiers in the latter two. The
cartoon and the watercolor could
have served as the basis for TASS
1027, which is one of many instances
of a studio image that appeared in
multiple iterations.

Fig. 1 Kukryniksy. *Two Cauldrons*, before July 8, 1944. Watercolor, crayon, and india ink on cardboard; 31.7 × 28.3 cm. Ne boltai! Collection. In exhibition.

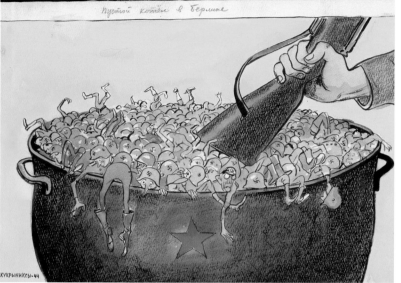

Fig. 2 Kukryniksy. "Two Cauldrons," *Pravda*, July 8, 1944. The caption reads, "The empty cauldron in Berlin ... / And the Russian cauldron near Minsk."

Image: Viktor Sokolov, Andrei Plotnov
Text: Aleksei Mashistov
Edition: 620
Stencil

179.5 × 86 cm
The Art Institute of Chicago, gift of The
U.S.S.R. Society for Cultural Relations
with Foreign Countries, 2010.166

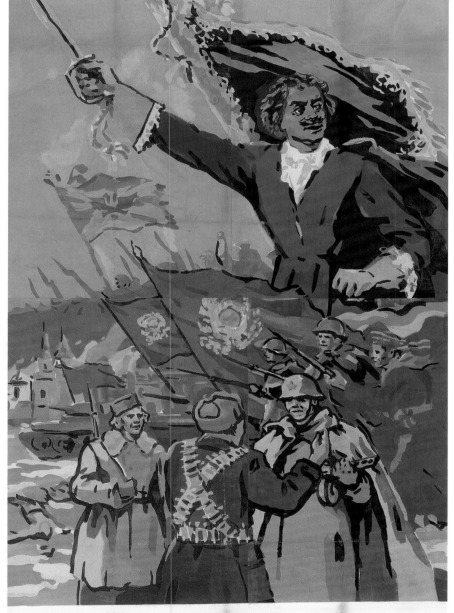

Narva Is Liberated!

Once upon a time, many years ago,
A terrible battle raged near Narva.
Here the guard of Peter bravely fought
And our soldiers earned great glory.
Years have passed, and again Narva sees
Russian troops in combat,
Our guard destroying the Teutonic
* barbarian,*
The Russian bayonet chasing him away.
A powerful "hurrah!" rolls like a wave,
Estonian or Russian – everyone rejoices.
And our soldiers celebrate their victory,
Just as they celebrated in the days of
* Peter!*

On August 20, 1704, Peter the Great
(1672–1725) and his troops besieged
the city of Narva and wrested it back
from the Swedes, who, under Charles
IX, had won it in a victory over the
Russians in 1700. Here, looming
large against the backdrop of the
city and his troops, Peter the Great
is surrounded by imperial and Soviet
ensigns. The Red Army advances
beside him. In the foreground, two
Estonians – a woman and a man –
welcome a Soviet soldier. Mashistov's
perfunctory verses are as uneven as
ever; the fourth line is two syllables
shorter than the rest, while the
penultimate line is slightly ungram-
matical (this is not discernable in the
English translation).

On July 26, 1944, the Red Army
captured Narva, located at the far
northeastern corner of present-day
Estonia, near the border of the
Russian Federation. Unfortunately,
between aerial bombardments by
the Soviets (March 6–24) and detona-
tions inflicted by retreating
German forces, the city was almost
completely leveled.

Image: Petr Shukhmin
Text: Dem'ian Bednyi
Edition: 620

Stencil
186 × 87 cm
The Art Institute of Chicago, gift of The U.S.S.R. Society for Cultural Relations with Foreign Countries, 2010.162

Repin and the White-Finnish Savages

Here our great Repin lived
But the slimy band of gorillas
Has completely burnt down his
 "Penates."
This act has clearly shown
That the White-Finnish soldiers
Have learned well from the Germans.
– Burn! Pillage! Grab! Take! –
At the hour of final reckoning
These savages will pay
The punishment for their crimes,
And will know what it means to ruin
The altars of our culture!

The reference in this poster's title to "White-Finnish Savages" relates to the civil war (January 27–May 15, 1918) in which the White-Finnish Army, led by Carl Mannerheim and assisted by Germany, defeated the Red-Finnish Army, which was supported by the fledgling Russian Soviet Republic.

Il'ia Repin (1844–1930), a Russian Realist painter best known for his late-nineteenth-century social genre paintings, was upheld in the 1930s as a precursor of Soviet Socialist Realism. This was despite Repin's own anti-Bolshevism, which he voiced loudly from his home, located in Kuokkala, Finland (Repino, Russian Federation).

TASS 1032 revisits the same topic as TASS 30-XII-1941 (pp. 203–04): the pillaging and destruction of Russian monuments and cultural property. Here Repin's countenance rises from the flames of his burning home-museum.[1] The gate to his property, which he called Penates (referring to Roman household gods), has crashed

to the ground. Finnish soldiers take off with loot. The sign at bottom right reads: "Home-Museum of I. E. Repin." The Repin Home-Museum was established in 1940.

TASS 1032 addresses both the centenary of Repin's birth, on August 5, 1844, in the Ukraininan town of Chuhuiv, and the alleged destruction and looting of Penates during the Soviet Summer Offensive on the Karelian peninsula (June 9–September 19, 1944), the final phase of the Continuation War (June 25, 1941–September 19, 1944) between the Soviet Union and the Finnish-German forces under Mannerheim. Kuokkala was recaptured by the Red Army on June 11, 1944.

A commemorative postage stamp that featured Repin's celebrated oil painting *Reply of the Zaporozhian Cossacks to Sultan Mehmed IV of the Ottoman Empire* (1880–91; Russian State Museum, St. Petersburg) was issued about the same time as TASS 1032. In that nationalistic work, the Cossacks write a letter full of insults and profanities to the Turkish sultan, who has demanded that they submit voluntarily to Turkish rule, even though they had defeated the sultan's forces in battle. The stamp is another instance of an exemplary image from the past being grafted onto a current situation; in this case, the Cossacks' defiance against an enemy is likened to that of the Soviets against Hitler.

Image: Nikolai Denisovskii
Edition: 1,000
Stencil
166 × 86 cm

The Art Institute of Chicago, gift of The U.S.S.R. Society for Cultural Relations with Foreign Countries, 2010.78

A "Statesman" of Contemporary Germany

The Lublin camp, with its calculated and fearsomely methodical technique of exterminating people, again strongly underscores the STATE-SPONSORED nature of the German organization of mass murder and torture. ([From the newspaper] Krasnaia zvezda)

Against a darkened sky broken by a horizontal pattern of jagged yellow clouds, a bespectacled infantryman, wearing a bloodstained apron, stands at attention to receive the Iron Cross in a pool of blood filled with human remains in various states of decay. In this chilling poster, the soldier being honored symbolizes all of the occupying German forces along the Eastern Front, which were Hitler's willing executioners.

The particularly macabre nature of this image relates to the Allies' first encounter with a Nazi death camp. The 1st Belarusian Front forces, under General Konstantin Rokossovskii, entered Majdanek, the Waffen-SS–run multipurpose concentration and extermination camp on the outskirts of Lublin, Poland, on July 24, 1944. In operation since October 1941, Majdanek had various functions: it was a detention facility, a transitory site, a labor-penal camp, and a prison for Polish and Soviet prisoners of war. It also operated as a place of extermination for prisoners of war, ideological enemies of the Reich, partisans, members of the resistance, and Jewish and non-Jewish civilians from Poland and other Nazi-occupied European countries. An estimated three hundred thousand inmates of all ages passed through the camp. Some two hundred and thirty thousand perished either through systematic extermination – asphyxiation by gas or execution by firing squad – or as a result of starvation, disease, exposure, exhaustion, forced labor, torture, or suicide. An extensive account detailing the atrocities perpetrated at Majdanek, including photographs documenting strewn skeletal remains, first appeared in *Krasnaia zvezda* on August 3, 10, and 18, and in the August 11 issue of *Pravda* (see fig. 1). The

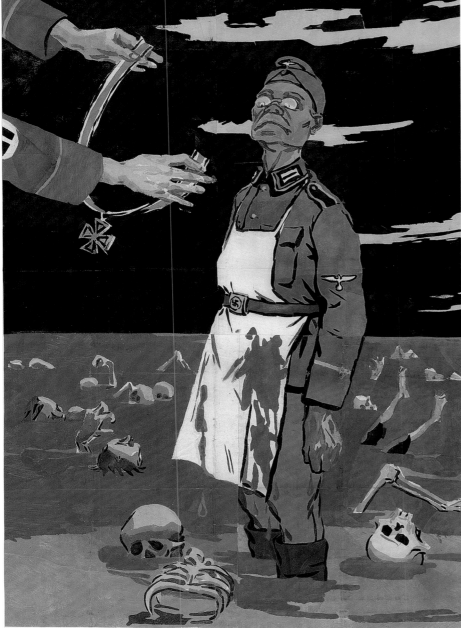

ОКНО ТАСС № 1040

"ГОСУДАРСТВЕННЫЙ ДЕЯТЕЛЬ" СОВРЕМЕННОЙ ГЕРМАНИИ

Люблинский лагерь с его обдуманной и страшной в своей методичности техникой уничтожения людей еще раз с огромной силой подтверждает ГОСУДАРСТВЕННЫЙ характер организации немцами массовых убийств и истязаний.

художник—Н. ДЕНИСОВСКИЙ („Красная звезда").

August 10 story in *Krasnaia zvezda* was written by Konstantin Simonov and entitled "Extermination Camp."

American journalists and cartoonists immediately seized upon the extermination-camp topic (see fig. 3). Edgar Snow, an American journalist who visited Majdanek not long after its discovery, reported in the *Saturday Evening Post*:

I thought I had become inured to atrocities. This aspect of human nature is all too sordidly real for me, and I prefer to leave the writing of it to others. But here at Majdanek is a point of new and clinical interest. It is the diabolical system and efficiency, the comprehensive, centrally directed planning, that for the first time made a totalitarian modern industry out of the reduction of the human being from an upright ambulatory animal to a kilogram of gray ashes. No slaughterhouse was ever better organized for its purpose. All by-products were utilized. Here nothing was wasted.[1]

During the week of July 24, other forces in the 1st Belarusian Front came upon the labor and extermination camp Treblinka, northeast of Warsaw. Vasilii Grossman, embedded in the Red Army as a correspondent, detailed the horrors perpetrated at the camp in an article entitled "The Hell Called Treblinka" that appeared in the November issue of *Znamia*. The other Nazi killing sites in Poland that the Red Army encountered during the summer offensive westward – Sobibor, Belzec, and Chelmo – had been abandoned or destroyed by the hastily retreating Germans. Whether exposed to the horrors of these factories of death firsthand or learning of the atrocities through the press or political indoctrination sessions, Red Army soldiers were conditioned to exact revenge and extirpate the Germans. An article that appeared in *VOKS Bulletin* exhorted soldiers: "May Majdanek's ashes pound in your heart, summoning you to sacred revenge! May your heart not now rest and your hand not tire of striking the enemy until you reach his lair and kill him there."[2]

Fig. 1 Photographer unknown (Soviet). "The Lublin Extermination Camp," *Pravda*, August 11, 1944. This is one of two photographs printed under the heading "The Lublin Extermination Camp." The caption reads: "Ovens in which the corpses of murdered camp victims were burned." The photographs were the first visual evidence the Allies had of the Nazis' extermination ovens.

Печи, в которых сжигались трупы замученных в лагере.

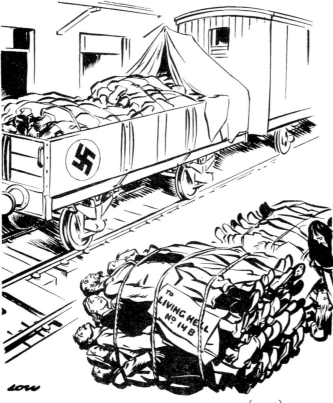

LEBENSRAUM FOR THE CONQUERED (1940)
In occupied countries the removal of Jews and inconvenient minorities to concentration camps was in progress

Fig. 2 David Low (New Zealander, 1891– 1963). "Poland – Lebensraum for the Conquered," *Evening Standard* (London), January 20, 1940. This prescient cartoon refers to the "resettlement" eastward of conquered Polish nationals and Jews in order to make room for German colonists. This turned out to be the first phase in the Nazi program of enslavement and extermination.

THEATER OF DEATH

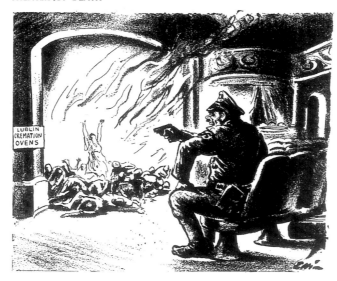

Fig. 3 Fred Ellis (American, 1885–1965). "Theater of Death," *Daily Worker*, August 31, 1944.

Image: Vladimir Ladiagin
Text: Vasilii Lebedev-Kumach
Edition: 620

Stencil
177 × 86 cm
The Art Institute of Chicago, gift of The
U.S.S.R. Society for Cultural Relations
with Foreign Countries, 2010.110

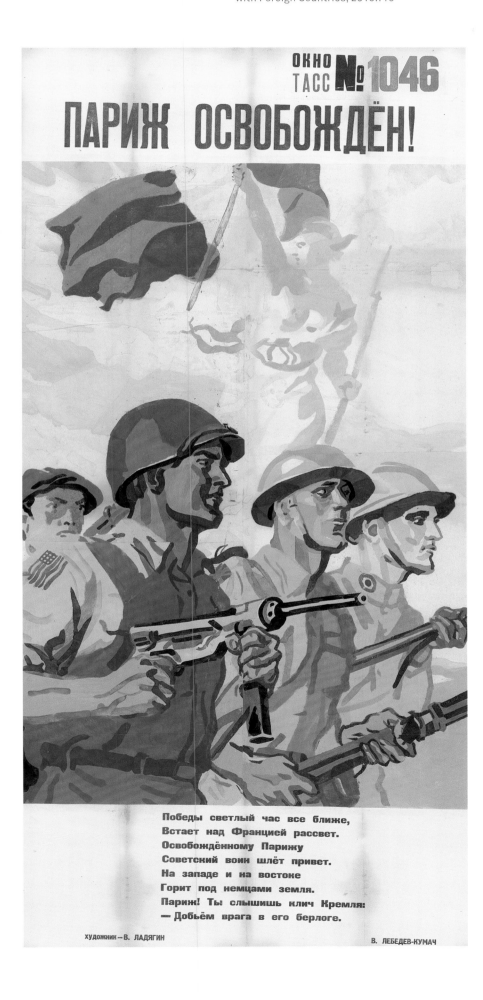

Paris Is Liberated!

*The bright hour of victory draws ever
 nearer,*
The dawn is rising over France.
The Soviet soldier sends his greeting
To liberated Paris.
In the West and in the East
*The ground burns beneath the Germans'
 feet.*
Paris! You hear the cry of the Kremlin:
"Let us finish off the enemy in his lair!"

Below the iconic flag-waving figure of Liberty from Eugène Delacroix's painting *Liberty Leading the People* (1830; Musée du Louvre, Paris), three soldiers – American, British, and French – move forward brandishing their weapons. Following behind them, in civilian dress, is a member of the French underground, known as the Maquis, the rural guerilla bands that became the symbol of the French Resistance; he resembles the worker at the left of Delacroix's painting. The final line of the rousing poem is close to the text of TASS 1005 (p. 298), with its image of a wounded beast retreating to its lair. It paraphrases Stalin's decree of May 1, 1944, which features in TASS 981 (p. 286) as well.

The Battle of Paris lasted just under a week (August 19–25, 1944). The city had been under Nazi control since June 1940. On August 24, members of the French Resistance attacked the German garrison in Paris. They, along with soldiers from the French Free Army and the United States 4th Infantry Division, forced the German occupying troops to surrender on August 25. The Allies' success in Paris resulted in the liberation of France and the founding of the provisional government of the French Republic (1944–47).

Image: Kukryniksy
Edition: unknown (probably 620)

Stencil
168 × 88 cm
Ne boltai! Collection

If while fighting one-on-one the Soviet Union has not only held off the onslaught of the German military machine, but has also inflicted decisive defeats on the German Fascist troops, then all the more hopeless will be the situation of Hitler's Germany when the main strength of our allies is deployed and the powerful and growing offensive of the armies of all the allied countries is unleashed against Hitlerite Germany. (From the order of the Supreme Commander in Chief, comrade J. V. Stalin, February 23, 1944)

Hitler, his posterior on fire, falls onto all fours trying to escape a giant tank, its tracks festooned with the Allies' national flags. He is flanked by two puny German tanks, which seem to cower before the Allies' overwhelming machine.

This poster celebrates Allied victories in Europe in the months after D-Day. It quotes from the speech that Stalin delivered in early 1944 on the occasion of the twenty-sixth anniversary of the founding of the Red Army, a speech much cited in TASS posters. In it he addressed the urgent need for a second front that would push the Germans out of western Europe. In effect, this had happened, and now Hitler's armies were engaged in a struggle on two fronts.

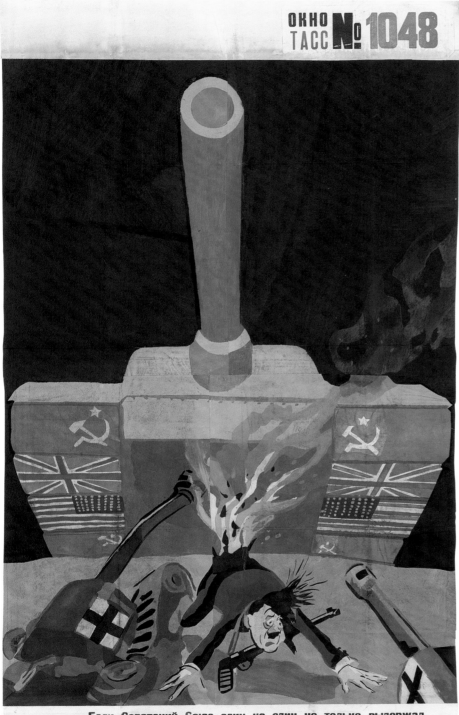

Fig. 1 Artist unknown (German). *The Universal Plague*, 1944. Offset lithograph; 81.3 × 66 cm. United States Holocaust Memorial Museum. The text at the bottom reads, "The Mob and Maquis / Resistance in the Wake of the Conqueror / This is the End!" A grotesque rendering of a Jew accompanies American soldiers who burn villages and shoot at innocent families. After the Allies invaded Normandy on June 6, 1944, the Nazi propaganda machine continued to spread anti-Semitic bile, as this poster demonstrates. In exhibition.

Image: Petr Sarkisian
Text: Aleksei Mashistov
Edition: 620

Stencil
151.5 × 118 cm
Ne boltai! Collection

The End of the Resort Season

The sudden incursion of the liberating troops of our Allies into southern France comes as a new blow to Hitler's invaders. (From the newspapers)

*There was a time when, near Nice
On the beach at water's edge
The Fritzes loved to spend
A restorative "dead hour."*

*But now, wherever they turn,
They cannot hide from their end.
There approaches for the Fritzes
A real "dead hour."*

The "dead hour" mentioned in the poem's fourth line refers to the afternoon siesta. Three armed Canadian soldiers, walking on a beach, come upon sunbathing German soldiers who take to their heels or try to hide within and behind a high-backed beach chair. Mashistov's poem is unusually lively; the first three lines of each stanza rhyme, as in a verse for children, whereas the tautological rhyme of the two final lines rings like a death knell.

Sarkisian's beach scene relates to the Allied invasion of southern France, by air and sea, on August 15, 1944 (Operation Dragoon, August 15–September 14). The invading forces included the American-Canadian 1st Special Service (known as the Devil's Brigade) and British and Free French forces.

Observing the familiar representational distinction between caricatured Germans — here in ludicrous disarray — and the liberators, Sarkasian demurred from according the Allies the glorified heroic representational treatment reserved for Red Army soldiers. The difference in focus across the pictorial field — the liberators are rendered more softly than the startled enemy — divides the composition into two halves, reinforcing the distinction between the identities of the two groups.

Image: Pavel Sokolov-Skalia
Text: Aleksei Mashistov
Edition: 620

Stencil
170.2 × 88.9 cm
Ne boltai! Collection

Expel the Pirate from the Black Sea!

The Berlin pirate has been knocked out
Of the Romanian bases on the Black Sea.
There's no base in the world
Where he can hide from us!

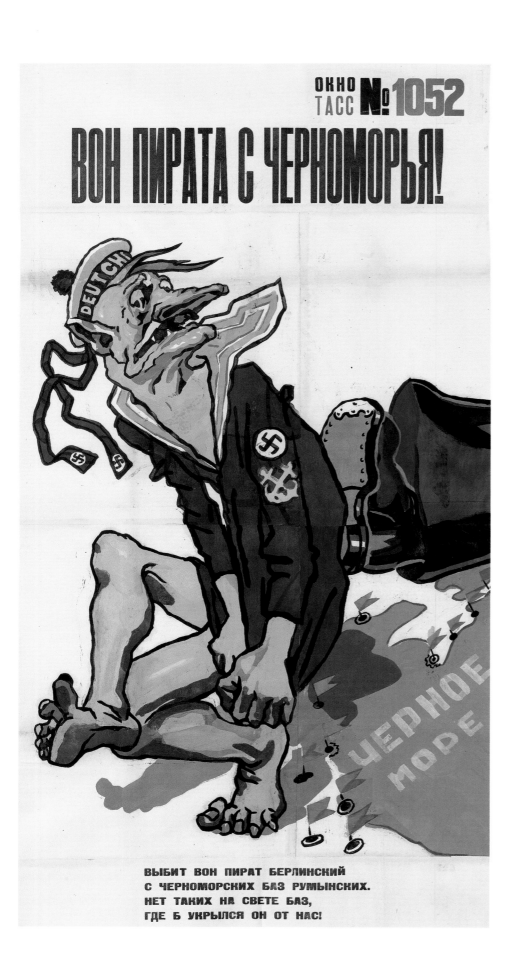

ОКНО ТАСС **№ 1052**

ВОН ПИРАТА С ЧЕРНОМОРЬЯ!

ВЫБИТ ВОН ПИРАТ БЕРЛИНСКИЙ
С ЧЕРНОМОРСКИХ БАЗ РУМЫНСКИХ.
НЕТ ТАКИХ НА СВЕТЕ БАЗ,
ГДЕ Б УКРЫЛСЯ ОН ОТ НАС!

Superimposed over a map of Romania, the Crimean peninsula, and the Black Sea, Hitler wears only the cap (with "Deutsche" misspelled) and tunic of a German navy uniform, which he pulls down to cover his genitals. The boot of a sailor from the Soviet Black Sea fleet kicks the Führer westward. The liberated towns in the Soviet Union and the conquered ones in Romania are indicated by red flags: Kerch, Feodosiia, Alushta, Sevastopol, Odessa, Tulcea, Sulina, and Constanta among them. The wit of Mashistov's two rhyming couplets lies more in their brevity than in their verbal invention.

This poster celebrates successful Soviet naval operations along the coast of Romania against Romanian and German navies during the Jassy-Kishinev Offensive (August 20–29, 1944). Between August 20 and 22, aviation units of the Soviet Black Sea fleet raided the Romanian ports of Constanta, home base of the Royal Romanian Navy; Sulina, a Romanian-German naval base; and Valcov (Vylkove, Ukraine). The latter two are located in the Danube Delta. On August 28, Soviet landing units crossed the delta and captured the river ports and naval bases of Tulcea and Sulina. Constanta was captured the next day.

Sokolov-Skalia's representation of a crocodile-like Hitler is more extravagant, and repulsively unreal, than depictions of the Führer in previous posters by him. Like Oscar Wilde's *Picture of Dorian Gray* (1890–91), in which the eponymous character remains forever young while a portrait of him records his aging and increasing debauchery, Sokolov-Skalia's visceral distortions of Hitler's countenance became more odious and loathsome over time. Beginning with TASS 506 (p. 215), and continuing in 757 (p. 244–45), 938 (p. 274), and 1000 (p. 294–95), among others, the Führer's features take on a mélange of bestial and reptilian attributes, as if attesting to his ever-deepening moral decrepitude. Subsequent designs, such as TASS 1147 (p. 338), would continue this teratology.

Image: Aleksandr Volkov
Text: Vasilli Lebedev-Kumach
Edition: 620

Stencil
150 × 81.5 cm
Ne boltai! Collection

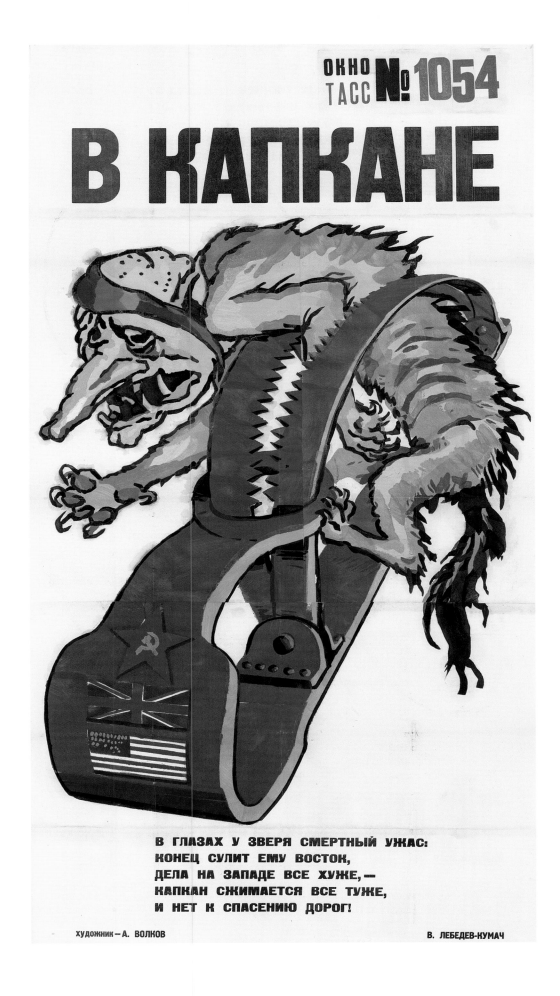

In a Trap

The wild beast's eyes show fatal terror:
The East portends his end,
In the West things are ever worse, –
The trap squeezes him ever tighter,
And there is no path to safety!

Hitler is caught in the jaws of a trap bearing the Allies' flags. He resembles a scruffy wolf whose facial features have been brutishly exaggerated. The pallor of his face, his elongated snout, and his snaggle-toothed jaw create a crocodile-like visual pun that evokes the Soviet satirical magazine of the same name, *Krokodil*.

As the poem indicates, Volkov's image is a graphic reminder of the fate of Hitler's armies on the various fronts to date. It suggests that victory is at hand, given the rapid Allied advance since the invasion of Normandy. However, at the time this poster was issued, the British and Polish troops were engaged in Operation Market Garden (September 17–26, 1944), hoping, in vain as it turned out, to cross the Lower Rhine at Arnheim. The American forces were caught up in a difficult struggle in the French region of Lorraine, gateway to the Rhine (Lorraine Campaign, September 3–December 16). On the other hand, the Red Army was involved in the Baltic Offensive (September 14–November 24), which would result in Soviet reoccupation of the Baltic states and advancement toward East Prussia.

Image: Pavel Sokolov-Skalia
Text: Aleksei Mashistov
Edition: 820

Stencil
180 × 95.5 cm
The Art Institute of Chicago, gift of The
U.S.S.R. Society for Cultural Relations
with Foreign Countries, 2010.183

Suvorov's Haunts

*The area around the Dnieper and the
banks of the Danube are radiant with the
glory of Suvorov's victories.*

*Where our grandfathers were victorious
 in battle,
Again the Russian knight has earned
 soldierly glory.
And Suvorov, proud of our victory,
Congratulates his valiant grandsons.*

Under a night sky, a Red Army soldier,
preparing his dinner next to a tank,
jumps to attention and salutes the
apparition of General Aleksandr
Suvorov (1729–1800). Mashistov's
verse is painful in its plodding, uneven
rhythm; somehow he made it rhyme,
but only just.

The Red Army's advances in the south-
ern theater of the Eastern Front are
compared here to Suvorov's exalted
military exploits for the Russian
Empire. Time and again, in word and
image – on magazine covers (see fig.
1), posters (see TASS 755/755A
[p. 243]and 1197 [p. 351]), and graphic
satire – the venerated Suvorov was
evoked to inspire, cajole, and amuse
the Red Army soldier. On July 29, 1942,
the Soviet state created the Order

of Suvorov, which was awarded for
exceptional leadership in combat
operations.

This poster speaks to the issue of
the effectiveness of TASS posters as
instruments of propaganda. Had the
poster been conventionally printed
in tens of thousands of copies, it
would certainly have reached a much
larger audience. But the design is
not inherently remarkable and, had it
been printed lithographically in two
or three colors, would not have been
arresting. What distinguishes TASS
1057 is the conceit of using the camp-
fire as the single light source. This
resulted in the striking intensity of the
palette – the brilliant blues, oranges,
and yellows – and dramatic light-dark
contrasts that effectively convey the
soldier's shock at the apparition of
Suvorov. Thus, while this poster would,
by virtue of its limited numbers, have
been seen by fewer Soviets than
mass-produced posters, for those
who did encounter it on the streets of
Moscow, this large-scale image must
have been arrestingly potent.

Fig. 1 G. Balashov. Cover of *Krasnoarmeets* 16 (August 1944).
Ne boltai! Collection.

Image: Kukryniksy
Edition: 650
Stencil
133 × 123 cm
The Art Institute of Chicago, gift of The U.S.S.R. Society for Cultural Relations with Foreign Countries, 2010.106

"New" Europe

"The young powers of all of Europe are now gathered in Germany," say Berlin's newscasters. By "young powers" they mean – apart from Sima and Tsankov – slobbering Petain, the runaway Duce and the clearly non-Finnish Finns. Never mind, let them gather: it will be easier to catch them. Krasnaia zvezda

Fig. 1 Boris Efimov. *The New "New Europe." Ersatz-Satellites*, 1944. Pen and india ink and brush and blue gouache; 23 × 16.7 cm. Ne boltai! Collection. The mannequins are labeled, from left to right: "Petain" (France), "Mussolini" (Italy), "Tsankov" (Bulgaria), and "Horia Sima" (Romania). The jars are labeled "mothballs" and "glue." This is the original drawing for a cartoon published in *Krasnaia zvezda* on October 4, 1944.

Cowering under a shot-up German steel helmet are, left to right, a resigned Petain, a pensive Mussolini, and a cowering Laval. The helmet is based on an actual example that the Kukryniksy found on a fieldtrip to the front lines. The posterior on display at right could be that of one of the other players mentioned in the text.

The taunting excerpt from *Krasnaia zvezda* provided the Kukryniksy with the ingredients for TASS 1079. But a disjunction exists between image and text. The latter included the names of only two universally recognizable men: Petain, the eighty-eight-year-old leader of Vichy France; and Mussolini, now head of the Fascist

Salò Republic, a puppet state of Nazi Germany. These two figures appear in the image, but the "non-Finnish Finns" (which refers mainly to Mannerheim, a Swede of German ancestry), Horia Sima, and Aleksandr Tsankov do not. This is because none was sufficiently recognizable to be transformed into caricature. Instead, the Kukryniksy included the Vichy regime's prime minister, Laval, who often appeared in lampoons as Petain's sidekick.

Sima and Tsankov were, respectively, Romanian and Bulgarian Fascist politicians. After Romania joined the Allied cause in August 1944, Sima attempted to set up a pro-Nazi puppet government in exile in Vienna. Prime minister of Bulgaria in the

1920s, Tsankov was appointed by the Nazis in 1944 as prime minister of the Bulgarian government in exile, which was established in Germany after Bulgaria sided with the Allies. This rag-tag group of Nazi stooges formed the "New" Europe to which the *Krasnaia zvezda* article referred. Efimov, on the other hand, in a cartoon inspired by the same article, chose to put faces on the principals that the Kukryniksy ignored (see fig. 1).

The extraordinarily rich yellow background infuses TASS 1079 with a chromatic energy that plays off the lassitude of the defeated enemies represented in the foreground.

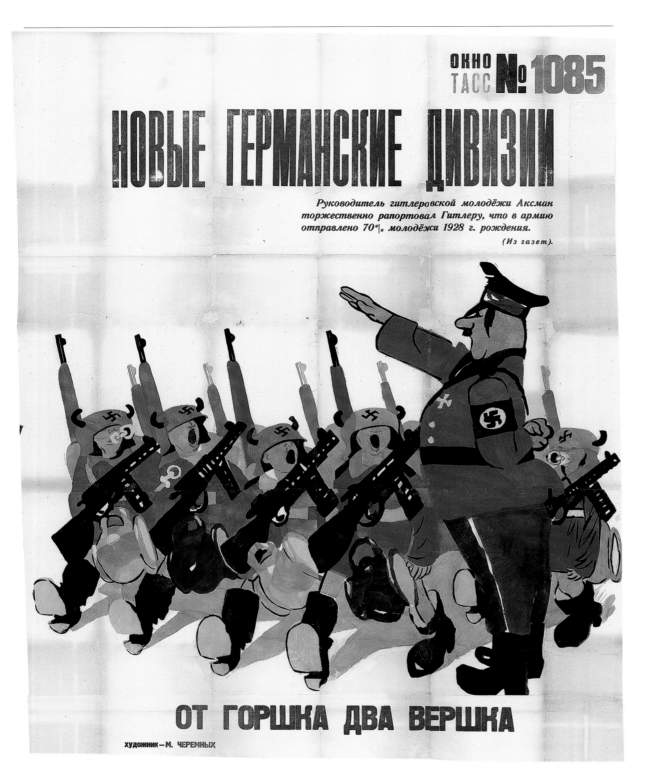

ОКНО ТАСС № 1085

НОВЫЕ ГЕРМАНСКИЕ ДИВИЗИИ

Руководитель гитлеровской молодёжи Аксман торжественно рапортовал Гитлеру, что в армию отправлено 70%, молодёжи 1928 г. рождения.

(Из газет).

ОТ ГОРШКА ДВА ВЕРШКА

художник — М. ЧЕРЕМНЫХ

Image: Mikhail Cheremnykh
Edition: 650
Stencil
134.5 × 107.5 cm
The Art Institute of Chicago, gift of The U.S.S.R. Society for Cultural Relations with Foreign Countries, 2010.70

New German Divisions

The director of the Hitler Youth triumphantly reported to Hitler that 70% of the young people born in 1928 have been sent to the army. (From newspaper)

Two inches from the potty.

Hitler Youth!

With pride and joy I have noted your enlistment as war volunteers of the 1928 age group. In this hour in which the Reich is threatened by our enemies, who are filled with hatred, you set a shining example of fighting spirit and fanatical readiness for action and sacrifice.

The youth of our National Socialist movement fulfilled at the front and in the homeland what the nation expected of it.... Today the realization of the necessity of our fight fills the entire German Volk, above all its youth. We know our enemies' merciless annihilation plans. For this reason, we will be all the more fanatical in waging this war for a Reich in which you will one day be able to work and live with self-respect. However, as young National Socialist fighters, you have to outdo our entire Volk in steadfastness, dogged perseverance, and unbending hardness.

Through the victory, the reward for the sacrifice of our heroic young generation will be the proud and free future of our Volk and the National Socialist Reich.[1]

Young soldiers – mere babies – parade before Hitler. They are equipped with pacifiers and chamber pots, along with submachine guns and rifles. Their uniforms – jackets, boots, and helmets – are much too large. The helmets – inspired by those of Teutonic knights – are particularly comical in the way that they entirely cover the children's eyes. The one-line caption is a common (and rhyming) Russian saying, equivalent to calling someone "green behind the ears."

On October 8, 1944, Artur Axmann, leader of the Hitler Youth (Reichs-jugendführer) announced that seventy percent of the Hitlerjugend born in 1928 (the draftees were sixteen years old) had "volunteered" for the army. A grateful Hitler commended these youth in a telegram (see sidebar).

The next day, Axmann responded:

This appeal of the Führer to his youth ... is our greatest obligation. We must and will now, in this hard and difficult time, stand before the Führer and carry his name with honor. After glorious victories, we had to endure heavy blows. Because we endured them bravely our awareness is strengthened by the fact that we will also master all future dangers.... The more difficult and ... serious [things become], the stronger the spirit of the youth will be. Heavy battles are always at first fought with the heart. Therefore great times require strong hearts.... We will win, because our soul is filled with the unconditional will for victory.[2]

Image: Vladimir Milashevskii
Text: Pavel Kudriavtsev
Edition: 650
Stencil

155 × 122.5 cm
The Art Institute of Chicago, gift of The
U.S.S.R. Society for Cultural Relations
with Foreign Countries, 2010.129

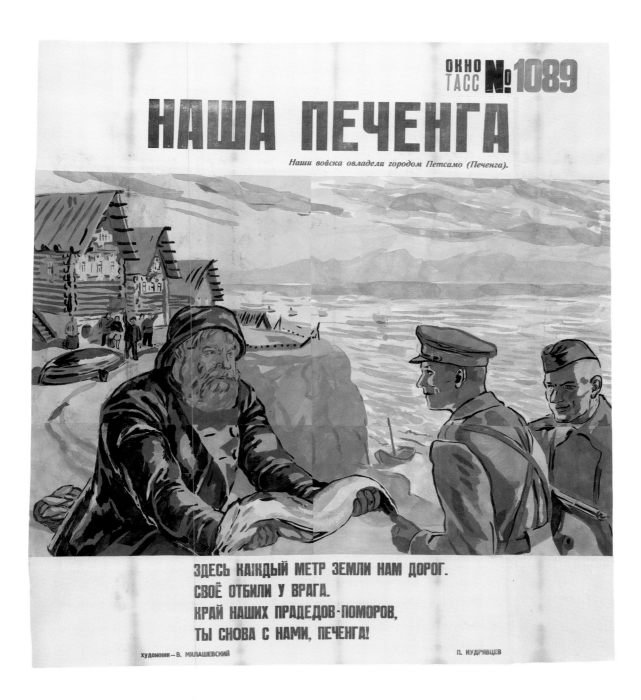

Our Pechenga

*Our troops have gained control over the
city of Petsamo (Pechenga).*

Here every meter of land is dear to us.
We have regained our rightful possession
 from the enemy.
Land of our ancestors the Pomors,
You are back with us, Pechenga!

Against a background of an Arctic
sunset and the decorated wooden
buildings of a rustic coastal village, a
fisherman presents Red Army officers
with his catch. Kudriavtsev's service-
able verse is in iambic tetrameter, the
most common measure of Russian
poetry, with approximate rhymes. It
expands on the title and image by
referring to ancient ties of blood
between European Russians and the
Pomors, a North Slavic population
on the White Sea who are regarded
as descendents of ancient Russian
settlers but possess a strong local
identity. In fact, the nature of the
relationship between the Russian and
Pomor ethnicities is disputed.

The port of Pechenga (Petsamo) is
located west of Murmansk on the
coast of the Barents Sea, where the
borders of Norway and the Russian
Federation meet. Pechenga became
part of Russia in 1533, but the Treaty
of Tartu of 1920 awarded it to Finland.

The Soviet Army, aiming to drive
German forces from northern Finland,
launched the large-scale Petsamo-
Kirkenes Offensive on October 7, 1944,
which involved operations on land
and sea. TASS 1089 celebrates the
capture of Pechenga by the Red Army
on October 15, welcoming the port
city, and the region's natural resourc-
es, back into the fold in the poem
and depicting a fisherman expressing
his gratitude with an offering to
the Soviets.

The poster, with its emphatic contrast
between the scale of the foreground
figures and a distant horizon, is
remarkable for its arresting incor-
poration of vivid complementary
colors – violet and yellow, red and
green – as well as its chromatic range
of greens, yellow-greens, and violet-
reds. This recalls similar color effects
in Przhetslavskii's TASS 1021 (p. 303)
and raises the question of whether
we are dealing with painters with
similar palettes or whether the colors
available to the TASS studio may have
determined, in part, the artists' chro-
matic strategies.

Image: Nikolai Denisovskii
Text: Mikhail Vershinin
Edition: 650

Stencil
147.5 × 112.5 cm
The Art Institute of Chicago, gift of The
U.S.S.R. Society for Cultural Relations
with Foreign Countries, 2010.79

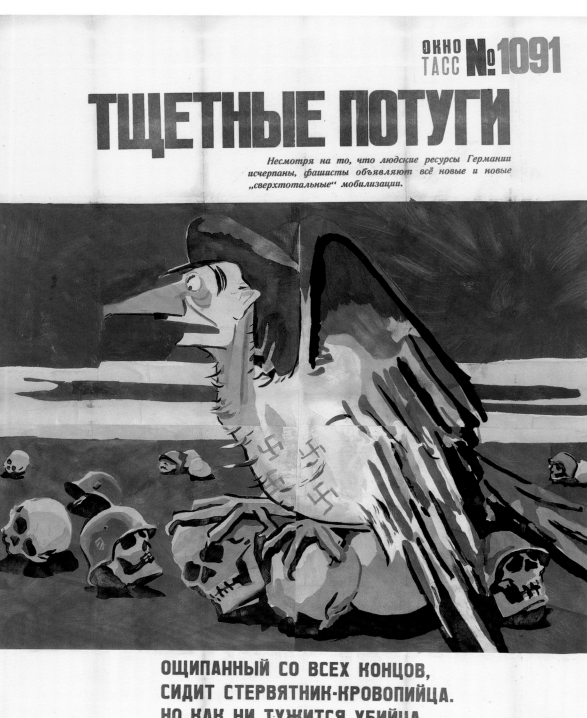

Straining in Vain

*Despite the fact that Germany's human
resources are exhausted, the Fascists
keep announcing new "super-total"
mobilizations.*

*Plucked clean from all ends,
There sits the blood-drinking vulture.
But no matter how hard the killer tries,
He cannot get his chicks to hatch.*

Against an ominous sky, a Nazi bird of
prey with Hitler's features sits on the
skulls of slain German soldiers as if
they were eggs from which it is pos-
sible to hatch new recruits. Its breast,
stripped of feathers, is covered with a
rash of tiny swastikas.

The text by the young satirical poet
Vershinin displays an admirable
economy of means, underscoring all
the ironies of the image – the plucked
vulture, its inability to create life out
of death – in just four brief lines.

Soviet graphic satirists never let an
opportunity pass to ridicule Nazi
attempts to replenish the ranks with
new mobilization drives (see fig. 1, and
TASS 930 [p. 272] and 1085 [p. 322]).

A reduced version of TASS 1091 was
published by the TASS studio in 1944
in an edition of twenty thousand.

Fig. 1 Iulii Ganf (born Poltava, Ukraine,
1898; died Moscow, 1973), "Total Effort,"
Krokodil 30–31 (September 2, 1944). A
disconcerted Goebbels holds a broken
comb over the head of a toothless old
woman, who wears a swastika earring and
a threadbare shirt labeled "Germany."
The new recruit inquires, "What is there to
brush? I'm already shaved bald."

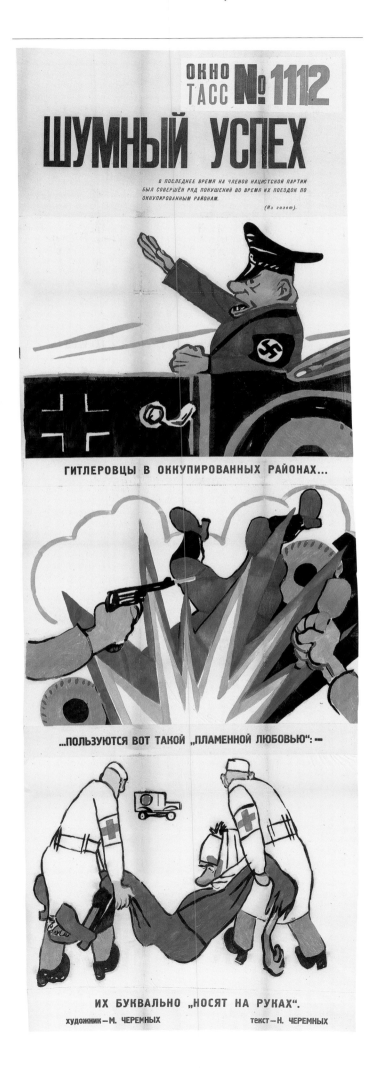

Image: Mikhail Cheremnykh
Text: Nina Cheremnykh
Edition: 650
Stencil
173 × 56.5 cm
The Art Institute of Chicago, gift of The
U.S.S.R. Society for Cultural Relations
with Foreign Countries, 2010.71

A Resounding Success

*Recently a series of assassination
attempts against Nazi Party members
have been committed during their
tours of occupied regions. (From the
newspapers)*

Hitlerites in the occupied regions …

… Enjoy such "fiery love"

That they literally get carried away.

In the top panel, a brutish-looking
Nazi dignitary, passing by in an open
car in an apparent motorcade, per-
forms the Nazi salute *Sieg Heil* (hail
victory). In the middle panel, citizens
attack the military officer with a
pistol and hand grenade, resulting in
an explosion that tosses him and the
car into the air. In the final scene, the
wounded and bandaged officer
is carried to an ambulance by two
male medics. The final line is an
untranslatable pun: to be "carried
by people's arms" can mean to enjoy
great popularity, as well as to be
physically transported. Its use here is
clearly ironic.

The simplification and limited chro-
matic range of TASS 1112 reflect the
posters of the ROSTA studio, of which
Cheremnykh was a cofounder. The
subject of an assassination attempt
here enabled the artist to employ his
trademark peaked explosion as a cen-
tral element. The multipanel narrative
format is also a hallmark of ROSTA.
Beyond recounting the moral lesson
of an enemy receiving his comeup-
pance, the visual anecdote serves as
a schematic model for a Soviet audi-
ence: this is how we will act to defeat
the enemy!

Image: Petr Sarkisian
Text: Dem'ian Bednyi
Edition: 650

Stencil
171 × 125 cm
The Art Institute of Chicago, gift of The
U.S.S.R. Society for Cultural Relations
with Foreign Countries, 2010.151

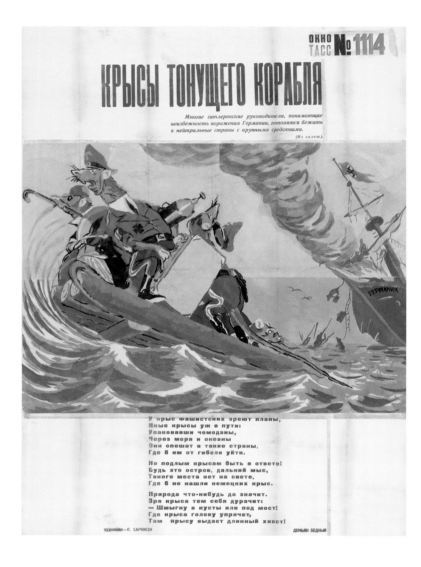

Like Rats from a Sinking Ship

*Many of Hitler's administrators,
understanding the inevitability of
Germany's defeat, are preparing to
abscond to neutral countries with
significant resources. (From the
newspapers).*

*The Fascist rats are making plans,
Some rats are already on their way:
Packing their suitcases,
Across the seas and oceans
They hurry to countries
Where they might escape their deaths.*

*But the vile rats must still answer!
Whether it's an island, or distant
 peninsula,
There won't be a place in the world
Where the German rats will not be found.*

*Nature will have its way.
 In vain the rat fools itself:
"I can scurry into the bushes or under a
 bridge!"
Wherever the rat hides its head,
His long tail will betray him!*

Bednyi's poem, first published in
Pravda on December 1, 1944, preced-
ed TASS 1114. In this case, the image
illustrates the poem, rather than the
poem amplifying aspects of the image,
as is most often the case. A group of
rats, identifiable by their natty outfits
as German officers and civil servants
and clutching such items as a cane
and a suitcase, move frantically on a
wooden raft away from the burning
and capsizing SS *Germany*, an anti-
quated sailing vessel. Other rats dive
off the ship along with their suitcases.

The exodus of military and civilian
Nazi personnel to safety in "neutral"
countries such as Spain, Switzerland,
Argentina, and other South American
nations went on unabated during the
advances of the Allied forces on the
Western and Eastern fronts, providing
new themes for satire (see fig. 1).

The pictorialism of this poster, with
its engaging and subtle color con-
trasts – the violet sky and grayish blue
waves – and details such as the comic
purple silhouettes of rats jumping
off the burning ship in the distance,
points to the difference in strategy
that separates TASS products from
contemporary conventionally printed
posters. The latter were designed for
immediate impact. Though their large
size, color, and design make them
instantly powerful, TASS images such
as this, with their lengthy accompa-
nying texts, require time to read as
well as absorb chromatic and picto-
rial nuances. Defying conventional
notions of poster design, works such
as TASS 1114 demonstrate how many
of the satirical TASS productions
share the painterly ambitions of other
TASS genres.

Fig. 1 Iulii Ganf (born Poltava, Ukraine, 1898; died Moscow,
1973). "A 'Neutral' Bandit Shelter," *Pravda*, December
10, 1944. A Nazi, escaping a conflagration over a wall, is
about to land in a safety net labeled "Neutrality" that is
held by Fransisco Franco, symbolizing Spain; a banker,
symbolizing Switzerland; and a gaucho, symbolizing
Argentina. The caption reads, "Jump away, we're holding
fast to our neutrality." The neologism *bandit shelter*
(*bandoubezhishche*) is formed by an analogy with the word
bomb shelter (*bomboubezhishche*).

Image: Aleksandr Przhetslavskii
Text: Aleksandr Zharov
Edition: 650

Stencil
128 × 101 cm
The Art Institute of Chicago, gift of The
U.S.S.R. Society for Cultural Relations
with Foreign Countries, 2010.137

A Sacred Duty

*From captivity, with its immeasurable
 suffering,*
From the dark German camps
Comrades, let us quickly liberate
Our kidnapped citizens in Germany!

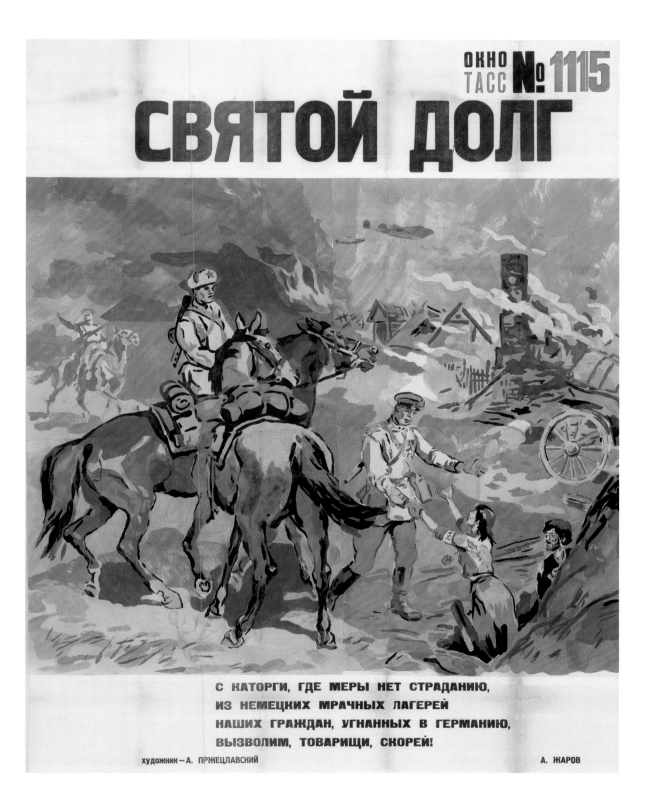

The burning and smoking ruins of a
hamlet or farmstead provide a back-
drop for a scene in which Red Army
cavalry officers greet two Russian
slave laborers who emerge from a
subterranean dwelling. The woman,
her arms outstretched in gratitude,
wears an armband labeled "Ost"
(East). This stands for *Ostarbeiter*
(Eastern laborer), signaling a prisoner
from German-occupied territories
in the East who was put to work in
Greater Germany (which included
Poland) (see fig. 1).

In their various offensive operations
westward, Soviet forces encountered
many labor and prisoner-of-war
(stalag) camps, often abandoned
or destroyed by retreating German
troops. Although its text suggests
that slave laborers were being liber-
ated in Germany, when TASS 1115
was issued Soviet forces had not yet
penetrated that country's prewar bor-
ders and therefore had not observed
firsthand the living conditions in
these camps. Przhetslavskii's scene
is, therefore, a product of the artist's
imagination. Only after beginning
the Vistula-Oder Offensive (January
12–February 2, 1945) did the Red Army
enter eastern Germany.

Zharov's poem is most notable for its
rhyming of "suffering" and "Germany."

Fig. 1 Photographer unknown (Soviet).
Female forced laborers wearing "Ost"
badges are liberated by the Red Army
from a camp near Lodz, Poland, after
January 12, 1945. United States Holocaust
Memorial Museum.

Image: Petr Sarkisian
Text: Osip Brik
Edition: 650

Stencil
133.5 × 124.5 cm
The Art Institute of Chicago, gift of The
U.S.S.R. Society for Cultural Relations
with Foreign Countries, 2010.152

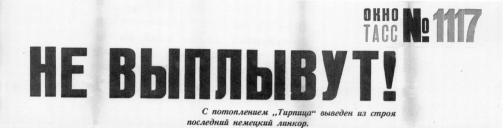

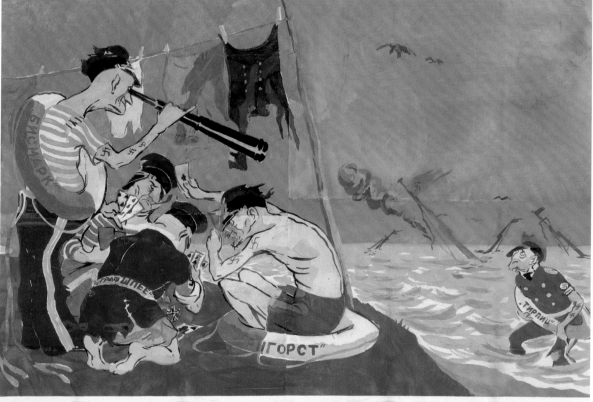

They Won't Escape!

*With the sinking of the "Tirpitz" the last
German battleship has been put out of
commission.*

*The naval fleet has sunk. Seeking safety,
The elite pirates are running away.
But they will not escape retribution,
They won't "come out of the water dry."*

Celebrating the decimation of the
German navy, this poster compresses
into a single scene military actions
that actually took place over five
years. Four disheveled naval officers
– three of whom represent the lost
German battleships *Bismarck* (far
left), *Admiral Graf Spee* (front center),
and *Scharnhorst* (right) – sit on a
sand dune playing cards. The tattered
garments of the man at the right of
the group, who is in his underwear, dry
on a makeshift clothesline. Wading
ashore is a naval officer symbolizing
the *Tirpitz*, the most recently lost
battleship. The masts of four sinking
ships can be seen behind him. The last
line of Brik's inventive poem features
a Russian saying – "to come out of the
water dry" – that is applied to those
who escape the consequences of their
actions. But, as the poem asserts, the
Nazis will not be so lucky.

The pocket battleship *Admiral Graf
Spee* was scuttled on December
17, 1939, in the port of Montevideo,
Uruguay, by its captain, Hans
Langsdorff, during the Battle of the
River Plate. The *Bismarck* was sunk on
May 27, 1941, during combat with the
British navy in the North Atlantic. The
Scharnhorst was destroyed during
the battle of North Cape, Norway, on
December 26, 1943, by Allied forces
protecting Convoy JW 55B, headed for
Archangel (Arkhangelsk) on the Soviet
Union's far-north White Sea coast.
The *Tirpitz* was destroyed by British
Royal Air Force bombs on November
12, 1944, west of Tromsø, in the bay of
Hakøbotn, Norway.

Image: Petr Sarkisian
Text: Aleksandr Zharov
Edition: 650

Stencil
182.5 × 80 cm
The Art Institute of Chicago, gift of The
U.S.S.R. Society for Cultural Relations
with Foreign Countries, 2010.153

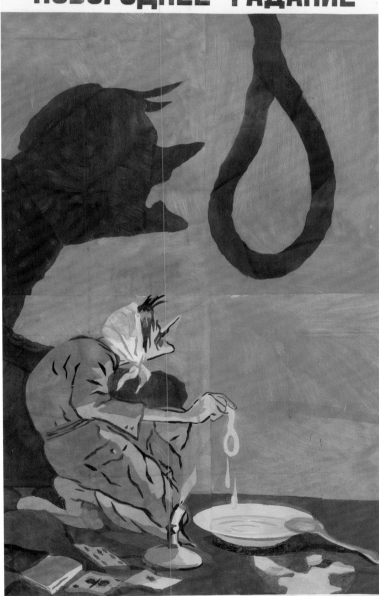

New Year's Fortune-Telling

Hitler, overcome with fear,
Went fortune-telling at the New Year.
He sat down, mumbled "Forty-Five,
What will it mean for me?"

He melted wax on the platter,
A shadow was cast upon the wall.
"What is it? What is it?
Oh! A noose! For me!"

"For me!" he cried like one possessed.
"Here . . . a noose . . . above my head!
Forty-five, forty-five –
The year of fateful retribution!"

A traditional Russian way to tell one's fortune around Christmas and New Year's is to melt candle wax into a spoon and pour it in a dish with cold water. The shape the wax assumes portends one's future. Here a cowering Hitler – wearing his greatcoat, a kerchief tied under his chin like a superstitious old woman (*babushka*), and slippers with pom-poms – sees what he is in for. Hunched on the floor before a saucer and spoon, where he has been using fortune-telling cards, the Führer lifts the wax shape from the saucer. On the wall behind him, his shadow is joined by another, in the form of a noose. The flickering light distorts the actual spatial relationship of the two shadows, drawing them together and signaling Hitler's fate at the gallows, which he contemplates with horror. The use of a cast shadow to foretell the end of the German aggressor can be found in World War I *lubki* (see fig. 1).[1]

The meaning of the image and its title are so clear that one might wonder what Zharov's poem adds to its effect beyond providing additional details. The words Zharov put in Hitler's mouth are mumbled and largely repetitive, which reinforces the impression of desperation that Sarkisian's design creates. If anything, the text blunts the wit of the image.

Fig. 1 Artist unknown (Russian). *Russian Sayings in Caricatures, No. 1*, 1914/18. Publisher: Tipo-lit. V. Rikhter. Edition: unknown. Offset lithograph; 43.2 × 30.5 cm. Hoover Institution Archives, Stanford University. The caption reads, "Two friends – the sausage maker and his wife. / A humorous portrait of Vasilii Fedorovich (Wilhelm II)." The "sausage maker's wife" is the figure of death holding a scythe. Thus, Germany's Kaiser Wilhelm II, pompous and inflated, casts a large shadow that is transformed into the specter of death.

Image: Sergei Kostin
Text: Dem'ian Bednyi
Edition: 650

Stencil
174.5 × 86 cm
The Art Institute of Chicago, gift of The
U.S.S.R. Society for Cultural Relations
with Foreign Countries, 2010.89

Bring the Bandits to Answer!

*Majdanek and Citadel were not only
 places for torture,
Where the stench of fiery furnaces
 poisoned the air.
The "Stalags" brought in a huge profit
For the disgusting German butchers.*

*The murderers, shaking with greed,
Have stolen everything from the
 tormented prisoners –
Rings, trinkets, golden teeth, earrings,
 and watches.
The world has never seen such pillage!*

*We will call the Fascist monsters to
 answer for their crimes.
There will be no mercy for the bandits.*

In a dimly lit storage facility, a pallid German officer who wears the Iron Cross is removing gold dentures from a skull. A hand grabs him by the collar of his greatcoat; the arm of the unseen captor bears the words "To Answer!" On the floor at the right are boxes filled with loot, including gold watches, and labeled with destinations: Berlin, Hamburg, and Frankfurt.

Majdanek, the multipurpose concentration and extermination camp near Lublin, Poland, was the first such camp encountered by the Red Army as it advanced westward. The Soviets entered it on July 24, 1944 (see TASS 1040 [pp. 309–10]). The Citadel, a fortress in the center of Lviv, Ukraine, served as a German prison and concentration camp for Soviet prisoners of war known as Stalag 328 Lemberg. Soviet soldiers died in the tens of thousands at the site from heinous torture, malnutrition, diseases, and extermination; many were taken to the nearby Lisenitz forest to be shot.

Here Kostin employed his signature overlapping washes and restrained palette to eerie effect. His use of echoing shapes and colors establishes a relationship between the elements of the composition that augurs the outcome of the encounter between the German and his captor. The human skulls from which the officer parasitically gleans gold teeth resemble his gaunt and angular head; the gold of the teeth and jewelry is repeated on the perpetrator's forehead and shoulder band. The abhorrent villain is himself close to death and retribution.

Image: Vladimir Lebedev
Text: Samuil Marshak
Edition: 650

Stencil
197 × 85.5 cm
The Art Institute of Chicago, gift of The
U.S.S.R. Society for Cultural Relations
with Foreign Countries, 2010.123

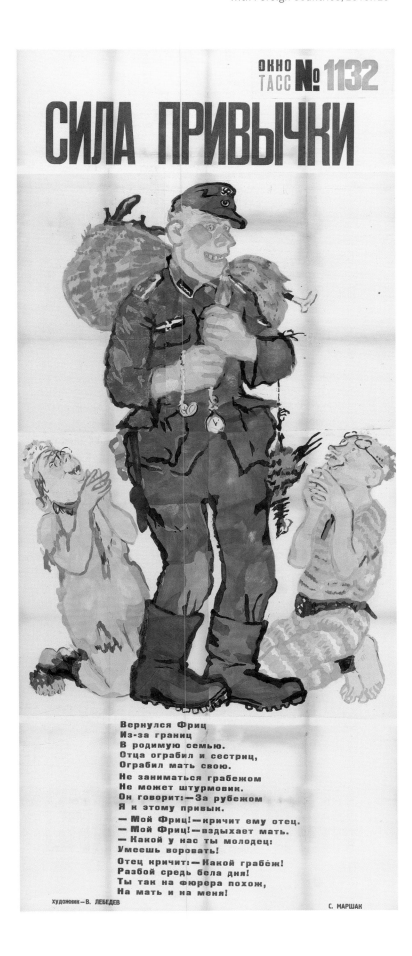

The Force of Habit

Fritz has returned
From overseas
To his native family.
He's robbed his father and his sisters,
He's robbed his mother too.

The German storm trooper is unable
To be anything but a robber.
He says, "Overseas
I just got used to it."
"My Fritz!" – says his father
" My Fritz!" – sighs his mom.
"What a talented boy you are!
"You can even steal!"

The father says, "What a pillaging,
It's robbery in broad daylight!
You've taken after the Führer,
After your mother and after me!"

A blond, ruddy-cheeked German soldier stands smiling, a sack of loot slung over his shoulder, his pockets stuffed full, a game bird tied onto his left arm, and two gold pocket watches in his right hand. His shoeless parents, dressed only in their undergarments, kneel adoringly at his feet like donors in traditional devotional paintings.

Marshak published a poem, "An Involuntary Confession," on the same topic in *Pravda* on December 7, 1944. Allegedly based on an appeal for good behavior in the German newspaper *Front und Heimat*, it tells of Fritz continuing to rob and pillage after he returns home: "You are not in France anymore, / Not in Ukrainian villages. /

Listen, Fritz, hurry to moderate / Your bestial instinct." Fritz responds, "I can no longer … stop." The poem concludes, "So in our day the world has heard / An involuntary confession / From the newspapers' hypocritical mouth / Of bandit Germany." A version of the poem was later included in collections of Marshak's work as "A Poor Upbringing."

Here Lebedev, typically building his image chromatically, underscored Fritz's sociopathic compulsions with the unnatural, reddish lavender on his face, a sickly pink-orange contour line, and pulsating blue accents. The artist created a contrast between the young man and his parents not only through the striking difference between the heightened skin tones of the son and the limited palette that defines his mother's and father's flesh, but also through his evocative drawing and eloquent expression of the couple's adoration of their son. This image masterfully demonstrates the wide expressive range of the stencil medium.

A reduced version of TASS 1132 was published in an edition of twenty thousand by the TASS studio in 1945.

Image: Pavel Sokolov-Skalia
Text: Vasilii Lebedev-Kumach
Edition: 650

Stencil
173.5 × 85 cm
The Art Institute of Chicago, gift of The
U.S.S.R. Society for Cultural Relations
with Foreign Countries, 2010.185

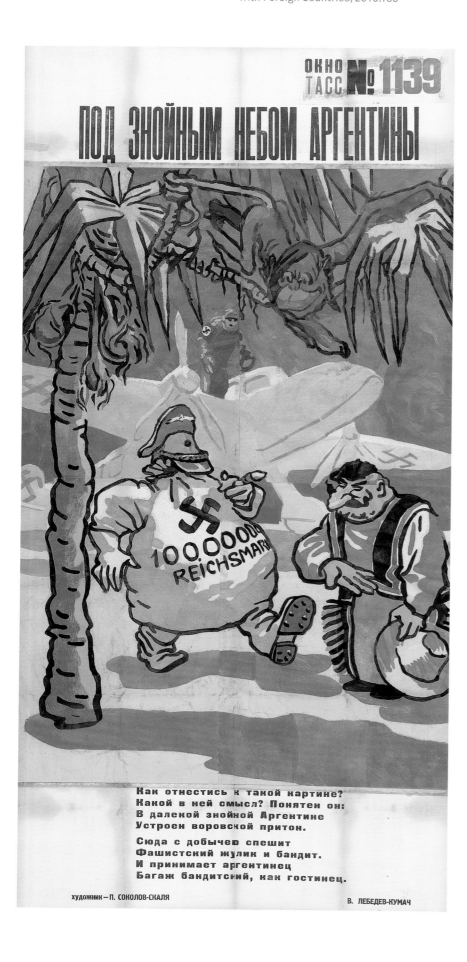

Under the Sultry Sky of Argentina

What should we think of such a picture?
What meaning's in it? We understand:
In far-away, sultry Argentina
A den of thieves has been established!

Here with this loot there hurries
The Fascist scoundrel and bandit.
And the Argentinian accepts
The bandit's baggage as a gift.

From a coconut tree under a blue sky, a monkey watches the arrival of a Nazi officer, disguised as a Reichsmark money bag, holding a cigar in his left hand. He is greeted by an Argentinean gaucho holding a sombrero and welcoming the new arrival and the money he represents. In the background, a pilot disembarks from a plane emblazoned with swastikas.

The third line of the poem is adapted from the title of an unattributed popular song, "In Sunny and Sultry Argentina," known under various titles ("Margo," "The Final Dance") and sung to the tune of Angel Villoldo's 1903 tango "El Choclo." It was popular in pre-Revolutionary Russia. As in TASS 1062 (p. 318), such songs not only provided a useful template for expressing the Nazis' melancholy mood, but also conveyed the sense of a decadent, dying civilization.

Argentina became a magnet for escaping Nazis and collaborators with a sordid past and the means to get there. While the nation had maintained its neutrality, it was pro-Nazi. Pressured by the United States, Argentina made a basically pro forma declaration of war on Germany and Japan on March 27, 1945.

The blue of the sky, bright yellow of the ground, and darker gray of the shadows economically and effectively evoke the brilliant sunshine and deep shade of the Argentinean paradise that beckoned fallen Nazis.

Image: Aleksandr Przhetslavskii
Text: Aleksei Mashistov
Edition: 650
Stencil

131 × 112.5 cm
The Art Institute of Chicago, gift of The
U.S.S.R. Society for Cultural Relations
with Foreign Countries, 2010.138

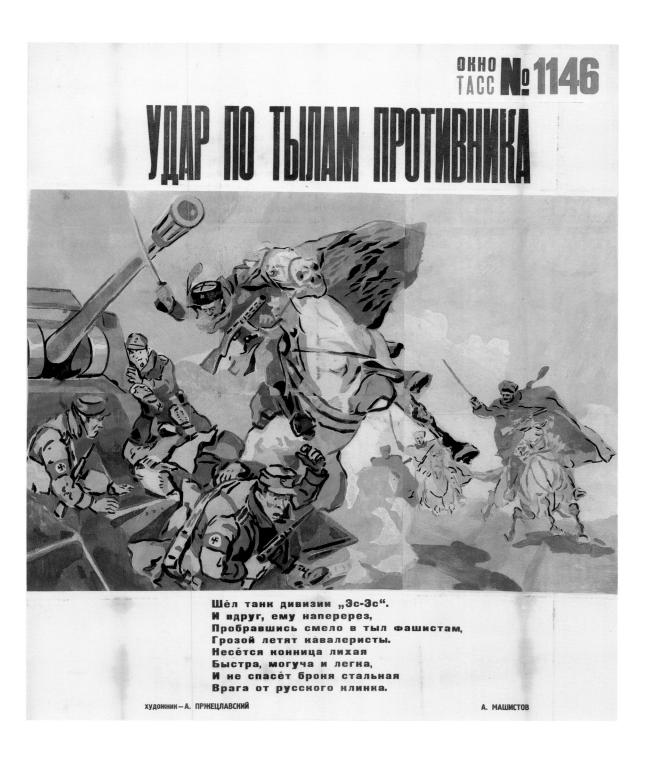

A Blow to the Enemy's Rear

An "SS" tank was moving along.
When its path was suddenly cut off,
Courageously reaching the Fascists' rear
* lines,*
The cavalry flew like a storm.
The wild cavalry flies
Quickly, powerfully, and lightly,
And steel armor will not save
The enemy from the Russian blade.

Soldiers of an SS-Panzer division
are attacked by saber-wielding Red
Army soldiers of a Kuban Cossack
cavalry division. It is worth noting that,
despite the apparent double entendre
in this poem's title, the Russian word
for "rear" (*tyl*) does not present the
same punning potential as its English
translation, which therefore pos-
sesses more humor than the earnest
Russian text.

Between both sides of the war on the
Eastern Front, tens of thousands of
horses were engaged in logistic and
combat situations. In the Red Army,
cavalry units were integrated with
infantry and tank divisions into a
type of military formation known as a
Calvary-Mechanized Group.

This image combines a depiction of
modern warfare with the tradition
of heroic battle paintings, in which
Przhetslavskii specialized.

Image: Pavel Sokolov-Skalia
Text: Osip Brik
Edition: 850

Stencil
177.5 × 83.5 cm
The Art Institute of Chicago, gift of The
U.S.S.R. Society for Cultural Relations
with Foreign Countries, 2010.186

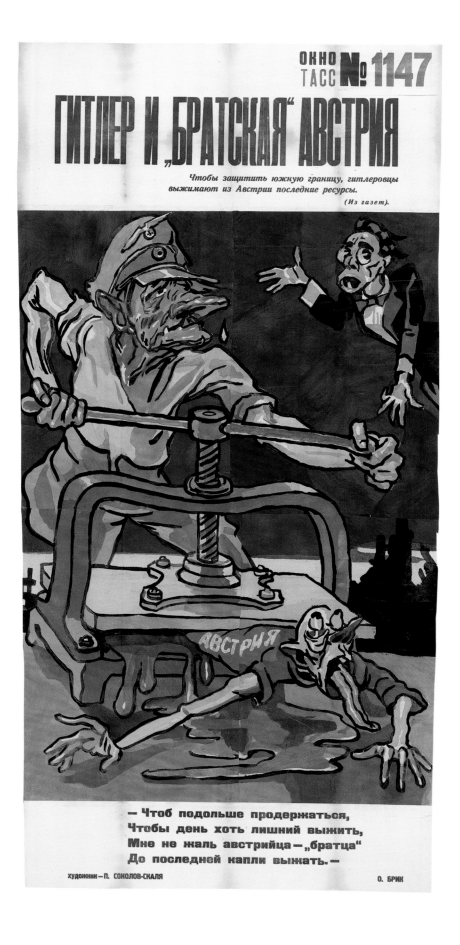

Hitler and "Fraternal" Austria

In order to defend the southern border, the Hitlerites are squeezing the last resources out of Austria. (From the newspaper)

*– In order to hang on longer,
To survive even one more day,
The Austrian – my "little brother"
I will gladly squeeze to the last drop. –*

Against a dark sky over a decimated landscape, a demonic, perspiring Hitler labors to turn the screw of a press that holds a figure labeled "Austria," blood gushing from his crushed body, his tongue extended and eyes bulging. Goebbels, in a tuxedo, soars into the composition from the upper right like an angel in a religious depiction of martyrdom. A grotesque master of ceremonies, he looks out toward the viewer, his hands gesticulating toward Hitler, exhorting his leader to squeeze harder. Austria is presented as Hitler's victim, a sympathetic take on a nation the Soviets would in fact invade on March 29, 1945. Brik's inventive poem is based on a verbal rhyme between the similarly pronounced verbs "to survive" (*vyzhit'*) and "to squeeze out" (*vyzhat'*).

Among Austria's resources, oil was a particularly crucial commodity. Taken literally, the phrase at the end of the verse, "to the last drop," seems to allude to oil. As had been the case with the Caucasus oilfields earlier in the war (Axis Operation Edelweiss, July 1942), access to Austria's oil facilities was of paramount strategic importance to Hitler in keeping the Luftwaffe in the air and the Wehrmacht in the field.

At the beginning of the twentieth century, Austria-Hungary was the third-largest oil producer in the world. After the annexation of Austria by Germany in March 1938, areas known to contain oil were licensed to German companies. By 1943 more than one hundred drilling rigs were in operation in the Vienna Basin area. Oil facilities – plants, refineries, storage depots, and marshaling yards – at Floridsdorf, Korneuburg, Kragan, Lobau, Mainz, Moosbier, Schwechat, Vösendorf, and Winterhafen – had been Allied strategic bombing targets since March 1944 and would continue to be until April 1945.

The ghastly distortions of the three protagonists and bizarre modeling of their faces – using a lurid palette of reds, greens, pale blue, and rose pink – serve to dehumanize them. The contrasting deep purple of the sky lends the scene an apocalyptic aura.

Image: Pavel Sokolov-Skalia
Text: Dem'ian Bednyi
Edition: 650

Stencil
168 × 126.5 cm
Ne boltai! Collection

A Fair Response (A Fable)

In Eastern Prussia, in the woods,
A moose met a dog. The dog ran at full speed.
"Friend," said the moose to the frightened dog,
"Why have you suddenly taken to your heels?
Has some trouble happened in the town you flee?"
"Ah," the dog cried plaintively, "I'm not here by choice:
The whole town is under enemy fire!
And what a town! How elegant it looked;
How it rejoiced when
In recent years along its streets
German forces trooped into Russia!"
"Fortunately, I've never had to be in the town,"
The moose answered glumly,
"But I do know the Germans and their habits.
In Russia, I hear, they have encountered trouble
And it's not a great stretch
To guess they didn't go there
To build new towns.
So do the Germans have the right to fault the Russians
For advancing their awesome front
Right up to Prussian towns,
Without any intention of fixing them up?"

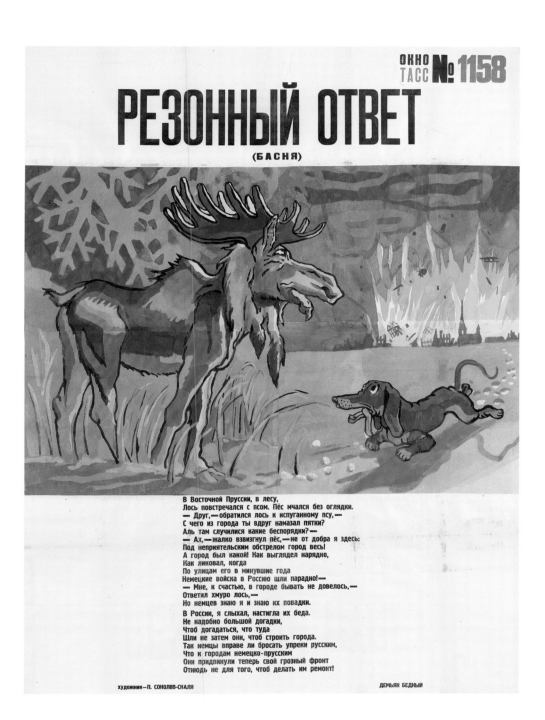

A moose encounters a panting dachshund, a traditional symbol of Germany, in a snow-covered landscape; fires devastating a town in the distance turn the sky red. This poster appeared during Red Army advances in East Prussia.

Bednyi's "Fair Response" was printed on January 24, 1945, in *Pravda*, where he frequently published throughout his long career. Sokolov-Skalia then produced what is essentially an illustration of the poem. "A Fair Response" takes the form of a poetic fable – familiar to readers through the work of La Fontaine and his Russian equivalent, Ivan Krylov – in which animals frequently act as allegories for particular kinds of human characters (see fig. 3.15). Bednyi's poem is written in a form traditionally found in Russian fables: iambic lines of varying length and rhyme schemes. The use of a folksy genre and diction supports the poem's point that revenge is a natural consequence of war.

The light emanating from the exploding city in the distance activates the entire composition, highlighting the contours of the moose in brilliant yellow and casting under both animals shadows and flickering reflections, which imply that the event continues to unfold. Flat, geometric patterns above the moose suggest foliage on snow-covered branches, with glimmers of the reddened sky beyond.

Image: Aleksandr Volkov
Edition: 650
Stencil
159 × 81.5 cm

The Art Institute of Chicago, gift of The U.S.S.R. Society for Cultural Relations with Foreign Countries, 2010.216

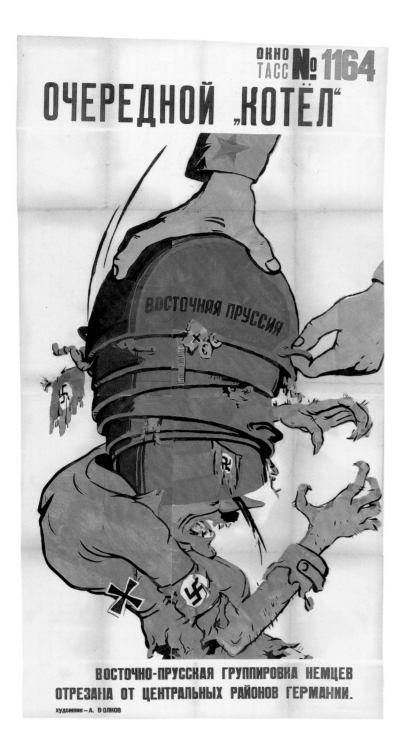

The Latest "Cauldron"

The Eastern Prussian grouping of German forces has been cut off from the central regions of Germany.

A number of cauldrons, such as the one filled with tiny dead German soldiers featured in TASS 1027 (pp. 305–06), have been turned upside down and pressed not only into one another but also onto Hitler's skull. Several bodies and two Nazi flags fall partway out; the topmost cauldron is labeled "East Prussia." A tattered Führer, wearing the Iron Cross, shrieks under the weight of his losses, which seem to crack his neck. His bloody

talons, grasping at air, contrast with the strong pair of hands, identified with a Red Star as Soviet, that smash the cauldrons down and hold them in place. Unlike Hitler's pallid features, the soldier's hands are rendered in a robust tone and embody the strength and resolve of the Red Army.

The early phase of the East Prussian Offensive (January 13–April 25, 1945), culminating in the Red Army's taking of Königsberg (Kaliningrad) on April 9, saw heavy fighting and massive casualties among the Germans caught in various pockets and encirclements.

Fig. 1 Boris Efimov, with text by Samuil Marshak. "From One Cauldron into Another," *Literatura gazetta*, May 1, 1945. The cauldron was a pervasive device among satirists. The poem reads: "One cauldron … Another cauldron … / I'll say without mincing words / That he has diligently passed / His front-line course of cauldrons. // A cauldron on the Volga, on the Dnieper / And at the Baltic waters … / He did not think that on the Spree / He'd also end up in a cauldron. // And he never dreamed, / When setting off for war, / That he had the possibility / Of a "home study" of cauldrons. // Why wander far from home / Amid foreign steppes / When the city of Berlin / Is the finest cauldron of all? // Throw more firewood into the stove, / Comrades, friends of ours, / Until the final cauldron of all / Boils up the pig!"

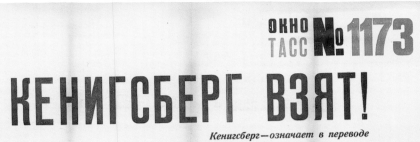

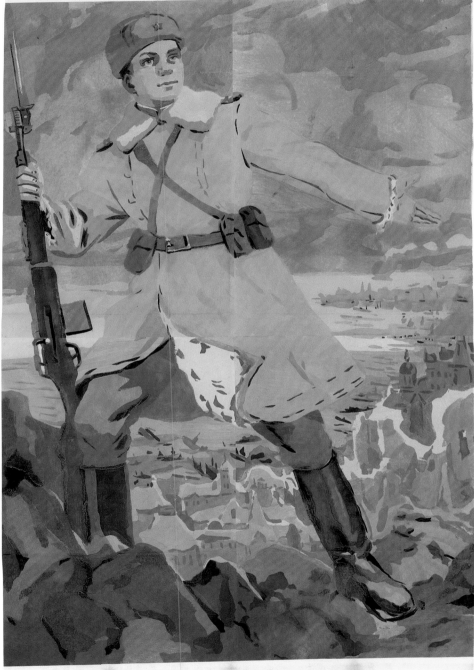

Image: Mikhail Solov'ev
Text: Aleksei Mashistov
Edition: 650
Stencil
177.5 × 85 cm
The Art Institute of Chicago, gift of The U.S.S.R. Society for Cultural Relations with Foreign Countries, 2010.204

Königsberg Is Taken!

In translation, Königsberg means, "Royal Mountain."

To the thunder of the Russians' triumphant "Hurrah!"
One more enemy fortress has fallen,
And the "royal mountain" has become
Yet another pass we have crossed!

A Red Army soldier, in winter field dress and holding a Simonov automatic rifle affixed with a bayonet, fills the composition from top to bottom. He gestures behind him toward the bombed-out, snow-covered city of Königsberg (Kaliningrad). The composition suggests that the soldier is standing on the ruins of Königsberg Castle in order to provide a bird's-eye view of the city, which sits below on a flat plain.

Employing lines of varying length, an imperfect rhyme, and an unusual stress in the final line, the poet Mashistov went to great lengths to include the word *Königsberg* (albeit, its Russian equivalent) in his rough verse. At the same time, the four lines bear a distinct similarity to old regimental songs from the imperial era, which also reference the "triumphant 'Hurrah'" and list the various "fortresses" that the regiment in question has taken. This similarity increases the association of the image of the "mountain pass" with the military legacy of Aleksandr Suvorov (see TASS 1057 [p. 316]). The central image is that of a mountain that has become a passageway to more victories.

TASS 1173 draws upon the long-standing art-historical tradition of exalting military leaders, here filtered through the visual rhetoric of Soviet Socialist Realism, a style in which Solov'ev excelled. The idealized soldier poses in a victorious stance and points to the accomplishments of the Red Army. Exhibiting none of the physical and psychological stresses of combat (see fig. 1), he transcends the realities of battle and signals a prosperous future. The vivid blue of his eyes is heightened by the billowing orange sky, and his gaze is clear.

The final assault on the city and castle of Königsberg, which had been surrounded by the Red Army since January 30, 1945, took place from April 6 to 9. Part of the Red Army's East Prussian Offensive, the four-day battle, after fanatic resistance on the part of the Germans and massive casualties on both sides, ended with the capitulation of the Germans on April 9.

This poster demonstrates the internal design and approval process at TASS. Its number – 1173 – situates it in the studio's numbering system in mid-February 1945, following three posters that were approved by the editorial board on February 22. While it was conceived and possibly designed in February, it was not put into production until April 10, the day after the Soviets took Königsberg. Such time lapses seem to have occurred in particular with liberation-themed posters, which suggests that the Soviets anticipated the capture of certain cities such as Königsberg.[1]

WEATHER
*Partly
Cloudy,
Warm*

Daily Worker

**
Edition

Vol. XXII, No. 86 New York, Tuesday, April 10, 1945 (12 Pages) Price 5 Cents

KONIGSBERG WON AFTER 70 DAYS

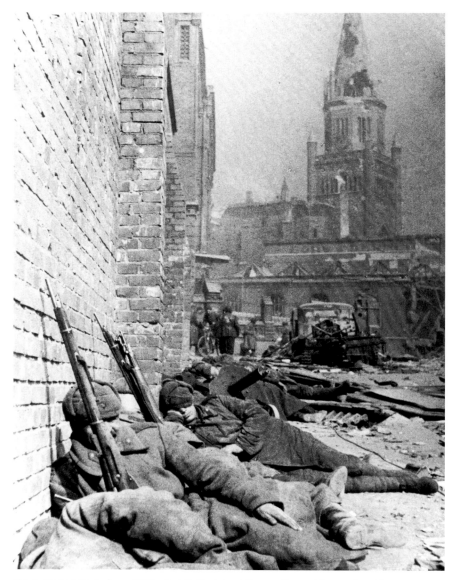

Fig. 1 Mikhail Savin (born 1915; died ?). Soviet soldiers, collapsed from exhaustion, after the capture of Königsberg, East Prussia, April 9, 1945. German-Russian Museum Berlin-Karlshorst.

Image: Petr Sarkisian
Text: Osip Brik
Edition: 850

Stencil
141.5 × 125.5 cm
The Art Institute of Chicago, gift of The
U.S.S.R. Society for Cultural Relations
with Foreign Countries, 2010.156

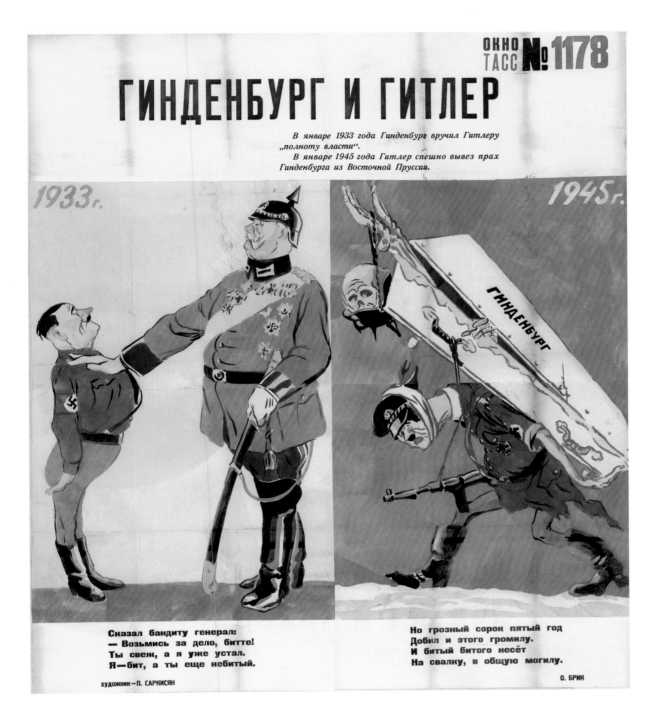

Hindenburg and Hitler

*In January 1933, Hindenburg gave Hitler
"full power."
In January 1945, Hitler hurriedly shipped
the remains of Hindenburg out of Eastern
Prussia.*

*The general said to the bandit:
"Get down to work, bitte!
You're all fresh, and I am tired.
I'm beaten, and you're not yet beaten."*

*But the awesome year of 1945
Beat even this old thug.
And the beaten one carries another
beaten one
To the rubbish heap, to a common grave.*

In the panel labeled "1933," Paul
von Hindenburg (1847–1934), field
marshal and president of Germany
from 1925 until 1934, anoints Hitler.
Hindenburg appointed Hitler chancel-
lor of Germany in 1933 and remained
in office until his death, whereupon
Hitler declared himself Führer and
chancellor. In the "1945" panel – Hitler,
his uniform in tatters, a gun hang-
ing over his shoulder and a scarf
tied around his chin and hat – bends
forward under the weight of the
partly open casket containing the
remains of Hindenburg that he car-
ries on his back over snow-covered
ground. Dangling from skeletal feet
hanging out of the coffin is a spiked
helmet (*pickelhauben*) containing
Hindenburg's skull. The second panel
reveals awareness on the part of
the TASS studio of the odyssey on
which, following Hitler's orders,
Hindenburg's casket had embarked
at the end of January 1945. But it
also evokes the complex history of
Germany, Poland, and Russia in which
Hindenburg figured.

Upon the outbreak of World War I
in August 1914, Hindenburg, then
sixty-seven and retired from the
military, was called up for active
duty. When Russia's imperial armies
crossed the border into East Prussia
(see fig. 1), Hindenburg's forces sur-
rounded and annihilated the Russians
under General Sergei Samsonov at
Tannenberg (Stebark). This major
encounter (August 27–30) – the first
between Russian and German armies
in World War I – was known as the
second battle of Tannenberg. The
first took place near the villages of

Tannenberg and Grünwald on July 15, 1410, when united Polish and Lithuanian forces defeated the Order of Teutonic Knights and halted its advance eastward. Nearly five centuries later, Hindenburg's victory over the Russian armies was seen as a vindication of the first battle of Tannenberg.

Reverberations of the defeat at the hands of the Poles and Lithuanians in 1410 emerged in the Nazis' Operation Tannenberg. Some four months before Germany invaded Poland (September 1, 1939), the Germans prepared a list of Polish activists and members of the military, the intelligentsia, and culturally prominent circles in Poland and Germany with the intention of exterminating them. They accomplished their goal quickly, completing the killings by October 1939.

On the tenth anniversary of the Battle of Tannenberg in 1924, Hindenburg dedicated what would become the Tannenberg Memorial, commemorating fallen German soldiers at a site near Hohenstein (Olsztynek, Poland). Built in 1925–27, the completed fortresslike memorial was unveiled on September 18, 1927, Hindenburg's eightieth birthday. Renamed Reichsehrendenkmal Tannenberg by the Nazis, the memorial became a symbol of the glory of the German armed forces and a place of pilgrimage for thousands of Germans. Upon Hindenburg's death in 1934, Hitler decided that the Tannenberg memorial should become a mausoleum for the leader and his spouse. The couple's remains were laid to rest in a lavish ceremony on August 7, 1934, with Hitler's funerary oration ending with the words "Supreme Commander, enter Valhalla" (see fig. 3).

On January 20, 1945 – just one day before the Red Army secured Tannenberg, along with other towns in the region – Hitler, concerned about desecration of the memorial by the rapidly advancing Soviets, ordered that the Hindenburgs' caskets be removed and the memorial's entrance tower, along with the tower that served as the mausoleum, blown up. The odyssey of the caskets was about to begin. From Tannenberg they were taken to Königsberg and placed on the SS *Emden*. Fearing the approaching Red Army, the German cruiser set out on January 25 for the port of Pillau (Baltijsk, Kaliningrad province) on the Gulf of Gdańsk and then to Kiel, where it arrived on February 1. The next stop was a bunker in Potsdam-Eiche, near the Sanssouci palace, in Potsdam, outside Berlin, where the caskets holding the Hindenburgs joined company with those of King Frederick Wilhelm I of Prussia and Frederick the Great, until recently entombed in the Garrison Church, Potsdam. On March 16, along with royal and military regalia and Frederick's library and works of art, the four caskets would be deposited in a walled-off shaft in a salt mine at Bernterode near Eichsfeld, Thuringia.

On April 27, 1945, American forces would became aware of the salt mine and its contents. Between May 3–9, the caskets would be transferred secretly to Marburg an der Lahn, the capital of the state of Hesse, in the American Sector, and deposited at the Landgrafenschloss. Drawn-out negotiations between American government agencies and German authorities after the war would result in a final resting place for the Hindenburgs, the Gothic Elisabethkirche, built by the Order of the Teutonic Knights, in Marburg.[1]

This poster's large edition – 850 was more, by almost a third, than the numbers issued for other posters in the several months before and after it was published – was not equaled until TASS 1243–1244 (pp. 363–65), a victory poster issued in May. This indicates that the studio believed TASS 1178 would prove to be a particularly powerful image.

WEATHER
Cloudy,
Moderate
Winds

Daily Worker

★★
Edition

Vol. XXII, No. 19 New York, Monday, January 22, 1945 (12 Pages) Price 5 Cents

TAKE TANNENBERG IN SOVIET SWEEP
Seize 600 Towns on German Soil

Fig. 1 Artist unknown (Russian). *Russia's War with the Germans: Russian Forces Enter Prussia*, 1914/17. Publisher: Tipo-lit. Torg. Doma A. V. Krylov i Ko. Edition: unknown. Offset lithograph; 53.3 × 40.6 cm. Hoover Institution Archives, Stanford University. The caption reads: "The border posts between Russia and Prussia. Having attached a portrait of the HIS MAJESTY THE EMPEROR to the post, the leader of the Russian detachment commanded forward,' and the troops entered the enemy's territory singing the hymn 'God Save the Czar.'"

Fig. 2 E. H. Shepard (English, 1879–1976). "The Removal," *Punch*, January 31, 1945. The caption reads, "Where do you want this put?" Ten days after Hitler ordered the removal of Hindenburg's remains from Königsberg, the English satirical magazine *Punch* illustrated the event with this cartoon, which shows Nazi soldiers taking the casket to the Führer's alpine hideaway, Berchtesgaden.

Fig. 4 Boris Efimov, with text by Vladimir Dykhovichnyi (born Moscow, 1911; died Rostov-on-Don, 1963). "Total Raw Material Reserves," *Krasnaia zvezda*, February 8, 1945. This cartoon takes up another aspect of the Hindenburg saga, indicated by the sign in the cartoon, which states, "Recycling Collection Point (Rags, Bones, Scrap Metal, etc.)." The caption reads: "German radio has reported the 'patriotic act' of the relatives of Field Marshal Hindenburg, who have donated to the clothes bank the uniform the field marshal wore in the battle near Tannenberg in 1914." The accompanying poem reads: "In a wave of loud publicity / They announce a recycling drive. / People bring rags, glass, and paper. / Rag and bone! Bring out your junk! // With countless holes / These are the relics of war: / After Hindenburg's uniform / Come Ludendorff's trousers. // They look inexpressive and wan – / We'll mention by the way / That the ideologue of total war / Wore holes in his pants in vain. // They bring their hordes of nonferrous metals, / The scrap of German medals, / Making glue from generals' bones. / Rag and bone! Bring out your junk!"

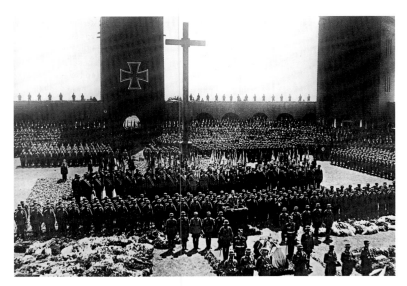

Fig. 3 Photographer unknown (German). Ceremony for the placement of the caskets of Paul von Hindenburg and his wife at the Tannenberg Memorial, 1934.

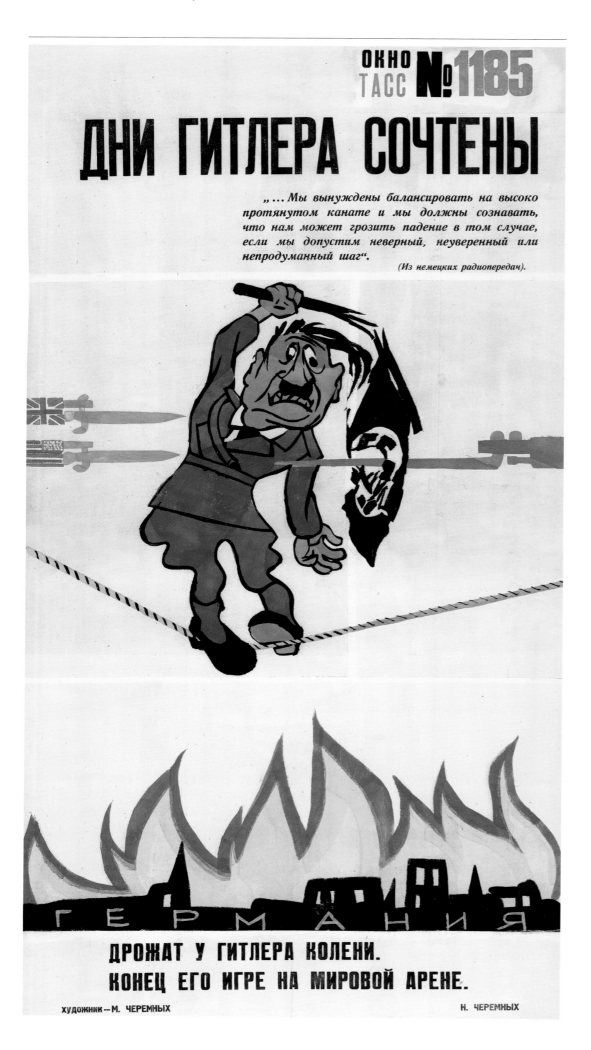

ОКНО ТАСС №1185

ДНИ ГИТЛЕРА СОЧТЕНЫ

„...Мы вынуждены балансировать на высоко протянутом канате и мы должны сознавать, что нам может грозить падение в том случае, если мы допустим неверный, неуверенный или непродуманный шаг".

(Из немецких радиопередач).

ГЕРМАНИЯ

ДРОЖАТ У ГИТЛЕРА КОЛЕНИ.
КОНЕЦ ЕГО ИГРЕ НА МИРОВОЙ АРЕНЕ.

ХУДОЖНИК — М. ЧЕРЕМНЫХ Н. ЧЕРЕМНЫХ

Image: Mikhail Cheremnykh
Text: Nina Cheremnykh
Edition: 650
Stencil
128 × 85 cm
Library of Congress

Hitler's Days Are Numbered

"...We are forced to balance on a high tightrope and we must acknowledge that we may fall if we make a wrong, reticent, or rash step." (From German radio broadcasts)

Hitler's knees are trembling.
His game is ending in the world arena.

Above a city in flames labeled "Germany," a frantic Hitler tries to use a torn and broken Nazi flag to balance on a tightrope while being attacked by rifles with bayonets bearing the Allies' national flags. Nina Cheremnykh's rhyming couplet harks back to the blunt puns of Mikhail Cheremnykh and Maiakovskii for the ROSTA posters.

TASS 1185 reflects the status of the conflict in the various theaters of war and the hotly debated question of which of the Allied armies would conquer Berlin. That here the Soviet bayonet is much closer to Hitler's heart than those of Britain and the United States indicates not only faith in the Red Army's ability to win the prize but also recognition that the goal was within its reach.

Mikhail Cheremnykh rarely depicted Hitler in his poster designs, and when he did (see TASS 5 [p. 166]), his approach to the Führer was comical – almost Chaplinesque – rather than biting.

Image: Aleksandr Danilichev
Text: Aleksei Mashistov
Edition: 650

Stencil
150.5 × 124.5 cm
Ne boltai! Collection

Kostrzyn (Küstrin) Is Taken!

After heavy fighting, the troops of the First Belarusian Front captured the city and fortress of Kostrzyn (Küstrin) on March 12. This is a key junction of the Germans' lines of communication and a strong point of leverage for the Germans' defenses on the Oder River, which have been blocking attacks on Berlin.

*At the junction of the enemy's roads
We battled fiercely.
From here, toward the East,
The Germans rushed trains with
 armaments.*

*With our heroic blow
We swept the enemy from his path.
So that the trains would go back West
With armaments for Soviet troops.*

This poster depicts combat between Soviet and German soldiers on the wet platform of a damaged covered railway station. In front of the boxcar at left is a transport of German tanks; beyond the station's arched, glass-paneled roof, burning buildings and church steeples can be seen. Reflected light on the wet pavement multiplies the shadows of the figures; the one that is second from the left seems to levitate over his own shadow. Though the image is realistic in style, the handling of the paint is abbreviated, which accentuates the sense of movement in the scene.

Since Danilichev probably had not visited Küstrin and may have taken artistic license in his depiction of the site, he probably looked at photographs or newsreels. TASS 1188 seems to feature the Neustadt

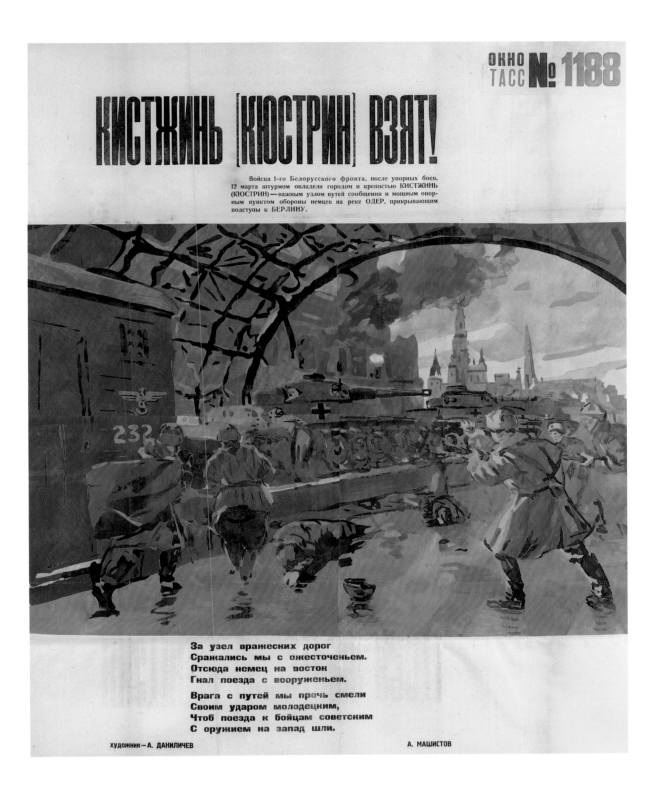

railway station, located in one of the four quarters that made up Küstrin. Mashistov's rudimentary verse suggests that Soviet forces would turn this strategic link in German defenses into a powerful pivot for the Soviet advance on Berlin.

The town of Küstrin, forty miles east of Berlin, was once in Germany and is now part of Poland. Named Kostrzyn nad Odra, it is located at the confluence of the Oder and Wartha rivers. A garrison and fortress town, it was a major railway hub between Berlin and Gdańsk and, as such, critical to the Red Army as it secured the approaches to Berlin. The advance of Soviet troops toward the German capital was a cause for celebration among the Allies (see fig. 1).

The importance of Küstrin was expressed by a German infantry soldier during a stage of the battle for the city:

While we were quelling the Russians' surprise attack, train after train rolled past behind us southwards over the Warthe bridge, taking numerous wagons, mainly goods wagons, to safety. The engine cylinders hissed barely a meter from our boots. The trains left Küstrin close together, without lights and almost without a sound. We could not concern ourselves with them and did not know what they were taking: wounded, refugees, military or civilian goods?[1]

After heavy fighting, the town was secured by the 1st Belarusian Front forces on March 12, 1945. Prior Allied air raids on this major communication center and the subsequent heavy fighting in the battle for the town resulted in its destruction.

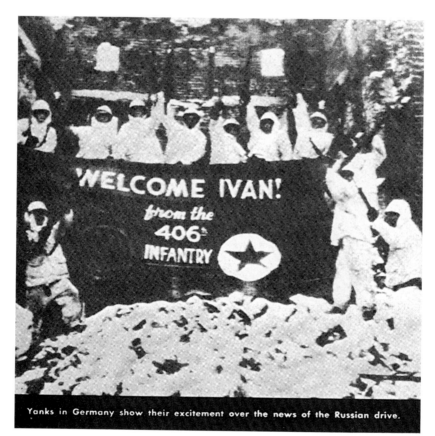

WEATHER
Clearing
And
Mild

Daily Worker

★★
Edition

Vol. XXII, No. 62 New York, Tuesday, March 13, 1945 (12 Pages) Price 5 Cents

ZHUKOV TROOPS TAKE KUESTRIN
Oder Fortress Is a Key to Berlin

Yanks in Germany show their excitement over the news of the Russian drive.

Fig. 1 Photographer unknown (American). "Yanks in Germany Show Their Excitement over the News of the Russian Drive," *Yank, The Army Weekly* (February 23, 1945). American soldiers display a sign, "WELCOME IVAN! From the 406th Infantry," upon hearing that the Soviets had reached the Oder River (the Vistula-Oder Offensive). At the time, the 406th Infantry Regiment of the 102nd Infantry Division was engaged in Operation Grenade – crossing the Ruhr – which began on February 22, 1945.

Image: Petr Sarkisian
Text: Vasilii Lebedev-Kumach
Edition: 650

Stencil
139 × 122 cm
The Art Institute of Chicago, gift of The
U.S.S.R. Society for Cultural Relations
with Foreign Countries, 2010.157

The Last Masquerade

The hardened SS Fritzes
Are playing a last-gasp masquerade. –
Attempting to hide from the Red Army,
They change their visage and their
* clothes.*

Fleeing from justice and from
* punishment,*
They shave off their beards and
* mustaches,*
They put on peaceful robes
And ladies' bonnets instead of helmets!

But no kind of masquerade
Will ever trick the Soviet fighter. –
Behind any mask or costume
He will expose the Fascist scoundrel!

ОКНО ТАСС № **1191**

ПОСЛЕДНИЙ МАСКАРАД

Матёрые эсэсовские фрицы
Затеяли предсмертный маскарад, —
Стремясь от Красной Армии укрыться,
Они меняют облик и наряд.

Спасаясь от суда и от расплаты,
Они сбривают бороды, усы
И надевают мирные халаты,
А вместо касок — женские чепцы.

Но никаким подобным маскарадом
Не провести советского бойца, —
Он под любым обличьем и нарядом
Фашистского откроет подлеца!

ХУДОЖНИК — П. САРКИСЯН В. ЛЕБЕДЕВ-КУМАЧ

Fig. 1 Joseph LeBoit (American, 1907–
2002). *Untitled*, from *Herrenvolk Suite*,
1942–43. Woodcut; 46 × 35 cm. The Art
Institute of Chicago, gift of Mollie LeBoit,
2007.320. LeBoit's prints concern many
of the subjects treated by Soviet graphic
artists. In this scene, two cross-dressing
Axis soldiers, both sporting military
decorations, surrender in a snow-
covered mountainous setting.

In two scenes, a German soldier is
seen fleeing into a ramshackle house
through the front door while still in
uniform and exiting through the back
door dressed in a woman's garments.
The scene is enlivened by elements
such as a chained dog and a bird on the
roof that watch the soldier's actions
and by details such as his frostbitten
toe (the latter created by multipart
stenciling on his boot).

There are noticeable discrepancies
between the image and text. Instead
of shaving his facial hair and don-
ning a "peaceful robe" and a "lady's
bonnet," Sarkisian's soldier wears a
mustache and covers himself with a
fringed blanket. He also wears a fox
stole and a feather-decorated fedora
over his cap but does not conceal its
swastika. He has managed only to
remove one boot, replacing it with a
high-heeled shoe.

The notion of unmasking had a rich
history in official Soviet discourse,
which frequently called upon Soviet
citizens to reveal and denounce
enemies of one or another sort, from
former monarchists and kulaks
to Trotskyites.[1]

Image: Pavel Sudakov
Text: Nikolai Berendgof
Edition: 650

Stencil
134.5 × 125 cm
The Art Institute of Chicago, gift of The
U.S.S.R. Society for Cultural Relations
with Foreign Countries, 2010.213

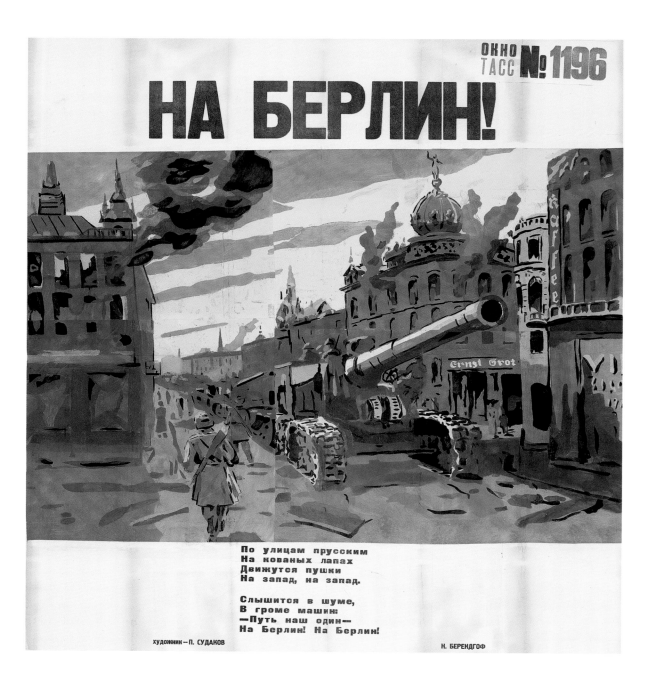

To Berlin!

Along Prussian streets
On metal feet
Cannons are moving
To the West, to the West.

You hear through the noise,
In the rumbling engines,
"There's only one way for us!"
To Berlin! To Berlin!

Red Army soldiers accompany a how-
itzer along a Berlin street lined with
bombed-out and burning buildings.

TASS 1196 actually anticipated the
arrival of the Red Army in Germany's
capital. It was issued on March 26,
1945, four weeks before the Soviets
encircled Berlin, on April 21. In
addition, perhaps, to taking artistic
license in composing this scene,
Sudakov must have consulted a post-
card, photograph, or some other
visual document made prior to the
outbreak of the war to arrive at this
composite image. The street can be
identified as the Oranienburgerstrasse,
at the corners of Montbijou and
Krausnickstrasse, based on iden-
tifiable buildings. The structure
in flames at the left is the for-
mer Haupttelegraphenamt (Main
Telegraph Office), and the imposing,
onion-domed building that burns
at the right is the Neue Synagogue,
the main synagogue of Berlin's
Jewish community.[1]

Berendgof's poem is an interesting
mix of ternary meters, culminating
in a galloping line that in Russian,
as in the English translation, is an
anapest (two unstressed syllables fol-
lowed by a stressed one). The brevity
of the lines, each with two stressed
words but ranging from four to six
syllables, turns the rhythmic varia-
tions into a drumbeat meting out the
command of fate.

Image: Aleksandr Przhetslavskii
Text: Nikolai Berendgof
Edition: 650

Stencil
150 × 79 cm
The Art Institute of Chicago, gift of The
U.S.S.R. Society for Cultural Relations
with Foreign Countries, 2010.140

In the Carpathian Mountains

Knee-high snow and wind in the
 Carpathians
Hamper the passage of our soldiers.
But there are no barriers for the Red
 Army.
And we remember Suvorov's words,
Which resound again for us today:
"Where deer cannot pass,
 Soldiers find a way."

Under a starry sky, Red Army soldiers
and heavily laden horses traverse a
snow-covered mountain ridge. The
landscape is layered with abstract
patterns of silvery, dappled reflec-
tions of moonlight; shadows are ren-
dered in hues of lavender, cold blue,
green, and white.

As in his previous effort (TASS 1196
[p. 350]), Berendgof seems to have
varied meters intentionally. This time
he used a ternary meter in the first
line before switching to an iambic
pentameter that dwindles to a shorter
iambic meter in the final two lines. In
effect, the first line belongs to a lyrical
song, while the rest of the poem beats
out a heavy march and culminates
in a folksy boast. The combination of
styles results in an interesting, if not
entirely successful, poem.

With no specific references to events,
battles, or locations, this poster
can be considered an homage to the
hardships experienced and the
endurance displayed by the Red Army
soldiers in various recent offensive
operations in the eastern and
western Carpathians.[1]

Given the nature of the terrain,
Berendgof's evocation of Aleksandr
Suvorov is apt, as it refers to his
Italian and Swiss expedition (1799–
1800) during the French Revolutionary
wars, in particular his strategic retreat
by crossing the Panixer Pass and the
snow-covered mountains of
the Bundner Oberland. Indeed,
Przhetslavskii's painting closely
resembles Aleksandr Kotzebue's
*Aleksandr Suvorov Crossing the
Panixer Pass* (fig. 1).

Fig. 1 Aleksandr Kotzebue (Russian, 1815–1889). *Aleksandr
Suvorov Crossing the Panixer Pass*, 1860. Oil on canvas; 338 × 285
cm. State Hermitage Museum, St. Petersburg.

Image: Sergei Kostin
Text: Dem'ian Bednyi
Edition: 650
Stencil
180.5 × 92.5 cm
The Art Institute of Chicago, gift of The
U.S.S.R. Society for Cultural Relations
with Foreign Countries, 2010.91

An Inescapable Date

*The fulfillment of the unshakable
 decisions
Of the Allied conference in the Crimea:
In Germany the rumble of fighting is all
 the louder!
The organizers of the Fascist crimes
Approach their end.*

*The day is near when we will note
On a new page of our calendars:
"Today we drove into a cage
The rabid Fascist beasts!"*

*The Fascists in a sudden panic
Still try to threaten us somehow,
Howling and screaming plaintively.
But from this terrible calendar date,
So nightmarish for them, those
 murderers,
There will be no escape!*

The butt of a rifle displaying the Allies'
flags forces into a cell a cloaked Hitler,
along with a diminutive Goebbels, an
obese Göring, and Himmler. The sign
on the bars reads, "War Criminals."

TASS 1198 refers to discussions that
took place at the Yalta Conference,
held at Yalta on the Black Sea, Crimea,
on February 4–11, 1945. There
Churchill, Roosevelt, and Stalin met
to consider Europe's postwar reor-
ganization politically, militarily, and
economically. Among the issues
covered was the reestablishment of
European nations such as Poland and
the partitioning of Germany and Berlin
into four occupied zones. And, as
articulated in Bednyi's typically prolix
poem, Nazi war criminals were to be
hunted down and brought to justice.

One of the most significant implica-
tions of the talks at Yalta was the ced-
ing of a geographic zone of influence
to Stalin, without representation from
the countries implicated. Although
it was agreed that all liberated
European and former Axis satellite
countries could hold free elections,

Communist governments would be forcibly installed in Albania, Bulgaria, Czechoslovakia, East Germany, Hungary, Poland, and Romania after the war, creating a zone that would lie behind the Iron Curtain for much of the remainder of the twentieth century. This new Eastern Bloc would be expanded even beyond the lands annexed before or at the very beginning of the war, in the Baltics, Belarus, and Ukraine.

At the conference, Roosevelt and Churchill were forced by political expediency to agree to a secret arrangement, according to which they would forcibly return to the Soviet Union all Soviet citizens – whether in the Red Army or not – whom they liberated from German prisoner-of-war and forced-labor camps. Between 1945 and 1947, the United States State Department and the British Home Office would see to it that thousands of Soviets were delivered into Stalin's "care." In effect, the repatriation would prove to be a death sentence, since most of these people would not go home but rather would be shipped to remote prison camps, where they would die.

Remarkable in this poster, as in others by Kostin, is the variety of ways in which the paint was applied to create veils of color. Staccato touches with a dry brush resulted in areas in which the pigment is stippled and the white of the paper breaks up the color field to produce the diaphanous effects of a watercolor. This yields complex chromatic passages that nonetheless retain translucency. The artist developed his composition with layers of planar hues independent of a linear framework. They teeter on abstraction, forcing the viewer to participate in making out significant forms.

Süddeutsche und Münchener Ausgabe
40. Ausgabe / 58. Jahrgang / Einzelpreis **15 Rpf.** „Freiheit und Brot!"

Süddeutsche und Münchener Ausgabe
● München, Freitag, 16. Februar 1945

VÖLKISCHER BEOBACHTER

Kampfblatt der nationalsozialistischen Bewegung
Großdeutschlands

Deutschland einziges Gegengewicht gegen Moskau
Jalta - das Todesurteil für Europa

Die deutschen Feststellungen über Roosevelts und Churchills Kapitulation vor Stalin allgemein bestätigt

The headline from the February 16, 1945, Munich issue of *Völkischer Beobachter* reads, "Germany Is the Only Counterweight to Moscow / Yalta – Europe's Death Sentences / German Assessment That Roosevelt and Churchill Have Capitulated to Stalin Is Confirmed."

Fig. 1 Photographer unknown. "Yalta Conference Group Photograph," *Krasnaia zvezda*, February 13, 1945. The caption states: "At the conference in Crimea of the leaders of the three allied powers – the Soviet Union, the United States and Great Britain. The photograph shows: Mr. W. Churchill, Mr. F. D. Roosevelt, and J. V. Stalin among their military advisers. From left to right stand: Field Marshal Alexander, Field Marshal Wilson, Admiral Cunningham, Field Marshal A. Brooke, General H. Ismay, Air Force Marshal Ch. Portal, Admiral W. Leahy, General J. Marshall, Army General A. I. Antonov, General L. Cutter, Navy Admiral N. G. Kuznetsov, Air Force Marshal S. A. Khudiakov."

BETRUGSMANOVER
„Genosse Stalin, die Reisenden kommen vielleicht eher, wenn wir das Reiseziel verdecken!"

Fig. 2 Hetto (?) (German). "Deceptive Maneuver," *Das Reich*, February 25, 1945. The caption reads, "Comrade Stalin, perhaps the travelers will arrive sooner if we cover up the destination." The sign Roosevelt and Churchill carry says "Freedom." Although the Germans could not yet have known about the secret agreement made at Yalta concerning the forced repatriation of Soviet prisoners of war, this cynical cartoon nevertheless accuses the American and British leaders of being complicit in determining a fate for such Soviet citizens that had nothing to do with "freedom."

THE NATIONAL FLAG OF THE POLISH STATE HAS BEEN RAISED OVER GDAŃSK

Image: Mikhail Solov'ev
Text: F. Fedorov
Edition: 650

Stencil
172 × 85.5 cm
The Art Institute of Chicago, gift of The
U.S.S.R. Society for Cultural Relations
with Foreign Countries, 2010.205

*The National Flag of the Polish State Has
Been Raised over Gdańsk*

*Our strength is growing and multiplying.
We have captured yet another fortress –
The Red Army has hoisted high
Its victory banner over the port of Danzig!*

The hand of a member of the Red Army
plants the Polish national colors on a
map of the city of Gdańsk, or Danzig (the
German name for the city), which stands
on the Gulf of Danzig (as it is called in
the quatrain) and at the mouth of the
Vistula River.

The port of Gdańsk fell to the Red Army
on March 30, 1945. A free city under
the auspices of the League of Nations
(according to the Versailles Treaty) prior
to the German occupation in the fall of
1939, Gdańsk became part of Poland as
a result of the Yalta (see TASS 1198 [pp.
352–53]) and Potsdam conferences.

It is not clear why the map and the
poem use the German toponyms, while
the title uses the Polish version. After
all, the poster appears to have been
designed to celebrate the return to
Polish control of the city. The poem, by
Fedorov, an unknown writer, is extremely
rough in form.

TASS 1200 is notable in that it is one
of only a few posters from the studio
that broach the contentious relation-
ship between the Soviet Union and
Poland, a country whose borders and
much of its population both Hitler and
Stalin had planned to eliminate. In fact,
the "return" of Gdańsk to Poland by the
Soviets cloaked the latter's interests in
regaining access to a critical seaport on
the Baltic. In effect, the nation was far
from "liberated" by the Soviet occupa-
tion. Hopes for an independent Poland
were dashed by irreparable conflicts
between Stalin and the Polish govern-
ment in exile, culminating in the capture
and conviction of leaders of the Polish
underground and a trial, known as the
Trial of the Sixteen, in Moscow in June
1945. Soon it became illegal to speak
of the atrocities that the Soviets had
perpetrated in Poland during the war,
such as the Katyn massacre, which the
Soviets blamed on Germany. Russian
responsibility for this event was not
officially acknowledged until the 1990s.
Such complexities highlight how most
of the political "liberations" that took
place before, during, and after the war
were in fact not indicative of indepen-
dence as such, but rather of the transfer
of lands, peoples, and power from one
oppressor to another.

Image: Mikhail Cheremnykh
Text: Nina Cheremnykh
Edition: 650

Stencil
150.5 × 83.5 cm
Ne boltai! Collection

An "Unbreachable" Rampart

The Germans' reliance on strong defensive lines has failed. (From the newspapers)

A panorama of the Germans' "unbreachable" rampart
Following a visit by the Red Army.

This image of carnage does not refer to a specific battle or location. The Red Army's accelerated advances on Nazi-occupied territory and Germany itself and the destruction that ensued prompted Mikhail Cheremnykh's monochrome meditation on the final phase of the war on the Eastern Front. The poem is extremely plain; were it not for the rhyme (in Russian), it would read as a prose caption to the image.

This poster is remarkable for its emphatic palette of grays and the blurred differentiation between corpses and machines — armored vehicles, planes, artillery — that constitute the wreckage. The pale colors in the distant landscape contribute to the bleakness of this apocalyptic scene, relieved only by the vivid red and yellow in the artist's hallmark bursts of flame.

Image: Sergei Kostin
Text: Aleksandr Zharov
Edition: 650

Stencil
115 × 120 cm
The Art Institute of Chicago, gift of The
U.S.S.R. Society for Cultural Relations
with Foreign Countries, 2010.92

The Gauleiter's Trick, or A Futile Disguise

In order to escape revenge,
The living scoundrel gets in his coffin.

Changing his clothes, the bandit gets up
Looking like a peaceful civilian.

But the Fascist cannot trick us
With his false mask
Or his snow-white scarf.
He will not escape retribution!

Fig. 1 Kukryniksy. "Silesian Masquerade,"
Krokodil 10–11 (March 30, 1945). The
caption reads, "Well, Mr. Wolf, now I think
we look a lot like sheep! . . ." The two
wolves have decked themselves out with
white accents – flags large and small, hat
and arm bands, and big bows at the neck
– to ensure their safety at the hands of
the victors.

At the left, a uniformed German in a casket is mourned by a woman dressed in black. In the center, he changes into civilian garb, leaving his uniform, boots, and medals behind. He is attended by the same female – still in black – who holds his cane, glasses, and hat. At the right, his camouflage complete, the man walks down a street and raises his hat to unseen passersby. On his right arm, he wears a white band, which signals surrender and a plea not to be shot by his nation's captors. Zharov presented the brief narrative with wit in four rhyming couplets in iambic tetrameter, the usual meter for Russian narrative poetry.

With defeat in plain sight, flight to safe havens was the goal of military and civilian authorities (the gauleiter – a provincial governor in Nazi Germany – referred to in TASS 1210's title) tainted by their Nazi affiliation and in a position to escape the rapidly approaching Soviet war machine and retribution. The various subterfuges Nazis used to achieve freedom were a rich subject that Soviet graphic artists, Kostin among them, tackled with gusto (see fig. 1). This poster continues the theme of unmasking the enemy seen in TASS 1191 (p. 349).

The elaboration of this poster underscores how the TASS studio invested in chromatic subtleties – demanding increased numbers of stencils – that, while arguably not essential to the basic visualization of the message, nonetheless enhance the allover pictorial effects of its products. Thus, for example, a thin white wash was stenciled on the interior of the coffin, suggesting silk, where it would have been possible to simply leave the white of the paper untouched. Similarly, four different shades of red were used to depict the former Nazi's vest, where fewer might have sufficed. The result of such efforts is a richer visual experience.

Image: Aleksandr Volkov
Text: Aleksei Mashistov
Edition: 650

Stencil
131.5 × 112.5 cm
The Art Institute of Chicago, gift of The
U.S.S.R. Society for Cultural Relations
with Foreign Countries, 2010.217

No Pillbox Will Save the Enemy!

Every day and hour we multiply
Our countless strikes against the enemy.
There is no pillbox in the world
That will save the enemy gang!

In military parlance, a pillbox is a small, bunkerlike structure that is circular and domed. The Russian word for pillbox (DOT) is an abbreviation of "long-term point of fire" and denotes an armored machine-gun nest. Here a red arrow surmounted by a red star shatters a concrete pillbox, revealing Hitler, who is knocked off his feet by the force of the blow. Since mid-January 1945, Hitler had taken up residence in the subterranean Führerbunker in Berlin, beneath the garden of the Reich Chancellery building. By the time this poster appeared, the Red Army had penetrated deep into eastern Germany and was poised to gain and expand footholds along the Oder and Neisser rivers for a final assault on Berlin.

Volkov's design, though figurative, brings to mind El Lissitzky's Civil War–period Suprematist poster *Beat the Whites with the Red Wedge* (see fig. 3.10). The forceful Red Army arrow here echoes, or perhaps quotes, the martial and revolutionary sentiment of Lissitzky's red wedge as it penetrates the spherical encampment of the enemy. Whether or not Volkov knew the famous poster, TASS 1212 updates the stripped-down, geometric symbolism and abstraction of Lissitzky's design, which was criticized for its illegibility. Volkov's image delivers the punch of Lissitzky's composition within the representational vocabulary of caricature and emblematic metaphor of unambiguous and acceptable Soviet war satire.

Image: Pavel Sokolov-Skalia
Edition: 650
Stencil
174 × 100 cm

The Art Institute of Chicago, gift of The U.S.S.R. Society for Cultural Relations with Foreign Countries, 2010.188

Hitler declared: "In Germany the Allies will find only ruins, rats, hunger, and death." (From the newspaper)

The Final Conclusion to His Bloody Dictatorship.

Hitler and Goebbels, portrayed as rats, crouch apprehensively among burning ruins, desperately foraging for human remains. The helmet, boots, and gun identify the remains as those of Germans. This grim poster was issued just days before the Red Army surrounded Berlin. The collapse of the Third Reich was imminent (see fig. 1).

Sokolov-Skalia's caricatures here are so extreme in their grotesquery that they rely on the attributes the artist had earlier established – Hitler's officer's cap and the poison pen of propaganda lodged behind Goebbels's ear – to readily signify the figures' identities. The flaccid, bending gun barrel in the foreground signals that their militarism has been rendered impotent. The tension between the horrific and comic is a hallmark of the artist's poster production, as well as a significant strain in the overall production of TASS satirical posters.

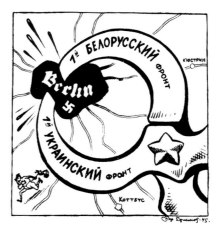

Fig. 1 Boris Efimov. "Grabbing It by the Heart," *Krasnaia zvezda*, April 24, 1945. The caption reads, "The last heart attack of Hitler's Germany." The map lists Küstrin and Cottbus. The pincers say, "1st Belarusian Front and 1st Ukrainian Front." A naked Hitler tries to escape to the southwest, pulling a tiny Goebbels along by his tail. Berlin is in the form of a heart, the center of the German circulation system. By controlling it, the cartoon suggests, Soviet forces will drain all life from the country.

Image: Pavel Sokolov-Skalia
Text: Vasilii Lebedev-Kumach
Edition: 650

Stencil
165.5 × 86 cm
The Art Institute of Chicago, gift of The
U.S.S.R. Society for Cultural Relations
with Foreign Countries, 2010.189

On Berlin's "Avenue of Victories"

*Berlin raised its hands and shouted
"Kaput!"*
*Our tanks advance along the "Avenue of
Victories."*
*Frederick is frightened and Bismarck
trembles,*
*And Hitler's shadow flees without a
backward glance.*
*And even the name "Avenue of Victories"
has apparently*
Changed to the "Avenue of Kaput!"

The Soviets won the race to Berlin,
capturing the Reichstag on April 30,
1945, after a ten-day siege. In this
poster, against the backdrop of a ris-
ing sun, a Red Army tank and soldiers
waving a red banner advance over
the Siegesallee (Avenue of Victory),
crushing statues of Germany's rul-
ers, statesmen, and cultural heroes,
Frederick the Great and Bismarck
among them. The statue behind
Frederick shouts, "Hitler kaput!"
Bismarck, having jumped off his
pedestal, dashes forward and yells
the same phrase. A frantic Hitler runs
just in front of the tank, dressed in
his underwear and clutching two
suitcases. Toward the end of the war,
one of the popular Soviet rallying cries
was "Hitler kaput" (roughly, "Hitler
is dead"). Variations on the phrase
appear in several of the later TASS
posters (see, for example, 1014 [p.

Fig. 1 Artist unknown (German). *Die
Siegesallee*, n.d. Featured on the cover
of this guidebook are the statues of
Frederick the Great and Johann
Sebastian Bach.

Fig. 2 Konstantin Eliseev (born St. Petersburg, 1890; died 1968). "The Avenue of Victories," *Krokodil* 18 (May 19, 1945). Ne boltai! Collection.

Fig. 3 Photographer unknown. View of the Siegesallee with the sculpture of Margrave Albrecht II, c. 1900.

Fig. 4 Willy Römer (German, 1887–1979). View of the Siegesallee with what remained of the sculptures following the war, c. 1949.

301] and 1248 [p. 366–67]), as well as in caricatures, satirical poems, and the like.

The Siegesallee was a leafy promenade in the Tiergarten district of Berlin, stretching from Königsplatz to Kemperplatz. Along the sidewalks on either side, the avenue was adorned at regular intervals with thirty-two independent sculptural groups, each of which featured a marble statue of a ruler from Brandenburg and Prussia from the time period 1157–1888. Made between 1896 and 1901 by the sculptor Reinhold Begas and over two dozen of his students, the statues of the rulers were accompanied by busts of illustrious contemporaries. The "puppensallee" or "avenue of the dolls," as it was nicknamed, was financed by Kaiser Wilhelm II, who had conceived of it as a way to glorify the impe-rial ambitions of the Hohenzollerns. During the war, many of the statues were severely damaged or destroyed (see fig. 4). Those that remained would be removed by the British and buried. Since then, they have been dug up and are undergoing conservation for eventual exhibition in the Lapidarium, a Berlin exhibition venue.

The Siegesallee statues of Frederick the Great and Otto von Bismarck provided Russian graphic satirists with plenty of fodder, as attested to in this poster, as well as in newspapers and satirical publications (see fig. 2).

To define his figures here, Sokolov-Skalia replaced the continuous strong black contour line he normally employed with a rippling, broken outline. This underscores the light emanating from the victorious tank, increases the sense of forward movement, and infuses the scene with a feeling of great activity.

Image: Mikhail Solov'ev
Edition: 650

Stencil
117 × 128 cm
Courtesy Ne boltai! Collection
Not in exhibition

Glory to the forces of the Red Army and of the Allied powers, who have met on the Elbe, at the center of Fascist Germany! (From the appeals of the Central Committee of the All-Union Communist Party for May 1, 1945)

Against a background of a town in ruins, Allied forces, arriving from the west, and Soviet forces, moving from the east, come together, each flying its national colors. The first meeting between Allied and Soviet soldiers took place near the German town of Torgau on the Elbe, on April 25, 1945 (see fig. 1). This heroic image is Solov'ev's interpretation of the event.

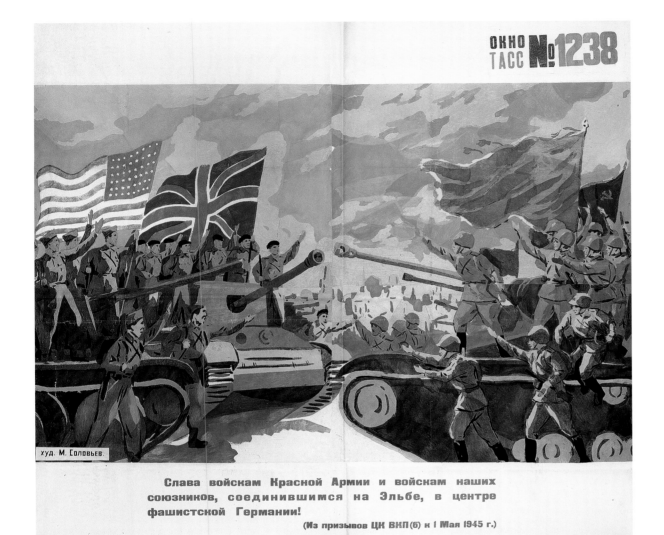

худ. М. Соловьев.

Слава войскам Красной Армии и войскам наших союзников, соединившимся на Эльбе, в центре фашистской Германии!

(Из призывов ЦК ВКП(б) к 1 Мая 1945 г.)

Fig. 1　Georgii Khomzor. "The Meeting of the Soldiers of the 1st Ukrainian Front and Anglo-American Forces," *Krasnaia zvezda*, April 29, 1945. Above: "Soviet and American officers in discussion." Below: "The Red Army guardsman Ivan Numladze, a native of sunny Georgia, and the American soldier Buck Kotsebu, a native of sunny Texas."

Image: Petr Shukhmin
Edition: unknown (probably 750)
Stencil
155.5 × 86.5 cm

The Art Institute of Chicago, gift of The
U.S.S.R. Society for Cultural Relations
with Foreign Countries, 2010.164

*Hail the great organizer and inspirer of
the Soviet people's historic victory over
German imperialism – our beloved leader
and teacher, comrade STALIN!*

This poster represents the victory
celebration over Red Square on May
9, 1945, which included a thousand-
gun salute, fireworks, and 160
searchlights illuminating the night
sky. The Kremlin's Spasskaia (Savior)
Tower can be seen under the dazzling
display.[1] Occupying nearly half of the
composition is a red banner with a
profile of Stalin. The glow around his
head underscores the degree to which
the "cult of Stalin" had granted him
hagiographic status. The poster's vivid
hues and arresting latticelike pattern
of light beams animate the surface
and brilliantly capture the dramatic
effects of searchlights and fireworks.

This image visually reinforces Stalin
as the apotheosis of Soviet state
power; his authority is underscored
here by the Kremlin tower. A rare
image of the deification of Stalin in
the TASS oeuvre, the composition
delivers an unmistakable message:
despite Stalin's flaws, ruthlessness,
and military missteps (many of which
remained unknown to the general
Soviet population), Stalin claimed
credit for the ultimate victory as the
absolute leader (*vozhd'*) of a one-
party nation.

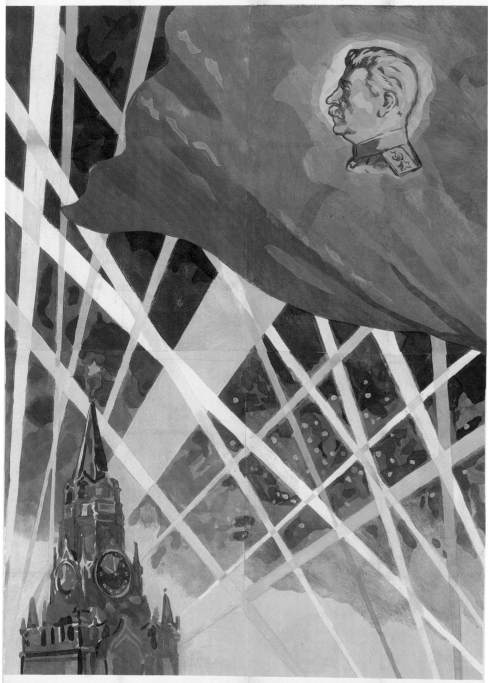

ОКНО ТАСС №1242

Да здравствует великий организатор и
вдохновитель исторической победы советского
народа над германским империализмом—наш
любимый вождь и учитель товарищ СТАЛИН!

художник—П. ШУХМИН

Image: Nikolai Denisovskii
Text: Vasilii Lebedev-Kumach
Edition: 850

Stencil
180 × 150 cm
The Art Institute of Chicago, gift of The
U.S.S.R. Society for Cultural Relations
with Foreign Countries, 2010.80

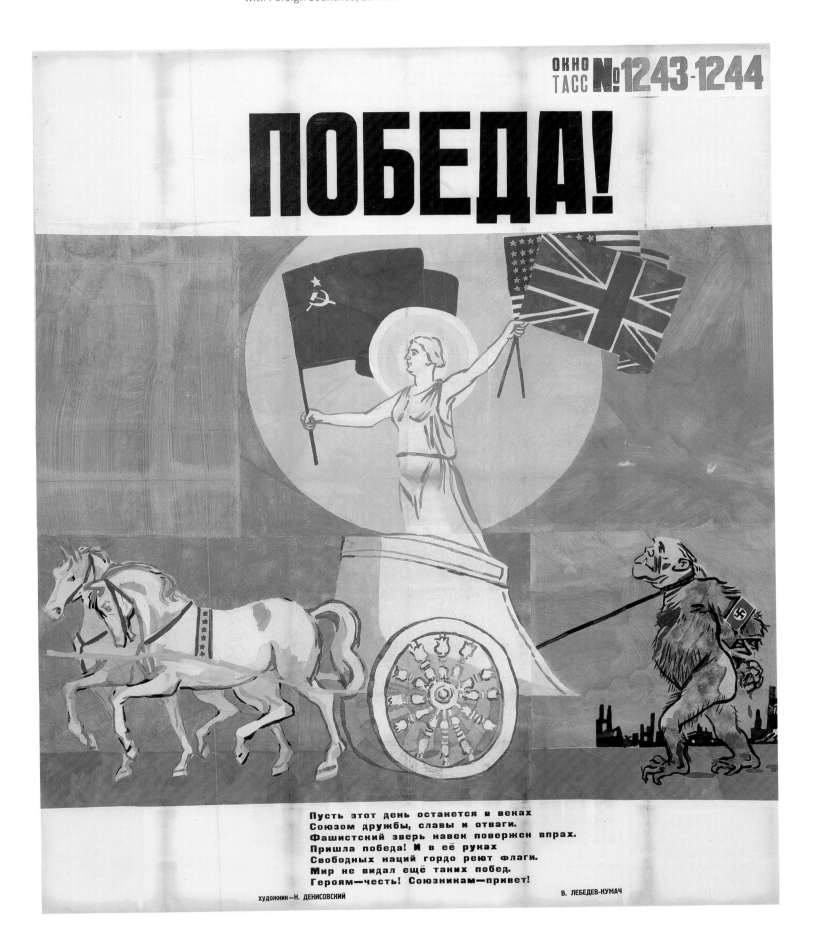

In this poster, a large sun rises over blackened ruins. A matronly personification of Victory stands in a chariot pulled by two white horses. With her right hand, she holds the national standard of the Soviet Union; with her left, the flags of the United States and Britain. Tethered to the back of the chariot is a gorilla wearing an armband with a swastika. Symbolizing the vanquished Nazi brute, the gorilla displays prominent, sharp canines; his bloody hands are tied behind his back; and he leaves behind him a trail of blood. For the TASS editors and artists, the image of the gorilla-cum-Neanderthal brute – the Fascist beast – remained a favorite device to express the Nazis' inhumanity (see, for example, TASS 527 [pp. 217–20] and 606 [pp. 227–28]). Both image and text assert the unity of the Allies while drawing a clear line of distinction between the Soviet Union and the Anglo-American partnership.

TASS 1243–1244 quotes a renowned landmark and symbol of German identity to celebrate German defeat. The image's dominant feature – the horse-drawn chariot carrying Victory – is based on the 1793 quadriga sculptural group designed by Johann Gottfried Schadow, which sat in Berlin atop the Brandenburg Gate, a triumphal arch that stands for Prussia's military prowess and ambition. It served as a backdrop for a number of posters celebrating the Soviet arrival in Berlin and long-awaited triumph over Germany, all featuring the Allies' national flags (see figs. 1–3). The gate was the site of a torchlight parade by the Nazis' paramilitary storm troopers

PARIS EDITION

EXTRA | **THE STARS AND STRIPES** | **EXTRA**

Daily Newspaper of U.S. Armed Forces in the European Theater of Operations

Vol. 1—No. 279 1 Fr. 1 Fr. Wednesday, May 2, 1945

HITLER DEAD

(brownshirts) celebrating the birth of the Third Reich, when Hitler became Germany's chancellor on January 30, 1933. The gate subsequently became the starting point for nationalistic parades down the avenue Unter den Linden, and the quadriga became the logo of the Nazis' nationalist mouthpiece, *Das Reich*. It was severely damaged in the last days of the war and has been replaced.

Schadow's Victory stands in a chariot pulled by four horses; she holds a standard displaying the Iron Cross framed by a garland of oak leaves and crowned by the Prussian eagle. In TASS 1243–1244, the colors of the victorious Allies have been substituted for these attributes of Prussian military prowess, signaling the end of the Third Reich.

Hitler committed suicide in the Führerbunker on April 30, 1945. His remains and those of his wife, Eva Braun, had been doused in petrol and set aflame in the Chancellery's bombed-out garden outside the bunker that same day. On May 2, the remains were discovered by a special Red Army unit charged with finding them.

The stenciling of orange over the yellow background of TASS 1243–1244 lends brilliance to a design that is not otherwise particularly forceful. Denisovskii's work is not as strong as that of many of his TASS colleagues; he may have been a better studio manager than a draftsman.

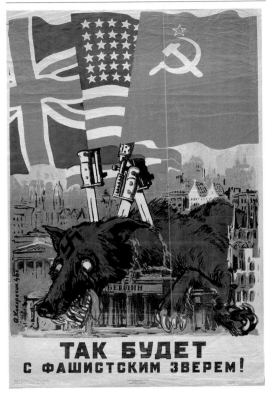

Fig. 1 Aleksei Kokorekin. *So Will It Be with the Fascist Beast!*, 1944. Publisher: Iskusstvo. Edition: 50,000. Offset lithograph; 77.7 × 50.8 cm. Ne boltai! Collection. Reflecting Stalin's May 1, 1944, speech, in which he invoked the death of the Fascist beast, this poster anticipates the fall of the Third Reich, showing the bloody Nazi wolf, slain by the Allies, collapsed over Berlin's Brandenberg Gate. In exhibition.

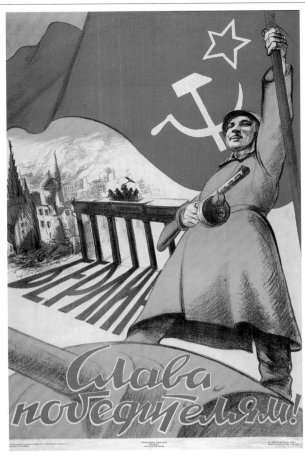

Fig. 2 Mikhail Gordon (born 1918; died 2003), Lev Orekhov (born Tula, 1913; died St. Petersburg, 1992), L. Petrov. *Glory to the Victors*, 1945. Publisher: Iskusstvo. Edition: 10,000. Offset lithograph; 88 × 58 cm. Ne boltai! Collection. In exhibition.

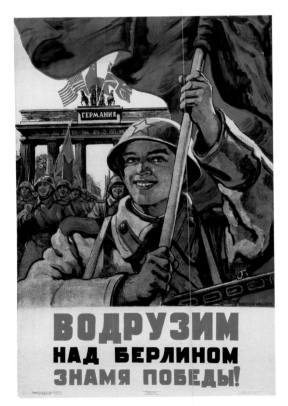

Fig. 3 Viktor Ivanov. *Let Us Raise the Victory Standard over Berlin*, 1945. Publisher: Iskusstvo. Edition: unknown (probably 50,000). Offset lithograph; 85.7 × 56.7 cm. Ne boltai! Collection.

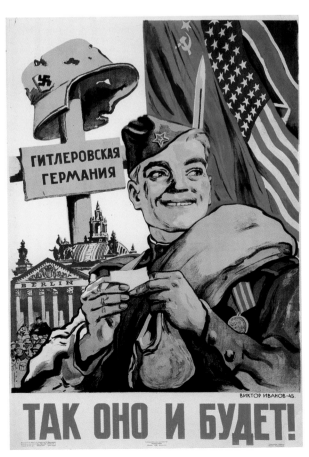

Fig. 4 Victor Ivanov. *So It Shall Be!*, 1945. Publisher: Iskusstvo. Edition: 50,000. Offset lithograph; 86 × 56.5 cm. Ne boltai! Collection. This poster substitutes the Reichstag for the Brandenburg Gate. The sign nailed to the cross reads, "Hitler's Germany."

Image: Petr Shukhmin
Text: Dem'ian Bednyi
Edition: unknown (probably 750)

Stencil
146 × 123.5 cm
The Art Institute of Chicago, gift of The
U.S.S.R. Society for Cultural Relations
with Foreign Countries, 2010.165

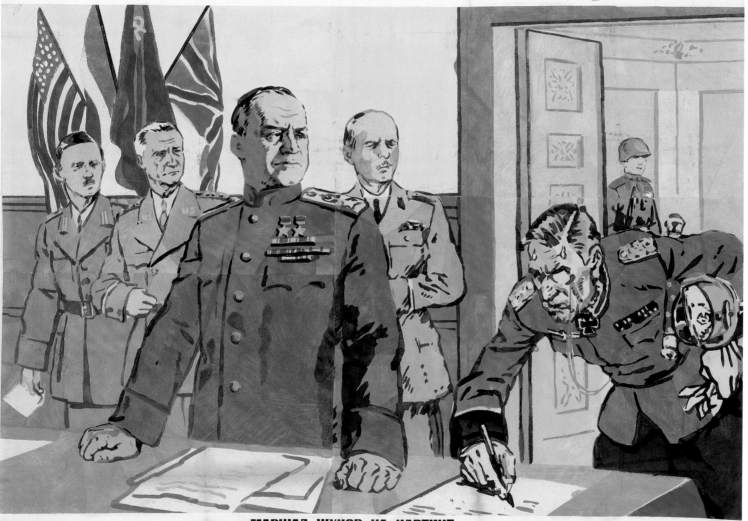

A stern and erect Marshal Georgii Zhukov (1896–1974) witnesses a bent and perspiring Field Marshal Wilhelm Keitel (1882–1946) sign the Act of Surrender. The grimace on the German's face could be read as either humiliation or defiance. Behind Zhukov, underneath the Allies' flags, stand, left to right, Arthur Tedder (1890–1967), marshal of Britain's Royal Air Force; General Carl Spaatz (1896–1974), commander of the United States Strategic Air Force; and General Jean de Lattre de Tassigny (1889–1952), commander of the 1st French Army. Although it appears to comment directly on the image, Bednyi's poem diverges from it in its particulars; instead of three high-ranking German officers, we see only Keitel.

The signing of the Act of Surrender took place on May 8, 1945, in Berlin-Karlshorst, a suburb of Berlin, at Zhukov's headquarters.[1] Photographs and newsreels of the event reveal that TASS editors or Shukhmin himself took artistic license in composing the scene. Zhukov was seated, as was Keitel, when the latter signed the unconditional surrender (see fig. 1). No doubt the TASS team understood that an upright Zhukov and a bowed Keitel made a dramatic portrait of victor and vanquished.

Following a now-established tradition, this poster exhibits two different representational styles, one for the enemy and another for the Soviets. This time, however, the artist adapted and modified an extreme oppositional dynamic in the service of portraiture. Though delineated with a coarser line and modeling that bring it close to the grotesque, Keitel's face is recognizable. It, like the poster's other portraits, was based on photographs.

WEATHER
Sunny
And
Mild

Daily Worker

★★
Edition

Vol. XXII, No. 111 New York, Wednesday, May 9, 1945 (12 Pages) Price 5 Cents

REICH SURRENDER RATIFIED IN BERLIN
Japan Next, Truman Vows

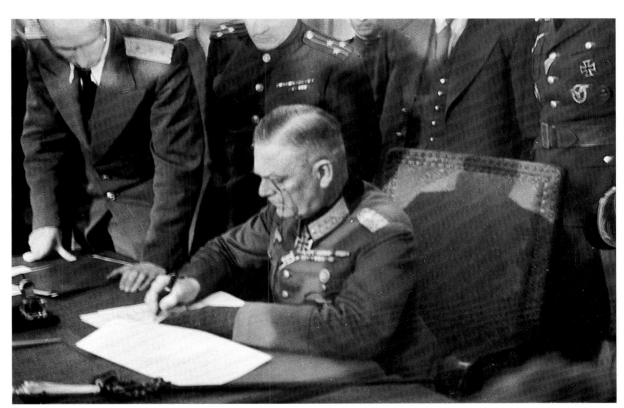

Fig. 1 Timofej Melnik (Soviet). General Field Marshal Wilhelm Keitel signing the Act of Unconditional Surrender, Berlin-Karlshorst, May 8/9, 1945. German-Russian Museum Berlin-Karlshorst.

Image: Petr Sarkisian
Text: Vasilii Lebedev-Kumach
Edition: 750
Stencil
175 × 82.5 cm
Ne boltai! Collection

Spring Cleaning

Aiming not for the brow, but the eye,
For four years at "TASS Windows"
We have displayed for all to see
The malicious faces of the enemy.

And now the great war
Has ended with victory.
And, like trash, out from the window
Fly the Führers and the Fritzes.

We are washing the "TASS Windows."
Friends! Happy spring, and happy victory.

A stray cat watches a pair of hands tearing up a TASS poster bearing illustrations of Hitler, Goebbels, Himmler, Mussolini, and the Nazi beast and tossing it from a window into a dumpster — figuratively, the garbage can of history. The building is identified as the TASS studio by a sign that reads, "Editors / of the War-Defense Posters / TASS WINDOWS."

The TASS studio fought for its legitimacy after the Allied victory dispensed with the enemy that had shaped the purpose of its operations. After the defeat of Nazi Germany, TASS artists would create posters focused on reconstruction efforts and on Stalin's new Five-Year Plan; they would return to the cheery Socialist Realist compositions that had permeated the visual culture of the 1930s. The studio's endeavors to establish its continuing relevancy, however, would prove insufficient, prompting the government to close it in 1946.

Fig. 1 Kukryniksy, with text by Samuil Marshak. "Holiday Cleaning," *Krokodil* 18 (May 19, 1945). The visual artists represented are, from top to bottom and left to right: the Kukryniksy (Sokolov, Krylov, and Kupriianov), Efimov, Ganf, Cheremnykh, Brodatii, Eliseev, Kanevskii, and Klinch. While this image and the poem that accompanies it (see the translation at right) relate specifically to the satirical weekly *Krokodil* and the artists and writers who worked for it throughout the war, they apply equally to the TASS poster studio, for most of these artists worked for both organizations, which shared the goal of using their art to wage war against the enemy.

Holiday Cleaning

The regiment of Soviet artists
Marches before us on parade.
They have fulfilled their duty,
Holding firm to their standard.

Neither bazooka nor machine gun
Has been awarded to their units.
These artist-warriors struck
The enemy with the point of a pencil.

Taking aim and firing
From three barrels at once,
Three Kukryniksy – Kupriianov,
Sokolov and Krylov.

The prize for sharpshooting
And never missing the enemy
Goes to the famous partisan
Boris Efimovich Efimov.

Like a sniper, with precision shooting,
The artist Iulii (not Czar) Ganf
Shot repeatedly at the Führer,
Adolf Hitler, author of Mein Kampf.

From the garrison towers
Upon the evil invaders
Shot artillery gunners
Cheremnykh, Brodatii, and Eliseev.

The pen of Kanevskii and Klinch
Worked like a bayonet . . .
Right into the rubbish bin
The Fascists fly with other waste.

The Soviet people won,
The Fritzes surrender their arms.
And Krokodil has begun
To clean its pages of their filth.

Here Hitler is thrown like trash
Into the rubbish bin.
For the last time we see the flash
Of his mustache and crooked fringe.

Look, falling on a steel blade,
Tumbling head over heels,
Von Göring the swinish ham,
His chest weighed down with medals.

Look at Goebbels, a mix of tadpole,
Weasel and spider:
His eyes like two black holes,
His mouth crooked as a swastika.

The entire crowd of brutes,
All of the cannibal throng,
Must leave Krokodil to the music
Of today's victory song.

The war has tempered so well
The regiment of our snipers
So every enemy beware
Whenever our Krokodil is smiling!

Samuil Marshak

Image: Nikolai Denisovskii
Edition: unknown (probably 1,000)
Stencil
124 × 119.5 cm

The Art Institute of Chicago, gift of The
U.S.S.R Society for Cultural Relations
with Foreign Countries, 2010.81

This poster reproduces the Berlin Declaration, which addresses the defeat of Germany and the assumption by the Allied nations of supreme authority over what had been the Third Reich. The declaration was signed in Berlin on June 5, 1945. On the medallions, clockwise from top left, are the signers: Zhukov, American general Dwight D. Eisenhower, Lattre de Tassigny, and British general Bernard Montgomery (see fig. 1).

The declaration as rendered in TASS 1257 exhibits a slight but significant change in the order in which the nations appear: on the poster, the Soviet Union is first, followed by the United Kingdom, the United States, and France, whereas the original list is headed by the United States, followed by the Soviet Union, the United Kingdom, and France.

Fig. 1 Photographer unknown. Signers of the Berlin Declaration, June 5, 1945. From left to right are Montgomery, Eisenhower, Zhukov, and Lattre de Tassigny.

Fig. 2 Boris Efimov. Cover of *Krokodil* 25 (July 30, 1945). Ne boltai! Collection. Three soldiers, drivers for the delegations symbolizing the three Allied partners, take a break from their duties at the signing of the Berlin Declaration. The caption reads: "Remember, John, when we were in Yalta I told you: See you in Berlin." In exhibition.

Fig. 3 Boris Efimov. "A Shortsighted Fritz," *Krokodil* 26 (August 3, 1945). The caption reads, "Frederick II: I wasn't expecting a conference in my palace!" The personification of Prussian militarism, Frederick the Great had a frequent walk-on part in Russian graphic satire. Efimov's cartoon refers to a conference held at Potsdam from July 16 to August 2, 1945. Attended by Stalin, Churchill, and the new United States president, Harry Truman, the meeting focused on the future of Germany and postwar Europe. While Potsdam is the location of Frederick II's Sanssouci and Neues Palais, the conference actually took place in the Cecilia Court Palace, built in 1914–17.

Image: Mikhail Solov'ev
Text: Inna Levidova
Edition: 800
Stencil
121.5 × 120 cm

The Art Institute of Chicago, gift of The
U.S.S.R. Society for Cultural Relations
with Foreign Countries, 2010.210

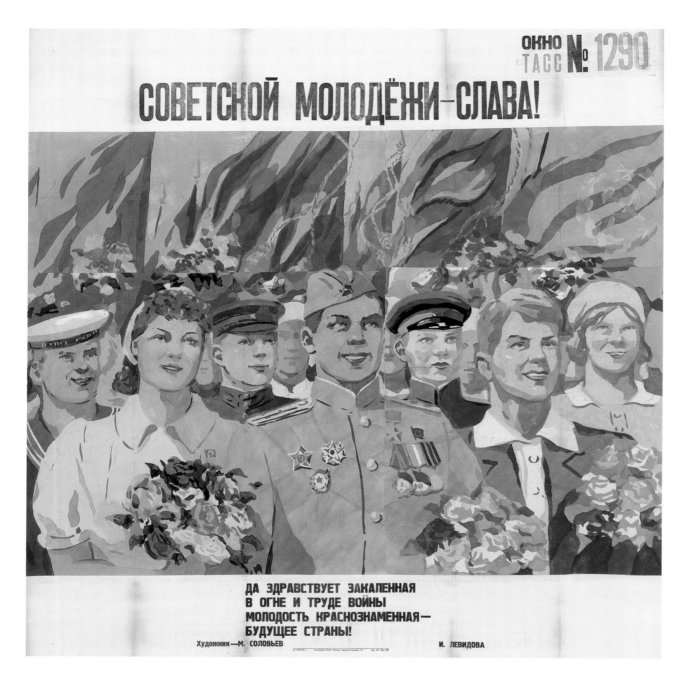

Glory to the Soviet Youth!

Hail youth!
Forged by the fire and labor of war.
Red-bannered youth –
The future of our country!

A group of smiling Soviet youths, dressed in military uniforms and civilian clothes and holding bouquets of flowers, is arrayed before a stand of red banners. Levidova's poem is a very rudimentary rhyme without discernable metrical pattern. If it were not broken into four lines, it might not be recognized as a poem at all.

Here Solov'ev employed a quintessential Socialist Realist style, drawn from painting, to depict a cadre of young Soviets. Unlike many of his earlier works, the heroism of the scene is not set against the trials of battle, but rather reveals a homogenous mood that matches the static pictorial vocabulary. Instead of a dynamic or contrasting use of facial color and shading, the poster exhibits a strong impetus toward naturalism and uniformity. Symptomatic of the style's idealizing aims are schematic modeling, generalization of facial features, and naturalistic flesh tones. Eschewing black outlines and adapting a decidedly more painterly than linear manner, Solov'ev utilized panels of abutting and harmonious color to build the composition.

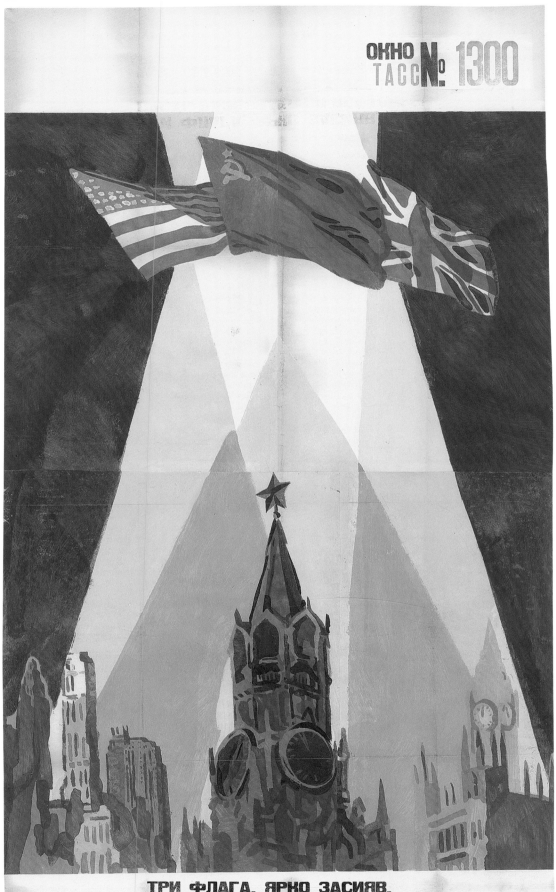

Image: Vladimir Ladiagin
Text: Osip Kolychev
Edition: 800
Stencil
160 × 85 cm
The Art Institute of Chicago, gift of The U.S.S.R. Society for Cultural Relations with Foreign Countries, 2010.113

Three flags, shining brightly,
Let them fly far and wide!
The three powers' alliance and friendship
Will secure peace over the entire world!

The Allies' flags, highlighted by searchlights that once looked for enemy planes but now celebrate victory, fly over landmark buildings that signal each nation: from left to right, skyscrapers in New York, the Kremlin's Spasskaia Tower in Moscow, and the Houses of Parliament in London. The arrangement of elements mimics the effect of a photomontage to create a symbolic cityscape in an artificial space. This pseudo-realistic grouping of buildings is set against a background defined by a very different visual vocabulary – diamond-shaped patterns of crisscrossing searchlights and fluttering flags – one that is much more modernist than naturalistic.

The poem is a rudimentary rhyme in an inconsistent iambic tetrameter. The final line, based on the homonyms "peace" and "world" (both *mir* in Russian), is an early appearance of an important Cold War–era Soviet slogan (directed against alleged Western militarism): "Peace to the world."

Unlike the Soviet Union and Britain, the American capital, Washington, D.C. – with such iconic structures to choose from as the Capitol and the White House – was not selected by the artist or the TASS editors for inclusion here. Rather, we see potent symbols of capitalism: buildings of lower Manhattan's financial district such as Farmers' Trust and Sixty Wall Street Tower are discernible among the cluster of skyscrapers represented. Photographs of New York's skyline from the 1930s very likely served as inspiration for TASS 1300.

Image: Pavel Sokolov-Skalia
Edition: 1,000

Stencil
151 × 85 cm
Ne boltai! Collection

We Accuse!

This courtroom scene is dominated by the projection on a wall of a distraught mother, wearing her prisoner number and carrying a dead child. This motif derives from an earlier poster by Sokolov-Skalia, TASS 714 (fig. 1), created when the war's outcome was still in doubt. Now the image becomes a monumental, spectral presence presiding over the trials of Nazi criminals. Under this depiction of the cruelty perpetrated on the civilian population of the Eastern Front is an audience of observers, the members of the international court seated under the Allies' national flags. A lawyer at a lectern points to the image. In the foreground, two soldiers holding rifles with bayonets attached stand guard over the accused, who sit together in a courtroom dock. The man with the heavy frame at the top of the group

Fig. 1 Pavel Sokolov-Skalia. *Warrior, Avenge!* (TASS 714), May 4, 1943. Edition: 800. Stencil; 163 × 85.5 cm. Ne boltai! Collection.

is Göring. Keitel is depicted to the lower left. The figure directly below Göring wearing earphones resembles Ribbentrop. The other two figures cannot be identified with certainty.

The "Major War Criminals" were the first to be tried before the International Military Tribunal held in the extensively bombed-out Bavarian town of Nuremberg. The city was the ceremonial birthplace of the Nazi Party and host to its annual rallies. Between November 20, 1945, and October 1, 1946, twenty-two of the most prominent Nazi cadre and military leaders who had been captured were tried (in addition to Hitler, Himmler and Goebbels had committed suicide). The Kukryniksy and Efimov attended the trials as war correspondents (see fig. 2 and TASS 1341, fig. 1 [p. 377]).[1]

The title of TASS 1338 calls to mind that of Émile Zola's famous article "J'accuse," in which the writer protested against the anti-Semitic treatment of Alfred Dreyfus. The Dreyfus trial served as a major reference for Efimov, in particular, in determining his depictions of Nazi war criminals (see TASS 1341, figs. 1–2 [p. 377]).

Dull colors define the thuglike prisoners in the dock. But the artist struck an odd note in the figure with pink ears, seen from behind. Though a caricatural touch, the ears humanize the faceless enemy, raising the issues that Hannah Arendt would famously summarize under the epithet "the banality of evil."

С ПОСЛЕДНИМ ГОДОМ!

Рис. Кукрыниксы (специальных корреспондентов «Крокодила» на Нюрнбергском процессе)

На скамье подсудимых в ожидании виселицы сидят: первый ряд— Гёринг, Гесс, Риббентроп, Кейтель, Розенберг, Франк, Фрик, Штрейхер, Функ, Шахт. Второй ряд — Дениц, Редер, Иодль, фон Папен, фон Нейрат, Фриче.
Остальные подсудимые, хотя и не попали на этот рисунок, но тоже сидят на скамье подсудимых в таком же положении.

Fig. 2 Kukryniksy. "Happy Final Year!," *Krokodil* 40 (December 30, 1945). The text reads: "Awaiting the hangman, the following defendants sit: first row – Göring, Hess, Ribbentrop, Keitel, Rosenberg, Frank, Frick, Streicher, Funk, Schacht; back row – Doenitz, Raeder, Jodl, von Papen, von Neurath, Fritzsche. The remaining defendants, although they didn't make it into our drawing, are seated on the same bench in the same situation."

Image: Mikhail Cheremnykh
Edition: 1,000
Stencil

131 × 84 cm
Prints and Photographs Division, Library
of Congress

*On the trial of the main war criminals in
 Nuremberg*

The Fascist bandits in their inner circle.

A noose frames accused Nazi crimi-
nals seated on a bench, their arms
and hands bloodied, as telltale evi-
dence of their crimes. An obese Göring
dominates the composition; the oth-
ers cannot be readily identified.

The word *criminals* in the first line of
text contains a spelling mistake.
It is possible, though not likely, that
this mistake was intentional, since
it raises associations with the verb
"to encroach": the Germans were
criminal in their encroachment upon
foreign territory.

Unlike Mikhail Cheremnykh, who was
in Moscow when he designed TASS
1341, Efimov was in Nuremberg, cov-
ering the trial as a war correspondent.
Based on firsthand observations, his
caricatures of the principal Nazi crim-
inals (see fig. 1) constitute a ménage
of assorted animals such as apes,
vultures, reptiles, and toads. Although
such images have been a favorite
device of generations of graphic
satirists, Efimov acknowledged the
influence of the poster-size broad-
sheets comprising the anti-Semitic
series *Musée des horreurs*, published
in France in 1899–1900, during the
Alfred Dreyfus affair (see fig. 2).

ОКНО ТАСС № 1341

К ПРОЦЕССУ ГЛАВНЫХ ВОЕННЫХ
ПРИСТУПНИКОВ В НЮРНБЕРГЕ.

ФАШИСТСКИЕ БАНДИТЫ В СВОЕМ КРУГУ.
Художник—М. ЧЕРЕМНЫХ

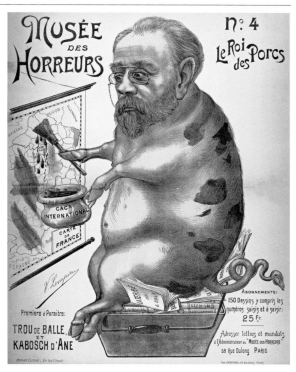

Fig. 2 V. Lenepvue (French). *Le Roi des porcs*, no. 4 from *Musée des horreurs*, 1899–1900. Jewish Museum. Caricatured in this image as a pig sitting on his published works, Émile Zola (1840–1902), author of the pro-Dreyfus manifesto "J'accuse," applies excrement from a container labeled "international ca-ca" onto a map of France.

Fig. 1 Boris Efimov. Nine drawings representing Nazi war criminals as a ménage of various beasts, 1945. Pen, brush, and india ink; 19.2 ×15 cm (max.). Ne boltai! Collection. From left to right, top to bottom are: Hjalmar Schacht, Alfred Rosenberg, Hans Frank, Joachim von Ribbentrop, Hermann Göring, Ernst Kaltenbrunner, Baldur von Schirach, Julius Streicher, and Wilhelm Keitel.

TASS 1

1 Attribution from an annotated copy of *Letopis' izobrazitel'nogo iskusstva Velikoi otechestvennoi voiny*, Osip Brik Archive, RGALI 2852.1.111, l. 38.

2 For more on the collective tradition among Soviet artists, see Gough 2011, esp. p. 174.

3 According to Larisa Kolesnikova, the first TASS poster hung in a TASS studio window on June 25, 1941; Kolesnikova 2005, p. 15.

TASS 9

1 Attribution from an annotated copy of *Letopis' izobrazitel'nogo iskusstva Velikoi otechestvennoi voiny*, Osip Brik Archive, RGALI 2852.1.111, l. 12.

2 The certain death of enemy parachutists is also the subject of panel 5 of TASS 33, issued on July 3, the day of Stalin's broadcast. This poster's six panels, each designed by a different artist, deal with passages of the speech.

3 The motif also surfaced in a range of periodicals. For example, on August 26, 1941, the left-wing American publication *New Masses* published a cartoon by the American artist William Gropper in which Hitler, hanging onto a tattered umbrella, falls from the sky directly toward pointed bayonets held by soldiers identified as "USA," "Britain," and "USSR."

TASS 13

1 Attribution from an annotated copy of *Letopis' izobrazitel'nogo iskusstva Velikoi otechestvennoi voiny*, Osip Brik Archive, RGALI 2852.1.111, l. 11.

TASS 22

1 Attribution from an annotated copy of *Letopis' izobrazitel'nogo iskusstva Velikoi otechestvennoi voiny*, Osip Brik Archive, RGALI 2852.1.111, p. 29.

2 Huxley and Haddon 1936, p. 13. Julius Streicher was a prominent anti-Semitic newspaper and book publisher.

3 Efimov recalled reading that, among Hitler's intimates, Goebbels was nicknamed Mickey Mouse. The artist liked the comparison and thus began to portray "the master of the big lie" as a cartoon rodent. Kolesnikova 2005, p. 159.

4 "Soldatenfreund," 1 (Jan. 1942). See Kharkevich 2008.

5 Lord Beaverbrook also received TASS 9, 37, 124, 143, 155, 173, 177, 178, 181, 190, and 197.

TASS 60

1 Attribution from an annotated copy of *Letopis' izobrazitel'nogo iskusstva Velikoi otechestvennoi voiny*, Osip Brik Archive, RGALI 2852.1.111, l. 32.

2 Later in the war, when Allied soldiers were captured, the Nazis moved from depicting the inferior enemy as "subhuman" to showing him as a "gangster." After all, Nazi race theory could not be applied to most of the soldiers from Britain, the commonwealth nations, and the United States. The epithet "subhuman" was now reserved for those with African and Semitic origins.

3 For further reading on these topics, see Berkhoff 2004, pp. 89–113; and Snyder 2010, pp. 155–86.

TASS 63

1 The other MoMA posters executed in a similar fashion are TASS 23, 40, 86, 89, 102, 107, 143, 158, 173, 207, and 301.

TASS 68

1 Attribution from an annotated copy of *Letopis' izobrazitel'nogo iskusstva Velikoi otechestvennoi voiny*, Osip Brik Archive, RGALI 2852.1.111, l. 25.

2 Gorbunova 2009, p. 8.

TASS 100

1 Attribution from an annotated copy of *Letopis' izobrtazitel'ogo iskusstva Velikoi otechestvennoi voiny*, Osip Brik Archive, RGALI 2852.1.111, l. 25.

2 Bourke-White 1942, pp. 115, 123.

TASS 109

1 On Aug. 7, two days after TASS 109 appeared, "A Bad Mistake" – a cartoon by Boris Klinch showing two armed German soldiers in a trench and bearing the caption "The Führer goes beserk, and they put us on a leash" – was published in *Krokodil* 18 (Aug. 7, 1941).

2 The posters were donated by the American Russian Institute, San Francisco. Carol A. Leadenham, assistant archivist for reference at the Hoover Institution Archives, Stanford University, to Peter Kort Zegers, Feb. 12, 2008.

TASS 124

1 Cyrus L. Sulzberger, "Fatalistic Moscow," *New York Times Magazine* (Sept. 21, 1941).

2 The pig-faced variety was the most popular. For example, a cartoon entitled "The Slave Market" shows a Russian female captive being sold into slave labor. A German officer offers the defiant woman to two pig-snouted, buxom housewives. The caption reads, "Look, Frau Martha, this humanoid Russian does not look at all like we do: [we are] representatives of a superior race." The cartoon appeared in *Krokodil* 30 (Aug. 17, 1942).

3 The two-verse poem in TASS 472 reads: "Von Drappe, the German officer, / Was an exemplary storm trooper / He could bravely run through small children / With a sharpened blade. // Our brave guardsmen / Subdued the insolent man / And found for the first time / That he was not Drappe, but a sheep."

TASS 143

1 Cyrus L. Sulzberger, "Fatalistic Moscow," *New York Times Magazine* (Sept. 21, 1941).

2 Werth 1942, p. 166.

TASS 159

1 Butler 2005, pp. 41–42.

2 The *New York Times* Moscow correspondent Cyrus L. Sulzberger reported on Aug. 18 in the article " Britain and Russia in Pact to Exchange War Supplies":

Another concrete step toward combining the huge resources of the Soviet Union, Britain and the United States into an economic block designed to facilitate the destruction of Adolf Hilter's Germany was accomplished today. It was announced that Britain and Russia had signed a trade agreement that would enable each country to benefit from the wealth of the other. This compact was signed two hours after Moscow loudspeakers had blared forth the announcement that Premier Joseph Stalin had accepted the Roosevelt-Churchill proposal for a Moscow conference of British, American and Russian experts on pooling the resources of that half part of the world directly controlled by the three nations.

3 For example, on Aug. 19, the *Daily Worker* (the American Communist Party's newspaper), published a celebratory cartoon by William Gropper entitled "Moscow Conference," showing the allies shaking hands across a table under which lies the corpse of Hitler.

TASS 177

1 There are a number of differing translations of this poem – for example, accompanying a reproduction of TASS 177 in the Sept. 5, 1941, issue of *Moscow News*, where it is titled "Confirmation of a Young Brute." The American artist Rockwell Kent produced another translation, entitled "Beastiality's Matriculation." The text presented here accompanied an image of the poster published in the Feb. 7, 1942, issue of the English weekly *Picture Post*.

TASS 178

1 The order continues:

The following will be shot as partisans: Russian soldiers in uniform and mufti who did not report to the nearest garrison or to the military authorities,... those civilians who are found on the high roads without a permit and who do not belong to the nearest village,...those civilians found in possession of arms of any kind or explosives.... If isolated partisans are found using firearms in the rear of the army, drastic measures are to be taken. The measures will be extended to that part of the male population who were in a position to hinder or report the attacks.... The fear of the German counter-measures must be stronger than the threats of the wandering Bolshevistic remnants. Being far from all political considerations of the future the soldier has to fulfill two tasks: 1. Complete annihilation of the false Bolshevistic doctrine of the Soviet state and its armed forces. 2. The pitiless extermination of foreign treachery and cruelty and thus the protection of the lives of military personnel in Russia. This is the only way to fulfill our historic task to liberate the German people once and forever from the Asiatic-Jewish danger.

"Commander in Chief Order Concerning Troops in the Eastern Territories," Oct. 10, 1941, signed by [Walther] von Reichenau, field marshal. The translation of Document UK–81 is found in United States 1946, pp. 572–82.

2 Geyer and Fitzpatrick 2009, p. 367. [Not yet in bibliography.]

TASS 191

1 "Soveshchaniia u t. Khavinsona" Feb. 6, 1942, l. 18.

TASS 307

1 They must have been aware of the 1933 German movie *S. A. Mann Brand*, whose main character is the heroic Aryan youth Fritz Brand.

2 See Samoilenko 1977, p. 72.

TASS 22-XII-41

1 According to Urvilova 1965, the first of these is TASS 3-XI-41.

2 Khavinson called TASS 22-XII-41 "N321." In the ROT Album, it is referred to as "OKNO TASS N321."

TASS 30-XII-41

1 For the report, issued by Viacheslav Molotov, see the Embassy of the Union of Soviet Socialist Republics Information Bulletin, Kuibyshev, Jan. 7, 1942, published in *VOKS Bulletin* 3–4 (Mar.–Apr. 1943), pp. 5–9.

TASS 460

1 See Chernevich, Anikst, and Baburina 1990, pp. 94–95.

TASS 468/468A

1 The jazz-band cartoon was incorporated into a German-language leaflet that the Russians dropped behind enemy lines. The leaflet, which encouraged German soldiers to surrender, could be used as a surrender pass.

2 The looseness of the translation on the RWR poster can be gauged by comparing stanza 5 ("Champion Robber") of "On Tour from Germany... " to a literal translation of the corresponding poem on the original Soviet poster, which is entitled "The Champion of Pillage": "Blood-thirsty Hitler is Champion / Of bandit gymnastics. / He totters precariously on / A crooked-legged swastika. // He stands on it as if on a precipice / In the guise of an arrogant dictator, / And he threatens the entire globe / With his leather whip. // How can he maintain his footing / On such a fragile pedestal? / He'll plummet head over heels / Never to be seen again."

TASS 500

1 Boris Makaseiev, *Artists of the Capital City-Red Army* (June–July 1941), newsreel, frame 2:00–06.

TASS 504

1 Henry C. Cassidy, "Allies Helping Reds to Know Them Better," *Washington Post*, Aug. 3, 1942, p. 2.

2 See Bonnell 1997, p. 223.

TASS 527

1 Kondoyanidi 2010, p. 441.

2 Tikhonov 1972, pp. 61–62.

3 For the gorilla in popular culture, see Gott and Weir 2005.

4 This translation is from Markov and Sparks 1967, no. 842, pp. 761, 763, 765.

TASS 530

1 See White 1988, pp. 83–84.

TASS 574/574A

1 An earlier poster, TASS 535, shows a mother on the run clutching a baby and pointing back to approaching German tanks. Its text reads: "The homeland commands us: – Forward! Not a step back! / For us every inch of native soil is as dear as the air we breathe! / Comrade, gather your entire will and all your valor: / Fight back the enemy! Throw back the enemy!"

2 In 1943 Sokolov-Skalia wrote:

Some posters are dedicated to victories of our courageous Red Army. They depict battle scenes and portray our heroes. There are posters that were created during very harsh days when the shameless enemy was striving to reach the most important centers of our country. They appeal to the most noble of the Soviet people's feelings, the feeling of patriotism. These posters are Not a Step Back!, The Voice of the Motherland [TASS 535], We Will Not Surrender Moscow [TASS 15-XI-41]. During those days when our army, breaking the line of the enemy's defense, started moving forward, the streets of Moscow and other cities were covered with posters: Forward to the West! [TASS 419], Our Offensive Continues [TASS 603], and others.

Sokolov-Skalia also stated:

In spite of the large thematic diversity, there is one topic that unifies all the posters and gives them specific direction. This topic comes from Stalin's speeches, reports, and orders. Stalin's every public speech imbues artists and writers with enthusiasm to create more agitational posters. New posters appear immediately after every speech by Stalin.

Sokolov-Skalia, "Okna TASS," *Trud*, June 10, 1943, p. 135.

TASS 612

1 The entire article ran in *VOKS Bulletin* (Mar.–Apr. 1943), pp. 10–12.

2 Sovetskii soiuz rabotnikov 1942. *Literatura i iskusstvo* published the speeches on Nov. 30, 1942.

3 The topic of German appropriation of cultural property has received a great deal of scholarly attention. See, for example, Hartung 1997, Heuss 1997, Liechtenhan 1998, and Grimsted 2005. In reprisal the Soviets became involved in similar appropriations. On the Soviet Trophy Brigades, see Akinsha and Kozlov 1995.

TASS 633

1 Maiskii 1942, pp. 6–7.

TASS 637

1 "Soveshchaniia u t. Khavinsona" Feb. 6, 1942, l. 14.

TASS 640

1 A related drawing, probably preceding the poster, includes more lines of troops and crosses, all arranged in a more emphatic perspective. See Grabar', Lazarev, and Kemenov 1964, p. 53.

TASS 730

1 Elem Klima's 1985 film *Come and See* depicts such a mass killing in Perkehody, Belarus. The Nazis locked the villagers into a wooden church and then set it on fire.

2 *People's Verdict* 1944, p. 58.

3 *People's Verdict* 1944.

TASS 811

1 *People's Verdict* 1944, p. 29.

2 Bourtman 2008, p. 258.

TASS 849/849A

1 See Alissa J. Rubin, "Photos Stoke Tension over Civilian Deaths," *New York Times*, Mar. 21, 2011; and Mark Boal, "The Kill Team," *Rolling Stone* (Mar. 27, 2011).

2 See Agfa advertisement in *Das Reich*, July 2, 1944.

3 For more on the death of Zoia Kosmodem'ianskaia, see Gorin 2003; Pavel Lidov, "Tanya," in Von Geldern and Stites 1995, pp. 341–44; and Rosalinde Satori, "On the Making of Heroes, Heroines, and Saints," in Von Geldern and Stites 1995, pp. 182–91. The movie *Zoya*, by the Soviet director Lev Arnshtam, with an original score by Dmitri Shostakovich, opened in New York in Apr. 1945.

TASS 919

1 "Opisanie ordena Ushakova," *Pravda*, Mar. 4, 1944.

TASS 952

1 Cheremnykh 1965, p. 187.

TASS 960–961

1 The steps also feature in an earlier poster, TASS 242 (fig.1.29).

TASS 981

1 Kondoyanidi 2010, p. 443.

2 Also related to Stalin's May Day speech are TASS 980, 983, 984, 994, and 998.

TASS 986

1 The tricolored decal of the Whermacht on his broken helmet was rendered incorrectly; it was actually black over white over red.

TASS 992

1 Among the enlisted volunteers for Merchant Marine convoy duty was the author's great-uncle Captain Hendrik (Harry) Kort. Born in Amsterdam in 1870, he became an American citizen in 1901. He enlisted at age seventy-one, serving as captain of the Liberty ship *Cardinal Gibbons*.

TASS 1000

1 Maiakovskii 1958, p. 173.

2 Polevoi 1947, p. 182.

3 See, for example, TASS 757, 938, 939, 981, 1001, 1011–1012, 1052, 1147, and 1214.

TASS 1017

1 Howell 1996, p. 212.

TASS 1032

1 Repin's likeness here is based on an 1899 self-portrait in a private collection.

TASS 1040

1 Edgar Snow, "Here the Nazi Butchers Wasted Nothing," *Saturday Evening Post* (Oct. 28, 1944), p. 19.

2 Boris Gorbatov, "The Camp at Majdanek," *VOKS Bulletin* 8 (1944), pp. 22–30. See also Kondoyanidi 2010, p. 449.

TASS 1076

1 Rude's sculpture also served as a source for TASS 2-I-42, *To New Victories in the New Year*, by Daniil Cherkes.

TASS 1085

1 "Der Reichsjugendfuhrer meldete dem Fuhrer 70 vH. des Jahrganges 1928 als Kriegfreiwillige," *Volkischer Beobachter*, Oct. 11, 1944.

2 "Im unbedingten Willen zum Sieg!," *Volkischer Beobachter*, Oct. 12, 1944.

TASS 1126

1 The fortune-telling theme also appears in TASS 633 (p. 232).

TASS 1145

1 The filmmakers were N. Bykov, Katob-Zade, A. Pavlov, and A. Vorontsev. See Struk 2004, p. 147.

2 See Butterfield 1992, p. 92.

TASS 1173

1 Today Kaliningrad is still part of Russia, although it is cut off from the rest of the nation by Lithuania.

TASS 1178

1 Even the move of the Hindenburgs' coffins to the Elisabethkirche on Aug. 25, 1946, would have to be cloaked in secrecy. Frederick the Great's casket, along with that of his father, would be transferred from Marburg to the Hohenzollern's ancestral home, Burg Hohenzollern, Hechingen, Baden-Württemberg, in Aug. 1952. But then, in accordance with his final will, he would be reburied on Aug. 17, 1991 – after the reunification of Germany – in the Sanssouci palace grounds. Frederick Wilhelm's final resting place is also at Sanssouci, in the Friedenskirche.

TASS 1188

1 Le Tissier 2009, p. 53.

TASS 1191

1 See Fitzpatrick 2005. This became a common practice in the Soviet Union under Stalin.

TASS 1196

1 The synagogue, which had been burned but not destroyed by a Nazi mob on Kristalnacht (Nov. 9, 1938), was confiscated for use as a storage facility in 1940. It was badly damaged by Allied bombs in 1943. Its front portion would be reconstructed in 1958. Susan F. Rossen and Jay Clarke independently confirmed the identity of the buildings in TASS 1196 and the location.

TASS 1197

1 The range runs in an arc from Austria, the Czech Republic, and the northeast tip of Hungary to Poland, Ukraine, Romania, and Serbia.

TASS 1242

1 The Kremlin's tower features in earlier TASS posters that address the defense of Moscow against German invasion (see fig. 1.31).

TASS 1248

1 It is the present-day site of the German-Russian Museum Berlin-Karlshorst.

TASS 1338

1 Other TASS posters featuring the Nuremberg trials are 1267 and 1299.

SELECTED ABBREVIATIONS

AEF Allied Expeditionary Forces

AFC America First Committee

Agitplakat Agitatsionnyi plakat (Agitational Poster)

AKhR Assotsiatsiia khudozhnikov revoliutsii (Association of Artists of the Revolution)

AKhRR Assotsiatsiia khudozhnikov revoliutsionnoi Rossii (Association of Artists of Revolutionary Russia)

ARA American Relief Administration

ARI American-Russian Institute for Cultural Relations with the Soviet Union

Cominform Informatsionnoe biuro kommunisticheskikh i rabochikh partii (Communist Information Bureau)

Comintern Kommunisticheskii internatsional (Communist International)

CPUSA Communist Party of the United States of America

Detgiz Detskoe Gosudarstvennoe Izdatel'stvo (State Publishing House for Children's Literature)

Glavlit Glavnoe upravlenie po delam literatury i izdatel'stv pri Narkomate prosveshcheniia RSFSR (Central Committee and Main Directorate for Literary and Publishing Affairs)

Glavrepertkom Glavnyi komitet po kontroliu za zrelishchami i repertuarom (Committee for the Control of Spectacles and Repertory)

GSKhM Gosudarstvennye svobodnye khudozhestvennye masterskie (State Free Art Studios)

GUKF Glavnoe upravlenie kinofoto-promyshlennosti (Main Department of the Film and Photo Industry)

IZhSA Leningradskii institut zhivopisi, skul'ptury I arkhitektury imeni I. E. Repina (Leningrad Institute of Painting, Sculpture, and Architecture named after I. E. Repin)

Izostat Vsesoiuznyi institut izobrazitel'noi statistiki sovetskogo stroitel'stva i khoziaistva (Institute of Visual Statistics)

Komsomol Kommunisticheskii soiuz molodiozhi (Communist Youth Organization)

LEF Levyi front iskusstv (Left Front of the Arts)

MAKhD Moskovskaia assotsiatsiia khudozhnikov-dekoratorov (Moscow Association of Artist-Decorators)

Malegot Leningradskii akademicheskii malyi opernyi teatr (Leningrad Academic Malyi Opera Theater)

MGKhI Moskovskii gosudarstvennyi akademicheskii khudozhestvennyi

institut imeni V. I. Surikova (Moscow State Academic Art Institute named after V. I. Surikov)

MISI Moskovskii inzhenerno-stroitel'nyi institut imena V. V. Kuibysheva (Moscow Civil Engineering Institute)

MOPR Mezhdunarodnaia organizatsiia pomoshchi bortsam revoliutsii (International Society for the Relief of Revolutionary Fighters)

MOSKh Moskovskoe otdelenie Soiuza khudozhnikov RSFSR (Moscow Artists' Union)

MUZhViZ Moskovskoe uchilishche zhivopisi, vaianiia i zodchestva (Moscow School of Painting, Sculpture, and Architecture)

Narkompros Narodnyi komissariat prosveshcheniia (People's Commissariat for Enlightenment)

Narkomzdrav Narodnyi komissariat zdravookhraneniia (People's Commissariat for Health Care)

NKVD Narodnyi komissariat vnutrennikh del SSSR (People's Commissariat of Internal Affairs)

OBMOKhU Obshchestvo molodykh khudozhnikov (Society of Young Artists)

OCD Office of Civil Defense

OEM Office of Emergency Management

OFF Office of Facts and Figures

Ogiz-Izogiz Ob'edinenie gosudarstvennykh knizhno-zhurnal'nykh izdatel'stv-izobrazitel'nogo iskusstva (Soviet State Fine Arts Publishing House)

OMAKhR Ob'edinenie molodezhi assotsiatsii khudozhnikov revoliutsionnoi Rossii (Young People's Section of the Association of Artists of the Revolution)

OST Obshchestvo khudozhnikov-stankovistov (Society of Easel Painters)

OWI Office of War Information

Politplakat Politicheskii plakat (Political Poster)

Polituipravlenie Politicheskoe upravlenie (Political Department of the Front)

RAPKh Rossiiskaia assotsiatsiia proletarskikh khudozhnikov (Russian Association of Proletarian Artists)

RAPP Rossiiskaia assotsiatsiia proletarskikh pisatelei (Russian Association of Proletarian Writers)

ROPF Rossiiskoe ob"edinenie proletarskikh fotografov (Russian Association of Proletarian Photographers)

ROSTA Rossiiskoe telegrafnoe agentstvo (Russian Telegraph Agency)

ROT Redaktsiia Okno TASS (TASS Editorial Office and Studio)

RSFSR Rossiiskaia Sovetskaia Federativnaia Sotsialisticheskaia Respublika (Russian Socialist Federative Soviet Republic)

RWR Russian War Relief, Inc.

SKh SSSR Orgkomitet Soiuza sovetskikh khudozhnikov SSSR (Organizing Committee of the Union of Soviet Artists of the USSR)

Sovinformbiuro Sovetskoe informatsionnoe biuro (Soviet Information Bureau)

SVOMAS Svobodnye Gosudarstvennye khudozhestvennye masterskie (Independent Studio of the State Free Art Studios)

TASS Telegrafnoe agentstvo Sovetskogo Soiuza (Telegraph Agency of the Soviet Union)

TsUTR Tsentral'noe uchilishche tekhnicheskogo risovaniia barona Shtiglitsa (Central School of Technical Drawing)

UgROSTA Iuzhnoe biuro Ukrainskogo otdeleniia Rossiiskogo telegrafnogo agentstva (Southern Department of the Russian Telegraph Agency)

UNOVIS Utverditeli novogo iskusstva (Affirmers of the New Art)

USSR Soiuz Sovetskikh Sotsialisticheskikh Respublik (Union of Soviet Socialist Republics)

UzTAG Uzbekskogo telegrafnoe agentstvo (Uzbek Telegraph Agency)

VGIK Vserossiiskii gosudarstvennyi universitet kinematografii imeni S. A. Gerasimova (All-Union State Institute of Cinematography)

VKhUTEIN Vysshii khudozhestvenno-tekhnicheskii institut (Higher Art and Technical Institute)

VKhUTEMAS Vysshie khudozhestvenno-tekhnicheskie masterskie (Higher Art and Technical Studios)

VOKS Vsesoiuznoe obshchestvo kul'turnoi sviazi s zagranitsei (All- Union Society for Cultural Relations with Foreign Countries)

Vsekokhudozhnik Vserossiiskii soiuz kooperativnykh tovarishchestv rabotnikov izobrazitel'nogo iskusstva (All-Union Cooperative-Partnership of Artists)

VTsIK Vsesouznyi Tsentral'nyi ispolinitel'nyi komitet (All-Union Central Executive Committee)

VTsSPS Vsesoiuznyi tsentral'nyi sovet professional'nykh soiuzov (All-Union Central Council of Trade Unions)

WPA Works Progress Administration

SELECTED RUSSIAN-LANGUAGE PUBLICATIONS

30 dnei [30 Days]
Bedniak [Poor Peasant]
Begemot [Behemoth]
Bezbozhnik [Godless]
Bezbozhnik u stanka [Godless at the Machine]
Bich [The Whip]
Boevoi karandash [Combat Pencil]
Budil'nik [Alarm Clock]
Buzoter [The Rowdy]
Chizh [Siskin]
Chudak [The Eccentric]
Daesh' [Give]
Ezh [Hedgehog]
Frontovoi iumor [Frontline Humor]
Golos Moskvii [The Voice of Moscow]
Gudok [The Siren]
Iskusstvo [Art]
Izvestiia [Bulletin]
Kommunar [Commune Dweller]
Komsomol'skaia pravda [Communist Union of Youth Truth]
Krasnaia gazeta [Red Newspaper]
Krasnaia niva [Red Field]
Krasnaia zvezda [Red Star]
Krasnoarmeiskaia pravda [Red Army Truth]
Krasnye zori [Red Dawns]
Krasnyi perets [Red Pepper]
Krest'ianskaia gazeta [Peasants' Newspaper]
Krokodil [Crocodile]
Lapot' [Bast Sandal]
LEF [Left Front of the Arts]
Literatura i iskusstvo [Literature and Art]
Literaturnaia gazeta [Literary Newspaper]
Lukomor'e [Curving Seashore]
Mir iskusstva [World of Art]
Moskovskaia pravda [Moscow Truth]
Novyi LEF [New Left Front of the Arts]
Ogonek [Little Flame]
Pravda [Truth]
Prozhektor [Searchlight]
Pulemet [Machine Gun]
Rabochaia gazeta [Workers' Newspaper]
Rabochaia Moskva [Workers' Moscow]
Rampa i zhizn' [Footlights and Life]
Rannee utro [Early Morning]
Rost [Growth]
Smekhach [The Laugher]
Smena [Successors]
Solntse Rossii [The Sun of Russia]
Sovetskaia zhenshchina [Soviet Woman]
Sovetskoe iskusstvo [Soviet Art]
Trud [Labor]
Vechernie izvestiia [Evening Bulletin]
Vecherniia Moskva [Evening Moscow]
Visti [News]
Vorobei [The Sparrow]
Zanoza [Splinter]
Zhurnal zhurnalov [Magazine of Magazines]
Znamia [Banner]
Znamia revolutsii [Banner of the Revolution]
Zritel' [Spectator]

TASS ARTIST BIOGRAPHIES

PETR ALEKSANDROVICH ALIAKRINSKII

Born Orel, 1892; died Moscow, 1961

Petr Aleksandrovich Aliakrinskii entered the Moscow School of Painting, Sculpture, and Architecture (MUZhViZ) in 1900 to study with Sergei Ivanov, a celebrated history painter and member of the Realist group the Wanderers. Upon completing his studies in 1910, he began to exhibit his work publicly and, two years later, to submit his caricatures and theater sketches to various Moscow magazines. In 1917 he worked in Ryazan and Kozlov (Michurinsk) as a theater-set designer. From 1918 to 1922, he lived in Iaroslavl, where he taught in both the metropolitan art school and the Free Artistic Workshop. During the Civil War period, he served as head of the art department of the Iaroslavl branch of the Russian Telegraph Agency (ROSTA) and was involved in restoring local architectural monuments. He moved to Moscow in 1922 to collaborate with a host of emerging Communist periodicals, including *30 dnei*, *Bezbozhnik*, and *Krasnaia niva*. He was commissioned by the State Publishing House for Literature (Goslitizdat) and the State Publishing House for Children's Literature (Detgiz) to illustrate several books. He designed textiles after 1925 and wallpaper patterns after 1927 and prepared posters for several different publishing houses during World War II, contributing approximately eight compositions to the TASS studio between December 1941 and the spring of 1944. In 1945 he was awarded the title Honored Worker of Arts of the Russian Soviet Federative Socialist Republic.

FEDOR VASIL'EVICH ANTONOV

Born Tambov, 1904; died Moscow, 1994

From 1916 to 1921, Fedor Vasil'evich Antonov studied at the Tambov Art School under painter Nikolai Shevchenko. He then moved to Moscow to study at the Higher Art and Technical Studios (VKhUTEMAS) in the departments of textiles and painting under the tutelage of Abram Arkhipov and Sergei Gerasimov. From 1927 to 1929, he was a member of the Society of Easel Painters (OST), though he never participated in the group's exhibitions.

In 1932 he joined the Visual Brigade (Izobrigada), a group composed of many former members of OST. A retrospective of his work opened in Moscow in 1934. Antonov designed approximately eighteen posters for the TASS studio between November 1941 and March 1944, while also painting portraits of Soviet heroes. From 1948 to 1952, he taught at the Moscow Institute of Applied Arts, and after 1953 at the Moscow Textile Institute. Major retrospectives of his work were organized in Moscow in 1954 and 1964. He was awarded the titles Honored Worker of Arts of the Russian Soviet Federative Socialist Republic (1966) and People's Artist of the Russian Soviet Federative Socialist Republic (1975).

MIKHAIL MIKHAILOVICH CHEREMNYKH

Born Tomsk, 1890; died Moscow, 1962

A native of Siberia, Mikhail Mikhailovich Cheremnykh relocated to Moscow in 1911 to study with Il'ia Mashkov, a painter in the avant-garde Jack of Diamonds group. From 1911 to 1917, he studied with Konstantin Korovin and Sergei Malutin at MUZhViZ. Concurrently, he published political cartoons and caricatures of popular theater actors in the Moscow newspapers *Vechernie izvestiia* and *Rannee utro*. In 1919 he established the ROSTA studio in Moscow, for which he served as artistic director until 1922, when he cofounded the satirical magazine *Krokodil*, with which he would remain associated until his death. From 1922 to 1930, he published his drawings in a wide range of related graphic journals, including *Krasnyi perets*, *Zanoza*, *Smekhach*, and *Lapot'*. He was active as a book illustrator, and from 1939 to 1941, he worked as the set designer for both the Leningrad Academic Maly Opera Theater (Malegot) and the State Theater of Opera and Ballet of the Belorusian Soviet Socialist Republic in Minsk. When war broke out in 1941, he helped organize the TASS studio in Moscow, designing its first poster in June of that year and contributing over forty more compositions over the course of its existence. In 1942 he was awarded the Stalin Prize. Following the TASS studio's evacuation from Moscow, he served as the head of the poster studio in Biisk, returning to the capital in 1943. From 1950 to 1954, he served as professor and head of the poster work-

shop at the Moscow State Academic Art Institute named after V. I. Surikov, and in 1954 he was appointed chair of the school's Department of Graphic Arts. In 1952 he received the honorific title People's Artist of the Russian Soviet Federative Socialist Republic. In 1954 he was also named a corresponding member of the Academy of Art of the USSR, and in 1958 he became a full member.

ALEKSANDR TIMOFEEVICH DANILICHEV

Born Zhdanovo, 1921; died Moscow, 1994

Raised in the Tula region, Aleksandr Timofeevich Danilichev began to exhibit his paintings publicly in 1938, the year before he entered the Moscow State Academic Art Institute named after V. I. Surikov to study with Sergei Gerasimov, Il'ia Mashkov, and Pavel Sokolov-Skalia (his future colleague at TASS). When his academic pursuits were interrupted by the outbreak of World War II, he designed posters for the TASS studio in Moscow, contributing just under one dozen compositions between October 1941 and the summer of 1945. He returned to school to complete his studies in 1948 and is best known for the large historical paintings he produced in the decades after the war. An accomplished draftsman, he also made several major suites of drawings. In 1960 he was appointed professor of the Moscow State Academic Art Institute named after V. I. Surikov, and in 1982 he was awarded the title Honored Worker of Arts of the Russian Soviet Federative Socialist Republic.

ALEKSANDR ALEKSANDROVICH DEINEKA

Born Kursk, 1899; died Moscow, 1969

Aleksandr Aleksandrovich Deineka moved to Ukraine in 1915 to study at the Kharkov (Kharkiv) Art School. In 1918, upon returning to Kursk, he joined the municipal Criminal Investigation Department as a photographer, designed agitational trains, and took part in defending the city from the White Army. He served in the Red Army from 1919 to 1920, during which time he headed the art studio of the Kursk Political Department and contributed to the city's ROSTA studio. From 1920 to 1925, he studied in the Polygraphic Department of VKhUTEMAS under Vladimir Favorskii, among others. In 1924, as a member of the Group of Three (with Andrei Goncharov and Iurii

Pimenov), he exhibited his works at the *First Discussion Exhibition of the Associations of Active Revolutionary Art* in Moscow. In 1925 Deineka helped found OST. In the late 1920s, he was active as a painter and graphic designer, publishing his illustrations in the satirical magazines *Bezbozhnik u stanka*, *Daesh'*, *Krasnaia niva*, and *Prozhekto*. From 1928 to 1930, he taught at the Higher Art and Technical Institute (VKhUTEIN) in Moscow. He joined the artistic association October in 1930, and the following year the Russian Association of Proletarian Artists (RAPKh). During this time, he also illustrated children's books and served as head of the Department of Poster Art at the Moscow Polygraphic Institute. In 1935 he was sent on a creative expedition to the United States, France, and Italy. He was awarded a gold medal at the *Exposition Internationale des Arts et Techniques dans la Vie Moderne* in Paris in 1937. He contributed two designs to the TASS studio in November 1941, although he is better known for his monumental paintings about the Soviet war effort. In 1945, after the war ended, Deineka was sent to Berlin on another creative expedition. From 1945 to 1953, the artist taught at the Moscow Institute of Applied and Decorative Arts; from 1953 to 1957, at the Moscow Architectural Institute; and from 1957 to 1963, at the Moscow State Academic Art Institute named after V. I. Surikov. He was elected a full member of the Academy of Arts of the USSR in 1947 and a member of the presidium in 1958. He served as vice president from 1962 to 1966 and academician-secretary from 1966 to 1968. He was given the honorific title People's Artist of the USSR in 1963 and named a Hero of Socialist Labor in 1969.

VIKTOR NIKOLAEVICH DENISOV (DENI)

Born Moscow, 1893; died Moscow, 1946

Viktor Nikolaevich Denisov entered the studio of the portrait painter Nikolai Ulianov in the early 1900s. He began submitting his work to the annual exhibitions of the Society of the Independent in St. Petersburg as early as 1906. From 1910 he published his political cartoons in such satirical magazines as *Budil'nik*, *Lukomor'e*, *Pulemet*, *Rampa i zhizn'*, *Satirikon*, *Solntse Rossii*, and *Zhurnal zhurnalov*, as well as the newspaper *Golos Moskvyii*. He relocated to St. Petersburg in 1913 and then to Kazan in

1919, where he designed his first posters and contributed satirical cartoons to the Soviet political publications *Bedniak*, *Krasnye zori*, and *Znamia revolutsii*. After returning to Moscow in 1920, Deni designed stenciled posters for the municipal ROSTA studio, and in 1921 his cartoons began to appear in the newspaper *Pravda*. In 1932 he was awarded the title Honored Worker of Arts of the Russian Soviet Federative Socialist Republic. In July 1943 he designed two posters for the TASS studio.

NIKOLAI FEDOROVICH DENISOVSKII

Born Moscow, 1901; died Moscow, 1981

From 1911 to 1917, Nikolai Fedorovich Denisovskii studied at the Stroganov School for Technical Drawing in Moscow under the tutelage of Stanislav Noakovskii and Dmitrii Shcherbinovskii. Following the Revolution, he studied for two years at the newly formed State Free Art Studios (GSKhM) with theater designer Georgii Iakulov. Concurrently, he worked as a set designer for the Chamber Theater and the Free Opera of Sergei Zimin. From 1918 to 1928, he was employed as a set designer for the theater and chamber theater departments of the People's Commissariat of Enlightenment (Narkompros), and in 1918 he helped decorate Moscow for the city's first official May Day celebration. After graduating from GSKhM, he worked as a secretary in the Narkompros Department of Art Education. He cofounded one of the first Constructivist groups, the Society of Young Artists (OBMOKhU), and participated in its exhibitions in Moscow from 1919 to 1922. During the Civil War period, he cut stencils for the ROSTA studio in Moscow. In the 1920s, his drawings appeared frequently in the satirical magazines *Begemot*, *Bich*, *Buzoter*, *Krasnyi perets*, *Krokodil*, *Prozhektor*, and *Smekhach*. He was sent to Berlin and Amsterdam in 1922–24 to serve as secretary for the *First Russian Art Exhibition*. He helped found OST in 1925 and exhibited with the group until 1929. From 1928 to 1930, he taught at VKhUTEIN in Moscow. In 1931 he cofounded the Association of Workers of the Revolutionary Poster. He worked as an illustrator for several publishing houses, including Gosizdat and the All-Russian Cooperative-Partnership of Artists (Vsekokhudozhnik). He produced set designs for the State Academic Malyi Theater in Moscow toward the end of the 1930s. He was one of the founders of the TASS editorial office in

Moscow and served as its director from 1941 to 1946, during which time he designed approximately forty posters for the studio. In 1956 he joined the Agitplakat artistic association, and in 1962 he was awarded the title People's Artist of the Russian Soviet Federative Socialist Republic.

NIKOLAI ANDREEVICH DOLGORUKOV

Born Ekaterinburg, 1902; died Moscow, 1980

Nikolai Andreevich Dolgorukov moved to Moscow in 1928 to study at VKhUTEIN. After it dissolved in 1930, he transferred to the Moscow Polygraphic Institute, where he studied with Lev Bruni and Dmitrii Moor. Upon graduating Dolgorukov was active as a graphic designer, often collaborating with Viktor Deni on posters. He began providing illustrations to the newspapers *Krasnaia zvezda* after 1932 and *Pravda* after 1934, as well as the satirical magazine *Prozhektor* between 1932 and 1935. Active during World War II as both a cartoonist and a graphic designer, Dolgorukov contributed approximately two poster designs to the TASS studio between the fall of 1942 and September 1943. His illustrations began appearing in the satirical magazine *Sovetskii voin* in 1941 and in *Ogonek* in 1942. After the war, he continued to design posters. Between 1949 and 1953, five major retrospectives of his work were organized around the Soviet Union. Later exhibitions were mounted in Moscow, Budapest, and Prague. He received a prize for his work at the *International Poster Exhibition* in Vienna in 1948, and in 1969 he was awarded a gold medal by the Soviet Foundation for Peace. In 1968 he was awarded the title Honored Worker of Arts of the Russian Soviet Federative Socialist Republic.

BORIS EFIMOVICH FRIDLYAND (EFIMOV)

Born Kiev, Ukraine, 1900; died Moscow, 2008

Boris Efimovich Fridlyand (Efimov) published his first cartoons in the magazine *Zritel'* in 1918. The following year, he was appointed secretary of the People's Commissariat of Military Affairs of the Ukrainian Soviet Socialist Republic. After 1920 his cartoons began to appear in such newspapers

as *Bolshevik*, *Kommunar*, and *Visti*. From 1920 to 1922, he worked in Odessa as the head of the Department of Visual Agitation for the Southern Department of the Russian Telegraph Agency (UgROSTA). He then relocated to Moscow, where he provided illustrations to the newspapers *Izvestiia* and *Pravda* and the satirical magazines *Chudak* and *Krokodil*. His brother Mikhail was a famous journalist and military adviser for the Comintern during the Spanish Civil War. Following his brother's arrest in 1939 (and execution the following year), Efimov was prohibited from publishing cartoons. He was employed briefly as a book illustrator until the German invasion of the Soviet Union, when he was permitted to return to work as a graphic illustrator. During the war, he collaborated with the TASS studio, designing approximately five posters between August 1941 and January 1945, while concurrently drawing cartoons for various periodicals. From 1966 to 1990, he served as the editor in chief of Agitplakat. In 2002 he was appointed chair of the Department of Caricature at the Russian Academy of Arts in St. Petersburg, and from 2007 to 2008, he served as chief artist at *Izvestiia*. He received the Stalin Prize in 1950 and 1951, and in 1954 he was elected a corresponding member of the Academy of Arts of the USSR. In 1967 he was given the honorific title People's Artist of the USSR, and in 1990 he was named a Hero of Socialist Labor.

ALEKSANDR MIKHAILOVICH GERASIMOV

Born Kozlov, 1881; died Moscow, 1963

Aleksandr Mikhailovich Gerasimov studied at MUZhViZ from 1903 to 1915 under Abram Arkhipov, Konstantin Korovin, and Valentin Serov. After being drafted into the army during World War I, he returned to his birthplace, Kozlov, in 1918. Relocating to Moscow in 1925, he joined the Association of Artists of Revolutionary Russia (AKhRR). The favorite artist of Kliment Voroshilov, people's commissar of defense of the Soviet Union, Gerasimov was later appointed as Stalin's official portraitist, and as such he created canonical iconography of the Soviet leader. Arguably the single most powerful figure in the Soviet artistic establishment, Gerasimov served from 1939 to 1954 as head of the Organizing Committee of the Union of Soviet Artists, in which capacity he helped enlist painters and procure studio space and equipment for the TASS studio in Moscow during World War II. He contributed a window-painting to the studio in July 1941. From 1947 to 1957, he served as the

first president of the USSR Academy of Arts. He was a four-time recipient of the Stalin Prize (1941, 1943, 1946, and 1949), and in 1943 he was awarded the title People's Artist of the USSR. During Nikita Krushchev's de-Stalinization campaign, he was removed from his administrative post, and his paintings were transferred from museums to repositories.

SERGEI VASIL'EVICH GERASIMOV

Born Mozhaisk, 1885; died Moscow, 1964

Sergei Vasil'evich Gerasimov studied in Moscow at the Stroganov School for Technical Drawing (1901–07) and MUZhViZ (1907–12) under the direction of Sergei Ivanov and Konstantin Korovin, among others. He began showing his work publicly in 1906 at exhibitions organized by such groups as World of Art and Moscow Salon. In 1913 he joined the faculty of the art school maintained by the publishing company I. D. Sytin and Co. Drafted into the army during World War I, Gerasimov collaborated after the Revolution with various groups, including the Society of Young Artists (OBMAKhU), Makovets, and the Society of Moscow Artists. From 1921 to 1930, he taught at VKhUTEMAS/VKhUTEIN. In 1925 he joined AKhRR. He was awarded a silver medal at the *Exposition Internationale des Arts et Techniques dans la Vie Moderne* in Paris in 1937. During World War II, Gerasimov helped develop a model of heroic realist painting, and in the summer of 1941, he contributed three window-paintings to the TASS studio. Appointed director of the Moscow State Academic Art Institute named after V. I. Surikov after the war, he was dismissed from his post in 1948 for his liberal attitudes. From 1950 to 1964, he served as director of the Moscow Institute for the Decorative and Applied Arts (formerly the Stroganov School for Technical Drawing). In 1947 he was elected a full member of the Academy of Arts of the USSR. From 1958 to 1964, Gerasimov served as first secretary of the management board of the Union of Soviet Artists. In 1958 he was given the honorific title People's Artist of the USSR. He was awarded the Lenin Prize posthumously in 1966.

VITALII NIKOLAEVICH GORIAEV

Born Kurgan, 1910; died Moscow, 1982

Vitalii Nikolaevich Goriaev moved to Moscow in the 1920s. In 1929, on the advice of Vladimir Maiakovskii, he entered VKhUTEIN. After it closed in 1930, he continued his studies at the Moscow Polygraphic Institute under Vladimir Favorskii, Sergei Gerasimov, and Dmitrii Moor, among others. In 1936 the satirical magazine *Krokodil* began publishing his cartoons. He designed forty-three posters for the TASS studio between June 1941 and September 1942, departing only when he was appointed artist in chief of the illustrated magazine *Frontovoi iumor*. He continued to work as a graphic artist after the war, illustrating editions by such authors as Fyodor Dostoevskii, Nikolai Gogol, and Aleksandr Pushkin. He received the title Honored Worker of Arts of the Russian Soviet Federative Socialist Republic in 1966, the same year he was given the State Award of the USSR.

BORIS VLADIMIROVICH IOGANSON

Born Moscow, 1893; died Moscow, 1973

Boris Vladimirovich Ioganson began his artistic training in the studio of the painter Petr Kelin. From 1912 to 1918, he studied at MUZhViZ with Abram Arkhipov, Konstantin Korovin, Nikolai Kosatkin, and Sergei Malutin, among others. In 1922 Ioganson joined AKhRR. He achieved his greatest critical success for his paintings of the 1930s. From 1937 to 1961, Ioganson taught at the Leningrad Institute of Painting, Sculpture, and Architecture (in 1944 the school changed its name to the Leningrad Institute of Painting, Sculpture, and Architecture named after Il'ia Repin). He designed a single window-painting for the TASS studio in June 1941. After the war, Ioganson served as vice president of the Academy of Arts of the USSR (1953–58) and subsequently as president (1958–62). He began teaching at the Moscow State Academic Art Institute named after V. I. Surikov in 1964. He served as the first secretary of the management board of the Union of Soviet Artists from 1965 to 1968. Ioganson was twice awarded the Stalin Prize (1941 and 1951). He was given the honorific title

People's Artist of the USSR in 1943 and named a Hero of Socialist Labor in 1968.

VIKTOR SEMENOVICH IVANOV

Born Moscow, 1909; died Moscow, 1968

Viktor Semenovich Ivanov studied at the Academy of Arts in Leningrad from 1929 to 1933 with Mikhail Bobyshov and Boris Dubrovskii-Eshke. From 1933 to 1941, he worked as an art director for the Mosfil'm studio in Moscow. He designed approximately nineteen posters for the TASS studio between November 1941 and October 1943, publishing his lithographic work widely during the same period. He received the Stalin Prize for his wartime contributions in 1946 and 1949 and was awarded the title Honored Worker of Arts of the Russian Soviet Federative Socialist Republic in 1955. He was elected a corresponding member of the Academy of Arts of the USSR in 1958 and produced his last significant series of posters in 1963–64.

ALEKSEI ALEKSANDROVICH KOKOREKIN

Born Sarkamysh, Turkestan (Turkey), 1906; died Moscow, 1959

Aleksei Aleksandrovich Kokorekin entered the Kransondar School of Painting and Sculpture in 1918. In 1927 he enrolled in the Kuban' Art-Pedagogical School, and in 1929 he relocated to Moscow to begin a career designing posters. During the first two years of World War II, Kokorekin served as artist in chief of the Military Publishing House of the Main Political Department of the Workers' and Peasants' Red Army. In December 1941, he designed two posters for the TASS studio. In 1943 he was appointed artist in chief of the M. B. Grekov Studio of Military Artists, and in 1946 he became the head of the poster division of the Moscow Artists' Union (MOSKh). In the late 1950s, he contributed designs to Agitplakat and the illustrated magazines *Rost*, *Smena*, and *Ogonek*. He illustrated books for Detgiz and Komsomol's publishing house, Molodaia gvardia. Kokorekin helped design the Soviet pavilion at *Expo 58* (Brussels, 1958). He was twice awarded the Stalin Prize (1946 and 1949), and in 1956 he was given the title Honored Worker of Arts of the Russian Soviet Federative Socialist Republic.

VIKTOR BORISOVICH KORETSKII

Born Kiev, Ukraine, 1909; died Moscow, 1998

Viktor Borisovich Koretskii studied at the Moscow Secondary Professional Art School from 1921 to 1929. He achieved renown as a graphic designer after 1931, when he began collaborating with the major state publishing houses Iskusstvo and Ogiz-Izogiz. He was a member of the editorial board of the publishing house Relkamfilm from 1939 to 1987. He designed the first Soviet postage stamp dedicated to the Great Patriotic War, and he was active throughout the conflict, preparing posters for numerous government bureaus, including the TASS studio, for which he designed two posters in June 1942. He began working for Agitplakat in 1956. Koretskii was twice awarded the Stalin Prize (1946 and 1949), and in 1964 he was given the title Honored Worker of Arts of the Russian Soviet Federative Socialist Republic.

SERGEI NIKOLAEVICH KOSTIN

Born Moscow, 1896; died Moscow, 1968

A nephew of the painter Nikolai Sapunov, Sergei Nikolaevich Kostin began his studies in 1918 in Moscow at GSKhM. Concurrently, he took private lessons from painter Boris Grigor'ev. He graduated in 1919 from the Independent Studio of the State Free Art Studios (SVOMAS). From 1919 to 1922, Kostin was a member of OBMAKhU. From 1922 to 1924, he worked in the Artistic-Industrial Workshop for Toys in Zagorsk, and in 1924 he joined Gosizdat as a graphic designer. The following year, he collaborated with David Shterenberg to design the Department of State Trade in the Soviet pavilion at the *Exposition Internationale des Arts Décoratifs et Industriels Modernes* in Paris. He visited Japan in 1927 as part of a delegation accompanying an exhibition of Soviet art. During the 1930s, he worked as a stage designer for the Bolshoi Theater. From 1931 to 1932, he was a member of the Izobrigada, a group composed of many of the former members of OST. He designed fifty-nine posters for the TASS studio between June 1941 and October 1946. After the war, he joined the faculty of the Moscow Art Institute.

PORFIRII NIKITICH KRYLOV

Born Shchelkunovo, 1902; died Moscow, 1990

Born in the Tula region, Porfirii Nikitich Krylov trained in the studio of the painter Grigorii Shegal from 1918 to 1921. He then moved to Moscow to study at VKhUTEMAS under Petr Konchalovskii, Aleksandr Osmerkin, and Aleksandr Shevchenko. In 1922 he began to collaborate on cartoons, book illustrations, and poster designs with fellow student Mikhail Kupriianov under the names Kukry and Krykup. From 1924, after they were joined by Nikolai Sokolov, the artists worked under the collective name Kukryniksy. The Kukryniksy published their work widely, both in newspapers (*Pravda*, *Krasnaia zvezda*, *Komsomol'skaia pravda*, and *Literaturnaia gazeta*) and in magazines (*Krokodil*, *Prozhektor*, *Smekhach*, and *Smena*). In 1929 they designed the sets for Vladimir Maiakovskii's theatrical comedy *The Bedbug*. Between July 1941 and April 1945, they were among the most energetic illustrators working for the TASS studio in Moscow, designing approximately seventy-four posters. During and immediately after the war, the Kukryniksy illustrated books and collaborated on large paintings. Over the course of his artistic career, Krylov also worked independently, achieving renown as a graphic designer and still-life, landscape, portrait, and genre painter. For his collaborative work with Kupriianov and Sokolov, he was awarded the Stalin Prize five times (1942, 1947, 1949, 1950, and 1951), the Lenin Prize (1965), and the State Prize of the USSR (1975). In 1947 he was elected a full member of the Academy of Arts of the USSR in St. Petersburg, for which he served as a member of the presidium from 1947 to 1949. In 1958 he was given the honorific title People's Artist of the USSR, and in 1973 he was named a Hero of Socialist Labor.

KUKRYNIKSY (SEE KRYLOV, KUPRIIANOV, AND N. SOKOLOV)

MIKHAIL VASIL'EVICH KUPRIIANOV

Born Tetushi, 1903; died Moscow, 1991

Mikhail Vasil'evich Kupriianov first achieved prominence in 1919 at an exhibition of amateur artists, in which he was awarded first prize for a watercolor landscape. He enrolled at the Central Artistic Educational Studios in Tashkent from 1920 to 1921 and

then entered the Graphic Department of VKhUTEMAS to study with Nikolai Kupriianov and Petr Miturich. In 1922 he began to collaborate on cartoons, book illustrations, and poster designs with fellow student Porfirii Krylov under the names Kukry and Krykup. From 1924, after they were joined by Nikolai Sokolov, the artists worked under the collective name Kukryniksy. For more on the Kukryniksy's work, see the biography of Krylov. Kupriianov also worked independently, achieving renown as a graphic designer and painter of landscapes, portraits, and caricatures. For his awards, which he received along with his Kukryniksy partners, see the biography of Krylov.

VLADIMIR VASIL'EVICH LEBEDEV

Born St. Petersburg, 1891; died Leningrad, 1967

As a young man, Vladimir Vasil'evich Lebedev attended several private art schools in St. Petersburg, publishing his illustrations in magazines as early as 1911. From 1918 to 1921, he was a professor at GSKhM in Petrograd. During the final two years of his appointment, he worked for the Petrograd ROSTA studio. Although best known as a painter, Lebedev was active in a variety of other media, including sculpture. In the 1920s, he produced abstract counter-reliefs akin to those popularized by Vladimir Tatlin a decade earlier. His work with ROSTA led to a successful series of satirical drawings. He published a number of illustrated volumes, including children's books and several albums of poetry by Samuil Marshak. From 1924 to 1933, he served as director of the editorial office of literature for children and youth for the State Publishing House (Gosizdat) in Leningrad, during which time he produced several notable satirical, graphic portfolios. He then returned to painting in order to make experimental still lifes and portraiture. In 1931, after having been publicly accused of practicing formalism, Lebedev was the target of a fierce denunciation campaign, which culminated on March 1, 1936, with the appearance of an article in *Pravda* that attacked the illustrators of children's books active in Leningrad. He moved to Moscow and, between June 1942 and July 1945, designed approximately forty posters for the TASS studio. Following the war, Lebedev resumed work as a book illustrator, and in 1950 he returned to Leningrad.

VLADIMIR IVANOVICH LIUSHIN

Born Malino, 1898; died Moscow, 1970

Vladimir Ivanovich Liushin entered the artistic-industrial workshop of the Stroganov School for Technical Drawing in Moscow in 1913. After it was transformed into GSKhM, he joined the workshop of painter and set designer Aristarkh Lentulov. He later entered VKhUTEMAS to study under David Shterenberg. After graduating in 1925, he submitted his work to the *First Discussion Exhibition of the Society of Easel Painters* and continued to participate in group exhibitions until 1930. From 1931 to 1932, he was a member of the Izobrigada. He began publishing his cartoons in the 1920s in such satirical magazines as *Bezbozhnik u stanka* and *Smena* and such newspapers as *Komsomol'skaia pravda*. In the mid-1930s, he taught painting at the Moscow Art Institute. He designed approximately thirty-one posters for the TASS studio between December 1941 and December 1946.

VLADIMIR VLADIMIROVICH MAIAKOVSKII

Born Bagdadi, Georgia, 1893; died Moscow, 1930

Vladimir Vladimirovich Maiakovskii moved to Moscow with his family following the death of his father in 1906. In 1907–08 he was imprisoned for a short time for his involvement in revolutionary activity, and the following year he was arrested twice. From 1910 to 1911, he enrolled intermittently at the Stroganov School for Technical Drawing, taking time off to study painting in the studios of Dmitrii Kelin and Stanislav Zhukovskii. In 1912 he began participating in public debates on contemporary art. A gifted poet as well as an artist, he published his first book of poems the following year. In 1915 he met the literary critic Osip Brik and fell in love with his wife, Lily, with whom he had a long affair. Maiakovskii supported the October Revolution in 1917. In October 1919, he joined the ROSTA studio, contributing designs and texts until production terminated in February 1922. Between 1923 and 1925, Maiakovskii served as the editor in chief of *LEF*, a journal published by the group Left Front of the Arts. Over the next two years, he traveled widely, visiting Paris, Berlin, Mexico, and the United States. In 1927–28 he edited the journal *Novyi LEF*. In February 1930, Maiakovskii left Left Front of the Arts for the Russian Association of Proletarian Writers (RAPP), an orga-

nization associated with the rise of Socialist Realism. His tactical realignment was interpreted by his friends and comrades as a betrayal. He organized a retrospective exhibition of his work at the Writers' Club in Moscow; the show traveled in March to the Press House in Leningrad. On April 14, 1930, he committed suicide. The TASS studio paid tribute to the artist-poet by including his verses on seven TASS posters between October 1941 and April 1946.

VLADIMIR ALEKSEEVICH MILASHEVSKII

Born Saratov, 1893; died Moscow, 1976

Born and raised in Saratov, Vladimir Alekseevich Milashevskii studied at the Bogolubovskoe Drawing School in 1906–07. He moved to Kharkov (Kharkiv) in 1911 to join the workshop of Aleksei Grot and Eduard Shteinberg, and in 1913 he entered the Department of Architecture in the High Art School of Painting, Sculpture, and Architecture at the Imperial Academy of Arts in Petrograd. He studied in the New Art Workshop in 1915–16 with Mstislav Dobuzhinskii and Evgenii Lansere. Following the Revolution, he worked as a book illustrator, painter, and graphic artist. In 1921–22 he collaborated with the children's magazine *Vorobei* and prepared the illustrations for Nikolai Evreinov's *What Is Theater?* (1921). He went on to illustrate numerous books and to work for several publishing houses, including Academia, Detgiz, Gosizdat, and Molodaya gvardiya. In 1929 he helped found the art group Thirteen, with which he remained associated until 1931. Between November 1941 and September 1945, he designed approximately nineteen posters for the TASS studio in Moscow. Following the war, he resumed his career as a book illustrator.

MARK ALEKSANDROVICH ABRAMOV (MOA)

Born Kharkov, Ukraine, 1913; died Moscow, 1994

Mark Aleksandrovich Abramov moved from Ukraine to Moscow, where, from 1931 to 1936, he studied at the Moscow Civil Engineering Institute (MISI). During the 1930s, he and his brother Oleg published cartoons under the pseudonym Moa in such notable satirical newspapers and magazines as *Bezbozhnik*, *Prozhektor*, and *Rabochaia Moskva*. After 1932 Abramov submitted his work to a broader range of illustrated magazines, including *Krokodil*,

Ogonek, *Sovetskaia zhenshchina*, and *Znamia*. He also published his illustrations in local and national newspapers, including *Izvestiia*, *Literaturnaya gazeta*, *Moskovskaia pravda*, and *Pravda*. During World War II, he designed posters intermittently for the TASS studio. Between October 1941 and April 1945, approximately fifteen were released. He continued to design posters after the war, focusing increasingly on agricultural topics after 1956. In the 1950s and 1960s, he prepared a suite of drawings depicting the Congress of Peace in Moscow (1962) and published several noteworthy albums of cartoons with versified captions by Soviet poets. In 1964 he was awarded the title Honored Worker of Arts of the Russian Soviet Federative Socialist Republic.

DMITRII STAKHIEVICH ORLOV (MOOR)

Born Novocherkassk, 1883; died Moscow, 1946

Dmitrii Stakhievich Orlov relocated to Moscow with his family in 1898. While working at the Mamontov printing house, he submitted his drawings to illustrated periodicals. In 1908 he became associated with the satirical magazine *Budil'nik*, where he adopted the pen name Moor for the first time (deriving it from the name of the protagonist of Friedrich Schiller's 1781 play *The Robbers*). He entered the studio of the painter Petr Kelin in 1910 but never completed his artistic training. After the Revolution, Moor worked as a graphic designer, collaborating with such satirical magazines as *Bezbozhnik u stanka*, *Daesh'*, and *Krokodil*, and such newspapers as *Pravda*. From 1922 to 1930, Moor taught at VKhUTEMAS/VKhUTEIN, from 1930 to 1932 at the Moscow Polygraphic Institute, and from 1939 to 1943 at the Moscow Art Institute. He joined the artistic association October in 1928. In 1932 he was awarded the title Honored Worker of Arts of the Russian Soviet Federative Socialist Republic. Moor designed a single poster for the TASS studio in September 1943.

GEORGII GRIGOR'EVICH NISSKII

Born Novobelitsa, Belarus, 1903; died Moscow, 1987

Georgii Grigor'evich Nisskii studied at VKhUTEMAS/VKhUTEIN from 1922 to 1930, where in 1923 he joined the Department of Painting to study with Aleksandr Drevin and Robert Fal'k, among others. In 1925 he joined OST.

Over the following decade, he became active as a painter of landscapes and seascapes. During World War II, he painted numerous naval battles and illustrated historical novels about the Russian navy. He designed ten posters and window-paintings for the TASS studio between July 1941 and November 1942. After the war, he painted landscapes and railway scenes. In 1958 he was elected a full member of the Academy of Arts of the USSR, and in 1964 he was given the honorific title People's Artist of the Russian Soviet Federative Socialist Republic.

IURII IVANOVICH PIMENOV

Born Moscow, 1903; died Moscow, 1977

Iurii Ivanovich Pimenov studied at VKhUTEMAS from 1920 to 1925 under Vladimir Favorskii, Vadim Falileev, and Sergei Malutin. In 1924, as a member of the Group of Three (with Aleksandr Deineka and Andrei Goncharov), he exhibited his works at the *First Discussion Exhibition of the Associations of Active Revolutionary Art* in Moscow. In 1925 Pimenov cofounded OST, after which his painting bore the imprint of German Expressionism. In 1931 he joined the Izobrigada, a group composed of many of the former members of OST. Active during World War II as both a painter and graphic designer, Pimenov designed approximately seven posters for the TASS studio between September 1941 and January 1942. After the war, he illustrated books in addition to painting. Pimenov was twice awarded the Stalin Prize (1947 and 1950) and once the Lenin Prize (1967). He was elected a full member of the Academy of Arts of the USSR in 1962, and in 1970 he was given the honorific title People's Artist of the USSR.

ANDREI IVANOVICH PLOTNOV

Born Dankov, 1916; died Dankov, 1997

Andrei Ivanovich Plotnov moved to Moscow in 1933 to study at the Regional Art School of the Memory of 1905. Three years later, at the urging of art critic and future museum director Igor Grabar', he joined the Department of Painting at the Moscow State Academic Art Institute named after V.

I. Surikov. In 1942 he was evacuated to Samarkand, where he completed his course of study. He was drafted the following year and joined the Art Studio of the People's Commissariat of Internal Affairs (NKVD), where he worked under Pavel Sokolov-Skalia. Between December 1943 and December 1946, he designed approximately thirty posters for the TASS studio. Following the war, he returned to painting and participated in two noteworthy creative missions to Central Asia and Kazakhstan (1948–55, 1978–80). In 1968 he opened a gallery in his native Dankov, which he named the Little Tretyakov Gallery. In 1970 he was awarded the title Honored Worker of Arts of the Russian Soviet Federative Socialist Republic.

ALEKSEI ALEKSANDROVICH RADAKOV

Born Moscow, 1879; died Tbilisi, 1942

Aleksei Aleksandrovich Radakov graduated from MUZhViZ in 1900. In 1905 he completed studies at the Central School of Technical Drawing (TsUTR) in St. Petersburg. After moving to Paris to work in the studio of Théophile-Alexandre Steinlen, he lived in Italy for a brief period. Upon returning to St. Petersburg, he helped found the satirical magazine *Satirikon* in 1908 and then, after its editorial board splintered in 1913, worked for *Novyi Satirikon*. That magazine was shut down in 1918 by the Bolshevik government for publishing anti-Soviet cartoons. Radakov joined the Liteinyi Theater in St. Petersburg as a set designer in 1912. In 1919 he prepared set designs for the State Bolshoi Drama Theater in Petrograd, and in 1922 he worked for the Troitsky Theater in Petrograd and the Odessa Theater of Opera and Ballet. Throughout the 1920s, he published his cartoons in a wide range of satirical journals, including *Begemot*, *Bezbozhnik*, *Bich*, *Lapot'*, and *Smekhach*. In the 1930s, his caricatures appeared in the magazine *Krokodil*, and he designed several posters. In 1933 Radakov became involved in cinema, teaching animation at the Moscow House of Press for one year and working at the experimental animation workshop run by the State Directorate for the Film and Photo Industry (GUKF). Concurrently, he was employed as an artistic director and film director at the Mosfil'm studio in Moscow. He was especially active in the TASS studio during the early months of the war, designing approximately sixteen posters between June and August 1941. He died in Tbilisi after having been evacuated from Moscow.

NIKOLAI ERNESTOVICH RADLOV

Born St. Petersburg, 1889; died Moscow [?], 1942

In 1911 Nikolai Ernestovich Radlov graduated from St. Petersburg University, where he received a degree in history and philology. His family was deeply involved in the cultural life of St. Petersburg: his father was the director of the Imperial Public Library, and his mother was related to the Symbolist painter Mikhail Vrubel. Radlov studied at the Imperial Academy of Arts, where his teachers were Dmitrii Kardovskii and Evgenii Lansere. His critical essays on contemporary art began to appear in print in 1912 in such esteemed journals as *Apollon*, *Mir iskusstva*, and *Argus*. The following year, he began to publish his cartoons in the magazine *Novyi Satirikon*. He authored a monograph on the portrait painter Valentin Serov in 1914 and a book on contemporary Russian graphics in 1916. Together with his teacher Kardovskii and the artists Aleksandr Iakovlev and Vasilii Shukhaev, he established the St. Luke Guild of Painters in Petrograd in 1917. From 1923 to 1937, he taught drawing at the Leningrad Institute of Painting, Sculpture, and Architecture (IZhSA). In the early 1920s, he began to illustrate for newspapers, including *Krasnaia gazeta*, and for satirical magazines, including *Begemot*, *Krokodil*, and *Smekhach*. Concurrently, his work appeared in the children's magazines *Ezh* and *Chizh*, published by Detgiz. In 1937, at the invitation of the Union of Artists, Radlov relocated to Moscow to head the graphic section of the union's Moscow branch. Between July 1941 and October 1942, he designed approximately thirty-five posters for the TASS studio. He was among the most active painters working for the studio during its first year.

PETR ASHOTOVICH SARKISIAN

Born Moscow, 1922; died Moscow, 1970

A graduate of the art studio of the All-Union Central Council of Trade Unions (VTsSPS) in Moscow, Petr Ashotovich Sarkisian was one of the most dynamic designers for the TASS studio, generating approximately seventy-three posters between October 1942 and April 1946. Following World War II, he studied at the All-Union State Institute

of Cinematography (VGIK). An active book illustrator and animator, he joined the film studio Souzmultfil'm in 1952, first as an art director and then, after 1965, as a director.

GEORGII KONSTANTINOVICH SAVITSKII

Born St. Petersburg, 1887; died Moscow, 1949

The son of Konstantin Savitskii, a painter associated with the Wanderers, Georgii Konstantinovich Savitskii graduated in 1908 from the Penza Art School, where his father served as director, and was accepted to the Imperial Academy of Arts in St. Petersburg without taking any qualifying exams. He studied there from 1908 to 1915 under Vladimir Maiakovskii and Frants Ribo and was awarded a trip abroad for his thesis painting. Between 1913 and 1917, he exhibited his work at shows by the Society of the Independent in St. Petersburg, the Wanderers, and the Kuindzhi Society in Petrograd. From 1918 to 1922, the artist took part in decorating the streets and squares of the cities of the Penza region for Revolutionary holidays. In 1922 Savitskii cofounded AKhRR. He was active in the 1930s primarily as a battle painter, and from 1935 to 1938, he directed the brigade of artists working on the diorama *The Storming of Perekop* (Central Museum of Armed Forces, Moscow). Savitskii was a major contributor to the TASS studio, for which he designed approximately forty posters between June 1941 and January 1946. In 1942 he was awarded the Stalin Prize and given the honorific title Honored Worker of Arts of the Russian Soviet Federative Socialist Republic. In 1949 he was elected a full member of the Academy of Arts of the USSR.

PETR MITROFANOVICH SHUKHMIN

Born Voronezh, 1894; died Moscow, 1955

Petr Mitrofanovich Shukhmin apprenticed in the studio of Vasilii Meshkov in Moscow in 1912. He then moved to St. Petersburg to study in the Imperial Academy of Arts under Dmitrii Kardovskii, Aleksandr Makovskii, and Ivan Tvorozhnikov. His studies were interrupted in 1916, when he was drafted into the Russian army. At the beginning of the Russian Revolution, he was elected head of the Soldiers' Council, and during the Civil War that followed,

he commanded a regiment. In 1921, following his demobilization, he returned to Moscow, where he helped found AKhRR the following year. In the 1920s and 1930s, he published cartoons in the satirical magazines *Krasnaia niva* and *Krasnyi perets*. Between June 1941 and September 1945, Shukhmin designed roughly forty posters for the TASS studio. He was awarded the Stalin Prize in 1941. He taught at the Moscow Institute of Applied and Decorative Arts from 1948 to 1952.

NIKOLAI ALEKSANDROVICH SOKOLOV

Born Moscow, 1903; died Moscow, 2000

In 1920, when his family moved to Rybinsk in the Yaroslavl province on the Volga River, Nikolai Aleksandrovich Sokolov entered the art studio of Proletkult, where he studied under Mikhail Shcheglov and helped prepare designs for agitation trains, steamboats, and Revolutionary holiday festivities. When Proletkult was dissolved in 1923, Sokolov transferred to VKhUTEMAS in Moscow, where he studied with Nikolai Kupriianov, Petr L'vov, and Petr Miturich, among others. He participated in the *First Exhibition of Graphic Art* in Moscow in 1926, but as early as 1924, he had begun producing works with fellow students Porfirii Krylov and Mikhail Kupriianov under the name Kukryniksy. For more information on the Kukryniksy, see the biography for Krylov. Over the course of his artistic career, Sokolov also worked independently, achieving renown as a graphic designer and painter of still lifes, landscapes, and portraits. For his awards, which he received alongside his Kukryniksy partners, see the biography of Krylov.

VIKTOR PAVLOVICH SOKOLOV

Born Moscow, 1923; died Moscow, 1980

The son of Pavel Sokolov-Skalia, the artistic director of the TASS studio, Viktor Pavlovich Sokolov studied at the Moscow Secondary Professional Art School and then at the Moscow State Academic Art Institute named after V. I. Surikov. During World War II, Sokolov was a significant contributor to the TASS studio, for which he designed approximately thirty-four posters between July 1942 and November 1946. In 1942 he collaborated with the M. B. Grekov Studio of Military Artists. He began submitting his work to all-union exhibitions in 1951.

PAVEL PETROVICH SOKOLOV (SOKOLOV-SKALIA)

Born Strel'nia, 1899; died Moscow, 1961

Pavel Petrovich Sokolov moved to Moscow in 1914 to apprentice in the studio of Il'ia Mashkov. In 1919, while working as an artist-decorator in Troitsk, in the region of Orenburg, he adopted the pseudonym Sokolov-Skalia. He returned to Moscow in 1921 to study for a year at VKhUTEMAS and the following year joined the avant-garde art group Being. When the group dissolved in 1926, he joined AKhRR, with which he remained until the war. Toward the end of the 1930s, he painted several monumental panels. He achieved some critical success for painting nationalist subjects and worked as a book illustrator and theater-set designer. He was active in Moscow as an instructor during this period as well, teaching at the Central Art Studio of AKhRR from 1922 to 1930, and in the M. B. Grekov Studio of Military Artists from 1932 to 1941. During the war, Sokolov-Skalia served as the artistic director of the TASS studio. Among the most prolific artists working for TASS, he designed approximately 200 posters for the studio between June 1941 and November 1946, including roughly one seventh of all the posters issued during the first year of operations. Following the war, he produced several large paintings glorifying Stalin. Sokolov-Skalia was twice awarded the Stalin Prize (1942 and 1949). He was also elected a full member of the Academy of Arts of the USSR in 1949, and in 1956 he was given the honorific title People's Artist of the Russian Soviet Federative Socialist Republic.

MIKHAIL MIKHAILOVICH SOLOV'EV

Born Moscow, 1905; died Moscow, 1990

In 1930 Mikhail Mikhailovich Solov'ev completed his training as a painter at AKhRR, where he studied with Il'ia Mashkov and Pavel Sokolov-Skalia. Solov'ev was among the most prolific artists working for the TASS studio, designing 157 posters between August 1941 and December 1946. He spent most of his career preparing posters for such publishing houses as Izobrazitel'noe iskusstvo, Izogiz, and Plakat, and during the Cold War, he

joined Agitplakat. He was given the title Honored Worker of Arts of the Russian Soviet Federative Socialist Republic.

PAVEL FEDOROVICH SUDAKOV

Born Moscow, 1914

Pavel Fedorovich Sudakov studied at the Moscow State Academic Art Institute named after V. I. Surikov from 1935 to 1941. He designed about eight posters for the TASS studio; his first poster appeared in August 1943 and his last in February 1946. Toward the end of the war, he was appointed head of the Art Studio of the Frontier Troops, a position he held until 1947. Although he developed a reputation as primarily a portraitist after the war, he is also known for his monumental history paintings. In 1982 he was granted the honorific title People's Artist of the Russian Soviet Federative Socialist Republic. In 1984 he was awarded the Medal of the Academy of Arts of the USSR, the I. E. Repin State Prize of the USSR, and the State Award of the Russian Soviet Federative Socialist Republic.

VLADIMIR ALEKSANDROVICH VASIL'EV

Born Moscow, 1895; died Moscow, 1967

Vladimir Aleksandrovich Vasil'ev studied in the Department of Sculpture at the Stroganov School for Technical Drawing from 1909 to 1917 under Nikolai Andreev. He continued his education in the Department of Painting at VKhUTEMAS from 1918 to 1924, studying under Petr Konchalovskii and David Shterenberg, among others. Between 1925 and 1935, he worked predominantly as a book illustrator, collaborating with Detzdat, GIKhL, Goslitizdat, Ogiz, and Partizdat. An active graphic designer, he also contributed to the magazine *30 dnei*. He contributed four poster designs to the TASS studio between September 1941 and January 1942. After the war, he returned to painting, producing a series in the late 1940s dedicated to the Great Patriotic War.

KONSTANTIN ALEKSANDROVICH VIALOV

Born Moscow, 1900; died Moscow, 1976

From 1914 to 1917, Konstantin Aleksandrovich Vialov studied textile design at the Strogonov School

for Technical Drawing in Moscow. Following the Revolution, he continued his education in the school's successor, GSKhM, under Vasilii Kandinsky, Aleksei Morgunov, and Vladimir Tatlin. He then entered VKhUTEMAS to study painting under Aristarkh Lentulov and David Shterenberg. By the early 1920s, he was producing counter-reliefs, Constructivist sculptures, and abstract paintings. From 1922 to 1925, he served as head of the Studio of Visual Arts for Teenagers, operated by Narkompros. During the 1920s, he began to design posters, illustrate books, and construct theatrical sets in Moscow. In 1925 he cofounded OST, in which he participated until 1928. In 1932 he joined the Moscow branch of the Union of Artists, and from 1937 to 1940, he worked on various aspects of the All-Union Agricultural Exhibition. Between December 1941 and August 1945, he designed around twenty-six posters for the TASS studio. After the war, he was active as a painter.

ALEKSANDR NIKOLAEVICH VOLKOV

Born Skobelev, Uzbekistan, 1886; died Tashkent, Uzbekistan, 1957

Aleksandr Nikolaevich Volkov entered St. Petersburg University in 1905 after graduating from the Orenburg Military Academy. Dropping out of school after only a few years of coursework, he enrolled in classes in David Bortniker's watercolor studio. From 1908 to 1910, he studied at the Preparatory School of the Imperial Academy of Arts with Vladimir Maiakovskii. Volkov attended the private art school maintained by Mikhail Bernshtein from 1910 to 1911, where he studied with the painters Ivan Bilibin and Nikolai Rerikh and the sculptor Leonid Shervud. From 1912 to 1916, he studied at the Kiev Art School, Ukraine, with the painters Fedor Krichevskii and Vladimir Menk, after which he relocated to Central Asia. In 1919 he was appointed director of the State Museum of Central Asia in Tashkent. In 1922 he became director of the Theater of Proletarian Culture in Tashkent. He taught at the Turkestan Art Studios in Tashkent from 1919 to 1921 and at the Tashkent Art School from 1929 to 1946. He joined AKhRR in 1927 and the following year began participating in the group exhibitions of the Tashkent branch of AKhR. In 1929 he joined the artistic society Masters of the New Orient. Between 1931 and 1932, he led the art association Volkov Brigade. From 1930 to 1934,

he conducted a creative expedition to document various construction sites in Uzbekistan. In 1941 he was given the title Honored Worker of Arts of the Uzbek Soviet Socialist Republic. Volkov designed approximately sixteen posters for the TASS studio between December 1941 and the summer of 1946. In 1946 he was awarded the honorific title People's Artist of the Uzbek Soviet Socialist Republic. Retrospectives of his work were organized in 1943, 1944–45, and 1957.

BORIS SERGEEVICH ZEMENKOV

Born Moscow, 1902; died Moscow, 1963

Boris Sergeevich Zemenkov entered Moscow State University in 1919, the same year he enrolled in GSKhM to work with Aleksandr Shevchenko. From 1920 to 1921, he studied in the Main Department of VKhUTEMAS under the supervision of Liubov Popova, and from 1922 to 1923, he was in the Department of Metalworking. From 1925 to 1926, he apprenticed in the Studio of Material Culture of the Theater of Revolution, and in 1928 he began designing theater sets for the Railway Workers' Club named after S. P. Gorbunov. In 1930 he joined the organizational bureau of the Moscow Association of Artist-Decorators (MAKhD) and throughout the decade designed game models and furniture for the Department of People's Education. He began to work as a graphic designer toward the end of the 1930s. Zemenkov designed three posters for the TASS studio between January and April 1942. In 1961 he joined the Moscow chapter of the Union of Artists.

TASS POET BIOGRAPHIES

NIKOLAI AL'FREDOVICH RABINOVICH (ADUEV)

Born St. Petersburg, 1895; died Moscow, 1950

Nikolai Al'fredovich Aduev's first literary success was his anthem for the Russian scouts (1914). After the Revolution, he worked in the satirical press and musical theater, where he adapted the librettos of classic operettas for the Soviet stage and wrote original texts, frequently in collaboration with A. Gol'denberg (Argo). Aduev was a member of the Constructivist group and worked in the Blue Blouse movement

for agitational theater. From 1923 he contributed to *Krokodil*, *Krasnyi perets*, *Zanoza*, and other satirical periodicals, and he also published books. During the 1939–40 Soviet war with Finland, Aduev wrote texts for caricatures by the Kukryniksy. He was one of the most productive TASS poets during the first months of World War II. After returning from evacuation in Kuibyshev, Aduev became the literary editor of *Krokodil* and a member of the Communist Party in 1943. During the war, he published well-received musical comedies. He also adapted Aleksandr Pushkin's 1831 story "The Squire's Daughter" for Iosef Kovner's opera *Akulina* (1948). An edition of Aduev's selected works was published in 1963.

EFIM ALEKSANDROVICH PRIDVOROV (DEM'IAN BEDNYI)

Born Gubovka, Ukraine, 1883; died Moscow, 1945

Born into a peasant family, Efim Aleksandrovich Pridvorov excelled in school and was admitted in 1904 to St. Petersburg University, where he remained until 1914, becoming increasingly involved in radical politics. His original sentimental manner of writing gradually yielded to political verse and, beginning in 1911, verse satire; his first book of satirical fables was published in 1913. In 1912 Pridvorov adopted the pseudonym Dem'ian Bednyi (Dem'ian the Poor) and became a member of the Bolshevik Party, writing for *Pravda* and corresponding with Vladimir Lenin. His anticzarist and antireligious poetry enjoyed great popularity during the Civil War and was frequently published in inexpensive brochures. In the 1920s, Bednyi was close to the leadership of the Communist Party, occupying his own apartment in the Kremlin and publishing constantly in major newspapers and satirical magazines such as *Bezbozhnik*, *Krokodil*, *Lapot'*, and *Smekhach*. He wrote many texts for propaganda posters, often in collaboration with the artist Viktor Deni. His poems were set to music by composers such as Marian Koval', A. Liubimov, and V. Pergament. In late 1936, the prohibition of Bednyi's satirical play *The Heroic Knights*, proved to be a severe blow to the writer. Soviet authorities

determined that the play distorted and insulted Russian history. In 1938 he was expelled from the ranks of the Communist Party; unable to publish, he sold off his extensive library, one of the best in the country. By the beginning of World War II, Bednyi had been restored to official favor. Despite spending part of the war in Kazan, he was recognized as one of the most productive and successful TASS poets. He died just days after the war's end, but his work was frequently reprinted in subsequent decades.

NIKOLAI SERGEEVICH BERENDGOF

Born 1900; died 1990

Nikolai Sergeevich Berendgof's first collection of poems, *The Target of the Brave*, was published in 1918 and was followed in quick succession by several other books of poetry. A member of the All-Russian Union of Poets, Berendgof was close to older poets like Futurist Vasilii Kamenskii and Symbolist Andrei Belyi in the 1920s. He continued to write ballads and songs during the 1930s, many dedicated to Joseph Stalin's great construction projects. In 1934 the poet translated Jef Last's "The Unemployed" from the Dutch for Klementii Korchmarev's Second Symphony for Chorus. In 1944 Berendgof coedited a collection of poems by young poets. He wrote texts for five TASS posters in 1945–46. In 1948 he published a book of adaptations of the poems of Leib Kvitko. Berendgof's poems were set to music by composers such as Anatolii Aleksandrov and Anatolii Arskii. A collection of his selected poetry was published in 1971. Berendgof's brother Boris was a well-known landscape artist.

OSIP MAKSIMOVICH BRIK

Born Moscow, 1888; died Moscow, 1945

The son of a merchant, Osip Maksimovich Brik trained as a lawyer but came to prominence as a theorist of avant-garde literature and art. In 1912 he married Lily Kagan. In 1915, while he was on military duty in Petrograd, the young couple met Vladimir Maiakovskii, who became Lily's lover and in 1918 joined the Brik household. Brik funded the publication of Maiakovskii's first books. He was also active in the Society for the Study of Poetic Language, the cradle of the formalist movement. In 1918 he joined the art section of the

Commissariat for Enlightenment, lecturing, writing, and serving as an editor for the newspaper *Iskusstvo kommuny*. After moving back to Moscow in 1919, Brik worked for a variety of cultural and political agencies; his main activity was advocating for avant-garde tendencies in art, especially "production art" and later "the literature of fact." After a sojourn in Berlin in late 1922, Brik helped found *LEF*, the journal of group Left Front of the Arts, which in 1927 was renamed *Novyi LEF*. In 1926 he was appointed head of the literary section of the Mezhrabpom-Rus fil'm studio. A literary handyman, Brik experimented with many genres, writing operas, a novel, a radio "grotesque" (with Maiakovskii), and a screenplay. As formalism and leftist art fell into official disfavor, Brik adapted and became a prominent writer and critic in the Socialist Realist tradition, joining the Writers' Union in 1934. Together with dramatist Oleg Leonidov, he wrote several plays, screenplays, and other works. He also remained active in the cinema, as both a screenwriter and an editor. He wrote the librettos for two operas by V. Zhelobinskii. Brik was one of the first writers to join the TASS studio collective. He spent part of the war in Perm'. After returning to Moscow in late 1942, Brik continued to work in the TASS studio, serving for a time as its main literary editor, and began to write for the satirical magazine *Krokodil*.

NINA ALEKSANDROVNA CHEREMNYKH

Birth and death dates unknown

Nina Aleksandrovna Cheremnykh was living in Leningrad when she met the artist Mikhail Cheremnykh in 1928. From then on, she was the author or coauthor of many texts for her husband's posters. She also collaborated with him on a set of flashcards. In October 1941, the Cheremnykhs were evacuated to the city of Biisk in the Altai region. After returning to Moscow in mid-1943, they collaborated on a number of TASS posters. In 1965 she published a memoir about her husband.

SEMYON ISAAKOVICH KORTCHIK (KIRSANOV)

Born Odessa, Ukraine, 1906; died Moscow, 1972

The son of a tailor, Semyon Isaakovich Kirsanov was still quite young when he began fashioning himself as a poet

in the style of the Russian Futurists. Vladimir Maiakovskii, who published Kirsanov's poems in the avant-garde journal *LEF* in 1924, implicitly recognized the young writer as a fellow pioneer in the creation of new poetic forms for the Socialist state. Kirsanov also contributed to satirical magazines such as *Bich*, *Chudak*, and *Smekhach*. After Maiakovskii's death, Kirsanov carried the mantle of poetic experimentation into the 1930s. Many of his books were published with striking avant-garde designs. After losing his wife, Klava, to tuberculosis in 1937, he published *Your Poem*, one of the most touching works in Soviet poetry of the time. During the 1930s, Kirsanov's output was prodigious. He contributed to *Krokodil* throughout the decade, and after the outbreak of war, he became one of the first TASS poets. Subsequently, he worked for frontline newspapers and became well known as the creator of Foma Smyslov, an everyman Russian soldier who underwent various adventures in serialized installments. Kirsanov suffered a dramatic decline in critical recognition and popularity after World War II, though his poetic biography of a steelworker, *Makar Mazai* (1950), won him a Stalin Prize. He continued publishing original poetry and was also known for his translations of the work of such foreign Communist poets as Pablo Neruda and Nazim Hikmet. His poetry was set to music by Dmitrii Shostakovich.

OSIP IAKOVLEVICH KOLYCHEV

Born 1904; died 1973

Osip Iakovlevich Kolychev began publishing poetry in 1920 and contributed to the satirical magazine *Kirpich*. His debut collection, *Book of Poems*, appeared in 1930. Kolychev was active in writers' organizations in the 1930s as a loyal Stalinist. He contributed texts for TASS posters from 1941 to 1946. During the war, he also became a contributor to the satirical magazine *Krokodil*. After 1945 Kolychev wrote about the war and the Russian countryside. He was the author of numerous songs, set to music by Aleksandr Aleksandrov and Tikhon Khrennikov. An amateur painter, Kolychev also wrote poems dedicated to renowned Russian landscape artists such as Isaak Levitan. He was recognized as a translator of Yiddish poetry and as a children's-book author. A volume of his selected works appeared in 1958, and his last book, *Roots and Crowns*, was published in 1973, the year of his death.

PAVEL PAVLOVICH KUDRIAVTSEV

Born Sosnovets, 1903; died 1978

In the 1920s, Pavel Pavlovich Kudriavtsev published the poem "The Village Correspondent." He volunteered for service in World War II and was injured in an air raid. He contributed texts to three TASS posters from late 1943 to 1946. Kudriavtsev won a State Prize for the song "The Heroic Forest." His poetry collection *The Ocean Consists of Drops* (1964) was well received.

VASILII IVANOVICH LEBEDEV (LEBEDEV-KUMACH)

Born Moscow, 1898; died Moscow, 1949

From 1922 Vasilii Ivanovich Lebedev-Kumach wrote for *Krokodil*, as well as for *Bezbozhnik*, *Lapot'*, *Smekhach*, and many other periodicals. He gathered his work in volumes like *People and Things* and *Stories* (both 1927). Lebedev-Kumach also wrote the words to many popular songs of the 1930s. Isaak Dunaevskii and Lebedev-Kumach's "Song of the Motherland" was adopted as the unofficial anthem of the Soviet Union until 1943. Lebedev-Kumach's work was also set to music by such composers as Aran Khachaturian, Iurii Levitin, Anatolii Novikov, Dmitrii Pokrass, and Sergei Vasilenko. In 1941 his songs won him a Stalin Prize. In June 1941, Lebedev-Kumach published "Holy War," which quickly became one of the anthems of World War II. A member of the Communist Party from 1939, the writer was a deputy to the Supreme Soviet. He also served as a naval officer during the war, while writing songs and poems for the daily press, satirical magazines, and the TASS studio. Some of his wartime texts were collected in the volume *Young Communist Sailors* (1942). Selections of his work were gathered in a 1950 volume and republished repeatedly in subsequent decades.

INNA MIKHAILOVNA LEVIDOVA

Born St. Petersburg, 1916; died 1988

Inna Mikhailovna Levidova studied at the Maksim Gor'kii Literary Institute and became a member of the Writers' Union. She later gained renown as a translator, publisher, and scholar of British literature. Levidova compiled bibliographies of translations and studies of authors from Henry Fielding to H. G. Wells. Her translations included works by George Orwell, William Trevor, and Tennessee Williams. She contributed texts to numerous TASS posters beginning in October 1944.

SAMUIL IAKOVLEVICH MARSHAK

Born Voronezh, 1887; died Moscow, 1964

Samuil Iakovlevich Marshak first came to prominence as a lyric poet and translator of Yiddish and Hebrew texts, thanks to the patronage of critic Vladimir Stasov and writer Maksim Gor'kii. In 1912–14 Marshak studied in England and, after returning to Russia, gained recognition as a translator of the work of Robert Burns, Shakespeare's sonnets, and other English-language poetry. In 1923 Marshak began publishing works for children. Over the following decades, he wrote many popular children's tales, mostly in verse and frequently with the illustrations of Vladimir Lebedev. In 1923 he founded the children's magazine *Vorobei*, which lasted until 1939 under various titles, and for many years, he also served as editor in chief for the children's publishing house in Leningrad, where he cultivated numerous young writers. Marshak was awarded four Stalin Prizes (1942, 1946, 1949, and 1951) and one Lenin Prize (1963). During World War II, he worked closely with the Kukryniksy in the creation of TASS and other posters, as well as caricatures for periodicals and even labels for dry goods. Together they published four books of their wartime caricatures. Having begun to contribute to *Krokodil* during the war, often with the Kukryniksy, Marshak continued to do so in later years, while also writing for children's magazines like *Veselye kartinki*. He wrote the text for Sergei Prokofiev's oratorio *On Guard for Peace* (1950) and in the 1960s wrote autobiographical and theoretical works. His writings, especially his children's poems and translations, have been constantly republished since his death.

ALEKSEI IVANOVICH MASHISTOV

Birth and death dates unknown

Aleksei Ivanovich Mashistov is mainly remembered today for his work as a librettist and translator. He created the texts for two pieces by Sergei Prokofiev. In 1947 he wrote an anthem for the city of Moscow, using music by Mikhail Glinka. Mashistov collaborated with composers to adapt literary works as operas. His poems were set to music by composers such as Aleksandr Kastal'skii, Nikolai Rakov, and Aleksandr Sveshnikov. Mashistov translated Arvo Pärt's 1964 oratorio *The Step of Peace* and is also credited with the Russian translations of Giacomo Puccini's *Tosca*, Giuseppe Verdi's *Attila*, and Georgian folk songs. Mashistov was one of the most prolific writers for the TASS studio, contributing to dozens of posters from 1941 to 1946, though his texts were sometimes criticized for shoddy craftsmanship.

SERGEI VLADIMIROVICH MIKHALKOV

Born Moscow, 1913; died Moscow, 2009

Born into an aristocratic family, Sergei Vladimirovich Mikhalkov began publishing poems in youth newspapers and magazines in 1928. He first earned wide public notice with his 1935 tale for children, *Uncle Styopa*, and became a member of the Writers' Union in 1937. From the mid-1930s, Mikhalkov contributed to the satirical magazine *Krokodil*. During World War II, he wrote for army newspapers and was injured at Stalingrad. In 1944 he coauthored the new Soviet national anthem with Gabriel El'-Registan (he rewrote the words in 1977 and again in 2000). He contributed texts to four TASS posters between May 1942 and January 1944. After the war, Mikhalkov became one of the most popular authors of books and films for children. His play *Red Kerchief* (1947) was made into a hit film (1948), one of many for which he authored the screenplay. He also wrote many animated films and contributed song lyrics to Grigorii Aleksandrov's film *Spring* (1947). His poems were set to music by composers like Iosif Kovner. Mikhalkov regularly contributed to children's journals like *Veselye kartinki*, and from 1970 he chaired the Writers' Union. The writer was awarded three Stalin Prizes (1941, 1942, and 1950) and one Lenin Prize (1978). He was a member of the Communist Party from 1950.

MIKHAIL IAKOVLEVICH ROSENBLATT (PUSTYNIN)

Born Odessa, Ukraine, 1884; died Moscow, 1966

Mikhail Iakovlevich Pustynin made his debut as a satirist during the 1905 Revolution, when he moved to St. Petersburg and wrote for the magazine *Signal*. He later worked for *Satirikon*, the premier satirical journal in Russia before the Revolution, and the short-lived *Grubian*. In 1920–21 he worked for ROSTA in Vitebsk, where he helped found the first Theater of Revolutionary Satire (Teresvat). In 1922 he edited *Gazeta dlia chteniia*, a satirical broadsheet. Pustynin published in many satirical magazines, including *Chudak Krasnyi perets*, *Lapot'*, and *Smekhach*. He was best known as a contributor to (and sometime editor of) *Krokodil*. In addition to writing three texts for the TASS studio at the beginning of World War II, he contributed to the satirical magazine *Frontovoi iumor*.

ALEKSANDR BORISOVICH RASKIN

Born Vitebsk, 1914; died Moscow, 1971

From the mid-1930s, Aleksandr Borisovich Raskin contributed to the satirical magazine *Krokodil*. In the late 1930s and during World War II, he frequently collaborated with Moris Slobodskoi. In 1939, with the artist K. Rotov, they published *Exclamation Mark*, which included parodies of prominent writers. In addition to writing for the TASS studio at the beginning of the war, Raskin contributed to the satirical magazine *Frontovoi iumor*. In 1945 he and Slobodskoi published the comedy *Star of the Screen*. Raskin also contributed song lyrics to Grigorii Aleksandrov's film *Spring* (1947). In 1968 Raskin and the Kukryniksy collaborated on a book of graphic and lyrical caricatures of famous figures. His 1961 book for children, *When Papa Was Little*, was translated into English and is still in print today.

ALEKSANDR IL'ICH ROKHOVICH

Born 1908; died 1974

Aleksandr Il'ich Rokhovich's satirical verse was gathered in the 1968 volume *Truth in the Eyes*. He contributed dozens of texts to the TASS studio in the first months of World War II.

GEORGII L'VOVICH RUBLEV

Born Baku, Azerbaijan, 1916; died Moscow, 1955

In 1942 Georgii L'vovich Rublev published the play *Missing in Action*. After World War II, he traveled to Prague with Mikhail Vershinin to write a screenplay about Soviet forces abroad. He was active for the TASS studio in the first months of the war. The highpoint of his career occurred in 1950, when he published two books of propaganda verse. According to the memoirs of actress Tat'iana Okunevskaia, Rublev was also an informer, responsible for the arrests of Vershinin and Okunevskaia, among others, by the Soviet secret police.

STEPAN PETROVICH SHCHIPACHEV

Born Shchipachi, 1889; died Moscow, 1980

A member of the Communist Party from 1919, Stepan Petrovich Shchipachev served in the Red Army during the Civil War. His 1942 collection of poems from the front was well received. He contributed texts for TASS posters from the spring of 1942 to the spring of 1943. His postwar collections brought him two Stalin Prizes (1949 and 1951). Shchipachev's poems were set to music by composers such as Anatolii Aleksandrov, Vladimir Kriukov, Nikolai Miaskovskii, and Iurii Shaporin. His son Livii played the title role in two popular films about the pioneer Timur and later became a well-known artist.

KONSTANTIN MIKHAILOVICH SIMONOV

Born Petrograd, 1915; died Moscow, 1979

Though his mother came from an aristocratic family, Konstantin Mikhailovich Simonov grew up poor, having lost his father in World War I, and became a metalworker at age fifteen. After moving to Moscow in 1931, he worked as a mechanic at the film studio Mosfil'm and began to write poetry. In 1934 he produced his first major work, about the construction of the White Sea-Baltic Sea Canal. Later that year, he was accepted at the Literary Institute; he graduated in 1938 and became a member of the Writers' Union, having already published several poems in major journals. Simonov was deeply affected by his experiences as a journalist at the battle of Khalkhin-Gol in 1939, after which he underwent military

training. He volunteered at the beginning of World War II and served as an official war correspondent, joining the Communist Party in 1942 and finishing the war as a colonel. Phenomenally prolific, Simonov published numerous lyric poems, two plays, and two screenplays during the war, all of which were well received by critics and officials. His sole contribution to the TASS studio was an excerpt from his influential 1942 poem "Kill Him." After the war, Simonov traveled abroad extensively as a correspondent, documenting the rise of Cold War tensions between the Soviet Union and its former allies. Between 1959 and 1971, Simonov published a trilogy of novels, *The Living and the Dead*, based on his war experiences. In the late 1960s, Simonov spent much time in Vietnam; his poems on the war were gathered in *Vietnam, Winter of '70* (1971). The recipient of six Stalin Prizes (1942, 1943, 1946, 1947, 1949, and 1950) and one Lenin Prize (1974), the writer enjoyed unparalleled authority in Soviet culture throughout his life. The posthumous publication of his memoirs and diaries confirmed the importance and complexity of his legacy.

MORIS ROMANOVICH SLOBODSKOI

Born St. Petersburg, 1913; died Moscow, 1991

A member of the Writers' Union from 1938, Moris Romanovich Slobodskoi became prominent as a satirist during the Soviet-Finnish War of 1939–40, when he wrote captions for the cartoons featuring the character Vasia Terkin. Beginning in 1939, he struck up a close collaboration in poetry and theatrical comedy with Aleksandr Raskin, with whom he also worked closely on the early TASS posters. During World War II, Slobodskoi coedited the magazine *Frontovoi iumor*. He became well known for the poetic captions he wrote for artist Orest Vereiskii's popular adaptation of Jaroslav Hasek's character Brave Soldier Schweik, published in *Krasnoarmeiskaia pravda*. After the war, he frequently worked with the satirist and comic dramatist V. Dykhovichyi. He also contributed song lyrics to Grigorii Aleksandrov's film *Spring* (1947). Slobodskoi is best known today for his screenplay for the 1968 film comedy *Diamond Arm*, which he wrote with Iakov Kostiukovskii and director Leonid Gaidai.

SERGEI DMITRIEVICH SPASSKII

Born Kiev, Ukraine, 1898; died near Yaroslavl, 1956

Sergei Dmitrievich Spasskii studied at Moscow University from 1915 to 1918, during which time he published his debut book of poetry, *Like Snow* (1917). At the time, he was an avant-garde poet, friendly with Vladimir Maiakovskii and Boris Pasternak. He left the university before graduation in order to work with Proletkult – a government-sponsored organization for revolutionary culture – in Kuibyshev (Samara) and to serve briefly in the Red Army. After a sojourn in Moscow, in 1924 Spasskii dedicated himself to a literary career and settled in Leningrad, where he published a series of collections of poems and stories. In the 1930s, Spasskii worked as an editor for the Leningrad Writers' Publishing House. At the beginning of World War II, the writer volunteered for the defense force on the Leningrad front, worked for Leningrad radio, and contributed verse to posters published by the workshop Boevoi karandash. He spent most of the war in Perm'. He joined the TASS studio for several months at the end of 1943, producing texts for several posters. At the end of the war, he was decorated for his service. He coedited a volume of Estonian poetry in 1948. He was arrested in 1951 and sentenced to ten years of hard labor but was released in 1954.

MIKHAIL MAKSIMOVICH VERSHININ (SHUL'MAN)

Born 1923; died 1986

Mikhail Maksimovich Vershinin was a versatile writer, contributing to genres ranging from satirical poetry to cinematic screenplay. According to his autobiographical poem "Chronicle of the First Days" (1941–42, 1945), he joined the TASS studio during the siege of Moscow. Later Vershinin traveled extensively around the Eastern Front. The end of the war found him in Czechoslovakia, where a collection of his wartime poetry was published in 1946. Vershinin also wrote lyrics to popular songs. Soon, however, he was arrested and imprisoned in a labor camp, accused of making seditious comments while abroad. He was released and rehabilitated after Stalin's death. In the 1960s, Vershinin authored several books of poetry, much of it military in subject. In 1985 he published a book about the Soviet-Georgian

composer Aleksei Machavariani, having previously written the text for Machavariani's oratorio *The Day of My Motherland* (1954) and other works.

ALEKSANDR ALEKSEEVICH ZHAROV

Born Semenovskaia, 1904; died Moscow, 1984

Aleksandr Alekseevich Zharov began his writing career as a contributor to satirical magazines like *Komar*, *Krasnyi perets*, and *Zanoza*. He came to prominence in 1926, when his folksy narrative poem "Accordian" was published in *Komsomol'skaia pravda*. It appeared to herald the emergence of a new generation of poets who had grown up in the Komsomol. In the following years, he struggled to meet the expectations he had raised, publishing numerous narrative poems and collections of lyrics. Zharov also contributed to the satirical magazine *Chudak*. He enjoyed renewed popularity after the outbreak of World War II, parts of which he spent with the navy at sea. From the end of 1942 to the end of the war, Zharov was one of the most productive TASS poets, contributing texts for dozens of posters. Many of the poems and songs he wrote during and after the war are dedicated to naval topics. During the war, he also contributed to *Krokodil*. Following the war, Zharov became an active contributor to Agitplakat, which continued the tradition of the ROSTA and TASS posters.

PAVEL ILL'ICH ZHELEZNOV

Born 1907; died 1987

Pavel Ill'ich Zheleznov became known in the late 1920s as a homeless orphan who had educated himself and begun to write. His cause was taken up by Maksim Gor'kii, whom he viewed as his mentor. He volunteered for active service at the beginning of World War II and contributed texts to the TASS studio on his own initiative. Today he is remembered chiefly for his memoir *Mentors and Friends*, published in 1982.

BIBLIOGRAPHY

A

Ades 1995
Ades, Dawn. 1995. *Art and Power: Europe under the Dictators, 1930–45.* Exh. cat. Hayward Gallery.

AKhRR 1922
AKhRR. 1922. *Katalog Vystavki kartin, etiudov, eskizov, risunkov, grafiki i skul'ptury "Zhizn' i byt rabochikh."* Exh. cat. Revoliutsionnoi.

Akinsha 2006
Akinsha, Konstantin. 2006. "Alexander Zhitomirsky: The Last Photomontagist." *Zimmerli Journal* 4 (Fall), pp. 66–75.

Akinsha and Jolles 2009
Akinsha, Konstantin, and Adam Jolles. 2009. "On the Third Front: The Soviet Museum and Its Public during the Cultural Revolution." In *Treasures into Tractors: The Selling of Russia's Cultural Heritage, 1918–1938.* Edited by Anne Odom and Wendy R. Salmond, pp. 167–81. Hillwood Estate, Museum, and Gardens/University of Washington Press.

Akinsha and Kozlov 1995
Akinsha, Konstantin, and Grigorii Kozlov, with Sylvia Hochfield. 1995. *Beautiful Loot: The Soviet Plunder of Europe's Art Treasures.* Random House.

Akinsha and Kozlov 2007
Akinsha, Konstantin, and Grigorii Kozlov, with Sylvia Hochfield. 2007. *The Holy Place: Architecture, Ideology, and History in Russia.* Yale University Press.

Alaniz 2010
Alaniz, José. 2010. *Komiks: Comic Art in Russia.* University Press of Mississippi.

Arad 2009
Arad, Yitzak. 2009. *The Holocaust in the Soviet Union.* University of Nebraska Press/Yad Vashem.

Aulich 2007
Aulich, James. 2007. *War Posters: Weapons of Mass Communication.* Thames and Hudson.

Avron, Lemenuel, and Lyotard 1970
Avron, Dominique, Bruno Lemenuel, and Jean-François Lyotard. 1970. "Espace plastique et espace politique." *Revue d'ésthetique* 23, pp. 255–77.

B

Baburina 1984
Baburina, Nina. 1984. *Sovetskii politicheskii plakat.* Sov. khudozhnik.

Bahktin 1984
Bakhtin, Mikhail. 1984. *Rabelais and His World.* Translated by Hélène Iswolsky. University of Indiana Press.

Bargiel and Le Men 2010
Bargiel, Réjane, and Ségolène Le Men. 2010. *La Belle Époque de Jules Chéret: De l'affiche au décor.* Exh. cat. Arts Décoratifs/Bibliothèque Nationale de France.

Beaverbrook 1942
Beaverbrook, Max Aitken. 1942. *Spirit of the Soviet Union: Anti-Nazi Cartoons and Posters.* Pilot Press.

Beevor 1998
Beevor, Antony. 1998. *Stalingrad.* Penguin Books.

Beevor 2002
Beevor, Antony. 2002. *The Fall of Berlin, 1945.* Viking.

Beevor and Vinogradova 2005
Beevor, Antony, and Luba Vinogradova. 2005. *A Writer at War: Vassily Grossman with the Red Army, 1941–1945.* Pantheon Books.

Behrends 2009
Behrends, Jan C. 2009. "Back from the U.S.S.R.: The Anti-Comintern's Publications on Soviet Russia in Nazi Germany (1935–41)." *Kritika: Explorations in Russian and Eurasian History* 10 (Summer), pp. 527–56.

Bellamy 2007
Bellamy, Chris. 2007. *Absolute War: Soviet Russia in the Second World War.* Alfred A. Knopf.

Benton 1942
Benton, Thomas Hart. 1942. *The Year of Peril: A Series of War Paintings.* Abbott Laboratories.

Berkhoff 2004
Berkhoff, Karel C. 2004. *Harvest of Despair: Life and Death in Ukraine under Nazi Rule.* Belknap Press.

Bess 2006
Bess, Michael. 2006. *Choices under Fire: Moral Dimensions of World War II.* Alfred A. Knopf.

Biegeleisen and Cohn 1942
Biegeleisen, J. I., and Max Arthur Cohn. 1942. *Silk Screen Stenciling as a Fine Art.* McGraw-Hill Book Co.

Blood 2006
Blood, Philip W. 2006. *Hitler's Bandit Hunters: The SS and the Nazi Occupation of Europe.* Potomac Books, Inc.

Bois 1988
Bois, Yve-Alain. 1988. "El Lissitzky: Radical Reversibility." *Art in America* 76, 4 (Apr.), pp. 160–81.

Boltianskii 1929
Boltianskii, Georgii. 1929. *Foto-kruzhok za rabotoi.* Ogonek.

Bonn 2005
Bonn, Keith E., ed. 2005. *Slaughterhouse: The Handbook of the Eastern Front*. Aberjona Press.

Bonnell 1997
Bonnell, Victoria E. 1997. *Iconography of Power: Soviet Political Posters under Lenin and Stalin*. Studies on the History of Society and Culture 27. University of California Press.

Borisov 2006
Borisov, I. 2006. *Okkupatsionnyi plakat*. Izdatel'stvo MGOU.

Bourke-White 1942
Bourke-White, Margaret. 1942. *Shooting the Russian War*. Simon and Schuster.

Bourtman 2008
Bourtman, Il'ia. 2008. "'Blood for Blood, Death for Death': The Soviet Military Tribunal in Krasnodar, 1943." *Holocaust and Genocide Studies* 22, 2 (Fall), pp. 246–65.

Bowlt 1975
Bowlt, John E. 1975. "Art and Violence: The Russian Caricature in the Early Nineteenth and Early Twentieth Centuries." *Twentieth-Century Studies* 13, 14, pp. 56–76.

Bowlt 1978
Bowlt, John E. 1978. "Russian Caricature and the 1905 Revolution." *Print Collector's Newsletter* 1 (Mar.–Apr.), pp. 5–8.

Bowlt 1988
Bowlt, John E., ed. 1988. *Russian Art of the Avant-Garde: Theory and Criticism*. Translated by John E. Bowlt. Rev. ed. Thames and Hudson.

Bown 1991
Bown, Matthew Cullerne. 1991. *Art under Stalin*. Phaidon.

Bown 1998
Bown, Matthew Cullerne. 1998. *Socialist Realist Painting*. Yale University Press.

Bown and Taylor 1993
Bown, Matthew Cullerne, and Brandon Taylor, eds. 1993. *Art of the Soviets: Painting, Sculpture, and Architecture in a One-Party State, 1917–1992*. Manchester University Press/St. Martin's Press.

Braithwaite 2006
Braithwaite, Rodric. 2006. *Moscow 1941: A City and Its People at War*. Alfred A. Knopf.

Brandenberger 2002
Brandenberger, David. 2002. *National Bolshevism: Stalinist Mass Culture and the Formation of Modern Russian National Identity, 1931–1956*. Harvard University Press.

Brent 2008
Brent, Jonathan. 2008. *Inside the Stalin Archives: Discovering the New Russia*. Atlas.

Brian 1942
Brian, Doris. 1942. "Record of the Poster up to Date: II – Since 1939." *ARTnews* 41, 9 (Aug.–Sept.), pp. 10–12, 40–42.

Brik 1944
Brik, Osip. 1944. "Kartina vyshla na ulitsu." *Znamia* 2, pp. 187–91.

Burtin 1966
Burtin, Iu. 1966. "Stikhi chitatelei 'Vasiliia Terkina,'" *Literaturnoe nasledstvo* 78, 1, pp. 563–601.

Butler 2005
Butler, Susan, ed. 2005. *My Dear Mr. Stalin: The Complete Correspondence between Franklin D. Roosevelt and Joseph V. Stalin*. Yale University Press.

Butterfield 1992
Butterfield, Ralph, ed. 1992. *Patton's GI Photographers*. Iowa State University Press.

C

Chegodaeva 2004
Chegodaeva, Maria. 2004. *Zapovednyi mir Miturichei-Khlebnikoykh: Vera i Petr*. Agraf.

Cheremnykh 1965
Cheremnykh, Nina. 1965. *Khochetsia, chtoby znali i drugie*. Sovetskii khudozhnik.

Chernevich, Anikst, and Baburina 1990
Chernevich, Elena, Mikhail Anikst, and Nina Barburina. 1990. *Russian Graphic Design 1880–1917*. Abbeville.

Cienciala, Lebedeva, and Materski 2007
Cienciala, Anna M., Natalia S. Lebedeva, and Wojciech Materski, eds. 2007. *Katyn: A Crime without Punishment*. Annals of Communism. Yale University Press.

Clark 1999
Clark, T. J. 1999. "God Is Not Cast Down." In *Farewell to an Idea: Episodes from a History of Modernism*, pp. 225–97. Yale University Press.

Coeuré 1999
Coeuré, Sophie. 1999. *La grande lueur à l'Est: Les Français et l'Union soviétique, 1917–1939*. Seuil.

Cook 1973
Cook, K. M., ed. 1973. *On Literature and Art*. Translated by Avril Pyman and Fainna Glagoleva. 2nd rev. ed. Progress Publishers.

D

Demosfenova, Nurok, and Shantyko 1962
Demosfenova, G., Ariadna Nurok, and Nina Shantyko. 1962. *Sovetskii politicheskii plakat*. Iskusstvo.

Denisovskii c. 1942
Denisovskii, Nikolai. "Otchet o rabote redaktsii voenno-oboronnogo plakata 'Okna TASS' za 18 mesiatsev," c. 1942, f. 4459, op. 11, d. 1249, ll. 1–6, GARF.

Denisovskii 1970
Denisovskii, Nikolai. 1970. *Okna TASS, 1941–1945*. Izobrazit. iskusstvo.

Denisovskii and Sokolov-Skalia 1945
Denisovskii, Nikolai, and Pavel Sokolov-Skalia. June 1945. "Dokladnaia zapiska partkom TASS." Kolesnikova Archive.

Dobrenko 2007
Dobrenko, Evgenii. 2007. *Political Economy of Socialist Realism*. Translated by Jesse Savage. Yale University Press.

Dobrenko 2009
Dobrenko, Evgenii. 2009. "Raeshnyi kommunizm: Poetika utopicheskogo naturalizma i stalinskaia kolkhoznaia poema." *Novoe literaturnoe obozrenie* 98, pp. 133–80.

Doenecke 1990
Doenecke, Justus D. 1990. *In Danger Undaunted: The Anti-Interventionist Movement of 1940–41 as Revealed in the Papers of the America First Committee*. Hoover Institution Press.

Douglas 1992
Douglas, Charlotte. 1992. "Terms of Transition: The *First Discussional Exhibition* and the Society of Easel Painters." In *The Great Utopia: The Russian and Soviet Avant-Garde, 1915–1932*. Exh. cat., pp. 450–65. Guggenheim Museum/Rizzoli.

Druick and Zegers 1981
Druick, Douglas W., and Peter Zegers. 1981. *La Pierre parle: Lithography in France, 1848–1900*. Exh. cat. National Gallery of Canada.

Dullin 2001
Dullin, Sabine. 2001. *Des hommes d'influences: Les ambassadeurs de Stalin en Europe, 1930–1939*. Payot.

Duvakin 1975
Duvakin, V. D. 1975. *Rostafenster: Majakowski als Dichter u. bildender Künstler*. Verlag der Kunst, VEB.

E

Ellul 1965
Ellul, Jacques. 1965. *Propaganda: The Formation of Men's Attitudes*. Translated by Konrad Kellen and Jean Lerner. Knopf.

Erenburg and Grossman 2002
Erenburg, Il'ia, and Vasilii Grossman. 2002. *The Complete Black Book of Russian Jewry*. Edited and translated by David Patterson. Transaction Publishers.

Evans 2009
Evans, Richard J. 2009. *The Third Reich at War*. Penguin Press.

F

Fedorov-Davydov 1949
Fedorov-Davydov, Andrei. 1949. *Victor Borisovich Koretskii*. Iskusstvo.

Fitzpatrick 2005
Fitzpatrick, Sheila. 2005. *Tear off the Masks: Identity and Imposture in Twentieth-Century Russia*. Princeton University Press.

Fomin 2005
Fomin, V. ed. 2005. *Kino na voine: Dokumenty i svidetel'stva*. Materik.

Fox 1975
Fox, Frank W. 1975. *Madison Avenue Goes to War: The Strange Military Career of American Advertising, 1941–45*. Charles E. Merrill Monograph Series in the Humanities and Social Sciences 4, 1. Brigham Young University Press.

Friedrich 2006
Friedrich, Jorg. 2006. *The Bombing of Germany, 1940–1945*. Columbia University Press.

G

Gerasimov 1945
Gerasimov, Aleksandr. 1945. "The Soviet Fine Arts during the War." *The American Review of the Soviet Union* 7, 1 (Nov.), pp. 3–11.

Geyer and Fitzpatrick 2009
Geyer, Michael, and Sheila Fitzpatrick, eds. 2009. *Beyond Totalitarianism: Stalinism and Nazism Compared*. Cambridge University Press.

"Gl. Bukhgalter" 1945
"Gl. Bukhgalter Khrustalev. Zakluchenie po otchetu Redaktsii 'Okna TASS' na 1944 g. 11," 1945, f. 4459, op. 9–2, d. 62, ll. 100–07, GARF.

Glantz and House 1995
Glantz, David M., and Jonathan House. 1995. *When Titans Clashed: How the Red Army Stopped Hitler*. University Press of Kansas.

Glazkov 1989
Glazkov, Nikolai. 1989. *Izbrannoe*. Khudozhestvennaia literatura.

Goebbels 1935
Goebbels, Joseph. 1935. *Kommunismus ohne Maske*. 3rd ed. Zentralverlag der NSDAP.

Goldberg 1986
Goldberg, Vicki. 1986. *Margaret Bourke-White: A Biography*. Harper & Row.

Gombrich and Kris 1940
Gombrich, Ernst, and Ernst Kris. 1940. *Caricature*. Penguin.

Gorbunova 2009
Gorbunova, S. 2009. *Zusammenarbeit fur den sieg*. Zentrale Museum des Grossen Vaterlandischen Krieges.

Gorin 2003
Gorin, M. 2003. "Zoia Kosmodem'ianskaia (1923–1941)." *Otechestvennaia istoria* 1, p. 77.

Gor'kii 1953
Gor'kii, Maksim. 1953. *Sobranie sochinenii*. Gosudarstvennoe izdatel'stvo khudozhestvennoi literatury.

Gott and Weir 2005
Gott, Ted, and Kathryn Weir. 2005. *Kiss of the Beast: From Paris Salon to King Kong*. Exh. cat. Queensland Art Gallery Publishing.

Gough 2011
Gough, Maria. 2011. "Corps Concept." *Artforum* 49 (Feb.), pp. 172–74.

Grabar', Lazarev, and Kemenov 1964
Grabar', Igor, Viktor Lazarev, and Vladimir Kemenov. 1964. *Istoriia Russkogo Iskusstva*. Izd. Akademii Nauk SSSR.

Grayling 2006
Grayling, A. C. 2006. *Among Dead Cities: The History and Moral Legacy of the WWII Bombing of Civilians in Germany and Japan*. Bloomsbury.

Grimsted 2005
Grimsted, Patricia Kennedy. 2005. "Roads to Ratibor: Library and Archival Plunder by the Einsatzstab Reichleiter Rosenberg." *Holocaust and Genocide Studies* 19, 3 (Winter), pp. 390–458.

Grishunin 1976
Grishunin, A. 1976. "Istochniki i dvizhenie teksta. Printsipy izdaniia." In A. Tvardovskii, *Vasilii Terkin*, pp. 406–88. Nauka.

Groys 1992
Groys, Boris. 1992. *The Total Art of Stalinism: Avant-Garde, Aesthetic Dictatorship, and Beyond*. Princeton University Press.

Groys 1993
Groys, Boris. 1993. "The Soviet Poster: Art and Life." In *The Aesthetic Arsenal: Socialist Realism under Stalin*. Edited by Miranda Banks. Exh. cat., pp. 127–32. Institute for Contemporary Art, P.S. 1 Museum.

Groys 1996
Groys, Boris. 1996. "The Birth of Socialist Realism from the Spirit of the Russian Avant-Garde." In John E. Bowlt and Olga Matich, eds., *Laboratory of Dreams: The Russian Avant-Garde and Cultural Experiment*, pp. 193–218. Stanford University Press.

H

Hallward 1992
Hallward Library, University of Nottingham. 1992. *Soviet War Posters, c. 1940–1945*. Adam Matthew Publications.

Hamburg 1999
Hamburg Institute for Social Research, ed. 1999. *The German Army and Genocide, Crimes against War Prisoners, Jews, and Other Civilians in the East, 1939–1944*. New Press.

Hartung 1997
Hartung, Ulrike. 1997. *Raubzüge in der Sowjetunion: Das Sonderkommando Künsberg, 1941–1943*. Edition Temmen.

Heartfield 1994
Heartfield, John. 1994. "Born in the Flames of War." In *Alexander Zhitomirsky: Political Photomontage*. Exh. cat., p. 5. Robert Koch Gallery.

Hemingway 2002
Hemingway, Andrew. 2002. *Artists on the Left: American Artists and the Communist Movement, 1926–1956*. Yale University Press.

Henriot 1896
Henriot, Alexandre. 1896. *Catalogue de l'exposition d'affiches artistiques, françaises et étrangères, modernes et rétrospectives*. Exh. cat. Cirque de Reims.

Herf 2006
Herf, Jeffrey. 2006. *The Jewish Enemy: Nazi Propaganda during World War II and the Holocaust*. Belknap Press.

Heuss 1997
Heuss, Ajna. 1997. "Die 'Beuteorganisation' des auswartigen Amtes: Das Sonderkommando Kunsberg und der Kulturgutraube in der Sowjetunion." *Vierteljahrshefte für Zeitgeschicte* 45, 4 (Oct.), pp. 536–56.

Hindus 1933
Hindus, Maurice. 1933. *The Great Offensive*. H. Smith and R. Haas.

Hoopes 1985
Hoopes, Roy. 1985. *Ralph Ingersoll: A Biography*. Atheneum.

Howell 1996
Howell, Edgar M. 1996. *The Soviet Partisan Movement, 1941–1944*. Merriam Press.

Huxley and Haddon 1936
Huxley, Julian S., and A. C. Haddon. 1936. *We Europeans: A Survey of "Racial" Problems*. Harper.

I

Ianovskaia 2007
Ianovskaia, Galina. 2007. *Iskusstvo, den'gi, politika: khudozhnik v gody pozdnego stalinizma*. Permskii gosudarstvennyi universitet.

Iastrebov 1959
Iastrebov, Ivan. 1959. *Pavel Petrovich Sokolov-Skalia*. Sovvetskii khudozhnik.

Isserman 1993
Isserman, Maurice. 1993. *Which Side Were You On?: The American Communist Party during the Second World War*. University of Illinois Press.

Ivanitskii 1932
Ivanitskii, Ivan. 1932. *Izobrazitel'naia statistika venskii metod*. Ogiz-Izogiz.

J

Jahn 1995
Jahn, Hubertus. 1995. *Patriotic Culture in Russia during World War I*. Cornell University Press.

Jakobson 1997
Jakobson, Roman. 1997. "The Tasks of Artistic Propaganda." In *My Futurist Years*. Edited by Bengt Jangfeldt and Stephen Rudy, translated by Stephen Rudy, pp. 153–55. Marsilio Publishers.

James 1974
James, Robert Rhodes, ed. 1974. *Winston S. Churchill: His Complete Speeches, 1897–1963*. Vol. 6. Chelsea House Publishers.

Jolles 2005
Jolles, Adam. 2005. "Stalin's Talking Museums." *Oxford Art Journal* 28, 3 (Oct.), pp. 429–55.

K

Kamenetskii 1989
Kamenetskii, Ihor, ed. 1989. *The Tragedy of Vinnytsia: Materials on Stalin's Policy of Extermination in Ukraine during the Great Purge, 1936–1938*. Ukrainian Historical Association.

Kelly 2002
Kelly, Catriona. 2002. "'A Laboratory for the Manufacture of Proletarian Writers': The *Stengazeta* (Wall Newspaper), *Kul'turnost'* and the Language of Politics in the Early Soviet Period." *Europe-Asia Studies* 54 (June), pp. 573–602.

Kemenov 1943
Kemenov, Vladimir. 1943. "The Kukryniksy." *VOKS Bulletin* 8, pp. 46–56.

Keyssar and Pozner 1990
Keyssar, Helene, and Vladimir Pozner. 1990. *Remembering War: A US-Soviet Dialogue*. Oxford University Press.

Kharkevich 2008
Kharkevich, Ivan. 2008. *A Weapon of Counterpropaganda*. Kontakt-kul'tura.

Khudozniki 1941
Khudozniki Uzbekskoi, Kirgizskoi, Kazakhskoi SSR. Vystavka zhivopisi i grafiki. Katalog. 1941. Iskusstvo.

Kiaer 2005
Kiaer, Christina. 2005. "Was Socialist Realism Forced Labor? The Case of Aleksandr Deineka." *Oxford Art Journal* 28, 3 (Oct.), pp. 328–45.

Kirdecov and Moor 1931
Kirdecov, G., and Dmitrii Moor. 1931. *Kto oni takie? Kapitalisticheskii mir v 100 politicheskikh portretakh*. Krest'ianskaia gazeta.

Klutsis 1931
Klutsis, Gustav. 1931. "Fotomontazh kak novyi vid agitatsionnogo iskusstva." In *Izofront: Klassovaia bor'ba na fronte prostranstvennykh iskusstv; Sbornik statei ob'edineniia "Oktiabr."* Edited by Petr Novitskii. Ogiz-Izogiz.

Kolesnikova 2004
Kolesnikova, Larisa. 2004. *Khudozhnik Nikolai Denisovskii, 1901–1981: Katalog*. Gos. Muzei V. V. Maiakovskogo.

Kolesnikova 2005
Kolesnikova, Larisa. 2005. *"Okna TASS," 1941/1945: Oruzhie pobedy*. Bratishka.

Komashko Feb. 1, 1942
Komashko, A. "Otvetstvennomu rukovoditeliu TASS tov. Khavinson Iakovu Semenovichu. Dokladnaia zapiska. Ob otdeleniiakh 'Okon TASS,'" Feb. 1, 1942, f. 4459, op. 9–2, d. 62, ll. 73–75, GARF.

Kopelev 1977
Kopelev, Lev. 1977. *To Be Preserved Forever*. Edited and translated by Anthony Austin. Lippincott.

Kravets 1939
Kravets, Samuil. 1939. *Arkhitektura moskovskogo Metropolitena imeni L. M. Kaganovicha*. Izdatel'stvo Vsesoiuznoi Akademii Arkhitektury.

Krechetova 1966
Krechetova, E. 1966. "Govorit Moskva! ... Literaturnye peredachi vsesoiuznogo radio." *Literaturnoe nasledstvo* 78, 1, pp. 407–24.

L

Langa 2004
Langa, Helen. 2004. *Radical Art: Printmaking and the Left in 1930s New York*. University of California Press.

Le Men 1991
Le Men, Ségolène. 1991. "L'art de l'affiche à l'Exposition Universelle de 1889." *La Revue de la Bibliothèque Nationale* 40 (June), pp. 64–71.

Lenin 1965
Lenin, Vladimir. 1965. "The Character of Our Newspapers." In *Collected Works, Volume 28, July 1918–March 1919*. Edited and translated by Jim Riordan. Lawrence & Wishart.

Le Tissier 2009
Le Tissier, Tony. 2009. *The Siege of Küstrin, 1945: Gateway to Berlin*. Pen & Sword Military.

Leyda and Voynow 1982
Leyda, Jay, and Zina Voynow. 1982. *Eisenstein at Work*. Pantheon Books/Museum of Modern Art.

Liechtenhan 1998
Liechtenhan, Francine-Dominique. 1998. *Le Grand pillage: Du Butin des Nazis aux trophées des Soviétiques*. Ouest-France/Mémorial Caen Normandie pour la Paix.

Lindbergh 1970
Lindbergh, Charles A. 1970. *The Wartime Journals of Charles A. Lindbergh*. Harcourt, Brace, Jovanovich.

Lodder 1983
Lodder, Christina. 1983. *Russian Constructivism*. Yale University Press.

M

Macheret 1964
Macheret, Aleksandr, ed. 1964. *Sovetskie khudozhestvennye fil'my: annotirovannyi katalog*. Vol. 2. Iskusstvo.

Maiakovskii 1957
Maiakovskii, Vladimir. 1957. *Polnoe sobranie sochinenii*. Vol. 3. Goslitizdat.

Maiakovskii 1958
Maiakovskii, Vladimir. 1958. *Polnoe sobranie sochinenii*. Vol. 8. Goslitizdat.

Maiakovskii 1960
Maiakovskii, Vladimir. 1960. *Polnoe sobranie sochinenii*. Vol. 12. Gosudarstvennoe izdatel'stvo khudozhestvennoi literatury.

Maiakovskii 1975
Maiakovskii, Vladimir. 1975. *The Bedbug and Selected Poetry*. Edited by Patricia Blake, translated by Max Hayward and George Reavey. Indiana University Press.

Maiskii 1942
Maiskii, Ivan. 1942. "Introduction." In Francis Donald Klingender, *Russia – Britain's Ally, 1812–1942*, pp. 5–7. G. G. Harrap and Company.

Markov and Sparks 1967
Markov, Vladimir, and Merrill Sparks, eds. 1967. *Modern Russian Poetry: An Anthology with Verse Translations*. Bobbs-Merrill.

Maslennikov 2007
Maslennikov, Viktor. 2007. *Okna TASS, 1941–1945*. Kontakt-kul'tura.

Masta 1933
Masta, Ivan, ed. 1933. "Osnovy akhrovskoi ideologii i praktiki." In *Sovetskoe iskusstvo za 15 let: Materialy i dokumentatsiia*, pp. 359–62. Ogiz-Izogiz.

"Materialy o sozdanii" Jan. 1942
"Materialy o sozdanii sveto-okno TASS," Jan. 1942, f. 922, carton 1, ed. khr. 7, l. 1, Nikolai Denisovskii Papers, Department of Manuscripts, Russian State Library, Moscow.

Mazuy 2002
Mazuy, Rachel. 2002. *Croire plutôt que voir: Voyages en Russie soviétique, 1919–1939*. O. Jacob.

McFadden 1993
McFadden, David. 1993. *Alternative Paths: Soviets and Americans, 1917–1920*. Oxford University Press.

Merridale 2006
Merridale, Catherine. 2006. *Ivan's War: Life and Death in the Red Army, 1939–1945*. Metropolitan Books.

Munblit 1942
Munblit, G. 1942. "Neponiatye traditsii." *Literatura i iskusstvo* (Apr. 4), p. 4.

N

Nagorski 2007
Nagorski, Andrew. 2007. *The Greatest Battle: Stalin, Hitler, and the Desperate Struggle for Moscow That Changed the Course of World War II*. Simon and Schuster.

Nisbet 1987
Nisbet, Peter. 1987. *El Lissitzky, 1890–1941*. Exh. cat. Harvard University Art Museums/Busch-Reisinger Museum.

Novitskii 1931
Novitskii, Pavel. 1931. "Proletarskaia khudozhestvennaia kul'tura i burzhuaznaia reaktsiia." In *Izofront: Klassovaia bor'ba na fronte prostranstvennykh iskusstv; Sbornik statei ob'edineniia "Oktiabr."* Edited by Petr Novitskii. Ogiz-Izogiz.

P

Pasternak 1990
Pasternak, Boris. 1990. *The Voice of Prose: People and Propositions, Volume 2*. Edited by Christopher Barnes. Polygon.

Patenaude 2002
Patenaude, Bertrand M. 2002. *The Big Show in Bololand: The American Relief Expedition to Soviet Russia in the Famine of 1921*. Stanford University Press.

People's Verdict 1944
The People's Verdict: A Full Report of the Proceedings at the Krasnodar and Kharkov German Atrocity Trials. 1944. Hutchinson & Co., Ltd.

Petrov 1930
Petrov, Nikolai. 1930. *Svetovaia gazeta i diapozitivy dlia nee*. Aktsionernoe izdatel'skoe obshchestvo Ogonek.

Pisiotis 1995
Pisiotis, Argyrios K. 1995. "Images of Hate in the Art of War." In *Culture and Entertainment in Wartime Russia*. Edited by Richard Stites, pp. 141–56. Indiana University Press.

Plamper 2010
Plamper, Jan. 2010. *Alkhomiia vlasti. Kul't Stalina v izobrazitel'nom iskusstve*. Novoe literaturnoe obozrenie.

Polevoi 1947
Polevoi, Boris. 1947. *Povest' o nastoiashchem cheloveke*. Sovetskii pisatel'.

Polevoi 1957
Polevoi, Boris. 1957. *A Story about a Real Man*. 3rd ed. Progress Publishers.

Polonskii 1925
Polonskii, Viacheslav. 1925. *Russkii revoliutsionnyi plakat*. Gos. izd-vo.

R

Raskin 1963
Raskin, Aleksandr. 1963. "Nash strogii uchitel." In G. Munblit, *Vospominanii ob I. Il'fe i Evgenii Petrov, sbornik*. Sovetskii pisatel'.

Read and Fisher 1988
Read, Anthony, and David Fisher. 1988. *The Deadly Embrace: Hitler, Stalin, and the Nazi-Soviet Pact, 1939–1941*. Norton.

"Redaktsiia voenno-oboronnogo" n.d.
"Redaktsiia voenno-oboronnogo plakata 'Okna TASS.' Materialy o sozdanii sveto-okon TASS. Masterskaia 'Okna TASS.' Dokladnaia zapiska po voprosu sozdaniia proektsionnykh dinamicheskikh okon TASS. Kino-rezhisser: Znamenskii. Kino-inzhener: Markov," n.d., f. 922, carton 1, ed. khr. 7, l. 1, Nikolai Denisovskii Papers, Department of Manuscripts, Russian State Library, Moscow.

Reitblat 2005
Reitblat, Abram. 2005. "Glup li 'glupyi milord?'" In *Lubochnaia povest': Antologiia*, pp. 5–24. OGI.

Riutin 1990
Riutin, Martem'ian. 1990. "Stalin i krizis proletarskoi diktatury." *Izvestiia TsK KPSS* 9, pp. 165–83.

Roginskaia 1929
Roginskaia, Fainna. 1929. *Sovetskii lubok*. Izd-vo Assotsiatsii khudozhnikov Revoliutsii.

Ruegg and Hague 1993
Ruegg, Bob, and Arnold Hague. 1993. *Convoys to Russia: Allied Convoys and Naval Surface Operations in Arctic Waters, 1941–1945*. Rev. ed. World Ship Society.

S

Samoilenko 1977
Samoilenko, G. 1977. *Stikhotvornaia satira i iumor perioda Velikoi Otechestvennoi voiny*. Vyshcha shkola.

Saul 1991
Saul, Norman E. 1991. *Distant Friends: The United States and Russia, 1763–1867*. University Press of Kansas.

Saul 1996
Saul, Norman E. 1996. *Concord and Conflict: The United States and Russia, 1867–1914*. University Press of Kansas.

Saul 2001
Saul, Norman E. 2001. *War and Revolution: The United States and Russia, 1914–1921*. University Press of Kansas.

Saul 2006
Saul, Norman E. 2006. *Friends or Foes? The United States and Soviet Russia, 1921–1941*. University Press of Kansas.

Selivanova and Shkol'nyi 1995
Selivanova, I., and N. Shkol'nyi. 1995. *Leningradskie "Okna TASS," 1941–1945*. Rossiiskaia natsional'naia biblioteka.

Shatskikh 2007
Shatskikh, Aleksandra. 2007. *Vitebsk: The Life of Art*. Yale University Press.

Shiriaev 1941
Shiriaev. "Ob'iasnitel'naia zapiska k prikhodo-raskhodnoi smete 'Okna TASS' na IV kvartal 1941 goda," 1941, 4459, op. 9–2, d. 62, ll. 27–27ob, GARF.

Shklovskii 1972
Shklovskii, Viktor. 1972. *Mayakovsky and His Circle*. Edited and translated by Lily Feiler. Dodd, Mead, and Company.

Shumakov and Aleev 1985
Shumakov, A., and R. Aleev. 1985. *Plakaty Velikoi Otechestvennoi, 1941–1945*. Planeta.

Simon 1991
Simon, Gerhard. 1991. *Nationalism and Policy toward the Nationalities in the Soviet Union: From Totalitarian Dictatorship to Post-Stalinist Society*. Translated by Karen Forster and Oswald Forster. Westview Press.

Simpson 1998
Simpson, Pat. 1998. "On the Margins of Discourse? Visions of New Socialist Woman in Soviet Art, 1949–50." *Art History* 21 (June), pp. 247–67.

Slepyan 2006
Slepyan, Kenneth. 2006. *Stalin's Guerrillas: Soviet Partisans in World War II*. University Press of Kansas.

Snyder 2010
Snyder, Timothy. 2010. *Bloodlands: Europe between Hitler and Stalin*. Basic Books.

Soiuz sovetskikh arkhitektorov SSSR 1936
Soiuz sovetskikh arkhitektorov SSSR. 1936. *Voprosy sinteza iskusstv: Pervoe tvorcheskoe soveshchanie arkhitektorov, skul'ptorov, i zhivopistsev*. Ogiz-Izogiz.

Sokolov 1971
Sokolov, Nikolai. 1971. "S Kukryniksami." In *Ia dumal, chuvstvoval, ia zhil: Vospominaniia o S. Ia. Marshake*, pp. 216–17. Sovetskii pisatel'.

Sokolov-Skalia c. 1942
Sokolov-Skalia, Pavel. "'Tezisy dlia doklada na otkrytom zasedanii Orgkomiteta SSKh SSR' a vystavke sovetskogo plakata i 'Okon TASS' v Istoricheskom muzee," c. 1942, f. 922, k. 3, ed. khr. 10, ll. 1–7, Nikolai Denisovskii Papers, Department of Manuscripts, Russian State Library, Moscow.

"Soveshchaniia u t. Khavinsona" Feb. 6, 1942
"Soveshchaniia u t. Khavinsona s rabotnikami 'Okon TASS'," Feb. 6, 1942, f. 4459, k. 11, ed. khr. 1253, ll. 13–35, Nikolai Denisovskii Papers, Department of Manuscripts, Russian State Library, Moscow.

Sovetskii soiuz rabotnikov 1942
Sovetskii soiuz rabotnikov iskusstva i literatury. 1942. *A Protest against Fascist Vandalism: Report of Anti-Fascist Meeting of Soviet Workers in Art and Literature, Moscow*. Foreign Language Publishing House.

Spence 1991
Spence, Jonathan D. 1991. *The Search for Modern China*. Norton.

Stalin 1945
Stalin, Joseph. 1945. *The Great Patriotic War of the Soviet Union*. International Publishers.

Stalin 1951
Stalin, Joseph. 1951. *Sochineniia*. Vol. 13. Gosudarstvennoe izdatel'stvo politicheskoi literatury.

Stalin 1997
Stalin, Joseph. 1997. *Sochineniia*. Vol. 15. Izdatel'stvo pisatel'.

Stalin 2006
Stalin, Joseph. 2006. *Sochineniia*. Vol. 18. Informatsionno izdatel'skii tsentr Soiuz.

Stern 2007
Stern, Ludmilla. 2007. *Western Intellectuals and the Soviet Union, 1920–40: From Red Square to Left Bank*. Routledge.

Stratis and Zegers 2005
Stratis, Harriet K., and Peter Zegers. 2005. "Under a Watchful Eye: The Conservation of Soviet TASS-Window Posters." *Museum Studies* 31, 2, pp. 90–95.

Struk 2004
Struk, Janina. 2004. *Photographing the Holocaust: Interpretations of the Evidence*. I. B. Tauris.

Suslov 1990
Suslov, V., with N. Kashina and Dmitrii Oboznenko. 1990. *Vystavka plakatov Tvorcheskogo kollektiva leningradskikh khudozhnikov i poetov-satirikov "Boevoi karandash."* Khudozhnik RSFSR.

T

Taylor 1992
Taylor, Brandon. 1992. *Art and Literature under the Bolsheviks*. Vol. 2, *Authority and Revolution, 1924–1932*. Pluto Press.

"Tematicheskie razdely" Mar. 1942
"Tematicheskie razdely vystavki," Mar. 1942 [?], f. 4459, op. 11, d. 1253, l. 36, GARF.

Tikhonov 1972
Tikhonov, Nikolai. 1972. *Pisatel' i epokha: Vystupleniia, literaturnye zapisi, ocherki*. Sovetskii pisatel'.

Tillett 1969
Tillett, Lowell. 1969. *The Great Friendship: Soviet Historians on the Non-Russian Nationalities*. University of North Carolina Press.

Tumarkin 1997
Tumarkin, Nina. 1997. *Lenin Lives!: The Lenin Cult in Soviet Russia*. Harvard University Press.

Tvardovskii 1980
Tvardovskii, A. 1980. *Sobranie sochinenii*. Vol. 5. Khudozhestvennaia literatura.

U

Ungváry 2005
Ungváry, Krisztián. 2005. *The Siege of Budapest: One Hundred Days in World War II*. 2nd ed. Translated by Ladislaus Löb. Yale University Press.

United States 1946
United States Office of Chief of Counsel for the Prosecution of Axis Criminality, Department of State, and War Department, and International Military Tribunal. 1946. *Nazi Conspiracy and Aggression*. Vol. 8. US Government Printing Office.

Urvilova 1965
Urvilova, N., ed. 1965. "Okna TASS (Svodnyi katalog)." In *Trudy, Biblioteka SSSR imeni V. I. Lenina*. Vol. 8. Edited by I. Kondakov, pp. 163–339. Kniga.

V

Valiuzhenich 1993
Valiuzhenich, Anatolii. 1993. *Osip Maksimovich Brik: Materialy k biografii*. Niva.

Vladimirova 1992
Vladimirova, Elena. 1992. "Pis'mo [v TsK KPSS]." In *Magadanskii oblastnoi kraevedcheskii muzei. Kraevedcheskie zapiski*. Vol. 18, pp. 112–27. Upravlenie kul'tury Magadanskogo oblispolkoma.

Von Geldern and Stites 1995
Von Geldern, James, and Richard Stites, eds. 1995. *Mass Culture in Soviet Russia*. Indiana University Press.

W

Ward 2007
Ward, Alex, ed. 2007. *Power to the People: Early Soviet Propaganda Posters in The Israel Museum, Jerusalem*. Exh. cat. Israel Museum/Lund Humphries.

Waschik and Baburina 2003
Waschik, Klaus, and Nina Baburina. 2003. *Russische Plakatkunst des 20. Jahrhunderts: Werben für die Utopie*. Bietigheim-Bissingen.

Weinberg 1968
Weinberg, Sydney. 1968. "What to Tell America: The Writers' Quarrel in the Office of War Information." *Journal of American History* 55, 1 (June), pp. 73–89.

Werth 1942
Werth, Alexander. 1942. *Moscow '41*. H. Hamilton.

White 1988
White, Stephen. 1988. *The Bolshevik Poster*. Yale University Press.

White 2006
White, David Fairbanks. 2006. *Bitter Ocean: The Battle of the Atlantic, 1939–1945*. Simon and Schuster.

Whiting 1989
Whiting, Cécile. 1989. *Anti-Fascism in American Art*. Yale University Press.

Williams and Williams 1987
Williams, Reba, and Dave Williams. 1987. *American Screenprints*. National Academy of Design.

Woman in Berlin 2005
A Woman in Berlin: Eight Weeks in the Conquered City: A Diary. 2005. Translated by Philip Boehm. Metropolitan Books/Henry Holt.

Z

"Zamestitelu predsedatelia" June/July 1941
"Zamestitelu predsedatelia Soveta narodnykh kommissarov Soiuza SSR tov. Zemliachke R. S. Otvetstvennyi rukovoditel' TASS Ia. Khavinson," June/July 1941 [?], f. 4459, op. 9–2, d. 62, l. 19, GARF.

Zhukov 1939
Zhukov, Aleksandr. 1939. *Arkhitektura Vsesoiuznoi sel'skokhoziaistvennoi vystavki 1939 goda*. Izdatel'stvo Vsesoiuznoi Akademii Arkhitektury.

Zurier 1985
Zurier, Rebecca. 1985. *Art for the Masses (1911–1917): A Radical Magazine and Its Graphics*. Exh. cat. Yale University Art Gallery.

Zuschlag 1995
Zuschlag, Christoph. 1995. *"Entartete Kunst": Ausstellungsstrategien im Nazi-Deutschland*. Wernersche Verlagsgesellschaft.

Zuschlag 1997
Zuschlag, Christoph. 1997. "'Chambers of Horrors of Art' and 'Degenerate Art': On Censorship in the Visual Arts in Nazi Germany." In *Suspended License: Censorship and the Visual Arts*. Edited by Elizabeth C. Childs, pp. 210–34. University of Washington Press.

INDEX